Éric Rohmer

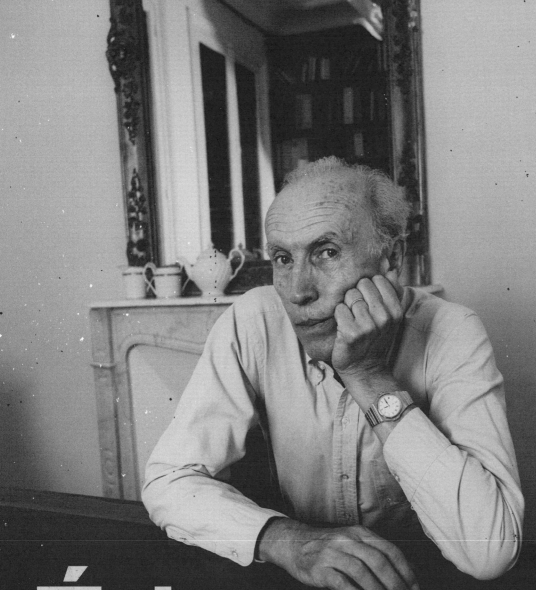

Éric
Rohmer:
A Biography

Antoine de Baecque
and Noël Herpe

Translated by Steven Rendall and Lisa Neal

Columbia University Press / New York

Columbia University Press
Publishers Since 1893
New York Chichester, West Sussex
cup.columbia.edu
Copyright © Editions Stock 2014
English translation © 2016 Columbia University Press

Library of Congress Cataloging-in-Publication Data
Names: Baecque, Antoine de author. | Herpe, Noël author. | Rendall, Steven,
 translator. | Neal, Lisa (Lisa Dow), translator.
Title: Éric Rohmer : a biography / Antoine de Baecque and Noël Herpe ;
 translated from the French by Steven Rendall and Lisa Neal.
Other titles: Éric Rohmer. English
Description: New York : Columbia University Press, 2016. | Includes
 bibliographical references and index. | Includes filmography.
Identifiers: LCCN 2015041586 | ISBN 9780231175586 (cloth)
Subjects: LCSH: Rohmer, Éric, 1920-2010. | Motion picture producers and
 directors—France—Biography.
Classification: LCC PN1998.3.R64 B3413 2016 | DDC 791.4302/33092—dc23
LC record available at http://lccn.loc.gov/2015041586

Columbia University Press books are printed on permanent
and durable acid-free paper.
Printed in the United States of America
c 10 9 8 7 6 5 4 3 2 1

Cover design: Andrew Kopietz
Cover image: © Robin Holland/Corbis Outline

Contents

Éric Rohmer

The Mysteries of "le grand Momo"

What do we know about Éric Rohmer?

Certain films are highly esteemed by film aficionados: *My Night at Maud's, Claire's Knee, The Marquise of O, Full Moon in Paris, A Tale of Summer, The Lady and the Duke* . . . A broader audience knows that Rohmer liked to film very young women—the so-called *Rohmériennes*—sometimes presenting them as symbols of the period, simultaneously charming, revelatory, and annoying. He also introduced a few actors who went on to have successful careers: Fabrice Luchini, Pascal Greggory, and others. Abroad, Rohmer seemed to embody a very French way of filmmaking.

But is it known, for example, that taken all together his twenty-five full-length films attracted more than eight million spectators in France, and several million more around the world? Éric Rohmer was not a pure product of Saint-Germain-des-Prés chic who made a limited number of films that were snobbish in a very Parisian way. In his work, sophisticated plots and delicacy of feeling went hand in hand with a classical ideal: their expression of emotions, their narratives, and their direction made his films capable of moving a broad audience while at the same time recording and expressing a certain atmosphere of the time in a critical or ironic mode.

Do people also know that another man, Maurice Schérer, was hidden behind the pseudonym Éric Rohmer, which he adopted when he was more than thirty years old? That was the source of the nickname—"le grand Momo"—that some of his oldest friends were to continue to use until the end of his life. He liked secrecy. More than that, it was probably the true passion of his

life: knowing how to conceal himself, creating doubts, remaining far from the spotlight. A pronounced penchant for playing with masks led him to invent doubles for himself; he took on alternate identities that allowed him to sow confusion regarding his private life, to protect his anonymity, and even sometimes to remain clandestine.

At the age of twenty-five, just after the war, he published a novel with Gallimard under the pseudonym Gilbert Cordier. Shortly after the war, he wrote articles on film and directed his first short films under another pseudonym, Éric Rohmer. A little later, in the mid-1960s, when Éric Rohmer was looking for work, he sent out a couple of CVs: in one of them, he was born in Nancy on April 4, 1920, while in another he was the son of "Louis Rohmer, professor," who after "studying at the lycée of Nancy and at the faculty of letters in Lyon," had pursued a career as a "professor of history and geography at a lycée."[1]

Most of these statements are false. This predilection for manipulation allowed him to cover his tracks. Rohmer maintained ambiguity with undisguised pleasure, and for a long time it was hard to assemble reliable facts concerning his private life. In 1986, entrusting to Gilles Jacob and Claude de Givray a few letters he had written to François Truffaut, he admitted to Givray: "In the event that you would like to publish passages in which reference is made, not to my articles on films but to me personally [. . .] I would ask that you seek my approval. Because, you know, I guard my secrets jealously, even the old ones."[2]

However, the secrecy he maintained did not conceal scandals, anti-conformist habits, or provocative commitments, and still less a complicated family romance or a closeted second emotional life. "My life has always been very ordinary. I have thoughts that everybody has,"[3] he wrote in one of the countless school notebooks he filled until the day he died with ideas, quotations, impressions, and memories of his reading. This secrecy seemed to him necessary, even if he liked to play with his masks: he was determined to protect his mother by hiding from her—until her death in 1970, after twenty years of make-believe—the fact that her son, who she thought was a professor of classics in a lycée, was one of the most admired French filmmakers. "That would have killed her,"[4] he assured a close friend. Maurice Schérer, a former professor of French, led an orderly life as a good son, good husband, and good father, a life into which Éric Rohmer never penetrated, preferring a more Bohemian and less respectable one spent in the company of starlets and dandies, the dream life seen on movie screens. However, on closer inspection, Éric Rohmer's life was not that of a brilliant seducer, either. When he

was asked the secret that allowed him to associate with all these ravishing creatures, he replied slyly: "Absolute chastity." If he liked listening to actresses, it was first of all in order to propose stories or scenarios to them and to subtly fit them into the geometry of his productions.

Éric Rohmer's critical writing is sometimes overlooked; he was one of the great critics and theoreticians of his time and the editor in chief of the *Cahiers du cinéma*. In 1955 he wrote a manifesto in five parts entitled "Celluloid and Marble," in which he stressed the importance and the influence of cinema: "Today one art possesses all the strength of this classicism and the splendid health that the other arts have lost forever." He thus legitimizes this major art and conceives the critic's role as residing in a "taste for beauty." Rohmer also enjoyed journalistic jousting and the polemics that surrounded films: he published a number of articles in *Arts*, the cultural weekly that was the Nouvelle Vague's iconoclastic, contrarian, and influential organ. In them we find a Rohmer who is fond of Westerns, defends Hollywood, and loves his actresses. A Rohmer who reacts to the films of his time, taking an opposing view, seeking to convince and to surprise a broad readership. He has to be restored to his place in critical thinking about the seventh art, and it must be emphasized that he is a genuine *écrivain de cinéma*.

If he liked to remain in the background, that is because he distrusted his own impulses and feared all kinds of excess. There is nothing more opposed to his character than the public display of an extremist or radical position. That did not prevent him from believing in values and affirming principles. Moreover, he enjoyed the discussion of ideas, the arts, and politics. He never hesitated to say that he was a conservative, seeing in the past a source of inspiration for the present and even for the future, and he long claimed to have a sensibility that was as royalist as it was Catholic. He was nevertheless not dogmatic: curiosity about the other, tolerance, and even a love for civilized contradiction and controversy define his cast of mind. This man of tradition and conversation was particularly sensitive to the arguments of militant ecologists and adopted them more and more overtly. He did not regard this as in any way incoherent on his part.

In June 2010, five months after his death, Éric Rohmer's family deposited his archives, as he had requested, at the IMEC (Institut mémoires de l'édition contemporaine). Of his ninety years of life, there remain almost one hundred and forty document boxes containing more than twenty thousand items. It is thanks to this impressive corpus that we have been able to retrace not only each

of Maurice Schérer's parallel lives—his simultaneous careers as a teacher, critic, movie-lover, writer, and filmmaker—but also his main apprenticeships, readings, references, correspondence, and revealing centers of interest.

At the heart of the artist's multiple activities documented by the Rohmer collection lies his work as a writer and as a filmmaker. Beginning in the early 1940s, we find manuscripts of narratives, short stories, and brief scenarios that testify to an intense activity as a writer and reappear in large measure in his later film scripts. Many films in Rohmer's great cycles (the *Moral Tales* and *Comedies and Proverbs*) drew on literary writings dating from fifteen, twenty, and sometimes thirty years before. The genealogy of Rohmer's films is thereby illuminated and renewed in depth.

The construction of the full-length films is also documented by this collection, which provides us with an opportunity to reconstitute Rohmer's work from beginning to end, from the conception, writing, filming, and direction of the actors to the reception of each of his works. As we follow this development, we will find that he undertook and filmed an initial full-length film as early as 1952, *Les Petites Filles modèles*, based on a story by the Countess of Ségur, which must henceforth be considered the very first Nouvelle Vague film.

In addition to making use of this treasure-house of documents, we also talked with members of the broad circle of friends or collaborators, technicians, artists, or intellectuals who worked with Éric Rohmer. More than a hundred people were consulted in the course of interviews carried out specially for our biographical investigation. These contributions, complementing those of the archives and our readings, testify to the extraordinary eclecticism of Rohmer's career, which includes stories, novels, plays, and literary criticism, as well as essays on cinema, literature, and music. Rohmer was not only a great film director but also a photographer, an illustrator, a designer of costumes and stage settings, and a composer of songs and music for his films. Thus we shall see the emergence of the portrait of a genuine one-man band who, though concerned about his complete independence, took his inspiration from the encounters elicited by his films and by the literary, pictorial, musical, and theatrical works that never ceased to feed his cinematographic projects.

In other words, we will discover Éric Rohmer as a secret man, as a complex personality, and as a well-rounded artist.

1
Maurice Schérer's Youth

1920–1945

Éric Rohmer was born Maurice Henri Joseph Schérer in Tulle, a manufacturing town in central France, on March 21, 1920.[1] His father's family came from Alsace, its main branch having earlier lived in Still, twenty kilometers west of Molsheim, in the foothills of the Vosges mountains. Since the middle of the nineteenth century, the men had worked either in crafts connected with the wine trade or in armaments manufacturing. An even older family tradition among Maurice Schérer's ancestors was black-smithing. The secondary branch of the family was from Lorraine, and lived in Château-Salins or Lafrimbolle in the department of Moselle. After the French defeat in 1870 and the annexation of Alsace-Lorraine by the German Empire, a considerable number of the Schérer's compatriots, who were patriotic Catholics, resettled in France. Maurice's grandfather, Laurent Schérer, a gunsmith, chose Tulle, where he found a job at the national armaments factory in the Souilhac quarter. He married Antoinette Vialle, a laundrywoman who came from a family that had long lived in Tulle. Her only son, Désiré Antoine Louis, born in 1877, was for many years the family's main support; declared unfit for military service in 1914, he became a department head at the prefecture. In 1919, after the death of his mother, he met and married Jeanne Marie Monzat, nine years his junior, the youngest of four daughters who came from Corrèze. Their grandfather owned a farm in Saint-Mexant; their father, born in Tulle in 1850, was a notary's clerk and an employee at the national treasury office. He took up residence on the street where the Schérers lived.

A Life in Tulle

Schérer's parents soon bought an old house in the style typical of the area, built in the late seventeenth century, tall and overlooking the banks of the Corrèze River. There Maurice and his brother René were born in 1920 and 1922 into a middle-class family that had risen socially, since its starting point had been lower-class on both sides; Désiré Schérer's father had been an artisan, his mother a peasant. Désiré, whose health was fragile, was an anxious, fearful man who was almost forty-five when his eldest son was born. He worked as a minor official in charge of the office of trades and commerce at the prefecture, which allowed his wife to stop working and raise the two boys. "It was not an upper-middle-class milieu," René Schérer noted. "But there was a little money, a house, a social status, and especially many traditions. An ordinary family, not even caught up in History."[2] The tradition combined Catholic observance with a Puritan family morality. In a city that was dominated by the moderate left and voted radical-socialist well into the 1940s, the Schérer family leaned toward conservatism, but never to excess. Its opinions, particularly in matters of politics and religion, were colored by royalist sentiments. Similarly, its culture was under Germanic influence, but its reflexes continued to be opposed to the German Empire, in memory of the humiliations suffered after the capitulation of 1870, and it quickly became anti-Hitler when dangers increased during the 1930s. That did not prevent the father, Désiré, from having to cope with rumors resulting from the foreign sound of his patronymic: he was accused of being "a Prussian" or even an "infiltrated spy" within the prefecture, as was alleged by Angèle Laval, the notorious Tulle informer and the author of a multitude of anonymous letters during the 1920s. Henri-Georges Clouzot took the inspiration for his film *Le Corbeau* from her.

Désiré and Jeanne Schérer were concerned about the future of their two sons and monitored their education closely. The three Monzat aunts, Jeanne's sisters, had strong personalities: they were all teachers in private schools, the two older sisters being secondary-school teachers of French at the École Sainte-Marie-Jeanne-d'Arc, and the third a primary-school teacher at the École Sévigné. The eldest, "Aunt Mathilde," played a role in the region as head of local associations and a columnist for the newspaper *L'Écho*. The youngest sister had three daughters, Régine, Geneviève, and Éliane, to whom the two Schérer sons were close during their childhood and adolescence.

This whole family group lived together in the home at 95, rue de la Barrière, a narrow lane that ran steeply uphill in front of the cathedral. The two maiden aunts occupied the two upper floors of this narrow, white, six-story building on the slope of one of the city's hills, squeezed between two other buildings of the same kind. The two lower levels, above a cobbler's shop that gave on the street, were occupied by the Schérers, while the intermediate fourth story opened onto a little garden located in back of the house; it had circular terraces on three levels that were covered with vegetation. On the other side of the wall surrounding the property, a path led toward the heights above the city and, a little further on, to the Lycée Edmond-Perrier, which Maurice and René attended. In the early 1940s, Maurice wrote about this path "crossing the Corrèze River by the Escurol bridge, and climbing the slope on the other side, no less steep."[3] The big house gradually filled up with the two boys' toys and possessions. They shared a bedroom and transformed the attic into a play space. The garden, poorly maintained and wild, was another important site of this shared childhood and youth, and aroused Schérer's early interest in nature. From the front of the house, the view extended to the Corrèze River below and to the hills across the valley, where the dense forest began. "When I was little," Éric Rohmer wrote later, "there was almost nothing between the house and the river. There was an embankment beside the river, and along it, a site where a Jesuit school had once stood [. . .] which was called 'the ruins.' In these ruins the neighborhood children went to play, especially 'the hooligans.' For in this city there was a subtle difference between the bourgeois and the workers: their houses were on the same streets but even as a little boy I could tell the difference between them. I knew that in the bourgeois houses the floor was waxed, and that it was not in the workers' homes; in one group people ate in the dining room, in the other they ate in the kitchen (because there was no dining room)."[4] Maurice and René Schérer were first of all boys from Tulle. Their attachment to the "city of seven hills," which was the seat of the prefecture of the department of Corrèze and had a population of fourteen thousand after the First World War, was deeply rooted. The city was neither particularly attractive nor terribly seductive: a quiet small town of industries and trades that lived on lace-making, armaments manufacturing, the Maugein accordion factory, and especially the imposing departmental administration and the garrison of the 100th Infantry Regiment; it was seldom given more than three or four lines in tourist brochures. "Tulle spreads its old quarter over the slopes of the hills, extending for three kilometers in the narrow, winding valley of the Corrèze, while at its heart

emerges the elegant stone spire of the Notre Dame cathedral."[5] The local glory was long the Tulle Sporting Club, the "blue and whites," a good rugby club that was soon rivaled and supplanted by the neighboring "black and whites" from Brive.

Maurice Schérer, a Tulle boy at heart, found other charms in his hometown—and preferred the athletic Union of Tulle-Corrèze, a basketball club, where he was a registered member. In his last years, Éric Rohmer took an interest in scholarly journals, the cartulary dating from the end of the ninth century, and archeological and historical works on the city—he was a member of the Society of Letters, Sciences, and Arts of Corrèze—and wrote two very learned works on the etymology of the city's name and on the complex hydrographic network of the region of "Tulle, goddess of the springs." We see in this Rohmer's attachment to his city. He had an intimate knowledge of it, based on regular walks, a knowledge more bodily and sensual than bookish: "The Tulle area is a lovely plateau, a peneplain easy to travel through, with a temperate climate, arable lands, rich in pastures, a plateau cut by the deep gorges of the Corrèze, Montane, Céronne, Solane, and Saint-Bonnette rivers, in which there is no traffic and no habitation, except in Tulle itself. The towns that are dotted along these gorges, Corrèze, Bar, and Aubazine, are perched on the heights, disdaining the lowlands. Tulle is the only town that is built in the valley."[6] For Tulle, Rohmer had the love of a "pedestrian geographer." As a boy and until late in his life, he loved to take the same walks through the leafy, steep forests to the falls at Gimel, on the Montane, and to the Moines canal, a beautiful aqueduct built near the eleventh-century Romanesque abbey, not far from the town of Aubazine. He even proposed another etymology for the name of the city: in the Limousin patois, "tuel" is supposed to translate to English as "hole." According to Rohmer's hypothesis, Tulle owes its name not to "tutelle" (trusteeship), as most historians of the region think, but to its unique function of providing access to the river, to its rare situation in the bottom of the valley. Thus for Rohmer, it is the topology of the terrain that makes it possible to reexamine history and its etymological assumptions.

The Roots of Early Passions

The two Schérer brothers received their primary and elementary education at the École Sévigné, a girls' school to which they were admitted thanks to the recommendation of their aunt, who taught there. They were good students and

continued their studies at the Lycée Edmond-Perrier, a large building dating from the end of the nineteenth century that was situated on the heights above the city, had extensive grounds, and could enroll as many as a thousand students. Maurice excelled in all his subjects; he was gifted in languages, took a keen interest in Latin and Greek, especially composition, and was a great reader, but he was also good in mathematics. His studies led him to a double baccalaureate in philosophy and mathematics, which he obtained with the very high average score of 17 in July 1937, at the age of seventeen. René did even better; he was an exceptional student who passed his examination at sixteen with a score of 18. Education was held in high regard by the family; "professors" were greatly esteemed by Désiré and Jeanne Schérer, who were themselves surrounded by teachers.

The two Schérer boys were excellent students and already extremely cultivated for their ages. Book culture was a high value for the family, and books were physically present in the living room and the father's study. Désiré worshipped certain authors—Émile Zola, Guy de Maupassant, Roland Dorgelès—and meticulously clipped articles from the book section of the *Figaro* newspaper. For their part, the two sons venerated Jules Verne and the Countess of Ségur; they had memorized by heart many passages from these authors. In the glass-fronted bookcase in the dining room stood the many volumes of the Nelson series, with white dust jackets and green bindings: Paul Claudel, Jules Sandeau, Alfred de Vigny, Victor Hugo, Pierre Loti, Rudyard Kipling, and all of Émile Erckmann and Alexandre Chatrian, the Alsatian duo. For the sentimental young Maurice, "the height of happiness," as he was later to confess to an actress in one of his films, was to "read a book with the woman with whom [he had] fallen in love."[7]

A familiarity with music, which also accompanied Rohmer throughout his life, came from one of his aunts, a former pianist who taught the young man to play the piano on the fifth floor of the house. When he discussed his childhood, Rohmer played down the extent of this musical education: "I learned the piano only vaguely, and with great difficulty; I didn't get beyond the elementary stage. Even at twenty I couldn't play with both hands! [. . .] Moreover, I don't have a very good ear. Nonetheless, I like music, and I like to learn how it is made."[8]

Finally, both Maurice and René Schérer had a talent for drawing and painting. "He was very good at portraits," René says, "at that time he had a better mastery of the techniques of watercolor and oil than I did."[9] In the house in Tulle, there are still many drawings and small paintings, most of them made by René in

the garden during vacations. Rohmer later wrote that he had approached paint-ing through "schoolbooks that reproduced the paintings in black and white. [. . .] I enjoyed recopying in watercolors the works of Raphael and Rembrandt that I admired (on larger surfaces, and thanks to the system of gridding, which allowed relative exactitude)."[10]

However, the future Rohmer's initial passion was undeniably the theater. First of all, there was the municipal theater, which was unusual with its large sculpted-wood doors, its bright colors, and its architecture in the Moorish style, which the Schérer brothers attended during the Baret tours that brought the Paris repertoire to the provinces. There were also the shows that Maurice himself produced very early on. At the Lycée Edmond-Perrier, with the help of the Latin professor, M. Margaux, he translated, adapted, produced, and acted, along with a few friends, Virgil's first Eclogue. Maurice, wearing a tunic, played Meliboeus, already taking on "a shepherd's air."[11] Then he produced George Bernard Shaw's *Pygmalion*, in which he was seen smoking a pipe with his younger brother, while the latter's first words were "We need two rooms." Then came Goethe's *Wilhelm Meister*, retranslated and adapted with the German professor. In each case, these end-of-the-year shows met with a clear success, as did the recitations Maurice declaimed before an admiring audience: whole speeches from Racine, Molière, and Corneille learned by heart. With his cousins, he produced *La Farce de Maî-tre Pathelin*, which he himself adapted from the octosyllabic verses of the late medieval play. At the age of fourteen, he made some of the costumes and stage settings and, according to his brother, proved to be "very punctilious regarding the production."[12] The inspiration derived from the Middle Ages was decisive and common to the Schérer brothers; it may have been connected with the motifs of the wallpaper of the staircase in the family home, which depicted medieval knights. These theatrical productions presented in the house's attic reached their high point the following year, 1935, with *Le Neveu du Baron de Crac*, adapted from the eponymous novel published by Pierre Henri Cami in 1927. All this was taken very seriously; there were many and assiduous rehearsals and strict and carefully thought-out stage directions: Maurice discovered an original vocation as a director. He adored this little theater of his own creation.

The only art that hardly influenced the young man at all was film. His par-ents disliked and mistrusted it. Tulle's cinemas were few in number and attracted small or unsavory audiences, and Rohmer, much later, could remember only three films that played a role in his childhood:

I discovered the cinema very late. My parents did not take me there. The very first time I saw films was on the square in Tulle, little silent films projected with a device cranked by hand! As for fictional films, when I was ten years old the whole family went to see *Ben Hur*, with Ramón Novarro, at the end of the silent film era. I liked it, but I wasn't enthusiastic. A short time afterward, we went to see a sound film, *L'Aiglon*, because my parents admired Edmond Rostand. With my father, I must have also seen *Tartarin de Tarascon*, which I didn't like at all. I also remember that I had to write a composition in high school on the question "Which do you prefer, the theater or the cinema?" I replied, of course, "The theater."[13]

The Student and the War

At the beginning of the school year in September 1937, Maurice Schérer went to Paris to attend the Lycée Henri IV, to which he had been admitted on the basis of his record. There he prepared for the competitive examination for admission to the École normale supérieure (ENS). He was a boarder; his parents, who were worried about him, expected the school to supervise him closely. The boy from the provinces was hardworking and his life revolved almost entirely around his classes and studying for them. He worked hard in Latin and Greek, and also in German. The professors were demanding, and Maurice was not quite up to the level of the best of his fellow students, but rather right in the middle of a class that included the cream of the students in literature. Despite this heavy workload, the young man got to know Paris and the Latin Quarter. Rohmer related this revelation which made him forever loyal to the fifth arrondissement:

> For you, the inhabitants of the Latin Quarter, I am the anonymous neighbor who tirelessly roams the old streets and is always finding more savor in them because they correspond to my deep love for an ancestral Paris. I am sensitive to the map of a city in which I find its soul and its past, even more than in its buildings themselves, and here I breathe in the aroma of the "Mountain." I need the layout of the winding streets, not yet spoiled, and I have no attachments elsewhere in Paris. I love urban journeys and I have never thought that in a city one is obliged to return home always by the same route. My taste for this

quarter has never changed, and although I have moved several times, I have never lived in another one. There is a harmony in this quarter that retains its university life, even if it has been somewhat adulterated by tourism. . . . Here, I came to study in [the lycée] Henri IV's splendid preparatory course, about which I am still nostalgic. I even made a film there, *Le Signe du Lion*, which took place near Notre Dame and the rue Mouffetard.[14]

There was in fact a nostalgia in Rohmer's relationship with the heart of his student existence: throughout his life, he remained a member of Henri IV's alumni association. And even though he did not like to appear in public, on October 20, 1990, at the age of seventy, he attended an alumni ceremony at the school.

Another discovery made in Paris: great literature that circulated from bed to bed in the dormitory of the preparatory students at Henri IV. "At Henri IV, I began to read what might be called the 'great authors,'" he recalls in an interview.

An older student gave me, though I was a beginner, the first volume of *À la recherche du temps perdu*. Proust enthralled me. Then the same student gave me *La Chartreuse de Parme*, which put me off a little. Then I read *Le Rouge et le Noir*, which I found easier. So far as Balzac is concerned, I had read a collection of extracts but none of his great novels. So I took everything and read it in order, volume by volume, in the lycée's library. I also remember having read a lot of Goethe, in German.[15]

In Paris, there was also an initiatory moment for music, even if the boy had already played the piano with his aunt in Tulle: "My discovery of music dates more or less from the year I turned nineteen, when I was at the Lycée Henri IV and had music-loving friends."[16] Phonograph records were passed around, as were musical scores and books about Mozart, Bach, and Beethoven.

But the main focus of the preparatory courses was philosophy. Maurice was intrigued by the challenge, discovered the work of the philosopher and teacher Alain, which impressed him greatly, as he noted:

When I was doing my preparatory course existentialism was getting underway. Heidegger had just been translated into French, and people were beginning to talk about him. Those who influenced me the most were certainly the existentialist and metaphysician Louis Lavelle, with a book I still have, *La Conscience*

de soi, and then, of course, Alain. Alain was surely the one who shaped me most, through the teaching of Michel Alexandre, who was his disciple. There is a book by Alain that I find exciting, *Histoire de mes pensées*. And then his *Idées*, which served me as a kind of breviary: Plato, Descartes, Hegel, and Auguste Comte . . . I think I remained a Cartesian in Alain's sense. I did not advance any further.[17]

As for films, Maurice, who was still only a novice in that area, discovered them at the Studio des Ursulines, a small historic theater near the Luxembourg Palace. "There I encountered what was shortly afterward called *le cinéma d'auteur*," Rohmer goes on, "with René Clair and with Georg Wilhelm Pabst's *Threepenny Opera*, which had a strong impact on me."[18] Elsewhere in the Latin Quarter, at the Cluny, the Studio du Val-de-Grace, and the Champo, which had just opened in April 1938, Maurice saw films by Jean Renoir, Marcel Carné's *Le Quai des brumes*, which he admired a great deal, some American films that interested him little, and Frank Capra's *It Happened One Night*, "the first Hollywood comedy I liked."[19] However, though these two years of preparatory classes were intensely formative, both deepening his studies and allowing him to discover Paris and the arts, they ended with a twofold failure: in 1939 Maurice passed the examination for admission to the ENS on the rue d'Ulm, but failed the oral examination in July. The following year, which was disrupted by the war, he took the written examination in the spring, but did not receive the results until November 29: he was not accepted.

In early May 1940, immediately after he had taken the written examination, Maurice was drafted into the French army, which had been ready and waiting for the enemy for the past year. But the "phony war" turned into a blitzkrieg, and the young apprentice soldier did not have time to take part in the French campaign before it was already lost. To the great relief of his frightened parents, he was demobilized at the barracks in Valence where he had arrived on June 9, 1940 for training before joining an artillery battalion. On June 10, he wrote to them: "I'm waiting. I don't know for what, though. I think we'll have a lot of free time; but what I need most is space. There are a few math majors here who have not yet taken the oral examination at the [École] Polytechnique."[20] Between June 1940 and January 1941, the young man and his parents corresponded frequently, writing almost fifty letters and notes that allow us to follow the itinerary of a student buffeted by the vagaries of a war that had broken out on the other side of France—but which quickly caught up with him.[21]

"Here are a few details," he wrote the next day, June 11.

In fact, here there is nothing but details: we are advancing more or less randomly, at least so it seems to me. We aren't doing much of anything, and at first I was afraid I'd be bored. But fortunately I brought along something to read. Up to that point, I hadn't worked, for the examination, I mean. But it might be easier than I thought. The noise is too loud and too indistinct to be a problem. And we have to find something to do, because we've been told that it is forbidden to leave the barracks for two weeks. In short, I'm not too bored. My comrades are very nice; the food is scant, but rather good in quality. Like the food at Henri IV but less abundant and probably less varied. The meals are epic, or rather bucolic, since we eat them outside. I'll try to study a little German and history despite the small number of books I have with me.[22]

Maurice's main concern was not really his country, which was breaking apart: he did not know that on June 10, the government had fled to Bordeaux, that Paris had been rapidly occupied by German troops, that millions of French people were engaged in an enormous exodus, that the National Assembly was soon to grant Marshal Pétain plenary powers. In his barracks in Valence, he was thinking primarily about the competitive examination for the ENS and the oral exams for which he had to prepare with what he had on hand, without knowing whether he would be accepted or even if the examinations would take place. After the French defeat and the armistice signed at Rethondes on June 22, Schérer was demobilized, but he remained in a military "youth group," one of the disarmed battalions in which the ex-soldiers were sent from camp to camp under the surveillance of French police supervised by the Germans before they returned to civilian life.

Thus between June 23 and June 27, Maurice Schérer and his comrades from Valence were transferred by train to the Barcarès camp, twenty kilometers north of Perpignan, which had formerly been used as a concentration camp for Spanish Republicans. He remained there for three weeks, during which he was chiefly worried about receiving a few books (Montaigne, Claudel, Rilke, and Charles Morgan were the ones he wanted), a little money to buy chocolate, cookies, and fruit. He pored over his lycée history textbook (Malet and Isaac) and played lots of sports (soccer, gymnastics on the beach, daily swims in the Mediterranean). Then he was sent with his group to Bompas, covering about twenty kilometers on foot. On July 15 the young men were housed in a group of farmhouses on a hillside,

surrounded by grapevines. Maurice lived in the "pistachio-colored house." Life there was very peaceful, even pleasant in the lovely Catalan countryside drenched in summer sun. "We do anything we want here," he wrote on July 18. "We walk all day long, eating peaches given us by the peasants."²³ It was difficult to prepare for an oral examination under such conditions, with no books or study guides and amid demobilized youths.

> Maurice started drawing and painting, using materials he found at hand, and sent his parents several sketches of landscapes. During a walk in Perpignan, he made the fabulous acquisition of beautiful art books on Picasso and Matisse. For him, this initiation into modern painting was an important event: "I came to know it through reproductions: for example, in a city in the south of France where Parisians had taken refuge from the Germans. [. . .] One might have thought that at such a time, only current events interested people! I happened to walk past a bookstore where a drawing by Jean Cocteau was displayed, and I found it amusing. [. . .] But there was also a book with reproductions of works by an artist whose name I knew. [. . .] It was Van Gogh, and I was thrilled! A little later, as I made the rounds of the bookstores in another provincial city, I discovered a book with reproductions of paintings by Picasso and a preface by the critic Jean Cassou. In it I read a sentence that made a great impression on me: the author said Picasso was our time's greatest creator of forms. I re-used this sentence in my book on Hitchcock. [. . .] Still later, in a bookstore in the same city, [. . .] I saw reproductions of Matisse's latest works. They also inspired an extraordinary feeling in me."²⁴

In mid-August 1940, the former soldiers moved again: they were transferred to the barracks in Mont-Louis, higher up, and henceforth had to maintain the roads in the region: "Swinging a pickaxe half the day, playing various sports the other half, along with military exercises without weapons, since it was absolutely necessary to keep us busy. The group is becoming more and more a work camp,"²⁵ he wrote disconsolately on September 13; he could no longer either read or paint. At the end of the month, Maurice and his group crossed Languedoc again to set up near Lodève, in the department of L'Hérault, in a stony, bare land. It was there that he remained the longest, for four months, during which earthmoving work took priority over reading and studying for examinations. "It's not worth the trouble to send the big Racine, which is bulky and incomplete," he wrote on November 11. "I would prefer *Phèdre* and *Bérénice* in the Petit Larousse edition. But this is not a place where I will be able to undertake serious and sustained

work. I'm too tired by the pickaxes and stones. From time to time, I do a little Latin, and I see that it's of little use. I haven't yet forgotten enough for intermittent work to be of any benefit to me!"[26]

Once he had learned, on November 29, that he had not been admitted to the ENS, the young man was unsure what to do, after two failed attempts: "I wonder if I will try a third time?"[27] He asked himself where he could pursue his studies: should he return to occupied Paris? Go to Clermont-Ferrand, near his parents, who had been living there since his father's retirement in 1939? Or to Lyon, where the two Schérer brothers could prepare for admission to the ENS, René for the first time, Maurice for the third? On January 31, 1941, when it was snowing in the Hérault, Maurice Schérer was freed of his military obligations and left youth group number 24, along with a classmate from Henri IV, the future *normalien* Henri Coulet, who was to become a university professor and an excellent specialist on the novel under the ancien régime. The trip was long and complicated, but two days later he arrived in Clermont-Ferrand, where his parents and his brother met him at the train station.

Désiré and Jeanne Schérer had moved into a gloomy apartment in the old city, at 20, rue du Général Delzons. But their elder son learned to love this city, seduced by its austerity and roughness, the black color of the volcanic stone from which it was built, and the mountains that surround it. It was there that he was to make, almost thirty years later, *Ma nuit chez Maud*, a film that testifies to the topographical and sentimental interest Rohmer took in the capital of the Massif Central. The two brothers chose to lodge together in a small house near the place de Jaude, in the rue Rameau and pursued their studies there. René was doing his initial year of preparation at the city's lycée, while Maurice was working on his *licence-ès-lettres classiques* at the university, where he had a few very good professors who had come from Strasbourg (whose university had moved to Clermont-Ferrand after the German invasion), particularly Pierre Boutang, a young royalist philosopher who was then a fervent supporter of Marshal Pétain and who was to have an enduring influence on Maurice by his energy, his taste for arts and letters, his ferocious writing, and his metaphysics. Music was equally important: "I'd rented an apartment in Clermont," Rohmer later wrote, "where there was a radio, and I listened to lectures on musicology. It was also on the radio [. . .] that I listened to a program broadcast every morning: Jean Witold's 'The Great Musicians.' I also listened to others, those of the music critic Émile Vuillermoz and the composer Roland-Manuel."[28] Maurice's musical culture was becoming deeper.

The following year, the Schérer brothers took up residence, again together, near Lyon, in a small attic room in Villeurbanne. René was preparing at the Lycée du Parc for the ENS admission examination, and Maurice was preparing to take the agrégation examination while at the same time earning a little money as a monitor at the Lycée Ampère, where he could also live, and in a warm place to boot. Their life was difficult and impoverished, but intellectually stimulating because they were in contact with a group that had a strong influence on them. This group was composed of disciples of the philosopher Alain—the Hellenist Maurice Lacroix, the Rousseau specialist Jean Thomas, the latinist Marcel Bizos, the philosopher Michel Alexandre and his wife Madeleine, and the writer Jean Guéhenno (the latter two men had been Maurice's teachers at Henri IV). The two students also participated in a small group of dissidents close to the Resistance, of which Lyon was then the heart: the people associated with the magazine *Confluences*, the philosopher Jean-François Revel, the future historian specializing in Jean Jaurès, Madeleine Rebérioux, the illustrator Jean Paldacci, and others. In the spring of 1943, after a year of intensive study, René Schérer was admitted to the ENS, while his elder brother passed the written examination for the *agrégation* in classics, but once again failed the oral examination, which was a dreadful trial for the anxious boy whose shyness was sometimes crippling. On the other hand, he succeeded in passing the CAPES examination in classics, which enabled him to teach in secondary schools.

In the fall of 1943 the Schérer brothers went to study in Paris. René, who was now twenty-one, became a boarder at the ENS rue d'Ulm; Maurice, who was twenty-three, found a furnished room at the Hôtel de Lutèce, at 4, rue Victor-Cousin, which he kept for about fifteen years. The hotel was run by a colorful tenant, Mlle Cordier, to whom he paid his rent regularly each month and who became fond of him. Small, austere, furnished with a single bed, a small desk, and a large armoire, the room lacked charm, but at least its occupant was once again living where he wanted to, in the heart of the Latin Quarter. Maurice often joined his younger brother at the rue d'Ulm, where they encountered or re-encountered a brilliant intellectual milieu that greatly impressed them: Pierre Boutang, who had come from Clermont-Ferrand to teach at the ENS; Maurice Clave; Jean-François Revel; Jean-Louis Bory; and Jean-Toussaint Desanti, who entered the ENS the same year as René, and whom Maurice had known at Henri IV. Through Revel, they also became acquainted with Marc Zuorro, who taught at the Lycée Janson-de-Sailly and whom Revel describes as

a "very handsome dandy, quite brilliant, provocative, and homosexual";²⁹ for a time, he absolutely fascinated the Schérers.

Financially, life was not easy; it was full of everyday privations, loneliness, lack of privacy, and work. There were a few small pleasures—several French films that influenced the young man, including Jean Delannoy's *L'Éternel Retour* and Jacques Becker's *Falbalas*; the books the brothers exchanged or that were circulating in their little group, Dostoyevsky, Balzac, Proust, Malraux, Sartre, Alain; and a radio playing classical music and programs on music. There were also sports; with the Sorbonne literature students' athletic association, the tall and slender Maurice Schérer regularly engaged in running, high-jumping, and especially basketball at the stadium in Montparnasse. Everything else was beyond his means: no restaurants, parties, cafés, theaters, or concerts; all that was too expensive. This life in a garret, more mean than romantic, more well-behaved than Bohemian, resembles the one that Rohmer was to portray from time to time in his films, such as *La Boulangère de Monceau*, *La Carrière de Suzanne*, and *Une étudiante d'aujourd'hui*, or short films such as *Rendez-vous de Paris* and *Quatre aventures de Reinette et Mirabelle*. It was a Spartan existence oscillating between student poverty and artistic mysticism: "With the magnificent naïveté of my youth," the filmmaker later confessed, "I had taken it into my head to practice a kind of asceticism as rigorous as that of the cubist painters whom I was getting to know through pale black-and-white reproductions, a rigor that was at that time also practiced by the twelve-tone composers of the Vienna school, who I didn't even know existed."³⁰

"I didn't hang out with female students, or with many male students, for that matter. I didn't see a lot of people," he later admitted. "It was a rather dreary life, rather dull, rather lonely, in which studying was the most important thing."³¹ However, he did have a young woman friend, Odette Sennedot, whom René Schérer describes as "very tall and beautiful."³² Between 1943 and the early 1950s, she regularly came to rue Victor-Cousin to talk or have tea at 5 P.M., a ritual that was already established in Maurice Schérer's life. He met her at a dinner at the home of Marc Zuorro, whose student she had been at Janson-de-Sailly. Right after the war, she became a stewardess for Air France, an occupation and a position that was very prestigious at the time. A photograph taken in July 1948 shows her in her dress uniform, helping Golda Meir, who was in New York collecting funds for the new state of Israel, to get on a plane leaving for Paris. Elegant, slender, brunette, impeccably turned out, she seems to incarnate a very French

kind of feminine distinction. The young man was greatly infatuated with her, but it was a platonic love: long letters to Odette Sennedot, from 1943 to the end of the war, testify to this infatuation whose most fervent expression seems to have taken the form of reading together the novel Maurice was writing, which was largely inspired by this affectionate but inaccessible muse.[33]

Oddly, the war and the Occupation have little place in Éric Rohmer's memories, or even in his work. It has to be assumed that he passed through them without wanting to look at them too much, and especially without getting involved in them. The young man may have cultivated close relations with the Resistance during the few months he spent in Lyon, and in Paris he may have associated with people who were attracted by collaboration, but he always refused to abandon a reserve probably inherited from his father, Désiré Schérer, a loyal government official, Catholic and conservative, a patriot of Alsatian origin who harbored anti-German feelings while at the same time laying claim to his German heritage. The Schérers were always wary of Pétainism, but they never showed any adherence to Gaullism. Neither Resistance nor collaboration.

However, a few events of the war shook up the young Maurice Schérer and strengthened his rejection of commitment, which he considered an excessive, partisan, and not very reasonable stance. During the night of June 8, 1944, the SS division Das Reich, which was moving north under the command of General Lammerding, entered Tulle, which had been liberated the day before. The repression was ferocious: ninety-nine people were hanged from the city's balconies, and one hundred forty-one others were deported, a hundred and one of whom would never return. Désiré and Jeanne Schérer, who had moved into their home in Tulle shortly before, told their son about this tragedy they had witnessed. The young man was deeply shocked,[34] just as he was terrified a few weeks later by the reprisals taken against collaborators in the city. Violence, no matter what kind—physical, psychological, political, ideological—or where it came from, was unbearable for him: he always remained absolutely nonviolent.

On two occasions during the summer of 1944 in Paris and its surroundings, he was more directly confronted by this brutality of history. These experiences are more limited, even cowardly, but they are also more personal, and they left their mark on Maurice Schérer. Relying on tips provided by one of René's classmates in philosophy, in mid-June the brothers set out on bicycles to buy eggs in Les Andelys. On the way, at Château-Gaillard, they encountered machine-gun fire and were then arrested by a German patrol because without knowing it they

had entered a forbidden, dangerous zone. They spent the night under surveillance in the offices of the Milice (French collaborationist militia) in Évreux, the neighboring town, because they were suspected of espionage at a time when, the landing in Normandy having already taken place, the occupying forces were constantly on edge.[35] Two months later, Allied troops were in Paris, and Maurice Schérer wanted to forget the fighting so that he could complete his novel, *Élisabeth*, in peace: "That book was written under fire," he recalled with a certain irony regarding his general lack of involvement in the present, even when it was historical and at its most exhilarating. "Bullets were whistling past my window. When Paris was liberated in August 1944, I was living in a hotel in the Latin Quarter, near the rue Soufflot, where several skirmishes occurred. It was at precisely that point that I was writing *Élisabeth*, stuck in my room, not daring to look out the window. At the same time, I was asking myself: 'Is it possible to write about present events?' My answer was: 'No, it isn't; you have to have some distance on them.' And my opinion on that point hasn't changed much."[36]

Two Brothers

Maurice and René Schérer, born two years apart, were very close. There are a dozen photographs of them taken during their childhood:[37] both boys are long-limbed, delicate and slender, classy, with almost feminine features marked by a certain haughtiness despite their smiles for the camera. But whereas René is small and was to remain so, with a miniature body, Maurice grew to be tall, with long, thin legs generally covered by cotton trousers and spindly arms emerging from a light-colored short-sleeved shirt, the whole making an impression of well-groomed elegance that suggests neither the endurance nor the athletic ability that less obviously characterized his powerful body. These middle-class children cultivated the appearance of the upper middle-class, and at least aspired to an aristocratic way of life and culture. What is also striking in these photographs is Maurice's concern for his younger brother: his arm is wrapped protectively around the boy, his hand on his shoulder or back: these gestures indicate the gentle care and attentive love also expressed in the way he passed books, objects, and knowledge to René. The two boys are often dressed in the same way, but the smaller one is always in front, in the first row, the orchestra seat, whereas the elder boy is behind, keeping watch over him. In a drawing

bearing the inscription "René Schérer, 1942,"[38] Maurice gave his brother a delicate, angelic face, and we can see in this the same concern for him, an idealizing kindness. Was little René the better of the two Schérer boys? Some photos taken during their adolescence might suggest that, since the relationship between the two seems to be reversed: René becomes the protector. At that time their relation changed, the younger brother teaching, training, transmitting to the elder abilities he did not have.

The better of the two Schérer boys? That was what their parents thought, especially the mother, who was so fearful and protective. It was clear to the family that René was intellectually superior: he rapidly became the brains of the family, the one who succeeded and was destined to go far, the one who added new rungs to the revered ladder of professorial ascension. A Schérer began as a schoolteacher, a low-level official, a department head, and became a professor in a private lycée and then a public lycée—that was the level Maurice reached, and that was not bad—but René was to pursue the dream as far as the prestige of a university professorship. Their test scores corroborated this family romance: Maurice Schérer was a very good student, but René was better, that was all there was to it. René entered the ENS at the age of twenty-one, whereas his elder brother failed three times in a row, at nineteen, twenty, and twenty-two; René launched a brilliant career in philosophical research while Maurice twice failed the examination for the Agrégration in classics, first in 1943 and then again in 1947, and this wounded him deeply. He failed all the important oral examinations he took between the ages of nineteen and twenty-seven, a sign indicating a lack of charisma combined with a great shyness and, on top of that, a halting way of speaking, an uneven, unclear delivery that sometimes verged on stammering. Everything considered, Maurice's performance as a student was far from shameful, to be sure: he earned a *licence-ès-lettres*, qualified as a teacher, and was twice allowed to take the examination for the *agrégation* in classics. But he was left frustrated, doomed to hold the laborious position of a certified teacher of Latin and Greek in a secondary school.

However, he never complained. He was neither jealous of his brother nor resentful of his parents, and he was not bitter against the system. No doubt that was a sign of pride: there is no room for bemoaning one's fate when one will accept nothing less than success. Confronted by his younger brother's success, he felt nothing but affection, protectiveness, and even pride. "He had great admiration for study, for knowledge," René Schérer writes. Teaching suited him, but

his two failures on the *agrégation* examination left him scarred. I think that if he had succeeded, he might not have had a career as a writer, and still less as a filmmaker. The most traditional kind of success would have amply satisfied him. Right up to the end, he regretted not having had a university career. He did not dream of being a Bohemian, or have a firm vocation as an artist or writer. On the other hand, after his relative academic failure, he had to shift much of his ambition to literature and cinema. Becoming a writer, being a filmmaker, represented a kind of revenge."[39] The two brothers never quarreled, and their bond remained extremely solid and perceptible: "We didn't agree about everything," René Schérer goes on. "We sometimes argued. I was more open, progressive, left-leaning, prepared to take risks; he was more conservative, prudent, traditional. I recognized my homosexuality quite early on, whereas he could not even utter the word, so foreign did all that seem to him—he spoke of 'esthetes.' All this could have divided us as early as the 1940s. But I believe that until I was twenty-five I never went a month without seeing him. We shared a sensibility: a love of beauty, the capacity to be moved by artworks, a common expression of what we felt at that time."[40]

The Schérer brothers' closeness was based on an ongoing communication: readings, writings, discussions, viewing and talking about art, a kind of fraternal maieutics, a philosophical friendship. A few fragments of this communication remain, letters dated from 1940 and 1941, during the few weeks the two brothers were separated, the younger writing a paper on Rousseau's novel, *La Nouvelle Héloise* at the University of Clermont-Ferrand, the elder being drafted into the army and then discharged in southern France. On August 3, 1940, Maurice commented on the drawings René had sent him: "There's a certain style, an original style, and that's what matters. I think you should continue along this line."[41] Their conversation continued, regarding the masters that the two brothers discovered at that time, especially Picasso. The elder brother concluded, referring to his own case: "I've never yet painted anything except an atrocious gouache. You have to travel at least three kilometers to find anything interesting. I await your comments on the smallest sketches. As for myself, I've found a few new ideas."[42] Ten days later, Maurice reacted to his brother's remarks and initiated a philosophical discussion of art: "I also believe that the idea can be grasped only in contact with the real. The value of a work of art does not derive from its metaphysical ambitions: there is no being without appearance, in painting any more than elsewhere. The work of art is self-sufficient, that is the great lesson taught

us by Picasso. We arrive at a pure art (the true art for art's sake) in which it is no longer a matter of depicting but of painting. And that is how we return to classicism."[43] In these letters we find, in addition to Rohmer's notion of a cyclical return of modern art toward its own classicism, a theme that is found in most of his writings on cinema, a touching consideration for his brother's ideas and works. "You've shown me," he wrote in November 1940, that what I wrote on my examination last year was incomplete and stupid in many respects. It's through these letters that I feel I am making progress and am not confronting hostilities all alone. I'm deeply grateful to you for that."[44]

A few weeks later, when they were back in Clermont-Ferrand and had decided to live together, this collaboration grew still more intense. Together, they wrote little essays on aesthetics and short fictional narratives arising from their conversations about literature and the novels they were rapidly going through, inventing a system of shared marginal annotations, a kind of "roped reading" that René calls "our common writings."[45] The authors they confronted in this way belonged to them and were to influence Maurice in his literary ventures— particularly the British author George Meredith and the Americans John Dos Passos and William Faulkner. Here we see the profoundly creative aspect of this close fraternal relationship. This core of deep friendship was inalterable. Even when they were far away from each other, as they were in the 1950s when René Schérer was teaching in Algeria, and even though they took completely separate, contradictory paths—René as the spokesperson for a libertarian philosophy, a defender of homosexuality as a mode of thought as much as a way of life, professor at the University of Paris-Vincennes, which was the center of an academic counterculture—or when confronting adversity—for example, in 1982, when René Schérer was indicted in a child sex abuse case on the charge of "inciting minors to debauchery"—their bonds were never broken.

The two brothers continued to read each other's writings, to see each other, and to follow each other's careers. They supported, helped, and promoted one another when that seemed called for. They remained brothers for life. They also remained sons, each taking care of their parents, whom they knew were more fragile than they: "My dear Maurice," René wrote from Algiers in December 1950, "could you send me a razor, a couple of shirts, and ties? I am living very frugally here. Are you going to Tulle for Christmas? I beg you, my dear brother, be as kind as you can to Papa and Mama, and reassure them regarding my fate. Affectionately, . . . "[46]

First Works, or How to Find One's Way

When Maurice Schérer was not yet nineteen years old, he was already showing precocious signs of creative abilities. Drawings, paintings, notes for a novel, short stories, then a first real novel, completed in July 1944 and published in April 1946 by Gallimard under the title *Élisabeth* and the pseudonym Gilbert Cordier.

The most substantial signs of artistic ability were pictorial. Between 1940 and 1942, Maurice Schérer made a number of sketches, drawings, and small-format paintings in oils or watercolors. He made "copies," of a few Picassos reproduced in color, for example, *La Femme au chat*, and a Matisse-like *Le Carnaval des femmes*, as well as experiments in the manner of Gauguin, Cézanne, or Van Gogh that allowed him to become familiar with the masters. This work was accompanied by a historical and theoretical investigation; he wrote critical studies such as the one on Jean Dubuffet in 1944, as is shown by a letter from the poet Francis Ponge, the editor of the weekly *Action* dated November 29 of that year, thanking him for his article. It was "accepted by our editorial committee," but "we do not yet know in which issue it will appear."[47] Never, it seems, and no further trace of this article has been found.

Maurice's favorite kind of painting was the portrait, and especially sketches of women in pencil, pastel, felt pen, and even ballpoint. About twenty of them still exist:[48] studies of faces, legs, or breasts, with titles such as *Desire*, *Seduction*, *Innocence*, *Envy*, and *Avarice*, dating from 1945, portraits of his brother René, landscapes in the cubist style, and a few overtly erotic works drawn in violet-colored ink. All this testifies to a certain graphic ease in a young artist who did not hesitate, either then or later on, to sketch out his characters, ideas, and situations on a sheet of paper.

The archives of Maurice Schérer's youth also contain many poems, mainly love poems devoted to the various parts of the female body. Generally dated from late 1942 and 1943, these verses correspond to the time he spent studying in Lyon and seem to have been in part the result of a collective composition or competition among young poets, since we also find texts signed by René Schérer or Jean-François Revel, who was Maurice's schoolmate at the Lycée du Parc. Taken together, all this resembles a lover's breviary, with precepts ("To love, one has to know how to keep quiet"[49]), slightly misogynist remarks ("I cease here the tedious enumeration of the qualities necessary in any woman"[50]), and

particular dedications ("You are the joyous ardor of victory"[51]). Finally, a few amorous embraces add spice to these youthful verses, such as those in "Vers toi me voici maintenant porté," (1943) or "Aimer de ton corps et de l'ardeur": "Dont tes yeux mis à part et l'éclat de tes lèvres / Ton ventre et ta joue et tes jambes / Lisses et plates comme une surface d'eau / Comme une petite partie de vague montante / Porter hisser dans l'air durci / La perfection immédiate de ta beauté."[52] The other poetic inspiration is death, the author lingering with melancholy over his own dying body in "Une ombre sur ma jambe a dessiné des veines": "Les fleurs qui germeront de mon sang sont livides / Je vis, je vis encor mais vivrai-je demain? / Mon coeur est noir de sang mes artères sont vides / Et les rayons de mai s'étreignent dans mes mains."[53] Éric Rohmer was never to give up these poetic exercises, but he later practiced them in a more playful, even juvenile way, or in the form of refrains and ritornellos, abandoning the romantic, dark, erotic, somewhat conventional inspiration of his youth.

In early 1939, when he was eighteen, Maurice Schérer signed his first plans, notes, and manuscript notes describing fictional characters and situations, thus testifying to his taste for writing, and indeed to his ambition to become a novelist. On the back of one of his Latin compositions dated February 13, 1939, he wrote a summary of a story entitled "Le Glorieux," subtitled "Trois mois de vacances" (The glorious one: Three months' vacation), and sketched in a few lines the portraits of three characters: Simone, Maud, and Max.[54]

Another text, undated but probably written a few months later, summarizes a more disturbing, even perverse plot and atmosphere under the Sadian title "The Misfortunes of Virtue": "That evening, chance had brought together the three characters in this story. Wanda, Franz, and Gertrud did not yet know each other. They soon acquired the habit of luxury and desire. Franz savored both his solitude and his power. Insensitive to scorn, Wanda loved Franz but patiently awaited his defeat. Too aware of her beauty to expect anything from chance, Gertrud was intoxicated by his indifference. But in the case of Gertrud, humiliation turned an evening's desire into a passion that daily grew more demanding. For her, the very purity of their love was the cruelest of offenses."[55] After many twists and turns in desire, the story concludes with these two abrupt but sentimental lines: "'Kiss me,' Gertrud said to Franz. Dazzled by their happiness, they contemplated each other for a moment, unmoving. And this was their first kiss."[56]

Soon thereafter came three densely written short stories of eight, nineteen, and twenty-five handwritten pages, dating from July or December 1943. "Carrelage"

(Tiling), the first, relates in a long monologue Gim's confession to Rolande regarding a young blonde woman he had admired near a pond, and whose whole existence he imagined on the basis of the way in which she entered the water—her poses, her manners, her airs, the straps and folds of her white swimsuit.[57] The second story, "Fin de journée" (End of the day),[58] is also connected with water and the friendly and amorous games played in the water. The action takes place on the banks of a river in the department of Pyrénées-Orientales, above Perpignan, in an enchanting setting bathed in summer heat, and brings together "kids" who come for the most part from Toulouse or Narbonne. A young duo lives secluded in a beautiful house deeper in the mountains. The group's plan is to go visit them. The play of glances, sentimental dialogues, convoluted and nebulous intrigues, swims, walks, and dances, shy caresses and flaunted haughtiness, sudden explosions of storms and the violence of feelings, even brutal and inappropriate acts, but especially detailed descriptions of attitudes, appearances, actions (eating a plum and spitting out the pit, smoking a cigarette on a seaside terrace, preparing for and attending a ball)—all this creates a universe signed with the pseudonym Gilbert Cordier—which appeared a few months later on the cover of Schérer's first novel, which included a number of elements from this short story, though the setting had been moved to the banks of the Marne, near Paris. "Une journée (A day),[59] the third, somewhat more developed tale, recounts the story of Gérard and Annie, an independent couple whose misadventures and dialogues oddly anticipate Rohmer's film *The Aviator's Wife*.

Then come the first publications signed "Maurice Schérer": two further short stories, "La Demande en mariage" (The marriage proposal) in *Espale*, a review published in Clermont-Ferrand, in early 1945, and "Le Savon" (The bar of soap), a minimalist chronicle of a flirtation that appeared in *La Nef* in September 1948. The first of these stories, set in a humble milieu of farmers, milliners, and café waiters, has as its subject the pathological timidity of a man named Roger Mathias, who dares not declare his love to Janine, the young woman he is seeing. He watches her, spies on her, breaks into her apartment when she is at the movies, is literally obsessed with her, until finally it is she who, by chance and abruptly, in the course of a anodyne conversation, proposes marriage.[60] This thirty-page narrative in dialogue can also be seen as a distant origin of *The Aviator's Wife*.

A last short story, "Rue Monge,"[61] a manuscript of forty-two pages dated August 1944, was to have a cinematic sequel as well. By chance, the narrator, a lonely young man wandering around Paris during the summer of 1943, meets

in rue Monge a woman he does not know. He is immediately certain that she will become his wife. He courts her insistently, but in the meantime he spends a night at the home of Maud, a seductive woman who is elegant, cultivated, and libertine. However, he continues to see the other woman, whom he ends up marrying. *My Night at Maud's* is already there, situated in the Latin Quarter in Paris and not in Clermont-Ferrand, twenty-five years before it was made.

At the age of twenty-four, in June and July 1944, Maurice Schérer put the finishing touches on the manuscript of a three-hundred-page novel entitled *Élisabeth*. He had begun it five years earlier, even before the war began, because the first traces of "Début de rupture" (The beginning of a breakup)[62] and "Pluie d'été" (Summer rain),[63] the two original titles, date from March 15, 1939, and consist of a manuscript summary with seven rubrics.[64] In addition, there are notes on the characters of Élisabeth, Michel, Claire, and Irène, as well as a few words on specific situations and lines of dialogue written down on paper. If Schérer labored for more than five years on this first novel, that is probably because it was for him a kind of revenge, as he himself suggests in a later interview.[65] His ambition to be a writer, even if it usually remains unacknowledged—his brother René mentions that he never heard his elder brother openly declare his literary vocation[66]—remained the only thing that allowed him to overcome the disappointments and humiliations of having failed his examinations and to cope with the pain of seeing others—his friends, his younger brother—succeed where he had not. It was the novel and literature in general that played this role, not cinema. It is noteworthy that at this point in his life Maurice Schérer had not produced a single film project, outline of a scenario, or stage direction. He was not a movie lover, because at the age of twenty-five he had seen only a few dozen films in all—and the ones he liked and remembered could be counted on the fingers of his two hands. Cinema was not a major factor in his youth, as it was for his future companions in the New Wave. At the same age, in the middle of the 1950s, Truffaut, Rivette, Chabrol, and Godard had probably seen thousands of films, organized film clubs, and written dozens of articles on cinema.

Élisabeth is a "novel of manners"[67] whose plot amounts to almost nothing: Dr. Roby lives with his wife Élisabeth, the caretaker of a lovely estate in Percy, near Meaux. In the summer of 1939 (the date is scarcely mentioned) their son Bernard, who is studying medicine in Lyon, comes home for vacation. He finds there his younger sister, Marité, his cousin, Claire, and two girls of her age, Huguette and Jacqueline, who are fickle and like to dance and flirt, as well

as a family friend, Michel, who is supposed to marry Irène, an older widow. Organized in three parts, the text revolves around these characters, avoiding transitions and traditional connections, advancing through short scenes of dialogue or description that are deliberately flat, and ends by weaving an indirect chronicle of the appearances and feelings of these summertime quadrilles. On two occasions, the anodyne turns into an uneasy abruptness, as when a character is seized by a fit of fury and almost rapes a young girl, or when Michel is gripped by hatred and scorn with regard to his mistress Irène, saying to himself over and over: "I hate her." Every character thus seems to have his own version of a group portrait on vacation and of the depiction of a place, Élisabeth's big house, of which we see only fragments in a complex and fragmented mirror.

Sensitivity to light, to temperature variations, to the caprices of climate and souls, reinforces this impressionism, this pointillism of tone and style. This is shown by the titles of certain chapters, ("Late Afternoon," "During the Rain," "Morning Thoughts"), descriptions ("The swimsuit she had been wearing three days ago in the meadow made her hips look fat, but dressed, she retained that somewhat rangy light-footedness that made her look like a small, jumping animal"), droll remarks ("If you're here to flirt, you're wasting your time!"), or a few sarcastic assertions ("Resembling a little girl doesn't make a woman look any younger"). Maurice Schérer took his time planning, writing, and rewriting this delicate ballistics of amorous approaches, these sentimental shimmerings, this gravity in writing about things that are nonetheless lightweight. The work is not entirely convincing because it smells of the lamp. The influences and readings of his youth sometimes make themselves felt too explicitly. For example, echoes of the Countess of Ségur can be heard in the dialogues and the situations of these children playing at being adults. But that makes the book extremely revealing. We glimpse Colette in the descriptions of nature and summer ambience, the gardens at the waterside, the flowers and fruits that open up and imprint their tastes, their colors, their smells. And the André Gide of *The Counterfeiters*, in the multiplication of the various characters' points of view, casting doubt on reality and linear narration. Finally and above all, the young man's initial attempt is deeply colored by the new American novel in the style of John Dos Passos (*Manhattan Transfer* and certain passages in *The Big Money*) or William Faulkner (the beginning of *Sanctuary*): the dry transparency of the narrative resulting from the disappearance of an omniscient point of view and the objectivity of the description of behavior and actions, characters being sometimes almost transformed

into objects. Rohmer later acknowledged his debt: "The clearest influence is the American novelists I had just discovered, in particular Dos Passos, on whom Jean-Paul Sartre had published an article in the *Nouvelle Revue Française* that I found impressive. These authors interested me not only by their content but also by their form, by their behaviorist way of describing things."[68]

In this sense, *Élisabeth* is a contemporary novel, which is paradoxical for a work that was written in the middle of the war but never mentions it, a work that avoids the very imperious reality of its troubled time. The contemporary context of *Élisabeth* is more stylistic and intellectual, it is the literary world of a postwar period full of novels that dared to experiment with new, less traditional, more descriptive ways of writing. A pre-Nouveau Roman context to which Rohmer was to lay claim: "In a certain way, I think *Élisabeth* was situated in a trend that anticipated the Nouveau Roman, though it remained very far from it on many points."[69] So that it can be said that of all the "new novels" of 1945 and 1946 to which it is related—Jean-Paul Sartre's *Âge de la raison*, Roger Vailland's *Drôle de jeu*, Raymond Queneau's *Loin de Rueil*, Julien Gracq's *Un beau ténébreux*, Claude Simon's *Le Tricheur*, and Jean-Louis Bory's *Mon village à l'heure allemande*—the one to which *Élisabeth* is the closest is Marguérite Duras's *La Vie tranquille*.[70]

"Claire's knee formed, beyond the sharp line of the dress, a small dark brilliant triangle," writes the author of *Élisabeth* (p. 131). This simple fetish suffices to indicate the Rohmerian posterity of a first novel that cannot be considered either decisive or important, but which occupies an interesting place in the genesis of the work to come. In the meantime, the young man concludes his novel with these lines: "Today Claire has put on a very flared pleated royal blue skirt that comes down just as far as her knee. She uncrosses her legs, holds out her hand, and violently drums the tips of her fingers on her skirt and rubs the fabric, pinching it. She withdraws her hand, puts the book on her belly, leans forward and lifts her skirt up to her thigh: she looks and scratches with a fingernail. She pulls down her skirt, crosses her legs, and begins to read."[71] Then, on the first of the three school notebooks[72] that comprise this manuscript, Maurice Schérer used a black pen to draw the *NRF*'s logo. His dream of being a writer was thus written in capital letters.

2

From Schérer to Rohmer

1945–1957

The publication of *Élisabeth* by Gallimard in April 1946 was a failure. Very few sales, no reviews; the novel went unnoticed. Maurice Schérer had used the pseudonym Gilbert Cordier, perhaps a wink at his landlady at the Hôtel de Lutèce, whose name was also Cordier, though this may be a mere accident.

The failure was painful, another nonrecognition, but the young man recovered by taking a dislike to this first novel. "After having written *Élisabeth* I detested that novel, I wanted to distance myself from it because it seemed to me sterile. [. . .] I therefore changed, I felt myself closer to nineteenth-century authors; for example, to Herman Melville, whom I was reading at that time."[1] The notes he wrote at that period on sheets of paper or in school notebooks reveal the hesitations of this young man who was trying to find himself and seemed to be out of sync with his contemporaries.

A Literary Postwar Period

Many of his contemporaries were in fact taking part in carrying out the tasks, often political and cultural, facing a country that had just been liberated and was trying to recover from the misfortunes of the war. There is none of that in Maurice Schérer's writing: no trace of current events, for instance, in the newspaper cuttings he was beginning to collect. In periodicals like *Combat*, *Samedi Soir*, and *France Dimanche*, he focused chiefly on human interest stories, reports on

society life, articles on art and music, and a few columns or editorials by André Malraux, Camus, or Sartre; or again, whole pages from *L'Équipe* on foot races and Marcel Hansenne, who had established himself as one of the "great 800-meter runners"[2] in the competition for the first postwar Olympic medal, awarded in 1948 in London. Maurice Schérer was inclined toward "disengagement."[3] The young man remained well-groomed, as can be seen in two pictures from the period, a photograph in which he looks directly at the camera, wearing a velvet vest and a carefully knotted tie, affecting a great reserve,[4] and a drawing with delicate lines in which he almost disappears behind a profound melancholy.[5]

At twenty-five, the longtime student had to think about his future. He took classes at the Sorbonne to prepare for another attempt at the *agrégation* in classics but once again failed the oral examination in July 1947. He henceforth had the status of "bi-admissible," which was granted to those who had twice passed the written examination for the *agrégation*. In September 1946 he found a position as a substitute teacher at the Collège Sainte-Barbe. For his first assignment, he shouldered a relatively heavy load: two groups of students in classical Greek and Latin language and literature, *seconde* and *première*, in this prestigious private lycée (Sainte-Barbe was founded in the sixteenth century and is the oldest secondary school in Paris), a red-and-white brick building on the Montagne Sainte-Geneviève, very close to his lodgings, where teachers had pupils who later became well-known, such as Christian Marquand, Pierre Lhomme, and Claude Lelouch. It was during his five years there that Rohmer's pedagogical vocation was born, supplemented by jobs as an academic coach at the Montaigne and Lakanal lycées.

Teaching was always a clear value for him, and his only goal was to provide his pupils with a solid foundation in the classics. He also professed an unconditional devotion to Latin and Greek. In a speech given at the award ceremony at Sainte-Barbe at the end of the 1948 school year, he declared himself proud to belong to "the battalion of Latinists" and promoted the dead language to the rank of an instrument of general culture, against the extreme specialization of modern society:

> It is a cultural tool, to be sure, but a tool of a refined form of culture reserved for the few. With it, we do not live entirely in our own time . . . and is that a bad thing? Mastering Latin is less a privilege than a mission, to pass it on from generation to generation. Along with the mathematical problem, it remains the

best criterion of intelligence available to us. It is a gymnastics of the mind just as essential as physical exercise to the body. Latin allows us to keep the messiness of life out of our schools.[6]

The Latin language, like the young professor doing it homage, has good manners. In the conclusion of this speech, a very Rohmerian idea already appears in Schérer the schoolteacher: "Let us free ancient authors from commentaries, from the welter of sophisms and clichés. Let us get to know them as they were; let us seek to discover in what way they were modern and resemble us."[7] Addressing his students, the professor advocates a rediscovery of tradition in the present. In other words, tradition is the true modernity: "The sense of balance, of harmony, suggests that we respect tradition in its contemporary aspects."[8]

In February 1945 Maurice Schérer made an important acquaintance, the first in a series that was to reorient his intellectual vocation. At the Café Flore he boldly sat down at the table of a man who was younger than he but already famous, Alexandre Astruc.[9] Astruc had made a name for himself as a journalist and was one of the most promising authors at the time. In 1942 and 1943 he had published articles about the cinema that appeared in *Confluence* and *Poésie 42*; then in the spring of 1944, at the age of 21, he joined the staff of *Franc-tireur*, Georges Altman's daily. Finally, he wrote for *Combat*, Albert Camus's paper, that "horrible paper that I read every morning," as General de Gaulle put it. Astruc acquired a reputation both political and literary through his reviews and articles (notably on the prosecution of collaborationists, and in particular Robert Brasillach's trial for collaboration with the Nazis, which began on January 19, 1945), the critical pieces he contributed to *L'Écran français*, and his novel published by Gallimard, *Les Vacances* (1945). What fascinated Schérer was not only the younger man's insolent literary facility but also his independence of mind, which allowed him to claim to be a "right-wing writer" at a time when everyone was supposed to be left wing, and an ability to gather around him an intellectual and artistic group within which he moved with incomparable ease. In return Astruc discerned in Schérer a mixture of erudition and analytic depth that impressed him. Long, almost daily, conversations transformed this acquaintance into a friendship. They discussed Balzac, Poe, literature in general, and politics—far more than they discussed films and filmmaking.

Astruc brought Schérer into the heart of Saint-Germain-des-Prés, an astonishing encounter between the shy young man with a classical culture, more

inclined to be a passive spectator than a party animal, and a world lived in an essentially extroverted and exuberant way. At the Café de Flore and the Club Saint-Germain, Astruc introduced Maurice Schérer to his friends—the red-haired poet Anne-Marie Cazalis, his companion and muse, and Juliette Gréco, who was not yet a singer or actress but was already a muse in plaid pants. Schérer reconnected with Pierre Boutang, whose subtle mind, shaped by Aristotle, Plato, Heidegger, Faulkner, and the rhetoric of Charles Maurras, he henceforth regularly mined. He also met there other authors published by Gallimard, Raymond Queneau and Jean-Paul Sartre (who considered Astruc brilliant and published him in *Le Temps modernes*), who were prepared to look with favor on everyone the younger man recommended to them. Schérer was undeniably influenced by Sartre at this time. He read Sartre's articles on Dos Passos, Faulkner, recent American literature, and on Husserl and phenomenology, which were reprinted in *Situations I* in 1947, and also *L'Imaginaire*, a phenomenological psychology of the imagination (1940), as well as the famous 1945 lecture "Existentialisme est un humanisme." As Schérer later willingly admitted, he saw the world "through Sartre's eyes,"[10] with that phenomenological attention to objects, to bodies, and to natural and social existence. "If you wish to follow my aesthetic and ideological itinerary, it begins with Jean-Paul Sartre's existentialism, which put its stamp on me at the outset," he told Jean Narboni in a 1983 interview. "I never talk about Sartre but he was nonetheless my point of departure."[11] Sartre's *L'Imaginaire* is crucial in Rohmer's intellectual development—as it was in that of André Bazin[12]—because it connects art with ontology. Art shows, it neither writes nor describes ex nihilo: therein lies its truth value, which alone can lead toward the imaginary.

The microcosm of Saint-Germain-des-Prés was a first-class laboratory for Maurice Schérer because there the theory and practice of a whole little world was elaborated in common. In the future filmmaker's archives, we find several traces of this interest, for example, a two-page spread cut out of *Samedi Soir* in 1947, "Here is how the troglodytes of Saint-Germain-des-Prés live,"[13] a report from the cellars, tribes, and sanctums of Saint-Germain-des-Prés written in the style of an ethnographic expedition. In 1952 Rohmer even made it the subject of one of his first film projects, entitled *Poucette et la légende de Saint-Germain-des-Prés*. This illustrates his precocious acuity in occupying the position of a witness to his time, mediating between documentary and analysis. The film is conceived in the form of a twelve-minute report whose outside scenes were to be

strictly documentary and filmed from real life. Only the inside sequences were to be acted. Poucette is a "young woman in Saint-Germain": she has written a novel, *De vraies jeunes filles* (Real girls), and spends every evening making drawings in cafés and cellars while at the same time keeping a record of her nights. In a sidewalk café she meets a young American who is conducting an investigation for his sociology thesis ("The Saint-Germain-des-Prés phenomenon and its effects on French youth"). She tells him about the peculiarities of the area, going to see places (La Pergola, Le Pouilly, Le Mabillon, Le Royal, La Polka, Le Village), prominent figures (Adamov, Giacometti, Pépita, Cazalis), rituals (a cellar, a band, couples dancing be-bop), and then taking him to her place for a final interview. The filmmaker presents his project as an investigation. Rohmer's art, situated between a love story ("The 1948 girl is the most pleasing form of woman"[14]), documentary verism (the flirting ritual in cafés), and voyeuristic fiction, is located at an equal distance from three poles: the document, empathy, and criticism.

An Extraordinary Figure

Thanks to a former regimental comrade from Mulhouse met by chance at a firemen's ball at the place Maubert on July 14, 1947, Maurice Schérer made another acquaintance that proved decisive: Paul Gégauff.[15] Gégauff was born in 1922 in Blotzheim near Mulhouse into a rather well-off Protestant family. He was hardly a brilliant student; his education was essentially autodidactic, focusing on the piano, which he played perfectly. When Alsace was annexed to the Reich as a German province on August 6, 1940, the young man was forced to perform his military service in a Nazi paramilitary group. At the same time he published his first work, a libertine tale entitled *Burlesque* and published by the J. Barbe publishing house, which had withdrawn from Mulhouse to Lyon. With his mother he left Alsace and took refuge on the Côte d'Azur, where he spent most of the war before moving to Paris immediately after the Liberation. There Gégauff, a handsome young man, blond, delicate, with deep blue eyes, sponged off old ladies whom he took out and entertained, frequented high society in Montparnasse and Saint-Germain-des-Prés, squandered the family inheritance, and established his reputation in a few scandals. He later talked about a great costume ball at the Rose Rouge cabaret held in 1946. "Most people came as parish priests or

nuns; I came in an SS officer's uniform. It was the Scandal Ball and indeed I made a scandal! But wasn't that the point?"[16] In Gégauff's case, this provocation went as far as anti-Semitic excesses that had been displayed as early as 1940 in his tale *Burlesque*. That is the misfortune, the damnation, and the desperate grandeur of Paul Gégauff: he could create only *against*, out of a deep antipathy toward intellectuals, conformism, and other people in general.

Gégauff never tired of mocking the postwar world, ridiculing every kind of commitment, demolishing its literary glories and its left-wing sensibilities, resolutely garbing himself in the dubious guise of the anti-conformist. His affected inflexibility, his unfashionable elegance—the military haircut, the oversize shirt collars—constituted the finery of this young man living in scandalous garments. What was fascinating about him was a manner situated between a supreme casualness and an ostentatious affectation, a distinction simultaneously natural and artificial, an exaggerated, brilliant, cutting voice, with intonations bordering on hypocrisy, or haughty, arrogant murmurs. This confirms the impression of a person oscillating between perpetual self-representation and a dandy-like indolence that comes close to the art of living. "What attracted us to him," Rohmer was later to say, "was a calm, nonchalant side associated with a certain insolence, whereas we were rather uptight. If we had a provocative side, it was the provocation of the timid. In him it was a title of nobility."[17] The last prestigious quality attributed to Paul Gégauff was being loved by women. He was a party animal who inhabited Parisian nights between Montparnasse, Saint-Germain, and the Champs-Elysées. In front of everyone, he seduced girls, took them, deceived them, left them, and returned to them. This "extraordinary figure,"[18] as fascinating as he was repugnant, was to serve as a model for certain masculine characters in Rohmer's work, and also in that of Claude Chabrol, Roger Vadim, and Jean-Luc Godard.

Schérer and Gégauff took an immediate liking to each other. They had things in common: their Alsatian origins, similar literary tastes (Dostoyevsky), the same love for music. Schérer discovered Monteverdi thanks to Gégauff, whereas the latter heard Beethoven's quartets and sonatas for the first time in Schérer's room in the rue Victor-Cousin. Gégauff created the nickname that was to accompany Maurice Schérer for the rest of his life, even after he had become Éric Rohmer: "le grand Momo." Rohmer testifies to this: "He is the only person who really influenced me, and I think the influence was mutual. He's like a brother to me and I don't need to see him to understand him; I know him

so well. While we were growing up, at the time when people exchange ideas, construct systems, and found new aesthetics, we discussed everything that can be discussed between the ages of 25 and 35. Nothing escaped us and that marked us for life."[19] Gégauff lived in a furnished apartment on rue de la Convention, and then with a friend in the 15th arrondissement, but the two friends often slept alongside one another, Schérer on the bed, Gégauff at his feet on a mat that was rolled up in the corner during the day. The room in the Hôtel de Lutèce became a laboratory for creation as well as for discussions that were essentially literary. Schérer and Gégauff were a couple in this writing workshop.

Gégauff wrote: he published four novels with Éditions de Minuit between 1951 and 1958: *Les Mauvais Plaisants*, *Le Toit des autres*, *Rébus*, and *Une partie de plaisir*. His editor, Jérôme Lindon, liked them even though they were not terribly successful. Gégauff also wrote a play, *Mon colonel*, that was staged by Jacques Mauclair at the Théâtre de la Huchette in 1956. Not to mention countless tales, fables, short stories, and two more novels preserved in Rohmer's archives. At the same time, Maurice Schérer was also writing short stories and left behind at least three attempts at novels. It would seem that Schérer's reading of Gégauff's texts and the discussions that followed triggered a burst of writing, because between January 1948 and December 1949 he put down on paper five short stories of about forty pages each, an unfinished novel of two hundred typed pages, and a plan for another novel—all of it inspired by Gégauff. The novel was entitled, *La Tempête*.[20] Placed under the sign of Shakespeare and the character of Prospero and set on an island off the coast of Brittany, the plot follows complex, intersecting love affairs in the large decrepit house of an old family that has lost all its money, and whose heiress is being courted by several wealthy suitors. Nature, and particularly the sea surrounding both the places and the characters, becomes more and more important. The final storm, unleashing furious waves, reveals the more or less energetic characters. In the introduction to this novel, Maurice Schérer offers a profession of faith that confronts the creator with his responsibilities: "Depict only what is noble, beautiful, elevating, consoling. The pleasure of writing must be immense [. . .] In short, my personal philosophy has been only that of good intentions: reconciling the rejection of passions and the impossibility of life without passion. I seek the aesthetic rehabilitation of good intentions. There is no good without the possibility of evil, but good is nonetheless in nature. I am sensitive only to a certain beauty of things or to the innocence of a good intention."[21]

In addition there are five short stories dated 1949. The first, untitled, is largely inspired by Goethe's *Faust*, a myth that regains its relevance in these apocalyptic times. The second story, entitled "Le Revolver," prefigures in the form of a literary narrative the scenario of "Suzanne's Career," which was written nearly fifteen years earlier. A somewhat unattractive girl, Paule, whom two boys are trying to pick up and take advantage of, considering themselves superior to her, ends up avenging herself socially by marrying well. The third story, "L'Homme de trente ans," is about Gervais, an engineer who is caught between two dissimilar women: Aline, an old acquaintance he knows only too well, and Françoise, a young girl of sixteen, sly and provocative, his landlady's daughter. This ends tragically when Gérard, Françoise's jealous boyfriend, strikes the man a fatal blow with a bronze bookend. In "Chantal, ou l'épreuve," a story dated November 17, 1949, the story is narrated by a foppish, right-wing diplomat. In an elegant, precious, detached tone it narrates the vengeance taken by a young woman on manifestations of masculine pride: this is already the subject of *La Collectionneuse*.[22]

The last story is entitled "Le Genou de Claire." Dated December 5, 1949, it returns to an obsessional fetish that had already appeared in *Élisabeth*. From the outset it is very close to the film adaptation of it that Rohmer made more than twenty years later. This is shown by these lines in which the crucial and the anodyne intersect:

> One evening when I was sitting on the bench at the tennis court, our couple sat down near me. Jacques had just played a brilliant game which had left him breathless. He'd leaned back against the wire fence, and his weary hand was resting gently on Claire's knee. Short skirts were fashionable at that time, and as she sat down, this one had revealed a narrow triangle of flesh that the boy's fingers partly hid from me. The sun's rays, which were low at that hour, were touching the inside of her knee and tinting pink the skin which was here paler and softer, slightly shaded by a delicate dimple. What exactly was happening to me? It was as if I had found the joint through which this hard flesh suddenly became permeable to my desire. I knew what I was looking for: a caress, but known to me alone, which would reveal to me the secret of Claire's body more profoundly than the most ardent promises she might have made me. [. . .] A right arises from the very violence of desire. Nothing in the world could forbid me to grant myself what was due only to me.[23]

Adding to these a text written a few years earlier, in 1944, "Rue Monge," Schérer completed a collection of a half-dozen stories that he submitted to Gallimard, which had published *Élisabeth*. Six months later, in June 1950, Gaston Gallimard, referring to a negative reader's report, rejected this collection. He told Rohmer: "It's not at all modern! You've lost the new, young aspect your first novel had." The door to literature suddenly slammed shut. There remains nonetheless a title, the one the author gave his collection, *Moral Tales* (Contes moraux). And also the literary matrix of a certain number of future films.

The Commitment to Film

As we have seen, films played no important role in Maurice Schérer's childhood or even his youth. The large-scale invasion of Parisian movie theaters by Hollywood cinema dates from the summer of 1946, following the commercial agreements signed by Léon Blum and James F. Byrnes, which put an end to the prohibition on showing American films in France that had been in place since 1939. Schérer was already twenty-six years old: he was not a child of the mania for Hollywood cinema, as were filmmakers ten years younger: François Truffaut, Jacques Rivette, Godard, Chabrol, and the New Wave generation as a whole. When he got to know film, he was an adult, already intellectually shaped and artistically committed. Cinema came late; for Maurice Schérer it was the "last" of the arts before it became the "first." Moreover, in his case, the initial, tangible signs of this passion for film—programs and cinema club membership cards, newspaper clippings, notes on films—go back to 1947 and the beginning of 1948. At this time he underwent an initial conversion to cinema through an accelerated apprenticeship in the art of film watching: becoming a movie lover and making up for lost time.

The oldest indication of this love of films is an annotated program for the university cinema club from February 1947. This club, created in the summer of 1944 by Jean-Paul Gudin at the SNCF Hall near the place de la République, seems to have been Rohmer's point of reference. The shows were often organized by Jean Boullet, a well-known figure around Saint-Germain-des-Prés, Boris Vian's illustrator, a free-thinker and homosexual who loved the bizarre and the forbidden; he was also a film critic fond of the fantastic and horror. But Gudin died young at the age of 24 in 1948, Boullet moved to other venues, and the club,

whose members included, in addition to Rohmer, film buffs like Jacques Rozier, Michel Wyn, and Georges Kaplan, rapidly went downhill. Schérer then began to frequent the Néo-club Cinéart run by the very active Armand J. Cauliez, who soon became the director of the film club at the Musée de l'Homme. In September 1948, the young movie lover also went to see the films shown at the Amis de Charlot and the Scéno-Club, and then those shown on Thursday evenings at La Tribune de l'écran in the hall at 31, avenue Pierre-Ier-de-Serbie, whose main organizer was Roger Régent. He could not know that, two decades later, the offices of his production company would be set up almost across the street.

Thus Schérer took a modest part in this rich and flourishing world of film lovers.[24] The Paris movie theaters were often packed, especially with young people who gathered there after the principal film club meetings, which were generally held twice a week. With some four hundred theaters, ranging from immense movie palaces to small neighborhood cinemas, postwar Paris was the ideal site for this passion for cinema, and the film clubs experienced their golden age, constituting a dense network throughout the capital. In early 1949, Armand J. Cauliez, the main herald of the movement, published a newsletter called *Ciné-Club*, authorized by the Fédération française des ciné-clubs, which had been created in late 1945, was presided over by Jean Painlevé, and was firmly left-wing. Cauliez was the "secretary responsible for questions of culture and propaganda." Another tutelary figure for film lovers was Jean Cocteau. He was their prince, their master of ceremonies. For example, he presided over Objectif 49, the most prestigious of the clubs at that time, or "the film club of tomorrow," launched on the occasion of the premiere of "Les Parents terribles" at the Studio des Champs-Élysées on December 1, 1948. The club included representatives of the "new criticism": André Bazin, Alexandre Astruc, Pierre Kast, Jacques Doniol-Valcroze, Claude Mauriac, and Nino Frank, who enjoyed the sponsorship of filmmakers like Robert Bresson, René Clément, Jean Grémillon, and Roger Leenhardt. Objectif 49, a rather closed but very influential club organized by Bazin, who was along with Astruc the main postwar critic, attracted Maurice Schérer, who attended its meetings.

On December 21, 1948 Bazin published the credo of this elite film club in *L'Écran français*, a kind of manifesto for a new criticism that defended a new cinema exemplified by the work of Welles, Renoir, Rossellini, Bresson, William Wyler, Howard Hawks, Preston Sturges, and Huston: "This avant-garde needs to be revealed, understood, and supported. That is the goal of Objectif 49, which will present recent films three or four times a month, most of which have not

been previously shown and have been chosen in this spirit. The films will be followed by an in-depth commentary, including numerous technical analyses of individual frames. These commentaries will be offered by critics, technicians, actors, painters and writers."[25]

Objectif 49's office was at 146, avenue des Champs-Élysées, but the film showings took place on Sundays at 9:30 A.M. at the Broadway, at number 36 on the same avenue, on Monday evenings at the Studio des Champs-Élysées, or on Saturdays at 5:30 P.M. at La Pagode.

But the main place to learn about cinema was Henri Langlois's Cinémathèque française.[26] Founded in 1936, it was established on the rue Toyon, near the place de l'Étoile, in December 1944, and then moved to the Maison des Arts et Métiers, avenue d'Iéna. In October 1948 a new theater set up in a private building at number 7, avenue de Messine in the eighth arrondissement. It was there that Maurice Schérer became acquainted with Langlois, his films, and many other young movie-lovers. The theater, where films were henceforth projected every day, could hold from sixty to a hundred spectators. The same people always sat in the front row. First they examined silent movies: Griffith, Feuillade, DeMille, Murnau, burlesques, Danish and Swedish films, then Renoir, Ford, Dwan, Walsh, Hawks, and King, as well as the first film stars. This generation of movie-lovers was the last that could acquire a full acquaintance with film culture in a few years of bulimic consumption: there were only fifty years of cinema to learn about; the pantheon of classics was well established; and Langlois, the "dragon," owned most of the treasures of an art that had not yet spread throughout the world. Chris Marker, who hung out there and was then writing a column in *Esprit*, paid homage to the Cinémathèque in an article published in June 1949:

> Although the price of admission is modest, it isn't easy to get into this darkroom which resembles the mortuary chamber in the Great Pyramid where the precious mummies of Douglas Fairbanks and Lillian Gish await you shrouded in their celluloid wrappings. Unreliable schedules, forgetful ticket takers, crowding in hallways, lost tickets, seats sold twice, all this orchestrated with brio by Henri Langlois, the irreplaceable manager, puts the spectator in a genuinely religious state, torn between an awareness of his indignity and the extravagant hope of finally seeing the film, it crushes, churns, flattens and purifies him so that he finally clings to the screen as if it alone could save him, and compared to what he has just endured, it seems a paradise.[27]

Langlois was aware of his role: to exhibit shadows, to discover old films and pass them on to the next generation. He would often say he felt like the father of the New Wave, laying claim to a way of seeing both as a spectator and as a creator, as if Maurice Schérer and his younger colleagues learned to make films by watching old films. "It was regular attendance at our films that gradually shaped the audience's critical perspective," wrote Langlois in 1949. "Last year, the spectators were essentially young people from 17 to 22. At first, they knew only films made in the previous four or five years. They had trouble adapting. But they were automatically educated by watching films and now some of them have told me they can no longer go to the cinema as they used to. Some films became so unbearable to them that they could no longer watch them."[28] Although Schérer was a little older than these young people "from 17 to 22," he shared in this apprenticeship through films: he too developed taste, judgment, and culture in contact with the works of the past that Langlois showed, and that was how he became a critic, and even a filmmaker, as was acutely noted by a journalist from *Combat*. "The Cinémathèque joins the past to the future."[29] Schérer preserved records of the things that first excited him, the mimeographed schedules for the films shown at Langlois's theater. Over a period of ten months, between October 1949 and July 1950, he missed few of the films that were shown. In the program for October 1950 he even underlined with concern the following warning: "The number of seats in the hall at the avenue Messine being limited, two kinds of passes will be sold, one for the Saturday showing and the other for the Sunday showing."[30] Rohmer probably tried to get both.

Newspapers and cinema magazines were the other vector of this renascent cinephilia. Alexandre Astruc is a good guide to this, because he wrote on cinema in virtually every postwar periodical, from *Combat* to *Poésie 45*, from *Opéra* to *L'Écran français* to *La Nef*, and also in *La Revue du cinéma*, a monthly edited by Jean George Auriol and published by Gallimard between October 1946 and the end of 1949 in nineteen issues that contained landmark texts. At the height of the Cold War, there were enormous cleavages within a deeply divided cinematographic criticism. Starting in the summer of 1948, communists took control of *L'Écran français*, the most widely read and most lively specialized weekly, which was for a time open to contradictory trends. The polemics blew up in a cinematographic press and milieu that seemed to be on edge: about Orson Welles's *Citizen Kane*, which was attacked by Jean-Paul Sartre and the communists when it came out in Paris in 1946 and was defended by

Bazin, Astruc, and Leenhardt; about Hitchcock, scorned by so-called "serious" criticism and the intellectual left, but supported as early as 1947 by the youngest Hollywood lovers, Jean-Charles Tacchella and Roger Thérond, in a few iconoclastic manifestos in *L'Écran français*. In the political context of the late 1940s American cinema divided people: for many people, liking Hollywood movies was tantamount to a right-wing, antinational provocation, a deviant taste that the Left could hardly understand.

An old guard, for which an artwork was first of all a great subject and a clear message, objected to the new criticism's predilection for form, the sophistication of its analyses, and its emphasis on an author's style and even on the way the film was directed. In this sense an article published by Alexandre Astruc on March 30, 1948, "Naissance d'une nouvelle avant-garde: la caméra-stylo" (The birth of a new avant-garde: the camera-pen), had the force of a manifesto. Striking an offensive tone, the critic insists that the author of a film, through his own style, has a writer's freedom to create and impose his personal universe. "After having been a fairground attraction, an entertainment analogous to boulevard theater, or a way of preserving images of the period, the cinema is becoming a language. A language, that is, a form in which and through which an artist can express his thought, no matter how abstract it might be, or his obsessions, exactly as is the case today for the essay or the novel. That is why I call this new age of cinema that of the camera-pen."[31] Maurice Schérer witnessed these critical jousts; he was still trying to find his place within the cinephile movement and the critical landscape, but he nonetheless understood what was at stake in these disputes.

The First Critical Texts

Schérer soon began to take part in these debates. Only a few weeks after having bought his first pass to the university film club, he thought he was ready to publish his first texts on cinema. Once again it was Alexandre Astruc who served as his mentor. Following the publication of "Naissance d'une nouvelle avant-garde: la caméra-stylo," Schérer told Astruc he wanted to write for *L'Écran français*. But Astruc knew that his periodical was ceasing to be pluralistic, and sent Schérer's proposal to *La Revue du cinéma*, where he had many friends, notably Jean George Auriol, the editor in chief, Doniol-Valcroze, and Bazin. Moreover, through a neighbor, Schérer knew Henri Rossi, one of Langlois's associates at

the Cinémathèque and a friend of Auriol, who was also able to recommend him. Éric Rohmer later had a perfect recollection of this crucial context of his debut as a critic: "I went to see Auriol,[32] who was by nature tolerant and open. The first article I wrote concerned the problem of color in films. I thought the future of film was in color, just as it had been in talkies in 1929. I also maintained that there was something specific about the use of color in film, that it had nothing to do with painting."[33] Auriol rejected the article on the grounds that he had recently published another on the same subject. Schérer then began an article on Eisenstein, who had just died. In it he emphasized, contrary to what was usually thought, that the great artist is not the author of *Potemkin* but rather of *Ivan the Terrible*, that in his work the important thing is not montage but the organization of space. Auriol again rejected the article, obituaries not being of interest to him. "I was not discouraged," Rohmer goes on, "and ultimately I wrote 'Le cinema, art de l'espace' [Cinema as a spatial art]. Auriol told me that it was a kind of synthesis of the two preceding articles and limited himself almost exclusively to remarks on the style of my article, because he was very much a purist. He said nothing at all about the substance of the article, and it was published."[34]

"Le cinéma, art de l'espace,"[35] Rohmer's first article, shows an astonishing maturity. In an author's first text we rarely find an already completely constituted system that establishes itself from the outset through its reflective power and the clarity of its style. This article, which has great theoretical ambitions, focuses on the "concern for spatial expression" peculiar to cinema, an art that "has to organize the semantic code it uses in relation to a conception of time and space." This latter being, according to Schérer, "the general form of sensibility that is the most essential to this art of seeing." In contrast to graphic, purely visual expression, cinema makes use of means that are specific to it and creates meaning when it moves about objects or bodies within the space of the frame and a flat surface, in accord with an organization inspired by nature.[36]

The article had a profound influence, especially on the generation of the future New Wave, those young people "from 17 to 22" mentioned by Langlois. Jean Douchet, for example, was to emphasize the importance of this text: "For me it was a revelation. This essay showed that the specificity of cinema resided in the way space was treated and the way bodies moved within it."[37] Jean-Luc Godard, who was ten years younger than Schérer, wrote in a similar vein: "He wrote the first article of what was for us the takeover of modern cinema. It was

the first text that was of major importance for us because it proposed a definition of cinema as an art of direction, an art of movement in space."[38]

Maurice Schérer continued to submit articles to *La Revue du cinéma*. In March 1948 it published his review of Alfred Hitchcock's *Notorious*, which most critics had treated with disdain and condescension as if, since his departure for the United States, the director of *The 39 Steps* no longer had "anything to say." For Schérer this was, on the contrary, the first stage of a long journey alongside the "master of suspense" (an already-established expression that he preferred from the outset to "the virtuoso of the camera"),[39] a journey that led nine years later to the publication of a book of film analyses coauthored with Claude Chabrol. Schérer put his finger on the originality of *Notorious*, in whose direction seeing becomes a kind of fetishism and a drive toward an extreme stylization based on magnification: "*Notorious* is a film of close-ups. Its best moments are the ones in which the actors' faces occupy the whole surface of the screen: for example, the extraordinary kissing scene, which deserves a special place in an anthology of cinematographic love or eroticism."[40]

The young critic had hardly begun to work for *La Revue du cinéma*, where he felt comfortable, before he found himself adrift: the periodical ceased to appear in the fall of 1949, having been sacrificed by Gaston Gallimard along with several others that he published. Shortly afterward, in a tragic postscript, Jean George Auriol died in an accident on April 2, 1950, run down by a car on the road to Chartres.

Alexandre Astruc once again came to the rescue of his friend and submitted to *Les Temps modernes* an article that Schérer had just written for *La Revue du cinéma*. *Les Temps modernes* was a monthly, founded by Sartre and edited by Merleau-Ponty, to which Schérer contributed several pieces over the next year. The article *Pour un cinéma parlant*, a manifesto directed against a nostalgia for silent films then widespread among critics, was published in October 1948. Schérer wanted speech to be "integrated into film," and thought it would be "desirable" that the author of the dialogue and the director of the film be one and the same person (what would soon be called an "auteur"). According to him, words are an integral part of a cinematographic work. This article outlines a Rohmerian creed: it tells us what the filmmaker will do with words, manipulations of meaning, finally making this astonishing confession: "There are not enough lies in cinema, except perhaps in comedies by René Clair, Ernst Lubitsch, and Frank Capra." Deliberately situating himself in this tradition, Maurice Schérer vows to engage in an ambiguous relationship with truth.

This was followed in January, March, and June 1949 by three reviews, suggesting that Schérer would be a regular contributor to *Les Temps modernes*. But in June 1949 he also published three articles in other periodicals.[41] On the fifteenth of that month he wrote the Objectif 49 column in *Combat* under the title "L'Âge classique du cinema," in which he proposed a thesis dear to him: by filming the modern, cinema naturally rejoins the archetypes of classical beauty. "Let those who are uneasy be reassured," he wrote. "In the cinema, classicism is not a step backward but a step forward."[42] This formula permanently marked Jacques Rivette, an eighteen-year-old movie-lover who had just come to Paris and who heard Schérer speak at the next meeting of the Objectif 49 film club. In the cultural weekly, *Opéra*, edited by the conservative and well-behaved Roger Nimier, Schérer published two articles one after the other. The first, *Réflexions sur la couleur*,[43] was a defense of the color film: it was probably the very first article Schérer wrote, the one he had planned for Auriol's *La Revue du cinéma* a year earlier. Next came "Preston Sturges, ou la mort du comique,"[44] a short essay on one of the most highly regarded filmmakers of the time who gave laughter a melancholy depth.

In October 1949 Maurice Schérer reviewed for *Les Temps modernes* the first Festival du Film Maudit which had been organized by Objectif 49. In his review he defended the films Jean Renoir had been making in the United States, *Swamp Water*, *The Southerner*, *Diary of a Chambermaid*. He also discovered Luchino Visconti's *Ossessione* and was enchanted by a new version of Jean Vigo's *L'Atalante*. He concluded with a portrait of this new generation of spectators that, according to him, had distinguished itself in Biarritz by demanding a new kind of cinema, with which he certainly identified. "In the youngest generation I see much less concern to proclaim its break with classical or 'bourgeois' tradition. Because it is considered proper to swear only by history, let us say that at certain moments in the evolution of the arts the values of conservation may deserve to be lent priority over those of revolution or progress."[45] This latter statement, which is openly conservative, was singled out a few days later by Jean Kanapa in an editorial in *Lettres françaises*, the communist weekly that competed with *Les Temps modernes*. Kanapa scolds Schérer but sees in his article above all a "proof" of the reactionary drift of Sartre and his magazine. This was considered fair play in these times of very great intellectual tension. Maurice Merleau-Ponty, the editor of *Les Temps modernes*, reacted immediately to this opening of polemics, putting out the fire before it endangered the line taken by his magazine. As Rohmer

was to write a few years later: "The editors of *Les Temps modernes* recognized the shot across the bow—and got rid of me."[46] This ended Maurice Schérer's participation in the most prestigious intellectual review of the time. Abandoned by the now defunct *Revue du cinéma*, sent away from *Les Temps modernes*, where was he henceforth going to express his love for the seventh art?

The Latin Quarter Film Club

In December 1948, Schérer found work as a film-club organizer. The opportunity came through the Collège Sainte-Barbe, which offered a classical education and, in the framework of a film club that had long existed at the school, a few courses on cinema. One of his students in film, Frédéric C. Froeschel, who had just turned eighteen and was bold, curious, and nonconformist, got his hands on copies of films that were about to be thrown away. With the help of his father, who backed him, he founded the Ciné-Club du Quartier Latin (CCQL), of which he was the first president. The club's statutes[47] were registered on December 9, 1948; the headquarters was at number 19, rue Cujas; and the club's goal was to be the "students' independent club." Maurice Schérer was one of the founding members: Froeschel asked him to organize the meetings, which took place every Thursday at 8:30 P.M. in the hall of the Sociétés Savantes at number 8, rue Danton, and every Friday at 5:45 P.M. at the Cluny Palace, a lovely old-fashioned theater with 385 seats, boxes, and a balcony, that was managed by the Troadecs, father and daughter, and that had long had the reputation of showing more Westerns than any other theater in Paris.

This free student film club had a varied and unusual program that attracted a wide audience; before long there were three thousand members. It was open to any kind of film; Frédéric Froeschel had uncovered English, German, and Russian films; war documentaries; and also many classic American movies from the 1930s that could now be seen again. The programs Schérer preserved and annotated provide interesting clues to the content of these stimulating shows. Thursday evenings on the rue Danton tended toward musicals, with fantastic or surreal aspects, and included a number of unusual films (for example, those made by Stalinists or Nazis), whereas the Friday showings alternated between silent films and American classics. "You could see an enormous number of films in this club," Éric Rohmer recalled. "Its interest was that it was purely for cinephiles and

showed as many things as possible, without discrimination. We showed all kinds of stuff, we had no pre-established ideology or hierarchy. We ran counter to conventional tastes; we surprised people, it was original."[48]

Rather severe-looking, though quite schoolboyish, combining erudition and humor with method, Maurice Schérer impressed his audience. He already had the prestige of someone who wrote for cinema magazines and hung out with respected cinephiles but was nonetheless close to students and young film lovers. Claude de Givray recalls a formal debate presided over by a Schérer who seemed "very professorial,"[49] giving the floor to a young, unruly audience and taking it back to provide analyses "of a certain breadth" or decisive opinions ("a regular demolition of *High Noon* as 'false intellectualism'"). Philippe d'Hugues, another cinephile, has preserved the notes he took as a young man: "Schérer was not the most brilliant one there, but he worked very hard to prepare for these sessions. He often stammered, spoke very fast, seemed ill at ease, remained reticent and shy after the sessions, but every discussion of a film taught us a great deal. That is why his sessions attracted us."[50]

Schérer was very involved in the organization of this film club, of which he became the president in March 1950. He had to prepare the showings, contact guests, and set up varied and appealing programs with the films that Froeschel offered him. Froeschel did not make it easy on him, as is shown by this little note from the autumn of 1949: "Momo my dear, when you get this message, write on the paper that you'll find in the envelope addressed to [Claude] Mauriac, asking him to come tomorrow evening because [Jean-Pierre] Melville really wants to see him in the discussion. For once I'm counting on you. And don't forget to take the message to the post office immediately. Urgent. Fondly, Froeschel."[51] Schérer did not get much in return for his efforts: no financial compensation, or very little, and above all problems with police headquarters and the courts.

On January 27, 1950, Schérer and Froeschel received a court summons on the charge that they had shown Robert A. Stemmle's *Ballade Berlinoise* without authorization and the German company that held the right had filed a complaint. "The advertising they have done and are planning to do to announce the showing of the film causes the plaintiffs serious prejudice,"[52] argued the lawyer for the company. The two young men were ordered to return the copy of the film, to halt all promotion of it, and above all to pay damages with interest in the amount of 10,000 francs, a substantial sum that had to be paid by Frédéric Froeschel's father. Fortunately his garage on the lower end of the boulevard Saint-Michel

was thriving. In June 1950, they had to pay further costs and fines for having pasted advertising posters on electoral signs on the rue Victor-Cousin. Schérer was having a run of bad luck; he was fined again and then summoned to police headquarters because some paperwork he had submitted for the club had been judged faulty.

But the Ciné-Club du Quartier Latin was first of all a place where one could meet people and exchange ideas, and that was of inestimable value and worth all the fines. Schérer drew to the club a large number of students and young movie-lovers. He was seen as a mentor, open to discussion, to listening to their expectations and tastes. The CCQL rapidly became the crucible of the New Wave, where the spirit of the future group of "young Turks" was born and developed. One of its habitués was Jacques Rivette, a shy boy from Rouen who soon became the best, the cleverest, the most erudite, the most clear-sighted. He arrived there from his hometown in 1948, along with his friend Francis Bouchet, and immediately began attending the sessions at the Studio Parnasse and the CCQL. "He was slight, dark-haired and had very lively dark eyes in an emaciated visage of a waxy pallor," Jean Gruault remembers. "Add to that a forced, nervous smile stuck onto this tragic face, the desperate smile of someone who has to make constant efforts to win acceptance by a society that he seemed to regard as irremediably hostile."[53] When Rivette spoke, he was brusque, cutting, irrefutable, and unstoppable, and seemed to set a permanent standard of taste. His hand fell like the blade of a guillotine: that was the truth. Then there was Jean-Luc Godard, a son at odds with his family—he was a Monod—who had come from Switzerland and the shores of Lake Geneva to study at the Sorbonne (a little ethnology, a little film studies); he was a dandy who spent much of his time in dark theaters. Claude Chabrol, who also came from a good bourgeois family, deserted the study of law to go slumming at the cinema; François Truffaut, the youngest of the group, had become André Bazin's private secretary at the age of 17, which gave him a certain prestige and counterbalanced his roguish, self-educated, low-class side. But there were also many other young cinephiles, such as Suzanne Schiffman, Jean Domarchi, Pierre Bailly, André Labarthe, Étienne Chaumeton, Georges Kaplan, Francis Bouchet, Jean Gruault, Jean Douchet, Claude de Givray . . .

Some of them recorded their memories of this unusual area of young Turk sociability. Claude Chabrol's comments are piquant: "Despite its location on one of the most noble streets in Paris, the enterprise was not irreproachable in the

way it handled its finances. Its accounting was rather evasive. The organizers did not hesitate to dip into the cash drawer. At its sessions, I met Éric Rohmer. Tall, skinny, brown-haired, this literature teacher looked like Nosferatu the vampire."[54] Paul Gégauff, who followed his friend Schérer to the film club, was thrust into the presidency on January 16, 1950: that was where he began to see films. But he was never to write film criticism. That did not prevent him from having a largely fantastical idea of the place that arose from an imagination that smelled of sulfur: "The CCQL was a criminal organization of which I was the president, a president who regularly dipped into the cash drawer. The money was used mainly to get laid. The truth must out: Froeschel thought only of money and screwing, and so did I, while le grand Momo, it goes without saying, was also interested in going after the daughters of concierges that he brought to the film club . . . No one thought of anything but screwing and stealing, it was horrible."[55] In February 1950, after an American war film had been shown, in a virtuoso act of pure provocation and schoolboy humor, Gégauff suddenly appeared in the spotlight dressed as a Nazi officer and, looking at a stunned audience with a malicious eye, cried out in an Alsatian accent: "Vee vill come back!"[56]

In late July 1949, a large part of this cinephile group went with Maurice Schérer to the Festival du Film Maudit in Biarritz, a prestigious event set up by Objectif 49. Schérer helped organize the sessions and agreed to introduce a certain number of films: *The Flame of New Orleans*, René Clair's first American feature film, Robert Bresson's *The Ladies of the Bois de Boulogne*, and Jean Grémillon's *Summer Light*. In his notebooks Philippe d'Hugues wrote for the date August 4, 1949: "I discovered Maurice Schérer, a little stammering in the morning discussion on Bresson, brilliant and at ease in his presentation of Clair [. . .] On the list of twenty-four people I saw at the festival, I ranked him sixth in order of importance, behind Cocteau, Grémillon, Bazin, Bourgeois and Auriol, and before Astruc, Mauriac father and son, Graham Greene and René Clément. His was the only name on this list I did not know, and that shows the strong impression he made on me."[57] On leaving for Biarritz from the Gare d'Austerlitz on the evening of July 29, Schérer met Jean Douchet, another young cinephile who was then twenty years old: "I'd read his article in *La Revue du cinéma*," Douchet wrote, "which had impressed me, I had seen him run a few sessions of the CCQL . . . At that time I was as shy as he was. But there, as I got into the train for Biarritz, I saw him. I went up to him. We talked all night in the corridor. We discussed *Shadow of a Doubt* and *Notorious*, Rossellini, John Ford,

Keaton, Renoir, and Murnau. We agreed about everything. For the first time, I was talking to an organizer who was not, first of all, a communist or a Catholic, but whose first principle was the love and knowledge of cinema. How should we watch a film? What do we see in it? All at once with him, you became aware that there was an art which was no longer politically conservative, which avoided the big questions, and which had a form."[58] Along with other aficionados of cinema such as Douchet, Rivette, Truffaut, Chabrol, Philippe d'Hugues, and Charles Bitsch, Schérer stayed in the Biarritz high school dormitory, feeling that he was closer to this group of young cinephiles than to the stars of Objectif 49 who were staying at the Hôtel du Palais and who frequented the formal balls at La Nuit maudite on Lake Négresse. However, Maurice Schérer appears in the festival's official photo that Cocteau organized on the main beach: in the last row on the right, Schérer is the big beanpole hiding under his cap.[59]

The *Gazette du cinéma*

In October 1949 Maurice Schérer published a review of the Festival du Film Maudit in Biarritz in a small film magazine for which he provided most of the articles, *Le Bulletin du ciné-club du Quartier Latin*. This monthly, which had been published since April 1949 as a supplement to the neighborhood newspaper, *L'Hebdo-Latin*, was run by Frédéric Froeschel, who signed its editorials. This bulletin presented the film club's programs: in it Schérer published a few reviews—which he signed "M.S., CCQL discussion leader"—of special sessions. In March 1950, he had an article on René Clair's participation in the session on his 1933 film *Quatorze juillet,* cosigned by François Truffaut (it was Truffaut's first published article), and another on Jean Renoir's presence for the showing of an unedited version of *Rules of the Game* (also written with Truffaut). Jacques Rivette was another author who made frequent contributions, notably an important article, "Nous ne sommes plus innocents," published in March 1950. This is a veritable New Wave manifesto in which the twenty-year-old Rivette asks the rising generation to embrace a reflective and melancholy cinema that has to be realized in the simplest way possible: "We are dying of rhetorical asphyxia and intoxication: we have to go back to a cinema of simple writing. To put on film the manifestations, the way of life and being, the behavior of the cosmos; to film in a cold, documentary way, where the camera is reduced to the role of a witness, of

an eye. And Cocteau has rightly introduced the notion of indiscretion. We have to become voyeurs."[60]

In May 1950 Maurice Schérer went further, creating *La Gazette du cinéma*. He chose a journalistic title that was very old regime—an allusion to the *Gazette* that Théophraste Renaudot founded in 1631, the first French periodical—and was well-suited to its traditionalist spirit. But *La Gazette du cinéma* was not in any way anecdotal; on the contrary, it was overflowing with ambition. Commercially registered by "Maurice Schérer, publication director" on May 27 and June 5, 1950, the monthly's statutes and motivations were clear:

> One of the goals of this new review of film criticism and news, which is absolutely independent of any organization, is to contribute to the expansion of the movement undertaken by film clubs to promote a greater knowledge and a more effective comprehension of the art of film. The editors of our review have secured the regular collaboration of Claude Mauriac, André Bazin, Roger Leenhardt, Jacques Doniol-Valcroze, Lo Duca, Pierre Bailly, Jean Boullet, Alexandre Astruc, Maurice Schérer, etc.[61]

La Gazette du cinéma had prestigious contributors, an affordable price of 15 francs, four large-format pages on glossy paper, and was available in a dozen Paris bookshops; it was published under the auspices of the Librairie du Minotaure, which specialized in the seventh art.

Schérer was able to launch *La Gazette* because he had the help of Francis Bouchet, a devoted, resourceful young man who was also a movie lover, whom he met at the same time as he met Jacques Rivette. The two younger men had gotten to know each other four years earlier at the Oiseaux film club in Rouen. There, in an isolated house on the heights above the provincial city, they had made an initial short film, *Aux quatre coins*, in 16 mm. In 1948 they moved to Paris, where Bouchet met Roger Cornaille, who hired him to work in his Minotaure bookstore. Bouchet aided Schérer, serving as a kind of editorial assistant. He had enough ambition for both of them: why not take advantage of the decline of *L'Écran français* to launch "an unbiased film journal that was curious, learned, and intelligent"[62] and could bring together cinephiles from both left and right around the common love of films? Not a review but a real newspaper: "Our model was *Le Monde*,"[63] Bouchet admits, referring to his beginner's audacity. A *Monde* of cinema, on four large pages per month, mixing Schérer's young friends

from the CCQL with the best-known writers of the new criticism. Thanks to Georges Kaplan, Schérer's student at Sainte-Barbe, who had been promoted to editor in chief alongside Francis Bouchet and whose father owned the Maison du Livre Étranger on the rue Éperon, *La Gazette* found a printer, the Beresniak company on rue Lagrange. An art gallery run by Nina Doucet on the rue Dragon provided a home for the venture.

However, the true headquarters was the Royal Saint-Germain, a bistro on the famous boulevard Saint-Germain, where the editorial committee met several times a week from ten in the evening until midnight. Those who attended included, in addition to Schérer, Bouchet, and Kaplan, the most regular contributors: Jacques Rivette, Jean-Luc Godard—then better known under the Germanic pseudonym Hans Lucas—Pierre Bailly, Jean Domarchi, Étienne Chaumeton, Guy Lessertisseur, and Jean Douchet. Douchet recalled the wrap-ups: "*La Gazette* was discussed in a bistro and it was produced in the little room where Schérer lived. The ritual of crackers and tea meticulously prepared by le grand Momo was already being established. The venture of *La Gazette* in 1950 foreshadowed *Les Cahiers du cinéma*."[64] Gégauff also came by regularly. François Truffaut volunteered for the army and was sent to Germany. "My old fellow," he wrote to Schérer (who was a dozen years his junior),

> I hope you're going to devote your best efforts to *La Gazette* instead of making vague, inaudible, hermetic films. I'm undergoing training for Indo-China. It's hell: I'm being martyred, subjected to incredible discipline, overworked, trudging through snow or in mud up to my belly, going on forced marches with 32 kilograms on my back . . . I've made up my mind, now I'm ready to put a halt to all this by becoming the editor of an informational magazine for the TOA [troops of occupation in Germany] in Baden-Baden. I need a letter from you. I'd be paid 30,000 francs a month, promoted to a higher rank, and I could fuck until I dropped and smoke until I couldn't talk; in short, I'd be living in an earthly paradise. I just need you to write on a letterhead: "I certify that M. François Truffaut was an editor of the monthly magazine *La Gazette du cinéma* from May to October 1950. He did a series of seven reports and twenty-two critical articles or film analyses for us. We were entirely satisfied with his work and he left *La Gazette du cinéma* of his own accord to pursue his military career." Don't laugh, I'm completely serious.[65] If you make a film, don't forget that cinema is an art of the small, inconspicuous detail, and that it consists in doing lovely

things to lovely women. Please say hello to Rivette for me. Don't forget that on the other side of the Rhine a friend is counting on you: if I die in Indo-China, it'll be your fault![66]

Truffaut later tried to desert, but was caught and ended up in a military prison.

Three thousand copies of the first issue of *La Gazette du cinéma* were printed in late May 1950. Distribution was a problem from the outset, because the kiosks did not sell *La Gazette*. So film lovers—led by Bouchet, Kaplan, and Schérer— hawked the newspaper in front of movie theaters on the place de l'Odéon and in cafés on the boulevard Saint-Germain. Bouchet wrote that "he did so, but discreetly, with a certain reticence."[67] However, Rohmer was to speak of this period as one of the happiest of his life: "We already knew each other so well, and we talked about films. The period of grace in which we all liked the same things in cinema had arrived. That was the time when *La Gazette du cinéma* was founded. It was naïve to launch into that; I'd financed part of it, and friends had given a little money as well. But we were lucky, we found customers among the members of the film club, and we made a profit on the newspaper's first issues."[68]

In five issues (and six months of existence, from May to November 1950), *La Gazette du cinéma* published about twenty significant articles, as well as notes on current films and the main film festivals. Alexandre Astruc wrote the lead article in the first issue, "Notes sur la mise en scène," in which he contrasted theater and cinema. The following month, it was Jean-Paul Sartre who was on the front page of *La Gazette*. This was a great editorial coup. Francis Bouchet had met Sartre's secretary, Jean Cau, at Gallimard, and gotten him to give the first issue to the philosopher. Sartre liked it and offered the paper a scoop, a long text running over two issues, "Le cinéma n'est pas une mauvaise école," that praised a cinematic education and greatly pleased the CCQL group. It was a flashback to twenty years earlier, in which Sartre saw himself again as a young teacher in a lycée in Le Havre, and admitted how much he had been moved to return to the movie theater and to the "art that did not yet know it was an art"[69] that had shaped his childhood. In this autobiographical article, the philosopher, who was at that time a central figure in French intellectual life, recognized the importance of "a cinematic education" in his career. In another important piece Jean Douchet went to Equirre in northern France where *The Diary of a Country Priest* was being made and came back with an interview with Robert Bresson.

In September 1950 the lead article, "Pour un cinéma politique," was signed by Jean-Luc Godard,[70] then a young critic of nineteen. It was one of his first articles, and in it he praised, surprisingly enough, Stalinist cinema, taking a view opposite to that of the readers and his friends. On the basis of a certain number of films seen in the shambles of the CCQL, Godard lauded the beauty of the bodies, the lyricism of the movements, and the vital energy of a cinema that he judged on a strictly formal basis. He went even further in his effrontery when he lumped the cinema of propaganda into a coherent whole and praised the other side, Nazi films—which, from the point of view he adopted, amounted to the same thing: Leni Riefenstahl's "sensational" shots and the "maleficent ugliness of the Eternal Jew." In the name of that aesthetics of political engagement, Godard deplored the gratuity and emptiness of French cinema, which he urged to learn from the epic: "You French filmmakers who lack scenarios, you wretches, why have you still not filmed the distribution of taxes, the death of Philippe Henriot, or the marvelous life of Danielle Casanova?"[71] Striking one blow on the right (Henriot, the collaborationist pamphleteer), another on the left (Casaova, the Communist member of the Resistance), Godard confused the issue and sought to shock the left-wing intellectual. Starting with its fourth issue, in October 1950, *La Gazette* adopted a smaller format, making it possible to increase the number of pages to eight. Another young critic, twenty years old, occupied an increasingly important role: Jacques Rivette published a damning front-page summary of the second Festival du Film Maudit in Biarritz and contributed, in the fifth issue, a long article on Alfred Hitchcock's most recent film, *Under Capricorn*. There was no sixth issue, because the review was not sufficiently profitable. Francis Bouchet explains: "We were stuck. One day in November 1950 the printer, to whom we owed money, told us: 'It's over.' It was as sudden as that."[72]

Compared to Astruc, Rivette, or Godard, Maurice Schérer wrote relatively few articles for *La Gazette du cinéma*; he mainly wrote notes on old films seen at the Cinémathèque (Chaplin's *City Lights*, Carl Theodore Dreyer's *Två Människor*, D. W. Griffith's *One Exciting Night*). At first he played a directing role and had others write rather than writing himself. However, in November 1950, he explained how he fell under the spell of Roberto Rossellini's *Stromboli*. This article is essential because Rossellini's film was a revelation for Schérer: "Personally I see only a few works that in our time so magnificently and so directly praised the Christian idea of grace, and that without rhetoric, by the evidence alone of

what it shows us, proclaims more openly the wretchedness of man without God. It may be that today cinema is the only one of all the arts that is able to move on these heights without stumbling, the only one that can still make room for the aesthetic category of the sublime." Schérer saw Rossellini's film, which starred Ingrid Bergman, in a preview showing in early September 1950. It marked an important stage in his life, a conversion. "It was Rossellini who turned me away from existentialism," he acknowledged. "That took place in the middle of *Stromboli*. In the first minutes of the film I recognized the limits of the Sartrian realism to which I believed the film was going to limit itself. I hated the way of seeing the world it encouraged me to take, until I understood that it was also encouraging me to move beyond it. And then the conversion happened. That's what is amazing about *Stromboli*, it was my road to Damascus: in the middle of the film I was converted and I changed my way of seeing things."[73]

Moreover, the appearance of the pseudonym "Éric Rohmer," or at least its first public use, dates from this time. On the front page of the third issue of *La Gazette*, for September 1950, we find "Director: Éric Rohmer." The use of a pseudonym was common in the press and a few of the young critics close to Schérer had used one: Jean-Luc Godard was already "Hans Lucas," François Truffaut was soon to be "Robert Lachenay" or "François de Montferrand," while Claude Chabrol chose the alias "Jean-Pierre Gouttes." In Schérer's case it was not merely a matter of literary dandyism or a way of being able to place more articles in newspapers, but rather the idea of creating a double who would shield him from the eyes of his students, friends, and especially his family. In particular he wanted to spare his mother—who was so frightened by his examination failures, so concerned about his teaching career, so preoccupied with having a good reputation and with Catholic humility—the shame of knowing that her son was an artist or a bohemian.

As we have seen, in the spring of 1946 the novel *Élisabeth* was published under an initial pseudonym, "Gilbert Cordier." In late 1949 a second pseudonym appeared; it is all the more mysterious because it never had a public incarnation: "Antony Barrier." He was an experimental filmmaker, an avant-garde artist; a few of his short films were shown at the sessions of the Latin Quarter film club. In January 1950 an article on Antony Barrier was published in the *Bulletin du ciné-club du Quartier Latin* by "Jean d'ER" (*sic*), which looks like a first step, via the initials, toward "Éric Rohmer." If Schérer chose "Rohmer," it was perhaps by pure invention, pure imagination—the filmmaker always backed that

interpretation—but isn't it possible to see in it a twofold personal reference? Sax Rohmer (itself a pseudonym for Arthur Henry Sarsfield Ward) was a popular English writer whom Schérer had read, an author of crime novels and the creator of the character Fu Manchu; his books had been translated into French in the 1920s. Then there is Régis Rohmer, a curator at the archives of Corrèze in Tulle and a historian of the Hundred Years' War, whom Schérer must have known about because his father had worked with him. But what about "Éric"? It may be an anagram of Maurice Schérer's own name (MaurICe SchÉRer). This was the first time that such a forename appeared in Schérer's life and work, but it was already better than Gilbert.

First Short Films

Maurice Schérer had all the greater need for a pseudonym when he began making his first films, an activity his mother would have regarded as even more disreputable. Several of these films have been lost, or else destroyed. Some have nonetheless resurfaced after fifty years: for example, *Bérénice*, in the form of a forgotten VHS tape found in a corner of Rohmer's study. And *The Kreuzer Sonata*, whose images were in the offices of Films du Losange, while the sound track was in Rohmer's personal archives.[74] Maurice Schérer's desire for cinema perfectly illustrates a preference for 16 mm film peculiar to the period, as Jean Cocteau said in *Combat* in 1949: "The 16 mm camera is not only an apparatus but also a spirit. It is cinema returning to its basis, given a freedom that is almost always paralyzed by money and by the weight and lack of flexibility of 35 mm cameras and their rails."[75] This predilection for 16 mm is crucial: in the late 1940s, many of the desires for stories, fictions, narratives, and stagings were imagined and realized in 16 mm, the typical format used by young filmmakers. In the late 1940s, Alexandre Astruc, who himself made this kind of film, wrote in *La Gazette du cinéma*: "The cinema has already changed the face of intellectual history. Today, a Descartes would hole up in his room with a 16 mm camera to film, or try to write while filming, the *Discourse on Method*."[76]

Schérer was also a supporter of 16 mm, of these filmed essays arising from the spirit of amateurism and lightweight technology. However, on one occasion, writing in *Les Temps modernes* in 1949, he was skeptical: "Let us give up basing too great hopes on the use of 16 mm. Except for some documentaries that

have the advantage of dealing with an exceptional subject, as in the case of Jean Rouch's excellent films about black Africa, we see only too many pseudocinematographic poems in which the lone hero, wandering about as if sleepwalking, has nothing to offer a fidgety camera but the features of a face distorted by cheap anguish. Nothing seems capable of replacing a studio with its homogenous lighting and movable walls. Up to this point, 16 mm appears to be nothing more than a school, albeit an excellent one, for those who burn with the sacred fire and are not afraid to make films that will never be shown."[77] An odd text in which the author begins by rejecting technical amateurism in favor of quality filmmaking in a studio and then treats it as a possible training ground for young people who are driven by "the sacred fire"—that is, himself.

Once he moved beyond these hesitations, Rohmer showered unreserved praise on amateur filmmaking, a school of cinema he defended for himself and his friends in the CCQL. The exercise was profitable, because it made it possible to assert oneself while at the same time regenerating cinema by the simplicity and poverty of its means. While 16 mm was an economic necessity, it was also a claim: it is both a good school and an opportunity to make films rapidly, lightly, as if the filmmaker saw himself as compelled to invent. In October 1949, the *Bulletin* of the Latin Quarter film club announced the creation of a "group on the work of the filmmaker Antony Barrier" organized by "three young members of the film club,"[78] who were in fact Schérer and his two students from Sainte-Barbe, Froeschel and Kaplan. Thus we enter the Antony Barrier period, about whom some mad fantasies have been propagated, notably by Paul Gégauff, who presents him as a perverse, fetishistic, sexually obsessed experimental filmmaker. In one of his rare comments on the subject Rohmer explained that "I had a colleague at Sainte-Barbe who taught courses on theater for his own amusement and produced plays. For my part, I amuse myself by teaching courses on cinema. One of my students, Kaplan, objected: 'But sir, you criticize this or that film, you should make some!' I replied that I had no camera. 'I have one, sir, I'll lend it to you.' That's how I began to make movies."[79]

With film lent by the Latin Quarter film club, Schérer and his two young companions invented a filmmaker for whom they organized collections at the sessions. They gave him a voice in the *Bulletin*, then made 16 mm shorts that were shown during some of the CCQL's meetings. Paul Gégauff played in some of these little films; Rivette edited them; and Godard shot a few scenes, his first for the cinema.

Antony Barrier was introduced in the CCQL's *Bulletin* in November 1949, in a report by Chantal Dervey (no doubt another pseudonym) on the making of a 16 mm film in front of Notre-Dame, directed by "a tall fellow with short brown hair wearing a khaki shirt, Antony Barrier, a young American avant-garde film director who has just won the prize given in the United States for the best amateur film."[80] The report continues: "We see that Antony Barrier makes maximum use of the most recent technical discoveries. The couple moves toward the camera until the viewfinder frames the heroine's mouth, at the very moment when the hero reveals to her the secret she had been trying to make him confess to her. The 16 mm camera is a marvelous instrument."[81] Two months later, Schérer himself, concealed behind the pseudonym Jean d'ER, wrote a wildly enthusiastic review[82]—which he invented from A to Z—of Barrier's supposed film *The Boy of the Portrait* (J'aurais pu vous aimer). André Bazin, in *Cinémonde*, "had to surrender to Antony Barrier, who has been able, to the third degree, to extract from the very superficiality of the profound all the profundity that it contains," while Jean Boullet in *La Semaine de Suzette*, Armand Cauliez in *La Revue du cinéma*, Claude Mauriac in *Les Temps modernes*, and Frédéric Froeschel in *Pravda* were overcome by delight on discovering the film's "controlled audacities." Obviously Maurice Schérer, in *La Revue surréaliste*, expressed tautologically his admiration for . . . himself: "I like this film very much. Finally cinema that is cinema because it refuses to be cinema. The originality of the subject is that it is without pretension and has a very classical simplicity. In what does its novelty consist? it will be asked. But doesn't progress often consist in moving backward?"[83] Schoolboyish humor, self-parody, childishness—Rohmer's tone is found entire in these often secret meanders that juxtapose the most elevated thought about cinema with the most ironic mockery of it.

According to the concordant testimony of Labarthe, Chabrol, and Rivette, Antony Barrier soon showed his first films at the CCQL, in the spring of 1951. They all mention having seen *D'amour et d'eau fraîche: rhapsodie sexuelle sur Saint-Germain-des-Prés*, also known as *Sexual Rhapsody*, an investigative film conducted by a young American artist. André Labarthe recalls "a [pendulaire] shot filmed by Rivette, who was very proud of it," and describes one of the first of Godard's shots, the one that ended the film: "For a rather long time, you looked at a street urinal, and finally a girl came out of it."[84]

In spring of 1950, Éric Rohmer made his first film under his own pseudonym, *Journal d'un scélérat* (The diary of a scoundrel). It was thirty minutes long,

was filmed in black and white, and starred Paul Gégauff. Although the film itself was almost entirely lost, a ten-page, handwritten scenario remains. The main character, "H.," is a seducer who moves from woman to woman, clearly inspired by Gégauff. From his window, he has spotted a pair of lovers who regularly meet on a bench, Françoise and Bernard. He cannot wait to seduce the girl, which he succeeds in doing with the help of a thug, Frédéric, who threatens to rape her. Comforting her, persuading her to go to his apartment so that he can give her a piano lesson, H. makes love to her and ends up abandoning her when Bernard learns that he has been betrayed. He returns to his cat and his piano.

On the back of a bill from LCM Laboratories dated June 13, 1950, Schérer wrote down editing notes, mentioning the two main actors: "Paul" [Gégauff] in the role of H . . . and "Josette" [Sinclair][85] in the role of Françoise. Finally, a manila envelope sent from Paris by Georges Kaplan on July 28, 1950, to Maurice Schérer, who was then visiting his parents in Tulle, contains fragments of a 16 mm negative. The title in the credits is clearly visible, and some forty fragments of twenty frames each make it possible to reconstitute about one minute of the film: we see Gégauff, half-naked, taking a fully dressed blonde woman in his arms while another woman, brunette and distant, watches.

The *Jud Süss* Affair

This period of intense moviegoing, criticism, and filmmaking ended in confusion and polemics. If *La Gazette* abruptly ceased publication in the autumn of 1950, it was not solely because of the accumulated debts to the printer Beresniak. And if at the same time Maurice Schérer and Frédéric Froeschel ceased working with the Latin Quarter film club, it was not simply because they had moved on to other things. The atmosphere had deteriorated. After Gégauff, drunk and violent, had for the umpteenth time broken a bottle and threatened customers, *La Gazette*'s team had been thrown out of its headquarters at the bistro Royal Saint-Germain. Francis Bouchet, who was tired of these constant shenanigans and was more left-wing, close to the communists, distanced himself from the group and went off to do his eighteen months of military service. Furthermore, the methods Froeschel used to attract people to the film club's sessions were based on provocation, the attempt to do something attention-getting: for example, he had a man walk up and down the boulevard Saint-Germain wearing a sandwich

board and promised to show Nazi propaganda films such as Veit Harlan's *Jud Süss* (1940) or Hans Steinhoff's *Hitlerjunge Quex* (1933). This focused attention on the CCQL and drew a response from communist students while at the same time mobilizing neo-Nazis who showed up ready to fight.

In October 1950, this tactic worked a little too well. It provoked a major protest demonstration and a scandal on the national scale. Hundreds of students from Jewish associations, war veterans, former deportees, and communist, socialist, or Catholic militants assembled in front of the movie theater on the boulevard Saint-Germain and demanded the prohibition of the showing of *Jud Süss* that had been scheduled for October 6. On October 3, Paris police headquarters issued an order prohibiting the showing. "Considering the posters put up on the public streets announcing the showing of the film *Jud Süss* at the Latin Quarter film club; considering that the film *Jud Süss*, which is Hitlerian in inspiration, lacks the visa of ministerial authorization, that it is surrounded by publicity, and is for that reason likely to cause serious disturbances of public order: (1) the Latin Quarter film club's showing of *Jud Süss* on Friday, October 6, 1950, at the Cluny Palace theater is prohibited; (2) the chief of the municipal police and the officers under his command are to execute the present decree."[86]

On the morning of October 3, the police occupied the Cluny Palace, seized piles of the *Gazette du cinéma* and material suspected of being neo-Nazi propaganda, and then went to the Hôtel de Lutèce on the rue Victor-Cousin to arrest the president of the CCQL, Maurice Schérer, while another police squad arrested the CCQL's commercial director, Frédéric Froeschel, at his apartment at number 3, boulevard Saint-Michel. A few days later, in the National Assembly a deputy addressed the minister of the interior, demanding "the cessation of these provocations that openly appeal to the darkest times,"[87] and expressed his wish that the film club and its financing be investigated. According to all the testimony given directly to the police, Froeschel did not have a copy of *Jud Süss*; it was a nothing but a publicity stunt. That is what saved the two film lovers, who were held for only one day and were released without being indicted or tried.

However, the CCQL smelled of brimstone: that was the end of its direction by Schérer and Froeschel. On December 1, 1950, the UFOCEL (Union française des offices du cinéma éducateur laïque) filed a complaint against Schérer and Froeschel for "fraudulent affiliation."[88] Froeschel's father, exasperated by these repeated scandals, denounced the CCQL, which claimed to belong to the UFOCEL, and decided that he would no longer financially guarantee the film club.

A month and a half after the *Jud Süss* affair, the secretary of the UFOCEL, Marcel Cady, resolved to settle the matter and demanded that Maurice Schérer and his young assistant resign. His letter was threatening: "I would rather not have to reveal all the reasons that have led to the exclusion of your association in the event of an investigation."[89] Schérer obeyed: he resigned as president of the CCQL. Three months later, the film club, having been purged, resumed its activities with a new director, Jean-Michel Aucuy, who this time affiliated the club with the International Avant-garde Film Group (Cercle international du film d'avant-garde). In March and April 1951, the club's bulletin reappeared under the title *Bulletin du nouveau CCQL*. On the program for the following May 25 was *Jud Süss*, but in the "anti-racist 1934 version"[90] starring Conrad Veidt, which had been made by Lothar Mendes in England. That was a way of exorcising the affair.

Moreover, the last issues of *La Gazette du cinéma* gave rise to a virulent polemic on occasion of the second Festival du Film Maudit in Biarritz, in September 1950. They led to a major break among French cinephiles. Organized by Objectif 49 and run by Jacques Doniol-Valcroze, this festival was strongly criticized by the upcoming generation of cinephiles gathered around the CCQL and *La Gazette du cinéma*. Jacques Rivette launched the offensive in issue number 4, reproaching the Objectif 49 team for its claim to superiority and its arrogance, and also for its bad choice of films. "It remains for us to render our verdict," the young critic wrote at the end of his article. "Objectif asked us to attend, but didn't show up. What conclusion can we draw but this one: 'Objectif destroys.'"[91] This dispute is important, because it reflects the fragmentation of French criticism: the generation of Bazin, Doniol-Valcroze, Objectif 49, and the new criticism was opposed by another ten years younger, that of the CCQL and *La Gazette du cinéma*, people like Rivette, Godard, Truffaut, and Chabrol, a generation led by the elder Schérer. The choice of films, the critical arguments, the place in the cinematographic milieu, the ideological positioning—all that differentiated them, sometimes in a radical way. Maurice Schérer found himself in a strange place, uncomfortable but strategic. By his age and culture, he seemed already part of the new criticism, a member of Objectif 49, conversing with Bazin, Doniol-Valcroze, and Astruc on equal terms. But he felt closer to the younger cinephiles, who were provocative, sometimes violent, and made themselves look like hoodlums or were politically unsavory. Gégauff and Froeschel embodied this group to the highest degree, fascinating in the way of young intellectuals at odds with the establishment. When in 1951 the older cinephiles founded *Cahiers du cinéma*,

a review that became the center of French writing about film, the younger ones dreamed of only one thing: taking the citadel by assault. Maurice Schérer was to play a pivotal role in this critical battle.

The Beginnings of *Cahiers du cinéma*: the "Schérer school"

Léonide Keigel was a developer and film distributor, a Resistance fighter, and a member of Objectif 49 who owned the Broadway, one of the finest movie theaters in Paris, located at the foot of the Champs-Élysées. In late autumn 1950, he decided to invest in a project proposed to him by Jacques Doniol-Valcroze: a review that would perpetuate the memory of *La Revue du cinéma* and thus honor its founder, Jean George Auriol. The project had been rejected by all the publishers Doniol-Valcroze had previously contacted, notably by Le Seuil. Gallimard, the publisher of *La Revue du cinéma*, had not granted the right to use its title, but the model was there: small format, rather long, well-behaved texts composed in a literary mode by well-known critics, writers, and filmmakers, a few elegant full-page or half-page illustrations, with a yellow cover. The first issue of the new review, whose offices were at number 146, avenue des Champs-Élysées, appeared in early April 1951: *Les Cahiers du cinéma* was born.[92] Its editor in chief, Jacques Doniol-Valcroze, had as collaborators André Bazin, the leading critic of the time,[93] and Joseph-Maria Lo Duca, who had worked for *La Revue du cinéma* and was soon to disappear from the masthead.

Cahiers du cinéma asserted itself with a certain prestige as the meeting place of the new criticism, the flagship of the motley group of fragile and ephemeral publications that made up postwar France's cinephile fleet: *Raccords, L'Âge du cinéma, Les Amis du cinéma, Saint Cinéma-des-Prés, La Gazette du cinéma*, and others. Doniol-Valcroze, who was around thirty, was an elegant, affable, polite man who had genuine literary and musical culture. He came from a large Protestant family in Geneva. A leftist and a former member of the Resistance, he got involved in cinema after the Liberation, at the behest of Jean George Auriol. Diplomatic, seductive, and a ladies' man, he gathered all kinds of competence around him. He was the one who coined the review's title, in February 1951, during a discussion in a café with Bazin and Keigel; it was he who contacted personally most of the critical writers who were contributing to *Cahiers du cinéma*.

He made things run smoothly, managed to reconcile contraries, maintained the best possible relations with the institutions of French cinema, went to meet recognized filmmakers, and aided by his wife Lydie, who was the copy editor, handled most of the everyday work: preparing each issue, ordering supplies, reading contributions, rereading them, doing layout and production, and organizing delivery to subscribers.

The critical soul of *Cahiers* was André Bazin, who was surely one of the world's most important "cinema writers."[94] In 1951, at the age of 33, he was already a leading figure, and he was the review's conscience. Thanks to his countless articles—two thousand six hundred in fifteen years—written for diverse periodicals (*Esprit, L'Écran français, France Observateur, Le Parisien libéré, Radio-Cinéma-Télévision, Cahiers du cinéma, Arts*, and others) until his death in November 1958, Bazin provided the tone, the opinion, the analysis, and the theoretical depth, but also the line, because he was not the last to enter a dispute when he thought it necessary to do so: against Sartre regarding Orson Welles; against Louis Daquin, Georges Sadoul, and the communists regarding American cinema or the myth of Stalin in Soviet films; against all the young critics whom he repeatedly accused of "neoformalism,"[95] the cult of style at the risk of ignoring the questions of the present time, even of drifting to the right. In the couple they formed in the direction of *Cahiers du cinéma*, Doniol-Valcroze was the publisher, the diplomat, the representative of the review to the outside; Bazin was the brains, the pedagogue, and the writer, the guarantee of a certain coherence in the line taken and critical points of view. He was incontestably the one who attracted (and sometimes worried) the youngest cinephiles, for whom he was either a spiritual father[96] or an intimidating authority or a guardrail: he was the one who ultimately decided whether a text would or would not appear in *Cahiers*.

It was logical that Maurice Schérer, who had contributed to *La Revue du cinéma* and was already a well-known critic, should soon publish work in *Cahiers*. His first piece, commissioned by Doniol-Valcroze, appeared in issue number 3, in June 1951. The eight-page article was entitled "Vanité que la peinture" and, drawing mainly on examples taken from Robert Flaherty's *Nanook of the North* and from F. W. Murnau's *Tabu* and *Sunrise*, demonstrated the glory of cinema, which replaces painting in the order of the arts by refounding beauty on the basis of capturing the movement of things themselves. Cinema is the art of its century because it naturally combines aesthetic representation with realism, whereas all the other arts are now compelled to exaggerate, to provoke, to take

refuge in grimaces. Schérer's text made a great impression, and at the time the very young Claude Chabrol even went so far as to call it "the most trenchant article on cinema that has ever been published."[97]

Over a period of four years, Schérer contributed a dozen important pieces to *Cahiers*.[98] He did not scatter himself, and established his reputation by the quality of his writings, not by their number. His work is characterized by a remarkable consistency of choice and line: among contemporaries he discussed almost exclusively Renoir—the American or postwar Renoir, which was unusual—Hitchcock,[99] Rossellini,[100] Howard Hawks,[101] and Fritz Lang,[102] whereas among the earlier filmmakers he wrote mainly about Murnau, whom he showed to be a major author in the history of cinema. There is only one incongruous oddity in the absolutely coherent corpus of early texts published in *Cahiers*, and that is the choice to devote a long study, in March 1952, to Isidore Isou, an avant-garde *lettriste* whom Schérer managed to connect with "things as they are" and with an astonishing power of realistic imagination.

If Schérer rapidly established himself as an authoritative critic in *Cahiers du cinéma*, he nonetheless remained the leader of a group, continuing as the head of the CCQL. More than that: thanks to him, this faction published an increasing number of pieces in *Cahiers*. Schérer constantly had his young protégés write for it. The conquest of *Cahiers* soon became the objective of the group that had been orphaned by the demise of *La Gazette*. This did not happen without resistance or polemics, and the instrument of this critical strategy was Alfred Hitchcock, around whom controversies about cinema crystallized at this time.

The generally held opinion among critics, whether French or American, was that since he began working in Hollywood, Hitchcock had lost all originality and ambition, limiting himself to a superficial brilliance as a "master of suspense." His films were popular, attracting millions of spectators, but many intellectuals scorned his decline to a mere moneymaker. In *Cahiers du cinéma* itself, this view was widely shared, notably by André Bazin, who did not care for Hitchcock, considering him artificial and vain. In November 1951, the review opened its columns to the skepticism of Herman G. Weinberg, its correspondent in New York and a promoter of cinema at MoMA. He reduced the "Hitchcock system" to a cynical "popcorn factory" intended to please young spectators: "Hitchcock tries desperately to dazzle us with technical tours de force and blows to the solar plexus. I fear that is no longer enough. He seems to no longer have much to say."[103] Hitchcock, who had not yet entered the pantheon

of unchallenged masters, was the filmmaker about whom French critics argued at that time.

In March 1952, Jean-Luc Godard, then twenty-two years old and recommended by Schérer, wrote a piece on *Strangers on a Train* for issue number 10 of *Cahiers*, offering an ardent defense of Hitchcock's film. With humor, the insolent young critic ended his article on a corrosive note: "The reader will have noted that every point in this article was directed against the editor in chief." He could not have been clearer. According to him, Hitchcock had a "directorial virtuosity" that made him the equal of Abel Gance or Dreyer. Finally, and this is what establishes the filmmaker's greatness, for Godard, Hitchcock is the true modern: "To be sure, Hitchcock challenges reality, but he does not escape from it; if he enters into the present, it is to give it the style it lacks." Thus the director of *Strangers on a Train* is the only one who knows how to combine stylization and realism, making films based on "the inseparability of the camera, the filmmaker, and the camera operator with respect to the reality represented," a formula taken word for word from Maurice Schérer's critique of *Notorious*.

This praise of Hitchcock did not go unnoticed. Pierre Kast, a respected critic and a former member of the Resistance who was on the left, replied two months later, also in *Cahiers*: "I see, of course, what is concealed behind the Schérer school's excessive, pleasantly hypocritical or youthfully paradoxical praise of Hitchcock's recent manner."[104] Was this school, whose point of view Jean-Luc Godard had just expressed, the crucible of the new film criticism? The debate quickly flared up again as Hitchcock's films came out or were shown again. Two months later the "Schérer school" expressed itself through the intermediary of its leader himself, apropos of *The Lady Vanishes*, a 1938 English film that some critics of the time considered its creator's masterpiece. Schérer polemically insisted that this film, though "certainly perfect," was "inferior to *Rope* or *Strangers on a Train*." He asks: Why is Hitchcock so great just now and in Hollywood? "Because he is the one who pays the most attention to the brute power of the thing he is showing."[105] Schérer closes his article with a plea: "No, Hitchcock is not simply a technician, but one of the most original and most profound authors of the whole history of cinema." The battle for the recognition of Alfred Hitchcock as an auteur was clearly launched in *Cahiers du cinéma*.

Challenged by Pierre Kast, Maurice Schérer responded in *Cahiers* (no. 26, August–September 1953) with the manifesto of this critical battle, an important stage in the conquest of the review by the group from the CCQL. The article

was entitled "On Three Films and a Certain School," an explicit reference to the "school" that was said to bear his name and to disturb *Cahiers*. As a kind of introduction and justification, he began by clarifying the point at issue:

> Since Pierre Kast did me the honor of making me the leader of a school that perhaps shines more by the ardor of its adepts than by their number, a school that André Bazin placed at the extreme—I accept that—of critical dogmatism, let me speak as the interpreter of the tastes of a group that is, to be sure, a minority, but nonetheless a minority that is part of the editorship of a review whose eclecticism, within a common love of film, is a sufficient guarantee of its competence and seriousness.

Schérer then locates his adversaries on the critical terrain, suggesting that they speak from that "left that associates the cinematographic value of a work with the virulence of a certain social demand." Finally, as a major component of his argument, Schérer proposes a triad of auteurs: rather than Huston, Chaplin, and De Sica, Bazin's favorites, Schérer chooses Renoir, Rossellini, and Hitchcock. For him, the new films by these directors—Renoir's *The Golden Coach*, Rossellini's *Europe 51*, and Hitchcock's *I Confess*—are the only ones that make it possible to "be modern." All three of them offer a realism that reveals the profound inseparability of the material order and the spiritual order. In Hitchcock's work, this involves a way of recording the real (the continuity of the action, suspense) that reveals "the mental torment visible on the hero's face." The hero's face thus becomes "spiritual flesh." Since Hitchcock was the only one of the three masters whose status was contested, Schérer concludes his manifesto by referring to him: "I want film criticism to finally free itself from the ideas dictated by its elders, to examine with new eyes and a new spirit works that I believe will prove much more important in the history of our time than the pale survivals of an art that no longer exists."

But it was only in October 1954 that the controversy over Hitchcock in *Cahiers* came to an end with the victory of his supporters and the publication of a special issue entirely devoted to his work. This issue is a landmark, because it places Hitchcock at the center of a metaphysical, even Dostoyevskian, interpretation of an auteur haunted by the eyes of God.[106] Schérer presents this interpretation in an article, "À qui la faute?" (Who is to blame?) that begins with this sly wink: "In this issue devoted to the most brilliant of technicians little attention

will be given to technique. One must not be too surprised to find in it, instead of terms like 'tracking,' 'framing,' and 'lens,' and all the atrocious jargon of film studios, more noble and accurate terms such as 'soul,' 'God,' 'devil,' 'concern,' 'redemption,' and 'sin.' I can see the reader frowning. That may be all right for Renoir and Rossellini, who do not disdain philosophical traits, but does this master humorist deserve or even claim such an excess of honor? And yet . . . ' "

The final impediment to the review's shift toward Hitchcock and its takeover by the Schérer school was André Bazin himself. Up to that point he had not intervened in his *Cahiers* regarding these quarrels. But Godard, Schérer, Rivette (in an important article on *I Confess* published in September 1953), and Truffaut and Chabrol (in their long interview with Hitchcock in the special issue) forced him to enter the debate. In issue number 27 (October 1953), Bazin took an explicit position supporting John Huston, a committed left-wing filmmaker who was critical of America, against Hitchcock, whom he limited to the role of a superficially brilliant technician. "Since I am reproached for shaking my head on hearing Hitchcock's name," he wrote, "to clarify my view I shall say that it seems to me obvious that the creator of *I Confess* has a personal style, that he is the inventor of original cinematographic forms, and that in this sense his superiority to Huston could be considered incontestable. But I nonetheless maintain that John Huston's *The Red Badge of Courage* or even *The African Queen* are works far superior to *Strangers on a Train*. Because the subject also counts for something, after all!"[107] Although there was a basic understanding between Bazin and the young writers grouped around Maurice Schérer regarding themes such as realism or the correspondence between the material and the spiritual in art, they could establish no dialogue on certain judgments of taste and certain choices that the Hitchcock dispute reveals. However, the Schérer school undoubtedly emerged from this critical duel stronger than ever.

Confronted by the group from the CCQL, which Doniol-Valcroze said was practicing "critical absolutism,"[108] André Bazin could have protested. He could also have opposed its rise to power. But he was clear-sighted enough to see in this movement federated around Maurice Schérer the future of *Cahiers du cinéma*. Thus, in February 1955, the editor in chief asked himself: "How can one be a Hitchcockohawksian [trans. note: Apparently an amalgam of Hitchcock and (Howard) Hawks]?" and wondered about the motivations of the young Turks who were defending a pair of Hollywood filmmakers who were then still largely scorned. To be sure, he offers a critical analysis of the arguments and strategies

of this "little group of our collaborators whose preferences run counter to generally received opinion." But paradoxically he defends this school, recognizing its energy, passion, erudition, style, and tone. "Since there is a misunderstanding, let us try to understand precisely the adversary's arguments": that is in substance his reasoning, and it illuminates in a very suggestive way the main aspect of André Bazin's personality: he listens to the Other. This tolerance allowed the Schérer school to take over *Cahiers du cinéma* in the mid-1950s.

"Life was the screen"

At that point, the little group led the life of cinephilia in Paris. However, everyone says that this life without money was rather dreary and meager. Cinephiles spent their time in movie theaters, in bistros where they discussed films, in editorial offices, and in tiny editing studios, swamped with work, avoiding social life and literary cafés, going out only enough to maintain a few professional relationships. That is what Éric Rohmer wrote:

> For us, there were no "good years," no "belle époque," and ultimately, if we can make any claim, it would be to say, with Nizan: "I won't let anybody say that the age of 20 was the best time of our lives." Those years were not the most unhappy, but they were rather gray: we were living on hope alone, we weren't living at all. When we were asked: "What do you live on?" we liked to reply: "We don't live." Life was the screen, it was cinema.[109]

Each person's private life remained secret. A residue of puritanism remained in these young people. Between them there were, of course, bonds of friendship, but no familiarity. Godard put it well: "It was a little like the way it was in old Protestant families, we didn't talk much about our lives. We were nevertheless experiencing things and knew what was going on, but we pretended that didn't exist. We knew that so-and-so was so-and-so's girlfriend, but that was all; what they said to one another was another world. It's true that it was taboo, introverted. We were a kind of clergy—what is called *une chapelle*—did St. Paul and St. Matthew talk about their temptations?"[110]

Paul Gégauff, the most extroverted, left a somewhat more personal and intimate portrait of Maurice Schérer between the ages of 30 and 35, when he was still

a bachelor, still living cheaply in his furnished room at the Hôtel de Lutèce. "He was a decent, honest fellow, very professorial," Gégauff says. "Within the white walls of his room, everything counted, every penny, every cracker, every tea-bag. He remained very well-groomed, but severe, no frills of any kind. We were young and broke, and he always gave us a little money, but we had to give him some kind of proof, from a metro ticket to a train ticket, by way of the grocer's bill."[111] Although he lived on little, in accord with a spirit of thriftiness that some-times verged on stinginess, Maurice Schérer was already established in life. After his years working as a substitute teacher at the private Collège de Sainte-Barbe, or as a tutor at the Montaigne and Lakanal lycées, he applied to be taken into the National Education system as a secondary school teacher certified in classics and with the rank of bi-admissible. His age, his limited experience, and his status as a bachelor without children prevented him from being assigned to a post in Paris and even sent him rather far into the provinces. For several years, he refused to take up his post, preferring to teach in a nearby private school. In 1952, he was offered a position at the Henri-Brisson lycée in Vierzon, a little closer to Paris: 218 kilometers from the Latin Quarter. He was to teach there from September 1952 to end of the school year 1955.

Maurice Schérer's archives preserve a few traces of this pedagogical activity, which basically took the form of courses on Latin and Greek. One of his groups of students gave him a copy of the official photo bearing this dedication on the back: "With fond memories from your students in 3e B."[112] The picture shows a tall, shy man amid sixteen students, fourteen-year-old boys and girls. In June 1954, he gave the speech at the prize award ceremony, on the theme of "the French spirit," in which we sense both the pride in claiming a tradition and a certain self-mockery: "We academics are certainly not smothered by the weight of traditions. There is nothing austere or starchy in us, as there is in so many schools in old Europe. Our external appearance is affable, familiar, very mod-ern. No old-fashioned uniforms, no beards or mortar boards, and our lycée is one of the last to maintain even the tradition that allows me to address you today. And yet the basic content of our teaching, our programs, our methods, have varied less over the past century than in other more conformist coun-tries."[113] All this left no deep mark on Maurice Schérer, who recalled little about these years of frequent trips to Vierzon, "a not very interesting town": "In the train on the way back, I often ran into a man who smoked a great deal, which made me shy away. But by his remarks, I understood that he taught philosophy

at the Henri-Brisson lycée. One day, I learned that his name was Gilles Deleuze, but I never spoke to him."[114] Real life was elsewhere, at *Cahiers du cinéma*, where he was taking charge along with his young friends, and in the films that he already had in his head.

Projects were multiplying, henceforth signed or cosigned "Éric Rohmer." *Le Carrefour du monde*, dated May 1951, is a very ambitious, sixteen-page scenario very unusual among those of Rohmerian inspiration, a kind of prefiguration of a historical film like *Triple Agent*, made fifty years later. It follows the character of Karel Carossa, a Hungarian fascist leader who has taken refuge in Paris. Pursued by Budapest's communist secret service, he is led to commit suicide in the middle of Saint-Germain-des-Prés.[115] In the same period we find the first version of a project to which Rohmer was to return several times, well into the 1960s, without ever being able to carry it out. It is another story of suicide, *Une femme douce*, a modern adaptation of a story by Dostoyevsky.[116]

With Paul Gégauff, Rohmer wrote *La Roseraie*, a film project that they published in the form of a short story in *Cahiers du cinéma* in September 1951. It greatly resembles the story *Claire's Knee* written by Maurice Schérer two years earlier and made into a film twenty years later, though here the fetishism concerns the ear of a very young woman, under which an older man places a kiss. Rohmer also worked with François Truffaut, notably on a project entitled *L'Église moderne*; for a time they hoped Roberto Rossellini would make it into a film when he was living in Paris and hanging out with the young Turks. There was a real connection between "le grand Momo" and "la Truffe," as is shown by this note scribbled by Truffaut to Schérer when he was feverishly preparing his very first short film, *Une visite*, in December 1954:

> Old knave, dear villain, crooked friend, and scoundrel brother, this is to inform you that I have countless things to reproach you for, starting with, with . . . You'll find out later! Know only that I'm offering you a chance to redeem yourself: you have to immediately lend me and also take to *Cahiers* everything you have in your lair that in any way resembles filmmaking equipment: lights, projectors, wires, film, money, etc. So stop messing around and phone me here at *Cahiers*, tomorrow if possible, otherwise you'll soon hear from me. Everybody here is fond of you, but more than one of us will hate you if you turn out to be incapable of helping out your friends and acolytes. *Ave* Maurice, and hope to hear from you soon.[117]

But it was Godard to whom Rohmer was closest and with whom he shared several ideas for films: in particular a modern version of Faust, signed with the pseudonym Antony Barrier, in which the man sells his soul to the devil and becomes an abstract painter who decides to make a living by producing copies of Van Gogh. Mephistopheles is his agent, salesman, and gallery owner. When the painter, who has become rich, meets a young woman and wants to marry her, the police come up with a stratagem that allows them to arrest the artist and his mentor. In Éric Rohmer's archives we also find a fifty-page scenario signed "Hans Lucas " (as we have seen, this was Godard's pseudonym) and entitled *Odile*; it was no doubt the very first scenario written by the future director of *Breathless*.

Rohmer and Godard also devoted a great deal of energy to a first ten-minute film, *Présentation*, which was based on a nine-page story Rohmer had written. He summed it up this way: "Idea that the strongest moment of the attachment is that of its betrayal. One never regrets so much what one is leaving, [as one does] at the moment when one makes up one's mind to leave it forever."[118] The little film was actually made, in two days, one in December 1951, the other in February 1952. Alongside two actresses, Anne Coudret and Andrée Bertrand, Godard played the role of the young man, Walter—somber, black glasses and overcoat, freezing to death—who flirts with the two girls, Clara and Alice. During a strange cooking scene in which the flirtation becomes insistent, he ends up choosing Alice, who cooks a steak and shares it with him before giving him a quick kiss. Rohmer says he gave Godard this role with a certain enthusiasm: "I thought of him because he was handsome. I've always thought he was an actor. He has an actor's body, and a slow, very distinguished way of speaking."[119] Godard helped locate the outside scenes, taking Rohmer, who wanted to film in the snow, to the ski resort of Saint-Cergues in the Swiss Jura Mountains, and then he helped construct the set of the kitchen in a Paris photography studio. Rohmer recalled: "I can see us again, Godard and me, sweating blood and water, carrying up the stairs a range that a neighborhood merchant had lent us. The pots and pans had been borrowed from the owner of my hotel. That's the tragic-comic side of the beginnings. I really learned my trade through amateurism."[120] In May 1952 *Cahiers du cinéma* published the "story" of the film below a photo in which we see Godard, called "Nick Bradford," with this caption: "After *Présentation*, Guy de Ray is going to make, in collaboration with Hans Lucas, a cinematographic story, *Week-end d'amour*."

Though hardly conclusive—"It's a film that is interesting as an archive, as a document," Rohmer himself later said[121]—this vaudeville in the snow allowed Rohmer to meet Guy de Ray, who really existed: a cinephile photographer and young critic (he coauthored with Schérer a text published in *Cahiers du cinéma*); de Ray conceived an admiring friendship for Rohmer and did everything he could to find money—he was quite resourceful—to produce Rohmer's first attempts at filmmaking.

The First New Wave Film

On October 30, 1952, Maurice Schérer signed a production contract for his first full-length film. He associated himself with Guy de Ray and Joseph Kéké, a representative of the Paris Consortium for Cinematographic Production (Consortium parisien de production cinématographique, CPPC), whose headquarters were in Montreuil, to make a film entitled *Les Petites Filles modèles*, with a budget estimated at 24.6 million old francs (about $70,000). The production company provided 16.4 million francs, while Schérer provided 8 million, and agreed, like the rest of the team, to work for a share of the profits. Guy de Ray contacted Joseph Kéké, a twenty-four-year-old student from Benin whose family fortune came from palm oil plantations in his country. He himself was colluding with his relative, Paulin Kéké, and it was these three who founded, on July 20, 1952, the CPPC, a film-producing company dedicated to financing *Les Petites Filles modèles*, since the latter was its only project.[122]

This contract[123] is the proof of an immense ambition. It was the first attempt made by a critic of the cinephile generation to accede directly to the production of a feature film without passing through the previously obligatory stage of assistantship. It was, in short, the first New Wave film.[124] This precociousness is astonishing: at that time, the offensive against "quality French cinema" had not yet been launched in *Cahiers du cinéma*. To see possible alternatives formulated, one had to wait for the publication in January 1954 of François Truffaut's "Une certaine tendance du cinéma français," which denounced French "quality" and promoted the politics of auteurs. *Les Petites Filles modèles* was thus a case of practice preceding theory. This shows how much the criticism written by the young Turks was connected with their concrete cinematic ambitions, with their experiences of filming and editing movies.

Maurice Schérer loved nineteenth-century French authors, especially Balzac, a taste he shared with all the members of his "school." But he had a special fondness for the Countess of Ségur, whom he had discovered as a child and then reread, as he said more than once, "every year."[125] In her work there are pre-Rohmerian characters. Of course, there are the girls, a motif that she established in French literature. But there is also a preoccupation with pedagogy, a concern for good manners and beautiful language, that may have touched the teacher of classical literature. The Countess of Ségur's titles are also pre-Rohmerian: a collection of her short pieces is entitled *Comedies and Proverbs*. Finally, even the countess's style seems to provide Rohmer with a text "almost ready to film right out of the book."[126] The abundance of dialogues, "particularly lively and fast-moving,"[127] is a characteristic of her novels that is obviously preserved in Rohmer's adaptation. He felt close to the Countess of Ségur because she does not emphasize her characters' thoughts, preferring to describe their external actions. "Sophie Fichini's adventures in Fleurville can compete with the most epic of Westerns,"[128] he liked to say.

The novel *Les Petites Filles modèles*, which appeared in 1856, is set in Normandy, and follows the education of four little girls. It is a work without men, the fathers being either dead or absent. Camille, eight, and Madeleine, nine, live in the family chateau with their mother, Mme de Fleurville, and their maid, Élisa. After an accident—a carriage is overturned in a ditch—the survivors, Mme de Rosbourg and her daughter Marguerite, six, are invited to stay in the chateau. Then Sophie Fichini, eight, an orphan who lives nearby, arrives. Her haughty, cold stepmother has left for a trip to Italy, permanently abandoning Sophie. The curious and bold Sophie has become secretive, hypocritical, and insolent. Little by little, in contact with Camille, Madeleine, and Marguerite, and in the course of adventures that take them to the pond, the mill, the forest, and the path to the bread oven, where they face many dangers and several tests both physical and mental, Sophie learns the principles of virtue.

Rohmer's archives contain several items important for tracing the work of adaptation, preparation, and then filming *Les Petites Filles modèles*, in particular, a hundred and fifteen handwritten pages in two school notebooks entitled simply "PFM" that outline his interpretation. However, this very literary scenario is divided, with the help of marginal annotations made in blue ink with a ballpoint pen, into three hundred and two shots, along with indications of the type of shot (three-quarter, wide, zoom, close-up), camera movements (tracking

backward, tracking forward, panoramic), and shot/reverse shot scenes that indi-
cate the author has carefully thought out the mode of shooting. The text has ten
chapters corresponding to ten sequences of nine minutes each and to ten quasi-
autonomous adventures.

The novel's action takes place over a period of ten years; Rohmer deliberately
condenses it into a few days and a ninety-minute scenario. Only the end of the
summer has been changed; the arrival of the cousins is cut out and the family
get-together refocused on Sophie's adoption by Mme de Fleurville. The novel's
many moralizing commentaries have been abbreviated or omitted "in order to
avoid slowing the rapid development of the story."[129] In general, the dialogues are
preserved intact, and others are added, transposing into direct discourse pas-
sages that are conveyed indirectly in the novel. This also shows that the scenario
is more than a mere film adaptation of the Countess of Ségur's text *Les Malheurs
de Sophie*, which Jacqueline Audry had already made into a film in 1946, using
a scenario by Pierre Laroche. The latter imagined his heroine's life as an adult,
invented characters, and above all suggested a political interpretation of the
period of the Second Empire. Rohmer considered this work "too free and easy,"
whereas he claimed to have produced a "very faithful" adaptation that "followed
the famous work to the letter."[130]

A statement of intent explains the working conditions as the neophyte
filmmaker conceived them in theory: "The making of this film must avoid the
dangers of excessive expenditures. The conditions of its filming will not be very
different from those of a fictionalized documentary. Scenes shot in a natural set-
ting, with a minimum of technical equipment, mainly nonprofessional actors,
no general director or set designer, since the owner of the chateau has kindly
made what we need available to us. Only the costumes will be adapted or made
from scratch, inspired by engravings in the Bibliothèque Rose."[131] That was a way
of adapting to the financial limits of the budget (which amounted to about one-
third of the usual financing of a French full-length film), but it was above all
a kind of Rohmerian creed. It anticipates the way many of his later films were
made, up to the 1990s: minimal crew and technical equipment, little-known or
nonprofessional actors, natural settings, voluntarily doing without certain posi-
tions (set designer, assistant director, property person, dresser, make-up per-
son), attention to the period style of costumes, documentary-style shots, filming
in the order of the narrative and the scenario, and so on. The contract with mem-
bers of the crew even stipulates one of the infrangible rules of life on Rohmer's

future sets, on-site lodging and meals—the latter prepared in this case by the mothers of the little actresses: "The difficulties of finding lodging in Normandy near the location where the film is to be made force us to lodge in the chateau of Champ-de-Bataille. The producers will provide for lodging, meals (breakfast, lunch, and dinner) and various other needs (laundry, etc.)."[132] This is a veritable *Discourse on Method* of Rohmerian filmmaking.[133]

Writing less frequently for *Cahiers du cinéma*—he published nothing in that periodical from the summer of 1952 to March 1953—the new filmmaker devoted his time to preparing his first film. He contacted actresses: Josette Sinclair, who came from Nice and whom Gégauff had met while making *Le Journal d'un scélérat*, for the role of Mme de Fleurville, and Josée Doucet, who had been spotted in a short film made by Paul Paviot, *Saint-Tropez, devoir de vacances*, for the role of Mme de Rosbourg. He offered the role of the negative character Mme Fichini to Olga Varen (a.k.a. Olga Poliakoff), a friend of Rivette's who had played in *Le Divertissement* in the spring of 1952 and was the elder sister of Odile Versois and Marina Vlady, with whom she had made her début on the Grenier-Hussenot company's stage.

The casting of the little girls was more complicated, since Rohmer knew hardly anyone between the ages of seven and ten. Through acquaintances, he found Martine Laisné (Camille), Anna Michonze (Madeleine), and Catherine Clément (Marguerite), but he lacked a Sophie, the main character. So he hung around playgrounds, parks, and schoolyards, which did not fail to cause him certain problems that were probably exaggerated for comic effect by Claude Chabrol when he talked about this phase:

> Intending to make a film of *Les Petites Filles modèles*, he thought it would be a good idea to seek his actresses in the parc Monceau. Imagine the scene: this tall, skinny, dark-haired silhouette wearing a cape, slithering silently down the garden paths with a package of candy in his hand. When he liked a little girl, he beckoned to her, saying: "Come here, little girl, I'm going to tell you a lovely story." After using this ploy for three or four hours, naturally he got himself arrested by the park guard. In his absolute innocence and entirely cinematic passion, he didn't understand why the cops hauled him off to the police station.[134]

Finally, Rohmer found his Sophie on the street, not far from the Henri-IV lycée, walking alongside her mother with an ice-cream cone in her hand. Her name was Marie-Hélène Mounier, and she was eleven years old.

The whole film was made in natural settings in Normandy, where Rohmer looked for his "chateau of Fleurville." After having considered shooting at the chateau of Gite, where the countess of Pitray, the Countess of Ségur's granddaughter, had spent her childhood, he chose the chateau of Champ-de-Bataille, twenty-five kilometers from Évreux, near the village of Neubourg and surrounded by extensive grounds and a beautiful countryside. Built in the seventeenth century, it is a magnificent structure with two symmetrical wings embracing a formal courtyard, forty rooms, a French-style garden, and façades in the classical style. The production company rented it from the duke of Harcourt—at least one of the two buildings, the one with the living quarters—for a modest price, because the whole had not yet been restored and had suffered from its recent functions: it had been a hospital during the 1930s and had been requisitioned by the German army during the Occupation. There had been heavy fighting there after the landing in Normandy, and eight years afterward the chateau still showed signs of damage. The outbuildings were virtual ruins, the lovely garden was untended, and the paths had been destroyed in places by the treads of German tanks. However, Rohmer was quite satisfied when he visited this almost abandoned chateau in early June 1952 in the company of Guy de Ray: here was a place that he could pass off as the more modest home of the Ségurs—the one that inspired the countess in her novels.

The constitution of the technical crew completely escaped Rohmer. He thought he could call on his young friends, Jacques Rivette for the camera work and Jean-Luc Godard and Georges Kaplan as his assistants, more experienced technicians coming in only as complements, particularly for the equipment most difficult to handle, that concerning lighting and sound. But Rohmer, who wanted to film in a professional way, in 35 mm with synchronous sound, had to conform to the strict regulations of the CNC (Centre nationale de la cinématographie), which stipulated that unless a dispensation was granted, only those holding a professional certificate could hold the main positions during filming. The shots could be directed by a neophyte only with the help of a duly mandated technical advisor who had the real power over the filming. Rohmer was forced to yield and accepted a team improvised at the last minute.

Guy de Ray dealt with the CNC. On July 23, 1952, ten days before filming was to begin, he wrote to Rohmer:

> Up to this point, everything is still going well. I've found a transformer and this afternoon I'm leaving for Neubourg. On Saturday I'm going with Mme Laisné

to buy fabrics [for costumes], and I wish you could be there. I'm very annoyed because I absolutely cannot send you any money before Saturday morning, and it won't get there until Monday. *Don't fail to take the ring to a jeweler* and tell him that you'll send the money next week to redeem the ring. The duke of Harcourt is very kind, but he wants me to take out fire insurance before occupying his chateau. Tomorrow morning I'll try to hire Guilbaut [*sic*] and his wife as continuity people. Godart [*sic*] is terrible; he won't arrive, I think, before next week. Don't worry about anything, it will all be ready. Tixador is working hard, and for his part, the sound engineer seems as neutral as he is. I'm going to Neubourg to see about the electricity, the beds, a cook, and a maid. Regards.[135]

Here we have the most important technical assignments. Pierre Guilbaud, who had studied at IDHEC (Institut des hautes études cinématographiques) and was pursuing a respectable career as a first assistant, had been proposed by the CNC along with Henri Verneuil and Yves Allégret; he was joining as an advisor to the team that was being constituted. The camera operator André Tixador and the sound engineer Bernard Clarens (whose first job was working on Becker's *Rendez-vous de juillet*) had already been chosen. Guilbaud suggested André Cantenys, his former classmate at IDHEC as first assistant, Jean-Yves Tierce as head camera operator, and his own wife, Sylvette Baudrot, as script girl; she had just worked with Jacques Tati on *Les Vacances de M. Hulot* and later pursued a long career with Alain Resnais, Gene Kelly, and Roman Polanski. Seven other technicians completed a crew that was still young but of genuine quality, relatively small for a film "in the French manner" at the time, and yet already much too large according to Rohmer's conception of filmmaking.

An Unfortunate Adventure

When the whole team arrived at the chateau in early September 1952, an impressive amount of equipment was waiting for them there: two powerful arc lights, a generator, a camera trolley, and tracking rails. At the last minute, the first day of shooting had been delayed until the thirteenth. The filming was difficult.[136] Living conditions in the chateau were impractical: the abandoned building had no running water, no telephone, and no heat. Everyone slept on the upper floor, on cots borrowed from the Neubourg army barracks. Various incidents impeded

the progress of the filming: sudden transformer breakdowns, the noise made by tractors in the middle of plowing season. The generator was not powerful enough and it turned out to be impossible to light both the chateau and the forest at the same time, as Rohmer wanted for certain scenes.

However, the most serious problem was dissension within the team. Pierre Guilbaud, the technical advisor, says this about it:

> My first impression was not very good. Rohmer was a neophyte, naïve, and soon encountered rather grave difficulties. For example, the notion of which way a character was looking did not exist for him, and often the shots could not be matched with one another. He didn't think about the montage that was going to come later. He was learning his trade. He had preconceived ideas, came in with a storyboard and shots set in advance, and really had no awareness of the constraints.[137]

Conflicts with the crew were frequent, especially between Rohmer and the camera operator, André Tixador, or the script girl, Sylvette Baudrot.[138] Most of the technicians soon became skeptical, and they ended up clucking over the way Rohmer directed the children who, according to the sound engineer Clarens, "spoke in a very false voice."[139] The children's parents began to complain, particularly as autumn approached, with the first cold spells, weariness, and the scenes in the pond, where the girls had to go into the frigid water.

Rohmer was isolated, uneasy, forced to accept compromises that he considered fatal, and had hardly any allies on the shoot, even though he could count on the actresses Josette Sinclair and Olga Varen, who were his friends. Guy de Ray was not sufficiently present, being forced to view the rushes in Paris and to negotiate on behalf of a production that was still fragile. Rivette, Truffaut, and especially Godard repeatedly came to the shoot at Champ-de-Bataille, but that didn't help matters. They were perceived as members of a cinephile clan without any field experience, arrogant, and even downright shady. One day, the typewriter used to prepare the daily reports disappeared, and Sylvette Baudrot was furious. Suspicions fell on the teenager who was taking care of the rented horses and carriages and who had been hired at the insistence of an organization that helped juvenile delinquents re-enter society. The crew was astounded when a few days later it learned that it was Jean-Luc Godard who had made off with the typewriter in order to sell it. This was the same Godard whom Gégauff describes

going through people's coat and jacket pockets during the preparatory tests for the film.[140]

It was again Jean-Luc Godard who did an interview with Éric Rohmer for *Les Amis du cinéma*. When it was published in mid-October 1952, right in the middle of filming, it threw oil on the fire. Rohmer mentions the film he is making and denounces "French technicians' routine way of working, which hampers inspiration," complains about being "flanked by a technical supervisor" whom he accuses "of slowing down work through an abusive fear of certain technical taboos," and concludes with a plea for new methods:

> The methods of filmmaking have everything to gain from being revolutionary, even if that means, paradoxically, that cinema is better suited than any other [art] to magnify a conception of man that is also that of Racine or Goethe. The true lesson of Italian cinema has not yet been understood by everyone. It is positively implausible for a camera operator to tell you: "Don't do this, I won't be able to light it. Don't move your actors around too much, I'll have to redo my lighting . . . " It has to be said: our cameramen lack boldness and I believe that schools like IDHEC are not likely to give them any. On the contrary.[141]

The atmosphere at the shoot was obviously affected by these remarks.

The filming was nonetheless completed on November 8, 1952, after fifty-two days of work. Three hundred and forty scenes were shot, a few more than the storyboard planned, and the crew, though it still had reservations, felt that the film "could be edited"[142] and that it should be possible to carry it through.

Jacques Rivette did a first, light editing, but the CNC's regulations called for a professional: the film was therefore entrusted to Jean Mitry, a historian and theoretician of cinema but also a writer, who had just collaborated with Alexandre Astruc on *Le Rideau cramoisi*. He worked on *Les Petites Filles modèles* for more than a month in January and February 1953, along with his assistant, Cécile Decugis, an intern who recalls "a few rather delicate transitions" but does not at all have the impression that they faced "insurmountable problems."[143] The technicians who were present at a preliminary showing in March 1952, notably Pierre Guilbaud, Bernard Clarens, Sylvette Baudrot, and Cécile Decugis, all agree in emphasizing that the film was not incoherent, that it was "a good job."[144] At that point there remained only a small amount of work to be done: the music, the mixing, the polishing of the sound montage, and certain sound effects. Another

month and the film, which was about an hour and twenty minutes long, would be finished.

That was when the coproducer from Benin, Joseph Kéké, halted the film. Three successive meetings were arranged with Guy de Ray, Éric Rohmer, and Pierre Guilbaud, but they got nowhere. Kéké remained firmly opposed to investing another centime in the project. Since the film had no distributor and Guy de Ray had no available funds, it was impossible to find a financial solution. However, the amount that was needed was small.

There is probably another explanation for the sudden and final abandonment of *Les Petites Filles modèles*, as Pierre Guilbaud sensed when he met with Joseph Kéké; he refers to "a young man at bay" and "a shady affair."[145] A newspaper clipping preserved in the archives might shed light on this. It is entitled: "My demands 2 million from Kéké."[146] It is an unsavory story. Joseph Kéké had met Lucette My, a striptease dancer, and offered her a role in the film being made. "But of course," the journalist explains, "he could not assign roles without checking to be sure that the anatomy of the future stars who were putting their destinies in his hands corresponded to the tastes of the audience—in this case his tastes." There was a fight; Lucette My was molested, slapped, suffered a broken tooth, and filed a complaint, demanding 2 million francs in damages, with interest. Is that the explanation for the difficulties that suddenly plagued Éric Rohmer's film: a coproducer in trouble with the law?

The negative of the film was long stored at the LCM laboratories and then, after the company went bankrupt, it was transferred to a firm that bought it, GTC. That was probably when it was lost. Only a few fragments of the film survive, having been taken out for checking by the assistant camera operator or to prepare photos for the press. In Rohmer's archives there are twenty-five pieces of film that allow us to illustrate about fifteen sequences. There are a few photographs of the shoot, taken by Rohmer, Baudrot, or Guilbaud: we see the girls working at a table, directed by the filmmaker, who is holding the scenario in his hand, or resting in the garden. There is also a picture of Godard, who had stopped by; he is holding a doll in his hands and joking with Guy de Ray. Another photo shows the whole film crew arriving at the station in Évreux. Standing at the extreme right of the picture, Rohmer is wearing a shy smile.

What can be said about this lost film? For the apprentice filmmaker, it was an unhappy experience, even if he was almost able to complete it. The filming, the quarrels with the crew, the mockery directed at him that challenged his

competence, the sudden halt—all that certainly bruised him. It emphasized the difficulty he had in asserting his authority and making himself understood by others. Rohmer henceforth preferred to forget *Les Petites Filles modèles*, and never mentioned it in interviews. There are rumors suggesting that he himself might have destroyed the film. Once, in the outtakes from the program *Cinéastes, de notre temps, preuves à l'appui* recorded in May 1993, he spoke about this film, with considerable annoyance: "I had the extremely unhappy experience of making a feature film very early on, *Les Petites Filles modèles*, the most unhappy of all, in fact, in which my cinematic ambition almost perished. I don't know why I launched into it, but in short it is absolutely certain that it was a failure."[147]

That was not exactly what those who saw the film at the time thought, though it is true that there were not many of them. Obviously, it was not yet a Rohmerian work, but Guilbaud found in it "a certain charm."[148] Claude-Maris Trémois, a journalist at Radio-Cinéma-Télévision who reported on the filming and saw a copy of the work, wrote: "I can vouch for the quality of *Les Petites Filles modèles*, I saw it, and the intelligence of an Éric Rohmer could appeal to audiences."[149] It was an important experience for Rohmer; starting in the 1960s, he was to see to it that his works were produced and directed in accord with his own methods and cinematic principles. And he did so with all the more conviction and energy for having suffered the humiliations of this aborted adventure.

Rohmer's Thought

Although the filmmaker's first attempt was a failure, the critic was now the center of attention.[150] Between the summer of 1951 and the spring of 1957, he wrote forty articles for *Cahiers du cinéma* and, also starting in 1956, the column "Books and Reviews." Through his regular comments and his choice of auteurs (Hitchcock, Rossellini, Hawks, Renoir, Dreyer, Nicholas Ray, Welles, Bresson, Ingmar Bergman, Kenji Mizoguchi, Anthony Mann), he embodied a taste and a way of thought characteristic of *Cahiers*, taking part in the polemics with *Positif*, which were then violent, and defending the politics of auteurs. At *Cahiers*, he was "our goal-keeper,"[151] as he says in issue number 68, using a metaphor that he pursued further in his articles on sports teams on the screen. Writing in a focused and serene way, with discernment and constancy, in his longish

articles (averaging ten pages) Rohmer established a simple, serious, classical, limpid style that was sometimes slightly contorted or pompous, as distant from Astruc's lyricism as from Bazin's demonstrations full of imagery, which had been his two initial models.

As *Cahiers'* ideologist, he was particularly attached to the concept of mise en scène, which for a critic of that review most precisely defines, from start to finish, the taste for cinema. In an important piece on Joseph Mankiewicz's *The Quiet American*, he explains: the "mise en scène is nothing other than the registration of a spatial construction and bodily expressions."[152] The director (*metteur en scène*) registers bodies put in relation in a space, that is the form of cinema as it might appear beyond all literature, painting, or psychologism. As a criterion for judging films, mise en scène calls for a criticism that is able to recognize its beauties. In October 1956, Rohmer called this kind of criticism a "critique of beauties."[153] He based this on a few classical authorities: "Alain had made this law one of his hobbyhorses, invoking Chateaubriand and his idea of the 'critique of beauties.'" A two-headed quotation, a double repercussion: the "critique of beauties" is a pedagogy (the reference to Alain) and moreover it is visionary, the only kind of criticism able to recognize the mark of genius in what is scorned (cinema, and even more the cinema defended by Rohmer). The "critique of beauties" can thus be defined as the education of the eye: it is a matter of learning to recognize, to see, the beauty peculiar to cinema. To see beauty is to ignore the conditions under which a film is made (its context, its history, its reception), to concentrate attention on the fragments of mise en scène in which the auteur reveals himself. In the critical practice of *Cahiers du cinéma*, this philosophy had a consequence that Rohmer pointed out in January 1957: "Since its foundation, *Cahiers* has adopted the critique of 'beauties' as its rule. The review of a film is usually entrusted to the one among us who is able to find the most arguments in its favor."[154] This involves a kind of moral requirement. With a few exceptions (an article by Rohmer on John Huston's *Moby Dick*, which he makes a countermodel, a foil, the object of an "accusation of ugliness"[155]), this ethic remained the rule for critical writing in *Cahiers*: "The ideal," Truffaut wrote in June 1957, "would be to write only about filmmakers and films you like."[156] Truffaut himself, the head polemicist, was in fact situated at the antipodes of this ideal, while Rohmer embodied it in the *Cahiers* tradition.

A disciple of Bazin, Rohmer nonetheless distinguished himself from his elder by offering his own definition of realism on the screen. It is also

infused with spirituality; in his case this is a matter of a faith in the cinematic exception—inspiring in him a veritable system of the arts in which the seventh is to literally save the others from their sclerosis. Thus Rohmer revived a debate that had more or less fallen into abeyance since the 1920s and that concerns the supposed specificity of cinematic art (which would distinguish it and allow it to assert itself as a kind of writing, or a language, in its own right). He sees cinema not in terms of language but of ontology; its goal is not to say differently what the other arts express but to say something different. The spiritualist nature of such an assertion is clear, and it was made at the same time that the young cinephile discovered Rosselini's *Stromboli*. It is tempting to identify Schérer the young teacher abandoning his excess of culture and disappointed literary hopes as the fantasized double of Ingrid Bergman in the last images of Rossellini's film. Far from being the seventh art, cinema is the first. It is the site not only of a resurrection, but also of a salvation, charitably showing the way for arts that have gone astray.

This is the source of Rohmer's obsession with classicism. By inverting a formula borrowed from Rimbaud that Rohmer uses as an epigraph to one of his first articles, we could sum up all his writings in a single credo: "We have to be absolutely classical."[157] A classicism among the ruins, as consubstantial with the chaos of the postwar period as Beethoven's music or Balzac's novels were with the period after the French Revolution. The cinema is definitely invested with a redemptive mission, that of exhuming the mythical underpinnings that the twentieth century is no longer capable of seeing. Of rediscovering, beyond catastrophe, the secret of an indubitable beauty.

The keystone of this construction is Rohmer's "Le Celluloïd et le Marbre," his theoretical magnum opus, a series of five articles published in *Cahiers du cinéma* in 1955.[158] Moreover, the first installment, dated February 1955, is the first article he signed with the name Éric Rohmer, and it seems finally to rise to the level of his cinematic ambition. At the outset, Rohmer writes that he would like to be "the Boileau of an art too new to fear [critics like] La Harpe,"[159] speaking "not in the name of the man of the street but of the enlightened movie lover who is, moreover, cultivated."[160] He set out to do nothing less than examine all the arts, the better to establish the ultimate sovereignty of cinema. Each study is presented as an assessment of an artistic discipline, always reduced, in the final analysis, to the role of a prestigious foil. It is up to cinema to reincarnate the classical ideal that the other arts are said to have abandoned.

This has to do with cinema's nature as a mechanical, impersonal instrument: it is the impartiality of the movie camera and the limits it imposes on human intervention that constitute the historical opportunity and at the same time the aesthetic supremacy of cinema. It is clear how much this idea, apparently loyal to Bazin's idea of realism, moves imperceptibly away from it: Rohmer does not give priority to any stylistic device. In Bazin's work, ontology is connected with the specificity of a grammar and also with a literary mimesis—which is said to allow the filmmaker to equal the great American novelists in terms of profusion and scale. Nothing of the kind is found in his disciple, who is even more Hawksian than Hitchcockian: the camera's "objectivity"—which he praises even in documentaries or in the televised rebroadcasts of sports exploits filmed in real time—ends up seeming to be a self-sufficient value, as the twofold witness to a truth and a beauty that will be manifested by themselves. Rohmer thus formulates a paradox: "We are told over and over that cinema is an art even though it is based on a mechanical mode of reproduction. I assert exactly the contrary: the power of reproducing exactly, simply, is cinema's most certain privilege."[161]

However, according to Rohmer, the filmmaker asserts himself not against the arts but among them: if he is capable of expressing a truth that belongs to him alone, if he is capable of reawakening a faith that has become rare in Western culture, it is at the cost of a continual, conflictual dialogue with the other arts—which will reveal all the better the singularity of what he has to say. And he will also reveal his peculiar privilege: that of seizing artistic emotion at its source, without giving it time to reflect or be alienated by words. This is, to be sure, an idealistic vision, and might be considered dated. But it remains that it makes Rohmer one of the greatest modern thinkers on cinema, because this vision is based (not unlike that of André Gide or Paul Valéry) on a sort of eternal return of the return, on a never-ceasing relaunching of the classical idea.

On the Right?

The reader will have understood that the connection Rohmer makes between modernity and tradition makes him a conservative, even reactionary thinker—but one who discerns in the classical the "true revolution."[162] As he wrote with a cheeky art of provocation in *Les Temps modernes*, in his view the "values of conservation" have priority over those of "progress" the better to establish

themselves in the present, and even in the future. Many texts written in the 1950s illustrate this reactionary thought through two main interpretations of the seventh art: its Christian spirit and its Westernness.

In *Cahiers du cinéma*, number 3, Pierre Kast, a secular leftist who was Rohmer's principal opponent at the review, defends Clouzot's *Le Salaire de la peur* against "those who gargle with water from Lourdes,"[163] and entitles his article "Un grand film athée" (A great atheist film). He concludes this way: "*Le Salaire de la peur* is a film that implies neither a supreme being, nor a Providence, nor religiousness, not even a heaven: it is a film that is entirely self-contained." Rohmer replied two months later by praising Roberto Rossellini's *Europe 51*. Under a title as explicit as Kast's, "Génie du christianisme" (Spirit of Christianity),[164] he responds to Kast directly: "Be an atheist and the camera will offer you the spectacle of a world without God in which there is no law other than the pure mechanism of cause and effect." In counterpoint, he develops an overtly spiritualistic analysis of Rossellini's film and of cinema in general, borrowing a certain number of arguments and motifs from the Christian Bazin. According to Rohmer, *Europe 51* offers us a "metaphorical art like that of stained-glass windows," in which "a woman sets the grace of her vocation against the grimace of the world": the soul is bared. For Rohmer, this dimension can appear only through the density of bodies, their very materiality: "The genius of cinema is that it can discover such a close union and at the same time such an infinite distance between the realm of bodies, its material, and that of minds, its object." In this "miraculous" correspondence between mind and body, which everything might be thought to separate, cinema finds its truth.

More generally, in the mid-1950s the line taken by the Schérer school was often constructed on the basis of a spiritualist approach to the great realist film directors. In this sense, Hitchcock inaugurated a series of "religious films" in his work that perfectly illustrate the "metaphysical" interpretation advocated by his defenders at *Cahiers* and that confirm their reading of cinema as a religious account of the real. Between *I Confess* and *The Wrong Man*, the line taken by the Rohmerian *Cahiers* seeks to be so much in accord with Hitchcock's themes that Truffaut, with his schoolboy attitude, could write: "The *Cahiers du cinéma* thanks Alfred Hitchcock, who has just made *The Wrong Man* solely to please us and prove to everyone the truth of our exegeses."[165] Bazin had found in Rossellini the ideal example of the perception of cinema he was forging in the late 1940s; in the same way, in Hitchcock the *Cahiers* found the verification of the

Christian interpretations mischievously advanced by Rohmer, Chabrol, Truf-faut, and Rivette. The eldest of the young Turks put it bluntly: "Christianity is consubstantial with the cinema";[166] for him, the latter was "the twentieth-century cathedral."[167]

Right in the middle of the period of decolonization, at a time when the "events in Algeria" were turning into a war of liberation, Rohmer's positions regarding the Western nature of cinema took a downright reactionary turn. The subject recurs frequently in the work of the critic, the "decent man of the twen-tieth century": "Cinema is not made for children but for old, solidly civilized people like us."[168] For example, Rohmer sees in Hollywood the ancient city or the Florence of the Renaissance, a "land of classical and spiritual creation,"[169] that of the West: "I am convinced that for a talented and fervent filmmaker the Califor-nia coast is not the hell that some people claim it is, but the homeland that was Italy in the Quattrocento for painters, or Vienna in the nineteenth century for musicians."[170]

Classicizing cinema, Rohmer conferred homelands on it: Hollywood, Ros-sellini's Italy, Renoir's France. Drawing on the dogma of the "great creative nations,"[171] he saw in the seventh art a "revenge of the Occident,"[172] as he put it in an analysis of Murnau's *Tabu*. This film, which Rohmer preferred over all others in the history of cinema, was made by the German filmmaker among the Tahi-tian natives, and thus very far away from the West. Published in March 1953, this distinctly tendentious article turns the island of Bora-Bora into a "classical land" and its exotic inhabitants into "Western beings": "Under their tanned skins, it is white blood that he [Murnau] causes to flow in the veins of these Polyne-sians, a race whose origin is contested and whose contact with Europeans merely increased their native languor. [. . .] Of all the works of our time, the exotic *Tabu* is the one that makes my European fibers vibrate the most deeply, grips my heart and soul, whereas Gauguin flattered only the intellect and the modern West's morbid desire to burn what it formerly adored."[173]

In the fourth installment of "Le Celluloïd et le Marbre," Rohmer returns to this racial idea and to the supposed Westernness of cinema.

> I deny neither India nor Japan the right to make films, any more than I deny
> them the right to build skyscrapers or automobiles, but I believe that the tra-
> ditions to which those peoples remain attached are less fertile than our own.
> The cinema is a kind of clothing so well adapted to the form of our bodies that

others cannot wear it without creasing it in the wrong places and splitting its seams . . . You have very little chance of making skilful use of this unprepossessing toy if the latitude and longitude of your birth have not endowed you with a dense past on which you can base yourself. We Occidentals are the people most suited to cinema, because the screen is repelled by artifice, and we have a more acute sense of the natural. The ethnologist can demonstrate all he wants that here no absolute judgments can be made, that it is just as normal to squat on a mat as to sit on a high chair like Homer's heroes. It would be hard to convince me that a race that loves sports played in a stadium is not more in conformity with the rule of the species than one that is devoted to yoga exercises. What matters to me is that a civilization, ours, has voluntarily confused the notions of ideal beauty and nature, and that it has attained, in that very way, an incontestable universality.[174]

This theory of cultural particularisms that divide the world into autonomous creative cells forming a hierarchy in which the West (the only civilization suited to produce a universal art and way of life) is supposed to be at the top is an old traditionalist idea. It was widely illustrated by the racist thinkers of the nineteenth and early twentieth centuries: Arthur de Gobineau, Gustave Le Bon, Cesare Lombroso, and Charles Maurras. This controversy had just been stirred up again by a famous dispute between Roger Caillois, as a defender of Western supremacy in the arts and thought, and Claude Lévi-Strauss, an ethnologist who relativized the supposed superiority of classical civilization in his book *Race et Histoire*.[175] Rohmer, who sided with Caillois, was ultimately only applying to cinema, with a certain audacity, this idea of the superiority of the West. In fact, according to him, a non-Western filmmaker could achieve beauty[176] only by adopting Western rules and values. Thus the African-American music in King Vidor's film *Hallelujah*, forgoing its "original languor," owes its genius only to the "happy marriage between African blood and Christian spirituality,"[177] and Mizoguchi, renouncing "yoga exercises," "touches us so intimately not by depreciating the West but because, having begun from a very distant point, he arrives at the same conception of the essential."[178]

Another aspect of Rohmer's discourse is the rejection of Western guilt with respect to colonized peoples. He not only ignores but rejects a view that is critical of colonization and respectful of what is different:[179] in a word, cinema has nothing to learn from "oppressed nationalities."[180] In the name of art, the fate of

the classical universality borne by cinema is destined to survive: "I do not believe that the explanation of our period, the most recent, by a *fatum* is the most profound, or the most attractive for art: Isn't sacrificing to this deceased deity the West's immense current error?"[181]

This ideology clearly places Éric Rohmer on the right-wing side of the French political chessboard. However, he did not situate himself that way, and distrusting excesses and extremes, he adhered to a strict "disengagement": it was a form of prudence, of reserve, of the rejection of simplifications, as much as a mode of tolerance. But other people—his adversaries, of course, such as the critics at *Positif* and Pierre Kast at *Cahiers*—nonetheless thought Rohmer was a man of the Right. And so did André Bazin, who admitted in a letter to Georges Sadoul in which he worried about the rise of a rough group at *Cahiers* that Schérer wasn't exactly a left-wing writer.[182] An understatement that Godard confirmed in an interview: "At that time Rohmer had a 'right-wing' aspect that must have bothered Bazin, who was ultra-secular."[183] Louis Marcorelles, a young critic of the early 1960s, was also to mention in a letter written to Rohmer ten years later the "traditionally right-wing line that you incarnate at *Cahiers*, which made me hate what you wrote," but which nonetheless "by provoking me caused me to revise nearly all my ideas about film."[184]

Rohmer's life showed a number of signs of conservatism at that time, and not only because he was a practicing Catholic. Since 1955 he had been a subscriber to and an attentive reader of *La Nation française*, the royalist weekly edited by Pierre Boutang, a Maurrassian philosopher and intellectual to whom he was said to feel close. He was also a member of an association called the "Louisquatorziens,"[185] zealous defenders of the "genius" and the "thought" of Louis XIV, which was organized by an eccentric, Georges Comnène, the self-proclaimed "duke of Santiago of Compostela."

Finally, several of Rohmer's close friends in the 1950s openly flaunted extreme right-wing or royalist ways of thought and commitments. We have already mentioned the case of Paul Gégauff, a tough in his provocativeness, a right-wing dandy in his pose. Another longtime friend, Philippe d'Hugues, represents a young, right-wing, laissez-faire cinephilia, enlightened and elegant, with whom we can also associate Pierre Restany, the organizer of the film club *Les Jeunes Amis de la liberté* at Sciences-Po, and also André Martin and François Mars, future contributors to *Cahiers du cinéma*. There were cinephile affinities, a common cult of Hitchcock, but also political ties, with the members of the

CCQL: anticommunism, the refusal to be politically engaged on the Left, a certain fascination with the provocative anticonformism connected with a love for Hollywood films. And even a deviant taste for Nazi films.

A certain Jean Parvulesco, who had arrived in Paris from Romania in December 1950, met Schérer at the Royal Saint-Germain and hung out with the members of the CCQL and the contributors to *La Gazette du cinéma* without ever writing for it. He proclaimed himself, openly and without ambiguity, a "fascist" militant and ideologist. He rapidly became a close friend of Schérer and Godard, and he also attended the Sorbonne and the Institut de filmologie. He later described a brotherhood of arms among the three young men, who met regularly in Rohmer's room in rue Victor-Cousin for nightlong discussions. He was to defend a political interpretation of this friendship:

> This was always an extreme right-wing group, except for Rivette. Of course, nothing was shouted from the rooftops, but in our talk among ourselves it was clear. Gégauff was right-wing as a pose, Godard as a dandy, Truffaut was fascinated by collaborators, whom he considered real heroes, while Schérer was a great mystic, Catholic and royalist. When a few years later people had to make their political sensibilities public, they all skedaddled, it was instinctive in them, and the extreme right-wing tone disappeared.[186]

But it persisted in Parvulesco, a militant supporter of French Algeria and a member of the Secret Army Organization, who was exiled to Spain, where he became a film critic for the Phalangist review *Primer Plano*. He was the first Iberian cinephile to write about the New Wave, supporting Godard's and Chabrol's films, but presenting the renewal of young French film as a "fascist revolution."[187] Godard paid ambiguous homage to him in *Breathless* by giving his name to the character of the writer played Jean-Pierre Melville. The real Parvulesco remained a close friend of Éric Rohmer right to the end.

The 16 mm Laboratory

After the unfortunate episode of the professional making of *Les Petites Filles modèles*, Éric Rohmer turned with relief to less constraining and more inspired experiments with 16 mm film. But henceforth he was no longer alone, an isolated

pioneer of amateur film. All the young Turks started making films.[188] In the credits for most of these films, they ended up playing all the roles, Godard as an actor, producer, and then director; Jacques Rivette as a camera operator, writer, or filmmaker; François Truffaut as an assistant or curious onlooker; Claude Chabrol as a director, producer, or lender of an apartment (notably for *Véronique et son cancre*, which Rohmer filmed there); Charles Bitsch and Michel Latouche as camera operators; Suzanne Schiffman, Jean Gruault, and Claude de Givray as assistants; Agnès Guillemot and Cécile Decugis as writers; Paul Gégauff as a source of inspiration or scenarios; Olga Varen, Anne Doat, and Nicole Berger as leading muses; and Jean-Claude Brialy, Gérard Blain, and Jean-Paul Belmondo in the leading male roles.

For his return to 16 mm, Éric Rohmer had several of his own stories in mind. In February 1953 he took up again, in the form of a seventy-six-page scenario, a tale he had written a few years earlier, *La Tempête*. In it, he juxtaposes four young people toying with their feelings around the heritage of a count who is partly bankrupt and lives in a large manor house on a Breton island. Another, less developed scenario set on an island, *La Fille de 18 ans*, a typescript of fourteen pages, is undated but was probably written during the same period. It is a variant of *La Tempête* that takes place on the island of Arz in the Gulf of Morbihan. In the first scene, which is very close to the initial plans for the film *A Tale of Winter* made forty years later, two swimmers rise out of the waves, Philippe, 23, and Christine, 18; they kiss and make love on the beach. In Rohmer's archives we find another three-page outline of a film entitled *Sur un banc*, whose field of action consists of two benches in a public park through which a gallery of characters passes from morning until evening: from an old man watching the children to a bum, from a young mother to a grumpy old lady, from a dreaming intellectual with a book in his hand to lovers.

In autumn 1954 Rohmer made in one weekend, in a large house in Meudon belonging to the parents of his actress, Teresa Gratia, a film adaptation of a story by Edgar Allan Poe, *Bérénice*.[189] This fifteen-minute film shows a shy and tormented young man, Egaeus, played by Rohmer himself, who gradually becomes fascinated and obsessed by his cataleptic cousin's teeth. In a contrasting black and white that recreates a fantastic atmosphere, madness overcomes the characters: Bérénice moves from prostration to convulsion, while Egaeus avoids the light or unveils himself in the shadows, like a vampire obsessed by his dental fetishism. The style suggests a crepuscular postexpressionism, that

of Murnau or Jean Epstein. Rivette shot the film, then edited it. It was made without sound; a sound track was then added by using JEL tape recorders that the writers at *Cahiers du cinéma* had been using for several years to record their conversations with filmmakers they admired. *Bérénice*'s very crude sound track is preserved in Rohmer's archives. After the text of the monologue inspired by Poe's story, read by Rohmer, we hear very clearly the latter talking with Godard for about twenty minutes in the offices of *Cahiers* about films they've seen recently.

In early 1956, Rohmer began filming in 16 mm a new adaptation, *The Kreuzer Sonata*, based on a short story by Tolstoy. He adopted the principle, inspired by Sacha Guitry, of a voice-over commentary on silent actions seen on the screen, and wrote a sixteen-page manuscript scenario. The whole text is divided into thirty-two sequences for a total length of about forty minutes. In a series of flashbacks, the story goes back to a year earlier, as far as the first meeting between a brilliant architect about thirty years old, played by Rohmer himself, and a pretty but self-effacing girl (played by Françoise Martinelle), during a party in a cellar in Saint-Germain-des-Prés. Very soon after they meet, he asks the girl to marry him, and she accepts. But shortly after their marriage, both of them realize that they do not love each other. The husband has met a talented, "very highly regarded" young critic who is very different from him, played by Jean-Claude Brialy. He introduces the young man to his wife. They like each other. The husband becomes jealous and stabs his wife to death. But the spectator wonders whether this tragedy existed only in the jealous husband's imagination, and in that of Rohmer, who was able to project onto the character played by Brialy his ambiguous relationship with Gégauff.

Rohmer once again called upon his friends: Godard bought the film with the money he earned as a press attaché at Fox—he is credited as producer and appears in the film during the party filmed at Gégauff's apartment. We also glimpse, during a short sequence filmed at *Cahiers du cinéma*, the whole editorial staff of *Cahiers du cinéma*, grouped around Bazin. Once again, it was Rivette who edited the film along with Rohmer. The couple's apartment was lent by Georges Kaplan, a friend from CCQL. Obviously, Beethoven's Sonata for piano and violin, no. 9 (called "the Kreuzer Sonata") accompanies the film.[190] The sound track also contains fragments of the same composer's *Diabelli Variations* for the piano as well as bits of jazz: Jelly Roll Morton's "High Society" and Louis Armstrong playing "Dallas Blues."

The technique of creating a sound track by using a tape recorder was not without risks. During the projection of the film at the Studio Parnasse in September 1956 the tape recorder repeatedly got out of synch, forcing Rohmer to interrupt the showing to reconcile the commentary with the development of the action. However, according to several concordant reports, this showing had a certain impact on the cinephiles gathered at the Studio Parnasse. It revealed to them a director with talent. It was the first time that Rohmer the filmmaker had impressed an audience of initiates, who had up to that point chiefly admired his critical writings. Claude Chabrol, Jean Douchet, Jean Gruault, Claude de Givray, and André Labarthe all said that they had the feeling of witnessing the birth of a cinematic world inhabited by a singular personality, as did Pierre Rissient, a twenty-year-old cinephile who had been invited to the showing: "What was fascinating was Rohmer himself, playing his role in a nervous, almost neurotic way. We had the feeling that we were entering his psyche, seeing a madman like a subjective camera, and we heard his voice commenting on his actions as if in a paranoid delirium. I loved this film, it was fascinating and revealing. It was the only time, I think, that he displayed himself so openly."[191]

Professional Critic

Éric Rohmer's double personality has no doubt never been as open to view as it was at the end of 1956. On the one hand, a grimacing specter haunting the silent, black-and-white 16 mm films, a vampire driven toward virginal girls, and a dandy finally stripped bare by his uncontrollable fetishism. On the other hand, a respected critic writing precise, clear, measured, resolutely classical prose, succeeding in justifying as the expression of beauty par excellence an art often considered minor by the intellectuals of his time, a thinker dealing with the seventh art and engaging in dialogue on an equal footing with André Bazin. Éric Rohmer was the only one of the young Turks who enjoyed an unchallenged aura within the critical community, even before the advent of the New Wave. Truffaut was famous and feared, but attacked; Rivette was admired, but reproached for his extreme dogmatism; Godard and Chabrol remained obscure and despised.

This recognition was crowned by an offer made by Truffaut that allowed Rohmer to become a genuine professional critic. On April 17, 1956, he sent

Rohmer a message: "Dear Maurice, *Arts* has run out of material: you have to take advantage of this before Friday. Bring me a 'secret' about something or other (American comedy, the crime film, whatever. Or a director, dialogue, adaptation, Balzac and cinema, or Poe, or Stevenson, etc.), readable, very readable. We can also imagine that you might write two or three critical articles while I'm in Cannes . . . Your friend Truffe."[192] Rohmer did as Truffaut asked and submitted an initial article, "Des goûts et des couleurs," published the following week in the column "Le secret professionel," which accepted reflective articles on cinema.

In two and a half years, Rohmer wrote 180 articles for this weekly, sometimes occupying the whole of the cinema page, with two or three texts appearing alongside one another. *Arts-Spectacles*, the review founded by the rich gallery owner and art lover Georges Wildenstein, was one of the most influential and interesting periodicals of the 1950s.[193] It owed its reputation to two editors in chief, Louis Pauwels in the early 1950s and Jacques Laurent starting in 1954. Pauwels modernized what was originally only a catalogue of exhibitions by giving it the mission of dealing with all the domains of the arts and culture, especially literature and shows. The tone was often polemical, doing battle against "thesis literature" and politically engaged artists in general. The weekly imposed its elegant and learned style on the prestigious contributions by Cocteau, Jacques Audiberti, Henri de Montherlant, Jean Giono, Marcel Aymé, and others. Laurent brought in still more brilliance and novelty. The author of *Les Corps tranquilles* was also, under the pseudonym Cecil Saint-Laurent, the creator of Caroline Chérie, a considerable success that gave him the means to found the review *La Parisienne* and to buy *Arts*, which he ran and relaunched as a "journal d'humeur et de parti pris" (a journal of temper and commitment).[194] He attracted his friends, polemical writers and journalists, both the cream of young right-wing writers and a few snipers from the other side: Roger Nimier, Antoine Blondin, Michel Déon, Matthieu Galey, André Parinaud, Alexandre Vialatte, Boris Vian, Jean d'Ormesson, Jean-René Huguenin, Jean-Loup Dabadie, and Philippe Labro. The cultural choices were often impertinent, the style omnipresent, and major interviews with currently prominent artists gave depth to a weekly that was situated in the very rich landscape of the cultural press in the 1950s, alongside, from right to left, *La Parisienne, Opéra, Carrefour, Nouvelles littéraires*, and *Lettres françaises*. *Arts* had an inimitable manner: it was simultaneously an indepth review (through its investigations, its interviews, the high standard of its

articles), a magazine of current cultural events (through the diversity and extent of its criticism covering all the domains of the arts, literature, and shows), and a committed journal. A steely gaze, cheeky tone, anticonformism, polemics—and a spectacular format, presenting articles like a daily paper, with provocative big headlines on page one—all that made it an effective platform. *Arts* was a success, some weeks having more than seventy thousand readers.

At the beginning of 1954, Jacques Laurent entrusted the cinema page to his friend Jean Aurel, a critic and filmmaker. This was an important decision, because in the weekly press film criticism was influential, as is shown by the columns written by Jacques Doniol-Valcroze in *France Observateur*, Claude Mauriac in *Le Figaro littéraire*, and Georges Sadoul in *Les Lettres françaises.* In the spring of 1954, Aurel had the inspired but risky idea of entrusting this page to a young man of 22, François Truffaut, who had just shocked Paris society with his article "Une certaine tendance du cinéma français," published in January in *Cahiers du cinéma.* Thanks to almost a thousand articles, in four years the young critic was to give this cinema page a considerable weight: it was often polemical, unfair, annoying, but always lively, full of opinions and discoveries, imbued with a droll and inventive tone. In *Arts*, Truffaut waged his "press campaigns"[195] with verve, passion, and a certain craftiness; it was there that he imposed his choices and his filmmakers, gave a militant and convincing turn to the politics of auteurs, fought against "quality French cinema" and its illustrious representatives, Henri-Georges Clouzot, Claude Autant-Lara, Jean Delannoy, Yves Allégret, and René Clément.

When he asked Rohmer to come help him at *Arts*, Truffaut was overwhelmed, the victim, as it were, of his own success. He was trying to make his first professional short film, *Les Mistons*, he was being asked for articles by a number of periodicals (*Le Temps de Paris, La Parisienne*), and he was working as an assistant to Roberto Rossellini. He had to go to the Cannes Festival in late May 1956, and knew that at the review in Paris there would have to be a critic who could write about all the current films. By choosing Rohmer, he was covering his back: his reputation as a serious critic was already made. Rohmer was neither a double nor a substitute, but rather a complementary critic, more measured, polyvalent, classical. This worried the management of *Arts*, especially André Parinaud, the editor in chief, who conveyed his concerns to Truffaut in a message sent on September 7, 1957: "I would like to know if you still take your work at *Arts* seriously. The cinema page has lost its dynamism. Your little friends,

like Éric Rohmer, however competent they may be, don't know their trade, and on that subject I think M. Rohmer should do his apprenticeship somewhere else. I ask you to tell him that."[196]

Truffaut supported Rohmer and succeeded in imposing him on *Arts*. Although Parinaud was not entirely wrong regarding Rohmer's lack of experience as a journalist and his lack of "dynamism"—his style was clearly less vivid and captivating than Truffaut's—he did not suspect the critic's capacity for work or the real pleasure that he took in this job. Rohmer enjoyed forging an alternative mode of writing in his great theoretical texts published in *Cahiers*. To be sure, he groped his way at first—but he created an eminently pedagogical style to enter into dialogue with his reader, to inform him or her, to lead the reader to discover unforeseen motifs in a film, to revisit a filmography in a few words, to understand unsuspected works. These are columns written day by day, referring to films many of which were for many people forgotten and forgettable, but this form of coded and calibrated writing allowed Rohmer to deepen the art of convincing.

Later on, he rarely talked about this experience, which was often ignored until half a century later, in an interview conducted in 2008 but never published: "A reader had to be addressed who was not a cinephile like the reader of *Cahiers*. The articles were shorter and were generally criticisms of current films, in a bright style, with cookie-cutter formulas. Let's say that *Arts* was a public forum, while *Cahiers* was more a withdrawn temple. Truffaut loved this journalistic practice of criticism, I was certainly less at ease, but it wasn't disagreeable."[197] Films came out on Fridays; the critic had to see them immediately and write fast on Saturday morning so the articles could appear the following Tuesday. "I often saw the films with Truffaut or others," Rohmer went on, "we talked about them, and then I wrote in the café every Saturday morning. It was also at that time that I got the 'green card' that was reserved for journalists writing about films and allowed me to get into movie theaters without paying."[198]

Truffaut and Rohmer made a good duo in *Arts*, and occupied virtually all the space, from May 1956 to the end of the following year. In this association we see a Truffaut who is a strategist, who juggles articles and films, assigns roles depending on the periodicals, rereads texts at great speed, cuts, reworks, imposes, and coddles or attacks. His instructions are precise, his eye sharp. Above all, he protected Rohmer, who became in his hands a kind of Truffaldian creature. A strange relationship between the two men, in which the elder by twelve years,

though one of the most recognized theoreticians of the time, lent himself (perhaps in part to earn a little more money) to the game his younger colleague was making him play.

In the middle of the summer, on August 9, 1956, Truffaut took over the controls at *Cahiers* while Rohmer went on vacation for a few weeks. In the letter he wrote him, we can see the nature of their relationship: "Everything or almost is going well here. We've done all the layout ourselves (Rivette, Bitsch, and I). This issue will have a certain look. For *Arts*, it would be all the better if you sent me the planned article on women and cinema. Better especially if you could return to Paris before the twenty-sixth in order to see us, Doniol[-Valcroze] and me, before we leave for Venice, for both *Arts* and *Cahiers*. The Schérer file in my drawer is getting thicker and thicker; it will allow you to put together the next issue. Send me a note and don't forget the cinema, your friends, Paris, journalism, your scenario, and all the rest. Get a tan and accept my friendly regards."[199] At the end of August, Truffaut handed control over to Rohmer and offered him a little advice before leaving to cover the Venice Film Festival for *Arts*:

> So far as *Cahiers* is concerned, correlate the photos with the texts, handle relations with the print shop, the proofs, the layout, Bitsch will be of great help to you there. As for *Arts*, it may be a little more delicate unless you can go to work around 8 A.M. on Monday morning, as I do every week. For the "Selection" and "Cinema News" sections, you can get help, but you'll have to handle the "Film Criticism" section yourself, unless I can do one or two secondary films in advance before I leave Paris. I'll also leave you a file of photos illustrating my articles from Venice. I'll send rather long articles so you won't have to find "secrets" in the pile to fill the gaps. In short, everything will go fine, I'm sure. All you have to do is put your letter alongside mine to realize that your typing is much better. Another triumph of the university man over the self-taught man! If you are also faster than I am, then . . . It's true that I don't use my left hand for either eating or working.[200]

Well trained, Rohmer learned his trade and became a true film journalist. After a few months, he knew how to shoot down in flames a mediocre French film or Hollywood fluff, report on a festival, its multiple films, and its atmosphere (the Venice Film Festival in September 1957), locate and convey what was new and exciting in a Western by Anthony Mann, and follow Jayne Mansfield's exploits in

Frank Tashlin's films *The Girl Can't Help It* and *Will Success Spoil Rock Hunter?*, which he placed very high in his personal pantheon. And even how to cross swords with respected international institutions: "*Friendly Persuasion*, which won the Palme d'Or at Cannes, offers a perfect definition of the worst kind of academicism." This headline ran across six columns on the front page of *Arts* on May 24, 1957.

Truffaut also managed to get Rohmer's work into *La Parisienne*, a literary monthly similar to *Arts* that had been founded by Jacques Laurent and was directed by François Nourissier. There, too, Truffaut, who had been writing a column for a few months, needed a collaborator, and sent Rohmer a message in the spring of 1956:

> I can't give *La Parisienne* my usual article. Nourissier agrees that you can replace me. So by 6:20 tomorrow evening you should take him an article on *les films presque maudits*, the ones that haven't had enough success this year, or haven't been sufficiently discussed: *L'Amore, La Paura, Lifeboat, Night of the Hunter, Anatahan, Night and Fog, Arkadin, The Man with a Golden Arm, Smiles of a Summer Night*, and—watch out, Nourissier has a high opinion of it—*La Pointe courte*.[201]

Once again, Rohmer took advantage of the opportunity. In a little less than two years, he wrote ten columns in *La Parisienne* before it ceased publication in the spring of 1958. They were film reviews, reports grouped by themes, connected by the relaxed, conversational tone and the familiar, logbook style.

A Mature Man

In the autumn of 1956, Henri Langlois presented at the Cinémathèque française a retrospective showing of Alfred Hitchcock's British films. Claude Chabrol and Éric Rohmer, who were among the first "Hitchcockohawksians," did not miss a single film. The first wrote: "Momo and I saw everything again, and we discovered certain films from the British period. [. . .] Then we wrote this book [. . .] I took the British phase, he took the American phase. With two exceptions; I wrote about two American films and he wrote about two British films. I won't tell you which ones; we've kept that secret for more than fifty years!"[202] Jean Mitry,

who supervised a collection of books on film at the Éditions Universitaires, told Rohmer he would like to publish this work.

For Rohmer and Chabrol, this was a kind of victory: since the late 1940s, they had been defending Hitchcock against the great majority of critics, and this book, the first of its type on his work, would be an argued response to his detractors. Rohmer had already written on almost all Hitchcock's recent films, from *Notorious* and *Rope* to *The Wrong Man*. The ten films of the 1950s made Hitchcock, as Rohmer wrote in the conclusion to the book, "one of the greatest creators of forms in the whole history of cinema. Perhaps only Murnau and Eisenstein can be compared with him in this respect."[203] Rohmer brought together his writings on Hitchcock that had appeared in *La Revue du cinéma, La Gazette du cinéma, Cahiers du cinéma, Arts,* and *La Parisienne,* and added ten more on the films made between 1940 (*Rebecca*) and 1945 (*Spellbound*) that he had not discussed.

The argument consists in revealing a powerfully metaphysical inspiration in Hitchcock's work, marked by the themes of guilt, dereliction, revelation, redemption, and sanctification, to the point that Rohmer, with subtle self-mockery, wrote on the yellow folder in which he kept the typed pages he was collecting for the book "Metaphysical Alfred by Zig and Puce."[204] In an interview conducted a few decades later, Rohmer retraced his discovery of "a metaphysical artist":

> The three films I admire most feature James Stewart, which is not unconnected with my support for them, since I think he is the perfect actor for Hitchcock. They are *Rear Window, The Man Who Knew Too Much,* and *Vertigo,* which were made between 1954 and 1958. The real subject of these three films is the same: Plato's philosophy. They are films in which a space-time of the transcendent is made visible.[205]

The reactions to this little fifty-page book published in September 1957 were generally lively. Most of the reviews mocked its argumentative tone and its philosophical pretensions, while at the same time recognizing that the analyses had a certain brio. For many critics, to talk about Hitchcock in this way was not serious criticism, or rather it was too serious for a director who had always been considered artificial and trifling. Only after a series of consecutive masterpieces (*North by Northwest, Psycho, The Birds, Marnie*) and the publication of a book of

conversations between Hitchcock and Truffaut in 1966 did Hitchcock make his definitive entry into the pantheon of great filmmakers.

At the time, some people were outraged that such a book was published by Éditions Universitaires. They denounced it as an imposture, a deviation into mysticism and right-wing ideology. For example, Ado Kyrou, the intellectual leader at *Positif*, who wrote in *Les Lettres nouvelles*:

> Hitchcock, promoted by the British who, being poor in the realm of cinema needed to laud their national products, and then promoted again by Holly-wood, which likes directors who are always prepared to follow producers' fash-ions, has just been promoted a third time by critics using him as a vehicle for their personal propaganda. In their work he becomes a canvas on which theo-ries can be embroidered; his pitiful thrillers become menacing eagles, and his little gags are loaded with ultra-metaphysical meanings. Only too happy to see himself dragged toward the summits (even if they are the summits of fascism), Hitchcock plays along. He smiles, he appears more and more often in his own films, and he makes money, a lot of money. His errors become brilliant dis-coveries; his gaps are filled with profound meanings; his personal tics increase tenfold, his so-called themes take on the proportions of symbols; and a whole group of young people is thereby led, not only toward a boring cinema (which is, after all, not a serious problem) but also toward a neo-Nazi culture.[206]

The violence of this attack is astonishing, and its politicization is surpris-ing. It took André Bazin to cool down the polemics by offering, in *Cahiers du cinéma*, praise for this stimulating work of interpretation, even if he remained basically inimical toward Hitchcock: "The intellectual, ideal, the virtual spec-tacle that Chabrol and Rohmer arouse in our minds is surely as good as Hitch-cock's best film."[207] Bazin's article was a kind of dubbing: in it, he paid homage to the thought and pertinence of Rohmer, who had succeeded him as editor in chief of *Cahiers*. In fact, weakened by illness, the founder of the review had handed it over in the spring of 1957 to Rohmer, who was two years his junior, and Jacques Doniol-Valcroze. Soon afterward, Doniol-Valcroze began making films, and Rohmer sailed the vessel by himself.

The head of *Cahiers du cinéma*, a contributor to *Arts*, a columnist at *La Parisienne*, the author of a first book on his favorite filmmaker, and the holder of the precious green card that allowed him free access to film theaters, Maurice

Schérer had definitively become Éric Rohmer, one of the most respected critics of his time. From then on, he lived on this work, as a legitimate professional: the payments from *La Parisienne* (3,000 francs per article) and *Arts* (around 1,000 francs per week), along with the half-time salary he earned as head of *Cahiers*, allowed him to take leave from the National Education system, giving up his position at the Vierzon lycée as well as the drudge work at the Montaigne and Lakanal lycées. He still lived frugally, but more comfortably than in the early 1950s.

One Saturday evening in December 1956, at a dance at the École des Mines, this very shy man had the nerve to approach a young brunette who was herself very reserved, and whom he had already "spotted" (one might think we are already in *My Night at Maud's*). In doing so, Rohmer, who had never been very bold with girls, suddenly made good on a wager he had just made with his friend Jean Parvulesco: "This evening," he had told him, "I will meet my wife." Her first name was Thérèse. She came from a good family in the north, having been born in Cambrai. She had been carefully brought up, was a practicing Catholic, and was twenty-seven years old. They began seeing each other. On July 13, 1957, Maurice Schérer married Thérèse Barbet at the church in Paramé, near Saint-Malo, where the young woman's family owned a vacation home. Rohmer, established in his profession, married, and aged thirty-seven, looked for an apartment for himself and his wife: his bachelor life was definitively over and he left, after fifteen years of Bohemian renting, his furnished room in the little Hôtel de Lutèce on rue Victor-Cousin.

3

Under the *Sign of Leo*

1959–1962

At the outset, a sinister story. That of a fellow named Paul Gégauff, who around 1955 was living in Barcelona, where he was serving as a straw man for a jewelry trafficker. In the unanticipated absence of his silent partner, Gégauff abandoned the local Ritz for more and more wretched hotels, which he left, one after the other, without paying his bill. Every day, the dandy who had become a bum walked eight kilometers on foot to the bank to pick up money that did not come. He was on the point of being forced to tie up the soles of his shoe with string. After four months, the payment of a large sum finally saved him. It was from this nightmare that Rohmer took his inspiration for a scenario for a feature film—for which he wrote even the dialogue, contrary to what we see in the credits. Gégauff merely listened to the dialogue imagined by Rohmer and "validated" it. His contribution consisted above all in inspiring the characteristics of the main character, his way of living at others' expense while draping himself in a flamboyant phraseology.

The Gentleman Tramp

This dimension appears clearly in the first synopses of *Sign of Leo*. The model is recognizable, and so is the painter:

> Paul loves his freedom more than anything. [. . .] Is he lazy? It seems rather
> that he fears the slavery of a specific task. He believes in his destiny, but at the

same time he feels an anguish that increases with age. He senses that a person like him is out of place in a modern society, and he has a sense of guilt that he conceals under cynical behavior. He congratulates himself for being good for nothing, likes to pass himself off as a buffoon, a spineless and frivolous character [. . .]. He has real talent as a violinist, but has never made up his mind to work on his art and to play concerts. He has a friend who is his exactly symmetrical counterpart. François C . . . , a journalist who is as frugal as Paul is prodigal, as hard-working as Paul is negligent. But their friendship is solid. Each finds in the other his complement.[1]

From the start, then, we have the masculine couple who will be at the heart of the *Moral Tales*. On the one hand, the bon vivant who expends a disorganized energy; on the other, the voyeur who remains in the background while awaiting his time. Developed in *Suzanne's Career*, *La Collectionneuse*, and even *Pauline at the Beach*, this autobiographical duo is less prominent in *Sign of Leo*, as is the satire of the Saint-Germain-des-Prés freeloaders, which was very present in the early versions of the scenario. While lingering on "Paul's" buffooneries (a parody of academic discourse that he babbles sinisterly in his decline), Rohmer dissects like a cruel ethnologist the habits and customs of a tribe. The all-nighters in Pigalle, where one is received by an "enormous old woman" and a striptease artist "with saggy flesh." The renunciations, once one has sobered up and it's every man for himself. The temptations to steal the silver, or whatever might be valuable. The first versions of the scenario were written under the sign of cynicism, including the party that concludes the story, where Paul drowns his recovered fortune in alcohol. "Misery seems not to have left any mark on him, either physical or mental. He accepts good fortune as he accepted bad. Or more precisely he deserves both of them."[2] And Rohmer cites Euripides, as if the better to emphasize this ironic fatalism.

Had *Sign of Leo* followed this line, it would be situated somewhere between Marcel Carné's *Les Tricheurs* and Claude Chabrol's *Les Cousins*, in their disillusioned chronicling of postwar generation that had lost its landmarks and its beliefs. There were to remain only a few traces of this line, like the surprise party that occupies the first third of the film, in which a few failed bohemians are timidly mocked. For example, the character Fred, a would-be artist played by Paul Crauchet, who is the scoffing observer of this whole little world adrift

(in this respect as well, the earlier versions of the dialogue went further in dotting the i's and crossing the t's: "Are you a musician, too?" "No, I'm a painter." "You are? Do you exhibit?" "I must have painted my last canvas, wait . . . it will be five years ago this July"[3]). Or that already very well-known unknown person (Jean-Luc Godard), who listens over and over to the same fragment of a Beethoven quartet, as if to give material form to the fetishist deviation of the relationship to art. These private jokes are scattered throughout this sequence (some of them can hardly be deciphered now), but it expresses, like the café arguments that punctuate the film, Rohmer's vaguely disgusted view of this hollow period in his life.

And of Gégauff as well. His somewhat diabolical aura remains present here and there. Jean Parvulesco (who is himself cited in *Sign of Leo*, with the allusion to a tall, bald Romanian named Radesco who engages in shady deals) later recalled this deliberately inflammatory figure: "Gégauff took the lead. In Saint-Germain-des-Prés, he shot a pistol into the ceiling! But our life was very simple: when we didn't know where we could sleep, we went to a hotel, and we left in the morning without paying."[4] Pierre Cottrell confirms this with greater precision: "Gégauff did crazy stuff! During a dinner with Rohmer and Truffaut, he shot a revolver at the chandelier in the Royal Saint-Germain (the future Drugstore) . . . Rohmer never reproached him for this, he accepted all his extravagances."[5] To the point of citing them almost literally in his film: the nighttime rifle shot aimed at Venus, and when dawn came, his antics to avoid the hotel owner. Like his faith in astrology, which he knows little about and which seems also to be inspired by Gégauff: an empirical and emphatic way of "trusting in his star" (located in his case in the constellation of Leo) in order to sublimate the accidents of fate.

In other respects, Rohmer sought to erase everything that might make it possible to identify him too closely with Gégauff. Whereas the first synopses were explicit ("Rotten with gifts, he neglected to deepen any of them. He once published a collection of short stories and a few articles and gave a violin recital. But he was an unstable person who believed only in his lucky star"[6]), the film shows only an intermittently inspired musician. For the Paul lost in the no-man's-land of Barcelona (and whom Rohmer decided not to play himself), the film substitutes an American lost in Paris: Pierre Wesserlin, played by Jess Hahn. He is also a bon vivant. But the sudden disappearance of all friends and all money leads toward a sort of silent Way of the Cross.

Celluloid and Stone

The reason is that Rohmer was interested less in the anecdote than in the parable. An expiatory parable, perhaps, through which he exorcised the "idle youth enslaved to everything"[7] that had been both his and Gégauff's. This was another reason to hide his sources, sometimes at the risk of a certain schematism in the conduct of the narrative. How can we explain, for instance, the abrupt departure of Pierre's girlfriend as soon as summer begins? The first manuscripts were more precise on this point, having a furious father come to get his daughter. How are we to understand that it never occurs to Pierre, in the course of his slow and certain decline into dereliction, to bail himself out by becoming a porter at Les Halles? These implausibilities decrease the fable's credibility, especially since they are followed by rather crude transitions (a journalist friend's expedition to the Sahara, reduced to a meager montage of stock shots) or disorienting shifts in tone (the final episode with Jean Le Poulain doing his great number as a lyrical beggar). They were to have, as we will see, a significant effect on the critical reception of *Sign of Leo*. They would have been better understood by avoiding a naturalistic interpretation: the very one that could still be applied to Chabrol's or Truffaut's first works. In his first full-length film, Rohmer did not seek so much to describe a social reality as to recount a spiritual itinerary.

This itinerary involves an element dear to Gégauff: music. But there, too, Rohmer seeks to cover his tracks, making his protagonist a composer for the violin. Sketched out straightaway, then abandoned, the musical theme returns at regular intervals—as if to manifest the persistence of a faithfulness to itself. A kind of underground advance that contradicts the misfortune in which the character seems to be mired. At the same time, Rohmer avoids giving this theme any kind of illustrative or sentimental value. He asked the avant-garde composer Louis Saguer (whom he had met through Jean-Louis Bory), to write something for him in the style of Bartok:

> So he composed a score . . . that wasn't exactly serial, but whose tonality was not classic. And he did this after having only read the scenario, recounting the walk through Paris taken by a man doomed to become a bum. His music is very beautiful! I wanted it to be present throughout the film, and I am grateful to

him for having encouraged me to forgo it at certain junctures . . . For example, when Jess Hahn walks down the rue Mouffetard, he advised me to use only the sound of his steps.[8]

Regarding this musical motif, we could speak of a melody that is looking for itself through stridency, that follows its path obscurely, no matter what the interruptions, hesitations, or misfires. From this point of view, as promulgated by "Le Celluloïd et le Marbre" (and as his book *De Mozart en Beethoven* was to repeat), in Rohmer music becomes the language of being, in its conflict with material contingencies. As in his theoretical writings, it proves to be the "true sister" of cinema—since these two arts are both founded on time and movement. The throbbing solo of the violin corresponds to Pierre's incessant walk for his survival. As if the true subject of the film were the unrolling of the celluloid that overflows a stone setting: the deserted Paris of the month of August, frozen in its clichés for tourists and its impassive monuments.

At the heart of this postcard configuration, the character of Pierre Wesserlin incarnates an unprecedented faith. It is no longer the Christian faith (even if the crossing of the desert of *Stromboli* remains Rohmer's great inspiration). And no doubt it is not faith in astrology, which is no longer much more than an illusion and the occasion for a fit of outrageousness (the shot aimed at Venus), for which the protagonist will be punished. The faith that governs the film seems to be based entirely on the powers of cinema: movement through which an individual detaches himself from a city that has become a mausoleum, the better to affirm his own vitality and also the act of viewing. The fresh way of seeing that Wesserlin, through the very fact of his decline, imposes on beings and things: birds taking flight over the Seine, the shimmering of the sun on the surface of the water. Rohmer's first great film is not only a postscript to "Le Celluloïd et le Marbre" that takes the place of a program for the work to come; above all, it tells us (with many detours) about the birth of the filmmaker's vocation.

The Last Laugh

More than anything, the auteur of *Sign of Leo* likes to conceal his cinematic origins (which clearly distances him from Truffaut and Godard). These origins nonetheless inspire, at the heart of the narrative, discreet homage to artists

admired in his youth, like Marcel Carné, whom the July 14 scene cites explicitly, with his superhuman bus straight out of *Hôtel du Nord*, or others he still admired, like Murnau, whose *The Last Laugh* was the matrix of the present film just as much as *Stromboli* was. In his own way, Rohmer returned to the radicalness of the German *Kammerspiel* by choosing to reduce the anecdote to the essential. In *The Last Laugh*, a porter in a grand hotel loses his privileges before recovering a miraculous fortune. In *Sign of Leo*, a Left Bank bohemian loses all social dignity before an incredible final dramatic reversal. In Rohmer as in Murnau, the ambition is immense: to film an individuality that is defined only in solitude. And the silence is even more deafening in the 1959 film, because sound films had existed for thirty years.

To meet this challenge, Rohmer called upon a historic figure in French cinema: Nicolas Hayer, who had been head camera operator for Jean Cocteau, Henri-Georges Clouzot, and Christian-Jaque. Should we see in this as a vague expressionist temptation? We might think so on seeing Jess Hahn come down a stairway striped with long shadows (in the great tradition of *Le Corbeau*). To do so would be to forget that Hayer had just worked for Jean-Pierre Melville, who convinced Rohmer to hire him by talking about his "logical" conception of light. Even if it is less advantageous for actors and actresses, the source of light has to be justified. To the conventional methods (which consisted of using a bank of overhead spotlights), Hayer preferred a diffuse, indirect lighting based on reflectors, which he was to use for *Sign of Leo* (and which Nestor Almendros was to adopt for Rohmer's later films). The apparatus remained rather heavy, but it responded to the New Wave's desire for simplicity. Philippe Collin, Rohmer's second assistant on this film, recalls Hayer as the "great Russian lord." But Hayer "began to be unhappy because people swore only by Henri Decaë (not yet Raoul Coutard, because he made *Breathless* six months later!). It was marvelous to see this guy who had had the most extensive equipment and who now made it a point of honor to do without it: at night, he lit the boulevard with three floodlights, and told me: 'Your friend Decaë wouldn't dare do that.' Another evening, at the bottom of the rue Mouffetard, he hooked up his three floodlights and said to me: 'I filmed *Trois Télégrammes* here with Henri Decoin. On each balcony, I had an arc light. But it was just as good that way, you could see just as much.' There was at the same time humor, a little nostalgia, a prodigious technical knowledge . . . and a more sensitive film."[9]

The Spirit of the New Wave

From the point of view of the conditions of filming, *Sign of Leo* is indeed a product of the New Wave. First of all because of these voluntary financial constraints. Made under the auspices of AJYM (a production company established by Chabrol to support his comrades' debuts), the film was made with the materials at hand—with the sounds of airplanes in interior scenes, reflections of the technical team in the display windows of shops, pals recruited at the last minute to make up for the lack of actors. For example, Chabrol's new girlfriend (Stéphane Audran) and his delegate producer (Roland Nonin) playing implausible proprietors, vociferously demanding their money from a disoriented Jess Hahn. The latter's trajectory is peopled by these more or less recognizable figures, who without looking like it, reconstitute the friendly constellation of the new cinema. Marie Dubois exchanges banalities on the terrace of a café, Françoise Prévost cultivates a sphinx-like silence, traveling companions (Jean Douchet or Pierre Rissient) melt into the anonymity of the crowd. "I went to see the filming two or three times," Rissient writes. "In particular, at a café on the Champs-Élysées, the Lord Byron. I must be visible from the back somewhere in that sequence. The extras (or the passersby) mixed with the technical team, it all remained very informal, very convivial."[10]

A small budget? Certainly (the film was made for 35 million old francs [about $70,000] in forty-five days, between June and August 1959). In addition, there was Rohmer's thriftiness, already legendary. On the shoot, he was nicknamed "Court-au-flan" ("Run for the flan") because he spent his time running and eating cakes. And it is said that he had a taxi stop in front of a certain hotel on the Champs-Élysées and then took a side exit and disappeared without paying. So many marks from past years that accompanied this film of farewells to bohemian life. But this thriftiness was also an ethics: faithful to the program he had set for himself ("[to] find his style in the texture of the real itself"[11]) Rohmer refused to fabricate a show. He made do. With what he had at hand, with the imponderables and accidents of everyday life. Les Deux Magots is not available? No matter, we'll film in a Latin Quarter café that has the same chairs. Do parked cars clutter up the frame? We'll move the camera. The street Jess Hahn is crossing is suddenly deserted (because a man has just jumped out of a

window, drawing all the attention of passersby)? Let's take advantage of that to film the shot.

No hesitations, no time lost. It was in the same spirit that Rohmer abandoned his initial idea of filming in Cinemascope. Or refused to do take after take, to the dismay of his camera operator, Pierre Lhomme: "It shocked me a great deal that we made only one take, in the event that it wasn't good—but Rohmer referred to destiny. If a shot wasn't the way he wanted it to be, that was because it couldn't be. I told him: 'Éric, we almost have what you wanted, let's do a second take and you'll be happy. At least you'll be able to choose.' That annoyed him. Toward the end of the filming, I got my way because a trust had been formed between us."[12] There again we can see the fear of wasting film. This was also a kind of "wager," both superstitious and Pascalian, through which Rohmer transcended his fears of filming and the (future) montage. But this act of faith in the moment was inseparable from a belief in the real as the raw material of cinematic experience.

In this sense, *Sign of Leo* is a fiction film that is almost indistinguishable from a documentary. First of all, a documentary on Paris, which Rohmer showed more concretely than any other filmmaker, even the representatives of the New Wave. Far from the adolescent or amorous romanticism that continue to imbue *The Four Hundred Blows* and *Breathless*, Rohmer filmed the city as an opaque setting, as a mass of impenetrable if not hostile stone. Far (this time) from the artifices of *Hôtel du Nord*, he took his team to a real July 14 dance, which Nicolas Hayer lit as best he could, and recruited an unknown woman on the spot to play a role: Macha Gagarine (soon renamed Macha Méril). That was one of the great audacities of this *Sign of Leo*, in which Rohmer concealed reminiscences of Murnau under a cinema vérité in the manner of Jean Rouch. In it he asks the man in the street to come *check* his scenario, for instance in the sequence of the theft committed by the main character at a grocer's stall. Since only the actor and a few extras knew what was going on, the vehement quarrel that followed had every appearance of being real. Not to forget Jess Hahn's claim to have been an adventurer and a bum, which probably inspired (along with his American accent, his imposing build, and his loud voice) the choice of this unusual actor.

This impure mixture of registers was to become the most distinctive mark of Rohmer's style. From the outset, it appears as a deliberate commitment

that Rohmer strongly reaffirmed in response to questions asked by his friend Parvulesco:

> I never cheated with Paris geography, or with the time of day, with my camera (or sometimes cameras) always hidden from passersby. [. . .] In general, in this film I tried [. . .] to achieve a perfect harmony between the performance of the professional actors and that of the passersby [. . .]; a pure documentary uses true elements, but by juxtaposing them without a genuine unity, it does not attain the "truth of art," while a film that is "rigged" (by the studio, the use of actors, etc.) will attain only a conventional truth. What interested me was to avoid the problems and combine the merits of the two methods, and what encouraged me most was the very great difficulty of the enterprise. I don't know whether I fully succeeded, but I think that at least at certain points I introduced the rigor indispensable for a work of art into the freedom of the real recorded live.[13]

An Anti-filmmaker

"The very great difficulty of the enterprise." The expression seems inadequate to describe the failures of communication between Rohmer and the participants in his film. From his point of view, it was fascination that prevailed on seeing this text that he had found so hard to write performed by an actor (amateur or professional). From the actor's point of view, it was a relative frustration that prevailed, that of being less an actor than an object of the camera's gaze. Regarding Rohmer's nondirection of his actors, one anecdote will remain legendary. The night when the walk to Pigalle was filmed, the director and his team got into a car that followed another full of actors who were supposed to make a hell of a racket. They were getting ready to start filming when the actors turned to Rohmer. "But tell us, what are we supposed to do?" they asked. "Act, act!!!" he replied. "There was nothing to do," Philippe Collin commented. "They just had to act like jerks."[14]

In reality, Rohmer simply asked his actors to *be*, just like nature or architecture, at the risk of a total absence of diplomacy in his way of speaking to them. If a new actress playing a secondary role wanted to know how to dress,

he limited himself to checking, in front of her, the instructions in the scenario: "'She is dirty and badly turned out,' you're fine the way you are." If an extra made so bold as to ask: "Since the film is in black and white, should I put on a colored shirt?" "Oh! You know, you can do what you want. If I take you on, it will be to fill out the frame." This casualness extended to his technical collaborators. Walking down the avenue de la Grande-Armée alongside the camera operator, the director spoke to him (with the staccato volubility that characterized him) about the shot to be filmed: the one in which Jess Hahn has to walk home from his miserable expedition to Nanterre. An indefatigable talker and an excellent runner, Rohmer went so fast that Pierre Lhomme had to hurry—to the point that he ran into a lamppost. When Lhomme caught up with Rohmer, the latter was still talking as though nothing had happened. They rejoined the members of the team, who were stupefied to see the young man's face bleeding. Neither he nor Rohmer had noticed.

According to Claude-Jean Philippe, Rohmer was later described by the first assistant on the film, Jean-Charles Lagneau, as "an absolutely ridiculous director. That was his view, and he was a professional."[15] More kindly, Pierre Lhomme recalled Rohmer hurrying to Notre-Dame because he had taken an ordinary piece of crumpled paper (thrown into the Seine to meet the needs of the action) for a signal. Or confining himself in a perpetual monologue that did little to clarify his intentions. Thus we can understand why the weakest sequence is also the most complex: the surprise party, where couples meet and exchange couplets. However, it benefits from the use of direct sound (unlike the rest of the film, which was made with a shoulder-held camera that was easier to handle outside). "Rohmer had never seen a silent Éclair 300 camera," Pierre Lhomme writes. "He was very impressed, and for once he wanted to look through the viewfinder. On the back of this camera, there is a button controlling the shutter. He put his eye to it, thinking it was the viewfinder!"[16]

On the screen, this sequence proved to be strangely stiff. The ballet of bodies and desires looked like a depressing wax museum. It was as if Rohmer had suddenly become uneasy when he had to direct a scene with several characters instead of filming Jess Hahn's solitary wandering around Paris. This had to do with his hatred of artifice and at the same time with a persistent timidity—which prevented him from communicating clearly with his actors, of asserting himself as a "group leader" in the traditional sense of the term. "He realized," Pierre Rissient explains, "that he was not made to direct scenes with lots of actors.

In *La Collectionneuse* he went to the opposite extreme. I think his best camera angle is not intersecting fields but (on the basis of a dialogue) face-to-face fields that oppose or confront one another. He is not a filmmaker of the sequence shot or the wide-angle shot."[17] Neither was he a filmmaker with a preestablished storyboard, with a script that controls everything, and very precise duty sheets. These were constraints that production imposed on him here, as in the time of *Les Petites Filles modèles*, and that he was to find a way to dispense with later on.

A Cursed Film?

It's clear: Rohmer was not (and never would be) a great communicator. Neither with his technical team nor with the few journalists who visited the shoot—and with whom he absolutely refused to talk. If we except one or two previews in *Cahiers* (in which the libertine aspect of the film is sometimes emphasized, sometimes its mystical import), *Sign of Leo* did not meet with the odor of sulfur and the murmur of impatience that surrounded the birth of *Breathless*. To be sure, in private the film elicited laudatory commentaries, like that of (precisely) the director of *Breathless*, which was made immediately afterward (the two filmmakers even considered "slipping" their main characters into each other's films!). Between two montage sessions, Godard attended a confidential showing of *Sign of Leo* at Joinville's laboratories. To his editor Cécile Decugis, who was enthusiastic about the beauty of the scenes shot around Notre-Dame, he replied by indicating his own rushes: "Yes, it's better than that. Besides, Rohmer is one of the two or three most intelligent Frenchmen." A remark that she reported to Rohmer fifteen years later and that bowled him over. Of course, on the basis of the title, Chabrol was able to sell this *Leo* somewhere in Africa. But no French distributor agreed to buy such a bizarre thing, being put off by the directorial awkwardness and the austerity of the central part (a lone man, walking through Paris for almost an hour)—in contrast to the juvenile and sentimental themes that guaranteed the success of the New Wave.

Made in the summer of 1959, in the spring of 1962 Rohmer's first feature film had still not been distributed. In the course of the three years, he had only one friendly showing at the Cinémathèque française (and even then it was booed). There were also a few laudatory articles by Pierre Marcabru and Jean Douchet. Finally, the film was (marginally) distributed in a truncated version, under

conditions that Rohmer denounced, but a little late. The management of AJYM had been entrusted to the not very scrupulous Roland Nonin, whom Chabrol subsequently accused of having "made off with the cash drawer."[18] In June 1959, Nonin sent Rohmer a draft contract in which we find the following clause: "We will have the right, for compelling reasons, such as legal or administrative orders, the length of the film, the requirements of French or foreign censors, or commercial necessity, to make cuts, both in the course of shooting and during the editing of the film or in the course of its distribution. You accept, without reserves, the present article and commit to not hinder the distribution of the modified film."[19]

Did Rohmer sign this one-sided contract? He probably did, even if it was accompanied by a standard formula: "in very precise circumstances, and on the condition that the director has previously given his complete accord, a second version may be prepared, based on a copy of the film, and distributed, concurrently with the first, in a part of the circuit clearly delimited in advance."[20] In any event, in the autumn of 1960 Rohmer was worried when he learned that his film had been re-edited. He contacted the company that was supposed to do the mixing, which referred him to AJYM Films. He then turned to the Centre nationale de la cinématographie (since it was the long version of *Sign of Leo* that had obtained an authorization and even a subsidy). The litigation office declined any responsibility so long as this new version had not been put into circulation. In May 1962, the film finally came out as Rohmer had conceived it, but letters exchanged with Roland Nonin allow us to glimpse a compromise. Nonin concedes that "it is understood that your version will be shown at La Pagode, in the art and trial cinemas, and in film clubs. In other venues, the choice of version will be left up to the management, and we assure you that no pressure will be exercised to make it choose the other version over yours."[21]

In the end, this other version did indeed circulate in the cinephile network. An indignant letter from Jean-Louis Laugier (to the editors of *Cahiers*) proves that it was shown in Locarno, and that the cuts concerned chiefly the "high-society" part of the film, making the walk through Paris a disproportionately long part of the film. Reduced to a running time of one hour and twenty-five minutes, deprived of Louis Saguer's austere music (which was replaced by motifs from Brahms and César Franck), this version of *Sign of Leo* had a career long enough to lead Rohmer to disavow it whenever he had an opportunity to do so.

Invited in 1966 to a Finnish festival on the new French cinema, he agreed to show his film only in the cut he claimed:

> This version is not the one that the Cinémathèque française owns and that it lends, despite my disapproval, to the Cultural Exchange office. [. . .] It is therefore important that you make it clear that you insist on having the long version, [. . .] of which there now exists only one copy. [. . .] You will understand that after having fought for many years, at *Cahiers du cinéma*, to defend a *cinéma d'auteur* and the auteur's rights to his work, I cannot in any way authorize the showing of a version of my film that has been, despite my wishes and without my knowledge, truncated and altered.[22]

Despite my wishes and without my knowledge? That is not entirely clear. But in 1966, the time when concessions had to be made was probably only a bad memory.

The Sign of the Cross

The complete version of *Sign of Leo* thus came out in May 1962 at La Pagode, accompanied by a short (*Mayola*, by Nicolas Schöffer) and a high-flown press release that repeated a few formulas we have already found in Rohmer's work: "This is a film about an adventure, about pure physical action. But instead of taking place on a desert island, or in the frozen wastes of the North Pole, it is set in a large city [. . .]. We tried to present it without trickery, without cheating with the geography or the hour of the day: the camera was always concealed."[23] That is precisely a constraint from which the filmmaker was to learn to free himself in his future urban films. For the time being, an effort was made to hide beneath the sheen of the spectacular (or the style of reporting) everything that might be repellent or radical in the film. For his part, Jean Douchet indulged in an enthusiastic exercise in autosuggestion: "I am delighted that distribution difficulties prevented Éric Rohmer's *Sign of Leo* from being shown earlier. Only the audience's evolution, an evolution seen over the past three years, made it possible to appreciate the true value of this austere, difficult, and detached film made in 1959, which I consider one of most important of the New Wave."[24]

However, it was the New Wave's biggest commercial failure—though it came at the end. Hardly five thousand tickets were sold. And among the spectators (Michel Mardore was to write) there was always someone who yelled at Jess Hahn on the screen, telling him to get a job at Les Halles. What made people uneasy was both the main character's indolence and the implausibility of the situation (right down to the final reversal). A failure of both identification and belief that a certain Bachollet, a former friend from Sainte-Barbe, making himself the interpreter of the vox populi, conveyed in no uncertain terms: "I was bored stiff. People had told me: 'It's interesting, but . . . ,' in short, I'd been warned. But I owed it to you to go see it because people also said no producer would ever bet on you again. I wasn't bored stiff because we watch people dialing telephone numbers all the way to the end, etc. No, it was the characters who bored me. Their fate didn't interest me at all, except for one or two guests at the party about whom I'd have liked to know more."[25]

Among critics, the most common reproach concerned those notorious phone numbers dialed all the way to the end. Or to put it another way, the monotony of a narrative that forgoes any kind of dramatic effect: that is Georges Charanesol's point of view in *Les Nouvelles littéraires*. At the other end of the journalistic spectrum, Bernard Dort (in *France Observateur*) shares the good sense of his friend from Sainte-Barbe. He too deplores the insignificance of the pale secondary characters, who are there only to emphasize Pierre Wesserlin's torment. But it was above all the Christian dimension that annoyed him, as did the Hitchcockian symbol of the evil eye: "Confronted by the failure [. . .] of these films by Rohmer and Chabrol, I cannot refrain from asking another question: here and there, doesn't the deliberate choice of a metaphysical problematics, the predilection for evil and guilt, betray, ultimately, an inability and a refusal to look the concrete reality of our society in the face?"[26]

If other critics chose to defend *Sign of Leo*, it was in the name of that same metaphysical problematics. That shows how much the New Wave remained, in 1962, at the heart of an ardent ideological debate between the partisans of politically engaged cinema and those of the "true values" of religion or tradition. In *Cahiers du cinéma*, it was a young critic named François Weyergans who was the latter's standard-bearer: he wrote a lyrical piece celebrating the expiation and purification to which Rohmer subjected his protagonist. Soon, still in *Cahiers*, Claude Beylie hammered home the nails in the cross: "*Sign of Leo* is perhaps nothing other than an abbreviated version of the cruel legend of a fall and a

redemption, of grace refused and then granted to man, of his wretchedness and his grandeur, of his death and his resurrection."[27] Not surprisingly, *Sign of Leo* was ranked fifth in *Cahiers'* selection of the ten best films of 1962. Even and especially if its editor in chief was . . . Éric Rohmer. A fellow traveler (Philippe d'Hugues, alias Philippe de Cômes) devoted a detailed study to the film in the very royalist *Nation française*. He entitled it "Les 'hitchcockiens' attaquent" (probably countering the title of Dort's article: "À la remorque de Hitchcock" [In Hitchcock's wake]). Like other critics, he compared *Sign of Leo* with Agnès Varda's *Cleo de 5 à 7*—but the better to emphasize the soberness found in Rohmer's film, so different from the "rowdy, superficial characteristics" to which people wanted to reduce the New Wave. He described the author of "Le Celluloïd et le Marbre" as "a revolutionary in love with classicism, the only one who sought in his writings, as in this first film, to rediscover at the outset the sources of an artistic tradition in order to receive and enrich its heritage."[28]

On the extreme right of *La Nation française* (if that is possible), we find Jean Parvulesco, who found it easy to exploit the esoteric allusions in *Leo* in order to indulge in one of the mad interpretations that Rohmer's "solar cinema" regularly inspired in him: "How can we forget [. . .] that in *Leo*, a spiritual hymn instructing the West's occult marriage with the resplendent milieu of sunlight, it is the absolutely solar countenance of Michèle Girardon that attracts us, hypnotically, into the very center of the mystery of the end of darkness and night?"[29] Not content with this enigmatic gloss, Parvulesco makes his friend talk (like the pedestal table in *Suzanne's Career*), putting into his mouth polemical remarks that are rather surprising when one knows the proverbial prudence Rohmer observed as a filmmaker. Thus in an interview that seems to have remained unpublished (and that dates from the time of the "purgatory" in which the film was held), he has Rohmer say that *Sign of Leo* could not please the audience of the Champs-Élysées, which loved strong feelings, but that it would please audiences in a country like Spain (that is, Franco's Spain, where Parvulesco was still living in exile), a country "that dislikes—and that is its right—the systematic immorality of some French films."[30] This passage was struck out by Rohmer. He also struck out (and commented on with an exclamation point) the conclusion of a paragraph in which he rejected precisely any political interpretation of his film. Here are the words Parvulesco put in Rohmer's mouth: "I believe that one can intervene effectively in social and political development only through the direct, lucid action of certain concentrated, monolithically unitary groups following

precise strategic and tactical lines; these groups can act for or against order, for chaos or for God."[31]

However, in this document Parvulesco sent him, there is one profession of faith that he did not strike out. He would no doubt have done so had the interview been published in France, because he kept his distance (at least when he was behind the camera) from any too explicit profession of faith. "I am a Catholic. I believe that a true cinema is necessarily a Christian cinema, because there is no truth except in Christianity. I believe in the genius of Christianity, and there is not a single great film in the history of cinema that is not infused with the light of the Christian idea."[32] One would think we had returned to the time of *Cahiers*, when Rohmer was celebrating this "genius of Christianity" in the Rossellini of *Europe 51*. But (as Rossellini might have done) he took care to qualify the solemnity of his declaration by adding: "A mystical cinema? Yes, if it is true that a clear grasp of immanence leads to transcendence."[33] Blessed be the critics who were capable of reading between the lines of this demand.

A Modern Cinema

In this text, Rohmer claims to adhere above all to a contemplative cinema inspired by Nicholas Ray as much as by Renoir and Rossellini. That shows how much he associates this idea ("paint the state rather than the action"[34]) with that of modernity. If a spiritual truth can be revealed, it necessarily comes through the rediscovered truth of cinematic representation. It even merges with the latter, is lost in it to the exclusion of any intentional message. That is seen very clearly by Philippe d'Hugues when he discerns in *Sign of Leo* "the phenomenon in a pure state,"[35] relieved of metaphorical winks and making us think of the Camus of *L'Étranger* (a parallel also made by Michel Capdenac in *Les Lettres françaises*). This phenomenological interpretation gave rise to a lively debate among the writers at *Radio-Cinéma-Télévision*. Whereas Jean Collet claims to decipher the moral aim that underlies Rohmerian realism, Jacques Siclier takes the opposite view. For him, *Sign of Leo* is essentially a study of behavior: its logic is that of description, not religious interpretation. André S. Labarthe goes still further. In the motif of the walk he sees only the experience recounted in the film. A pure experience, which is related to Alain Robbe-Grillet's Nouveau Roman and echoes Roland Barthes: "Here, the novel [Labarthe is citing Barthes] teaches us

to see the world no longer with the eyes of the confessor, the physician, or God, those significant hypostases of the classical novelist, but rather with those of a man who is walking through the city without any horizon other than what is to be seen, without any power other than that of the eye itself."[36] We find here the apprenticeship of the eye that is perhaps the true subject of *Sign of Leo*. Beyond the invocation of a god, or of absent gods, there is the contemplation of things as they are. Rohmer (who did not much like the Nouveau Roman) makes this contemplation the foundation of modern cinema.

He is an unexpected witness to this modernity, to behaviorism intransigently applied to the movie screen. Marcel L'Herbier, a member of the old guard, addressed a friendly salute to Rohmer across the generations, inviting the "young" filmmaker to speak about his unreleased film on television. But the day after the first showing, it was Nino Frank, the former brilliant critic of the 1930s, who wrote him a moving letter.

> If I absolutely had express an opinion, I think that—very demagogically—I would have said that the spectators of this film would be of two kinds: those who have never been hungry, and those who have—and that the judgments the latter might make (which would be primarily affective . . .) would not coincide at all with the ones made by the former! . . . For my part, I could not count myself among those who have been hungry . . . And that amply justifies how much I was upset, and the friendly, admiring handshake I offer you here [. . .]. You must know Knut Hamsun's *Hunger*, which is already not bad. Your film seemed to me much more sincere and poignant.[37]

Did Rohmer know this novel? Much later, he considered adapting the same author's novel *Mysteries*. What is certain is that he had experienced hunger during the lean years on rue Victor-Cousin and that Nino Frank divined an implicit autobiographical content that the director sought to mask. Whatever his reticence and his fears might be, this has to do with the extraordinary frankness of Rohmer's style. In the course of an hour, *Sign of Leo* develops a pathetic odyssey: that of a man abandoned by everyone, whose survival consists in mechanical acts (walking as long as possible, finding a place to sleep, gluing the sole back onto his shoe). One cannot imagine a more complete rejection of the picturesque or a more complete absence of dramatic, even metaphysical alibis: only references to the stars serve as a derisory vestige of them. All this is what gave the

film its power and won it an increasing number of admirers. For example, Rainer Werner Fassbinder paid homage to it in 1966 in his short film *Der Stadtstreicher*, perhaps not only because of the starkness of its situations but also because of the muted, indecipherable irony that runs through the whole epilogue of *Sign of Leo*—with its happy end too spectacular to be credible. Halfway—who would have thought it?—between Brecht and Beckett.

All this explains the film's failure in its own time. With this first feature film, Rohmer went farther than neorealism and even than the New Wave, but without greatly benefiting from the attention given the latter in the media or from the effect of novelty (which was no longer very new) produced by furtive filming and images taken from life. At a time when Godard, Truffaut, and Chabrol were setting out on their careers, Rohmer was acquiring, with the *Sign of Leo*, only the reputation of being an austere, difficult, not very likable filmmaker. Not until *La Collectionneuse* (and its acknowledged glamorous dimension) was this too puritanical image finally corrected. And above all, not until Rohmer ceased to adapt to conventional methods of production, to a professionalism that stifled him, and invented his own freedom. That was to be the Films du Losange adventure.

4
Under the Sign of *Cahiers*

1957–1963

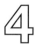n March 1957, Éric Rohmer was appointed editor in chief of *Cahiers du cinéma*. He succeeded in that capacity Joseph-Marie Lo Duca, one of the founders of the review who for some time had no longer been playing an active role. This promotion consolidated the gradual takeover by the new generation of critics—the "young Turks"[1] grouped around Rohmer—on the masthead of *Cahiers*.[2] It was also the successful conclusion of Rohmer's physical presence in the office at number 146, avenue des Champs-Élysées, where he had for several months been acting as copy editor alongside Lydie Doniol-Valcroze, performing the "work of reading and correcting that represents part of what is required to bring out the review."[3] His real responsibility for *Cahiers du cinéma*, defining a line, setting a tone, imposing a style, came somewhat later, in the course of 1958, when Rohmer, who was about to turn forty, found himself in sole command. Jacques Doniol-Valcroze, one of his coeditors, was too busy preparing and filming his first movies, *Bonjour, monsieur de La Bruyère* and *L'Eau à la bouche*, while André Bazin, his other coeditor and the spiritual father of the first *Cahiers*, died on November 11, 1958.

The *Cahiers du cinéma* Salon

"He [Bazin] was the Ariadne's thread," Jean Renoir wrote. "Without Bazin, the dispersion would have been complete."[4] Rohmer pledged to continue Bazin's work, taking up the "thread" left interrupted by his semicontemporary—Bazin

died at the age of forty—and pursuing his task. That was the sense of the article he devoted to criticism in the special number of *Cahiers* dedicated to Bazin in January 1959, "La Somme d'André Bazin."[5] Rohmer recognized in Bazin his mentor in thinking about cinema, and that was a way for him to ensure continuity in the review, despite differences regarding films, the battles Bazin had waged against the supporters of the politics of auteurs, and even fundamental divergences. For Rohmer, Bazin's "summa" structured all contemporary analysis of postwar cinema. The new editor in chief of *Cahiers* saw in the latter an "impressive coherence," even if the whole was certainly "scattered in a jumble of reviews, weeklies, and leaflets." But the essence was finally collected in four volumes published by Les Éditions du Cerf under the title *Qu'est-ce que le cinéma?* Rohmer reread the proofs of the first volume, which was in press, and then edited the three others over the following months. This collection left a deep impression on him by its breadth, its style, its demonstrative value: "There is no trace of the journalist's trade, but rather that of the writer. The occasional texts are in fact part of the development of a methodical plan, which is now revealed to us . . . Each article, and the whole, have the rigor of a genuine demonstration."

Rohmer found this coherence in the great idea that structures the whole of Bazin's work: "The cinema appears as the culmination in time of photographic objectivity." This sentence, written in 1945 in one of Bazin's first texts, produced an "aesthetic Copernican revolution" in the domain of the theory of cinema. Before Bazin, almost everyone insisted on the subjectivity of cinema[6]— legitimating a new art through the power of imagination that alone could transform the filmmaker into a true artist on an equal footing with the painter or poet creating a world from whole cloth. Bazin reversed this principle: the art of cinema consists in *denying itself as an art* by coming as close as possible to the real, by accepting its ontological realism. "The cinema," Rohmer wrote, "first of all, *is*. It is that being that should be explored beneath whatever appearance conceals it, silent or speaking, black and white or in color, whether it is called a Western, a comedy, or a documentary. What matters in it is not the way in which it is related to other arts but the way in which it does not resemble them at all. This revolution in the aesthetics of cinema seems to me to be of the same order as that Copernicus carried out in astronomy. For Bazin, it was in fact the purely mechanical quality of the reproduction that constituted the originality, and even the genius, of cinema."[7]

Rohmer wrote most of his important texts before he took over the direc-
tion of *Cahiers du cinéma*, just as the most important part of Bazin's work was
behind him when he founded the review in 1951. He wrote only about twenty
articles between 1958 and 1963, three or four of which produced an impact by
recalling the review's line ("Le goût de la beauté," July 1961) or referring to films
considered of major significance (Mankiewicz's *The Silent American*, Hitchcock's
Vertigo, Renoir's *Le Déjeuner sur l'herbe*, Bergman's *Brink of Life*[8]). Rohmer
made most of his remarks on roundtables (concerning *Hiroshima mon amour*
or criticism[9]) and in interviews with filmmakers and people he wanted to meet
(George Cukor, Astruc, Otto Preminger, Henri Langlois, Jean Rouch, Rossel-
lini[10]). He played elsewhere his role as editor in chief of *Cahiers*. It had to do with
the particular atmosphere that was established along with him in the office on
the Champs-Élysées.

Rohmer was very present at *Cahiers*, occupying the space in his special
way, working seated behind his desk, next to the big editing table, rereading
texts, annotating, correcting. Most of the time, he was seeing people, writers
were coming over, discussing things, sitting near the table, in an informal way.
The subjects of conversation were free, they talked about cinema, art, music,
books, and films in particular. Rohmer talked little; mainly he listened. A few
former collaborators occasionally came, Jacques Donial, Pierre Kast; others were
there more regularly, like Godard, Rivette, Jean Domarchi; whereas Truffaut and
Chabrol, after they began making films in the course of 1958, no longer came to
the *Cahiers* office. Rohmer received chiefly new people, young folks who gradu-
ally formed a circle around the review. They came to the office almost every day,
usually in the late afternoon, talked about films they had just seen in theaters
near the Champs-Élysées, proposed articles. The editor in chief listened, replied,
advised, reread, guided. It was not a formal editorial committee, with titles, days,
and hours, but a system that was much more like a salon. Michel Delahaye,[11] who
began frequenting the *Cahiers* circle in the autumn of 1959, explains it very well:

> There was no editorial meeting. It was a salon. Every writer was able, and even
> obliged, to come in to talk about this or that. This perpetual conversation was
> Rohmer, and all the articles had already been "conversed about" in the *Cahiers*
> office. People met around him. For me, he was the absolute pedagogue, giving
> everyone attention, listening to you, immensely tolerant and with a great open-
> ness of mind; telling everyone at the end of the conversation: 'You can come by

Cahiers anytime . . .' Moreover, if you didn't go there for ten or fifteen days, that
was a problem, you were in danger of leaving the circle. You had to be there or
let it be known that you would be absent.[12]

This salon-style socializing, which Rohmer later revived around tea in his office
at Films du Losange (but from then on involving women more), required a pre-
cise system. Rohmer received at the *Cahiers* office, but someone else instigated
and re-instigated the conversation, rounded up the young cinephiles, and oiled
the wheels of this informal group. Placed at the entrance to the office, near the
tall shelves of the library where the books on film were kept, comfortably seated
in his armchair, which he shared with Doniol-Valcroze's dog, Jean Douchet pre-
sided over the premises. He had been one of Rohmer's first cinephile compan-
ions, at the time of Objectif 49 and *La Gazette du cinéma*, but then he had had to
leave Paris in 1951 to do his military service. For a time, he lived near Lille, where
he tried to manage the metallurgy wholesaling business owned by his father, who
died in 1949. Bankruptcy was as inexorable as it was rapid. Douchet returned to
Paris in 1956, wrote for *Cinémonde*, *Cahiers*, and then *Arts* in the late 1950s. See-
ing films, writing about them and commenting on them with all the sophistica-
tion they deserved, advancing their formal interpretation, making them genuine
paths to the acquisition of knowledge—Douchet undertook all that with a great
deal of virtuosity, which amused and sometimes astonished Rohmer. His favor-
ite filmmakers were those who stood up best to this critical dissection, especially
Hitchcock, a constantly scrutinized universe and inexhaustible form, but also
Preminger, Minnelli, Lang, Ray, and soon Mizoguchi and Bergman.

Douchet and Rohmer understood and complemented each other: the tall,
skinny guy who listened and distilled a few recommendations and the round,
tubby one who spoke and received with a volubility that soon became pro-
verbial, leading the troops—whom he preferred to be young, masculine, and
ardent—to the Cinémathèque or the movie theaters on the Champs-Élysées.
Rohmer spent his days in the *Cahiers* office, where he worked almost without
interruption from nine in the morning to seven in the evening; in the late after-
noon Douchet livened him up with verve and affability, while at the same time
distractedly doing the crossword puzzles in *France-Soir* or *Le Monde*. "Douchet
captivated the young cinephiles; Rohmer listened to them and put them to
work."[13] That was how Barbet Schroeder, one of these active captives, summed
up the reciprocal qualities of the two men. Just next door, a little separated

behind her desk, the copy editor—Lydie Doniol-Valcroze, succeeded by Jeanne Delos, Jean Eustache's wife, and then Marilü Parolini—was amused by this salon ceremony experienced by a whole generation as a rite of initiation. "Rohmer tried to understand his interlocutor's thinking," Douchet recalled, "even if he didn't agree with him. And then he read texts with extreme precision. That was how he attracted many young writers to *Cahiers*. New critics had to be brought in as others left."[14] The two men opened the door wide, even if all who came in did not stay. There was no dogma, everyone had a chance, but one had to know how to take advantage of it.

The activity of this Rohmerian editorial staff followed certain rules, even if they were not formulated either in a precise charter or by a regular editorial committee. However, in an article in the review Rohmer himself stated the main rule, the "critique of beauties,"[15] by virtue of which the person assigned to write about a film was the one who liked it the most and defended it the best. "I was for the critique of beauties, to borrow the expression used by the philosopher Alain," Rohmer explained. "I thought only positive things should be said about films. If there was someone who would have positive things to say about a film, I ran his article. The other films, those that found no defenders—and they were numerous—were dealt with in one or two sentences at the end of the issue. That is why I preferred a favorable article about Bresson's *Pickpocket* that was not very good to a more brilliant article by Michel Mourlet."[16]

Under Rohmer, the composition of an issue of *Cahiers* followed an unchanging plan: each issue began with two or three feature articles, a filmmaker's observations or extracts from his memoirs, and a major interview with an auteur. Then came the "Petit journal du cinéma," a collectively compiled series of news items, photos with commentaries, and reports concerning the profession. Next was a critical notebook that brought together five or six articles about recently released films, followed by a bunch of short notes dealing with about twenty films representing the rest of current events in the world of film. On the last page appeared the "council of ten," a synthetic table bringing together the opinions of ten of *Cahiers*'s critics, which ritually concluded the issue. Films were rated using symbols ranging from a black dot indicating detestation to the four stars of approval for a masterpiece. Under Rohmer, very diverse texts could be found in the review, from a piece by the communist Sadoul on Dziga Vertov's films to the inflammatory prose of the young cinephiles associated with the Mac-Mahon cinema—that "nursery fascism,"[17] to use Louis Marcorelles's expression.

However, Rohmer's rigor was exercised: although he was open to ideas and political opinions, he was also intransigent regarding writing and mistakes in French, tedious passages, and repetitions. There are many testimonies to his attentive, even punctilious readings and rereadings of articles submitted to the editor in chief, which were returned with annotations and accompanied with a short note asking for revisions, corrections, re-writings. Thus he rejected two articles by Michel Mourlet, then sent a third, on Joseph Losey, back to him accompanied by a detailed note that concluded: "Okay, but write more economically and be clear, cordial regards."[18] To André Labarthe, he seemed almost "bureaucratic,"[19] and Jacques Rivette joked about his "schoolmasterly" side, while at the same time deploring the "provocative and reactionary immaturity"[20] of his young pupils. This severe side and the strictness of Rohmer the corrector amused the older collaborators, perhaps because they also knew the schoolboy, humorous side that was hidden under the mask of intransigence. Thus in the spring of 1958 Truffaut sent one of his last articles to his editor in chief with this little note: "Dear Momo, if I have a car accident, it will be partly your fault, because I slept only five hours last night in order to finally write that damned critique of *Passions juvéniles*. . . . So don't rip up too severely this little text whose pirouettes might amuse other people even if they leave you cold [*marbre*] and celluloid. I send your wife a kiss and shake your hand."[21] When all was said and done, Rohmer's *Cahiers* functioned smoothly for a while, as Jacques Doniol-Valcroze slyly put it, noting this modest, "unpretentious"[22] efficiency in a letter dated August 21, 1958: "The brevity of your message is a good sign. Successful issues have no story."[23]

Éric Rohmer was a severe but protective elder to the "young class at *Cahiers*,"[24] seeing to it that the review was well-behaved at the same time that he encouraged the blooming of a new critical generation left free to express itself, even polemically, to be provocative so long as there were no spelling mistakes.[25]

A Tranquil Life

In late 1957, Maurice Schérer and his wife Thérèse moved into an apartment at number 72, rue Monge, in Paris's fifth arrondissement, a few steps from the place Monge and its Republican Guard barracks. The building was ordinary, the fifty-five-square-meter, three-room apartment was simple, light, tasteful. The toilet

was on the landing, which shows how modest this purchase was. What mattered first of all was its location: Rohmer was faithful to the Latin Quarter, which he was never to leave; as we have seen, he established himself there at the age of eighteen, before the war, and he spent his university years in the students' Paris of bookstores, little movie theaters, and steep walks between the Montagne Sainte-Geneviève, rue Mouffetard, rue Cardinal-Lemoine, and the Arènes de Lutece. Rohmer was at home there, getting around mainly on foot and taking the Metro at Censier-Daubenton or place Monge, line number 7 and then number 1, to go to work on the Champs-Élysées. He never drove or owned a car—he was horrified by pollution, and the back problems that plagued him from the age of forty on made it difficult for him to get in and out of automobiles. The few people he received at home—Douchet and Schroeder went there a few times, as did Truffaut and his wife Madeleiine Morgenstern, the only couple from the film world that he was able to shyly socialize with—all testify to the austerity of the place: the decor of the dining room consisted solely of a wooden table, a few chairs, a chest of drawers, and white walls. There he dined at home every evening, never going to restaurants, and only very occasionally to the theater or the cinema. It was the only meal he allowed himself; he never ate at noon, as a matter of both "life hygiene"[26] and thriftiness. Rohmer went to mass on Sunday, at the Saint-Médard church at the bottom of rue Mouffetard, and belonged to a parish different from that of his wife, who went to Saint-Étienne-du-Mont several times a week.

This austerity was a choice, but it was also an obligation: Rohmer led a thrifty life because he was not rich, and his wife did not work and had no money of her own. On his 1957–1958 tax return, he declared a monthly income of less than 50,000 old francs (roughly $100).[27] *Cahiers* paid him a salary of 25,000 francs a month as editor in chief, which was not much. The commission that issued press cards continued to refuse him this status, considering that his "principal press revenue did not correspond to current salary rates, even minimal ones, for the office of editor in chief or assistant editor in chief."[28] He experienced this as a humiliation. On January 15, 1958, he justified himself in these terms: "The amount of the salary was set by an agreement between me and the management of *Cahiers du cinéma*. In reality, the economic conditions under which this review, which has been in deficit ever since it was created, can continue to exist require of all its collaborators a financial sacrifice that they are willing to make, given the intellectual and artistic level of the review and the total independence

it enjoys with regard to any private or public organization."[29] Then his monthly salary was gradually increased, rising to 750 new francs in 1960, then 800 in 1962 ($150 and $160, respectively), but it still remained far below the "current salary rates." Starting in spring 1956 and continuing until summer 1959, Rohmer also counted on payments from *Arts*: he wrote about fifty articles a year for the weekly's cinema page, ceasing his collaboration there only when he began making *Sign of Leo*. *Arts* did not try to keep him, and turning to other contributors, did not call him back. After 1960, a few jobs (broadcasts on France Inter's program *Le Masque et la Plume*, pieces on Howard Hawks and Nicholas Ray for Éditions Debresse and the *Présence contemporaines* series directed by Pierre Leprohon) brought in about one-third of his supplementary income. For the fiscal year 1962, Rohmer declared income in the amount of 11,000 new francs ($2,200). All this remains extremely modest, especially in relation to the amount of work done.

Maurice Scherer's everyday life consisted of habits punctuated by regular departures and returns—he left home at 8:30 A.M., after running around the Jardin des Plantes for forty-five minutes, and came back at 7:30 P.M.—spending all his weekdays at the office. The rest of his time, apart from his activities at the office, was equally well-regulated. Evenings were devoted to reading, a glance at the newspaper (during the 1960s, *France-Soir*[30]), and a few radio programs, especially classical music, which he listened to a great deal. He spent his weekends working with a 16 mm camera, filming and then editing short and middle-length films that took months to make, even with a certain amateurism. Vacations—"the sacrosanct family vacations,"[31] as Lydie Doniol-Valcroze, who knew his habits well, put it in a message to him—were inevitably spent at the Schérer household in Tulle, where they walked around Corrèze, or in Biarritz, at the home of the Barbets, where they could combine swimming and beach games with hikes in the nearby hills of the Basque country.

Few things could distract him from these habits. Nevertheless, the birth of two sons in 1958 and 1961, Denis and Laurent, forced him to reorganize space and time a little bit. A room was reserved for the boys in the apartment, leaving the Schérers cramped for space. "It was very little," Thérèse recalled: "We were very aware that we mustn't spend too much money. He didn't like waste, he was thrifty. I was too. But he could be generous with friends in need."[32] After a few years, when the boys were more grown up, evenings and Sundays were devoted to them. Their mother read Jules Verne aloud every evening. Their father

communicated to them his passion for poetry. He knew many poems by heart: Baudelaire, Verlaine, Rimbaud, or, an unparalleled success, Victor Hugo's "Mon père, ce héros au sourire si doux . . . ," which his sons ended up knowing by heart as well. The Sunday day of rest was spent visiting an exhibit. "We might visit a museum for hours," Laurent Schérer recalls. "We went everywhere as a family, all four of us, from the Louvre to the Carnavalet, and all the municipal, local museums my father loved. He also taught us to love music. He wrote an enormous amount, but I always heard him listening to records or radio broadcasts on classical music. For example, every Sunday afternoon we all listened together to *La Tribune des critiques de disques* . . . That was his secret garden. He would have liked to be a musician."[33] Preparation and organization were omnipresent. "He liked to foresee everything," Laurent remembers. "Every time, we had to buy our train tickets long in advance. Everything was like that; he didn't like improvising or being hurried. He hated the unanticipated and being caught unprepared."[34]

Regulated as it was by this logic of habit, Maurice Schérer's family life has almost no interest for the biographer! Without scandal or uncomfortable secrets, it was simple, tranquil, reassuring, and no doubt dull; but certainly happy, like everything that has no story. But don't stories sneak precisely through that? An everyday life that is controlled and organized around its banality, completely cut off from the milieu of cinema, offers a breach for fictions: the smallest of them becomes a novel. If Éric Rohmer deeply desired this partitioning and tranquility in his life, that was certainly because every short-circuit, even if infrequent and small, could become the subject of a future film. Besides, his wife was enlisted in this escape from banal reality toward fiction. Each week she wrote to her mother-in-law, who would neither understand nor endure the truth, to talk about her two grandchildren who were growing up harmoniously as good Catholics, loving their father who was a classics teacher at the lycée.

The Crisis of the New Wave

At the very beginning of the 1960s, Rohmer's *Cahiers* seemed, to judge by their tables of contents and columns, rather distant from the New Wave phenomenon, of which they were, nonetheless, the origin. Therein lies a genuine paradox.[35] The "council of ten," the review's monthly tribunal, had at least reservations about the movement's films, and especially those made by the former "young Turks."

At first, setting aside a roundtable on Resnais's *Hiroshima mon amour* and Luc Moullet's admiring defense of Godard's *Breathless*, *Cahiers* published no general lead article seeking to present, understand, and evaluate the New Wave.

How could Rohmer talk about himself and about the first works of Chabrol, Truffaut, Godard, and Rivette? He certainly tried; for example, he wrote about Chabrol's *Le Beau Serge* in the February 11, 1959, issue of *Arts*, describing it as "genuinely new" and "a beautiful film because it is moral but not at all moralizing," with "images superbly expressing the suffering of the provinces," and also regretting cuts that resulted in a "rather weak construction that is sometimes jerky and incoherent." He concluded that "Chabrol did not yet have the film in his head, but he had something better: its story, its landscape, its characters, and also—and this shows that he is a born filmmaker whose gift is less plastic than lyrical—the ability to load the slightest image with meaning, to make it vibrate and especially sing through the mediation of camera movements, his favorite mode of expression."

Rohmer was even the first to write about Godard and one of his initial short films, *Une femme coquette*, in May 1956, when no one was yet talking about the New Wave:

> A pleasant surprise, a 16 mm film that its large-format siblings can rightly envy. Such a success is extremely rare and deserves to be noted. With perfect ease, Jean-Luc Godard's *Une femme coquette* takes us on a walk through the streets of Geneva, following an artless story inspired by Maupassant. How deftly and nicely it is recounted! Others should follow the trail he has blazed: that of the filmed short story. A perfect example of "what should be done," whereas so many supposedly "avant-garde" opuscules are good only to show us "what shouldn't be done."[36]

Rohmer resumed this kind of eulogy, combining clear-sighted anticipation and praise for a friend, in his piece on Rivette's *Le Coup du berger* (Fool's mate), which he picked out of a group of a dozen experimental films presented at the Studio Parnasse in 1958:

> This film [. . .] has the art of mise en scène. I'm not going too far here, and I'm not blinded by bias or factionalism, when I say that in these thirty minutes there is more truth and good cinema than in all the other French films released

in the past year. [. . .] It has a clear, spare style, and yet it is full of novelties that are essentially cinematic, because they are the ones that can arise only on and for the screen. I've seen this film five times, and five times I've loved it for new reasons.[37]

In these few texts we feel the weight of the moment: they all precede the real wave of these young filmmakers' first full-length films. Rohmer was writing in the pre–New Wave era. But once the movement was on its way, he was reluctant to get on the fashionable train, as if he thought that time had not yet done its work and that without historical distance it was difficult to evaluate the importance of the phenomenon. "I cannot make a choice that is not subjective among these works of the new French cinema that are so close to me," he wrote in *Cahiers*. "All I know is that the New Wave as a whole will be part of history, but I suspect that history will be selective, and I cannot say to whose detriment or advantage its selection will be carried out."[38] It is as if Rohmer feared that his choices and his articles might be interpreted as evidence of "cronyism" (*copinage*). The expression was used, and it obsessed Rohmer's *Cahiers*, which was not prepared to endorse what Truffaut, the creator of the politics of auteurs, rather mischievously called the "politics of cronies."[39] Discussing this subject in the review's columns even became a delicate matter. Between 1960 and 1961, *Cahiers* gave far more attention to Losey, Lang, Preminger, Samuel Fuller, Raoul Walsh, Cukor, and Joseph Mankiewicz, to the Italian epics, or even to poseurs like Vittorio Cottafavi, Richard Quine, Stanley Donen, Frank Tashlin, or Ludwig, than it did to French films, and to the New Wave in particular. Rohmer openly acknowledged this: "In the early 1960s we had a disagreement with Truffaut. He thought *Cahiers* should take the offensive in defending the New Wave's films; I thought that would be a mistake, that from the outside it would look like we were forming a clan of cronies."[40]

When the new filmmakers' second or third films came out—Truffaut's *Shoot the Piano Player*, Godard's *A Woman Is a Woman*, Chabrol's *Web of Passion* (À double tour), *The Good Time Girls* (Les Bonnes Femmes), and then *Wise Guys* (Les Godelureaux), or films by Jacques Demy, Astruc, Rouch, Rozier, Kast, and Doniol-Valcroze, all of which were more or less failures commercially and prompted attacks on the movement—Rohmer's *Cahiers* was not there to defend them. In 1961, the New Wave was not successful with audiences. A large part of the press accused it of damaging the image of French cinema and emptying

movie theaters. As Pierre Kast wrote, quite rightly: "There is no doubt that there is something wrong. Concerning the nature of the malady, there is room for debate. It is said that audiences are getting smaller. And people are beginning to look for the microbe. Under the microscope a weird-looking monster appears: the New Wave. It squirms, pushes out pseudopods in all directions. It arouses snobbism. It contaminates criticism. In short, all that is needed to cure the patient is a good injection of Dr. Audiard's elixir. Strange medicine."[41] In an article published in *Arts*, the scriptwriter Michel Audiard had accused the new filmmakers of making the general public sick of films:

> Truffaut [or Godard] make connoisseurs laugh, but they impress poor Éric Rohmer. Because while in the old days people who had nothing to say gathered around a teapot, now they gather around a movie screen. Truffaut applauds Rohmer, who, the preceding week, applauded Pollet, who the following week will applaud Godard or Chabrol. These guys are doing this among themselves. That's what French cinema has been playing at for more than a year. The Nouvelle Vague is dead. And we see that it was ultimately much more *vague* than it was *nouvelle*.[42]

In a letter dated September 16, 1960, Truffaut speaks of a movement "insulted every week on the radio, in the newspapers." "I'm not a persecuted man," he adds, "and I don't want to speak of a conspiracy, but it's becoming clear that the moment the films made by young cineastes deviate a little from the norm, they are currently met with a barrage of criticism from distributors and the press. It looks like the Old Wave's revenge."[43]

Confronted by this confusion in French cinema and this crisis of the New Wave, what should the reaction be? Truffaut, though he was not deceived by the overall weakness of many of the films branded as New Wave, decided to counterattack. "Formerly, in interviews Godard, Resnais, Chabrol, I, and others, said: 'The New Wave does not exist, it's a meaningless expression.' Later, I acknowledged my participation in this movement. Then people had to be proud of the New Wave the way they'd been proud of being Jewish under the Occupation."[44] After the failure of *Shoot the Piano Player*, and then that of *A Woman Is a Woman*, Truffaut and Godard were eager to remind people that was is a "New Wave spirit," despite the diversity of its auteurs. At *Cahiers*, the situation was more ambiguous. Facing the onslaught, Rohmer's editorial team and the editor

in chief himself preferred to take refuge at the Cinémathèque and devote themselves to the most classical kind of cinema. Moreover, in 1962 Henri Langlois organized a very timely retrospective of Howard Hawks's work. The young critics, taken by Rohmer himself to many of the showings, camped out in the theater in rue d'Ulm for what appeared to be the keystone of *Cahiers du cinéma*'s line in Rohmer's period.

On the other hand, this withdrawal with respect to the New Wave surprised, and then astonished, the older cinephiles associated with the review. Chabrol was outraged by the timidity of *Cahiers*'s defense of certain symbolic films: "I know one thing, and that is that over time, a film a beautiful as *A Woman Is a Woman* would have succeeded, thanks to us. We would have managed it somehow, I don't know how, but the film would have succeeded. What is good has to prevail, and in order to make it prevail, any means, any means at all, is good. Including insulting those who deserve to be insulted. Just look at what Truffaut did when he was writing for *Cahiers*, he disturbed things. We all owe him a little debt for having been able to begin as we did. Today, important films fail, and you people at *Cahiers* are thinking about something else! So long as a film like *A Woman Is a Woman* is not made successful, your work will not be done."[45] Under the same circumstances, Godard speaks of demobilization: "The *Cahiers* were commandos; today, they're a peacetime army that goes off on maneuvers from time to time."[46] Truffaut was surprised by this reserve, and was indignant as early as 1961 when the new cinema was attacked from all sides.

If Rohmer did not like war, polemics, or "the politics of cronyism," he nevertheless understood that he had to take a stand, because henceforth, in the eyes of his friends, his legitimacy as editor in chief of *Cahiers* seemed to be at stake. To show its solidarity with the auteurs who had emerged from its ranks, the review decided to move closer to the New Wave. This change of direction was gradual, but primordial, because it was to contribute, little by little, to restoring a more militant tone to *Cahiers*, which was going through an identity crisis. It was Rohmer himself, so prudent up to that point, who in the pages of his review intervened on the terrain of French cinema after more than two years of silence. In July 1961 he published a manifesto, "Le goût de la beauté" (The taste for beauty), in which he made up his mind to assess the New Wave in an "objective" manner by setting three recent films, Astruc's *Shadows of Adultery* (La Proie pour l'ombre), Chabrol's *Wise Guys*, and Rouch's *The Human Pyramid* (La Pyramide humaine), alongside the eternity of classical marble. He compares

the three auteurs of these works to the filmmaker he then considered a bench-mark for the "cinematic absolute," "the work of pure beauty," Otto Preminger. The text is all the more a manifesto when he speaks, in the name of *Cahiers*, of a "we" who "cultivate the ambitious project of judging sub specie aeterni-tatis." Rohmer's point of view is "that of the museum," whose foundations he wants to lay for cinema by selecting its most beautiful works. Placing three New Wave films in this cinematic pantheon, he says he is waging "the most active, most precise, most relevant of battles." That was his way of replying to those who exhorted him to take a militant stand: he could do so only by relating to the pres-ent of the movement the criteria of eternity and the museum. "I want to show," he wrote, "that from a certain point of view, these works present beauties—yes, that is the right word—that easily balance, mask, or erase the defects that it has pleased the press to discern in them. I say that here the perception of novelty is indissociable from the sense of beauty." Thus a sovereign, august gesture worthy of Boileau was made; it was no doubt one of the summits of Rohmer's writing and thought about cinema.

But it was rather maladroit, especially in terms of critical strategy. Rohmer did not mention Truffaut, or Godard, or Rivette, or Doniol-Valcroze, or Kast . . . and he entered the arena of the critical battle only to immediately extricate himself from it in the name of eternal beauty. Here we are far from Chabrol's assertion that "any means, any means at all, is good," including "insults" and "disturbances," in defense of the New Wave. Rohmer's main auteurs did not recognize themselves in the classical praise he offered; they were skeptical and doubted its efficacy. In short, they were furious.

The Anti-Rohmer Offensive

The core of the New Wave then decided to go on the offensive against Rohmer. These longtime collaborators at *Cahiers* wanted to transform the review into a militant supporter of the movement. This offensive, in what was surely a mis-take, was not conducted overtly, in the open space of the judgment of taste that the review offered. On the contrary, it looked—especially to Rohmer who denounced it as such—like a conspiracy.

This conspiracy was formed in early June 1962. Doniol-Valcroze, Rivette, Truffaut, Godard, and Kast got together and decided to propose to Rohmer a

"collegial management" for *Cahiers* as a way of fully integrating the New Wave
into the review's direction and thereby quite sharply alter its orientation. During
the first informal discussions, Rohmer pretended not to hear what they were
saying. Very soon, the five insurgents concluded that a text would be necessary
to clarify their intentions and propose a manifesto for the new *Cahiers* they
wanted to create. Doniol-Valcroze was to write it. He was then in Istanbul, where
he and his companion Françoise Brion were acting in Alain Robbe-Grillet's film
The Immortal—but on June 15 he sent Truffaut the draft of an editorial to be
published at the front of the review to justify these changes. The terms were care-
fully chosen and diplomatic, attacking Rohmer's line only implicitly. Doniol-
Valcroze, who sought a compromise, did not forget Rohmer's historical role as
the only one who had volunteered to take over the direction of the review at
a time when everyone else was leaving to make films. This "manifesto of the
five,"[47] signed by Doniol-Valcroze, Godard, Kast, Rivette and Truffaut, called for
Cahiers to be consubstantially linked to the New Wave:

> There is—and it may be a little more true this time—a crisis in French cinema,
> and since someone has to be blamed, people say: it's the New Wave's fault. If
> that label designates the directors who came directly from *Cahiers*, plus bril-
> liant individuals such as Resnais, Varda, and Demy, the assertion is as gratu-
> itous as it is false . . . We are therefore not ashamed of our contribution; but we
> know that it is pointless to argue about it: the condemnation is not statistical in
> nature, but depends on a certain morality that decrees that one must not make
> films of this kind, that it harms the French [film] industry. As for the audience,
> it does not have a voice: decisions are made for it and about its tastes. As for
> *Cahiers du cinéma*, the pharmacy where these dirty tricks are concocted, it has
> to be burned.[48]

Then Doniol-Valcroze tries to explain the other, concomitant crisis, that of
Cahiers:

> Do we have to let *Cahiers du cinéma* be burned? Maybe it has done its time,
> and, first of all, why have the very people who made its reputation disappeared
> from the table of contents? First, because we wanted to give younger people an
> opportunity to express themselves, to clarify their vocation; second, because
> making a film takes a lot of time; finally and especially, because it seemed to

us awkward, at a time when we ourselves had started making films, to criticize others and praise our friends. Without our having planned it, *Cahiers* had been a springboard for us, and it could not become an enterprise of self-congratulation or self-justification.

Finally, at the last moment, comes the "homage to le grand Momo," as Doniol-Valcroze put it, followed immediately—and this is clever—by the manifesto's real justification:

> It happens that today we feel a common desire to resume a more active role in the making of *Cahiers*. When we migrated toward real interiors, only one of us was willing to remain at the helm. Éric Rohmer was thus the faithful guardian of the flame. Thanks to him, a small yellow-and-black review appeared each month and had readers throughout the world, and thanks to him, *Cahiers* remained worthy of Auriol and Bazin. His rigor tolerated no compromises, his hard work never ceased. So here we are gathered around him, leaning over the cradle of the grown-up child for which we are again going to care, trying to make *Cahiers* the instrument of combat it once was and needs to be again.

The review as a "instrument of combat" to be used on behalf of the New Wave and the return of its former collaborators, prestigious and legitimate, dispersing the young writers who were still too green and confined in a fetishist cinephilia that privileged the classic auteurs of American cinema—this was a rather direct, twofold response to Rohmer's "taste for beauty." The positions are incompatible and discord broke out. Rohmer categorically rejected the manifesto of the five, refused to associate his name with it, and refused to publish it in *Cahiers*. On July 5, 1962, Truffaut wrote to Doniol-Valcroze a rather distraught letter:

> Along with Kast and Rivette, I have slightly abbreviated and modified your fine text, but there is a problem: le grand Momo refuses to publish it. Here are his reasons: (1) He deplores the fact that you didn't send him a personal note, and he complained about that. (2) He thinks *Cahiers* has never been better than it is right now, that's his opinion and he isn't about to change it. (3) He acknowledges that changes need to be made, and says that he is calmly considering them. (4) He declares that the circulation of reviews decreases when there are editorials. (5) He is sorry that we no longer take part in the composition and editing of

Cahiers, but thinks it would be preferable for us to prove ourselves first, that is, for us to begin by doing actual reading and editing for three months, starting in September, and then if the results are conclusive, the composition of the editorial board would be announced at the end of the year. There you have it. There remain only two solutions: give in or throw him out, as the main stockholders and especially the manager have the right to do. Naturally, I favor the third solution, but what is it?[49]

Tensions had to be reduced, and the "third solution" Truffaut mentions had to be found. The diplomatic Doniol-Valcroze went to work on it. He wrote directly to Rohmer, explaining:

I hear you are upset by the plans for an editorial board that Truffaut, Rivette, Kast, and I talked about, and that you suspect that a conspiracy has been formed behind your back . . . Do I have to remind you that when we last met, a few days before I left for Istanbul, I talked to you at length about my idea of bringing the old team back to *Cahiers* and also about the meeting I had with Truffaut to discuss all that? So there is no maneuvering or conspiracy. Moreover, those who would like to work on *Cahiers* again have a perfect right to do so. After two years of existence, *Cahiers* became successful only when Truffaut and Rivette began writing for it. As for myself, do I have to justify my own claims to authority? What you do every day—*Cahiers*—I also did every day, more or less successfully, for five years. Thus I know what I'm talking about and I can also understand your annoyance at seeing some of us who have "dropped out" wanting to come back and get involved in the writing and editing. I felt the same when Truffaut and Rivette began to put their mark on an enterprise that I had originally conceived in a quite different way. Bazin was able to make me understand that I had to give them a role, and he was absolutely right. Although today the problem is framed in different terms, in substance it remains the same. *Cahiers* is threatened by a certain doctrinal numbness. At a time when all that people talk about is the crisis in French cinema and when it is true that any valid attempt to do something is systematically blocked, *Cahiers* cannot remain an ivory tower from which to observe Goethe's little horsemen doing battle on the plains below. We have to return to the battle, in our own way and our own style, and not be afraid to look like we're defending our own bastions. We could, of course (you've done it) call upon new writers . . . but those who

have been found are the most abstract, the most doctrinaire, vague mixtures of Mac-Mahonians and positivists. I have no desire to "revolutionize" *Cahiers*, but rather to add something to it. The Truffaut-Rivette-Kast-Godard team, by its very variety, indeed by its antagonisms, could help that something come into being. What do we have to lose by trying it? I know what *Cahiers* owes you—its continued existence, first of all, and also its rise to a very high level of style and expression—and it is not a question of renouncing the work that has been done, but rather of adding to it.[50]

Rohmer replied to this letter with a *pro domo* plea, a veritable countermanifesto, a thirty-three-page rambling response sent to Doniol-Valcroze in mid-July 1962, in which he lists one by one the contributions made by his team and the strong points of the review as he sees it. One idea dominates this justification: under his direction, Rohmer writes, *Cahiers* has become "the cinephiles' review," and its influence and rigor consist in "not having hitched its wagon to that of the New Wave."[51] A few days later, on July 21, 1962, Doniol-Valcroze summed up this bittersweet exchange of letters:

> Grosso modo, le grand Momo rejects any change in the current status quo, and remains convinced, despite my denials, that there was in fact a "conspiracy." He has great doubts about the "purity" of our intentions . . . Given that, he is in no way prepared to resign and insists, on the contrary, on the fact that he draws all his income from *Cahiers*, a paltry resource that allows him to eat only once a day . . . In short, we can't make any decisions before we've met.[52]

Since Rohmer was yielding no ground, the "group of five" decided to play for time and keep an eye open for an opportunity. Doniol-Valcroze returned from Istanbul on August 8; at the end of the month, the group met at Films du Carrosse, Truffaut's place, and decided to form a kind of informal and unofficial "supervisory committee" before perhaps taking action if they thought that necessary or vital for the review. During its last year, from the summer of 1962 to the summer of 1963, Rohmer's *Cahiers* was thus a review that had been placed under surveillance: the sword of Damocles hung over it.

Rohmer completely understood that. Thus, being more open than he wanted to let on to Doniol-Valcroze, he decided to put a little New Wave water in his cinephile wine. His *Cahiers* would descend more often onto the field of

combat, leaving the heights of eternal beauty, even if that sometimes meant neglecting the retrospectives at the Cinémathèque. Thus in August 1962, the review decided to respond openly to the accusation of "cronyism" which had up to that point paralyzed its commitment in favor of the new French cinéma. This task fell to Pierre Kast, one of the five conspirators of that summer; he wrote a review of *Un Coeur battant*, a film by Jacques Doniol-Valcroze, the leader of those same conspirators. This was an awkward exercise in which Kast shows a certain liveliness, and his piece is one of the best on the New Wave. [53] A neo-adept of the New Wave, Jean Douchet, declared his support in September 1962. This was important, because Douchet was Rohmer's main lieutenant and had been, in *Cahiers* at least,[54] rather lukewarm about the nascent movement, but in Venice, in 1962, Douchet presented an impassioned eulogy of Godard's *My Life to Live* (Vivre sa vie), which was a kind of revelation: "*Vivre sa vie* goes right over many people's heads, their eyes, and their hearts. It is a pure masterpiece, the first absolutely flawless film made by Godard and the New Wave."[55] Rohmer himself did not hesitate to support Truffaut when French censorship banned *Jules and Jim* for spectators under the age of eighteen on the ground that it was "immoral." Mounting a broader defense of the movement, he wrote:

> Among all the accusations brought against the "New Wave," one of the most surprising is that of "immorality." Have people forgotten that eight years ago François Truffaut, in an article that attracted attention, was already denouncing, in the French masters of "quality" cinema, a bias toward wickedness, meanness, salaciousness, and sordidness too systematic and rowdy to invoke the excuse of realism? At the least, it is rather comical to be charged with the crimes of which you have accused your neighbor. So why these loud protests? It is true— history proves it—that a sincere love of truth has often aroused more censors than an affectation of immorality—which is reassuring precisely because it is conventional.[56]

Similarly, in one of the very first interviews Rohmer gave, to Gérard Guégan for *Les Lettres françaises*, he identified the singularity of the New Wave: "I believe that the innovations that we have made in the style of filming and the method of production are not essential; what matters is rather the renewal of the subject. The awareness that something new has to be done."[57]

From then on, Rohmer's *Cahiers* became more and more supportive of the New Wave, and the tone of the review more openly militant. In December 1962, as an outcome of this visible evolution, a special issue on the New Wave was published—almost four years after the beginning of the movement. With hesitations, Rohmer endorsed the publication of this issue edited by Jacques Rivette but delayed its appearance for more than five months, even though it was ready to come out. Chabrol, Godard, and Truffaut expressed themselves in it for the first time as film auteurs in the register specific to *Cahiers*, the long interview, while all the new French filmmakers were listed in a dictionary of more than a hundred and fifty entries. Critics who scorned the New Wave—Georges Charensol, Jean Cau, Jacques-Laurent Bost, Louis Pauwels, Henri Jeanson, Michel Audiard, and the team at *Positif*—were taken to task directly. Finally, Rohmer's editorial, written by a Rohmer placed under surveillance but whose sincerity was not questioned, outlined the new critical line, that of a more systematic defense of "our truth":

> We are reproached for not speaking about the new French cinema. That cinema is not only dear to our hearts, but close to us, and one always feels a certain reluctance to talk about oneself. We can neither judge with the necessary objectivity nor even consider with sufficient distance this "New Wave" whose birth we have more than facilitated. And yet on the other hand our review cannot afford to ignore the existence of a fact that is already part of history. So let us henceforth silence our scruples. If distance cannot be taken, well, we won't take it. Since it is hard for us to position ourselves outside the New Wave movement, let us remain within it. This perspective is peculiar, but fertile. Lacking truth, let us give our truth: it will be taken for what it is worth, but we do not believe that knowing it is a matter of complete indifference.[58]

Would this defense, even if it was sincere and detailed, suffice to save the editor in chief of *Cahiers*?

Between Charlotte and Véronique

Sign of Leo's failure with audiences did not discourage Rohmer, whose primary ambition remained filmmaking. However, it relegated the film to the category of "amateur cinema," outside the framework of professional production and institutional financing. That never bothered him. He enjoyed the freedom of being

able to express himself as he wished, even modestly, in this amateur context. Rohmer accepted and claimed this modesty and freedom through his advocacy for 16 mm film. In an annotated chronology of his own life he wrote in the mid-1970s, he gave a clear explanation for this choice:

> I saw my pals making films and I wanted to do the same, whatever the cost. And that is how the idea came to me to return to 16 mm film, or more precisely, to amateur film. Sixteen-millimeter film was not recognized as a professional format, it was seen as a substandard format. It was reserved for amateurs, for the contexts of occupational or pedagogical training, and for television, which had from the outset understood that there was no point in burdening itself with such a cumbersome support as reels of 35 mm film.

Rohmer made his decision on the basis of a few attempts that fascinated him and were able to show him how to proceed, notably films by Jean Rouch, from *Moi, un noir* to *La Pyramide humaine*, by way of *Chronique d'un été*, which he called, using the ethnographer's own formula, "free cinema";[59] Michel Brault's documentaries financed by the National Film Board of Canada; and "Direct Cinema" films like those of the American Richard Leacock and the Maysles brothers.

Most of these experimenters with 16 mm used a new camera that came out in the late 1950s and had a synchronization cable allowing direct sound, the Éclair NPR, also known as the "Coutant" after the name of its inventor. (Up to that point, virtually all 16 mm cameras had been spring-driven, like the American Bell & Howell and the French Beaulieu and Paillard cameras.) This technological advance, which was supported by equipping some theaters in Paris with 16 mm projectors or by an easier enlargement of films ("inflating" them to 35 mm, even if it remained rather expensive), promised an imminent "professionalization" of the amateur format.

Thus for Rohmer, 16 mm was more than a return to the past and his first love. It was a bet on the future that the filmmaker did not hesitate to make, as he maintained in an interview given in early 1962 to the magazine *Nord-communications* that amounted to a veritable manifesto of amateur filmmaking. "So you believe in the future of 16 mm?" the journalist asked. Rohmer replied:

> Definitely. I'm betting on it, in fact I've already made the bet. I have the firm intention of devoting, over the coming years, part of my time to making 16 mm films. I won't give up 35 mm, but 16 mm seems to me, on reflection, the ideal

format for filming certain subjects that are important to me. I've worked with 16 mm in the past, but in a spirit of sketches, drafts, exercises. I'm returning to it enriched by my experience in the standard format, with the additional advantage of the immense progress made by technology. Sixteen millimeter is no longer a poor relation, and if I make my films in that format, it is so that they will be better, not relatively but absolutely better. In actuality, I see them not as independent works but as a series. They support one another. They make up a kind of album, a collection of stories. In short, I trust in the march of history. We are very close, it seems to me, to the era of the "camera pen" advocated by Astruc in an article written in 1948. I would like to embark upon an enterprise similar to Rouch's, but with different assets and in an entirely different spirit. Up to this point, "personal" cinema has been conceived as a kind of report, a diary, a sketchbook. It is not that tone I want to give it, but rather that of the short story.[60]

Rohmer conceived the first of these "series of cinematic short stories" with Jean-Luc Godard as early as the mid-1950s, under the title *Charlotte et Véronique*. It was a series of sketches, between twelve and seventeen, the number depending on the initial versions of the overall outline of the various episodes,[61] constructed around the characters of two twenty-year-old students who have "gone up" to Paris, two young heroines who are pretty, naïve, and ensnared in sentimental fables or economic conditions that put them in paradoxical situations. In early 1957 Godard and Rohmer wrote down a few characteristics[62] ("pretty, but that's all," "level of education: grammar school, but not stupid," "read *Elle* from time to time, but are also endowed with a certain intellectual curiosity," "they are trying to make do"), and together they wrote an outline of the first episode, entitled "Charlotte and Véronique," which was not the first in the series but was the first to be filmed. This short, five-page narrative has these two girls encounter the same person: Patrick, a seducer and smooth-talker. He meets Charlotte in the jardin du Luxembourg and takes her to have a drink; he meets Véronique on the street right after he has left Charlotte. He makes a date with each of them for two days later. Since they are university students and roommates, they confide in each other and are amused by these coincidences: they have both just fallen in love with a handsome man. To the girls, the two men seem very different even though they have the same first name. The next day, as Charlotte and Véronique are walking near the jardin du Luxembourg, they run into Patrick, who is busy

seducing a third girl he has met in the backseat of a taxi: "All men are named Patrick," they seem to say to each other as they swallow their disappointment. Pierre Braunberger produced this little film for his company Les Films de la Pléïade. Godard made it in three days at the beginning of June 1957. When it came out in the spring of 1958 under the title *Tous les garçons s'appellent Patrick*, Rohmer was frustrated, because Godard had dispatched his scenario in a completely offhand, scornful way. They were estranged for a time, and Rohmer and then Godard made further episodes separately: *Véronique et son cancre* and *Charlotte et son Jules*, respectively.

Rohmer made *Véronique et son cancre* thanks in large part to Claude Chabrol, who had taken over, immediately after Rohmer's first full-length film, the technical team used for *Le Beau Serge*, notably Jean-Claude Marchetti for the sound (which allowed him to film with direct sound) and Jacques Gaillard doing the montage. He used Chabrol's apartment as a setting, and the AJYM company was the main producer for *Véronique et son cancre*. Rohmer wrote this episode in Véronique's life (eleven pages of development entitled *Un petit cancre modèle* and a precise, two-page storyboard[63]) based on his personal experience: "It's a film in which I invented almost nothing," he was to say. "A few years earlier I'd stopped teaching in order to remain in Paris, and my sole means of support was not private lessons but a single private lesson! In math and French composition. Two or three times a week, I taught a young boy who talked back to me and amused me very much."[64] And in fact Véronique tutors an eleven-year-old boy who has no interest in his work: he argues about the assignments and instructions, remembers nothing, opposing his concrete good sense and down-to-earth will to do as little as possible to the classical teaching she is giving him. Véronique is also bored, constantly taking off her shoes and playing with her feet. When the clock sounds, exactly one hour after the beginning of the session, the child sends Véronique away and recovers his freedom. The only thing he has acquired is probably a fetishistic fascination with the female foot, since as soon as she has left, the little rascal drops to the floor at the exact spot where his tutor bared her toes. The film concludes as it began, with the tune "Il pleut, il pleut, bergère" played in music-box chords.

The film was very carefully made, quite different in that respect from Rohmer's first attempts and from the 16 mm works that emphasized their "amateurism" in the enlightened sense of the term. Rohmer's complicated relationship with professionalism makes this opus a pure exercise in style, almost a little cold

and distant. *Véronique et son cancre* was shown in theaters on February 11, 1959, preceding *Le Beau Serge*. Unlike Chabrol's film, it went unnoticed.

When Rohmer tried to go back to 16 mm and amateur cinema in the autumn of 1961, he returned almost naturally to this series. But Godard had become a star of mise en scène, and had no intention of making further films about the adventures of Charlotte and Véronique. However, Rohmer found an ally, his old pal Guy de Ray, the penniless producer of *Les Petites Filles modèles*. He agreed to set up this series as a coproduction with Georges de Beauregard, Godard's usual financier. Rohmer and Ray wrote a note to present the series:

> Charlotte and Véronique, two girls about twenty years old, arrive in Paris to study at the university. This series will follow some of their encounters and adventures. The direction of the sketches will be entrusted to Éric Rohmer, who will not only create some of the mises en scène but also provide general supervision. For some of these short episodes, M. Rohmer may recommend directors. The same privilege will be granted to Guy de Ray, but all the directors must be approved by M. Rohmer. Each episode will be presented to Godard before it is filmed. Guy de Ray will also act as producer. It should be possible to distribute this series in France and in Germany in the form of a feature film. The profits will be shared as follows: Éric Rohmer: 40%, Guy de Ray: 40%, Jean-Luc Godard: 20%.[65]

Two lists follow, one of six episodes, the other of thirteen, no doubt determined by financing possibilities found by Guy de Ray. A document from the same period provides an explanation for the division of labor set by Rohmer, who foresaw a kind of collective film consisting of sketches like those he had already made: "1. Arrival in Paris (Rohmer); 2. Apartment (Rohmer); 3. Sorbonne (Luc Moullet); 4. Lost key (Jean Douchet or Charles Bitsch); 5. Surprise party (Marcel Moussy, with Anna Karina); 6. Intrigues, love, work, money (Rivette)."[66]

The project was never realized, Georges de Beauregard rather quickly dropping out of the venture. Guy de Ray managed at least to complete one episode in October 1961: he remade *Présentation*, a short film made by Rohmer in 1952 with Jean-Luc Godard as an actor; it became *Charlotte et son steak* to preserve the coherence of the series. With Godard's agreement, a sound track was added to the little film, since ten years earlier it had been made as a silent film. Godard

recorded his own lines, but the two actresses in the 1952 version did not; they were replaced by Anna Karina's voice for Véronique and Stéphane Audran's for Charlotte. The film was shown at the Journées internationales du court métrage in Tours, in November 1961, and then in a few theaters. *Charlotte et son steak* was sold for 6,000 new francs to Bata Films for distribution in theaters; moreover, the quality film subsidy amounted to 3,000 new francs, and this represented a significant profit that Rohmer immediately invested in his next project, *La Boulangère de Monceau* (The bakery girl of Monceau). It was ultimately thanks to this remake of *Charlotte et son steak*, an artificial orphan of an initial orphaned series, that Rohmer was able to pursue his cinematic plans. "I didn't expect it at all," he explained. "In fact, *Charlotte et son steak*, this little film made at the very beginning, almost without financing, was decisive for my career."[67]

Georges de Beauregard was, however, associated with another of Rohmer's unfinished projects, *Une femme douce*. For a few years, Rohmer had been wanting to adapt this short story of Dostoyevsky's, since we find in his archives a ten-page outline going back to the 1950s. "Imagine a husband looking at his wife's body lying on a table. It is a few hours after this woman has committed suicide by jumping out of a window. The husband is extremely disturbed, and has not yet been able to collect his thoughts. He paces back and forth in the apartment and tries to explain the event, to concentrate his thoughts on a single point: 'Why, for what reason, is this woman dead?' "[68] That is how this short narrative begins in the perspective of a film adaptation. The story is that of a cynical man, the editor of a literary review and former aviator. He meets a beautiful young woman who is full of admiration for him and who has applied for a job as secretary at the review. He seduces her, they marry. But she is obsessed by suicide. "This shared disgust for life brought us together." Everything in their marriage quickly deteriorates: he is ill-tempered and irritable; she takes refuge in silence and withdrawal. "My love was rapidly transformed into hatred," the synopsis notes. The man ends up being violent and strikes his wife. She runs away; he goes in search of her. She falls ill: he cares for her. Just as their relationship seems to be calming down, the wife, taking advantage of her husband's absence, jumps out the window. When he returns, she is lying on the ground, her face "strangely peaceful, serene, as if she were asleep." A passerby says, pointing to a pool of blood: "Have you seen that little bubble of blood that has run out of her mouth? She seems to be smiling."

In October 1961 Rohmer, who had submitted an estimate of 409,964 new francs for this feature-length film, met several times with Georges de Beauregard. Godard had warmly recommended him. Rohmer had just completed the scenario and proposed a plan for making the film in five weeks with a small technical team in order to record in 35 mm and direct sound. Three weeks of shooting in a studio, one week in an interior (hotel, café), and one week outside (in Vincennes, at the Buttes-Chaumont, at the Foire du Trône) were planned. Thanks to Georges Sadoul, Rohmer even got information about *Krotkaya*, a Russian film based on the same story, that had been made by Alexandre Borissov for Lenfilm. But there was nothing to be done: Georges de Beauregard and his company, Rome-Paris Films, totally absorbed by Melville's current project, *Le Doulos*, and then confronted by the trouble Godard's *Le Petit soldat* was having with the censors, who were blocking the revenues expected from the film, decided not to produce *Une femme douce*.

The Birth of *Moral Tales*

Faced by adversity, Rohmer did not give up cinema. He never considered concentrating on a career as a critic, even though at that time it offered him greater recognition. *Sign of Leo* had been a failure, drawing hardly five thousand spectators in Paris. *Une femme douce* collapsed, and the *Charlotte et Véronique* series bogged down, but these trials strengthened Rohmer's perseverance. "After *Sign of Leo*, he said, "I found myself flat broke. Shortly before Christmas 1961 someone asked me: 'What film do you want to make?' I replied: 'I don't know . . .' I was really lost."[69]

The eureka moment emerged from an old short story collection that Gallimard had rejected in June 1950 and that was already entitled *Moral Tales*. "While my comrades in the New Wave were experiencing success and making film after film, I was still running on empty. [. . .] And then, all of a sudden, an idea occurred to me: why not adapt *Moral Tales*?" Elsewhere, he explains: "I'd already made *Sign of Leo*, and I was not finding other subjects, so I asked myself: what are my friends in the New Wave doing now? They made a first original film, then Truffaut made *Shoot the Piano Player*, based on a novel by David Goodis, and Chabrol made *Web of Passion*, based on a novel by Stanley Ellin. I was the only one in the group who had written literary works. Why not take my inspiration from them?"[70]

Most of these scenarios had already been written in the form of short stories and narratives even before they were considered for film adaptation, and this gave *Moral Tales* a depth and a coherence rarely found elsewhere. Thus *Suzanne's Career*, *La Collectionneuse*, *My Night at Maud's*, and *Claire's Knee* were written fifteen to twenty-five years before they were made into films. In addition to their literary conception and themes, these tales are connected by a common theme: "I found a relationship among them," Rohmer explains, "the story of a man who, seeking one woman, finds another."⁷¹ There was a great originality in that: such a style of series had never before appeared in the cinema.

The *Moral Tales* presuppose a tone and a genre, both of which are based on ambivalence. Rohmer acknowledged in an interview that the very term "moral tale" (*conte moral*) is ambiguous:

> Each of the two words can be interpreted in more than one way. "Conte" usually means "an account of facts," but it can also refer to "marvelous adventures." Now, my films are little chronicles of present-day life developed through a sustained novelistic plot, but they emphasize the unreal nature of the subject. And in the [French] word "*moral*" there is something that relates to behavior—in my work, it takes on a more psychological than sociological meaning—that has to do with considerations on morality, on judgments of value in relation to good and evil. It would be nonsense to believe that I am proposing a moral of some kind, but anyone seeing my films is free to draw from them the moral that suits him.⁷²

The tone of this series takes the form of a personal narrative and implies the interpretation of facts rather than facts themselves. Here again, Rohmer is the best equipped to explain what this means: "My intention," he wrote in the preface to the 1974 book that brought the six tales together, "was not to film the raw events, but the story that someone made out of them. One of the reasons why these tales are called 'moral' is that they are almost completely without physical action: everything happens in the narrator's head. Told by someone different, the story would have been different, or it would not have existed at all."⁷³ The result is a form of illustrated intimate account that from the outset situates and supports the remarks made in these films on the level of the individual psychology of a narrator or privileged observer. It is in this broad sense that we must understand the expression "moral tale."

Rohmer never expressed himself more clearly regarding this series than he did at the beginning, even before he had filmed the first episode in early 1962, when he gave a completely unrestricted interview to the magazine *Nord-communications*. Although the interview was never published, he reread the text very carefully:

> I would like to give my cinematic story collection the title "Moral Tales." These story-films will all be first-person narratives. It is very certain that cinema, from its first efforts, has sought to show what happens inside people, to move from the objective to the subjective. What I would like to express constantly in my tales is, if I may be so bold, a pure relationship between self and self. The goal is to explore the most absolute subjectivity without rejecting the principle of cinematic objectivity. I seek to explore, in a form more amiable than austere, certain hidden worlds of our inner life, of our souls. We will therefore witness an incessant portrayal of ulterior motives. Finally, to cleanse the story of any dramatic slag, I shall be very careful to recount only the anodyne, limiting myself to the domain of sentimental relationships, which does not mean that I am not interested in the setting, the physical and social milieu. But I shall move through my interior labyrinth with all the more agility because the "great subjects" will never be put in question. I would like to explore our moral behavior.[74]

But for his first moral tale, Rohmer did not take a story written in the 1940s as his point of departure, but rather a personal memory. When he was a penniless university student after the war, some nights he used to eat at the Mabillon student restaurant, while on other nights, because he had to study or because he had even less money, he limited himself to a raisin bun bought in a bakery on rue de Buci. At that time, his fantasies were oscillating between a coed from a good family who ate at the university restaurant and the salesgirl at the bakery.

A first draft of the scenario, written in early 1962, merely embroiders a sentimental intrigue on the alternation between two young women who are very clearly situated socially.

On his way to the Mabillon university restaurant, a student passes on the boulevard Saint-Germain a girl whom he finds very beautiful and who, for that very reason, he cannot follow or ogle too much, much less accost. But one day when he is looking for her on the sidewalk across the street, he finds himself face to face with her. He has bumped into her; he excuses himself and begins a

conversation that continues until she goes into a store. He does not dare follow her. They part without promising to meet again. But he does not see her the next day or the following ones. Irritated, but not wishing to waste time (he is a good student), he skips dinner and walks into a neighboring street, in the middle of a crowd at the intersection with rue de Buci, to eat a few raisin buns, being careful that his idol doesn't see him munching on them. The little bakery girl is of a friendly and cheerful nature. A familiarity grows up between them. He courts her a little, without being too serious about it, just to kill time. He gets caught up in his flirtation, ends up forgetting his initial goal, and finally arranges a rendezvous. As he is going there, he runs into the coed on the boulevard. As a result, the bakery girl is forgotten. The number one girl proves affable, even exuberant, and addresses him as if he were an old friend. She has been very ill and, during convalescence, she watched him walking back and forth in front of her door, because she lives just across the street from the bakery. In short, they get married and have many children, while the little bakery girl, who had dressed to the nines for the occasion, thinks her nice client was making fun of her.[75]

Rohmer adds, in a lucid final notation: "When it is told, this story seems very banal. I hope I shall enrich it with a few nuances. Because it's time for nuances, don't you think?"[76]

These nuances are of two kinds. First, there is the social implication of seduction. Sylvie, the well-dressed young lady, and Jacqueline, the apprentice baker, do not belong to the same world. There is the "high-class" woman whom one tries to seduce, who is cultivated, complicated, probably well-off, and who rejects and attracts, plays, disappears, reappears. And then there is the girl who is "not my type," as the narrator says, and who is pretty and fresh, with whom contact is easy and natural. A simple, modest girl, who is attractive for that very reason, without anything like the sentimental conflict of the "high-class" being involved. "What shocked me," Rohmer's narrator confesses regarding Jacqueline, "was not that I might please her, but that she might have thought she could please me in some way. I felt a desire to drive her into a corner to punish her for having tried to make up to the wolf."[77]

The other Rohmerian peculiarity concerns the geographical or topographical situation of the space filmed. As the narrator succinctly says, "I opted for walking and strolling about," which implies a very localized action that had to be followed both faithfully and rigorously. Rohmer was extremely attentive to this, to the point of being maniacal: everything in the movements and the sites had

to be true. The film's realism resides in every curbstone, every detail of the street, every step, and every shop window. The result was that the situations might seem banal and repetitive, like the ones experienced by a subject in the grip of obsessional rites of movement, if the narrator's voice-over did not explain them by revealing their motives and effects.

However, in precisely that way Rohmer was compelled to carry out a spatial transfer: the initial narrative, which remains faithful to the primitive memory, is situated between the Mabillon student restaurant, Saint-Germain, and the rue de Buci. Instead, the film explores the Villiers neighborhood, between rue de Lévis and rue des Dames, the parc Monceau and Les Batignolles. This experiment saw the emergence of a new constraint: the scenes inside the narrator's little room had to be filmed in an apartment Rohmer had been lent in rue Legendre, at the intersection with rue de Lévis, and he reconceived the whole film around this space; for example, he found a suitable bakery on rue Lebouteux. For Rohmer, the camera had to situate this space with a precision that was, if not scientific, at least objective. Thus he went exploring and located minutely the spaces in this neighborhood, which in the nineteenth century was known as the Monceau Heights.

Rohmer did not intend to work with professional actors or with an experienced technical crew, because he had no money to pay them and did not consider them necessary. He preferred to surround himself with young people he knew and with whom he worked almost every day at *Cahiers du cinéma*. Their goodwill would make up for their inexperience. Moreover, for Rohmer, this was a way of getting around the profession's set habits—among both the actors and the technicians—with which he had collided while filming *Les Petites Filles modèles* and also, to a lesser degree, while filming *Sign of Leo*. Jean-Louis Comolli, Bertrand Tavernier, Michel Mardore, and Barbet Schroeder, young Rohmerian cinephiles who belonged to the *Cahiers* group, took part in the adventure of *The Bakery Girl of Monceau*. Comolli was assistant director, Tavernier did the narrator's voice-overs, and Mardore acted the part of a customer in the bakery. Schroeder—a very important acquaintance Rohmer made in 1962—played the leading role.

During his childhood, Barbet Schroeder had traveled widely between Iran, where he was born, and Colombia, where he grew up, following his geologist father. He had subsequently studied at the Condorcet and Henri-IV lycées in Paris, then earned a degree in philosophy at the Sorbonne. A cinephile, he first

became acquainted with Rohmer as a fervent reader of *Cahiers*, and then met him at the Cinémathèque. Finally, in late 1961, he joined the review.

> Rohmer was my idol, along with Douchet. I'd spotted them at the Cinémathèque. I decided to go up to them, using as a pretext for going to the office on the Champs-Elysées the claim that I needed to consult a back issue of the review. Douchet gave me a warm welcome. Then I came back every evening at 6 P.M. to participate in the discussions. I wrote little, two or three texts, but I was present and that's what counted. Douchet captivated the young people, and in turn I introduced to him a few of my cinephile friends, Jean-Louis Comolli, Jean-André Fieschi, Serge Daney, guys from the Cinémathèque. I recall that we saw all of Hawks's films there with Rohmer. It was there that he impressed me the most. Rohmer was more a Hawksian than a Hitchcockian, he had understood everything and he laid bare Howard Hawks's system of mise en scène. It was also for that reason that I liked *Sign of Leo*, the most Hawksian of the New Wave films.[78]

Schroeder told Rohmer about his interest in his film. "A few weeks later," Schroeder went on, "he told me that he wanted to rely on me and told me about his projects: filming the first 'moral tales,' *The Bakery Girl of Monceau* and *Suzanne's Career*. I jumped at the chance."[79]

Barbet Schroeder was twenty-one years old and classically handsome: blond, tall, svelte, elegant—a "Hawksian" beauty, that of a man of action. That was his strength; he was fearless and seemed ready to do anything to advance the realization of his mentor's destiny, which had up to that time been frustrated. In early 1962, the task was to prepare for the filming of *The Bakery Girl of Monceau*. Along with Rohmer, Schroeder explored the site in detail: "Five or six different walks between the market on rue de Lévis, the café on avenue de Villiers, and the bakery on rue Lebouteux."[80] And he became accustomed to eating pastries to the point of losing his appetite for them—"Rohmer loved pastries—*pains aux raisins, financiers, mendiants, sablés*; he had a collection of five or six different cakes that he served with tea at 5 P.M."[81] Finally, and above all, Barbet Schroeder organized the film's production. He could count on the few thousand new francs Rohmer had invested from the profits on *Charlotte et son steak*. But he was short 3,000 francs. This was a ridiculously inadequate budget, of course, "and yet I didn't have them [the 3,000 francs], nor did Rohmer, or anyone else at *Cahiers*."[82]

So Schroeder found a coproducer: Georges Derocles and his Société algérienne de production des studios Africa (SAPSA), a small company with headquarters on rue Saint-Lazare that specialized in films for businesses, and especially those made in the Maghreb. Derocles provided a thousand meters of 16 mm film and laboratory work, development of the rushes, and printing of the standard copy. In return, the profits from the film were to be divided on a 50/50 basis between him and Rohmer.

When the contract was signed on July 6, 1962, the filming had already been proceeding in Villiers for almost two months, every weekend in May and June. Rohmer had prepared for it meticulously, writing down every detail in a beige-colored spiral notebook. The cover bears the title "1. *The Bakery Girl of Monceau*," and the flyleaf reads: "Éric Rohmer, 'Six *Moral Tales*.'"[83] The notebook contains a shot-by-shot decoupage accompanied, in five parallel columns, by "effects," "ambience," "dialogues," and "commentary." There were to be a hundred and sixty-six shots, all recorded using two 16 mm cameras that followed one another on the shoot: first a Paillard, then a Bell & Howell. Both were borrowed and had the same problems: since they were run by springs, the length of a shot could not exceed twenty-two seconds, and they did not record sound. "I could not afford to use the sound-recording Coutant camera," Rohmer explained. "I had no amateur camera, but I could borrow one. I even found a volunteer camera operator who later worked in television and made a name for himself as an abstract painter, Jean-Michel Meurice. In most of my amateur films, I had never gone all the way to the end of the twenty-second duration, or at least rarely. For a film with sound, twenty seconds may seem short, and moreover, I don't like montage films, fragmented films. I always wanted a certain continuity, and more particularly in this film, I wanted to show the continuity of the space. It was the difficulty of that very enterprise that attracted me: making the transitions invisible, knowing how to choose the right moment for connections."[84] This resourcefulness remained, for Barbet Schroeder, one of the characteristics of Rohmer's cinema: "He took advantage of everything, and for that reason constraints interested him. This direct, effective, simple side corresponded to his idea of cinema."[85]

The Paillard camera was borrowed from Films du Carrosse, where it was used for film tests for actors and certain scouting tasks. Claude de Givray recalls: "Rohmer came by to pick up the camera at Carrosse. I have to say that the idea of knowing that this gentleman, who intimidated me so much, timed his twenty-two-second shots to put them end to end, took on a very moving character.

This modesty in his work, combined with such a structured conception of cinema, seemed very beautiful to me, it touched me a great deal."[86] Jean-Michel Meurice brought the other camera with him during the second part of the filming.

Barbet Schroeder had all the actors in the film gather in cafés in Villiers for quick rehearsals, and everyone paid his own tab. Among the actors, we may note in particular Michèle Girardon in the role of Sylvie—a Hawksian heroine, according to Louis Skorecki, who called her an "Angiedickensonian star"[87]—a pretty blonde whose career had been launched by Luis Buñuel (*Death in the Garden*) and Louis Malle (*The Lovers*). Rohmer had already given her a role in *Sign of Leo* and had grown fond of this sensitive and intelligent actress, with whom he corresponded, notably during the filming of Howard Hawks's *Hatari!* in Tanganyika, where she was acting alongside Gérard Blain; she recounted her experience in *Cahiers du cinéma*. Michèle Girardon was in fact the first of the "Rohmerian girls"—the *Rohmériennes*.[88]

Since the filming was done during the day, no lighting equipment was used, and the 16 mm film was not entirely fresh, so that sometimes the developed image has a grayish-yellow cast. However, a few inventive ideas made more complicated shots possible, even if they were limited to twenty-two seconds: tracking shots with a dolly, the camera placed at a window or on top of a car, reflections in mirrors and window panes. The filming was completed as planned thanks to the thousand meters of film Derocles had provided. Over the following weeks, Rohmer, using a splicer (a simple, cheap machine that was easy to move around—he could work at home as well as at *Cahiers*), put together a twenty-two-minute film. This was not particularly difficult, because Rohmer had meticulously planned each of his shots so that they fitted together seamlessly, reducing the work of montage to a minimum.

The other difficulty, which may have been greater, concerned adding a sound track to such a "talking" film. Everything was filmed silently, recording only simple direct sound using a JEL portable tape recorder borrowed from *Cahiers*. The goal was thus to record noises and ambient sounds adequate for the microphone, to synchronize the dialogues (which were minimal in *The Baker Girl of Monceau*), to record a commentary and to place it on the shots, then to edit and mix this sound track with the preexisting film track. Once again, Rohmer went hunting, carrying an open microphone through the streets, markets, parks, and cafés. He even recorded sounds at his home, in the stairway of

his apartment building on rue Monge, and at the offices of *Cahiers du cinéma*, as André Labarthe testifies: "One day around 5 P.M. I came into the office on the Champs-Élysées and found Rohmer there all alone, doing something at the window. He was dangling a microphone on the end of a cord toward La Pergola restaurant below him to record ambient sound. I greeted him with a loud 'So, are they biting?' He was delighted. That kind of thing amused him a great deal."[89]

The commentary, written out down to the last comma and calibrated to the precise second, was recorded in a single day by Bertrand Tavernier, as Barbet Schroeder recalls: "We got along well with Tavernier, who had written several articles for *Cahiers*. We did not always share the same tastes, and were even never in agreement, but we remained friends. Since my voice was a little too Parisian, Rohmer asked him to speak the commentary."[90]

The montage and mixing were done in the studio, in a small sound laboratory in Boulogne-Billancourt that was owned by Gérard Vienne, a cousin of Jean-Daniel Pollet; that was where the latter made his animal films, which Rohmer particularly admired. There, a twenty-two-year-old assistant editor, Jackie Raynal, was working on the sound for Pollet's film *Méditerrannée* and Jacques Rozier's film *Blue Jeans*. In late 1962 to early 1963, at a discount price, she helped Rohmer do the sound montage and mixing for *The Baker Girl of Monceau*. That was the most expensive step in the process, and Derocles and his company, SAPSA, could not pay for it. Barbet Schroeder was thus forced to set out again in search of financing, even minimal, to finish the film.

At the Origin of Losange

With money acquired by hocking a German expressionist painting by Emile Nolde that belonged to his mother (who had a fine collection in her apartment on the rue de Bourgogne), Barbet Schroeder suggested to Rohmer that they found a small production company intended to finance the completion of *The Baker Girl of Monceau*. At the end of 1962, Films du Losange was born. "My initial idea," Schroeder recalls,

> was to call our production company Les Films du Triangle, an allusion to Griffith, whom we admired, and to Rohmer. But we discovered that a bankrupt French company already bore that name. Shortly afterward, one day when I was

dining with Philippe Sollers, whom I had met through my friend Jean-Daniel Pollet, I was telling him about our problem and he said to me as a joke: "No problem, call it Les Films du Losange. That's twice as good, a losange is two triangles!" It all started there.[91]

The new company's headquarters was Schroeder's mother's large apartment at number 30, rue de Bourgogne, next to the National Assembly in the seventh arrondissement, and its office was in his bedroom. At the outset, Losange was entirely devoted to finding financing for Rohmer's films; he was, along with Barbet Schroeder, the main stockholder, while Jean Douchet and Georges Bez were minority stockholders. Douchet recalls that

> Barbet Schroeder did not seek to work directly in the mise en scène, but instead tried to enter the trade through production. Although this was a concerted step on his part, he threw himself into it. This experiment in minimal production was possible only because it was connected with a rigorous thrift. Losange's basic principle, to which Rohmer adhered all his life, based aesthetics on economy, which is a matter of morals. It could also be said that at the foundation of Films du Losange there was an idea of cinema close to that of *Cahiers*. Losange was its continuation. One of its major principles is that art is subject to the real, not the other way around.[92]

Films du Losange's first funds were used to finish *The Baker Girl of Monceau*, paying for the montage and the mixing of the sound, the development of a 16 mm negative, and the printing of a copy in the LTC laboratories. Schroeder and Rohmer immediately started working on the second moral tale, *Suzanne's Career*, in early 1963. On February 26, Losange rented a Paillard Bolex camera for 21 francs a day; the coproduction contract for the film (between Losange, Éric Rohmer, and Georges Derocles's SAPSA, which reproduced the financial clauses in the contract for *The Baker Girl*) is dated March 13. Rohmer also repeated the same conditions for the filming: he was assisted by Jean-Louis Comolli, Barbet Schroeder, and another very young, equally fanatical cinephile, Pierre Cottrell. The three of them also acted as extras. The only card-carrying professionals involved in the project were the beginners Daniel Lacambre, a student at the ETPC, as camera operator and Jackie Raynal for the montage and mixing. All the others were amateurs, cinephile friends, or friends of these friends. This was also true

of the actors and actresses: Catherine Sée, who plays Suzanne, was introduced to Rohmer by Barbet Schroeder; Christian Charrière, who plays Guillaume, the narrator, was a schoolmate of the producer, a young man as handsome as he was discreet. Similarly, Philippe Beuzen, who plays Bertrand and who had an admirable physique and spoke well, was proposed by Catherine Sée (and accepted by Rohmer when he learned of his diabolical past as a member of the Secret Army Organization). Finally, Patrick Bauchau (Frank, Suzanne's fiancé) was a friend of Schroeder's, a Saint-Germain-des-Prés dandy known for being the husband of Brigitte Bardot's sister, Mijanou. The attentive spectator could also spot Jean-Claude Biete, another cinephile and young critic; Jean Douchet waiting in line in front of a movie theater; Jean Narboni and Jacques Bontemps having a drink on the terrace of a café; and Rohmer himself, appearing very surreptitiously speaking Latin at a séance table.

Rohmer was proud of working with nonprofessionals and justified it:

> I took absolute amateurs who had no desire to become professional actors. It was the innocence of their acting that pleased me. I didn't teach them to act, I never "directed" actors as little as I did these. And I have never been so distant, so cold as I was with them. In reality, they knew each other and felt at ease. I felt like I was making a documentary, even though there wasn't even a trace of cinema vérité in the film: I wrote the text, in advance and from end to end.[93]

If *The Baker Girl of Monceau* was a film shot outside, *Suzanne's Career* was a inside work, even a "student's room film," most of the action taking place in confined spaces—apartments, clubs, and cafés, and in conversations continuing into the evenings and nights, notably at the famous party organized at the Tilbury club by the student association of the École des hautes études commerciales in 1963—with the exception of brief passages in the jardin du Luxembourg and at the Deligny swimming pool. The characters move about little, hardly budging: the dramatic tensions consist basically in standing up or sitting, a few gestures and words. The dialogues are essential. The filming is also very different from that of the preceding film; it is generally limited to confined spaces lighted by the camera operator Daniel Lacambre, with direct sound recorded by Jean-Louis Comolli using an ambience microphone plugged into a tape recorder. The constraint imposed by the camera's twenty-two-second limit was still an issue,

but Rohmer was by then a past master in the planned cutting-up of dialogues. Here again, his archives contain a notebook with the different divisions of the film, written in rigorous, precise, parallel columns: "images," "sounds," "effects," "ambience," "dialogues," "commentary." Two hundred and ninety-eight shots were planned, listed, and described, for a final film fifty-three minutes long.[94] But the filming was spread out over a year, occupying weekends in several different seasons between February and November 1963 to give the impression of time passing.

Suzanne's Career was long in the making: the first version of the story was the heart of a thirty-seven-page short story Maurice Schérer had written fourteen years earlier, dated January 7, 1949, and entitled "Le Revolver." The story begins with this maxim: "Eighteen is an age without excuses," and then goes back to the "first months of 1935" and the exuberant escapades of a "group of students hanging out at the Café d'Harcourt." A narrator, himself a medical student, recounts his fascination with Max, a "handsome, extremely brilliant boy with a touch of courtesy and that affectation of cynicism that guaranteed him every conquest." The two students meet Paule, a young woman who is—according to the narrator—"rather ugly." They look down on her because she is already working as a secretary, but nonetheless flirt with her and go out with her because she pays for all their drinks. She ends up stealing from the narrator the revolver that he has hidden in his room (after dark machinations against a rival) and sells it to a trafficker for a few thousand francs, about the amount the boys have extracted from her during their nights out. Paule disappears . . . A few months later they see her again, transformed into an attractive young woman and married to a rich industrialist, whereas they have remained poor and have also failed their examinations. She speaks to them, one last time, to avenge herself for past humiliations: "If I saw you dying on the street I wouldn't go out of my way." As a kind of moral, the last line of the story resounds like a slap: "This indifference is still more terrible than hatred; by depriving me of the right to complain, Paule had guaranteed her genuine vengeance."[95] As often happens, at the origin of the film there was a literary narrative, the trace of initial literary ambitions that have been transformed into the filmmaker's inspiration.

When he went back to "Le Revolver," Rohmer rewrote it and turned it upside down, while at the same time preserving its plot and its main characteristics. The revolver itself disappeared, as did the machination that served as a pretext for it, and was replaced by "a few 10,000-franc bills" given to the narrator by

his parents. The narrator retains the name of Guillaume; he is a pharmacy student and is fascinated by another young woman, the beautiful and inaccessible Sophie. Max becomes Bertrand, who has now gone through Sciences-Po, and Paule becomes Suzanne. She is much less manipulative and ultimately there is no reason to believe that she has stolen Guillaume's money when she spent a morning alone in his room. Ambiguity reigns: Bertrand, the cynic, is also a suspect. And when Suzanne returns, in the end, on the arm of a husband prestigious by his age and money, she limits her revenge to a subdued pleasure that is surely more effective and "moral," as the narrator himself notes:

> Toward the end of the school year, I will see Suzanne again two or three times, in particular at the swimming pool. And I think, she hasn't done badly for herself. In fact, there's something about her that pleases men—especially men more mature than I am. While I am deep in these thoughts, someone pushes me into the water. The girls laugh. This year was doubly fatal for me. Even before the vacation, I quarreled with Sophie, and I failed my exam.[96]

In May 1964, Barbet Schroeder and Films du Losange had the 16 mm negatives of the first two "moral tales" printed by the SIM laboratories at Saint-Maur. *The Baker Girl* and *Suzanne*, as Rohmer affectionately called them, were submitted in 1964 to the International Short Film Festival in Tours, but they were rejected by Pierre Barbin, the festival's director, on the ground that they were "without interest." Schroeder recalls that he was very upset and depressed about this rejection.

"That's not going to help us," I told Rohmer. We're going to have problems, *Moral Tales* will take another ten years!" He replied serenely: "This rejection is a good sign! Ten years is nothing. Cinema is an art of maturity. Believe me and trust me." He was convinced of his talent, he was writing and filming for eternity, sure that the negative, even sniggering judgments of the present would be revised and corrected by posterity.[97]

The Baker Girl of Monceau and *Suzanne's Career*, filmed almost simultaneously and completed together, were in fact to find their way—under a title grouping them together, *Two Moral Tales*—to a theater, to critics, and to an audience. On January 4, 1965, Henri Langlois organized a showing of the films at the Cinémathèque to honor Rohmer. A few initial articles were devoted to them

on this occasion. "Le souffle de Radiguet" was the title *Combat* put on Henry Chapier's column for its January 6, 1965 issue:

> One might think one had returned to those exciting evenings eight years ago, when the loyal spectators occupying the front rows at the incomparable little theater on rue d'Ulm were named Rohmer, Truffaut, Godard, Chabrol, Resnais, Doniol-Valcroze, and Pierre Kast. . . . In these *Moral Tales* we get a whiff of [Raymond] Radiguet, his alternation between cruelty and tenderness, his fascination with the secret, tenacious, and stubborn ambiguity of our inner life. Everything here is dizzyingly ambiguous.

In *Les Lettres françaises*, Marcel Martin saluted an obstinate, singular figure: "With the courage and recklessness of loners, Rohmer continues to practice a difficult and severe cinema that one may not like, but whose intransigent and meritorious purity cannot be denied."[98]

In October 1966, *Suzanne's Career* was broadcast in prime time on French television, offering Jean-Pierre Léonardini an opportunity to introduce to the readers of *Humanité* a "completely clear-sighted artist" and a "cinema of intelligence and culture where nothing exists that has not been analyzed with a fine-toothed comb."[99] But not until March 1974—after the ten years Schroeder and Rohmer had talked about—was *Two Moral Tales* shown in movie theaters. At the Pantheon, very near the building on rue Victor Cousin where Rohmer lived for more than fifteen years, the double film attracted 33,748 spectators in a few weeks, which was an interesting performance. In *Le Monde*, Jacques Siclier wrote a bittersweet commentary under the title "An entomologist in the grip of morality": "Rohmer's male characters are in possession of morality. They behave with a certain cynicism, in the philosophical sense of the term, a certain intellectual perversity inherited from the eighteenth century. And women are contemplated with a kind of cerebral eroticism." But Siclier nonetheless emphasizes the assertion of an "auteur who is profoundly, specifically French, through a subtle combination of the elegant, somewhat haughty literature of analysis and the cinema of behavior."[100] Guy Braucourt, in *Les Nouvelles littéraires*, is more enthusiastic: "The understanding of cinema and the analysis of feelings that underlies each shot will not be forgotten, and that is not nothing!"[101]

In late 1966, the accounts of Films du Losange were credited by French tele-
vision with 50,000 francs for the first two *Moral Tales*, 20,000 of which were
immediately invested in the third tale, *La Collectionneuse*.

Rivette Versus Rohmer

In the spring of 1963, the attacks on Rohmer were resumed at *Cahiers du cinéma*.
This time Jacques Rivette was at work, even if he was smart enough to remain
in the background. He was repeatedly annoyed by Rohmer's critical approach;
made use of a few of the editor in chief's flaws, unsavory relationships, or
négligences; took advantage of the current political and cultural context; put
together a counter-team; and then openly proposed himself—since he was free
and was having difficulties making a second feature film—as an alternative at the
head of *Cahiers*.[102]

Rivette had the ear of Truffaut, Kast, and Doniol-Valcroze, while Rohmer
remained close to Chabrol and Douchet. The difference between them was
less intellectual—even if their relationship to modernity was not the same—
than it was a matter of character. Whereas Rohmer was measured, polite,
restrained, tolerant, and open to contradictions, Rivette was more peremptory.
He was a leader in discussions, he had fixed ideas, his self-assurance impressed
people, and he did not hesitate to excommunicate adversaries or mediocri-
ties. Perpetually dissatisfied, he lived in permanent doubt, and his reversals
were sensational, but he had a definite ascendancy over some of the authors
at *Cahiers* and over some cinephiles. His adversaries did not like him, even if
they respected him, describing him as brusque, arrogant, and dogmatic. At
Cahiers, that was how he was seen by Jean Douchet—"Rivette was furious to
see that he was no longer running things surreptitiously. He has become a con-
spirator, he's a 'Father Joseph' "[103]—and by other old hands like Jean Domarchi,
Fereydoun Hoveyda, Philippe Demonsablon, as well as by young Rohmerian
cinephiles like Claude Beylie and Philippe d'Hugues. The latter angrily noted:
"Rivette had a Saint-Just side, he was an intransigent Jacobin who considered
you a moron if you didn't agree with him. He determined what was moral
and right, like a hall monitor."[104] His allies, on the contrary, emphasized his
daring, his intellectual brio, and his artistic curiosity; they liked his some-
what abrupt intransigence. That was the case for his two principal lieutenants,

Michel Delahaye ("Rivette was the most brilliant, with a peerless charisma"[105]) and André Labarthe ("I loved it when he opened the mail at *Cahiers*, throwing into the wastebasket the long, boring articles written by apprentice cinephiles, and saying with a dismayed and mischievous air: "I'm tossing them in the trash, otherwise Momo will end up publishing them"[106]).

Rivette and Rohmer respected one another, they were both Hawksians by taste and anti-conformist by temperament. Rohmer even had a definite admiration for Rivette's boldness, his way of ending his articles without an escape hatch, and was always to retain an esteem for him and for his films, especially the most experimental and improvised ones made in the 1970s. For a long time, there was no direct conflict between them. The first quarrel came, however, in December 1962, with the appearance of the special issue of *Cahiers* on the New Wave for which Rivette was responsible. He had exceeded the budget allocated for an issue that had grown very large and came out late. "Nothing could annoy Rohmer more than a budget overrun," Barbet Schroeder notes. "He considered it the gravest fault, that of carelessness and immorality."[107] The editor in chief was furious and sharply reproached Rivette for this offense. "It was one of the rare times I saw him get angry at someone,"[108] Schroeder reports. From then on, Rivette openly opposed Rohmer, all the more because the subject of the special issue, the New Wave, was an extremely sensitive one. "There was a clash," Michel Delahaye writes, "that turned into a visceral quarrel. From then on, they were opposed on everything. Rivette had a genuine obsession against Rohmer."[109] Labarthe confirms this: "Rivette gathered us together to tell us: 'There's a problem with Rohmer. He and Douchet are making decisions all alone, but they're letting themselves be had: some articles are very bad, reactionaries come into *Cahiers* whenever they want, the New Wave is not being sufficiently supported, there's no editorial board. We have to make a change and get rid of Rohmer.' A small ad hoc group was immediately formed around Rivette, with Truffaut, Doniol[-Valcroze], Kast, Delahaye, and me. We met at the home of Janine Bazin, in Nogent, on weekends."[110]

In addition to the New Wave, other points of conflict appeared. The main one was politics, which was Rivette's most effective angle of attack against Rohmer. For Rivette, Rohmer's *Cahiers* had become a right-wing outfit, and some of the articles it published came close to being fascist or racist. Rivette and Doniol-Valcroze—the latter seeing himself as the depository of a left-wing tradition that had been important at *Cahiers*, especially at the time of its foundation—accused

Rohmer of certain conservative ideological excesses and allowing a "doctrinaire and reactionary"[111] cinephile tendency to exercise too much influence over the review. They were referring to the Mac-Mahon school,[112] which took its name from the theater on avenue Mac-Mahon, near L'Étoile, where a cinephile group scheduled the films of its "four aces" (Losey, Lang, Preminger, and Walsh) as well as those of Fuller, Maurice Tourneur, Cottafavi, Allan Dwan, and Cecil B. DeMille, scorning all the rest and condemning them as boring, bombastic, and degenerate: Welles, Kazan, Visconti, Fellini, Antonioni, Bergman, and other New Waves, each and all of which they considered overvalued by fashion. This school had its supporters and defenders, who were erudite and enthusiastic—Michel Mourlet, Jacques Lourcelles, Michel Fabre, Jacques Serguine, Marc Bernard, Alfred Eibel—and some of them, like Mourlet, wrote for *Cahiers*.

Mourlet wrote the main Mac-Mahonian text, "Sur un art ignoré,"[113] published in the review in August 1959. It was a manifesto for a pure cinema, exercising its fascination solely by its mise en scène, virtually abstract, with lines straight as a die, exalting beauty and violence in a cathartic vision. Everything else was excommunicated as ugly or ridiculous. Thus Mourlet opposed the actor Charlton Heston, a living, breathing paradigm of mise en scène in all its purity,[114] to Giulietta Masina, whom he considered an "idiotic gnome, stupid, wretched, grotesque,"[115] a degenerate and monstrous figure who could engender only films that were themselves repulsive. This absolute hierarchy of kinds of cinema, ranging from the fascination with the beautiful, violent body to disgust with the ugly body, not only found formal correspondences in the quest for an aesthetic of purified lines, as opposed to curves and deformities considered mannerist and depraved. It also had ideological equivalents. Mourlet himself recognized this: Mac-Mahonian mise en scène exalts the brilliance of a elite race, and it will end up tending toward "what some people call 'fascism' "[116]).

Naturally, in 1959 none of the Mac-Mahonians were openly active in an extreme right-wing movement; as a rule they remained apolitical and disengaged, but this school nonetheless smelled of brimstone. Moreover, that was why "Sur un art ignoré" was published, with certain precautions, by Rohmer and Douchet in August 1959. The article is printed in italics and preceded by an introductory paragraph: "Although *Cahiers*'s line is less rigorous than has sometimes been thought, this text clearly intersects with it at only a few points. However, every extreme opinion being respectable, we think it important to submit this one to the reader without further commentary."[117]

Rivette and Doniol-Valcroze reproached Rohmer and Doucet for accepting this kind of prose, even at a distance, even while retaining control over a review that never became entirely Mac-Mahonian. In addition, Rivette pointed to another ideologically problematic article: Philippe d'Hugues critique of John Ford's *Two Rode Together*, published in January 1962. Rivette denounces a passage that might lead to confusion about racism, an issue that was red-hot as the Algerian War was coming to an end: "Very far from our contemporary debates," Philippe d'Hugues wrote, "John Ford sees racism for what it really is, when it does not take the modern, execrable form of a more or less scientific doctrine: nothing other, ultimately, than a kind of rather provincial snobbism, hardly more ferocious than the real one—in short, a pure product of life in society."[118] Seeing in this a minimization of the dangers of racism, Rivette rages and counterattacks in *Cahiers* itself, writing a short pro-FLN (National Liberation Front) piece regarding the massacres in October 1961, an attack that led to almost two hundred and fifty deaths of North African immigrants in Paris. In this article, Rivette openly supports Jacques Panijel's *Octobre à Paris*, a militant testimony to the condition of North Africans in France and to their battle during the winter of 1961–1962. "This film is a capital document for the history of our time,"[119] Rivette wrote in December, 1962.

Two conceptions of history were dueling, usually with buttoned foils, and Rivette accused Rohmer of allowing his political opinions to show through in the review. He did not like to read articles by Philippe d'Hugues (who was moreover a critic at *La Nation française*, a royalist weekly), and he hated finding in the offices *of Cahiers* certain old friends of Rohmer's—particularly Jean Parvulesco, a member of the OAS, one of the intellectual leaders in the Rocher Noire government, and a sort of minister of culture for the clandestine Algérie française movement, who had returned to Paris in 1962 after being exiled to Spain for a few years.

Sometimes Rohmer acted a little provocatively, not hiding the fact that he was reading *La Nation française*. But he was neither a militant nor an extremist, and he took care not to let his review commit itself to one camp or the other. Thus with the exception of Rivette's text cited above, under Rohmer's direction no direct allusion to the Algerian War was published in *Cahiers*, which testifies to a neutrality that was both rare and odd in the French press of the period. But it was precisely this refusal of commitment that Rivette and Doniol-Valcroze reproached Rohmer for, regarding both the New Wave and politics. Rohmer himself did not hide his opinions. He was angry at de Gaulle for having "sold

out Algeria and betrayed General Salan,"[120] he was close to the Algérie française group, and he understood the arguments of those who thought they had been "abandoned by France."[121] "He was shocked by de Gaulle's attitude,"[122] Barbet Schroeder, who was himself a young progressive, explains. Michel Delahaye, another man of the Left, adds: "Rohmer was a great gentleman. His traditional political opinions were known, but he never prevented the publication of a single text in *Cahiers*, and that is very admirable."[123]

The other terrain of conflicts regards the relationship to cultural modernity.[124] Jacques Rivette wanted to make a program of it: he advocated reaching out to the new cinemas that were being born at that time outside France, in Italy with Bertolucci and Pasolini, in America with Cassavetes, in Britain with Free Cinema, in Germany around the manifesto of Oberhausen, in Japan with Nagisa Oshima, in Central Europe thanks to young Polish, Czech, and Hungarian filmmakers. He objected to the small amount of space *Cahiers* gave to the "great modern filmmakers," Antonioni and Buñuel, and demanded that the review pay proper attention to the trends that were asserting themselves on the intellectual scene—structuralism, semiology, concrete music. In his opinion, film criticism had to be open to the contributions of Barthes, Lévi-Strauss, Michel Foucault, Jean Paulhan, Philippe Sollers, Marcel Pleynet, Pierre Boulez, Olivier Messiaen, and Karlheinz Stockhausen. "What strikes me," Rivette wrote for example, "is to what point American cinema, which we loved so much, is a cinema of the past . . . Willingly or unwillingly, this cinema is doomed to evolve toward bastardized forms of European cinema. And whether one likes it or not, this new European cinema, almost in spite of itself, is currently, historically, in the avant-garde, I don't like that word, let's say rather: the "exploring head" of world cinema. We have to follow this evolution of modern art, even if it's a gamble, but that's what it means to live."[125]

Éric Rohmer had a different relationship to modernity—old, paradoxical, fertile. He was a curious man, fascinated by experiments, some of which were the bearers of modernity at the transition from the 1950s to the 1960s. For example, in *Cahiers* he wrote about Isidore Isou's lettrism,[126] about television, about filming sports;[127] he was excited about architecture, including that of the new cities then being planned. He absorbed the revolution carried out in modern painting by Picasso and then by the abstractionists; the music in his film *Sign of Leo* is not far from being concrete; and he supported the 16 mm laboratory and the ventures of Rouch, Richard Leacock, Brault, and Direct Cinema as well as cinema vérité.[128] It would make no sense to suggest that Rohmer was a strict

adherent to a classic cinephile line.[129] His thought is stimulating because it is paradoxical: modern art seen from a classical point of view.

But Rivette's strength was to be "programatically" modern, whereas Rohmer was paradoxically modern. Rivette bet on a conception of criticism as the "exploring head" of modern cinema, adopting the ideas of Barthes, Boulez, and Lévi-Strauss, and offering that to *Cahiers du cinéma* as a program for action. Even if Rohmer and Douchet were able to rise up against this effort to put criticism "on a leash,"[130] Rivette's position, which was strategic and manifest, was on target in the spring of 1963. In the political, intellectual, and cultural context in which *Cahiers du cinéma* was immersed, the place occupied by Rivette ultimately corresponded to a desired renewal.

The End of Rohmer's *Cahiers*

Desired by whom? That is the question. If Rivette, Doniol-Valcroze, Truffaut, Kast, Labarthe, and Delahaye were pushing for change, Rohmer, Douchet, Domarchi, and the young cinephiles were able to counteract them. The opposing forces were, so to speak, approximately equal. Of course, the first group had the legal power to "throw Rohmer out," as Truffaut pointed out in July 1962, since Doniol-Valcroze, the review's manager, held—along with the other stockholders in *Cahiers*, Léonard Keigel (the son-in-law of Léonide Keigel, a founder of *Cahiers*, who had died in 1957) and Dossia Mage (the owner of the Le Broadway cinema)—the true power of decision. But such a coup could take effect only if an already-organized team was prepared to follow Rivette in pursuing the adventure of the new *Cahiers*. Thus the battle was fought at the base, within a group of writers into which the young cinephiles had been largely attracted and trained by Douchet and Rohmer in person. What was involved was a reversal of the situation: Rohmer's eviction could be effected only through an about-turn made by a new generation, the one that was entering *Cahiers* in 1962 and found itself immediately caught up in this factional struggle.

Jean-André Fieschi wrote his first article (on Nicholas Ray) in March 1962 ; Jean-Louis Comolli wrote his first article in September 1962 (on Howard Hawks and Otto Preminger). His manifesto, "Vivre le film," published in March 1963, established him as the leader of these young critics. Behind them appeared Paul Vecchiali, Jean Narboni (the "Corsican clan," as their adversaries at *Positif*

ironically called them), Serge Daney, Louis Skorecki, and Jacques Bontemps. They entered *Cahiers* as Rohmerians, which was logical, or else as "Douchetians," but they quickly understood that the review was divided. They were attracted by Jacques Rivette, his charisma, the program of "modernization" he was proposing, and the prospect of an important role at his side. They assessed the power relationships, as Delahaye said,[131] and then ultimately went over to the stronger camp. Rohmer could only watch it happen, writing retrospectively: "March–May 1963: a revolution at *Cahiers*, Jean-Louis Comolli and Jean-André Fieshci are pushing me out the door."[132] For his part, Douchet regrets it: "I took it badly when some of the young people I'd brought in stabbed me in the back."[133]

However, a careless mistake made by Rohmer in March 1963 sped up the process. *L'Immortelle*, the film Alain Robbe-Grillet had made in Istanbul the preceding summer and in which Doniol-Valcroze was the leading actor, came out in theaters on March 27. Only one writer from *Cahiers*, François Weyergans, went to see the film at the press previews. A few days before the film came out, a furious Doniol-Valcroze wrote to the editor in chief of "his" review: "The showings of *L'Immortelle* have up to this point drawn full houses. We turned people away. Paulhan went to the trouble to go see it this morning at 9 A.M.; Cocteau, Malraux, Resnais, Queneau, et al. asked to see it and came. We had planned a special showing for *Cahiers*, for which we had reserved fifty seats. The result: one spectator . . . No comment. It's hard to imagine ruder treatment of well-intentioned people who, whatever one may think of the film after having seen it, worked in a direction that ought not to leave *Cahiers* indifferent. I'm dismayed—not personally, nothing at *Cahiers* astonishes me anymore—but for those who were somewhat surprised."[134] Rohmer and Doniol-Valcroze met in the wake of this misunderstanding. Doniol-Valcroze was frank with Rohmer, telling him that he was henceforth going to work toward his replacement at the head of the review. Moreover, financially the news was not good, either. Nothing to worry about, but the *Cahiers* enterprise was bogging down in a peaceful routine. Sales, which had increased between 1959 and 1961—without counting the very profitable collections of back issues—had stopped growing and were even stagnating. For the first time since 1957, the review lost money during the first quarter of 1963. Rohmer was bruised by this, putting the blame on Rivette and his special New Wave issue, the very one that Doniol-Valcroze and his "group of five" had so insistently asked for.

Doniol-Valcroze warned Rohmer one last time: the way of running *Cahiers* had to change, the complacent cinephile hum had to be shaken up, an editorial

board with older and younger writers had to be formed, and they had to set out in search of a solid publisher who could relaunch the review with a new formula.

Rohmer refused in particular to remove Jean Douchet[135] from the review's direction. Doniol-Valcroze writes: "I warned him. It did no good. Rohmer is a very stubborn, obstinate man. It's one of his great strengths as a filmmaker, but in May 1963 it led to a meeting of the officials of *Cahiers* to study the changes that needed to be made. For Rohmer, this meeting was utterly scandalous, because he absolutely insisted on remaining editor in chief. Confronted by this divergence, the conflict exploded."[136]

This meeting took place in mid-May 1963 at the home of Léonard Keigel. He writes:

> Rivette's takeover was a kind of machination, and the conspirators needed me to have a majority and ensure the outcome. Jacques Rivette called me: "It's important that we see each other." He was courteous but firm. He came to my place with a delegation. There were the old hands, Doniol-Valcroze, Truffaut, Kast, and the young people, Fieschi, Comolli, Labarthe, Delahaye. "We have a problem with Rohmer," they told me, "he's no longer capable of putting the paper to bed, there are financial concerns, we want to entrust *Cahiers* to Rivette . . . " Doniol[-Valcroze] insisted; I gave them my green light, whereas I'd always supported Rohmer.[137]

For his part, in late April 1963 Rohmer felt threatened, and he looked into his rights, what he could demand, what recourses were available to him. He contacted the French Journalists' Syndicate of the Confédération française des travailleurs chrétiens (CFTC) and asked for an appointment with its head, André Tisserand, who received him on May 24. He also went to see a lawyer, Marie-Claire Sarvey, who reviewed the situation with him in a letter dated May 11, 1963: he had the right to prior notice, a compensatory indemnity for paid vacations, and a termination indemnity. She also advised him regarding a possible complaint for "abusive breaking of a contract," but was pessimistic about his chances: "The criterion of the illegitimacy of the reason given is not very clear. But I strongly hope that things will not be rushed and that you will find an amicable gentlemen's agreement."[138]

However, Rohmer's dismissal was approved by the three main stockholders, Doniol-Valcroze, Keigel, and Mage. In a letter dated May 31, 1963,

Doniol-Valcroze, who was still nominally the review's editor in chief, warned his alter ego:

> My dear Rohmer, when this message arrives, you will be about to receive the official letter terminating your functions. I'm sorry that it has come to this, and also that I must seem to you to be doing the dirty work. But as the last living father of *Cahiers*, it undoubtedly fell to me to play this role, and I am not in the habit of fleeing my responsibilities. Nearly a year ago, I proposed certain reforms. I've always thought that they could have succeeded without all these upheavals. But you didn't believe in them. Then events took a different turn. By temperament, I was not in favor of this turn, but now it can't be undone. Although my conception of *Cahiers* has always been significantly different from yours, I have respected and esteemed your conception . . . and admired your scrupulous devotion with regard to the review. That makes me regret even more that we could not all try to save the boat together. In any case, please believe that in all this I have never broken the rules of moral decency and that the only interest I have defended with regard to you and others is that of *Cahiers*.[139]

In fact, the registered letter from *Cahiers du cinéma* arrived at number 72, rue Monge on May 30 at 6 P.M.:

> Dear friend, you know that in the context of the reorganization of *Cahiers* it has seemed to us necessary to terminate your functions as editor in chief, starting June 1, 1963. Consequently, you are owed the following sums, which we hold at your disposal, along with a work certificate: prior notice of dismissal, 2,400 francs; indemnity for dismissal, 4,535 francs; paid vacations, 600 francs; total, 7,535 francs.[140] Given the treasury difficulties of *Cahiers du cinéma*, which you know better than anyone else, we would appreciate it if you agreed to this sum being paid you as follows: 3,535 francs immediately, and the rest in four successive monthly payments of 1,000 francs. You know that we will always be happy to have you write for *Cahiers*, and we beg you to accept our best wishes.[141]

As we have seen, *Cahiers* provided Rohmer's only income at this time, and he asked for more: 10,568 francs, or about fourteen months' salary, which he ended up getting. For Jacques Doniol-Valcroze this episode was a very bad memory: "To think that one day we fired M. Rohmer."[142]

5
The Laboratory Period
1963–1970

Dismissed from *Cahiers du cinéma*, Éric Rohmer received some support. There were his close friends: Jean Douchet stopped working with the review a few months later, after writing one last article about Alfred Hitchcock's *Marnie*; Barbet Schroeder worked even harder at Losange to allow Rohmer to film. Georges Sadoul sent him a message once Rohmer himself had told him about the "putsch": "Your letter touched me deeply. I didn't know this context, which hardly reflects well on *Cahiers* . . . I wish you a new start, but I am not concerned about your abilities, to say the least. Very sympathetically yours."[1] Even those who had carried out the putsch wanted to hear from him: "When will you come by *Cahiers*?" Michel Delahaye asked, as if disoriented.[2] "My dear Momo," Truffaut wrote to Rohmer, "I really enjoyed seeing *Sign of Leo* and the 16 mm films again. I know you're convinced that I acted against you at *Cahiers*, and that you're angry with me. I can't do anything about that, but I am very capable of admiring and loving someone with reciprocity, so faithfully yours. P.S. The young producer Claude Nedjar is interested in doing a series of films based on Edgar Allan Poe. He would like to see your *Bérénice* with a view to buying it and including it in this series, and would ask you to make another story by Poe in 35 mm. Do you want to get in touch with him?"[3]

Mourning *Cahiers du cinéma*

In the pages of *Cahiers*, the rupture was glossed over. In July 1963, the editorial presented the new orientation in polite terms:

> Starting with this issue, an editorial board will handle the editorial direction of *Cahiers du cinéma*, replacing the former editor in chief. This is only a change in the internal structure and organization of our team. Both old hands and new ones are on this board, whose diversity will allow us—we hope—to report with flexibility and effectiveness on the constant modification of the cinematic situation. Thus *Cahiers du cinéma* is changing neither its line nor its orientation; it simply seemed to us that in addition to its original role as an organ of culture and information, it had to become an instrument of combat once again.[4]

The declared harmony (Rohmer and Douchet were still listed as members of the editorial board) was a mere deception, and if the editorial proposed a single innovation—becoming once again an "instrument of combat," that is, supporting the New Wave—deeper changes appeared. The Rohmerians left, following Jean Douchet: Jean Domarchi, Fereydoun Hoveyda, Barbet Schroeder, Claude Beylie, and also the neo-cinephiles who disagreed with Rohmer's dismissal, Bertrand Tavernier, Jacques Goimard, and Yves Boisset. Soon, a new formula for the review was being considered, and it went into effect in November 1964. It marked a profound break in the life of *Cahiers*, the critical milieu, and in cinephile society.[5] Friendships that had been forged years before broke up, sometimes forever. In the October 1964 issue of *Arts*, a pessimistic article by Christian Ledieu even saw in this development a kind of catastrophe, the end of a world:

> In reality, the editorial published in July 1963, which was almost laconic, concealed a palace revolution. The Rohmerians, following their mentor, gradually withdrew in disorder, except for a few—the traitors—who went over to Rivette's side. Now that things have settled down, one fact has become clear that, at that time, already seemed an impression that would turn out to be true. Wounded by the death of Bazin, further weakened by the dispersion of its "first string," *Cahiers du cinéma* was genuinely beginning its death throes and was never to recover.[6]

We know that these symptoms of betrayal, renunciation, and agony (and even of rebirth) punctuated the review's tumultuous life, from the beginning right down to the present day, but it is certain that in the summer of 1963 they were painfully etched on the flesh of Éric Rohmer.[7] It has often been said that his dismissal

from *Cahiers* put him on the path to directing films, and that ultimately only this trial allowed him to fully become a filmmaker. Rohmer himself was not far from sharing that notion, referring in this respect, but many years later, to a "very amusing conspiracy,"[8] and writing, upon Truffaut's death in 1984:

> I am compelled to acknowledge that I have, in a certain way, a very great debt of gratitude to pay him. There was a little quarrel with him that finally turned to my advantage. Let's say that he had a role in *Cahiers du cinéma*'s decision to replace me by Rivette in 1963. I can now say that he was right, insofar as I am not really a journalist and that I had better things to do as a filmmaker.[9]

Nonetheless, in 1963 he felt a profound discontent and a genuine concern regarding the immediate future, especially his financial future—since he had to support a wife who did not work and two boys aged two and five. He withdrew into himself, as he admits: "When I'm not doing well, when I am in doubt or when I'm sick, I don't like to talk to other people, and especially not my wife, who isn't there for that. I find myself alone with myself, with what isn't going well, and I try to overcome this obstacle on my own."[10] Thérèse Schérer testifies to this as well: "He didn't tell me much about his career. Above all, he didn't want me to worry, and especially not his mother. In cinema, projects are often delayed, there's no security. He didn't want to involve me in all that. And I didn't insist on it."[11]

One sign of Rohmer's worrying is the multiplication of his CVs in which the marks of his fictive identity are more and more present—for example, "Éric Rohmer, born in Nancy, April 4, 1920."[12] These are the traces of a feverish search for a job, but also of a doubling of his personality masking from his mother and from those who first knew Schérer, the halting, uneven career of a Rohmer who was in bad shape, fired from his magazine and confined to amateur cinéma. At the same time the trial he was going through strengthened his desire to be alone, anonymous, entrenched behind a body of work that had already been elaborated internally but had not yet emerged before the eyes of others. A desire that Rohmer confirmed by rejecting public appearances and photographs: "I'm sorry not to be able to grant your request, but I have decided not to appear in public before I've finished making my 'Six Moral Tales,' "[13] he wrote to the organizer of a film club in Lyon. This refusal was then becoming a Rohmerian form letter. The hermit retired to live discreetly, the better to make progress on his work to come.

In the summer of 1963, he was actively seeking work. "After *Cahiers du cinéma*," Thérèse Schérer recalls, "he had nothing. That worried him a great deal. He was a government employee of National Education, having put himself on leave for personal reasons in 1957 when he became editor in chief. So in June 1963 he requested another teaching position, but for the following fall the ministry offered him only positions in provincial lycées, notably at Sables-d'Olonne in Vendée. He refused to go there."[14]

Rohmer refused because his family lived in Paris and he did not want to force them to move. Above all, he did not want to abandon the cinema milieu, which was centered on the capital. But what could he do there? There was no lack of projects to be realized by a mature man of forty-three who was refounding his destiny with the energy he had shown fifteen years earlier when he was starting out.

Should he create another cinema review? Rohmer toyed with the idea, according to Barbet Schroeder, but probably only as a way of taking revenge on *Cahiers*. Another possible form of revenge that was embodied in a more fully accomplished project was writing studies on cinema and more particularly, collecting his main texts, those that had been published in *Cahiers*, *Arts*, *La Revue du cinéma*, and *Les Temps modernes* in order to reconquer through books a legitimacy that his own review had just put in doubt. This would be Éric Rohmer's summa, paralleling that of André Bazin, which had appeared shortly before.[15] Publishers who were interested by Rohmer's reputation also asked him to write for them. Pierre Lherminier, who had started a fine collection of monographs on filmmakers at Seghers—one on Fritz Lang, by Luc Moullet, had just come out—suggested a book on Nicholas Ray;[16] Paolo Lionni, an Italian publisher, was prepared to bring out in Rome and then in English translation, a collection of "memorable articles" from *Cahiers du cinéma*, because this review aroused deep interest abroad.[17] But Rohmer was primarily interested in the collection of his own texts. In July, 1963, he chose a group of twenty articles published between the late 1940s and the early 1960s with a table of contents precisely organized chronologically and thematically.[18] Two titles were considered for this collection: *L'Âge classique du cinéma* and *Le Celluloïd et le Marbre*, though it was not necessarily planned to reprint the five 1955 texts that Rohmer thought would require, a decade later, "revision and updating."[19] In a preface of some twenty-five pages dated July 1963, he engages in an exercise in self-criticism on the theme of his blindness to a certain aesthetic modernity: "I shall

limit myself to briefly indicating in what way my ideas in 1963 conflict with my ideas in 1948 or 1945. On rereading myself, what is it that shocks me? Above all, the narrowness of my point of view, which I would qualify, in my turn, as others have, as 'reactionary.'" And he meant that in the ethical and aesthetic sense of the term.[20] Although Rohmer says he is "faithful to his ethics," and although we sense that he is rather proud of the work he has done, he also recognizes that he had "a retrograde spirit" and accepts a few "more serious reproaches."[21] The essential point is this constant oscillation between the construction of a mausoleum, glorifying his own critical work, and the exercise in absolute lucidity that leads him to challenge some of his positions, notably concerning the connection between classical and modern. This is perceptible in his remarks on Arnold Schönberg and Anton Webern ("These judgments concerning contemporary music now make me indignant"[22]), and even Jean Renoir. It is extremely rare to find such self-criticism in critics: Rohmer evaluates the evolution of his own thinking about art.

This project was not immediately realized. In 1967, it was taken up again by Dominique de Roux, a friend of Rohmer's who directed Éditions de l'Herne. Together they envisaged a new, "annotated" edition of *Le Celluloïd et le Marbre* accompanied by standard Rohmerian texts. But Roux did not manage to bring out the book before his death in 1977, and in 1974 Philippe d'Hugues, another friend of Rohmer's who was then Pierre Viot's representative at the direction of the CNC, proposed to bring it out. But the context had changed, and Rohmer, who was busy making films, declined the offer in these terms:

> On reflection, I would really get no pleasure out of seeing my old texts republished. Actually, it would bother me. If I were going to publish something, I'd prefer, of course, the new to the old. What I have to say now may not be better, may not be very different from what I said back then, but you can understand why if I have to choose between two truths—or two errors—I choose that of the 1970s rather than that of 1950. Many of my arguments have lost their power, what then sought to be provocative is now merely naïve. In any case, these texts could not be presented without commentary. And frankly, the time I would spend in annotating them I would prefer to use writing a study on more contemporary cinema. Criticism is what goes out of fashion most quickly. Articles written in the heat of battle for a cause that has been won in spite of everything

and for which every weapon seemed to us suitable, no longer interest anyone but specialists in the history of cinema who will have no difficulty finding them in libraries. Perhaps you will find me too modest. In fact, to publish them would be to recognize that I can't do better. Let me keep my illusion.[23]

The collection of Éric Rohmer's critical writings was finally published in February 1984, thanks to Jean Narboni, by *Cahiers du cinéma* under the title *Le Goût de la beauté*. "I'd always wanted *Cahiers du cinéma* to publish books," Narboni explains, "and when the opportunity presented itself in the early 1980s, I quickly sought to publish the texts of the founders of the New Wave. Truffaut had done it, Godard was going to do it again with Bergala, Rivette had repeatedly declined my invitation: he didn't want to reread himself, had neither the desire nor the time to write the indispensable notes."[24] On May 23, 1983, Narboni wrote to Rohmer: "As I told you a few weeks ago on the phone, I'd like to talk with you about publishing your own texts and how they might be, not "updated," but "surrounded" today (preface, connecting texts, or an interview between you and me . . .)."[25] They agreed to meet at the offices of Films du Losange in June 1983. Narboni goes on: "Rohmer said to me, 'I'm not eager to do it, but I accept your offer. I don't want this book, but if you want it, go ahead. I have only two wishes. First, I don't want to republish *Le Celluloïd et le Marbre*, which should appear independently, with extensive notes that I don't have time to write. Second, I want the article on Isidore Isou and Lettrism to be included."[26] The former critic did not want to write a preface, but he accepted the formula of an introductory interview. "The conversation went very well," Narboni recalls. "The interview resituated the context, his positions, the battles being fought at the time. He cut out only one thing, concerning what a man finds attractive in a woman, the texture of her skin. There we were coming close to a zone of tactile danger!"[27] In the end, Rohmer was delighted with the book. It was a definite success, going through several printings, and selling almost 10,000 copies. The cinephile, student, curious audience that wanted to read Rohmer's texts was far greater than the few historians of cinema who read them at the library.

Having rejected the position as professor of classics at Sables-d'Olonne offered him by the National Education system, Rohmer was trying to get into the CNRS (Centre national de recherche scientifique). Thus he needed a research topic, a thesis project, and a director to support his candidacy. He wrote a presentation of a future thesis on "The evolution of myths in American cinema

since 1945" and signed up with Étienne Souriau, a professor of aesthetics at the University of Paris I. In this project, Rohmer argued for a "nonsociological" and "nonpsychological" conception of myth in opposition to, for example, Edgar Morin's work on cinema or Hollywood stars. "The term 'myth,'" he wrote,

> is intended to mean that cinema possesses the fertility of invention proper to all primitive or popular arts. It does not elaborate schemas handed down by tradition, but proposes new ones. The types it creates are endowed with such a power of fascination that they become exemplary and seem to live their own life. Charlie Chaplin is a mythical character, insofar as his behavior is not only governed by certain constants but also illustrates a precise conception of man and the world. Similarly, Garbo and Bogart both gave birth to a myth that was different in each case from the actors and the characters they played successively. It is this myth, understood in the broadest sense, that will be the subject of this study: love, violence, adventure, success, failure, good or bad conscience.[28]

The apprentice researcher then enumerated a few films on the basis of which he planned to write this study of "American mythical schemas": Alfred Hitchcock's *I Confess*, Howard Hawks's *Gentlemen Prefer Blondes*, Preston Sturges's *Sullivan's Travels*, George Stevens's *A Place in the Sun*, John Huston's *The Asphalt Jungle*, Billy Wilder's *The Seven Year Itch*, Joseph Mankiewicz's *The Quiet American*, Lázló Benedek's *The Wild One*, Vincente Minnelli's *The Long, Long Trailer*, and George Cukor's *A Star is Born*.

Despite his prejudices against sociology, Rohmer had his project read by Edgar Morin, whom he met at his home in Rueil-Malmaison, and submitted his application to the CNRS committee in October 1963. Since we have no information about what came of this project, we have to conclude that Rohmer's candidacy failed.

The Entrance Into Educational Television

Finding himself at a dead end, Rohmer turned to what he knew how to do: teach, but now making use of cinema. At this time, only one course of this type existed in France, the "cinema class" directed by Henri Agel at the Lycée Voltaire, which

prepared students for the IDHEC. Rohmer knew Agel, a Christian thinker about cinema who had been close to André Bazin, and met with him in mid-June 1963 to ask his advice. It was through Agel's mediation, in the person of Jean-François Allard, a technical adviser to the Ministry of National Education, that the former professor of literature at the lycée in Vierzon returned to his alma mater. On June 24, 1963, replying to Rohmer's offer of his services, Allard pointed him down the path to follow:

> Monsieur, I assure you that I am very willing to take an interest in your case. Certainly it should be possible to make use of your competence in the domain of cinema at a time when audiovisual means are being developed in education. I advise you to contact, in the office of the minister, Monsieur Le Page, a representative who specializes in these problems. Ask him, on my behalf, for an appointment and explain your proposal to him.[29]

Through this new intermediary, Rohmer found a sympathetic ear in Georges Gaudu, the representative for educational television in the National Education system's Department of Audiovisual Media.

In a letter to Gaudu written on June 26, 1963, Rohmer proposed to "collaborate in educational television broadcasts for the next year."[30] Gaudu immediately replied: "I would be very glad to meet you so that we can consider together the disciplines and subjects that might be of interest to you,"[31] and suggested that they meet with Henri Dieuzeide, who was the director of RTS (Radio-Télévision scolaire). Everything went well, since on October 8 Rohmer was hired by RTS as the "producer and director" of an initial film, *Les Cabinets de physique au xviii^e siècle*.

At this time when a major social transformation was taking place, the student body in French lycées was evolving, ceasing to be composed solely of the privileged and including more and more students of all social classes. New ways of transmitting knowledge to this expanded audience were being studied, and among them was educational radio and television, which combined two hopes of innovation: the power of the image as a forceful means of learning through the senses and emotion; and the belief in the pedagogical utility of television.[32] A part of French television had been reserved for educational purposes since 1945, and from 1951 on was organized under the supervision of the Ministry of National Education. But it was in 1962 that RTS came into being with an administrative

structure and became a service in its own right directed by Henri Dieuzeide under the authority of the National Institute of Pedagogical Research (INRP), which was itself directed by Pierre Chilotti, the inspector-general of public education. RTS created and distributed educational programs. It had its own producer-directors who were either paid in-house, like government employees, or externally, film by film and by the workday, like Éric Rohmer.[33] It also had its own professional 16 mm equipment; a film studio on avenue Général-Michel-Bizot in the twelfth arrondissement, which had thirty-four technicians, set designers, assistants, machinists, and electricians; and studios for editing, calibration, and mixing located in an old industrial building in Montrouge, on the outskirts of Paris. Finally, it had offices and a workroom at the INRP on rue d'Ulm, not far from the Cinémathèque française.

Distribution took place through a special channel received by schools, every day except Thursday—a school holiday in National Education at that time—in accord with precise schedules, because between 10 A.M. and 6 P.M. five or six programs of twenty or thirty minutes were generally broadcast in succession. In each school, from elementary schools to lycées, there was a room equipped with a television set (or a radio) where students gathered under the supervision of teachers to watch the programs. Between 1962 and 1978 several thousand programs were broadcast. Each was accompanied by instructions for teachers—initially sent out by the regional centers for pedagogical documentation, and then, starting in 1964, broadcast in the *Bulletin de la Radio-télévision française* bulletin—that indicated the "pedagogical intentions" and the "content of the broadcast" and offered "suggestions for use."

Educational television made programs on several subjects: mathematics, technology, physical sciences, history, philosophy, geography and travel, views on the world, letters, foreign-language learning. Soon, programs entitled *Theater and Introduction to Works* and *Going to the Cinema*, were to be created, and these also interested Rohmer. He worked primarily for the literary section, dividing his time between several programs, *In Profile in the Text*, *French Composition*, *Civilizations*, *Toward World Unity*, and then *Going to the Cinema*. In charge of the division and thus responsible for the programs, Georges Gaudu was an alumnus of IDHEC and a literature teacher who ran educational television with a forthright, elegant, and cultivated authority that went with his glasses and neatly trimmed beard. Two people were responsible for each program: a producer who conceived, wrote, and conducted interviews, and a director, who

supervised the work of creating the images and sounds. The producer was usually a practicing teacher, the director a professional filmmaker. Éric Rohmer, who held a secondary-school teaching certificate and had both taught and made films, could perform both tasks—which gave him broad latitude for conceiving as freely as possible the programs Georges Gaudu assigned him to make.

In the 1960s the RTS was a hotbed of innovation and the transmission of knowledge. The programs produced by Dina Dreyfus and Alain Badiou in philosophy, by Jean Bolon in mathematics, and by France Ngo Kim in history are jewels that have unfortunately been forgotten—and in which a significant number of the important French intellectuals of that time were to be seen. For cinema, figures such as Georges Rouquier, Philippe Pilard, Jean Douchet, Jean Eustache, Bernard Eisenschitz, Jean-Paul Török, and Serge Grave did their best. A technical skill was also kept alive through these programs, which were halfway between the television studio and more experimental filming in the tradition of Direct Cinema. The directors included Nestor Almendros, Pierre Lhomme, Pierre Guilbaud, Jacques Audollent, Marc and Catherine Terzieff, and Maryvonne Blais.

Éric Rohmer was at ease in this context, being both teacher and film director—an auteur in the full sense of the term—and the twenty-eight little films of twenty or thirty minutes that he produced and/or directed for RTS, from "Cabinets de physique au xviiie siècle," broadcast in January 1964, to "L'enfant apprend sa langue" in late 1970, were an exceptional laboratory for his work. These "little things" (*petites choses*),[34] as he called them, reflected his curiosity, his taste for literature, history, architecture, nature, urban planning, and cinema, and combined conceptual elaboration with concrete work. They allowed him audacities that the production of feature films frequently denied him, and authorized formal experiments (with the interview, the personal diary, the montage of images or extracts with commentaries, narrative in costume, filmed writing, etc.). They appear to have been a marvelous tool, and several of his later films bear their mark: *My Night at Maud's*; *The Marquise of O*; *Perceval le Gallois*; *The Tree, the Mayor, and the Médiathèque*; and *The Lady and the Duke*.

To be sure, Rohmer did not deeply commit himself to a pedagogical mission in which he had little faith, as he himself recognized: "So far as I was concerned, this represented first of all a job at a time when I needed one. It was very down to earth. I did not have much faith in educational television, except for very young students, showing them the countryside or the city, or teaching them languages.

In literary domains, I think these films were far over the heads of these students, who must not have understood very much in them. We deviated widely from the syllabus, with a great freedom that Georges Gaudu guaranteed us. These little films had some success with cinema people and critics, on the rare occasions when they were shown, but I wonder if they were really watched by students."[35] He was paid a 150 francs for each day of work. We can estimate that by working around seventy days a year to make three or four programs for RTS, he earned around 10,000 francs a year, or the equivalent of the salary Cahiers du cinéma had paid him. But he very quickly got into this work and saw these films as a personal workshop. As he put it in an annotated chronology of his life: "1963. Leaves Cahiers and goes to work for educational television where he makes, completely independently, thanks to the director, Georges Gaudu, programs that are not merely potboilers."[36]

Adventures in 16 mm

When Rohmer, having been fired by Cahiers du cinéma, suggested to Barbet Schroeder that they "create another review," the latter replied, quick as a flash: "Let's go further, let's make films." The young boss of Films du Losange had two projects in hand. One could be filmed very rapidly because it was a commission from the Ministry of Foreign Affairs for "the French woman at work"—a series of short films intended for embassies, consulates, and the Alliance française throughout the world—for which the "pilot"[37] had to be made. The other project, *Paris vu par . . .* (Paris seen by . . .) was still underway: a collection of sketches on certain quarters in the capital.

Thus in September 1963, Rohmer was preparing the first film in the ministry's series. He wanted it to be about a female foreign student in Paris. "They suggested a film about the Cité universitaire,"* he recalled. "The subject wasn't clear. I preferred to meet a foreign coed who was living at a residence hall, and make the film based on what she told me, without imposing anything on her."[38] He did not know many foreigners, but he had just met Nestor Almendros, a Cuban

* A complex of residence halls for university students located on the southern outskirts of Paris.—Trans.

filmmaker about thirty years old, who had a room at the Cité universitaire. He was giving Spanish classes to support himself and had made a few friends among the students at the Cité universitaire. Thus it was that Rohmer met one of them, Nadja Tesich, an American girl of Yugoslav origin who was writing a thesis on Proust.

Rohmer spent time with her, went for walks with her, drank coffee in her company, which he enjoyed. She was cultivated and curious, a rather pretty, delicate brunette, and he listened to her a lot. He taped several of their conversations and then used the recordings to produce a text. "I wrote with her words, on the basis of her suggestions, I showed her this text, and she urged me to make it more sober."[39] This method, which Rohmer was to use again in some of his feature films, is corroborated by the signature at the end of Nadja's five-page typescript commentary on the film: "p.c.c. ER," that is, "pour copie conforme Éric Rohmer" ("certified true copy, Éric Rohmer).[40] The filmmaker saw himself more as relaying the student's story, acting as its illustrator, than as a true auteur. In the archives there is also a decoding of the main interview Rohmer conducted with Tesich, which runs to eleven pages. In it the young woman describes life in the university residence halls, her theatrical activities, her strolls through "the old streets on the Left Bank."[41] We find certain Rohmerian sites—book displays outside bookstores, sidewalk cafés—but also a few fashionable clichés. "People come to Paris to talk," Nadja goes on. "That's how I made lots of friends among the Bohemians, painters, and writers from Paris or other countries. You can spend whole nights talking."[42] These meetings were experienced by the young woman as initiations into modern art. But that was not enough for her:

> I often feel the need to separate myself from all these people in Saint-Germain and Montparnasse, to go outside the narrow perimeter of intellectual Paris. Then I go to a park deep in Paris: Les Buttes-Chaumont. I like this place because it is deserted and wild. And the popular quarter of Belleville, which I started exploring for whole days. I like the markets, with the dignity of old people that Americans don't know about. That Paris is scorned because it is not historical, but it is also my Paris: those worn signs, the little squares with their slender trees. A kindness subsists there that has disappeared in other places. People know I'm a foreigner but they accept me. They don't look at me as if I were an intruder.[43]

Between April and June 1964 Rohmer filmed at the university residence halls, then elsewhere in Paris, depending on the sites chosen by Nadja Tesich. With his Paillard 16 mm camera, without direct sound but with a script, the little team attracted little attention, even in cafés. "No one noticed us," the filmmaker, who liked go unnoticed, said with great satisfaction, "because my camera operator, Nestor Almendros, didn't look like a film person. He was too well-dressed for that."⁴⁴ On the other hand, in a sidewalk café we see Jean-Pierre Léaud drinking a cup of coffee.

Nadja Tesich ended up spending two years in Paris. After the filming, she left the Cité universitaire to take up lodgings in the Marais, on rue des Archives. Rohmer went to see her: she was one of the first "Rohmériennes" he surrounded himself with. On August 22, 1964, after the first showing of the film, she wrote to him:

> Yesterday we saw *Nadja in Paris*. Douché [*sic*] said that it is very, very good and that it's a film that is worthy of you. I leave tomorrow. I'm sad, very, too sad. I'm afraid I have trouble leaving this city. Barbet tried to console me by saying that nine months will pass quickly. But for me nine months is a whole life. It's almost half the time I've lived here. I could just as well die or become someone else. We'll see. I would like to tell you something cheerful, but there isn't anything. Except that the weather is good in Paris, it feels like summer. I still drink red wine in little cafés. Write to me if you have the time.⁴⁵

The showing of *Nadja in Paris* convinced the commissioners at the Ministry of Foreign Affairs to confirm the series of three films on "The French woman at work": a student, a farmer, an athlete. The decision was accompanied by an initial payment, which Losange immediately invested in the production of *Paris Seen by . . .*, a far more ambitious project. This sum was supplemented by the investments made by a young American, Alfred de Graaf, another friend of Nestor Almendros. The latter took him to the *Cahiers* office in the spring of 1963. There De Graaf met Rohmer, Douchet, and Schroeder, and then traveled by car with the review's youngest contributors to attend the Cannes Festival. The American had been an assistant film editor in New York and had come to Paris to learn French. He had a certain personal fortune and decided to devote a small part of it to Losange for the production of *Paris Seen by . . .*, of which he would consequently be a kind of "general assistant,"⁴⁶ or what might be called a

director-patron. De Graaf fulfilled this function for *La Collectionneuse* and *My Night at Maud's*, becoming one of the members of the little professional family and foppish association that was Films du Losange. Another friend, the new coproducer Patrick Bauchau, who appears at the end of *Suzanne's Career*, also had a little money. He invested part of it in Films du Losange, thereby acquiring membership in the Rohmer-Schroeder confraternity.

Barbet Schroeder was the project manager for *Paris Seen by . . .* ; he produced the film, lending coherence to a whole that might otherwise have been heterogeneous by choosing the six auteurs, discussing with them the six short films and the six quarters of Paris to be visited. He thus succeeded in transforming this project into an armed wing of the late New Wave, its swan song. He wanted to make it a manifesto, insisting in the press kit that "Films du Losange is no longer a simple production company":

> Its goal is to be an aesthetic movement connected with certain financial conceptions. First of all, producer/directors: they seem to us to belong to the most lively part of the current French cinema. What holds for publishing houses or for art galleries also holds here: what matters is choosing a line and holding to it. We are sure that in the long run the public will follow—at least part of it. We do not seek to establish the reign of a sterile avant-garde, but the reign of auteurs. [. . .] What emerges from *Paris Seen by . . .* is a new aesthetic of realism. In all these sketches, despite the profound originality of each producer/director, there is a common will to represent milieus, social classes, and characters without loading them. The use of "direct sound" and color testifies to this respect, which we would like to make the rule. It is the technique that will come, is already coming, to the aid of the financing. Thus 16 mm allows us to make significant savings and allows a greater freedom for the camera. Although 16 mm is not a panacea for all our ills, it can be the instrument of a revolution. The remedy: reduce prices and increase sales. In that way the success of a single film could finance four more.[47]

Schroeder imposed a common theme—for a long time, until just before it came out, the title of the film was *Les Quartiers de Paris*—and agreed with each of the six filmmakers chosen—Chabrol, Douchet, Pollet, Rouch, Rohmer, and Godard—on a precisely delimited space, so that they could develop within it a fifteen- to twenty-minute fable or short narrative.[48]

If we consider the auteurs Schroeder chose we can see that this New Wave experiment, which concluded the movement, was also a polemical response to the conspiracy at *Cahiers*. Apart from Godard—who followed the conspiracy only from a distance—none of the members of the "group of five"—Rivette, Truffaut, Doniol-Valcroze, Kast—took part in this venture. The paradox was that those who were evicted from *Cahiers* for having failed to adhere to the New Wave applied its principles in their only collective manifesto. Éric Rohmer, Jean Douchet and Barbet Schroeder gladly took what looked like revenge.

The quarter Rohmer chose for his part of *Paris Seen by . . .* was the place de l'Étoile. It was an area he knew well, having worked every day at the top of the Champs Élysées. He was interested in its circular open spaces around the center. Jean-Marc, Rohmer's hero, a former four-hundred-meter runner who reads *L'Équipe** every day as a connoisseur, is a salesman in a men's clothing store on avenue Victor-Hugo. Every morning, he takes the Metro to L'Étoile to go to work. One day, annoyed by a woman who has stepped on his foot in the Metro, he bumps into a passerby on the place de l'Étoile, a grumpy old man. An altercation ensues, followed by a fight; the old man collapses after Jean-Marc hits him on the chin with his umbrella.[49] Jean-Marc runs away, thinking the other man is wounded or even dead. For a few weeks, he prudently avoids the place de l'Étoile, systematically going around the site by taking peripheral streets, playing hide-and-seek with his fear and his guilt. Until one day he sees his "victim," an eternal grouch, fighting with other travelers in the Metro.

The subject and the mise en scène are entirely derived from the geometrical structure of the place de l'Étoile, which determines the itineraries, the detours, the meetings, and the hero's racing about. Rohmer registers these urban pedestrian rituals with the minuteness he had already employed in the very precise filming of *The Baker Girl of Monceau*. He adds to it a defense and an illustration of the detour that is not too distant from the theory of *la dérive* put forward by Guy Debord not long before:[50] "Man," Rohmer writes, likes to retain the possibility of going to a place in two different ways. His reverie must be able to lead him there."[51] For the first time, he attacks the aesthetics of contemporary urban life that forbids this vagabond reverie and that is "destroying Paris." "That is why," he concludes, "I believe that my film deals with an important subject and that when

* A French nationwide daily newspaper devoted to sports.

we speak of Paris, the essential problem is to understand its beauty and make it understood. My film is a committed film."[52]

Rohmer was filming under professional conditions, with a limited but suitable budget;[53] modern equipment, including a Coutant 16 mm color camera with sound, courtesy of Nagra;* and a small but effective technical team (which included for the first time Nestor Almendros, the future filmmakers Pascal Aubier and José Varela, and the producer Stéphane Tchalgadjieff). When he signed the contract on May 9, 1964, he had already delivered the film, which was shot the preceding November and December and edited (with Jackie Raynal) in early spring. In it we see Jean-Michel Rouzière, an actor who directed the Théâtre du Palais Royal and who plays Jean-Marc; Marcel Gallon, a former French boxing champion and stuntman, in the role of the victim; and several of Rohmer's friends or relations—Jean Douchet, Philippe Sollers, Maya Josse, and Georges Bez. But for Rohmer, the essential collaborator was Nestor Almendros. Rohmer knew what he owed Almendros: "Nestor's quest consisted in locating the privileged instant when the natural light was as favorable for photography as the best artificial lighting."[54]

Nestor Almendros, born in Barcelona in 1930, had joined his father, a Spanish republican living in exile in Havana, in 1948. He organized the first film club in Cuba, which was a cinephile's paradise, and then began, at the age of twenty, to make 8 mm films. He studied in New York and at the Centro Sperimentale di Cinematografia in Rome, then returned to an island that was now ruled by Fidel Castro, where he made, with his Bolex camera on his shoulder, a few documentaries for the Cuban Institute of Art and the Cinematic Industry. Working outside, in the fields, in factories, on the streets or beaches, he began to perfect lightweight, flexible, rapid techniques. When in 1961 Cuban cinema was put under the persnickety and authoritarian control of Guevara Valdés, Almendros secretly made *Gente en la playa*, and then decided to go into exile in France, a country whose cinema he admired after having seen *The Four Hundred Blows*, *Cousins*, *Elevator to the Gallows*, and *Hiroshima mon amour*. He arrived in Paris in the summer of 1961 with his film under his arm and enrolled at the Sorbonne as a philosophy student. Henri Langlois, whom he knew through his film club, organized a showing of *Gente en la playa* and announced: "It's cinema vérité."[55]

* A company that makes professional sound recorders.

Jean Rouch—who had just finished making, with Edgar Morin, *Chronicle of a Summer*, which was launched as a manifesto for this new school of Direct Cinema—was immediately alerted and won over; he arranged showings of the film at the Musée de l'Homme, at the Festival dei Popoli in Florence, and at the colloquium in Lyon organized by the Office de radiodiffusion-télévision française on the techniques of 16 mm cinema. *Gente en la playa* thus enjoyed an astonishing career at festivals, being also shown in London, Oberhausen, Barcelona, and elsewhere.

It was in this way that in 1963 Alexandros met Louis Marcorelles, who at the same time introduced Rouch and the cinema vérité experiments to *Cahiers du cinéma*. Rohmer was extremely interested in Rouch's efforts and in Direct Cinema, to the point that in June 1963 he conducted with Marcorelles the first interview with Rouch published in *Cahiers*. From that point on, Almendros visited the *Cahiers* office in the late afternoon. There he met Rohmer's team. He got Schroeder to allow him to observe Losange's film shoots and was thus present at the place de l'Étoile one day in November 1963, "witnessing everything and not much,"[56] following around the team of *Paris Seen by. . . .* Annoyed by Rohmer's torturous directives, the head camera operator, Alain Levent, abruptly announced that he had just signed a contract with Georges de Beauregard, and left the shoot, leaving everyone speechless. "We all looked at each other," Schroeder recounts. "What should we do? A small voice rose up from the people watching: 'I know how to use that . . . ' It was Nestor Almendros. He put the Coutant camera on his shoulder, and he also knew about lighting. Rohmer was delighted. It's the kind of thing that pleased him enormously."[57]

Almendros, who was hired by Losange to finish Rohmer's episode, continued with Douchet's, and then helped out with all the others. "*Paris Seen by . . . ,*" he writes, "constituted an incomparable experience, a testing ground. Filming in 16 mm was a state of mind. And I had made my entrance into French cinema."[58] When Almendros died in 1992, Rohmer wrote:

> Nestor was a person made of contrasts. Prudent in ordinary life, when he was filming he would try anything. Apparently not very talented with manual things (he didn't like to plug in an electrical cord), he knew perfectly well how to manage all by himself without grousing, and he excelled at filming with the camera on his shoulder. Meticulous in his remarks, seeming to hesitate as to what to do, he was nonetheless the fastest camera operator I've known.[59]

The release of *Paris Seen by . . .* in Paris theaters in October 1965 gave Films du Losange broad recognition. In *Combat,* Henry Chapier devoted a whole page to the film, with a laudatory portrait of the six "film adventurers" under the title "A Manifesto for a *Cinéma d'Auteur.*"[60] For Chapier, it was "a new preface to *Cromwell,*"* and he was prepared, he said, to take part "in this *bataille d'Hernani*† for the modern artists of 16 mm film." A portrait of Rohmer followed: "Little known, he is indisputably one of the greatest French filmmakers." Marc Buffat, in another column in the newspaper entitled "The Greatness of Éric Rohmer," went even further: "[Éric Rohmer] is a man about whom people talk little, and whose greatness I would like to state here. For he is the bard of the beauty of the world."[61] In *Télérama* Jean Collet was no less enthusiastic: "Six directors took a risk on the most worn-out of themes: Paris. Why? It's a matter of being free. Of making an inexpensive film without having to cope with the horde of cinema merchants who tell you for every page in the scenario: I need a kiss here and a breast there. In short, it's a matter of opening, perhaps, the narrow gate to tomorrow's cinema."[62]

Losange's Aborted Projects

In the middle of the 1960s, Films du Losange appeared to Éric Rohmer to be a space for experimentation in which a number of projects were being carried out. This man "without imagination"[63] was not blind to the opportunities offered by these commissions or by chance meetings. Moreover, it was probably the time in his career when film projects were the most numerous. When Rohmer's path became clearer after his first successes, these cinematic possibilities thinned out. In the meantime, even though they frequently remained unrealized, they testify to an uninterrupted quest. Thus in December 1963 he tried once again to get the ORTF (Office de radiodiffusion-télévision française) to cofinance his most literary project: the adaptation of Dostoyevsky's short story "Krotkaya" (A gentle spirit; in French, *Une femme douce*). Schroeder and Losange combined

* A reference to Victor Hugo's famous preface to his play *Cromwell* (1827), often seen as a manifesto for French romanticism.

† A reference to the polemics and demonstrations aroused by Victor Hugo's play *Hernani* (1830).

with Mag Bodard and his company Parc Films, which liked to work with New Wave auteurs. But Albert Ollivier, the program director for the television channel France 2, read the development Rohmer had written and issued "a favorable opinion with reservations." Although he recognized the high quality of the first part of the adaptation," he suggested that "the second part be rewritten," stating that "the text seems to become abruptly summary as soon as the characters begin to act. Then they seem to act much more out of the author's will than out of an inner life. This part needs to be rewritten so that the characters make us feel that they are living beings. In the event that M. Rohmer agrees to rewrite this second part, I would be interested in realizing your project."[64] Rohmer's response, dated February 10, 1964, was, as might be expected, scathing and revealing:

> I do not think that at this stage of the adaptation, it is necessary to rewrite the text to make my heroes more plausible or more moving. I admit that on paper, it might disappoint the reader; but why would one expect it to suggest in advance what it is up to the image to show? It exists only in relation to a mise en scène: mine. The defect that has been pointed out to me derives mainly from my very intense concern to avoid any redundancy and not to infringe, before the filming begins, on the prerogatives of the mise en scène.[65]

Rohmer liked series. In November 1964, he outlined one in thirteen thirteen-minute episodes, under the title *Fabien et Fabienne*. It is a suburban/housing projects version of the *Charlotte et Véronique* series. Rohmer was clearly adapting to his present, that of the consumer society of the early 1960s. He integrated into contemporary life, rendered in a realistic manner, situations and characters that came from his own past. A process of fusing times that he was soon to make systematic. Fabien and Fabienne, a young petit-bourgeois married couple, are looking for an apartment and end up getting the one they dream of in a low-cost housing project. One episode illustrates the art of living in large groups. In another, there are difficulties of supply and transportation. Another sketch: Fabienne receives the visit of a "door-to-door salesman who persuades her to buy an article she doesn't need and that leads her into an endless series of expenses."[66] Finally, the last two episodes concern two ultimate type-situations: the purchase of a car, and then camping, a growing practice that Rohmer knew well, punctuating the weekend hike. This "sociological" project can be compared to the contemporary investigations of the working-class suburbs conducted by Chris

Marker in 1961, and then in 1967 by Jean-Luc Godard in *Two or Three Things I Know About Her*, films that impressed Rohmer. But *Fabien et Fabienne* also testifies to Rohmer's direct and ironic, documentary and distanced perspective on the social customs of his time. After the world of postwar Saint-Germain-des-Prés (*Poucette*) and life in a student's room in the 1960s, and before moving on to new cities and the transformations of the rural world, with this project he illustrated his suburban period.

The most curious idea is entitled *Un fou dans le métro* (A madman in the Metro). This is virtually a self-portrait, obsessional and intimate, that recounts the ordinary misadventures of a fifty-year-old man who, after having stood in line almost everywhere, at the butcher shop, at the newspaper stand, at the subway ticket window, takes the Metro and encounters a minor problem when tickets are being inspected. He is both within his rights and at the same time not within them. Holding a valid ticket, he has stepped out to buy a newspaper, twice passing the ticket-taker, but she does not recognize him. The inspection deteriorates. The man, who is in a hurry, is initially courteous, explains himself, then gets annoyed and become arrogant. The station chief arrives, and then two policemen, and the matter is pursued at police headquarters. Exonerated after a few hours of intense discussion, the man goes home, exhausted, mumbling to himself and in a loud voice. Hearing him, two passersby comment: "It's crazy how many crazy people there are in Paris."[67] An incessant commentary murmured by the man accompanies the narrative, that of a lonely, manic-depressive who falls victim to all the dysfunctions of everyday mechanisms. The world resists him, and he turns against it in a way that is as unanswerable as it is logical. About this harrowing typescript of thirty-four pages, which would no doubt have produced a short film of pure paranoia, Barbet Schroeder can say: "There's a key to understanding Rohmer in it. The madman is also him a little bit, like the character at the place de l'Étoile. He's someone who's much more complex than he seems to be."[68]

The last of Rohmer's unrealized projects dates from 1966 and resulted from an explosive encounter with Zouzou, a famous figure in Parisian nightlife whom he met through Patrick Bauchau. After having repeatedly run away and gotten in trouble, the young woman was launched by fashion photography, spotted by the director of *Jardin des Modes* and then by Catherine Harlé. With her large, sensual mouth, her slightly crooked nose, her lovely pale brown skin, her bermudas, and her mad desire to dance the twist until the wee hours of the

morning, she embodied the tumultuous 1960s in Paris. In Saint-Germain, at Castel and at the Golf-Drouot discothèque, she danced and partied the night away, earning evocative nicknames: "Zouzou the Twister," according to a piece in *Paris Match*, "Kowalski" or "La Marlonne," referring to the leather jacket resembling Brando's that she often wore. Her image was the absolute opposite of Rohmer's—he avoided parties, light, and society life. Nevertheless, through Bauchau and Schroeder, he took an interest in her. He was attracted by her incredible naturalness. And he was not the only one: Zouzou made two rather successful records with Donovan and Dutronc, went to London with Brian Jones and the Rolling Stones, and made five films: Bertrand Blier's *Hitler, connais pas*, André Michel's *Comme un poisson dans l'eau*, and three works by Philippe Garrel, *Le Lit de la Vierge*, *La Concentration*, and *Marie pour mémoire* (she was one of his first muses). Rohmer suggested to her a television series, *Les Aventures de Zouzou*, halfway between *Dim' Dam' Dom'** and the "comic-strip style"[69] so characteristic of the mid-1960s. In thirty times thirteen minutes, the young woman would move from her country birthplace (she would be a "farmers' daughter") to the unbridled life of the city, having all kinds of adventures and meeting all kinds of people. The whole was to be "created by Zouzou, and serialized by Éric Rohmer."[70] He drafted a short presentation of the project and submitted it to the ORTF:

> The heroine of this serial will interest and amuse audiences not only by her misfortunes, her naïveté, and her silliness, but also by her incredible ability to get out the most perilous situations, her quick-witted repartee, her power of seduction and persuasion, and her amazing boldness, all of this combined with the greatest naturalness in the world. Zouzou is really a woman of her time: nothing intimidates her, nothing astonishes her. By her way of being, living, acting, and dressing, she is ahead of her time, which gives her the slightly unreal aspect of science-fiction heroines. She is not a girl like those met every day on the street—though it is true that she is sometimes their archetype—she seems to have emerged from a comic strip. Yet she exists; and in our view it is this way of belonging both to the world of reality and to that of myth that constitutes the interest of this project.[71]

* A show for women broadcast on French television between 1965 and 1970.

From Rohmer's correspondence between March and June 1966 with Jean José Marchand, head of the Service des Moyens extérieures et du Cinéma at the ORTF, we learn that the project proposed by Losange was not approved. It was given a "favorable but reserved assessment,"[72] and the ORTF agreed to supply only 130,000 francs, less than half the total cost, while Films du Losange would have to come up with the remaining 160,000 francs. That was more than Barbet Schroeder could pay. The idea was abandoned, but with her spontaneous beauty and her free way of speaking, Zouzou left a singular mark on Rohmer's later heroines. Moreover, she was to return, embodying the temptation faced by a married man in *Love in the Afternoon* (1972).

A Didactic Cinema

In November 1963, Éric Rohmer made his first program for educational television, "with a neophyte's ardor."[73] In the studio on avenue Bizot, he filmed in 16 mm *Les Cabinets de physique au xviiie siècle*, a forty-five-minute didactic work on scientific experimentation during the Enlightenment. Drawing on descriptions by Abbé Nollet, Voltaire, Mme de Châtelet, Sigaud Lafond, and the *Encyclopédie*, Rohmer had extras reconstitute five experiments conducted during the period. The film ends with Abbé Nollet "playing" with static electricity, spectacular effects (hair standing straight up, sparks) transforming the scientific laboratory into a cabinet of curiosities, the ancestor of the Palais de la découverte.* Everything was filmed in a studio, where books and eighteenth-century physics instruments were arranged, while Rohmer's voice converses with a physicist. "I note," Rohmer wrote humorously, "that this was a subject as photogenic as a love scene or a shoot-out between gangsters."[74] The filmmaker and the teacher fuse in the attention to concrete details, the juxtaposition of experimental protocols with readings of texts, the contextualization using engraved plates, and the instruments themselves. Rohmer read a great deal, working at the National Library on rue Richelieu, where he acquired a reader's card.

From the outset, Rohmer was stimulated by this research, this obligation to find a visual equivalent of historical or literary knowledge, this fitting together

* A science museum in Paris.

of acts, attitudes, costumes, and texts from the period read as commentaries. The teacher in him was resuscitated and kept alive by these short programs of twenty to thirty minutes with a simple narrative registered neutrally and playfully. Almost thirty of them followed the initial one, constituting a corpus of a dozen hours that testifies to a profound investment.[75] As Pierre Léon wrote in his article on "Rohmer éducateur": "Without seeming to, these cinematic experiments form a portrait of Rohmer painted by himself, and shed a nuanced light on the thought of a man, revealing all the power of attraction that this classical, steely, vertical thought exercises on us."[76]

The critic Olivier Séguret went further in *Libération*:

> Poetry is the sole true subject of these miniatures. It surges up, emanates, radiates, but it is not filmed as such, as an object to be looked at, tracked, or trapped. Except, perhaps, if one is Rohmer. Poetry can be filmed if one has a certain genius. Not the intimidating genius of exaggeration and posing. But on the contrary, a certain genius of craftsmanship and authentic modesty. [...] These films are a strange combination in which the pedagogical mission is never lost from sight, no matter how crooked the paths leading to it. Though made for educational purposes, these films were above all formative for Rohmer.[77]

Rohmer regarded this exactitude in the depiction of the little, true fact as essential; in it he saw a cinematic ethics as well as a paradoxical path to poetry. Isolating this factual truth and filming it directly: seldom has the nature of Rohmer's work, his experimental approach, in the literal sense of the term, to art, literature, history, life, through cinema been grasped better than in these three dozen short films. In this laboratory, the filmmaker carried out experiments, as Philippe Fauvel sees in a text entitled precisely "Le Laboratoire d'Éric Rohmer": "The films made for RTS were for Rohmer what the *cabinet de physique* in Mme du Châtelet's chateau was for Voltaire: a place of experimentation that allowed him to see whether his conjectures were off track or not."[78]

Rohmer's experiments in this laboratory were mainly of two kinds. On the one hand, he juxtaposed text and image to produce knowledge. In the *Bulletin de la Radio-Télévision scolaire* for May 1968, he wrote:

> Not only must the image serve to better understand the text, but the text must serve to better understand the image, that is, the world. What is education for,

if not to improve our understanding of life or of art in general? And the great authors are interesting to study not only because they were stylistic craftsmen, but also because they give us a new and different idea of the world. Juxtaposing their texts with the world that inspired them is the essence of television, and it is in that way that it can be useful and that it can have a truly formative function. The ideal program is one in which the author's text is sufficiently precise, sufficiently concrete, to designate a visual reality, and preferably a physical reality that can be shown. Our work thus consists in showing in relation to the text.[79]

On the other hand, Rohmer used his cinematic knowledge to mix the different arts, reflections of his curiosities and his tastes: poetry (the films on Chrétien de Troyes, Poe, Hugo, Mallarmé), music (that of Debussy in the film on Mallarmé, the compositions chosen for *Perceval* or for *Nancy au xviiie siècle*), painting (in *Les Cabinets de physique, Perceval, Don Quichotte, Les Caractères de La Bruyère*), architecture (in *Métamorphoses du paysage, Victor Hugo architecte, Entretien sur le béton*), and, of course, cinema (*L'Atalante, Louis Lumière, Boudu*). Here we have once again the main Rohmerian arts, the ones he put into perspective and questioned in "Le Celluloïd et le Marbre."

Rohmer quickly realized the importance of these broadcasts in his practice of and thinking about cinema. He himself reevaluated them in the mid-1960s, refusing, for example, to consider them secondary with respect to his cinema films: "An image on a screen is an image on a screen, whatever its dimensions. Everything depends above all on one's distance from it."[80] In an unpublished article written in November 1966, "Le Cinéma didactique,"[81] he strongly defended this televisual and pedagogical practice:

> For the past two years I have made a certain number of programs (eight, to be precise) for educational television. I say "programs," but I could say "films," because none of them was made "live" (*en direct*), and in my opinion they are all part of my work, on the same footing as my fictional films. And I don't think that they are minor works: they are as valuable as the rest.[82]

Rohmer tried to explain what interested him in this type of cinematic miniatures:

> I go less and less to the cinema, because current films bore me. They bore me because they don't teach me anything. In the old days, films always taught you

something about man, about the world, or about the art of cinema. Today, cinema no longer does anything but contemplate itself, imitate itself, or, possibly, criticize itself. But it no longer knows how to look elsewhere. So it doesn't tell us anything we didn't already know: it bores us.[83]

That is why he compares educational programs with contemporary experiments in documentary film:

A welcome development is emerging in the domain of informative film that resembles less and less a picture album accompanied by a sonorous and hollow commentary. The time will soon come, Eisenstein wrote forty years ago, when we'll be able to make a film of [Marx's] *Capital*. Today, there is no notion so abstract that it cannot be made the subject of a television program. The means used are very direct, drawing mainly on the speech of the interview, on debate, on conversation, all of which are means, despite what people have said, that are highly cinematic and modern. Thus alongside the fiction film, a domain that is infinitely vaster than that of the classic documentary is being constituted.[84]

To define the extent of this unprecedented domain Rohmer verged—and this was rare in him—on visionary enthusiasm:

It is not only a question of teaching, in the strict, scholastic sense of the word, or of informing, in the journalistic sense, but of seeing to it that no part of the field of human knowledge or reflection is closed to cinema. It is within this vast ambition that didactic cinema is finding its place. Cinema can say everything, it does not replace, it adds, just as the art of cinema adds to the other arts and does not replace them, it makes it possible to look at things differently and see what was up to that point invisible.[85]

In another text written for a lecture on educational television given in May 1964 in Paris, the new convert says:

Teaching children to see is one of the most urgent tasks of our teaching. This means, first of all, seeing with one's own eyes, not trusting in "what people say," returning to the facts, the sources. Educational programs allow us to put the document within the student's reach, making him emerge from his lack of

curiosity. What matters is that the document appears not as the illustration of a speech, but as the material on which an investigation can be based. The film tries to reproduce the development of such an investigation and to communicate a taste for it. It is always a question of associating aesthetic judgment with the knowledge of the document. "Nothing is as true as the beautiful," that is our motto. Educational, ultimately, does not mean rebarbative: pleasure here is not to be avoided but sought. This pleasure is the one that is provided by the sight of the things themselves. Television is an incomparable instrument for carrying out this resurrection and holding the young viewer under its spell, forgetting even that he is in a classroom. Then it is up to the teacher to dissipate the enchantment—or to prolong it.[86]

Television Courses with Professor Rohmer

Between 1964 and 1970, Éric Rohmer conceived and filmed approximately four programs a year for educational television,[87] allowing him to make a living and occupying a significant part of his time, especially before he made *My Night at Maud's* in the winter of 1968.

Perceval, ou le Conte du Graal, then *Don Quixote de Cervantes*, made one after the other in the autumn of 1964, testify perfectly to Rohmer's method in the area of "didactic cinema." First he did extensive research in the National Library or in the library at the INRP. Then came a "filming based on documents,"[88] as he himself wrote: textual quotations, work on images, in this case the miniatures in manuscripts of Chrétien de Troyes's poems that belonged to the National Library or engravings representing Don Quixote, from Coypel to Natoire, and those of the romantics, Tony Johannot, Doré, and Daumier, who invented and permanently determined the legendary character, most of these images never having been filmed or photographed. Finally came a "vocabulary lesson":[89] Rohmer retranslated Chrétien de Troyes very faithfully, reproducing in a new versification the twelfth-century author's Old French text. This iconographic and literary work, which was excessive for twenty-three-minute programs, was to stand him in good stead a dozen years later when he was conceiving and filming *Perceval*.

This activity was also the occasion for an important encounter. Through Pierre Gavarry, the RTC producer for the collection "Lettres" and a man of the

theater who had worked at the Maison de la Culture in Bourges, Rohmer, who was looking for an actor to speak Chrétien de Troyes's texts, met Antoine Vitez. At the age of thirty-four, this actor trained by Tania Balachova was beginning to make a living doing readings on the radio and dubbing films, after having been, from 1960 to 1962, Louis Aragon's private secretary. He had worked in the theater with Claude Régy, Roland Monod, and Jean-Marie Serrau—in 1958 he played in Michel Vinaver's *Les Coréens*—and had just played his first major role in Corneille's *Nicomède*, staged by Pierre Barrat at the Maison de la Culture in Caen. It was also in Caen in 1966 that Vitez did his first mise en scène, Sophocles's *Electra*, which greatly impressed Rohmer. Vitez's militant communism did not separate the two men—on the contrary, Rohmer was always to be interested, even stimulated, by the "atheistic Jansenism"[90] of the man of the theater. They collaborated on six educational programs,[91] in which the spectator can listen to Vitez's deep, calm, modulated voice read the commentary and the literary text.

In *Les Histoires extraordinaires d'Edgar Poe*, Rohmer was dealing with a favorite author. He no longer used engravings and paintings, but extracts from films, which makes this an unusual experiment in his work, though he found films that "quoted" other films unbearable. Thus Rohmer commented on Poe's work, in which the "fantastic becomes thought,"[92] thanks to the "non-Hollywood" tradition of adapting Poe's tales, notably the films of Alexandre Astruc (*The Pit and the Pendulum*), Jean-Luc Godard (*To Live One's Life*, the oval portrait episode), Jean Epstein (*The Fall of the House of Usher*), and Dirk Peters (*Bérénice*). Peters was, as we have seen, a hoax (an allegedly British filmmaker invented by Rohmer, on the basis of the name of one of Poe's characters), and his film is a spoof: in fact, six minutes of the silent short made in 1954 are included in the television program! The ghost of Maurice Schérer, with his mocking and tortured face, was thus to haunt the visions intended for French high school students.

In 1965 Rohmer made *Les Caractères de La Bruyère*, with a dozen "silent" actors, filmed like figurines against the background of a historical setting. The silhouettes of the fool, the conceited Philemon, the burlesque, the prune-lover, Celse the scribbler, peasants, Zélie the misanthrope, and Ruffin the laugher, and finally the Versailles court grouped around the Sun King seen in three-quarter view from the back, illustrate quotations from the classical moralist. The whole work forms a visual reconstitution of the world in which La Bruyère, a tutor at

the Château de Chantilly, lived, moved, and wrote. Rohmer and his team filmed on site and at Versailles, in the chapel, the gardens, and the surrounding countryside, while Vitez's voice read selected extracts and a commentary written by the filmmaker.

With *Entretien sur Pascal*, Rohmer introduced, as the title indicates, a technique of conversation dear to his heart that he was to generalize in a several educational programs and reuse in some of his fictional films. Rohmer liked conversations: he had done interviews for *Cahiers du cinéma*—about fifteen of them were published in the review—listened to them on the radio, for example, those conducted by Jean Witold, and watched them on television. "It's an instrument of televisual knowledge that permits us to come closer to great authors," he said. "We hear them, we see them, and it's both interesting and pedagogical."[93] Thus he organized around Pascal a "controversy" in the elevated sense of the term, amiable, philosophical, theological, between Brice Parain, an atheistic theorist of language, and the Dominican priest Dominique Dubarle. Rohmer directed and guided this twenty-two-minute discussion. If we recenter the argument on Pascal's wager, and replace Parain by Vitez and Dubarle by Trintignant, we obviously have the foundations of a famous sequence of café conversation in *My Night at Maud's*, which was made only three years later. Rohmer devoted two programs to Victor Hugo, one of his favorite poets. The second, *Victor Hugo architecte*, broadcast on April 14, 1969, adopted a by then classic schema of Rohmerian television: the juxtaposition of text (extracts read from *Notre-Dame de Paris*, from *Quatre-vingt-treize*, *Le Rhin*) and images (ink drawings, engravings, Hugo's sketches, Atget's photos of old Paris) with the commentary written by Rohmer and spoken by Vitez. The form of *Victor Hugo, Les Contemplations* (1966) is more original. Rohmer traveled to the island of Jersey to find and film, alone and with a small Paillard 16 mm camera, the places that had inspired some of his favorite poems: "J'aime ta mouette, ô mer profonde . . . ," "Le vallon où je vais tous les jours est charmant," and also "J'ai cueilli cette fleur pour toi sur la colline" or "La bouche d'ombre." The incitement to go there came from Victor Hugo himself, who wrote to a friend on August 8, 1852: "Verses emerge by themselves, as it were, from this splendid nature."[94] Rohmer made his program a pilgrimage, but also an on-site investigation, drawing on the localizations and dating written on the manuscripts he consulted at the National Library. He showed the big house called Marine-Terrace on the south coast of Jersey and the famous *rocher des*

proscrits (outlaws' rock), but he also strolled along the north side of the Anglo-Norman island, which is wild and fissured by a multitude of creeks, visiting grottoes and strangely shaped recesses, the ruins of the Gros-Nez chateau on the northwest point, the hamlet of Grouville, and Queen's Valley, with its rustic freshness and grazing flocks. Rohmer, meticulous and precise, took advantage of this trip to correct a few of the poet's imaginary localizations, which greatly amused him.

The visit to Jersey took place in two stages: a preliminary scouting trip in the autumn of 1965, and then the filming proper the following April. Rohmer caught a bit of the air breathed by Hugo, and through the plastic vibration of his misty, trembling shots, he reproduced the texture of the rock and the infinity of space peculiar to the exiled poet. Alone on site, he learned a great deal, having to cope with a considerable number of technical problems—notably filtering and luminosity—for which he had to find empirical solutions. The most important of these concerns was connected with the Paillard Bolex camera borrowed from Nestor Almendros. Not only did it have only about twenty seconds of running time, but since it was probably accustomed to a warmer climate, when the weather was frosty it jammed and slowed down after about ten seconds. In the still-windy cold of late April, Rohmer adapted and protected the machine in every way he could, to the point of warming it up at night under the blanket on his bed, holding it against his body. The anecdote is delightful and some forty years later it earned Rohmer an enamored column by Olivier Séguret in *Libération*: "This is a golden admission that Éric Rohmer makes here: yes, he acknowledges, he slept with a camera. To digest such a considerable bit of news, one would have to be able to sigh hoarsely: 'Finally, everything is explained,' and immediately take six months of critical distance in an Alpine monastery. The scene is really too beautiful. It is comic, of course. And also tender. A clear, raw truth about the practical realities of the trade. Charming and mischievous. Above all, it is poetic."[95] Victor Hugo's *Les Contemplations*, a work reread, walked, and filmed by Éric Rohmer, is in fact one of the filmmaker's most poetic miniatures. In this case the simplicity of its treatment of a national treasure is exemplary.

Stéphane Mallarmé is another nugget filmed in November 1967 and broadcast on January 19, 1968. For Rohmer, this film was first of all a challenge: Mallarmé was a poet he cherished but who does not yield himself easily, every explanation of his verses proving arduous, both for initiates and for high school

students. Rohmer was aware of this difficulty and kept clipped to his "Mallarmé file" a quotation from the poet written on a scrap of paper:

> Ce ne serait pas la peine que j'eusse passé quinze ans
> De ma vie à composer un sonnet pour qu'un monsieur
> Pût en saisir le sens en un quart d'heure.
> [It wouldn't be worth it to have spent fifteen years
> Of my life composing a sonnet so that some fellow
> Could grasp its meaning in a quarter of an hour.][96]

To get around the problem of Mallarmé's esotericism, Rohmer decided to make use of the interview, but this time in the form of a direct conversation with the poet . . . who had died two decades before the filmmaker's birth. Working at the National Library, Rohmer came across an interview Mallarmé gave Jules Huret that had been published in *L'Écho de Paris* in 1891, and decided to make it the heart of his film. A heavily made-up actor, Jean-Marie Robain,[97] would "replay" the replies, while Rohmer's voice would ask Jules Huret's questions. For the occasion, Rohmer engaged a specialist on the poet, Andrée Hinschberger, who helped him with the documentation, the selection of the texts, and the localization and reconstitution of Mallarmé's apartment, where the interview takes place. Using drawings, paintings, and photographs, Rohmer's set-building crew reconstituted the décor in great detail at the studio on avenue Général-Michel-Bizot. The interview with the "master" was conducted in a playful tone, and the last response is revelatory of the style of this gem that is as precious as it is droll: "In the end, you see, the world is made to result in a beautiful book" (Mallarmé). Rohmer had fun conceiving and preparing this film, particularly with Andrée Hinschberger, who communicated to the filmmaker, like a playful and contagious disease, a mania for Mallarméan plays on words. For example, she wrote to her partner using versified addresses and envelopes personalized like this one: "Porte à Monsieur Éric Rohmer, véloce comme la cigogne, Facteur, écrit du bord de mer, ce mot, 30, rue de Bourgogne"[98] ("Take to Monsieur Éric Rohmer, swiftly like the stork, postman, written from the seaside, this message, 30, rue de Bourgogne"). The filmmaker never ceased to revive these poetic plays on language in his relationships with his friends and collaborators. Unfortunately, however, Andrée Hinschberger did not survive the making of the film; she died of acute leukemia on November 21, 1967. Rohmer was deeply affected by this, having lost more than a learned collaborator: a partner.

Listening to Artists

In the mid-1960s, Rohmer was occupied by another work for television, this time for the ORTF. In April 1964, Janine Bazin and André S. Labarthe launched the series *Cinéastes de notre temps*,[99] which was broadcast on France 2. For André Bazin's widow and Labarthe, this was a "reflected echo"[100] of the cinephile work carried out in the review with a yellow cover, a 16 mm variation on the politics of auteurs. Thus from the outset the idea consisted in sketching portraits either of filmmakers or of schools and movements, entrusting them to young directors, most of whom had been, or still were, critics. "To make these programs," Labarthe explains, "we avoided the drudges and called on people—filmmakers and/or critics—who loved and knew cinema, whom we knew could produce a portrait, an essay, or the equivalent of a good feature article."[101]

The series began with *Luis Buñuel: un cinéaste de notre temps*, broadcast on April 21, 1964, and then came, in May and June 1964, *La Nouvelle Vague par elle-même*, a plural portrait in two parts, followed by Jacques Rozier's *Jean Vigo* and Hubert Knapp's *Abel Gance, portrait brisé*. In the end, Janine Bazin's and André S. Labarthe's companionship—"She is the flame, I am the fuel,"[102] the latter was to say—built the ORTF a treasury of fifty-eight programs made between 1964 and 1975.

Éric Rohmer made the sixth program in the series, filmed in early 1965: *Carl Th. Dreyer*. At first, Labarthe considered entrusting the portrait of the Danish master to Alexandre Astruc, who declined because he was preparing his feature film *The Long March*, but recommended his friend Rohmer. Labarthe and Rohmer were not in the same camp during the battle at *Cahiers*, but they always shared a genuine esteem for each other. Moreover, Janine Bazin had great respect for her husband's successor at *Cahiers*. Rohmer immediately accepted the proposal: Dreyer was an important filmmaker in his personal pantheon, even if he had written only twice on the Dane's work, a note in the *Gazette du cinéma* in 1951[103] and then a reference article on *Ordet* entitled "Une Alceste chrétienne" (A Christian Alcestis), published in *Cahiers* in 1956. The two filmmakers' universes are strongly connected by their cinematic moral rigor and austere beauty.

Rohmer left to film in Copenhagen from February 8 to February 15, 1965, accompanied by Janine Bazin, André Labarthe, the camera operator Jacques Duhamel, and the sound engineer Daniel Léonard. Dreyer received the little

team in his office on the second floor of a beautiful apartment in the center of the Danish capital. The interview was conducted and filmed in the classic manner, with medium-distance shots. It mentions the main formal and thematic characteristics of Dreyer's cinema. Rohmer asked the Dane to speak in his own language, having his remarks simultaneously translated. "At the end of the second reel, Dreyer stopped," Labarthe writes. "He didn't want to go on, and we were annoyed. Then he resumed in French. We had vexed him by asking him to speak Danish."[104] Interviews were also conducted with Dreyer's collaborators, his actress Lisbeth Movin, the actors Preben Lerdorff Rye and Bendt Rothe, and the filmmaker Jorgen Roos, as well as with the director of the Danish film center. Finally, Labarthe and Rohmer asked Anna Karina (the New Wave's muse, who had been born in Denmark and met her husband Jean-Luc Godard when she passed through Paris in November 1964), to read fragments of his texts on cinema (which helped conceal the imperfections of the recorded interview). Extracts from films illustrate the mastery of mise en scène possessed by the author of *Dies irae*. His last film, *Gertrud*, came out in French theaters two months before the program was broadcast on April 8, 1965. In an article in *Télérama*, Jacques Siclier saluted Rohmer's work, comparing it with that of the Danish master:

> Éric Rohmer has filmed Dreyer more or less as Dreyer filmed the characters in *Gertrud*. I meant that by voluntarily eschewing effects, he has simply watched Dreyer talking, a Dreyer who his actors and friends tell us is a secretive, solitary, taciturn man, and who, urged on by questions regarding his art, gradually defines his whole creative procedure as if he were only then discovering it himself in the course of a meditation. This clarity, this limpidness of writing are very well suited to this noble and solemn man.[105]

Two months later, one of André Labarthe's assistants, Claude-Jean Philippe, who had written a few articles for *Cahiers* that were accepted by Rohmer,[106] approached his critical mentor with the idea of adapting for the series *Cinéastes de notre temps* the long text Rohmer had written ten years earlier, "Le Celluloïd et le Marbre." To fit with the principle of the program, which was based on interviews, and in order to stress the shift in Rohmer's position over the past decade, it was now a question of asking creators—painters, architects, poets, musicians, sculptors—to talk about cinema. In 1955, the classical cinephile glorified the

seventh art, whose triumph was based on the sublimation of the six others, even exploiting and prolonging their strengths; in 1965, the man who never ceased to question his relationship to modernity made artists talk. The evolution was remarkable, and it was made central to this new television project. "This time," Rohmer confirms, "it is no longer the cinephile who judges the other arts; it is the artists who judge cinema."[107]

André Labarthe couldn't help being attracted by such an idea. Wasn't he the critic who introduced into the rather closed milieu of cinephilia a curiosity about contemporary art and also conversations with artists? "That 1955 text had marked me," Labarthe explains. "Rohmer was the first to have written in such a direct way about cinema's relationship to what it was not. It is certain that I did not share his view. But Rohmer always interested me, in a 'critical' way, because he had first asked this question in a cinephile text."[108] This same question was later at the center of the battle at *Cahiers*: it was what drove Rivette and his group, and it allowed them to weaken Rohmer because he proved reluctant to put cinema in dialogue with other contemporary thinkers and artists. "For Rohmer," Labarthe goes on, "raising this question again by making artists talk was surely a way of telling us, Rivette and me, that he was only an old-fashioned cinephile. Thus he was saying to us in his way: 'I too am capable of taking an interest in artists, of listening to them and understanding them.' "[109] Regarding this out-of-phase play on artistic modernity, the program *Le Celluloïd et le Marbre* proves fascinating.

Labarthe and Rohmer were working on parallel paths. Labarthe mobilized his networks and his knowledge to find and convince a dozen artists to enter into dialogue about cinema. They would film Kurt Sonderborg and his "action painting," the sculptors César and Takis, Victor Vasarely and optical art, the musician Iannis Xenakis, the writers Claude Simon and Pierre Klossowski, the film director Roger Planchon and the architects Georges Candilis—entrusted with developing the coast of Languedoc— Claude Parent, and Paul Virilio (also a theorist and sociologist). Rohmer prepared the interviews, less by taking an interest in each of the artists encountered— whom he knew little or not well—than by defining the framework of the questions that he wanted to ask them. Thus he re-read *Le Celluloïd et le Marbre* in its 1955 version and gauged how much his position had changed, putting it down on paper in the form of quick notes: "Don't repeat what has already been said in *Le Goût de la beauté*," or "On re-reading myself,

what shocked me: first, the narrowness of the point of view."[110] Rohmer also explained his project for future interviewees:

> What we want to do is carry out an investigation of cinema with people who are not filmmakers, but painters, sculptors, musicians, novelists, theater directors, architects. The essential thing is that they situate their art, their activity, in relation to cinema—not only as a means of expression, but also as a way of responding to a certain need of modern man. Not only at the level of fabrication but also at that of function. It will be called "Celluloid and Marble." The celluloid is the film, it's us. The marble is you. It seems that marble is less and less marble and that celluloid is entering the museum. One might wonder whether the opposition between cinema and the other arts is justified. In any case, we have no preconceived ideas, it's an investigation. What interests us is a view of cinema from the outside, yet it's not completely from the outside because cinema participates in all the arts and all the arts now participate a little in it.[111]

This is followed by several precise questions:[112] "How important is tradition?," "Are you making something enduring or perishable?," "Do humans need escape?"

Rohmer and Labarthe filmed during part of the autumn of 1965, conducting the interviews together. They talked with about ten artists "who might have interesting ideas," Rohmer said. "I was accompanied by Labarthe, who knew them a little better, and who was nosier than I. [. . .] I'm not someone who has read thousands of books or seen a thousand exhibitions." He was interested above all in Virilio's and Parent's architectural proposals, because they did not threaten the urban fabric of Paris. "That was my intention," Rohmer admitted regarding this part of the film. "It was a reactionary intention, basing itself on those of the avant-garde."[113] For his part, regarding these memories of Rohmer's, Labarthe explains: "He listened to everything, he was open and sometimes voluble. He clung to his idea that cinema is first of all realism, but he was perfectly capable of moving on other people's terrain. For that I gave him the nickname "Momo with the big ears."[114]

Rohmer and Labarthe both recalled just one serious clash, with Claude Simon, which comes through clearly in the program itself. According to Rohmer, Simon said, "Currently cinema tells stories the way people did in Zola's time; not as if it were contemporary with the Nouveau Roman."

Among the filmmakers he liked were Alain Robbe-Grillet (*L'Immortelle*) and Alain Resnais (*Last Year at Marienbad*). In his view, they were the only film-makers worthy of attention—along with the surrealists . . . I told him what I didn't like in cinema was present perception and memory being put on the same level [. . .] That was the starting point for the discussion that we had in the film.[115]

The montage was complicated, because it involved weaving these twelve interviews together in a coherent manner. Rohmer, who was busy with other concurrent projects, was for once less present than he would have liked to be at this stage, which was basically taken over by Labarthe. "This montage, what a job!" the latter recalls. "In the end, I got a message from Rohmer excusing himself for his absences, accompanied by a check representing part of his fee for the film. He was tactful in that way. For me, he was definitely a great gentleman."[116]

The program, the twelfth in the series, was exceptionally long (ninety minutes) and was broadcast by France 2 at 9 P.M. on February 3, 1966. The day before, *Le Monde* reported that: Éric Rohmer has chosen artists representative of the most modern trends, so that this approach to cinema through an unusual investigation sheds light on the paradoxes of twentieth-century art and leads to a much more extensive reflection on the future of civilization. Here we are in the domain of aesthetic thought, of specialized analysis, and the general public may perhaps be disconcerted by these debates.

If *Le Celluloïd et le Marbre* greatly resembles Labarthe, Rohmer gave the program a spirit and a tone: curiosity and the sly art of opposition.

Rohmer Conducts the Investigation

Part of Éric Rohmer's ambition in the mid-1960s had to do with the model of the investigation. The means he employed (seeking documentation, interviews, 16 mm film), the goals he pursued (convincing, interesting, informing, gaining a footing on the social terrain), and the projects he proposed (the sociological series *Charlotte* . . . or *Fabien* . . .), as well as the commissions he received from ORTF, educational television, and the Ministry of Foreign Affairs—all that took

the form of an investigation. Rohmer was not the only one operating on this terrain, which was heavily populated cinematically: Edgar Morin's and Jean Rouch's experiments with cinema vérité; Canadian, American, and Italian Direct Cinema; Chris Marker's poetic cine-sociology; protest cinema in Godard's style; Bertrand Blier's first efforts (*Hitler, connais pas*); not to mention the many programs of this kind broadcast on television.

Rohmer had two ideas in mind. First, he managed to grasp the ephemeral signs of the contemporary; but the investigation, present in the image as a source of information, was also a work method, because he combined part of his material with his dialogues by interviewing his actors or his witnesses himself. The investigation constitutes the film. At the same time, an amused skepticism allows the filmmaker not to adhere "sociologically" to what he is filming. The investigation is never entirely satisfying, even if it succeeds in stressing profound truths and being on personal terms with reality. So that these films are both fair to their period and critical regarding the present: Rohmer plays the sociologist, to be sure, but with distance and humor, a sociologist who does not quite believe in what he is doing, an out-of-phase investigator.

Because Films du Losange received a commission from the film office of the Ministry of Foreign Affairs, Rohmer responded with interest, even though at that point his work for ORTF and for educational television left him little spare time. But Films du Losange needed the money, and Rohmer was very concerned about that. To help him carry out the investigation, he called upon a young woman, Denise Basdevant, whom he had met at the RTS. She did a great deal of documentation and writing for him—at first about the female university student. She submitted an initial synopsis of six pages that follows Anne, "a student on the Montaigne Sainte-Geneviève" from the Henri-IV lycée, where she has just taken her baccalaureate, to the Sorbonne, where she enrolls in the faculty of letters. She is seen at home, with her parents and her brother, and her dreams are visualized: becoming a doctor, a CEO, or an architect. Soon, she is going to lectures, studying, taking sports courses, going out to the movies with a boy. The last sequence shows a family meal after classes have started.[117] The whole film is not very Rohmerian, especially since he never liked the dream scenes or the mixtures of student life with family life. Denise Basdevant thus revised her proposal and at Rohmer's request, put together a mass of more objective data: statistics (123,326 female students in France in 1964–1965), percentages (constituting 43 percent of all students, women represented 29 percent of the students

in law, 64 percent of those in medicine, 12 percent of those in physics, 28 percent of those in biology, etc.), and detailed notes on women's employment prospects. On the basis of this investigative report of about a dozen pages,[118] Rohmer wrote a concrete, precise commentary, spoken by Antoine Vitez, which accompanied the images in *Une étudiante aujourd'hui*, the student being played by Denise Basdevant herself. The film was made without sound by Nestor Almendros on the new campus of the faculty of sciences in Orsay in February 1966.

Rohmer also worked with Denise Basdevant in preparing and filming the program on a woman farmer, *Fermière à Montfaucon*, which was coproduced by the Ministries of Foreign Affairs and Agriculture. On a scouting trip to the little village of Montfaucon, near Château-Thierry (Aisne), Denise Basdevant found a farm run by M. and Mme Sendron. She got information about them and went there twice in late 1967. The result was a four-page handwritten document, "The Schedule of Mme Sendron, a farmer in Montfaucon,"[119] that provided the basis for the filmmaker's work. Mme Sendron had to bring thirty-six milk cows in from the pasture twice a day, at six in the morning and six in the evening, to milk them in the stable. Her husband grew wheat on 120 hectares of land. His wife had little time left over to take care of the chickens, her son, and family life, and to devote to her role as a municipal council member. Rohmer liked this kind of objectivization of an existence, which for him took on a hint of poetry. This schedule became a commentary on Monique Sendron's life, spoken by herself, accompanying images filmed with the 16 mm Coutant color camera held or put on a tripod by Rohmer himself. He took a great interest in farm life, which he discovered in situ in January 1968.

These two short films of twelve and thirteen minutes were supposed to be accompanied by a third part devoted to the woman athlete. It was never made, but a file on it was preserved in Rohmer's archives. In it we find multiple newspaper clippings collected by Rohmer on Évelyne Letourneur, a promising French gymnast, Sylvie Telliez, the "blonde racer," the French champion in the 100- and 200-meter dash—both of them were chosen to represent France at the next Olympic Games in Mexico, in the summer of 1968. Rohmer also met with a woman who rowed on the lake at Villefranche-sur-Saône, and took notes. "What we are trying to do," he explained, "is not to describe a sport, but to describe the life in which sport has its place."[120] This time, he hired no collaborator: sports, and particularly track and field, had long been one of his passions. In an interview, he acknowledged a single regret in his cinematic career: "Not having made

La Femme sportive; I'd found a promising and very photogenic woman athlete. The film was not made, and I regretted that, because it was Colette Besson, who to everyone's surprise won the 400 meters a few weeks later at the Olympic Games!"[121]

On this model of the investigation, Rohmer also made a certain number of programs for educational television, notably for the series *Civilizations*. That was the case for the seven interview films, each about thirty minutes long, that he made in 1967 and 1968, on subjects that did not necessarily interest him; as a director, he then became a pure technician: *L'Homme et la Machine, L'Homme et son journal, L'Homme et les Images, L'Homme et les Frontières* (in two parts), *L'Homme et les Gouvernements* (two more parts). In these films, competent persons, academics and experts, appeared one after another.[122] In *L'Homme et les Images*, the filmmakers René Clair, Jean Rouch, and Jean-Luc Godard expressed their opinions in interviews conducted by Georges Gaudu. The Rohmerian touch is obviously more perceptible in this film.

Rohmer was much more personally involved in *Métamorphoses du paysage*, made in the spring of 1964. He began by scouting, alone or in the company of Barbet Schroeder, industrial landscapes in northern France (a mill, the port of Dunkirk, a mine shaft, slag heaps, factories near Béthune), the working-class suburbs north and east of Pris (La Plaine Saint-Denis, an excavating machine in Aubervilliers, the Pont du Landy, a construction site at the Porte de Pantin, apartment buildings being constructed at La Défense) or in the capital itself (the Pont de Passy, the elevated train along the boulevard de la Chapelle, bridges on the Saint Martin canal and the rue de Criméé). Then he returned to these sites with the camera operator Pierre Lhomme and his 16 mm camera to capture in long, sweeping shots the "beauty of the industrial landscape."[123] This essay on beauty and ugliness continues all Rohmer's reflection on modern art: "Modernism," he wrote, "is not ugliness alone. We have to learn to see it. [. . .] Thus it is not so much a matter of noting that the face of the world has changed under the impact of the Industrial Revolution, as of finding in this metamorphosis of the landscape the opportunity for a poetic meditation and reverie. The reasons for taking delight in it have to win out over our regrets."[124] This "discourse on method for a solitary walker" [A double allusion to works by Descartes and Rousseau—Trans.][125] reveals in Rohmer the singer of a different beauty. In twenty-two minutes, he put his mark on a cinematic terrain that was fertile in the first half of the 1960s—think of

Maurice Pialat's *Love Exists*, Chris Marker's and Pierre Lhomme's *Le Joli Mai*, or Jean-Luc Godard's *Alphaville*.

Rohmer's interest in urban architecture gradually asserted itself in these programs for educational television. It was soon to drive an important part of his work. It led him first to make one of his most personal little television films, *Entretien sur le béton* (A conversation about concrete). Claude Parent, a defender of this material and the inventor of the concept of "oblique cities," literally captivated Rohmer, even if Rohmer did not share his taste for inclined floors. "The foundation of tomorrow's cities," Parent wrote,

> will be a single discipline, a single philosophy: oblique life, life on inclined planes. These facilities are erected to receive this new mode of life in immense, leaning, rectilinear, or incurved structures, on inclined sites, in continuous or isolated "inclinists." They allow, or even elicit, communal and individual human relationships that are different from those we practice, close to those of a future.[126]

With the help of an expert on concrete, Jean Rudel, Rohmer got Parent and his partner Virilio to talk. The architect was very responsive, appreciating the attention of a man who was so different from him. Thus he wrote to Rohmer on May 16, 1969:

> Dear friend,
>
> I have seen the program on concrete . . . and I can only send you my enthusiastic thanks. Beyond any aesthetic formulation, beyond the mastery, beyond the quality, this film has the exceptional merit of being reality. Apart from you, I know only one man who obtains this weight of the real in a parallel discipline, photography, Gilles Ehrmann. All my personal efforts in architecture aim at the same result. In this period of visual abjection it is difficult and long. An attitude like yours is an encouragement, a protection against solitude. But ten men for the glory of a population, still remains little.
>
> Friendly regards[127]

The last programs Éric Rohmer made for educational television, in 1970, opened up for him another terrain to be investigated: linguistics, and more

particularly language learning, the teaching of French. For this man who was so attached to the exactitude of words and the preservation of older French, this was an essential subject—he had many disagreements with most of the linguists putting pressure on the INRP to "reform" the language.[128] After accepting the RTS's commission, Rohmer ardently sought documentation, poring over Saussure and Benveniste and then participating in June 1969 in several preparatory meetings, working in a collective, student-like way that delighted him. In the end, he made three programs. The first, *Du Stylo au Style*, featured a roundtable of linguists presenting the characteristics of the French language; the second, *Le Français langue vivante?*, dealt with the teaching of French on the basis of an example, Michel Butor's novel *La Modification*. The third, *L'Enfant apprend sa langue*, traced the first sentences that came to a little boy, his sessions in class with new expressions, and the first of his plays on words, in which we see Rohmer's signature: "La lampe est cassée, elle ne marche plus. Moi, je marche." (Roughly: "The lamp is broken, it doesn't work any more. But I work.")

In early January 1968, Rohmer received a card from Paul Virilio. On a photograph of a riot in Detroit, seen against the background of an urban landscape on fire and police in action, we read the customary words: "Best Wishes for '68."[129] The filmmaker did not maintain such an explosive relationship with social and political reality. His main memory of May 1968 is of another kind:

> During one of the demonstrations I had placed myself on a crosswalk on the boulevard Saint-Michel. I'd come to check the number of demonstrators. The question interested me because the police gave one figure, the demonstrators another, and I had worked out a system for counting. All at once, I saw Antoine Vitez go by in the procession, amid a group of actors. I called out to him, and walked into the demonstration to join him. Then I said to him: "Can we get together tomorrow at the Café de Cluny?" He replied in the affirmative, and I left him to continue counting. The next day I was going to offer him the role of Vidal in *My Night at Maud's*.[130]

The Rohmer of 1968 is all there: a spectator at a distance, but interested, intrigued, sometimes amused, sometimes irritated; not drawing any political conclusion from the revolutionary violence. He was watching history pass by, remaining a conservative, in his life and in his ideas. What mattered more than anything was his work as a filmmaker.

The man had no inclination toward change, either revolutionary or reformist. As he put it in an interview he gave *Cahiers du cinéma*, he was anything but a leftist:

> I don't know if I am on the Right, but in any case, one thing is certain: I'm not on the Left. Yes, why would I be on the Left? For what reason? What forces me to be on the Left? I'm free, it seems to me! But people aren't. Today, first you have to pronounce your act of faith in the Left, after which everything is permitted. So far as I know, the Left has no monopoly on truth and justice. I too am for peace, freedom, the eradication of poverty, respect for minorities—who isn't? But I don't call that being on the Left. Being on the Left means endorsing the politics of certain people, parties, or regimes that say they're on the Left and don't hesitate to practice, when it serves them, dictatorship, lying, violence, favoritism, obscurantism, terrorism, militarism, bellicism, racism, colonialism, genocide.[131]

He could hardly have been clearer.

Even regarding what primarily concerned him, the cinema, Rohmer rejected any "progressive" commitment. In April 1968, when he answered questions asked by *Cahiers*, which was becoming more and more politicized, he seems very much out of step with the barrage of radical proposals being made by most politically committed filmmakers. "Are you satisfied with the role played by the state, through the intermediary of the CNC, in the cinematic profession?" the review asked. "What doesn't satisfy me," Rohmer replied, "is that the state plays a role in it at all. Cinema is not a public service, it's not a monopoly, it's not a subsidized entity. So then what role could the state play? Always a backseat driver, and too often a monitor."[132] Here we are far from the desires for the "nationalization" and revolutionary enlistment of cinema that were massively expressed in the profession during the Estates General of cinema held a month later.

However, Rohmer was not inactive, far from it, during the events of 1968, but his activity was aimed chiefly at keeping him out of phase with respect to the commitment of demonstrators in the street—whose excesses, simplifications, and collective behavior he always deplored, even when they were exercised in the other direction at the time of Algérie française and the OAS. We always find the same metaphor to designate Rohmer's attitude in 1968: standing alone, at a distance from the mobilized crowd. The preceding May, during the cinephile mobilizations in the Langlois affair,[133] Rohmer already occupied this solitary

place. When Henri Langlois was dismissed as director of the Cinémathèque française in February 1968, as the result of a conspiracy fomented from André Malraux's Ministry of Cultural Affairs, Rohmer was the only one of the great old guard at *Cahiers* who did not publicly commit himself to defend the "dragon who [watches over] our treasures,"[134] either in the street, in press conferences, in the newspapers, or in the committee of support. Thus he did not encounter the mobilizing fever, the tracts, the banners, the riot police's charges, the blows of the nightsticks, or the commando actions in which people chained themselves to gates and harangued the crowd alongside a young redhead named Cohn-Bendit.

Pierre Kast summed up this accelerated education in politics in the April 1968 number of *Cahiers*, which was dedicated to Langlois:

> I am well aware that although it is impossible to shout "Vive Castro!" without shouting "Vive Langlois!," one can perfectly well shout "Vive Langlois!" without thinking "Vive Castro." But after all, these brawls, these tracts, these sit-ins, these discussions go far beyond the Cinémathèque affair. The cinema has become something other than a product retailed in specialized places. And defending the existence of the Cinémathèque française is, strangely enough, a political act.[135]

Rohmer did not shout "Vive Castro!" or even "Vive Langlois!" and remained totally unmoved by this politicization of cinema.

However, he was, in his own way, at the heart of the matter. It couldn't be put better: in March 1968, he made a program for educational television with Jean Renoir and . . . Henri Langlois. To be sure, replying to Rohmer's questions, they talked about something entirely different: Louis Lumière and the art that arose with the cinematograph's images seventy years earlier. But in private, Rohmer assured Langlois of his support, and the latter made many asides on the "revolutionary" development of the rebellion against the state. This is shown in the rushes for the program, which have been preserved in the audiovisual holdings of the Centre national de documentation pédagogique,[136] in which Langlois mentions the dirty tricks played by the ministry and the CNC, and its strategy of remaining in the background, letting its supporters among the filmmakers claim the primary responsibility for them. Langlois understood Rohmer's attitude of "active reserve" and counted him among his main benefactors, sending him, once the matter was settled and he had kept his job, personalized good wishes

against a background of a (falsely) peaceful dove: "Peace! Long live peace, that is, war—war on mediocrities, war on bureaucracy, war on false criticism. My best wishes from the Cinémathèque. And thanks again, my dear Rohmer. Henri Langlois."[137]

In May 1968 the uncommitted filmmaker discoursed, in the *Bulletin de la Radio-Télévision scolaire*, on the love of literature and the didactic vocation of images, in a paradoxical and out-of-step performance that was once again typical of him. Nevertheless, he was attentive to the movement, as is shown by some of the press clippings, tracts, watchwords, and appeals from action committees that he saved from this period; on the other hand, there are the announcements of meetings and notes showing his participation—always in the background, of course—in the political assemblies of the cinematic and television milieu, a spectator's presence that led him never to sign a petition, a manifesto, or a demand, and never to engage in political action. He deliberately preserved his position as a witness but understood what was going on. This could be confirmed by Jackie Raynal, who did his montage and was herself very much engaged in militant political action.

> How he protected me in '68! I'd done stupid things, I'd ended up at the police station—Barbet Schroeder and Jacques Baratier got me out. I'd been traumatized, they'd convinced me to record my testimony for the Estates General of cinema, and it was picked up in the press the next day. A 7 A.M. I got a call from Rohmer: "If I were you, I'd go stay with a girlfriend." That's what I did, and my concierge told me that the CRS [riot police] had in fact come to my apartment.[138]

Rohmer attended one of the meetings of the Estates General of cinema, in Suresnes, on May 28, without getting involved in any of the motions proposed. Next he attended the founding meeting of the Society of Film Directors, the general assembly on June 25, 1968, alongside Doniol-Valcroze, Rivette, Resnais, Kast, Moullet, Malle, Pollet, and Rozier, but without Truffaut, Godard, or Chabrol. Then he went, on June 29, 1968, to the meeting of the Education Télévision Cinéma group, which brought together directors and technicians working for educational television, and was headed by Pierre Guilbaud, his former assistant for the shooting of *Les Petites Filles modèles*. The motion approved that day—it seems that Rohmer did not take part in the vote—had to do with audiovisual

teaching and outlined an assessment followed by a project, both colored by mistrust with regard to the Gaullist government:

> We greatly regret that audiovisual teaching does not have the place in France that it should have, and in particular that educational Radio-Télévision and the audiovisual means connected with it have not had the opportunity make themselves better known and to be of more use. We ask that: (1) each educational institution really have a complete audiovisual setup; (2) the programs be prepared by mixed groups (students and multidisciplinary teachers) in close collaboration with directors and technical teams. The goal of these groups being to give teaching a genuine polyvalence in opposition to the traditional separation of the disciplines.[139]

It is not certain—and that is an understatement—that Rohmer supported this motion, especially concerning the second point. On the other hand, he participated in the social movement that shortly afterward mobilized, still in the spirit of May, the directors of educational television: to join the strike in March 1969 demanding a 50 percent increase in the payment for workdays at the RTS, he interrupted for one day the filming of *Entretien sur le béton*. That was his most audacious revolutionary feat of arms.

A few years later, Rohmer reviewed the place and the meaning he gave to May 1968:

> I wasn't hostile to May '68, but whereas the people who participated in it saw it as a beginning, I saw it rather as an end. May '68 was the first stone thrown into the pond of Marxism. The ideological collapse of Marxism began in '68. Because I believe that May '68, paradoxically, cured many people, including perhaps me, of communism and anticommunism. I think that the kind of Marxist fever that took place after May '68 carried within it its condemnation and its end, it was a last flare-up. That's how I saw May '68, and that is why, personally, I remained absolutely indifferent, serene, with regard to what might happen. I continued with my work.[140]

What was Rohmer doing if not politics? At that point, he was mainly making programs on cinema for educational television, exploiting his cinephilia at a time when the latter was dying out, at least in its classical form. For that purpose,

he recontacted Jean Douchet, who had created, at Georges Gaudu's request, the series *Aller au cinéma* for RTS. Starting in 1962, about ten programs on cinema had already been made, notably by Georges Rouquier, Robert Benayoun, Philippe Pilard, Georges Gaudu, or Éric Rohmer himself (*Les Histoires extraordinaires de Poe, L'Homme et les Images*). But it was with Douchet that consistency and coherence entered this program. Thus between 1967 and 1969, Douchet personally conceived fourteen broadcasts on cinema,[141] while under his direction the series was enriched with films by Jean Eustache, Jean-Paul Török and Roger Tailleur, Bernard Eisenschitz, and Georges Rouquier. In all about forty programs were made in three years.[142]

Rohmer naturally found his place in this friendly framework. He prepared and made three programs: *Postface à L'Atalante, Louis Lumière*, and *Postface à Boudu sauvé des eaux*, broadcast between January 24, 1968 and December 16, 1969. The first film is a seventeen-minute interview with François Truffaut regarding his view of Jean Vigo's cinema; the third is a half-hour conversation between Jean Douchet and Éric Rohmer about *Boudu sauvé des eaux*, the complexity of the character, his evil, destructive side, Renoir's classical, enlightened culture, and so on. A Renoir who is omnipresent in these films, as much in Rohmer's work as in the series *Aller au cinéma*. The "boss,"[143] who had recently returned to French cultural life—he was living in Paris, on avenue Frochot, regularly received his friends from the New Wave, and headed the committee of support for Henri Langlois in 1968—established himself as the model par excellence of the auteur.

Renoir took part in person in Rohmer's main film on cinema: *Louis Lumière*. It was he who, at Rohmer's request and responding to his questions, commented on the cinematic views. Comfortably settled in an armchair and soon joined by Langlois, Renoir, lively and brilliant, talked about his astonishment upon discovering Lumière's short films. He mentioned their pictorial and civilizing context, which made them the equivalent of an impressionist work, he praised the vibrant capture of real life, and lauded the composition, which is far more elaborate than has generally been thought, the shots, the durations, the movements. Rohmer, thanks to Renoir and Langlois, contributes humbly, in the position of the one who makes others talk, to the definitive recognition of Lumière, the genius of the cinematograph.

With a mutual wink, like a poorly kept secret, Douchet and Rohmer allow each other schoolboy appearances in make-up in these films for educational

television. Thus Jean Douchet ceremoniously plays Louis XIV in the chapel at Versailles in *Les Caractères de La Bruyère*. For his part, Éric Rohmer puts on a false mustache and a mask to talk about Renoir in the INRP's projection room on the rue d'Ulm, where *Postface à Boudu* was filmed (and also Renoir's *Tire-au-flanc*, with Douchet as director, this time).

In June 1969, Henri Langlois celebrated the discreet friendship he had formed with Éric Rohmer and saluted his work on educational television by presenting a selection of these broadcasts in a program at the Cinémathèque devoted to the RTS. In this cinephile framework, these broadcasts were transformed into real films. Langlois introduced them:

> Educational television is thus a seedbed where people don't theorize about films, where cinema is really learned (according to an old method of Griffith's and Méliès's) by hand, through practice. [. . .] It is clear that someday, when people go back to the sources of this or that filmmaker, they will end up with a film: one commissioned by educational television.[144]

Langlois was right: by emphasizing the importance of Rohmer's work for educational television, he gave the 1960s a place in his development. The 1960s were the decade in which Éric Rohmer, the former editor in chief of *Cahiers du cinéma*, became a filmmaker.

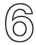 6
Four *Moral Tales*

1966–1972

Everything was foreseen. The third "moral tale" was supposed to be *La Fille à la bicyclette*, a project particularly dear to Éric Rohmer because he had been thinking about it for more than twenty years. An ambitious project, it involved well-known actors (Jean-Louis Trintignant and Françoise Fabian) and a relatively long film shoot in Clermont-Ferrand. Under these conditions, the failure to get an advance on receipts made it necessary to rearrange the work plan: *La Fille à la bicyclette* would have to do another lap (though it would retain the number three position in the strict nomenclature of the *Moral Tales*). With the money that the television broadcast of *The Baker Girl of Monceau* and *Suzanne's Career* had brought in, Barbet Schroeder was able to produce an inexpensive film—one that would at least allow Rohmer to get back to the feature film. It would be *La Collectionneuse*.

The Broken Vase

This project was also an old one. It dates from a draft of a story Maurice Schérer composed in November 1949, entitled "Chantal, ou l'épreuve." It was one of the short stories conceived in the wake of *Élisabeth*, and from it was born the first, literary version of *Moral Tales*. In it we can discern, already, most of the themes of the film that would be made in the summer of 1966. It deals with two dandies who hole up in a villa with young woman with a bad reputation who combines "an angelic face, a dazzling complexion, and the manners of a middle-school

student."¹ One of the men sleeps with her, the other refuses to do so. Playing with fire, he throws her into the arms of a third man, a smooth talker who likes to boast about his finds as a collector:

> Garnier had fatuously dilated on the beauties of a vase in his collection that was connected, he said, to the memory of a youthful love affair. All three of us had drunk a lot, and I saw Chantal maneuvering to draw him close to her, right up against the table on which the vase had been placed. [. . .] I saw her give me a complicitous wink and then, all of a sudden, lean back so far that she almost overturned the table.²

This scene was sufficiently crucial to inspire in the young Schérer a second title, which was "Le Vase brisé" (The broken vase). But for the time being, this fetish object is spared a fall, and so is the narrator of this text: a kind of morose Narcissus who never ceases to look for reasons not to yield to the charms of the beautiful Chantal.

Is this situation autobiographical? We can at least recognize in it, at a distance of fifteen years, the nuclear core of *La Collectionneuse*. Around this core a few ideological points of reference gravitate that were destined to disappear in the final version. In the 1949 version, the action takes place at the time of the Front populaire, and shows us two Rastignacs of the political world. Less opportunistic than his comrade, the narrator prefers to withdraw from affairs of state at the "advent of left-wing governments."³ Like his future counterpart in the film, he retires into solitude and reading Jean-Jacques Rousseau. Not in order to indulge in some naturalistic reverie, but rather to write a veritable diatribe against democracy:

> It was a question of nothing less than redoing all of Rousseau in reverse, laying bare the roots of the evil that is gnawing away at the modern world, of seeking the origins of the disastrous idea of Equality that is killing all our governments, even those that are apparently the most authoritarian. I admit that the general interest is the sum of each individual's happiness; but the latter can come into being only by rejecting certain rights guaranteeing the coherence of the whole. It is a strange contradiction to claim on the one hand that man is good, and on the other to imagine no other spring of public life than the hateful demand for a theoretical equality garbed in the name of virtue.⁴

This claimed elitism does not exclude (on the contrary) a somewhat decadent populism. The hero likes to flay his blasé nerves in poor neighborhoods, where he is on the lookout for any trace of a lost vitality. He is the lover of a young working-class girl whose beauty excuses her stupidity. These are just so many ways of increasing his proud superiority and so many motives for unease when confronted by Chantal, who comes to embody the revenge of the "weaker sex" and the defeat of a certain misogyny. All this is expressed in an icy, clinical style halfway between the libertine tradition and Paul Morand's short stories. Only one clear vestige of this remains in *La Collectionneuse*: the commentary, a phantom structure of the analytical novel in the French manner that allows the narrator's self-satisfied discourse to be more or less maintained. But Schroeder insisted on reducing its importance in the final montage, and Rohmer later said he had still given it too great a role. As if the essential thing now was to film a reality that escapes the devices of literature.

The New Cheaters

There is no doubt that people talk a lot in *La Collectionneuse*, and not only in voice-overs. We hear the echo of the original paradoxes when Adrian (the narrator) refuses to join the vulgar crowd of workers. Or when Daniel (who was called "Dombreuse" in *Chantal, ou l'épreuve*[5]) crushes their new female adversary with his haughtiness. Oddly, this 1966 film even brings to the surface elements of Rohmer's personal history that remained diffuse in the 1949 text: thus Daniel, a provocative and flamboyant dilettante, resembles Gégauff much more than Dombreuse does. In many respects (his voyeurism, his taste for self-analysis, his fear of being trapped by the Other), Adrian proves to be the secret double of the young Schérer. In a tour de force, Rohmer completely masked this autobiographical (of autocritical) field by transposing the narrative into full modernity. The young lancers of 1949, who cultivated their egotistical rhetoric and their contempt for women, are replaced in 1966 by "new cheaters," who are already blasé from having transgressed all taboos and are now helplessly witnessing the fading of their desire. In short, it is the endgame of the disillusioned postwar generation—of which Rohmer was both the hostage and the prosecutor.

From this to attributing vengeful intentions to him is only a short step, which his friend Dominique de Roux, the founder of *Cahiers de l'Herne* and a right-wing polemicist, blindly took, writing to him that:

Your film is one of absolutist reaction. [. . .] In *La Collectionneuse*, I finally realized your worldview through these four antiquarian *tontons macoutes* taking delight in their egoism [. . .] your hatred of the anti-France element and all the obscenity of this momentary decline that flattens the arts reveals a canine indifference to ordure and immediately transforms any ass into a songbird. It seems to me that through *La Collectionneuse* you have laid in the most subversive way, through the scorn and hatred of your characters, [the foundations?] for a future Nuremberg Trial of culture, before which we will be able to summon people like Picon and Butor, one or two pretty women, all painters, and secretaries. You believe only in France, a France with its eyes directed inward, a France that has rehabilitated Goethe and Beethoven and Mozart. And it is you, the fanatic, who will turn out to have been able to achieve this tour de force.[6]

Just as Parvulesco had earlier done with *Sign of Leo*, Roux attributes to Rohmer polemical intentions that he took great care to expunge from his project. Rohmer might think that the characters in *La Collectionneuse* represent a certain kind of decadence, a kind of artistic and amorous dead-end, the final stage of the disillusion denounced in 1955 in "Le Celluloïd et le Marbre," but he is careful not to say it. He limits himself to showing it.

What does he show? Three young people who are "with it" (*dans le vent*), as people said then. As free in their behavior as Rohmer is puritanical, as cynical in appearance as he is idealistic. In theory, his absolute opposite. But he nonetheless brought them, through a subtle play of supervised freedom, to express his own thought. In an interview given when the film came out (for a broadcast by Pierre-André Boutang), the three actors seem a little embarrassed upon discovering, after the fact, the perversity of the trap Rohmer had set for them. They thought they only had to be themselves, but they were merely portraying figures decided in advance by a mischievous demiurge. *La Collectionneuse* inaugurates a whole new mode of representation that consists in calling up the outside world in order to confirm an inner vision, in

concealing its moral aims behind the unpredictability of life. In pursuing this logic, Rohmer is acting less as a maker of fiction films than as a maker of documentaries: he seeks to put on film neither actors nor characters, but people in their own right, caught up in the currents of their lives and the impurities of their biographies.

First it was Patrick Bauchau, the handsome son of a good family, who flaunted his elegant looks at the Café de Flore and at *Cahiers du cinéma*. He had already appeared in *Suzanne's Career* (playing the lucky man chosen by that "collector" *avant la lettre*) and in the televised version of La Bruyère's *Les Caractères*. This time, he was to be the incarnation of the modern dandy. Alongside him was his friend Daniel Pommereulle, whom he had introduced to Rohmer and who played more or less himself, an experimental artist making assemblages of unusual objects and talking with brio about his work. That is what he does in the prologue to the film, in the company of the art critic Alain Jouffroy (the same who hastened his scandalous notoriety by displaying his works among those of the artists he called "the Objectors"). Another speaker was a film journalist who took the pseudonym Seymour Hertzberg to play the figure of the collector. Barbet Schroeder writes:

> Rohmer would never have issued a casting call to choose among a thousand people. His casting always proceeded through connections. Patrick Bauchau was close to the *New York Times* film critic Eugene Archer, and the latter was given the role of the rich American in the film. The problem was that he had a tendency to drink too much and that he was really not a born actor! There, we suffered . . . I saw how the system that consists in filming only with amateurs could degenerate.[7]

But Rohmer needed these amateurs to embody his fiction, so that it existed in him before it existed outside him. Thus one evening at Paul Gégauff's villa in Pontoise (which was rather similar to the one seen at the beginning of the film), he made the acquaintance of a beautiful stranger who was preceded by a whiff of brimstone. Like the Chantal in his old story, she combined "an angelic face, a dazzling complexion, and the manners of a middle-school student."[8] In addition, she had a Louise Brooks haircut and just enough androgyny to complete the portrait of a dream-woman. Her last name was Politoff, and her first Haydée,

an allusion to a fabulous character in the *Count of Monte Cristo*. She worked in real estate, which was less romantic—but Rohmer had finally found his collector. Jackie Raynal recounted how Rohmer told him this in the middle of the editing of *Place de l'Étoile*:

> One day I saw Rohmer coming, and he told me: "I found her!" He showed me a photo that she'd given him, because he'd told her that he was a film director. He put the picture, which was the size of a postage stamp, on the drum. And then he began to write *La Collectionneuse* on the basis of that photo.[9]

In reality, Rohmer never wrote *La Collectionneuse*. Instead, he constructed a trap, a rather closely woven dramatic canvas that would allow him to watch his three young people develop. The first draft of the scenario left a certain number of speeches unfinished and focused on working out the situations in detail. On that basis, the film was written on a tape recorder, an instrument that Rohmer discovered with delight when he was declaiming verses by Racine or the commentary for *La Sonate à Kreutzer* in his office at *Cahiers*. For hours, he recorded the remarks made by his actors, who had been asked to speak freely about their passions and love affairs but urged to keep their eyes on the ball, always with a view to the film to be made. It was only during the day-to-day filming, for once in a rather Godardian (or Truffaldian) manner, that Rohmer gave them the dialogues he had imagined. To a very great degree, he took his inspiration from their expressions, their linguistic tics, their ways of being. The work in progress did not stop there. The custom was to prepare for the shots through multiple rehearsals, in which Haydée, Daniel, and Patrick (all three of whom kept their real first names in the story) continued to invent the text they were going to perform in front of the camera. For Rohmer, this was an unprecedented experiment, one that he dared repeat only twenty years later when he was filming *4 Aventures de Reinette et Mirabelle*. However, care was taken to send the recordings of all these experiments to Pierre Cottrell, Barbet Schroeder's very young assistant. "This dialogue was not improvised," he explains, "but worked on the spot, on the basis of a subject set by Rohmer, with their own vocabulary, which was rather exotic for him. My assignment was, in addition to informing him about the rushes, to write a scenario on the basis of these cassettes—a scenario that was to be royally rejected for an advance on receipts!"[10]

The Taste for Beauty

Thus people talk a lot in *La Collectionneuse*, in the written form of commentary or in the oral form suggested by the actors (with the active complicity of the director). But they do so the better to emphasize what goes beyond language, what cinema alone can show: the beauty of a body filmed from every angle, as the prologue shows it to us. The grace of the movement of an arm, the mystery of a smile—whose meaning Adrien wonders about. More broadly, everything that escapes the (masculine?) grasp of consciousness and discourse, including the bodily lapses that betray, in the two male characters of the film, the rage they feel on seeing Haydée and the ineffable something she represents escape them. For example, Daniel's feet constantly bumping into the fireplace as he is making a violent indictment of the so-called "collector," in a feverish compulsion that was improvised by Pommereulle and emphasized by Rohmer. Thus the director is like a spy, seeking to discern in his actors a disposition of which they themselves are not aware (no French actor, Rohmer remarks, would have been able to kiss a pebble as gracefully as the Belgian actor Patrick Bauchau did), revealing how far being exceeds the limits of speech, how much the real, in its splendor and its surprises, is irreducible to the meager categories within which we claim to confine it.

To capture this splendor and to welcome these surprises, Rohmer found in Nestor Almendros the ideal head camera operator, one who combined a subtle pictorial culture with an amazing resourcefulness. It was he who convinced Rohmer to make *La Collectionneuse* in 35 mm (which would be no more expensive than enlarging a 16 mm copy); and it was he who refined, on the shoot, a system of indirect lighting by using mirrors that marked a milestone in the history of cinema. A future head camera operator, Philippe Rousselot (Almendros's second assistant starting with *My Night at Maud's*), referred to this small revolution:

> I was still in film school when I saw *La Collectionneuse*. And I said to myself: "I absolutely have to work with the guy who did the lighting for this film!" That was the first time I hadn't noticed the means by which a film had been lighted. Which didn't prevent the images from being magnificent![11]

The means were all the less perceptible because they did not exist: five mini-floodlights and mainly sunlight bounced off the walls and the ceiling. Controlled

outside thanks to Rohmer's trick of filming the dialogues under a tree, thus avoiding decreases in the intensity of the light. This constant recourse to improvisation was not only a constraint connected with a more or less deliberate shortage of money (the budget was limited to about 30,000 francs), it was also a form of asceticism that protected the film from the artifices of the "beautiful image" and helped it retain its core of lived experience.

The same holds for the filming conditions, which had all the marks of amateurism. Unpaid actors and technicians, all housed in the villa that the producer had found near Saint-Tropez, which was also the film's main setting. A beach down below, but one that resembled "a dump," Rohmer wrote, "where plastic bags piled up. With the actors, we spent two hours cleaning the beach. What pleased me in this landscape was the long path that descended from the village to the sea and that enabled us to fit in the long commentary that accompanies the film."[12] Meals were entrusted to a little Italian lady whom Schroeder had recruited on the spot. "The problem was," he liked to say, "that she knew how to make only one dish: minestrone. It was always the same thing, and people complained a little. For the last day on the shoot, I tried to be generous: I bought a big leg of lamb and gave it to the cook. But when we sat down to table, we were served minestrone. We told ourselves that it wasn't a problem, and we ate it out of politeness . . . and I asked her when the leg of lamb would arrive. "Ah! Didn't you see the pieces of meat in the minestrone?"[13] This improvised conviviality created a bond among the players more surely that any direction of the actors could have done; but Rohmer also made use, without letting on what he was doing, of the tensions between the Bauchau-Pommereulle pair and Haydée Politoff, which were frequently manifested in macho sarcasms, the very ones that their characters later uttered on the screen.

In this strategy of trapping, the onetime shot played a central role. Here too, this corresponded to a financial imperative: not wasting the small amount of film available, to the point that hardly 5,000 meters of negatives were made, so that the lab entrusted with developing them thought the film was a short! And each shot, as we have said, was prepared by meticulous rehearsals. Rohmer even asked his actors to begin moving before "Camera!" was called out, in order to be immediately in situation. Everything was done to give that moment maximum intensity, to create a kind of dramatic epiphany—in which the player no longer differs from what he is playing, in which it becomes true before the simultaneously perverted and delighted eyes of the director. Thus the meagerness of the

means, the reduced number of technicians, the errands that had to be run in St. Tropez at the last minute to dress Haydée, and so on were of little importance. This austerity served Rohmer's purposes: it made all the false prestige of "cinema" fall away and allowed the blossoming of the nature of beings (and nature itself) in the pure state.

A Whiff of Scandal

Similarly, Rohmer decided not to add experimental music to the film (as had for a time been discussed with the composer Michel Fano), focusing instead on the materiality of ambient noises, crickets or airplanes. "A year in advance," his editor Jackie Raynal wrote, "he had noted down all the sounds that were heard around the house, in the scrubland (warblers, nightingales). On the shoot, there was only direct sound. But he made use of Michel Fano's sound library and birdsongs recorded by amateurs. I heard him say on the telephone: "Are you sure it's a grass warbler? The one that sings between 2 and 5 in Saint-Tropez?"[14]

If music came in—and this was a principle Rohmer was to respect scrupulously in the future—it was insofar as it was physically present in the field of the narrative. The only exception to this rule was the credits. Wanting them to be accompanied simply by a drum set, Rohmer found an African tom-tom at Schroeder's place. He seized it and recorded himself, accompanied by his producer tapping on a copper basin. He had his editor listen to this "model": Did she know a musician who could take his inspiration from it? "She was well-connected—and she told me: 'We can just use that! It's great!' And that's what we did, we used this thing without rhythm, completely crazy. So from then on I told myself that it wasn't worth the trouble to find musicians for films!"[15]

To put this work on the sound track, they had to find new financing. On the basis of a film that was silent and in black and white from end to end (and which Rohmer had put together all by himself in his corner, as he was often to do as a prelude to the montage of his films), Schroeder organized a showing for Georges de Beauregard. After thirty minutes of this austere film, Godard's and Demy's producer started to nod off. It was then that a voice (that of Pierre Rissient, called in as a reinforcement) whispered in his ear: "Look! The mental orgy is about to begin." Beauregard sat up, and once the film was over, he agreed to provide the money necessary for the postsynchronization of the film. He left, chuckling at a

joke made by Rissient, who immediately rejoined a sickened Rohmer. "Pierre," the filmmaker sighed, "I know that you said that for the good of the film . . . but please! Don't talk about it that way."

But that was in fact how the film was sold. As an erotic chronicle of the liberation of the way people behaved, not very different from Roger Vadim and his audacious illusions. The preview was conceived in this spirit, assembling (apparently) spicy extracts. And so was the poster, which represents a woman's hand caressing hairy legs . . . *Claire's Knee* before its time and in reverse? All this had little to do with what *La Collectionneuse* is about, but it was this legend that was printed in the newspapers. And then the film was banned for minors, which finished making the film as glamorous as it was taboo. It was shown in March 1967 at Studio Git-le-Coeur, which had recently opened and presented itself as an "up-to-date" place. The film was launched on the occasion of a very exclusive preview attended by Paris high society. There were two Baron Rothschilds. Fernand Gravey and Marcel Carné—who might have seen in *La Collectionneuse* a reminiscence of his *Tricheurs* (which in any case had won over Haydée Politoff, since she agreed to be in his next film, *Les Jeunes Loups*)—were also there. Along with Alain Robbe-Grillet, Marguerite Duras, and Catherine Deneuve, who was soon to write a laudatory letter to Rohmer ("I often think about it and it is a very pleasant feeling not to be able to forget a film"[16]). And even, hidden under a dark wig, Brigitte Bardot, who came to applaud her young sister Mijanou, who appeared furtively at the beginning of the film, where she plays herself as Patrick Bauchau's girlfriend. People were particularly moved to know that Brigitte Bardot was in the audience, and they clucked with pleasure at the most cynical speeches: "I find it less dishonorable to live with a friend than to work for the state."

With *La Collectionneuse*, Rohmer found success: in general release, the film drew more than 300,000 spectators. Many young women adopted Haydée's short haircut, and many young people wore djellabas like Patrick Bauchau's, or the polaroid sunglasses worn by Dennis Berry (the future husband of Jean Seberg and Anna Karina). The film was shown exclusively at Studio-Git-le-Coeur (its advertisements called it "the youngest theater in Paris") and won the first prize at the Prades film festival, where the jury was headed by René Clair. It won over even the most blasé critics. Michel Duran, for example, who summed up well the general craze for the film in the weekly *Le Canard enchaîné*: "The rural landscapes of Ramatuelle, a few views of Saint-Tropez, the house in the Var, the interiors, everything is pleasing to the eyes, especially because in the middle of all that we

see a girl with a round face, a turned-up nose, and eloquent eyes who is as perfect as they come."[17] The few dissenters (Michel Aubriant, Robert Chazal, Pierre Billard) who denounced the emptiness of the script or the aridity of the mise en scéne merely added thereby (in contrast to what happened with *Sign of Leo*) to making the film desirable because it was modern, as if the vaguely ribald, picturesque quality of the situations made the austerity of the writing acceptable, and identified Rohmer (against his will?) with some prophet of the events of May 1968.

Two or three columnists proved more perspicacious as to the ambiguity of Rohmer's point of view, whether to stigmatize his "right-wing" culture, as Marcel Martin did in *Les Lettres françaises*, or to attach him ironically to the tradition of Marivaux, as Jean-Louis Bory did in *Le Nouvel Observateur* (this was the beginning of a long career for that convenient journalistic label). In the course of a "for and against" discussion with the Catholic Francis Mayor in *Télérama*, Claude-Jean Philippe raised the level of the debate (he repeated almost the same arguments in *Cahiers du cinéma*). Of course, the characters in *La Collectionneuse* are immoral: they certainly do not read *Télérama*! Of course, they are incapable of communicating with others. But their problem goes beyond that:

> They want to make their minds go blank, to find nothingness, but the mirror is always there and it reflects their thoughts back to them infinitely, producing a kind of vertigo. Rohmer thus emphasizes the drama of modern thought. Its inability to get outside of itself. [. . .] The film had to be beautiful, supremely beautiful, to bring out, in a light that was never so warm and golden, this feeling of a paradise offered and refused, of an innocence doomed to anxiety. We are surrounded by an obviousness of the world, of things, of people, of beings. This obviousness is marvelous at the first glance, that of the artist.[18]

One could not more subtly unmask Rohmer's secret procedure: exhausting all of consciousness's pretenses the better to celebrate the absolute truth of cinema.

If All the Guys in the World of Cinema . . .

Despite the success of *La Collectionneuse*, the third of the *Moral Tales* was still a dead letter in the spring of 1968. Little concerned with political events, Rohmer was thinking only about making his film *La Fille à la bicyclette*—which became

My Night at Maud's. But the film encountered two obstacles. First, Jean-Louis Trintignant's indecisiveness; Rohmer had offered him the leading role in his next film, that of a Catholic engineer who likes to seduce women but is tormented by moral scruples. But Trintignant was not a Catholic, and he saw himself more as a victim of love than as a Don Juan. His hesitations confirmed Rohmer's notion that the actor cannot be basically different from the character he plays. But Rohmer wanted Trintignant to play the part and was prepared to wait as long as it took to get him to agree (and for him to be available). The second obstacle: the project failed twice to get an advance on receipts, and this caused its production to be suspended, because the budget was considerably larger than that of the preceding film (about 600,000 francs). To convince the president of the CNC, Rohmer wrote him a carefully argued letter reminding him of the necessity of making the *Moral Tales* in a certain order and of the efforts he had made to reduce the amount of commentary in his scenario (that was the main sore point).

> Finally, couldn't I adduce a "new fact" in my favor, namely the release of the fourth tale, *La Collectionneuse*? It may have given an idea of my way of filming and shown to what point my mise en scène is irreducible to discursive speech. My strongest supporters praise its discretion and even, they say, its "transparency." Is a virtue on the screen a defect on paper? Only the effects, the tricks— everything I hate—can be written down. That is why I admit that my bare text is not sufficiently convincing: if it appears provided with its literary characteristics alone, that is because I refuse to say what cannot be said.[19]

There was nothing to be done, and *My Night at Maud's* might have remained in the shadows of Rohmer's filmography (as had *Une femme douce*, which joined that of Robert Bresson), had a providential figure not intervened: François Truffaut. Was it a desire to offer revenge to his great elder, who was still seen as the humiliated father of the New Wave? Was it remorse for having helped evict Rohmer from *Cahiers*? We know that this double movement (kill the father/ pay homage to the father) was to some extent Truffaut's weakness. However that may be, the maker of *The Four Hundred Blows* was prepared to spend whatever it took to ensure that the film's financial needs were met. First of all, by becoming a coproducer, alongside Barbet Schroeder and Gérard Lebovici. Second, by developing the luminous idea of a consortium of producers—in which each one would "purchase," by making a modest investment, part of the future dividends.

By late 1967, the undertaking was well advanced, as is shown by a letter from Truffaut to Mag Bodard:

> I believe it would unjust to go back on this, given that Rohmer is one of the greatest French filmmakers and also one of the most serious. [...] Claude Berri, Abicocco, Gérard Lebovici are loyal and faithful, and so are Barbet Schroeder (who is taking two shares of the production) and Jean-Luc Godard, who told me this morning: "It's an honor for me to put my name on a film by Rohmer."

Truffaut adds, referring to the other film he was trying to cofinance with Berri (Maurice Pialat's *L'Enfance nue*): "We will certainly not participate in either of these two affairs with a view to earning money, but in the hope of not losing any and especially with a desire to help realize these two fine projects."[20] But fissures soon appeared in this admirable unanimity: Mag Bodard withdrew, and so did Godard and Jean-Gabriel Albicocco. Michelle de Broca, Nicole Stéphane, and Louis Malle, who were busy putting together other difficult financial packages, all declined to help with *My Night at Maud's*. Claude Lelouch, who had been asked to handle the distribution of the film, indulged in a strange waltz of hesitation.

In the middle of May 1968 Lelouch wrote Truffaut a long letter that looks for all the world like a flat refusal. In it he expresses the foreseeable reservations. Too much commentary, too many references to Pascal, too much austerity—all of which make the film unsalable. Curiously, he adopts and reverses the arguments that Rohmer defended at the CNC:

> *My Night at Maud's* seems to me very literary, not at the level of the dialogue, which is well-written, but at the level of the conception of the film. I mean that on reading this scenario I never had the feeling that I was reading a scenario, but rather a book; that may be what Rohmer wanted, since he wrote in the first person what is usually written in the third. That worries me, because I don't sense a filmmaker's will, but rather that of a storyteller. Now, anything can happen, for better and for worse, in the mise en scène.[21]

These concerns did not prevent Lelouch from leaving a door open at the last minute: "However, I am delighted that several producers are associating to produce a film considered noncommercial from the outset, and I am eager, at any price, to participate in this kind of experiment."[22]

Barbet Schroeder took Lelouch at his word, and even persuaded Rohmer to go with him to meet this possible distributor. The meeting (arranged by Rohmer for 5:30 A.M.!) led nowhere, because Lelouch claimed that he had just noticed that the film was planned to be in black and white. Another cold shower came from the Union générale cinématographique, in the person of its president, Claude Contamine. Invited the see the final product, almost his only reaction was a laconic remark: "You've made a nice film, M. Rohmer." Contamine, a good Catholic (who had just been married in the Church) hurried off to telephone Truffaut and ask him whether he could get his friend Rohmer to shorten the church scenes. In any case, he abided by the distribution agreement, and the CNC ended up giving 100,000 francs after the battle. A singular way, Rohmer was to say later, to apply the principle of an advance on receipts . . . In the meantime, Truffaut put together a board of seven producers. In addition to those already mentioned, it included Danièle Delorme, Claude Zidi, Pierre Braunberger (who came in at the last minute), and Jean-Louis Trintignant, who had decided to join the venture. His partner Françoise Fabian was also tempted to participate, but Rohmer balked at that—because eleven shares had already been distributed. This was supplemented providentially by Pierre Cottrell, when they were getting ready to film in Clermont-Ferrand and money was running short. Thanks to his grandmother, he was able to give the 20,000 francs necessary to cover the costs.

Cottrell also had no share of the receipts from the film. But having taken over Schroeder's functions (Schroeder had left to make his film *More*), he was the one who paid out the dividends to each of the shareholders—not without arousing some bitterness on Truffaut's part. As he wrote to Rohmer:

> Every time I've committed Carrosse to coproduce a film made outside, I've been disappointed in one way or another, and when I wasn't, the director and his financier seemed to regret the arrangement. Thus Pierre Cottrell, a year after *My Night at Maud's* was released, said straight out: "I think the coproducers of the film received a sufficient profit, and we're going to stop sending them money." I mention the example of *My Night at Maud's* because it is, along with *The Testament of Orpheus*, the only coproduction that fulfilled the hopes I had for it.[23]

Truffaut was a good sport, and he finally agreed to give up his rights (at the request of Margaret Menegoz, the future treasurer of Films du Losange). But he did so to return to Rohmer the ownership rights to his film. On that day, he even

wrote a fine letter to all the 1968 producers asking them to do the same. Most of them agreed. In the case of *My Night at Maud's*, *la politique des auteurs* was not an empty phrase.

La Fille à la Bicyclette

What made this project so scary? In the first place, as we have seen, it was its "literary" dimension, conveyed through an omnipresent commentary (at least in the early versions of the scenario). As for *La Collectionneuse*, it is in reality the trace of a hidden, very old infrastructure that also took the form of a novella. In 1944, Maurice Schérer was writing a text entitled "Rue Monge," in which we find the essential elements of *My Night at Maud's*, beginning with a theme that was to run throughout Éric Rohmer's films: that of voyeurism, spying, tailing. Long before *The Aviator's Wife* or *Triple Agent*, the narrator of "Rue Monge" was someone who wants to see without being seen, who follows a pretty girl in the street, as if to take possession (through his eyes) of her life. When she almost spots him he takes refuge on a square, in no hurry at all to give up his observer's position. An obsession that tallies with two other obsessions, no less Rohmerian *avant la lettre*. On the one hand, the obsession with controlling space. The geography of the Latin Quarter, with its intersections and bifurcations, is described with extreme precision, as if it were a trap carefully prepared for a female prey. On the other hand, it is time that has to be controlled, in all its implications—including that unreliable ally, chance, which the narrator constantly invokes the better to ward it off. Under these conditions, the famous "night at Maud's" (already more or less what it later was in the film, right down to the name of the character and the presence of an obliging third party) turns out to be the inconceivable moment par excellence, the one that escapes the influence of premeditation.

> It's true that, being a very slender brunette, Maud hardly corresponded to the kind of woman I'd previously desired, and even on the day when I first spoke to her in the Metro, the idea of having a fling with her never occurred to me. [. . .] My series of failures ought to have encouraged me to be bolder when I got the opportunity. But the contrary is no less plausible, and one might very well think that after searching for what can only be called the impossible, I must have felt an instinctual repugnance toward something that was offered so naturally.[24]

There we have the bases of the idealism that was to inspire Rohmer's whole work (whose culmination may have been *La Marquise d'O*). An idealism that called from the outset for the cinema, as the sole power capable of both satisfying and transcending it, but which for the time being retained a narrowly rhetorical form: that of an endless calculation of causes and consequences, of ins and outs—to the point of verging at times on an interpretive delirium. The young writer's tendency to split hairs was not abandoned by the mature filmmaker without hesitations. When he went back to this foundational canvas in the early 1960s, he continued to decorate it with an omnipresent voice-over, a voice-over of the consciousness that comments in the first person on the protagonist's actions. But it is also a voice of the unconscious (which is less common in Rohmer) that makes itself heard at dawn after the long night spent at Maud's: "I was with Françoise, lying in the big farmhouse bed, at the bottom of the crater of a volcano in the Auvergne, white with snow. Maud and Vidal were standing, one on each side of the bed, dressed as Mephistos, laughing mockingly: "Well! That's pretty! That's pretty!" Françoise's body was pale, hard, and frosty as marble, and we lay down naked and immobile, like statues. And the cold invaded me, paralyzing me more and more."[25] Other significant elements reinforce the symbolism of the remarks: the first homily heard in the church, which denounces the modern superstition of chance (the very one that the narrator defends); the dialogue with the character of Vidal, a Marxist philosopher who engages in brilliant developments of Blaise Pascal's dialectical thought.

So many residues of the literary project that erase the making and the editing of the film. The commentary? There remain only two occurrences of it, at the beginning and at the end of the narrative, as a discreet way of establishing (and putting in doubt) the theoretical framework in which the narrator claims to be situated. The sermon from the pulpit? It was freely delivered, on the basis of the fundamentals of the mass, by Father Guy Léger, a Dominican friend of André Bazin's, a movie lover who returned to his monastery at the end of his day on the set. As for the philosophical dialogue, it was entrusted—at least insofar as the Marxist point of view is concerned—to the improvisation of Antoine Vitez, Rohmer's spokesman on educational television. "I am very struck," he wrote to Rohmer, "by the coincidence between Vidal's ideas about Pascal—and in general, the ideas debated by the two men—and my own reflections. If you wish, I will tell you what I myself had in mind, and you can use it, if the occasion arises."[26] In this way, the application of Pascal's wager to the Hegelian meaning

of the story becomes a solo in its own right, sung by Vitez, and the object of a documentary view right in the middle of the fiction, on the same footing as the violinist Leonid Kogan's performance or the discussions in the cafeteria at the Michelin factory. More secretly than in *Sign of Leo* or *La Collectionneuse*, Rohmer seeks to blur the original architecture of his scenario by giving it, here and there, the style of a newspaper report.

Actors Without Paradox

He went still further. Just as he asked Vitez virtually to play his own role, he did everything he could to make Françoise Fabian feel that she was Maud. First, by choosing her for the same reason his narrator chose to marry Françoise, the "girl on a bicycle" met in the street: because she was who she was and not someone else, in a way as obvious as it was arbitrary. This begins like a vaudeville scene at the Marigny theater, where she was playing in *La Puce à l'oreille*. Timidly, Rohmer slipped into her dressing room, gave her the scenario of the film, and immediately disappeared. Without knowing it, Truffaut followed him, telling the actress: "Éric Rohmer, who is a great filmmaker, is going to offer you something, you absolutely have to do it." Convinced by the text as much as by Truffaut, she said *yes*. That was the beginning of a long series of lunches at Lipp's, which Françoise Fabian described this way:

> Rohmer and I talked about the most diverse subjects. About life, about death, about love, about desire, about fidelity, about religion . . . but never about film! I think that I amused him (I made him laugh, I provoked him a little), and that he would like to get to know me better . . . So I experienced the filming of *My Night at Maud's* as a continuation of our conversation.[27]

There was no gap between the private person and her cinematic avatar. Remaining loyal to this principle (which he had set for himself as early as *La Collectionneuse*), Rohmer gave Fabian (Maud?) a maximum of initiative: she could choose her navy blue jersey and her bedspread, stop in the middle of a speech to light a cigarette, or forget the presence of the director (the same director who had told her, after viewing the first rushes: "I no longer have anything to tell you. Maud is yours"). This freedom was not without risks for the actress, because Rohmer observed

a second principle: that of the single take, a take without a net and without any second thoughts. Françoise Fabian found out how hard that could be when she was making her most difficult sequence, Maud's confession, which was filmed in close-up and dealt with the tragic end of a love affair. Displeased with her performance, the actress wanted to redo the shot. She asked it as a favor, for her last day on the set. Her partner, Trintignant, even offered to pay for the retake and took out a 500-franc bill. As if it were a matter of saving money! Rohmer ended up yielding, but he knew very well that he would end up using the first take.

We might call that a "tactics of the flagrante delicto," which consists of making the actor his character's hostage, while at the same time pretending to give him free rein. It was to have effects far beyond the film. Thinking she was free to play anything at all after the sublime Maud (in this case, the role of a corrupt banker in a spaghetti Western), Fabian received a very curt letter from Rohmer telling her how much he disapproved of her choices. The only already known actress he had ever used, she nonetheless remained identified with Maud more than with any of her other roles. She willingly acknowledged this, with a mixture of fatalism and melancholy: "The character resembles me. I'm an atheist, independent, I work, I'm a widow, I live alone. I don't fit into a mold."[28] The capture of a personality, so to speak, through which Rohmer transfigured the autobiographical elements in his narrative.

The procedure became more tortuous with Trintignant, precisely insofar as he was perceived as an alter ego. By giving him (at least in the scenario) his own first name of Jean-Louis, by going to film the epilogue in his vacation home in Belle-Île, Rohmer also suggests a confusion. As for the rest, he limited himself to giving the actor technical advice connected with articulation. Trintignant recalls:

> The scenario was written in a very rigorous way. Even the "uhs" of hesitation were written into it . . . You had to remember all that and say it faithfully, and at the same time listen to Rohmer, who talked a lot. Since I was trying to concentrate on my role, I'd bought wax earplugs so that I wouldn't hear him too much . . . But when I took them out, I realized that he was saying very intelligent things![29]

Rohmer gave the same kind of "indirect" direction to Marie-Christine Barrault, who, like Trintignant, had been chosen for her physical and mental resemblance to her character—even though she was truly Catholic and had just emerged

from a convent for young women. She had played only a few roles in the theater, under the direction of her uncle Jean-Louis Barrault. Once hours had been spent taking tea and talking in the offices of Films du Losange, once hints about how best to make tea (but this time in a scene in the film) had been given, the director limited himself to watching her act. Each time, it was as if Rohmer had made a bet on a person. And as if he expected a cinematic reward a hundred times over.

A Gamble on the Cinema

We know that this theme is at the heart of *My Night at Maud's*. It was far from the sinister Paris that was the setting of "Rue Monge," in which people got mired in schemes to mitigate the penury of the Occupation. In the 1968 film, we sense that Rohmer was seeking to sublimate his youth, or more precisely to displace it, because we find it in it many personal elements, but nothing is in the same place anymore. The impoverished student of the 1940s has become a brilliant engineer. The Latin Quarter is replaced by Clermont-Ferrand, where Rohmer did preparatory studies (as we recall), but also where Blaise Pascal was born. In this new framework, the scenario arranges encounters and recognitions that are easier to justify in a provincial city: at mass, Jean-Louis meets an unknown woman with whom he falls in love. Also by accident, he runs into a former schoolmate (Vidal), who introduces him to the beautiful and sensual Maud, at whose home he spends the night. With her, he remains chaste, because he is faithful to the image of the young woman he met the day before: Françoise, the unique, the Catholic. Again by chance, he meets the woman who will become his wife—but about whom he learns, in a final and cruel coincidence, that she has been the mistress of Maud's husband. Thus strengthened, the canvas of the 1944 narrative allows private memories (Rohmer's platonic passion for Odette, his marriage proposal to Thérèse) to hover at the same time that it establishes a great Rohmerian subject: the hesitation between fidelity and independence in love. It was, moreover, under this sign that Rohmer sold to the press the whole *Moral Tales* series: bound to a woman, a man flirts with another woman and finally comes back to the first. In reality, only *Love in the Afternoon* explicitly realized this formula.

The film's second major theme is Pascal's *Pensées*, around which the protagonists' conversations gravitate. A reminiscence of student bull sessions? The influence (to imagine Vidal played by Vitez) of the communist philosophers who

were then acknowledging their spiritual questionings? Rohmer had no doubt read Lucien Goldmann's *Le Dieu caché* (The hidden God), which reinvented Marx in the light of the Jansenist philosophy of Port-Royal. When he was doing his university preparatory studies, he seems to have met Roger Garaudy—whose disavowal of Marxism in favor of Islam was later to be a sensation. Not to mention the *Entretien sur Pascal* that Rohmer had recently made for educational television, in which the philosophical paradox of *My Night at Maud's* can already be discerned: in both cases, it is the representative of Christianity that plays the devil's advocate, that is, the advocate of a humanity excessively denigrated by Pascal. But as was often to be the case in Rohmer's work (and already for Rousseau, in *La Collectionneuse*) the work quoted in the body of the film is hardly more than a theoretical reference point, a prestigious Plato's cave from which the character is literally summoned to free himself.

The Jean-Louis of *My Night at Maud's* can reread and quote Pascal all he wants, he is in no way one of the latter's disciples. He rejects Pascal's rigorism, having no intention of giving up the pleasures of the table or those of love. He even goes so far as to indulge in a certain Jesuitism (at least that is what Vidal accuses him of) by developing a complete more or less specious system of casuistry to reconcile nature and grace. Besides, he is completely aware of these contradictions, and if he deludes himself, it is rather regarding his "luck"—which allows him to avoid the anguish of choosing and gives him the impression that he has found his beloved by chance. Here we are very far from Pascal and from the simultaneously terrifying and thrilling risk that the famous wager offered. On the other hand, we are very close to "Rue Monge" and the self-portrait of Schérer as a young fanatic, infatuated with an evanescent female image that he had to catch in a trap. That is perhaps the hidden theme of *My Night at Maud's*, and it has directly to do with cinema; with the curse on cinema, to adopt the Catholic terminology that Rohmer (secretly) shares with his character. Consider the opening shot in which we see Trintignant's dark silhouette take possession of the landscape by the intensity alone of his gaze (as if he were the reincarnation of Murnau's great predators, Nosferatu or Mephisto). Or consider all the sequences filmed inside a car, from the point of view of a man who is avidly scouring the city's streets, seeking—and knowing—someone to devour. At such moments, it is a kind of guilty ambition that Rohmer is staging: the ambition to imprison the real by keeping an eye on all its external signs. The very ambition that he put to work while filming *My Night at Maud's*.

For the first time, he had an adequate budget and a "real" assistant, in the person of Cottrell (who carried out the slightest of his desires). He applied as much as he could the program of the narrator of "Rue Monge," and that of the theoretician of *La Revue du cinéma*: first of all, control space. When filming the trips back and forth in the car, it was not a matter of going down just any street with the camera. There was a very precise trajectory to be respected, even if it meant that the team had to turn around for each sequence. A fetishism that was increased by the use of black and white, with its contrasts and its stylization that ended up evoking silent film. But recourse was also made to the studio, situated (think of that!) in the Mouffetard quarter, for the very long scene in Maud's apartment. Rohmer decided on that in order to obtain total silence and to be able to compose the set in his own way: in that ascetic room dominated by a snowy white (echoing the snow that is supposed to be falling outside), he himself placed the elegant Knoll furniture and the reproductions of works by Leonardo da Vinci—which correspond to Françoise Fabian's style of beauty. Before engaging in the gamble of the single take, he spent hours placing this or that object, mumbling to himself all the while. This irritated his main actor, who was not used to this strange way of working. "What are we doing?" he whispered to his partner. One fine day, Trintignant openly criticized Rohmer for paying less attention to him than to the ashtrays. To which the filmmaker replied: "I'm less worried about you than about the ashtrays."

Next, control over the weather. No matter what the imponderables of the forecast. Did snow start falling after the street sequences in Clermont-Ferrand had been filmed? Too bad, they will be filmed again. Was Trintignant supposed to find his car covered with snow the next morning? Fine, they'll just let the snow fall all night. All this was based on a subtle calculation of the probabilities, which was only one of the countless tricks for taming chance. This premeditation even played a role in the shooting schedule. "Rohmer wanted our filming to end at a certain time of year," Trintignant recalls, "and I didn't know why. One day, he told me that he was supposed to run in the Figaro cross-country race—and that it was very important to him not to miss it . . . So the film had to be finished first."[30] Rohmer's perfectionism was not limited to the filming, as two newcomers to the little crew later testified. Jean-Pierre Ruh, the apostle of direct sound whose work Rohmer had admired in Jean Eustache's films, and who, from *Maud* on, provided him with that supplementary aspect of realism. A realism that could be obtained only at the price of a maniacal precision: "He often came

in," Ruh said, "only to record sound matchings, silences, atmospheres (for example, to cover the apartment in *My Night at Maud's*), he came to listen with me. I said to myself: "How much trouble he's taking to edit the stages, waiting an hour to have the right atmosphere, for the cut to be made and redone."[31]

The same meticulous jewel-maker was described by Cécile Decugis, who became, from this film onward, his official film editor (replacing Jackie Raynal, who had left to live in New York). This pal of Godard and Truffaut, a woman politically active on the Left, who had gone to prison for having helped the FLN at the end of the Algerian War, and who wasn't afraid to say what she thought, was henceforth to adapt more or less to Rohmer's discipline. She recalled:

> He [Rohmer] knew exactly what he wanted. There was no hesitation. There was never one shot too many. As for me, I was merely an executor! He sometimes made comments. While we were viewing the scene in which Marie-Christine Barrault admits to Trintignant that she has had a lover, he murmured: "This heart-breaking scene . . . " In fact, I always thought he behaved more like a writer than like a filmmaker. One day he said to me: "To make films, you have to think a lot."[32]

At every stage, Rohmer thus sought to extend the control traditionally reserved for literary practice (at least his, at the time when he was writing "Rue Monge"), to delegate to cinema the ideal of the demiurge that literature had abandoned. However, if *My Night at Maud's* is perhaps his masterpiece, it is insofar as this ideal is challenged. Through the alterity of his actors, as we have seen, the filmmaker confiscates and encourages at the same time. Through the emergence of the unexpected, summed up magnificently in the last sequence, when the suspicion regarding Françoise's past indiscretions disturbs the vacation picture-postcard. For this new "moral tale," Rohmer went far beyond the hide-and-seek game between image and language to which *La Collectionneuse* could be reduced. It is the cinematic project itself that he stages, entirely aspiring to what escapes it.

A New Thrill

Even if the project evolved along the way, Rohmer never gave up the "radicalness" that so frightened his first readers. A black-and-white film whose action

takes place in Clermont-Ferrand and is articulated around theological discussions; a forty-five-minute scene in a room in which nothing happens—except words . . . Another wager, and not a small one, on the audience's capacity to listen and pay attention. In the editing studio, the filmmaker himself wondered about his chances of success ("After all, it's a film in which there are three masses!"). Nominated for the Palme d'Or at Cannes, *My Night at Maud's* was shown after an endless black-and-white short from Eastern Europe: the story of a child who chases a cat through a church. When this was followed by Father Léger's sermon in Rohmer's film, the audience gave free vent to its impatience and sarcasm. Trintignant returned to Paris in a black mood. Soon afterward, however, the retribution came from the United States: invited to present the film at Lincoln Center in New York, Françoise Fabian was applauded by a wildly enthusiastic audience and deluged with requests for autographs. Pierre Cottrell met with the same response in Los Angeles, where the film was in competition for the Oscars. Barbet Schroeder still can't get over it: "One of my great experiences was having seen *My Night at Maud's* in Cannes, with its audience of hairdressers and free seats: they didn't like it all, they were bored, they got up and left. It was a flop as bad as Antonioni's *L'Avventura* . . . A little later, I saw the film again on the other side of the Atlantic: there they saw all the humor in the dialogues, it had become an American comedy!"[33]

Once the misunderstanding in Cannes was over, *My Night at Maud's* became (who would have thought it?) a success in France as well. The film was to be shown for a very long time, and to date more than a million tickets have been sold. That makes it the greatest commercial success in Rohmer's career, even though it is certainly also his most austere work. How can we explain this paradox? Cottrell offers a somewhat trivial answer: "Rohmer was not an idiot: he knew that by choosing Françoise Fabian (Pierre Lazareff's protégée) and Marie-Christine Barrault (the wife of Daniel Toscan du Plantier, then assistant to the advertising executive Bleustein-Blanchet) he was increasing the chances that his film would win support in the press."[34] In any case, the film would gain in glamour. More seriously, it seems that critics and spectators liked (against all expectations) exactly what had put off the financiers. From the veteran Claude Mauriac (in the *Figaro littéraire*) to the neophyte Michel Ciment (in *Positif*) and the militant Jean-Louis Bory (in the *Nouvel Observateur*), critics were unanimous in praising the spiritual and intellectual elevation maintained by *My Night at Maud's*, the quality of its writing, the rigor of its mise en scène. Including even

the very conservative Robert Chazal, who as early as the showing at Cannes, minimized his reservations: "This unconventional film, in which Catholic morality plays a large role, surprised and in large measure won over an audience that current cinema had little prepared for this kind of film. The success is only all the more meritorious, and with *My Night at Maud's* Éric Rohmer has placed himself, at the age of 49, in the first rank of our film directors."[35]

Henceforth there were few reservations . . . except in *Cahiers du cinéma*. Bonitzer, writing in the name of the review's new leftist orientation, offered a clearly ideological analysis. According to him, *My Night at Maud's* is a right-wing film that praises the conjugal ideal at the expense of freely lived desire and plays with the idea of chance only in order to reinforce the moral mission of destiny. Taken inversely, this tendentious reading of the film explains the magnitude of its success. *My Night at Maud's* came out at a propitious time, just when people were getting tired of the excesses of May 1968 and the audacities of the New Wave. Finally, characters who are less interested in making love than in talking about it! And talking about it in such an elegant language, far from student provocations, worthy of the highest French tradition. From this point of view especially, Rohmer fully succeeded. It was Michel Mardore, one of his former pals at *Cahiers*, who noted mischievously:

> Ten years ago, a subject like that would have made people laugh. This film wouldn't have drawn five thousand spectators. Today, "old-fashioned" feelings have a faithful audience, whose numbers are growing. [. . .] It is becoming clear—and the interest taken in Rohmer's film confirms it—that God and morality are gaining ground in our society. [. . .] How did a single filmmaker, in France, succeed in becoming aware of this reality? Why was he the only one who, before everyone else, realized the existence of this desire for reflection, for seriousness, while his colleagues still adhered to the sempiternal theory of gadgets and yé-yé [This is the French version of the Beatles's "yeah! yeah!," but it became an independent term and style, especially in figures like Serge Gainsbourg.—Trans.] dances? In short, why is Éric Rohmer on time? Because he was always late. Knowingly. With a backward-looking obstinacy that found its justification only two years ago, when *La Collectionneuse* showed his harmony with the century.[36]

A strange irony of fate that made the old postwar puritan the best observer of the late 1960s. A status that Rohmer was not soon to lose.

The Weeping Girl

Thanks to the consecration of *My Night at Maud's*, Rohmer had free rein to give concrete form to his last two *Moral Tales*. The fifth of them was entitled *Claire's Knee*, and as in the preceding films, it was a story that had been conceived long before. It derived from an almost immemorial image, a kind of childhood "Rose-bud" that the filmmaker mentioned casually in the course of a conversation: "It's the primary element, water . . . The idea of tears and rain . . . It seems common-place, because people say that when 'someone weeps'—at least, people said it in the countryside where I lived—then 'it's going to rain.' But I like simple things like that. And then it might also involve a childhood memory, one of my oldest, that of a little girl who was crying in a barn or shed while it was raining outside, and her big sister was consoling her."[37] To return to this "primal scene" forever associated with his little cousins in Tulle, many detours and false routes had to be followed (as always in Rohmer's work).

At the outset, a draft of a story strangely entitled "Who Is Like God?" (*Qui est comme Dieu?*), which begins with this sentence taken from the Marquis de Sade: "It is not pleasure that makes people happy, but desire and the obstacles that are put in the way of realizing that desire." This is already the whole program of *Claire's Knee*, and the latter was already the title taken by the second version of the story, which is dated 1949 and dedicated to Jean Parvulesco. In a style reminiscent of Rousseau's in the *Confessions*, or of the Proust of *Les Jeunes Filles en fleurs*, Maurice Schérer confirmed his favorite themes. Especially voyeurism, practiced in this case by a Don Juan in his thirties who has decided to turn over a new leaf by marrying a certain Lucinde, but who cannot help ogling two adolescent girls playing ten-nis below his windows. He goes so far as to climb out on a branch the better to enjoy the show and even to hide their stray tennis balls in his apartment in order to attract them into his lair. And then there is a blatant fetishism that gradually invades the narrator's consciousness and focuses on a specific part of the body: the knee. He intends to limit the possession of the body of Claire (the wilder of the two) to touching her knee, and to do so he elaborates imaginary situations—until one rainy day when he succeeds in making her cry by speaking ill of her boyfriend.

What measure is there of pleasure, if not the idea we have been able to form of it in advance? My fingers lay so precisely on the spot that I had marked out

for them that the contact with this unknown flesh did not cause my senses the surprise that should have been its value. I was thinking of only one thing, that I was doing what I had desired and this idea alone exhausted the infinity of my pleasure. [. . .] It seemed that I had suddenly cut myself off from the world and there no longer existed anything but this body that was pouring all its life along my fingers.[38]

Two other motifs as contradictory as they are complementary assert themselves in the course of this text: fidelity, which is cultivated as a value in itself, even if it suffers imperceptible strains (causing the narrator to resort to a "bad faith" clearly indicated at the outset). And jealousy, which triggers the perverse machination. It is when Claire is seen allowing a young greenhorn to caress her that a strategy of revenge has to be pursued: a revenge of the mind on the flesh, the revenge of the manipulating adult on the insouciance of adolescence. All these elements find their place in the 1970 film, but not without a bizarre intermediary step. This is a scenario entitled *The Rose Garden* (La Roseraie), published in the fifth issue (1951) of *Cahiers du cinéma* under the signatures of both Éric Rohmer and Paul Gégauff. The tone has changed. It comes closer to cinematic objectivity, through a division into sequences and a coolly descriptive narrative. In it, we see the emergence of a confidante (Mme de B . . .) whose function is to hear the narrator's confessions. And in it we see especially the sadistic mark of Gégauff, who makes this character a distinguished dilettante who gives the young Claire piano lessons (between sessions devoted to gardening or photography). When she learns that she is pregnant by a boyfriend, M. H informs her of his doubts regarding the boy's fidelity, driving her to despair and suicide. M. H feels no remorse, as this handsome "scoundrel" admits to his old woman friend as he sabers a bottle of champagne at Monte-Carlo—without ever mentioning Claire's knee.

Drastic Measures

Almost twenty years later, Rohmer returned to his original scenario, stripped of the melodramatic pathos that Gégauff had given it. This was the time when Rohmer made up his mind to make a final break with his diabolical mentor of the 1950s. Shortly after *Maud* came out, he went to visit Gégauff and told him, out of the blue: "It's over, I have freed myself from your influence." He subsequently

focused this new story around a minimal psychological question: How was the protagonist (whose first name was now Jérôme) going to manage, with the most honorable intentions, to touch the famous knee? Hitchcock himself would never have dared construct a film around such a slender MacGuffin. And Rohmer had never before had such resources at his disposal, whose deployment contrasted with the modesty of the intention. This was because *My Night at Maud's* had made such a great impression in the United States, as we have seen, especially on a bold young producer named Bert Schneider. He was the son of a big shot at Columbia Pictures who had just dazzled everyone (including even his father) by producing the flagship film of what was soon to be known as "New Hollywood": *Easy Rider.* Thus he had been given a blank check to finance any project he wished, and he chose *Claire's Knee*, which his friend Pierre Cottrell had told him about. As Cottrell told it,

> Columbia made contact with the Films du Losange agent for foreign sales, Alain Vannier (who was a former collaborator of Truffaut's). Vannier told them: "This isn't really a film for you." They insisted, and insisted . . . and finally they offered us a sum that was $500,000 more than the estimated cost of the film! They wrote up a fabulous contract for Rohmer giving him 30 percent of the profits.[39]

These terms were all the more munificent because it took hardly six weeks to film the picture (from mid-June to the end of July 1970) in a single setting, namely Lake Annecy in Haute-Savoie. For the first time, Rohmer had a set photographer in his crew, and he also had a camera dolly (with a zoom lens). He took the time to view the rushes as they came in, and he even allowed himself to refilm a sequence. At the request of his sound engineer, Jean-Pierre Ruh, who had invented a clever system for producing artificial rain, he even allowed himself the supreme luxury of having the mixing started over again. This comfort in the final touches went along with an extreme preparation, Rohmer's weakness, which nothing frustrated this time. Taking his inspiration both from Gauguin's Polynesian paintings and from Murnau's *Tabu* (one of his main references when he was a critic), he planned the interplay among the colors of the actresses' clothes, which were supposed to stand out against the blue of the mountains and the lake, thanks to the 1.33 format. He also played the Great Clockmaker of nature, planning to film the cherry-picking scene only on the day when the fruit was completely ripe. "But the maddest case of anticipation," Barbet Schroeder

recalled, "was for the sequence in which Jean-Claude Brialy leans down to pick a rose. A year earlier, Rohmer had planted the rose at the spot where it was supposed to bloom, calculating the date when it would open, which was written down in the work plan . . . Everything happened as planned!"[40]

Jean-Claude Brialy: there, too, Rohmer prepared the ground long in advance, to ensure the participation of an actor very much in demand. At the time of *Cahiers*, they knew each other and were on familiar terms, and we can guess that it was Brialy's dandyism in the style of Gégauff (a memory of *Cousins*?) that led Rohmer to offer the role of Jérôme to him rather than to Trintignant, who was very eager to get it. The offer was made, moreover, before *My Night at Maud's* was filmed, while Brialy was acting in *La Puce à l'oreille* at the Marigny theater, with Françoise Fabian. Attracted by a text that was already written, Brialy immediately agreed. Two years went by. In the spring of 1970, he received a telephone call from Rohmer asking him to be ready to film the following June, and giving him only a single directive: to let his beard grow. Rohmer's one oversight was forgetting an essential element of Brialy's personality: his taste for luxury. Brialy showed up at the shoot in a chauffeur-driven Rolls-Royce and was amazed to find the spartan room that had been reserved for him. After a sleepless night, he moved to a chic hotel in Talloires.

A Summer Camp

Rohmer discovered the future setting of *Claire's Knee* when he came to Annecy to present *La Collectionneuse*. The filming took place in two villas that corresponded perfectly to the dramatic configuration he envisaged. The one in which Jérôme is supposed to be staying, with its mural frescoes (one showing a "blindfolded Don Quixote" that was to play a role in the final scenario). And the other, where the two girls are spending their vacation, which was in fact to house the whole film crew. It was a leisure center for employees of the company that made Gillette razors. Except for the few privileged people invited to sleep in the house, and except for Rohmer, who was lodged not far away with his wife and children, everyone else stayed in rather uncomfortable little cottages. In one of them, Cottrell went through the rushes every evening on an improvised Moviola. Not content to correct Columbia's extravagances by his obsession with waste (his "collector's drives,"[41] as Schroeder drolly put it), Rohmer insisted on observing

a quasi-military schedule. Rising at dawn, he began with his morning run, and on his way he sometimes woke up his troops. Sometimes the sound recordist disappeared in the middle of breakfast to go off and record birdsongs. As Cottrell emphasizes, "Rohmer had been able to elicit a devotion rarely seen."[42] Even he mysteriously disappeared in turn, only to return hours later and resume the filming at a steady rate.

Photos of the shoot show us a Rohmer who is tense, concentrated, obsessed with the countless details of making his film. But all around him, the atmosphere was that of a summer camp, where everyone yielded good-humoredly to the demands of this rather mad big brother, because Rohmer had the brilliant idea of surrounding himself solely with young people. Fabrice Luchini, for instance, an apprentice actor (and former hairdresser) whom Rohmer discovered in a small role in one of Philippe Labro's films, and who impressed him from the first time they met by reciting Nietzsche to him. He was twenty years old, crackling with intelligence and humor, and he made the whole *Claire's Knee* group laugh until they cried by imitating Rohmer or by developing one of the far-fetched theories that were his specialty—to the point that Rohmer let him improvise his own text in front of the camera, reducing Brialy to the role of a dumbfounded listener. There was also Gérard Falconetti, the grandson of the actress in Dreyer's film *The Passion of Joan of Arc*, whose impeccable physique was displayed in a swimsuit on the lakeshore. His insolence immediately seduced the filmmaker: it was precisely the insolence of Gilles, Claire's arrogant fiancé, responding haughtily to the plebeian campers who dared to walk on his flowerbeds. That sequence was also improvised, as if Rohmer were trying, with each of his young actors, to blur as much as possible the boundaries between reality and fiction.

The same thing happened with the actress playing Claire. But the choice was more difficult, because it was a question of finding "a young high-school student with fascinating knees"[43] (that was the wording in a advertisement in *France-Soir*) who would be more or less capable of playing the role. Several of Rohmer's friends scoured the notable sites on the Left Bank, looking for the rara avis. Until one day one of them spotted, as she came out of the Royal Saint-German hotel, a young woman who seemed to have the desired characteristics. Her name was Laurence de Monaghan. She was a pretty sixteen-year-old blonde, reserved and quiet, who was getting ready to take her baccalaureate examination at the convent school in the rue de Lübeck (not far from Films du Losange). Rohmer visited her respectfully in her parents' apartment, where they engaged in a contest

of timidities worthy of a play by Labiche. Rohmer finally made so bold as to take her to the Trocadero garden, where he photographed her bare knees and her face, which his camera captured as that of a hunted animal. He hesitated. He wondered whether he was going to hire this girl "who is not particularly talented," he recognized, "but who has a voice that I like a lot, but it isn't a theatrical voice. I think I'll take her."[44]

Laurence de Monaghan was not at all an actress and had hardly any desire to become one (it was her mother, a movie lover, who urged her to accept the filmmaker's offer). This made her all the better suited to the confusion Rohmer wanted between the actress and the character, to the point that only the person subsists, in her individual brilliance, instantaneous and ephemeral. Her mentor even took care to warn her against the mirages of celebrity, and he arranged special treatment for her (as he did for other beginners in his film): the opportunity to improvise her text in certain sequences, and even to play with very private feelings in the manner of a follower of Actors Studio. She recalls:

> For the scene in which I was supposed to cry, he had talked to me to put me in the mood, to help me find in myself the emotions I might have felt . . . but without telling me: "At such and such a moment, you will do this." He had put me in a state conducive to tears . . . After the scene was shot, I saw that he was satisfied. But it can't be said that his direction of actors was very clear.[45]

Can one even speak of directing actors? By inviting Laurence to play Claire as her own role, by choosing her clothes from her girl's wardrobe, and by reducing to a minimum the number of takes and the waiting time between them, Rohmer set a clever trap that sought to make his actress forget the presence of cinema.

The Three Muses

Better yet, he gave her the illusion of being the author or coauthor of the film. Today, that status is claimed by Aurora Cornu, who is convinced that she invented her speeches on the spot, whereas they were at most inspired by her particular verbal style. A verbal style that Rohmer knew well, because he had known this Romanian woman of letters for several years and liked her frankness and anticonformism. Together, they spent whole afternoons reorganizing the world on

the second floor of the Café de Flore or visiting Parisian churches. She was even (along with Parvulesco) one of the few people invited to dinner at the home of Maurice Schérer, because he suspected her of not always having enough to eat. Around her, he practiced with delight the art of conversation that was his most constant passion. Thus it was quite natural for him to offer her the role he had once imagined with Gégauff: that of the confidante whose function is to listen to Jérôme's erotic turmoil and hesitations. But he added a supplementary dimension to it that was connected with both the personality and the culture of Aurora Cornu. Aurora (her first name in the film) was to be a novelist, recounting to her interlocutor, in order to stimulate him, a sketch of an abandoned narrative: in it we recognize the episode of hide-and-seek played with the girl tennis players in the first version of *Claire's Knee*. She plays at being God, constructing an imaginary novel in which Jérôme is the main character, and little Laura and her sister Claire as virtual partners.

Why in the world did Rohmer, who was not much inclined to this kind of *mise en abyme*, allow himself for once to embed a narrative in the narrative? The answer must perhaps be sought in a text written after the film came out, entitled "Letter to a critic . . . " Criticism in general was to greet with enthusiasm *Claire's Knee*, the brio of its dialogues, and the beauty of its photography—to the point of awarding it the Louis-Delluc Prize for 1971. At the same time, considering Rohmer's intentions "reactionary" (because he advocated the refusal to take action, within an idle and protected micro-society), Jean-Louis Bory did not conceal the pleasure he found in this fifth "moral tale." He compared it mischievously with Jacques Demy's *Donkey Skin*: "Once upon a time on the shores of a lake . . . The wolf doesn't eat Little Red Riding Hood(s). Not because he's a moral wolf. Because he's a complicated wolf. Eating the pot of butter is enough to make him happy."[46] No, the reproaches came mainly from the eternal defenders of a "visual" cinema who accused Rohmer of lending priority to the word and according little importance to the image. Those were to be the arguments (already heard many times) of a Georges Charrensol or a Pierre Marcabru—who, during a broadcast of *Le Masque et la Plume*, relegated Rohmer to the literary tradition of Benjamin Constant and Jacques Chardonne.

"My cinema, you say, is literary: what I say in my films, I could just as well say in a novel."[47] To which Rohmer opposes precisely what constitutes the nature of his cinema: the diversity of the elements of the world that he limits himself to showing and in which the word plays only one role among others. Although

he recognizes the novelistic origin of the scenarios of *Moral Tales*, he situates it more in the neighborhood of Balzac or Dostoyevsky (authors whose works teem with vivid characters). For him, to make a film is to lend the complexity of life to a linear argument: "I no longer think so much about the latter, which is a simple framework, as about the materials with which I cover it and which are the landscapes in which I situate my story and the actors that I choose to play it. The choice of these natural elements and the way I can hold them in my nets without altering their life forces, occupies most of my attention."[48] At the same time, he explains why he gave up on the commentary that in the first *Tales* created a rather abrupt gap between the narrator's thoughts and his actions. Especially since in *Claire's Knee* the actions are limited to a dreamed-of moment (the one in which it will be possible to touch the knee in question). That is when the woman novelist intervenes, making it possible to analyze after the fact Jérôme's timid audacities, whether they are imagined or real. Through Aurora's mediation, Rohmer escapes from both the conventions of commentary and those of the "confidante," while at the same time pretending to dispossess himself of his narrative. It is no longer the filmmaker (or his double Jérôme) who wanted this whole story, it was an exotic and exuberant demiurge who amuses herself by pulling the strings. While he, the true author, withdraws into the shadows.

We spoke of dispossession. It takes a still more complicated form with the film's second muse: the young Béatrice Souriau, whom Rohmer renamed Béatrice Romand, and who quickly made herself the choice for the role of Laura. Descended from a rather modest pied-noir family, this somewhat rough-hewn girl had nothing in common (except inexperience) with the distinguished Laurence de Monaghan or the haughty Haydée Politoff. However, she pleased Rohmer with her tomboy side, her frankness, and her inexhaustible glibness. With her, he resumed the practice begun for *La Collectionneuse*, which consisted in talking about this and that with his actress, recording it all on tape. This allowed him to use a few of her formulas and reflections in the final version of the dialogue: "I must need paternal or maternal affection. That's why I'm comfortable with someone older. I find in him something like a father. I want to be always at his side, I want to be little with him, I feel good. [. . .] I'm not at all friends with the people I love. That makes me nasty. [. . .] When I'm in love, it occupies me entirely."[49] By making Laura talk with Béatrice's words, Rohmer pursued the previously discussed strategy of delegating his powers to the other person and erasing his own tracks.

He did so at the risk of putting in question his authority as a director. He had to reassert it when a violent argument broke out between Brialy and "little" Béatrice who, right in the middle of filming a sequence, whispered to her elder to look at her. Or when Béatrice complained about the liberties she claimed Fabrice (Luchini) had taken with her, forcing Rohmer to decide between them. With the exclusiveness of her tender years, the teenager pulled every imaginable trick to ensure that she was the preferred one: "During the shooting," she recalls, "Rohmer situated himself in line with the camera, and took delight in watching me act. I was able to act exactly the way he wanted, it was magical, telepathic."[50] She even aroused an emotional response in him, insofar as he seems to have identified with the character of Jérôme. For example, during the trip to Annecy, when he dared to touch her knee and ask: "What effect does that have on you?" A response sufficiently serious for Aurora Cornu, who was a great mystic, to take her friend Éric to meditate in a church, while she poured a few drops of holy water under his temptress's pillow! On reading a letter that Rohmer wrote Béatrice Romand a few months later, we can hardly doubt that he did in fact fall under her spell. But she had flown off to Iran and never received this letter, which was returned to the sender.

> I'm writing to you from an anonymous café in the Saint-Lazare quarter, which will be the setting of my next film. What an idea to film amid the roar and pestilence of motors, when all I had to do was come up with a story that took place on some enchanted island or in a green valley, and to invite my friends to join me there—as we did last year! So far as I'm concerned, it's as if you were currently on the moon. A Persian Béatrice defies the imagination. I can dream only of the one in Talloires, and more precisely, these days, of the one of the first moments of our stay there. But what do you care? I suppose you are sufficiently absorbed by the present; and anyway, I am too—aside from these brief instants of nostalgia—ruminating on the final episodes of *Chloe in the Afternoon*, before picking up my pen to write. I told you that I have to miss something in order to feel like writing. Missing you is probably reason enough.[51]

Between the lines, this tells us everything about the relationship with Béatrice that loomed during the filming on the lakeshore: the dream of an idyll with a girl, the danger of sin barely approached, the return to normal and especially to work—to the point that one wonders whether this parenthesis did more

than nourish the filmmaker's imagination. Not only the imagination of *Chloe in the Afternoon*, as we will soon see, but already that of *Claire's Knee*, which saw Jérôme's feelings with regard to Laura only the better to make them visible.

But one muse can hide another. The true story of *Claire's Knee*, at least the one that gives the film all its weight of embodiment despite the chastity of its theme, was lived by Rohmer some time earlier. We find its point of departure in a little note sent him by Jacques d'Arribehaude, a writer and television man, just after *La Collectionneuse* came out:

> I would like to meet with you as soon as possible regarding a film that a pro-
> ducer and Haydée [Politoff] are interested [in making]. If I could [. . .] choose
> a "master" for my first feature film—if it depended on me alone—it is certain
> that my choice would be you, who enjoy the full approval of the producer and
> the woman friend who had the initial idea for the scenario.[52]

The woman friend in question was Roussia Rotival, a rather capricious Russian who conceived a script entitled *Les Deux Filles*. Against all expectations, against Marcel Carné, and Éric Rohmer, she obtained the prestigious advance on receipts offered by the CNC for 1968. She wanted her project to be carried out by d'Arribehaude (her companion), and she also wanted the "two girls" whom she had imagined to be played by her two daughters. One of these was an enigmatic brunette, the other an extroverted, excitable blonde whose name was Irène.

This is where Rohmer came in. Officially, to advise d'Arribehaude, who had never made a feature-length film, and who, moreover, soon distanced himself from the project to devote his time to television work. Unofficially, Rohmer spent long hours drinking tea with the mother and the two girls in their house in Dreux. Or directing Irène in little amateur films that were supposed to prefigure the work to come, while at the same time he encouraged the teenager to take courses on theater. She had no interest in that. Because she was lazy, to the great despair of her mother, who was eager to make her an actress. Because she was in love, especially, from the moment Éric Rohmer appeared before her. "I was often compared to Jean Giraudoux's Ondine," she recounted.

> I saw him as the knight, Hans. We saw a lot of each other, we spent afternoons
> together. Since I was dreaming of becoming an archeologist, he took me to the
> Tutankhamun exhibition. Then he took me back home, then I accompanied

him back to the Metro, then he took me back home, and so on . . . He told me: "You are the only woman who walks at my pace." I told him I was in love with him, but he replied: "My little Irène, I'm married and I love my wife." "No, you're going to divorce her." My mother (who was rather accommodating with regard to all this) told me: "You have to make Éric dream so that he can write his subjects." I think our affair made him dream.[53]

Who Is Like God?

It was the dream element that nourished *Claire's Knee*, far more than any particular memory. The scenario of *Les Deux Filles*, which was never made into a film, was forgotten; of it there remained in Rohmer's film only bits and pieces of situations. The figure of Irène was doubled through the characters of Claire and Laura. One got the attractive blondeness (and at the same time the ability to arouse jealousy as soon as she takes an interest in a boy of her own age). The other got an intimidating way of throwing herself at an older man. It is as if the filmmaker were playing with these flirtations with girls, Irène Skoblin and soon Béatrice Romand, the better to protect himself from them through the cinematic fiction. What does *Claire's Knee* represent, if not a man who prefers his desire itself to the object of his desire? A triangular desire, according to René Girard, since it asserts itself as if by chance at precisely the moment when Jérôme finds Claire in the company of a man. At the apex of an unfolded ladder that takes the form of a . . . triangle. But for all that it is not a question of stealing the girl away from her young boyfriend but of experiencing around her a more mysterious power. That of staging.

By focusing on the furtive contact with Claire's knee, rather than on the conquest of her body as a whole, Jérôme puts in motion the Freudian mechanism of sublimation and its artistic development. By indulging in spying and manipulation in order to achieve his goals, he acts as a *metteur en scène*, obscurely realizing the ambition of the short story written in 1949: "Who Is Like God?" Let us recall these few lines: "I was thinking of only one thing, that I was doing what I had desired and this idea alone exhausted the infinity of my pleasure. [. . .] It seemed that I had suddenly cut myself off from the world and there no longer existed anything but this body that was pouring all its life along my fingers."[54] The wheel has come full circle, and it even takes us back still further. To the barn

surrounded by rain where as a child Maurice Schérer had seen a little girl crying, and fixed on that image.

But there is another source of information that resurfaces along the way. In a famous passage in his *Confessions*, Jean-Jacques Rousseau described his pastoral escapade in the area around Annecy . . . and the encounter he had there with two girls: Mlle Galley and Mlle de Graffenried. After having led their horses to shelter, and after having dined sitting between them "on a three-legged stool,"[55] the young Jean-Jacques indulged in very innocent games with his new friends. He climbed to the top of a tree and threw down cherries that sometimes landed in a bosom. He made so bold as to kiss the hand of one of the girls, and began to dream about the other as a confidante.

> Those who read this will not fail to laugh at my gallantries, and remark, that after very promising preliminaries, my most forward adventures concluded by a kiss of the hand: yet be not mistaken, reader, in your estimate of my enjoyments; I have, perhaps, tasted more real pleasure in my amours, which concluded by a kiss of the hand, than you will ever have in yours, which, at least, begin there.[56]

By thus giving priority to the suspended time of the imagination, where ordinary mortals would have rushed onward toward the goal, Rousseau was already writing *Claire's Knee*.

The Magic Ray

Rohmer was to deploy these powers of imagination openly in the following film. For him, it was a new challenge to be met, as he wrote in the previously quoted letter to Béatrice Romand:

> By the way, I think I've found my leading man, an actor who has been sidelined and whom I would like to rehabilitate, he's blond, blue-eyed, a little mad: but my earlier characters were too lacking in madness. This film has to be a little crazier than the others, closer to dreams, more sinuous, denser. The background will be the crowd. I'm more and more eager to film it. Tomorrow I'll go back to sit in the same place with my Beaulieu [camera] and film the people passing in front of me. It won't be picturesque at all. It will be very close to a cliché. I like that.[57]

The same year that Bresson made his *Four Nights of a Dreamer* (1971), Rohmer, not yet over his failed encounter with Dostoyevsky, also took his inspiration from latter's story "White Nights," developing the theme of a double life: Can one love two persons at the same time? But first, making his narrator an impenitent dreamer who is fascinated by the flow of urban life and dreams vaguely about women he has met on the street. To this reference to Dostoyevsky we must probably add a memory of Jules Verne, with the allusion to a magical talisman that is supposed to allow the dreamer to attract the desired creatures.

This was to be the most famous sequence in *Chloe in the Afternoon*, in which we can agree to see a fanciful parenthesis in Rohmer's work, which is usually so Cartesian. In reality, it merely prolongs the reflective intuition already sketched out in *Claire's Knee* (and in the short story "Who Is Like God?"): like Jérôme, the Frédéric of this sixth "moral tale" takes up the position of the film director, voyeur, manipulator, and spiritual guide. A guide who bears a striking resemblance to Rohmer when the latter speaks of his actors: "My relation to them is mysterious. I wouldn't say that it is a magnetic phenomenon, but in fact I don't see any other expression."[58] Especially since each of the women desired (and for the most part seduced, thanks to the talisman) emerges from one of his earlier films with the essential attribute that characterized her: irony for Haydée Politoff, outspokenness for Françoise Fabian and Aurora Cornu, hesitation for Laurence de Monaghan—who is accompanied, moreover, by a boyfriend who closely resembles the one in *Claire's Knee*. In one of the first drafts of the scenario we find an explicit definition of this revealing effect produced by the amulet:

> In order to spice up, through a convention, the rules of a game that is too easy, I suppose that the machine can't do anything by itself. It simply deprives my victims of all the false modesty that stood in the way of my logic, and confronts them with their truth. That's why I have to formulate my request differently in each case. And success is not automatic.[59]

Here we are at the heart of the Rohmerian paradox. Even as he asserts himself as a demiurge, as the absolute master of his creation, the filmmaker feels a resistance of the real that proves to be the stronger. A resistance of which Béatrice Romand is the spokesperson, though she was the least wild of the girls in the *Moral Tales*.

When Frédéric (Rohmer?) tries to make her succumb in her turn to the spell he has perfected, she escapes, and that produces the following dialogue:[60]

> **I:** Are you coming with me?
> **She:** No.
> **I:** Why not?
> **She:** I'm going to someone else's place.
> **I:** I . . . uh . . .
> **She:** There's no point in saying "uh"! You won't find any argument. He's the only one I love, I'm happy only with him. That, dear sir, is irrefutable.

A word ("irrefutable") that the actor was to have trouble pronouncing during the postsynchronization session Rohmer wanted (to add to the oneiric side of the scene). But which clearly shows the limits of the dream—limits to which this film quietly leads us.

The Resistance of the Real

If *Chloe in the Afternoon* is a fantasized autobiography of Rohmer, it is also a self-criticism, the most lucid possible. In it, the director represents himself in the figure of a petit bourgeois (Frédéric) who leads a well-regulated life with his wife, his children, and his office. He surrounds himself with pretty secretaries and spends more and more amorous afternoons with a beautiful loser named Chloé . . . until he gets scared and returns, in extremis, to the conjugal home. How can we not see in this an almost transparent chronicle of Rohmer's everyday life? Although he was somewhat older than his character, he too was a young married man raising two little boys. And he too had founded his "company": Films du Losange, with an associate played on the screen by Daniel Ceccaldi. He too—and this is the main thing—divided his time between evenings spent at home with his family, working in his office, and empty stretches: the ones he spent in the metro and on buses, inventing adventures for himself. Or afternoons spent talking, over a cup of tea, with young women who were virtually (borderline) actresses. On the one hand, real life, under the name of Maurice Schérer, with all its weight of tenderness, fidelity, and obligations, and on the other the dream life, under the sign of Éric

Rohmer, in which adolescence is prolonged through meetings with women that never have any consequences. And without these two parallel arcs having the slightest chance of intersecting.

"You've never dreamed of living two lives at the same time, simultaneously but in a complete and perfect way?" "That's impossible." "It's a dream." This dialogue between Frédéric and Chloé inaugurates a theme that was to run through all of Rohmer's subsequent work. Up to that point, the crucial question (which was to remain crucial right to the end) was that of the choice: Françoise or Maud? Laura or Claire? Starting with *Chloe in the Afternoon*, it was accompanied by a utopia of doubling, as developed in *Full Moon in Paris* and *Triple Agent*: a mad hope of escaping the limits of the conjugal bond, of identity, as if one could be several persons at once. Not the temptation of adultery in the classic, boulevard-comedy sense of the term. In Frédéric's flirtation with Chloé, we divine a tacit contract that prescribes the impossibility of a conclusion, as in the filmmaker's light-hearted gallantries with the creatures who passed through Films du Losange. We have seen it in the romantic episode with Irène Skoblin and also in the more nefarious episode with Béatrice Romand: if Rohmer liked to play with others' desires or with his own, that was only in order to reaffirm his attachment to his wife, as well as an inalienable free will.

To be sure, we could discuss (and people have not failed to do so) the gap between the logos and the libido, as it is manifested more obviously than ever in Frédéric. And of course we can only be impressed by the sequence in which Frédéric races down a staircase to avoid risking a carnal union with Chloé. Especially since on this occasion Rohmer uses a Hitchcockian high-angle shot the better to emphasize his alter ego's panic. But at the same time he reveals a profound truth that is in any case his own and that of his characters: the idea that "freedom expresses itself by limiting itself,"[61] that among the profusion of possibilities and the choice of the One, there is a necessary balance through which it is important to safeguard one's mental health—and certainly one's freedom. What Frédéric is fleeing when he runs away from Chloé is perhaps less carnal sin than the threat of being caught in a trap, confiscated by the other, torn away from his position of an eternal dreamer. By taking refuge in the arms of his wife, he recovers the right to construct castles in the air, as the verses from La Fontaine soon to be quoted as an epigraph to *A Good Marriage* put it. And as is magnificently suggested, as the couple slips away to make "love in the afternoon," by the final panoramic shot of a window.

The Foreseen Unforeseen

If Rohmer reveals himself here more than in any of his other films, as one might expect, he does not do so without modesty or reservations. Or without hesitations, as Pierre Cottrell testifies: "Where he lost his grip a bit was in the organization of the shooting: it didn't go smoothly, as usual. At certain points he said: 'No, we'll stop there for today.' It was probably connected with the subject of the film."[62] This uneasiness reached its apex when he had to film the erotic sequence between Chloé and Frédéric. He began by arranging the naked body of his actress on the bed. He blushed with embarrassment and went to find his male lead, Bernard Verley, and asked him to do it for him. Once it was done, Rohmer was heard to cough from the upper floor, to which he had retreated: "It's fine like that!" Verley recalled that:

> Leslie Caron was visiting the set, and she died laughing. He had put himself in the position of a voyeur, whereas he had every right to occupy that of the director . . . During the whole shoot, he was very cool toward me, even though he had earlier been quite warm. It was only when the last shot was done that I saw him relax: "How are you?" For a moment, he had projected some aspect of himself onto me. I was his double to some extent.[63]

To make Bernard Verley his double, and thus avoid making the confession too obvious, Rohmer developed a strange strategy. Faithful to his taste for following people around, for the "position of a voyeur" his actor talks about, he spread a vast spiderweb all around the latter. First, by consulting a rich collection of images of him put together by Pierre Cottrell's wife, who worked for *Paris Match*: photos of him on television, in Edmond Rostand's *L'Aiglon*, the day of his marriage, and so on. What was it he found so attractive in Bernard Verley? It was certainly the "rather mad" side he had stressed in his letter to Béatrice Romand, combined with a massive physique that resembled that of the Gaullist minister Olivier Guichard. A mixture of romanticism and banality that went well with the character's ambivalence. Thus Rohmer was to spy on the actor, observe his habits in the bars of the Saint-Germain quarter, and especially in the Café de Flore (where he was a member of the "Pouilly Club"). As soon as Verley agreed to play the role of Frédéric, everything was done to make him see in it not a role

but a pure and simple continuation of himself. Rohmer took him to the ninth arrondissement and showed him a building: "This is where your office is." One morning he asked Verley to meet him at 7 A.M. in a café across the street from the Saint-Lazare railway station. Treated like a regular customer, Rohmer asked Verley: "Do you see that escalator going down into the station? Among the people who are going to take it, you'll see three blonde women, one after another. You have to go down the escalator among them, if possible in the third position, in front of the third one." Prepared in this way, the scene was filmed the next morning by Rohmer with his little 16 mm camera. According to Verley, these young women had been spotted earlier by Rohmer and were completely unknown to him. According to Cottrell, Rohmer recruited a woman who was only apparently unknown to him, Tina Michelino, who was supposed to be surreptitiously filmed by the young assistant camera operator Philippe Rousselot. However that may be, Rohmer's obsession was satisfied: he had thrust his actor into a lie that looked for all the world like truth.

Four months before filming began, the scenario of *Chloe in the Afternoon* (the only one of his *Moral Tales* that Rohmer did not take from a preexisting short story) was finally ready. But there was still some uncertainty regarding the actress who was going to play Frédéric's wife. Rohmer remained evasive on this subject until one day he told Verley: "I've seen photos of your wife, she could act in the film . . . with your daughter, maybe?" Verley: "She's just a kid!" Rohmer: "At her age she won't understand." And even if Françoise Verley was not an actress (she had worked as a stylist and cover girl), she only enhanced the main actor's immersion in a familiar environment. Not without a slight discomfort: when she appeared on the television program *Aujourd'hui madame* after the film was released, she took pains to distinguish her real-life marriage from the one that appeared on the screen. Bernard Verley was less categorical. Even today, in this bizarre alchemy, it is hard for him to sort out what belonged to his private life and what belonged to Rohmer's imagination:

> He was a thief who stole chances, on the lookout for the foreseen unforeseen. He had reflected at length on people's obsessional character, on the acts they repeat, on their reactions . . . He took advantage of that, and also of chance, which contributed a slight difference (it was that difference that he elicited). Thus because it was hot, I was the one who suggested the detail of the sweater in which my head is framed . . . but I knew that in doing that, I was completely Rohmerian! He's

someone whose fiction is so strong that it coincides with reality. And who forces
you to enter into his fiction while at the same time retaining your real face.[64]

To complete this identification, Rohmer gave Verley another partner he knew
well, and with whom he had maintained for years a virtual flirtation compa-
rable to that between Frédéric and Chloé: Zouzou, the muse of Saint-Germain-
des-Prés. On several occasions Rohmer had already considered using her as an
actress: for instance, in *La Collectionneuse*, before he decided on Haydée Politoff,
and in *Les Aventures de Zouzou*, one of his numerous unrealized projects in the
1960s. It was on seeing her again in a short film made by Dennis Berry and at
a New Year's Eve dinner in 1970 that he decided to offer her the role of Chloé.
An unexpected choice, because she had neither the suaveness nor the sweetness
peculiar to Rohmer's women (with the possible exception of Béatrice Romand,
of whom her poise and freedom of manners reminds us). It was precisely this
radical alterity that fascinated him. The fact that her presence was so jarring
amid the bureaucratic grayness in which his double had been set. "I wanted
there to be a clash between Frédéric and Chloé," he explained to Jacques Siclier,
"so that people would say to themselves: they don't make a good couple, those
two. I wanted to show that they weren't made for one another. Here, the tempta-
tion has to be something surprising."[65] In this way, Rohmer finished disguising
his autobiography under the mask of a documentary: a documentary on the
generation that came out of May 1968, with its vague aspiration to happiness and
its refusal to enter into the boxes left to them by their elders. Even more than
Haydée, Chloé (from whom Zouzou also took care to distinguish herself, at least
in interviews connected with the film) will remain as an almost Balzacian type.
"The slut," as the actress sums up the character. "The professional slut."[66] How-
ever, there is no trace of Balzac the preacher: Rohmer limits himself to showing,
as he had in *Nadja à Paris* and *Une étudiante d'aujourd'hui*, a female model that
was emerging and whose bloom must not under any circumstances be hindered.

Interiors

We have spoken of the documentary. This dimension is very present in the pro-
logue, with its sequences showing the train trip or the stroll around the Saint-
Lazare quarter (combined with an erotic reverie that anticipates Truffaut's *The Man*

Who Loved Women). As we have seen, these "stolen" shots were in fact carefully prepared, and in them Rohmer cultivated a fragile alliance of premeditation and improvisation, though he sometimes had to choose sides, notably regarding Chloé's room. The latter is so precisely described in the scenario (with its door next to the shower, and the other one that allows Frédéric to slip away) that there could be no question of filming it anywhere but in the studio. The scenes in the office also had to be filmed in the studio, in order to avoid traffic noises and the excessive number of takes they made necessary. Nestor Almendros was not unhappy to be filming under these conditions, because they helped him cope with variations in light. He even suggested moving from one season to the other, which a natural setting would not have allowed in such a short time frame (these interior sequences were filmed in two weeks after the outside sequences, which had been finished in the fall of 1971). Rohmer was less comfortable, and this unease influenced his direction of the actors. "Even if the set was realistic," Verley explained, "it rang a little false, because of the fictional and conventional aspect the studio involved. Rohmer would have been much cooler with Zouzou had we filmed in real settings—and she herself would have been more on the mark. I recall having made as many as fifteen takes with her!"[67] That was unusual, to say the least, given Rohmer's ethics and thriftiness.

After the success of *Claire's Knee*, Columbia allied itself again with the "small business" of Losange. Making a virtue of a necessity, Rohmer transposed his maniacal verism to the Boulogne studios, as he was to do in the case of the pictorial and digital framework of *The Lady and the Duke*. Not without taking a secret pleasure in this trompe-l'oeil effect, this impure mixture of genres. On the one hand, he had the two secretaries played by young women who had really worked as secretaries. On the other hand, he had the office's windows covered with enlarged photos that were supposed to represent the streets of Paris. Chloé's room was decorated in a deliberately banal style—but the better to set off the actress's nudity; she seems to have come straight out of one of Ingres's paintings of a harem. At each step in the creation of his film, Rohmer thus combines illusion and reality, as if cinema allowed him to reconcile his conflicts.

A Moral Tale?

Through all these shortcuts, *Chloe in the Afternoon* sketches a miniature portrait of a period. A chronicle of Pompidou's France, which was sinking into the

"boredom" denounced by Pierre Viansson-Ponté at the same time that it nurtured dreams of escape in which the flare-ups of 1968 vaguely survived, confining itself in ordinary ugliness while continuing to pursue the fantasy of a beauty that rises up out of nowhere. This mirror effect was to create a certain confusion among critics, who held different views regarding the author's intentions. Some of them (and they were many) saw in it only a defense of old values:

> This chamber cinema is ultimately the equivalent of boulevard theater. A modernized boulevard, repainted and redone in accord with today's taste, but that cannot see beyond its little bourgeois horizon, a sentimental microcosm closed in on itself, atemporal, completely cut off from reality. The qualities of the style do not make up for the vacuity of the intention, which, on the pretext of studying characters, is very comfortable with the dominant morality.[68]
>
> Rohmer raises human problems in moral terms: that is the contrary of a left-wing attitude. [. . .] In this little world, moral behavior seems to be determined solely by the characters' will: it is a deracinated, idealist, and thus finally reactionary view.[69]
>
> The moral tale becomes moralizing—and reactionary. If there is to be love in the afternoon, it will be with the missus. The fun will be conjugal or it won't exist at all.[70]

These last lines were written by Jean-Louis Bory. That did not prevent him from continuing to defend Rohmer's cinema, including on the television program *Le Masque et la Plume*, where *Chloe in the Afternoon* was the subject of a fierce debate: unlike Bory (who praised the rigor with which Rohmer developed his point of view), Pierre Billard could see only the deficiencies of the mise en scène and the cowardice of the main character. Off the record, Jean Eustache did not hesitate to express his irritation: "A man who flees a naked girl! I don't understand it at all." On the other hand, some commentators went into raptures over the figure of Chloé, who incarnated, in their view, a challenge to patriarchy:

> Every great period of civilization is necessarily marked by feminism, and thus by eroticism [. . .], thus by the perturbation of all values [. . .] In this respect, Rohmer is both one of the most modern of our film directors and—perhaps without knowing it—one of those whose work is most revolutionary.[71]

This feminist and leftist reading gave rise to a delicious misunderstanding at the New York Film Festival, where Rohmer, making an exception to his usual rule, had gone to present his film. He was accompanied by Pierre Cottrell, who for the nonce delegated his functions as interpreter to Pierre Rissient. The latter faithfully translated the filmmaker's remarks, to the great dismay of the woman journalist, who wanted to hear a discourse promoting the emancipation of women. She accused Rissient of distorting Rohmer's thought, Rohmer defended his translator, and the discussion became heated. Rissient recalled: "The questions intimidated him, he began stammering, and it all got out of hand: the woman was angry, Rohmer was angry that she was angry, and I was having a good laugh."[72] There were many other interviews, especially for television, where Rohmer appeared with a small mustache that fooled no one. He greatly enjoyed this stay in America. While Zouzou was getting ready to pal around with John Cassavetes (at the Los Angeles Film Festival), Rohmer made friends with Bob Rafelson and met many other people. This effervescence was connected with the very favorable reception of *Chloe in the Afternoon*. It was to become the most successful of the *Moral Tales* in the United States.

Was this another misunderstanding? The popularity of *Chloe in the Afternoon* on the other side of the Atlantic seems attributable to extra cinematic grounds, the thrills and chills of adultery French style, all the more exciting because it was not consummated. In any case, that was the dimension remembered by the African-American comedian Chris Rock in his 2007 remake of the movie (under the title *I Think I Love My Wife*). Rohmer's name is not mentioned anywhere in the credits, and the action is transposed into the New York business world. However, the main lines of the original scenario are respected—with one important difference: sex. Sex separates the husband and the wife because they have not made love in ages, and that makes the husband want to see what else might be on offer (even at the price of a conjugal happy ending). The 1972 film did not dot the i's and cross the t's as clearly, and Rohmer denied that he had intended to plead in favor of marriage *or* free sex. As we have said, the true theme of this last "moral tale" is more enigmatic, and that is why it has elicited so many contradictory interpretations. It is Rohmer's most self-reflective film, the one in which he questions the powers and limits of fiction, the one in which he moves into a new position that he was soon to make his own in the *Comedies and Proverbs*: that of the spectator.

7

On Germany and the
Pleasure of Teaching

1969–1994

Around 1970, Éric Rohmer's standing changed entirely. The unexpected and phenomenal success of the three last *Moral Tales* marked a turning point. In three years, Rohmer not only made three important works but also attracted almost three million spectators, among whom his reputation, especially in the United States, Japan, Italy, and Scandinavia reached its apex. It was a kind of paradox and at the same time an irony of history, even a kind of revenge taken on fate: at the very moment when the first leaders of the New Wave—Jean-Luc Godard (who disappeared from the screen for ten years), François Truffaut (who was undergoing financial and personal crises), and Claude Chabrol (who was usually forced to work on commission)—were encountering obstacles and suffering defeats, Éric Rohmer seemed to be the true survivor of the New Wave, even if belated. He was not a popular filmmaker but the author of a particular kind of film that is undeniably personal, uncompromising, and demanding and that benefited from an unparalleled public response. *My Night at Maud's* attracted more than a million spectators, while *Chloe in the Afternoon* drew a little less than a million, and *Claire's Knee* almost 700,000. The filmmaker invented a successful genre of which he was long to be the sole practitioner: the "Rohmer film."

Rohmer's Changes in His Fifties

This success obviously had repercussions for Éric Rohmer's professional and private life. First, it allowed him to set up Films du Losange in more spacious and

comfortable offices. When Barbet Schroeder married in 1968, the production company had to move out of the part of the family apartment on the rue de Bourgogne that it had occupied since its beginnings. It initially moved to number 6, rue Jean-Goujon, near the Champs-Élysées, where Schroeder, Cottrell, and Rohmer shared two unprepossessing rooms that had earlier served as maids' quarters. In late 1969, the first dividends from the triumph of *My Night at Maud's*, and especially sales abroad, allowed Films du Losange to move a few hundred meters away, to avenue Pierre-Ier-de-Serbie, an opulent, quiet street that leads from the place d'Iena to avenue George-V. In the substantial building at number 26, Alain Vannier, one of the best agents for French films abroad, especially those of Truffaut and Rohmer, had his offices. He told his friend Barbet Schroeder that the offices on the other side of his landing were going to become available. Films du Losange moved to avenue Pierre-Ier-de-Serbie, where it remains forty-five years later. Rohmer gave himself a small office in which he placed an austere wooden table, facing the window. Just behind him was a bookshelf, in which books on film and the fine arts were dominant. It was also there that he kept most of the files concerning his films, whether completed, in progress, or planned. At the back, there was a small room that served simultaneously as a kitchen, a bathroom, and a storeroom. Schroeder and Cottrell also worked there, and Losange was finally able to employ a full-time secretary, Cléo. The production house did not grow larger until a dozen years later, in the early 1980s, at the urging of Margaret Menegoz, buying other offices in a building at number 22 on the same avenue. Éric Rohmer was to have a second office, just as austere, which was reserved for professional meetings, while the office at number 26 was used for meetings with his friends.

With part of the money from the advance Columbia had made to finance *Claire's Knee*, and the guarantee of 30 percent of the profits, Éric Rohmer was able to buy a private apartment, paid for in cash, into which he and his wife and two children moved. In spring of 1970, he found, in a quarter where his Paris roots were located, a ninety-square-meter apartment. It was in a building at 4 bis, rue d'Ulm, right next to the Panthéon, not far from the Henri-IV lycée where he had studied, and almost across the street from the Cinémathèque française where he had seen so many films. The apartment was more spacious than the one on rue Monge, and each of his sons could have his own room, as could Rohmer and his wife. But the whole apartment remained rather spartan: a very simple dining room adorned with one or two paintings in the classical style,

waxed parquet floors, a small office where the master's armchair was placed facing the window, a modest bookshelf in which Rohmer's favorite authors were predominant, notably Balzac, Jules Verne, Dostoyevsky, and a corner holding an increasing number of videocassettes of films and plays recorded from television starting in the 1980s.

On May 18, 1970, shortly after Rohmer and his family moved to the apartment on the rue d'Ulm, Rohmer's mother, Jeanne Schérer, died at the age of eighty-four. He had remained close to her and had never stopped seeing her throughout his life; the shock of her death was severe. "She had a strong personality," Laurent Schérer, her grandson, recalls. "She was rather cultivated, traditional, Catholic, with set ideas, very attentive to the fate of her two sons, and very considerate regarding her grandchildren."[1] For the filmmaker, it was also a kind of liberation: let us not forget that he never wanted, or dared, to reveal his true personality to his mother, and that the fiction of Maurice Schérer, a teacher of classical literature in a good provincial school, was always maintained. Jeanne Schérer died without knowing Éric Rohmer, and this is confirmed by Laurent Schérer: "My grandmother did not know about my father's filmmaking activities, which she never for a minute suspected. She thought he was a schoolteacher. Making films was unthinkable for her."[2] For a long time, the discreet Rohmer refused to do interviews for television. It is certain that after spring of 1970, he felt more comfortable asserting his personality as a filmmaker. For the first time, he allowed himself to be filmed in a few television documentaries. During the summer of 1970, he even lodged his family not far from the site where *Claire's Knee* was filmed, on the shores of Lake Annecy.

However, the success of the last "moral tales" did not produce any deep changes in Éric Rohmer. To be sure, his life was more comfortable and he was no longer needy, as he might have been, or feared to be, at certain times during the 1960s. But the major recognition that he finally received, at the age of fifty, did not cause him to claim a place and a way of life that were not his own. It could even be said that paradoxically, a strange uneasiness took hold of his mind, as if he had persuaded himself that these successes were going to be merely ephemeral. The new quarters, both professional and private, taken up in 1969–1970, did not prevent him from having questions, worries, and fears. For example, he did not seek to exploit the "genre" of films that he initiated or to profit from his undeniable skill in the domain of the moral fable with its elegant and sophisticated emotional distress. He had no intention (at least immediately) of launching into

a new cycle of tales, which he considered as too easy and showing a lack of curiosity or daring. To his hesitation regarding which professional career to follow must be added a desire to diversify his activities and the fear that his inspiration would dry up.

Three personalities coexisted in Rohmer: the teacher he had always dreamed of being, the filmmaker curious about everything, and the man without imagination. When in 1974, at the end of an interview for the review *Écran*, Claude Beylie asked him how he would describe himself, Rohmer replied:

> I have in reality three activities: (1) the cinema; (2) teaching cinema, which is a kind of theoretical reflection; (3) a more open pedagogy, teaching through cinema. I did that for educational television, and now I am doing it in the service of research. I am very happy with this triple vocation, because I don't want to confine myself in a personal universe that is a pure fiction. I seek to retain, in every possible way, contact with the world.[3]

Rohmer, Murnau, and Germany

If, after the *Moral Tales*, Rohmer the filmmaker was uneasy, going through a "period when inspiration dried up,"[4] the two other Rohmers, who were more Schérers through their rootedness in the world, were able to provide solutions for him. The teacher found a way of making use of his taste for "theoretical reflections," and the curious pedagogue saw a field of exploration opening up in which he could deploy his research. At the University of Paris-I, in the wake of the reforms and innovations that followed May 1968, the Department of Arts and Archeology, directed by Étienne Souriau and housed at the Centre Michelet, a fine Moorish building of red brick at the top of the boulevard Saint-Michel, decided to start a program of instruction in cinema that was entrusted to Jacques Goimard, who put together a small team. An anti-conformist figure within the university and a great specialist in genres that were still considered "minor," such as science fiction and crime novels, Goimar asked Rohmer to join his team. Rohmer accepted with enthusiasm, and in November 1969 he began teaching as a lecturer.

In order to have a better academic status and so that he could be elected assistant professor and thus get a permanent position and a salary, the "young"

teacher decided to follow Goimard's recommendations and undertake a doctoral program that involved three years of research followed by the submission of a thesis the candidate had to defend before a committee. A few years earlier, in 1963, Rohmer had already had that idea, as we have seen, when he was looking for work after his departure from *Cahiers du cinéma*; he had contacted Étienne Souriau at the Sorbonne and Edgar Morin at the École des hautes études en science socialesregarding a proposed thesis on "The Evolution of Myths in American Cinema since 1945." Six years later, he changed his subject and chose Friedrich Wilhelm Murnau. The professorial ideal Rohmer had persistently maintained now took him beyond the Rhine.

Rohmer had a certain predilection for Germany. He was imbued with Germanic culture. Since his school days, he had known and read the language of Goethe, whom he admired along with the principal German authors of the early nineteenth century, Heinrich von Kleist, Friedrich von Schiller, Novalis, Jean Paul, Friedrich Schlegel, and Friedrich Hölderlin. Charles Tesson was perfectly right when he pointed out, in *Cahiers du cinéma*: "Rohmer [is] with Godard the great Germanist of the New Wave, not only because of German cinema (Murnau, Lang), but also because of German culture (art, philosophy, literature) and its political history."[5]

In Rohmer's archives we find many testimonies to this German culture: from notebooks full of vocabulary to dozens of books in German; texts and letters written directly in German; notes taken on films, novels, poems, philosophical treatises, press clippings (notably from the *Süddeutsche Zeitung*, a center-left national newspaper published in Munich, which was enlightened and cultural, and which he preferred); and translations he had done, transcribing into French quite a number of extracts from Goethe, Kleist, Hegel, Schiller, and even from the contemporary dramatist Heiner Müller. There are also illustrated books on Bavarian castles and maps of the Tyrol, where the Rohmers spent family summer vacations in the mid-1970s, hiking in the mountains. And even an unrealized television project dating from 1977: a Franco-German coproduction for which the filmmaker, in the cultivated and elegant company of Jean José Marchand, hoped to take his inspiration from interviews given by Ernst von Salomon, the author of *The Outlaws*, to the *Archives du XXme siècle*, a program broadcast by the ORTF.

In an interview with Jean Douchet, Rohmer talked about this "German tendency" in his personality, his culture, and his work: "I think that philosophically I belonged to the school of transcendental idealism descended from Kant via

Hegel . . . and perhaps even through Marx, though I was not a Marxist. There was literature, of course, Goethe or Kleist. And I was also very imbued with German music."[6] His younger son, Laurent Schérer, who was an adolescent during this period, testifies to his father's regular use of the German language: "He liked Latin and German. He'd begun German in lycée, and his father, who was of Alsatian origin, spoke it. On the other hand, though he spoke a little English and could read it, he didn't like that language. In the early 1970s, he took a few more German lessons in order to be able to read Kleist and Goethe easily in the original. He read German and wrote it, but didn't like to speak it very much. If he had to, he launched into plays on words, often to make jokes, between the two languages, charades. I recall that on a walk in Austria, another walker spoke to him in English. He replied in German: 'Excuse me, I don't understand very well, What dialect are you speaking?' During these vacations in the Tyrol, he read the local papers, and did crossword puzzles. We kids also studied German at lycée."[7]

By choosing Murnau as his thesis subject, Rohmer was faithful to his German training, both intellectual and artistic, which he continued in a "German period" in his work and his life. Thus he went through the 1970s under that influence: *Faust*, *The Marquise of O*, *Catherine of Heilbronn*, but also lectures, stays in Germany (at least a dozen, usually for a few days, to work on his thesis and films), a film made in Franconia, and vacations in the Tyrol. Above all, it was a source of inspiration for several projects, between two cycles that are more French, the *Moral Tales* of the 1960s and the *Comedies and Proverbs* of the 1980s.

It was not the first time that Rohmer had taken an interest in Murnau. He had chosen him as one of his great authors during his time as a critic, devoting to him (in part or in whole) four major articles, "Le Cinéma, art de l'espace" in 1948, "L'Âge classique du cinéma" in 1949, "Vanité que la peinture" in 1951, and "La revanche de l'Occident" in 1953. Rohmer discerned a paradox: Murnau's is a cinema of emotional turmoil through the mastery of space, in which everything is shown without pathos, without sentimentalism, thanks to "vibrant plastic expression"[8] alone, that is, the movements, displacements, gestures, looks. This expression of the invisible through the visible—a "cinematic visible"[9]—of a beauty by the occupation of space, of the soul by outward behavior, is Murnau-style turmoil par excellence.[10] In his very first text, Rohmer wrote:

> It is fitting here to render very special homage to F. W. Murnau, who is not always accorded, for lack of more frequent showings of his work, the place he

deserves among the great film directors, a place that may be the first. [...] Murnau was not only able to avoid any concession to the anecdotal, but also to dehumanize subjects that appear to be the richest in human emotion. [...] All the elements that might draw our attention to something other than this immediate registering of the transcendence within the sign are eliminated. *Nosferatu, Tartuffe, The Last Laugh*, the admirable—and yet greatly disputed—*Faust, Sunrise*, and the "fictionalized documentary" *Tabu* reveal, through the totality of the shots, the richest cinematic imagination of all.[11]

In this article, Rohmer outlined, as it were, his thesis project twenty years in advance: tracking down in "the totality of the shots" that "cinematic imagination" that neglected the accessory in order to materialize concepts in space. It even signaled Rohmer's interest in *Faust*—"admirable and yet greatly disputed"—an adaptation of Goethe's myth dating from 1926.[12] That is the film that in the end he chose as the subject of his thesis in the autumn of 1969. Rohmer gave three reasons for this unusual choice:

> It was not a greatly-admired film. It was less well-known than *The Last Laugh, Nosferatu, Sunrise*, etc.[13]
>
> In it, the construction of the image is constant and fascinating to dissect: the arabesque is very easy to bring out.[14]
>
> This film was available at the Cinémathèque française, which kindly obtained a copy of it for me.[15]

Faust is in fact not a popular film. An immensely ambitious project, it was prepared and made over a period of two years by dozens of technicians, set designers, costume designers, lighting engineers, and actors put under the maniacal, persnickety direction of Murnau. The film disappointed critics right from the outset. Its bad reputation subsequently relegated it to the second rank in the order of its author's masterpieces. Georges Sadoul, in his *Histoire générale du cinéma*,[16] dispatches it in two lines, and criticism in general has reduced the film to an academic pictorialism made starchy by the dreary presence of Gösta Ekman, the actor who plays Faust. Rohmer sometimes liked to restore damaged reputations, a nonconformist taste, an offbeat form of originality that naturally led him to *Faust*.

A large part of his work on his thesis was to consist, in addition to extremely erudite bibliographical research,[17] in analyzing each image precisely, describing

and reproducing with drawings the 620 shots assembled by Murnau. For this task, he took as his point of departure the Danish copy at the Cinémathèque française, lent him by Henri Langlois, which he viewed shot by shot on the editing table installed in an office at Films du Losange. But Rohmer dug up two other copies, which he viewed by traveling to where they were. The first, which was English in origin, was in Brussels, at the Cinémathèque Royale of Belgium, directed by Jacques Ledoux. It had five additional shots. The second, which was German, was found at the Deutsches Institut für Filmkunde in Wiesbaden, directed by Eberhard Spiess. It is interesting, because it includes a whole new scene, in which Mephisto (Emil Jannings) pulls the petals off a sunflower in the presence of the widow Martha.

Based on this meticulous division, Rohmer's analysis distinguishes three spaces in the film—a pictorial space, an architectural space, and a filmic space. Murnau's *Faust* had long been considered an essentially pictorial enterprise, with its chief ambition being the cinematic reproduction of the paintings of German or Dutch masters, notably Dürer and Rembrandt. Rohmer's project seeks first of all to dissipate this ambiguity by focusing his reading on light and movement. Murnau is indeed a painter, but not a pedant whose goal is to reproduce paintings. Instead, he is a film director who is essentially pictorial, who "paints" with light and movement. Light "shapes the form, sculpts it," Rohmer writes. "If *Faust* is the most pictorial of films, that is because the combat between shadow and light constitutes its subject. The filmmaker, without abandoning his principle of humility, seems to be there only to record this act of creation."[18] As for movement, it gives rise to the lines of force in the structure of space in Murnau's work. What Rohmer demonstrates in his thesis, with the meticulousness of his shot-by-shot analysis, is the extent to which in *Faust* space is organized by a dynamics, and indeed by contradictory dynamics revealing the profound nature of the characters, of feelings, and of the great narrative frameworks.[19]

Thus body language, far from any kind of theatrical rhetoric, is a "direct manifestation of a character's emotion that would find no outlet in words."[20] According to Rohmer, the love scenes are conceived as combats in which sometimes the man, sometimes the woman is the attacker or the attacked, the pursuer or the pursued."[21] The thesis brings all these movements together in a twofold schema of convergence/divergence and of attraction/repulsion in relation to an apparent or hidden center, which he calls the "privileged directions," the true heart of his demonstration. "These movements," he writes "sometimes centripetal,

sometimes centrifugal, appear to be endowed with a dramatic efficacy and a certain symbolic power. They signify expansion, blossoming, generation, or on the contrary, withdrawal, fading, death. Or again Good and Evil, God and Satan, light and darkness."[22] All the themes in *Faust* obey this dynamic schema. "Never," Rohmer goes on, "has any filmmaker succeeded in painting inner emotion so intensely through the pure play of forms in space."[23]

This thesis, described as a "study in plastic expression,"[24] was deposited in two volumes at Paris-I's thesis office in November 1971. The first volume contains a 142-page text entitled "L'Organisation de l'espace dans le *Faust* de Murnau (l'espace pictorial, l'espace architectural, l'espace filmique)"; the second contains a complete shot-by-shot dissection of the film, serving to support his thesis. The form is perfectly academic but the style remains classically Rohmerian, sometimes taking on an "erudite stuffiness."[25] In two years, Rohmer the thesis writer was able to achieve his aims, while at the same time directing two films, *Claire's Knee* and *Chloe in the Afternoon*. His thesis defense took place simply and discreetly on January 14, 1972, before Étienne Souriau, his thesis director, and Jacques Goimard and Jean Mitry, the members of the committee. The candidate sat alone, facing the rostrum; the room was otherwise empty, because contrary to custom, Rohmer had invited neither his family nor his friends. He was awarded top honors and received the thesis committee's congratulations.

In theory, this work was not intended for publication. However, Jean Collet, a critic and a friend of Rohmer's, proposed that the Armand Colin publishing house bring it out in a collection that he directed. Rohmer accepted, but the publisher rejected the project at the last minute, in June 1974, having decided that the book was "excessively specialized."[26] Pierre Lherminier then took it over, including it among the books to be published by the new company he was then founding under his own name. But he too had to abandon the project a year later. Finally, Rohmer's thesis, which was in fact rather austere, was brought out by Christian Bourgois, who directed the Union générale d'éditions and its paperback series, 10/18. On October 12, 1976, Bourgois wrote to Rohmer:

> This summer I read in *Études* a very fine article on your latest film [*The Marquise of O*], and the author [Jean Collet] drew publishers' attention to your thesis, but I didn't dare make a decision. I currently have more than two hundred contracts in advance, that is, enough for two years of production at the current pace of publication in the 10/18 series. Thus it is difficult or even impossible

for me to make further commitments. But last evening, as I was watching and listening to Peter Stein's admirable mise en scène [Gorki's *Summerfolk*, at the Odéon theater], I thought a great deal about you, because I was reminded of the actors in your film, and said to myself that a publisher worthy of the name owed it to himself to take chances, despite his financial problems, otherwise publishing was in danger of becoming the repetitive activity of a fearful bureaucrat. I therefore propose to publish your fine text next June. And to demonstrate my proposal, I am sending you a draft contract.[27]

L'Organisation de l'espace dans le Faust *de Murnau* was in fact published in 1977 in the 10/18 series directed by Dominique Rabourdin.[28] At the same time, *Avant-scène cinéma* published Rohmer's complete dissection of the film in a special number on Murnau.[29]

Although the book did not sell many copies, it nonetheless earned Rohmer the congratulations of Robert Chessex, a Swiss who had been Murnau's assistant for four months in 1925, during the filming of *Faust* in the Universum Film AG studios at Tempelhof. Rohmer went to meet him in November 1977; he visited Chessex at his home on the heights above Lausanne, where the old man showed him photographs, working documents, and valuable information regarding the many special effects Murnau had used to film the most spectacular scenes in the film: when the plague ravages the city and the Devil and his horsemen pass through on their way to the diabolic pact made with Faust.[30]

In Germany and France, Rohmer received regular invitations to speak about Murnau and *Faust*, which he accepted without too much reticence. As much as the filmmaker disliked presenting his films in public, the professor showed considerable willingness to give lectures in a strictly academic framework. Thus he traveled to the complete retrospective of Murnau's work mounted by the Kommunales Kino in Frankfurt[31] to deliver a paper in German on January 26, 1979.[32] In 1988, he received the first Murnau Prize awarded by the F. W. Murnau Foundation in Bielefeld, which went on to honor, every two years, figures in cinema such as Wim Wenders, Henri Alekan, Steven Soderbergh, Rivette, Werner Herzog, and Enno Patalas, a historian and the curator of the Filmmuseum in Munich. On this occasion, Rohmer went to the cemetery in Stahnsdorf, Berlin, where Murnau's tomb had been discovered by Professor Lothar Prox. It still contained the filmmaker's glass-windowed coffin and his embalmed body. Rohmer brought back Murnau's death mask, which he later kept in his office at Films du Losange.

In Germany, Rohmer enjoyed a good reputation: his works were translated into German[33] and some of his films were well received. *Pauline at the Beach*, *Full Moon in Paris*, *Rendezvous in Paris*, and *A Tale of Autumn* all attracted more than 100,000 spectators. To the point that a resident of Neustadt, Rainer Böhlke, wrote in February 1993 to inform Rohmer about the provisions of his last will and testament. Since Rohmer was "the filmmaker I admire most in the world," he wished, since he was old and alone, to bequeath to him what he said was a "considerable fortune." Rohmer immediately replied in German:

> You do me great honor, but in all conscience, and at the risk of annoying you, I must tell you that I cannot accept your offer. I have made a success of my career, and at present I have no difficulty producing my films or finding the money necessary for my work. And then my career is coming to an end, I am already at an advanced age (73). I advise you, if cinema interests you so much, to give your money to a foundation to help young artists who are experiencing difficulties.[34]

Die Marquise von O in the Original

In order to prolong this taste of Germany, Rohmer decided to make a German film. Or more precisely: to film in Germany, in German, with German actors and actresses performing a German text. He explained:

> Why a German film? I'd gone back to the study of German and I'd started reading a few books. I'd begun with Goethe, during the filming of *Claire's Knee*. Then one day, as I was digging around on the shelves of German classics at the Gibert bookstore, I came across Kleist's novellas.[35] I immediately saw that this was a subject that could be filmed without changing anything, but I didn't think about doing it myself. I even went so far as to talk to friends who were looking for subjects. (I have since learned that Polanski had thought about filming it, but changed his mind.)[36]

But it was not only because he had discovered, at the end of the summer of 1972, Kleist's novellas and their "cinematic writing" that Rohmer chose *The Marquise of O*. To be sure, this mode of narrative, which concentrates on external description, on the details of actions, movements, gestures, attitudes, places, and space,

was an essential factor in his choice.[37] Nonetheless, it was the "immersion in Germany"[38] that inspired Rohmer to the highest degree. He goes on:

> When I was preparing *The Marquise* I met Alain Resnais by chance in the Metro. He told me that in the 1960s he had made long visits to the United States without being able to realize his projects. "But," he added, "at least I learned English, and yet I will know it perfectly only once I have made an English film." Resnais made *Providence* to learn English and I made *The Marquise* to learn German. My approach to Germany (its literature, its music, but also its geography, the country, the people) was much more interesting around Kleist, with Kleist as the focal point, than it would have been by chance, as a "tourist." That is one of the pleasures of being a filmmaker.[39]

In this frame of mind, he would consider it a betrayal to make *Die Marquise von O* or any other film adapted from a German text, in any language other than the original.

Regarding his motivations, Rohmer adds: "The subject pleased me. It entered into my world, even though it escaped in other respects. In a way, it is a 'moral tale'—although its morality is quite distant from that of the *Moral Tales*. And then, there was Kleist . . . "[40] Rohmer was fascinated by the young writer and dramatist who committed suicide on the banks of the Little Wannsee in 1811, at the age of 34, after publishing his collection of novellas, including *Die Marquise von O*, in 1810. From this short life of writing, wandering, rages, and imprisonments, marked by deep physical and mental crises, emotional, sentimental, political, and nationalist commitments, there remain a few historical dramas, *Penthesilea*, *Das Käthchen von Heilbronn*, and *Die Hermannsschlacht*, short narratives such as "Michael Kohlhaas" and "Die Marquise von O," and philosophical essays, for example, "On the Marionnette Theater." His spare but vibrant writing, realistic but lyrical, aroused a certain incomprehension in his own time before it became, through its precision and accuracy, a model of language between classicism and modernity. Lotte H. Eisner got it right when she wrote to Rohmer after having seen his *Marquise*: "You are one of the rare French people who understands what the word *Raum*[41] means for a German who is still infatuated with metaphysics. I would like to express to you the pleasure I took in seeing your *Marquise of O*, that marvelous novel of Kleist's. To keep my German style intact, I read Kleist's novellas often, even though my eyesight is very poor."[42]

Reading Kleist, with his concentrated, lively style, one often says to oneself that he could have written commentaries on many of Rohmer's *Moral Tales*. Moreover, Rohmer shares with Kleist a certain structure: a conflict between characters with a desiring, active subjectivity and an indifferent objective reality.[43] The characters' obsessions collide with the indifferent nature of things. As Pascal Bonitzer wrote in his essay on Rohmer, his cinema is based on the relation between "a foreground of the visible world in which everything seems to work out in accord with the narrator's desires" and a "background, less visible, in which things live their lives without him, in a way that is virtually threatening for him." The articulation of the foreground and the background figures "the dissimilarity between the world of fiction and that of reality, between a deluded subjectivity and a delusive objectivity."[44] From this point of view, Kleist is close to Rohmer: the Marquise of O lives in this dual universe. The virtuous young woman finds herself "innocently" pregnant, whereas everything seems to show that she has gone astray. Her subjectivity is innocent, but objectivity designates her as guilty.

The Marquise of O presents the reader with a story of an audacity unusual at the time. The action takes place during Bonaparte's first campaigns, in the late 1790s in Austrian northern Italy. During the assault on a citadel under the command of the father of a young widow, the latter faints. The marquise is discovered by a Russian officer who takes her to a safe refuge, thus saving her from falling into the hands of the Cossacks. She retains a profound gratitude toward her savior, who has continued the fight and about whom she has heard nothing further. A few weeks later, she discovers that she is pregnant; her father, refusing to believe in the innocence that she proclaims, expels her from the family home. The unhappy woman then decides to publish the story of her misfortune in a newspaper, inviting the guilty party, whom she will marry, to make himself known. The latter appears; he is none other than the Russian officer, who admits that he abused her while she was unconscious. Scandalized, she orders him to disappear immediately after the marriage. But in the course of the infant's baptism, he shows such generosity that the marquise pardons him and reconciles with him. The story, some fifty pages long, concludes with a kiss and this sentence: "She threw her arms around his neck to answer him that she would never have seen him as a demon, on that day, had she not seen him as an angel when he first appeared." To which Rohmer added in the film, in the form of a final title card drawn from a sentence written by Kleist: "A long series of young Russians succeeded the first one."[45]

A third reason led Rohmer to make this film. "I had always wanted," he wrote retrospectively,

> to put a novel on the screen without changing anything. When I was a critic at *Cahiers du cinéma*, there was a leitmotiv that always appeared in the old criticism when a literary work was adapted for the screen: "It's not as good as the book." This was not wrong, because the adaptation was bad, the filmmaker changed things, invented equivalences, put into dialogue what was not in dialogue, concentrated, abridged, when there was no reason to make changes. But the critics added: "Still another proof that cinema is incapable of competing with a great literary work." On that point, I was not in agreement.[46]

Rohmer refused to accept this as an immutable truth. He refused to forge a "false cinematic naturalness."[47] He preferred to "film the novel,"[48] in this case a text by Kleist that was "cinematic in itself." He writes in a "Note on the mise en scène," a kind of handbook to the film, that

> *Die Marquise von O* was already a veritable scenario on which the work of the mise en scène could be based directly, without the intermediary of what is called an "adaptation." First, the dialogues in the future film are already entirely written in a form that seems to us to perfectly capable of "passing" to the screen. Next, the narrator refrains from any mention of the heroes' private thoughts. Everything is described from the outside, contemplated with the same impassiveness as the lens of a camera. Finally, Kleist informs us, with more precision than the most meticulous of scriptwriters could, regarding the attitudes, movements, gestures, and expressions of his heroes. At every moment we know whether a character is standing, sitting, or on his knees, whether he is embracing his partner or taking her hand.[49]

Thus Rohmer's work consisted above all in cutting and pasting, sometimes moving a phrase or an expression, and in resituating in context, reconstituting settings, costumes, ambiences, gestures, and attitudes, to make the period and the details of the narrative rise up on the screen with the same truth as Kleist gave them in his novella. The notebooks containing the scenario of *The Marquise* testify to this preparatory work, with the text of the film in German on one page and on the facing page the corresponding text in the writer's novella, cut out

with scissors and pasted in. Here fidelity takes a very material form and seeks to respect the whole of Kleist's text.[50]

Moreover, Rohmer translated the novella into French himself, with the help of a young student who was studying with him at the Sorbonne, Cheryl Carlesimo. In the end, he modified the text significantly on only one point. In the scenario, the marquise is sleeping under the influence of drugs when she is raped, whereas in the novella she has simply "fainted." "I will be faithful to the letter," Rohmer explained in an interview given to *Film français* just before filming began.

> What interests me is the text, the slightest *nicht* that I want to respect. I have made only a small transformation. Not only does it not change the text, but in my opinion it removes an implausible aspect that might have shocked spectators. Because the spectator must not think that the heroine is lying, or that she is feigning. So that the spectator can believe that she has been deceived, I have to deceive the spectator a little. In other words, I "Hitchcockize" this story, which in my view is already very Hitchcockian. In such a way that the spectator of our time, who has read and seen detective novels and films, and who is not as naïve as the reader contemporary with Kleist, will come to a certain moment in the film where he will say to himself: "Maybe I was wrong after all, the truth is not what I thought it was." That will suffice to establish the marquise's sincerity.[51]

Rohmer accumulated a considerable documentation, following the suggestions of his "historical advisor" Hervé Grandsart, a young scholar specializing in the seventeenth and eighteenth centuries who worked for Films du Losange. In his preparatory files we find books and newspapers from the period, images of military and civilian clothing, dresses, shawls, headdresses, notebooks and texts taken from the Sembdner Kleist Archive in Heilbronn, notes taken on works dealing with Kleist, on Napoleon's campaigns, on the armies, on the history of the empire and the French occupation of northern Italy and Germany. We also find the text, the program, and the review of the Théâtre National Populaire corresponding to Jean Vilar's famous production of *The Prince of Homburg*, starring Gérard Philipe and Jeanne Moreau, which was a highlight of the Avignon Festival between 1951 and 1955.

As he had done for some of his educational television programs, Rohmer took a great interest in the pictorial aspect of his project. For him, the goal was to

immerse himself in a moment of the history of painting, in this case in the German tradition of the early nineteenth century, the German neoclassical school influenced by Jacques-Louis David. Using books and exhibition catalogues published in Germany, Rohmer collected reproductions of significant works: the theatrical sets painted by Karl Friedrich Schinkel (particularly for *The Magic Flute*), the interiors or very stylized gardens of Carl Gustav Carus, and Caspar David Friedrich's late landscape paintings, such as *Woman at a Window*. In the archives we also find about thirty tracings, with additions drawn with a fine-point felt pen in blue, black, and red, reproducing women's figures, old men posing, family scenes, architectural details, parts of furniture, semi close-ups of clothing, and hairdressing types taken from paintings and engravings of the French neoclassical school. Rohmer also showed the actors a color reproduction of Fragonard's famous painting, *The Lock*, in which the sexuality is implicit and the bed in disarray.[52]

In 1969, the Museum of Modern Art in Zurich presented the first major retrospective of the work of Johann Heinrich Füssli (better known in English as Henry Fuseli), a painter who was born in Zurich in 1741 and died in Britain in 1825. Rohmer obtained the catalogue, from which he tore out one page, the reproduction of *Die Nachtmahr* (The nightmare), a famous canvas dating from 1781 that represents the nightmare hallucinated by a young woman thrown back on her bed, surmounted by a demonic succubus and an ass's head with fiery eyes.[53] It was the only time in his career that Rohmer deliberately reconstituted a painting in a film. "For the scene that precedes the marquise's rape," he explains,

> when she has fallen asleep before the eyes of the Russian officer, [. . .] I used the work [. . .] of Johann Heinrich Füssli. It was the first time I tried to imitate a painting. Well, I didn't succeed: from an anatomical point of view, this image of a stretched-out human body is completely implausible; it bends the body in an extraordinary way, and even after rearranging the cushions we were not able to reproduce the elegance of the pose. This sequence is not my most successful one: it amply proved to me that one mustn't try to imitate paintings.[54]

What matters in this direct use of painting is how Rohmer takes advantage of it: it is a matter of creating an image at a moment in Kleist's text where the ellipsis is almost total. In the novella, the marquise's rape is reduced to a single sentence, and even to a surreptitious gesture:

"Then—the officer instructed the marquise's frightened servants, who presently arrived, to send for a doctor; he [the officer] assured them that she would soon recover, replaced his hat and returned to the fighting." Rohmer's imitation of Füssli's *Nightmare* incarnates what this gesture of replacing a hat conceals in Kleist. The offbeat eloquence of the painting, the minimal visual distance referring to what Lacan called the "painting function."[55]

In the Spirit of the Schaubühne

A film made in German, *Die Marquise von O* is also an adventure in production with a German tint. In the history of Films du Losange, it represents an important stage: the first opus after the *Moral Tales*, and the search for a new organization after the move to avenue Pierre-Ier-de-Serbie. In 1972, Pierre Cottrell, who codirected the company, encountered health problems, while its founder, Barbet Schroeder, wanted to pursue his film career, which had begun with his own films, *More* (1969) and *La Vallée* (1971). He made *Maîtresse* in France, with Gérard Depardieu and Bulle Ogier; worked on his documentary in Africa, *General Idi Amin Dada: A Self-Portrait*; and then made *Koko: A Talking Gorilla*, *Tricheurs*, and *Barfly* in the United States. "There was a Cottrell problem," Schroeder bluntly explains. "He refused to get medical treatment and his health problems sometimes turned into delirious episodes. This worried Rohmer a lot, who at one point thought that Cottrell could no longer be allowed to sign checks and contracts. It was annoying: at the very moment when I wanted to leave, he was falling apart."[56] Pierre Cottrell finally agreed to sell his shares in Films du Losange for 2,000 francs, Rohmer and Schroeder becoming the owners in equal parts.

Rohmer set out to find a new production director to help Schroeder and then succeed him. He was not in a hurry, having no immediate project. But in 1974, as *The Marquise of O* took form, Rohmer and Schroeder looked in Germany for someone who could handle the preparations for filming. The director of the CNC, Pierre Viot, whom Rohmer met through his friend Philippe d'Hugues, advised him to contact Margaret Baranyi, a young Hungarian woman living in France who was married to the documentary filmmaker Robert Menegoz. She had been born in Budapest thirty-three years earlier and was of Swabian origin. At the end of the war, her parents left their country when the Russians arrived and went to live in Tailfinger, a village south of Stuttgart in West Germany, where

she grew up. At the age of twenty she was working in Berlin for a small company making films for businesses when she met Robert Menegoz during the 1961 Berlin Film Festival, where they had each presented a documentary. Living in Paris, polyglot, and soon a director, producer, and the mother of a child, she worked with her husband on a number of documentaries. Ten years later, she was looking for a steady job.[57]

In the summer of 1974, Margaret Menegoz met Rohmer and Schroeder, who were working on the writing and production of *The Marquise of O*. "They were looking for a 'maid of all work,' someone to 'take care of the house,'" she recalled. "Schroeder hired me for a salary of 5,000 francs a month."[58] Her first job consisted of supervising the French translation of *The Marquise of O* and rereading with Rohmer the German adaptation proposed by Hartmut Lange, the dramatist of the Schaubühne, regarding which she proved to be very skeptical, which encouraged Rohmer to propose his own version. The young woman subsequently followed all the filming during the summer of 1975, "supervising" or "handling the production of the film." Even more, she was a kind of "all-purpose assistant,"[59] one of the female collaborators with multiple functions and resources that Rohmer liked to have around him on a shoot.[60]

Earlier, Margaret Menegoz aided Barbet Schroeder in his contacts with German coproducers. In November 1973, Losange associated itself with Janus, a small company in Frankfurt directed by Klaus Hellwig, whom Schroeder had met through Patrick Bauchau. For ten years, Hellwig was Losange's closest collaborator in Germany. For instance, it was he who contacted television companies, indispensable partners for any cinematic coproduction in Germany from that time forward, first the one in Cologne, which backed out, being worried about the principle of the film. Then the one in Frankfurt, which agreed despite its reservations. Janus also associated itself with Artemis, a Berlin production company connected with United Artists and run by Jochen Girsch. So that so far as financing is concerned *Die Marquise von O* was a 70 percent German film, divided equitably between the television company and the two film production houses, the remaining 30 percent being taken on by Losange and Gaumont, which had agreed to handle the international distribution of the film. The budget was set at 2.55 million francs or 1.5 million marks. "On the level of organization," Margaret Menegoz explained, "the Germans took complete charge of the actors and everything concerning costumes, sets, and travel. On the other hand, the technicians, filming equipment, and laboratory work were French. We had to

get a special dispensation from the CNC, because it was impossible to include a French actor in the cast of the film; on the other hand, we had to come to an agreement with the German authorities so that the laboratory could be in France, whereas the coproduction accords normally provided that it had to be in the country that bore the majority of the costs."[61]

For Rohmer, the crucial point was working with German actors. In a letter to the coproducer Klaus Hellwig dating from April 29, 1974, he wrote:

> For the past few weeks, feeling that the time had come, I've gone back to work, and I'm rereading the text line by line, trying to see each scene in my mind's eye, as it will appear on the screen. What matters to me is the absolute fidelity to the period and to the letter of the text. [. . .] I would like to represent every aspect of the work in its complexity and ambiguity. In particular, I would like to distinguish no more sharply than Kleist did between what is comic and what is poignant. It is not easy, I know, because the mise en scène will force me in spite of myself to lean in one direction or the other, but it is that difficulty that I find so attractive. In *My Night at Maud's*, there was also a delicate balance to be maintained; I managed it, more or less, thanks to my actors. This time the cast will have to be just as remarkable. What scares me a little is not having to direct people in a language not my own, because in my films I always try, speaking very "falsely," not to give any hint as to intonation or diction; it is rather having to deal with stage actors who will emphasize whatever seems to them theatrical in the behavior of the heroes of this story. Such an interpretation would be exactly the opposite of what I want. The expression of emotion, although it is here almost always pushed to its paroxysm, has to be shown with a realism—a naturalness—that is peculiarly cinematic and even, if I may say so, "New Wave."[62]

Hellwig, with the agent, critic, and dramatist Peter Iden, organized a German "tour" for Rohmer so that he might see a large number of actors. The filmmaker reviewed the main theatrical troupes of the time and assessed their actors and actresses: in Düsseldorf (where Peter Zade was directing Sonja Karzau), at the Burgtheater of Vienna (Joachim Bissmeier, Frete Zimmer), in Basel (Verena Buss), in the Theater am Turm in Frankfurt (Elisabeth Schwartz, Marlen Dieck-off), at the Kölner Schauspiel (Angela Winkler), the Kammerspiele in Munich (Peter Lühr), and of course in Berlin, where he attended the performances of the Deutscher Theater with Edda Seippel and Bernhard Minetti, or those of the

Schaubühne directed by Peter Stein. Rohmer accepted "with great pleasure"[63] the principle of this tour of German theaters, traveling twelve days in September 1974 on the occasion of the opening of the fall theater season, on the condition that he was "able to wander at will." "I'm uncomfortable," he wrote, "on a trip that is too well planned. And then I absolutely have to enrich my experience of Germany and its language; for the moment, it is very, very poor!"[64]

After this immersion in one of the richest theatrical cultures in the world, Rohmer decided to give priority to working with a more particular troupe, the Berlin Schaubühne. He had seen two of its productions, the second part of Ibsen's *Peer Gynt* and the premiere of Peter Handke's *Die Unvernünftigen Sterben Aus* (They are dying out), directed by Peter Stein, which had impressed him. The Schaubühne,[65] which had been founded in 1962 by Jürgen Schitthelm and was housed in an old, gray building on the Hallesches Ufer in the Kreuzberg quarter, near the Wall, had been regenerated, as it were, by Peter Stein's arrival in 1970. At the age of thirty-three, the new artistic director led a troupe of very talented young actors, including Bruno Ganz, Edith Clever, Otto Sander, Jutta Lampe, Michael König, and soon Angela Winkler. The Schaubühne became *the* most innovative and most respected theatrical stage in Europe. It was a theater comanaged on the post-1968 democratic and egalitarian model, in which each individual had the same salary, and decisions—from the choice of repertory to financial questions—were made in common, and to which the actors were enormously committed; they did not have the right to work elsewhere. Peter Stein[66] had a reputation for his attention to texts, both ancient and modern, giving priority to a precise, meticulous, contextualized approach. "Only the strict respect for a text of the past makes it possible to acquire the freedom to read and interpret this past from today's point of view,"[67] he explained, and of course this resonates with Rohmer's ambition. The way the actors performed—which was the result of long, intense work around the table and then of a transition to the set, where, as Klaus Michael Grüber, an associate director at the Schaubühne since 1974, put it, "everyone has to feel purifying effect of a deep and light respiration,"[68]—was also in harmony with Rohmer's principles, particularly with regard to *The Marquise of O*, which the filmmaker envisaged as "a film in which the atmosphere will be very tense and somewhat Spartan."[69]

Rohmer discovered this work on the text, this approach to performance, this troupe of actors, and for him it was a breeding ground as much as it was a miracle. *The Marquise of O* was to be both a fully Rohmerian film and a testimony to an

essential moment in the history of theater. "By common agreement," wrote Peter Iden, "the actors of the Schaubühne chosen by Rohmer decided to follow Kleist's text word for word, and thus to communicate to the spectator the direct relation that exists between a story and its period."[70] This is confirmed by the filmmaker:

> The actors' performance must not fall into pathos, but instead remain natural, with a naturalness that, though no longer natural by current norms, was nonetheless natural at the time. That is why we will avoid any kind of parody. It will be said that we are walking a tightrope, but that's what Kleist himself was doing, and that is the difficulty, in this place, of the enterprise that has, along with the objectivity of word-for-word interpretation, directed our interest to this work.[71]

The Marquise of O is situated as much in the continuity of Rohmer's work as it is in the theatrical context of his time.

Though he did not collaborate directly with Peter Stein—who did not visit the film shoot—Éric Rohmer worked intensely with his actors. After tryouts between October 7 and 9 in Berlin, photos, costumes, readings, and acting on the set, in which Angela Winkler, Oskar Freitag, Ruth Leuwerik, and Josefine Schult-Prasser also participated, Rohmer chose Bruno Ganz for the role of the count, Edith Clever for that of the marquise, and Otto Sander for that of her brother, the forest warden—all three of them from the Schaubühne. The first two, who were then triumphing in *They Are Dying Out*, accepted Rohmer's offer by telegram on October 25, 1974. Klaus Hellwig wrote:

> We contacted Edith Clever and Bruno Ganz yesterday. We have informed them of your desire to engage them for the main roles in your film. Their reaction was very positive and they asked us to tell you that they are very happy to have been chosen. Edith Clever has already read the text as a whole. The conception and the series of sequences greatly pleased her.[72]

The two actors confirmed this in a letter they sent Rohmer a month later: "The scenario and its freedom of conception greatly impressed both of us. We were convinced that it would be possible to make a film of Kleist's novella in your way. Moreover, Edith Clever promises you that she will not cut her hair."[73] Later on, the cast was joined by Peter Lühr as the father, the commander of the fortress, and Edda Seippel as the mother, both of them chosen outside the Berlin troupe.

For these last two roles, Rohmer had nonetheless had a twofold dream that he was unable to realize. On the one hand, he wanted to hire Maria Schell, the Austrian actress in Visconti's *White Nights* and Astruc's *A Life*, who "could give the character of the mother an originality and a charisma that no other actress would possess."[74] Rohmer, having contacted her, finally drew back, fearing that the charisma of the actress, who was perhaps a little too young for the role, might somewhat eclipse that of the couple from the Schaubühne and perturb the internal architecture of the film.[75] Rohmer's other desire was for Bernhard Minetti, a legend of the German stage, who declined the invitation "because of a lack of time and for health reasons."[76] Two other actors proposed themselves. On November 4, 1974, Marthe Keller, "who has a great admiration [for Rohmer] and would be very glad to work under [his] direction,"[77] and Oskar Werner, who played Jules in Truffaut's film. On April 27, 1975, he wrote to Rohmer:

> I've read the electrifying novella that you plan to film, *Die Marquise von O.* For at least fifteen years I've also dreamed of making a film of it, but Austrian cinema no longer exists, and the Germans are rather narrow-minded with their greatest poets. Kleist lives permanently in my heart, and I played his Prince of Homburg two years ago. Have you already chosen a count? I would be very happy to play him for you.[78]

Rohmer was also preparing for the filming with the costume designer at the Schaubühne, Moidele Bickel, one of the most respected in the world, and the company's set designers. This work was carried out on the basis of earlier productions of Kleist in Berlin, as well as on that of engravings and paintings from the period—to which there remain many testimonies in the filmmaker's archives. In addition, following Hervé Grandsart's counsels and scouting with Klaus Hellwig and Nestor Almendros, Rohmer found a medieval castle that had been remodeled in the eighteenth century, the citadel of Virnsberg, an elegant Bavarian building perched on a wooded hill above the town of Flachslanden, in the Frankenhöhe nature park. The film's team could also sleep in the castle, which was important in Rohmer's view. The rest of the filming would take place in Obernzenn, a lovely city a few kilometers to the north, with its eighteenth-century castle, and in Ansbach, a small town a little farther south, in Bavarian Franconia, an old romantic center and the adopted country of the unfortunate and enigmatic Kaspar Hauser.

From Ansbach to Cannes

After several trips for scouting and preparation in Germany, notably in Munich, where the Schaubühne was touring with *The Prince of Homburg* in the spring of 1975, Éric Rohmer filmed *The Marquise of O* from July 7 to August 4, in the heat of the continental summer. Since it was a school vacation period, he lodged his wife and children in a small house near Ansbach. He spent every evening with his family but did not talk about the film he was making, and there were no plans for his sons, then seventeen and fifteen, to visit the shoot. Laurent Schérer, the younger son, testifies:

> We didn't talk about films. I had been to the cinema a single time to see one of his films with him, *Perceval*. Instead, we went to the Cinémathèque to see Keaton's or Chaplin's films. My father was reserved and never boasted about making films. He didn't like being recognized or bothered and didn't like it when his family was disturbed by that. None of us ever went to Films du Losange; any mixture of his craft and his family would have seemed to him incongruous and out of place. For our part, it seemed natural to respect this choice. I did not grow up as the son of a filmmaker.[79]

The filming began with the sequences in and around the citadel of Virnsberg, repeating the beginning of Kleist's novella: the assault, the count's appearance, aerial and angelic, and the marquise's rape. Rohmer liked to make his films respecting the order of the narrative as much as possible. Nothing spectacular, everything is suggested. However, there were a few explosions, and shots of soldiers in movement. The filmmaker, who gave himself a small, silent role as a Russian officer, delegated these scenes to Margaret Menegoz, his assistant, who directed in German the extras, who did not speak French. Rohmer understood German very well, she recalled,

> but he was afraid to talk, especially in a group. I was assigned to talk to the extras, the technicians, to negotiate everything that concerned supplies and production. The American army was carrying out maneuvers near the castle, which made a lot of noise, with airplanes and tanks. We weren't very far from the border with East Germany. Rohmer was very nervous about that. We

invited the person in charge, an American colonel, to visit the shoot. He left delighted, and had the maneuvers halted earlier than planned! On the other hand, I was never to talk to the actors: that domain was reserved for Rohmer.[80]

Bruno Ganz spoke French, but neither Edith Clever nor the other actors from the German theater did. Therefore Rohmer asked his American student, Cheryl Carlesimo, who was at that time working with Werner Schroeter, to be present on the shoot to help him in his contacts with the troupe from the Schaubühne. "He had a blockage when it came to speaking," she wrote, "so I helped him talk with the actors. One evening after the filming he told me that Japanese was the only language he would learn very quickly!"[81] Margaret Menegoz recalled that:

Éric had an amazing strength and resistance, despite his slender, fragile appearance. On a film shoot, he had a great deal of energy. On *The Marquise of O*, the beginning was very physical: we had to film at the citadel very rapidly, in just a few days. We began early in the morning and continued on through part of the night, and once we had to go on and film a scene at dawn, the execution of the soldiers, which was not retained in the final version. He was the one who set out in the wee hours of the morning, on foot, to find the right place for those shots.[82]

Next, the filming moved to Obernzenn, in the halls of the Stadtwohnung, the municipal building, a small, unrestored Italianate castle where the interior scenes were to be shot. The rooms had been prepared, repainted and reconfigured by the Schaubühne set designers, but in a baroque style that Rohmer did not like. Hervé Grandsart quickly rounded up some set elements that he had sent by truck from Paris. Various scenes were then shot in the countryside, not far from Ansbach, and finally in the marquise's bedroom, in an eighteenth-century house in the town. Rohmer came to Germany with a technical team that was essentially French,[83] the one that he now knew after various collaborations on the *Moral Tales*. Nestor Almendros's work on lighting was particularly remarkable. As he explained it,

The Marquise of O is distinguished by its luminosity . . . the white of its sets and its costumes made of fabrics that are ecru in color or dipped in tea-baths. [. . .] We painted the interiors [of the castle of Obernzenn]: the wall gray, a neutral color that gave just the right, noble value to furniture, clothes, and faces,

without chromatic contaminations. As I often did, I participated in the choices regarding the set, the costumes, and even the accessories. [. . .] With its long row of rooms, the castle was oriented and conceived in such a way that the sunlight coming in through the windows cast a superb perspective on the floor. As for *La Collectionneuse*, we studied the different positions of this sunlight (it was summertime) to give priority to its most aesthetically moving moments. [. . .] Thus it was the eighteenth-century architect who composed all the film's lighting! The superfluous annoys us, and so does too much sophistication: simplicity alone pleases us. [. . .] My photographic work on *The Marquise of O* probably makes it my most accomplished film up to this time.[84]

Rohmer considered it important to spend time with his actors, so as to rehearse at length, listen to them, and take into account some of their remarks. As usual, the filming proper was done more quickly, generally in a single take, sometimes two, without feeling the need to "cover oneself" by filming from several different camera angles. The general atmosphere was good-natured, serene, without tensions, benefiting from the collective spirit of a troupe like that of the Schaubühne. In the set photos, we see a real complicity linking Rohmer to both Bruno Ganz and Edith Clever.

In the autumn of 1975, the film was edited by Cécile Decugis in the Auditel auditorium, near Montparnasse; Rohmer was there every day.[85] He also put together a French version, at the urgent request of Gaumont, the film's distributor, on the same principle of respecting Kleist's novella almost word for word. He asked Marie-Christine Barrault to dub the role of Edith Clever, Féodor Atkine to dub that of Ganz, and Hubert Gignoux and Suzanne Flon to dub the roles of the marquise's parents. But it was very clear to him that the only version that really counted was the German one.

The Marquise of O was selected for the Cannes Festival in May 1976. Logically, in the competition it represented West Germany, and Rohmer was proud of that. It was not necessarily understood in France. "It is piquant," Jacques Siclier wrote in *Télérama*, "to find Éric Rohmer, our filmmaker who is most connected with a very French tradition of the psychological novel, representing [West] Germany at the Cannes Festival."[86] Rohmer was very nervous about appearing publicly before the festival crowd—the rituals of mounting the platform and giving press conferences literally terrified him. A few weeks before the event, he wrote to festival's president, Robert Favre Le Bret, a letter excusing his absence:

I regret to inform you that I do not intend to go to Cannes in the course of May, and will therefore not be able to hold the usual press conference. [. . .] Although I owe the audience a work suited to it, and though I willingly admit that its presentation may, for the prestige and the good of culture, be surrounded by a certain pomp and circumstance, I nonetheless insist on remaining the jealous master of my private life. The success I have recently achieved would be too costly if it came at the price of the freedom that so many years of struggling in obscurity have made dearer to me than anything else. I am no longer of an age where I can get over a timidity before crowds that I grant you the right to call pathological. If all my colleagues were to show the same reluctance to appear in public, I can see that it might greatly inconvenience the organizers and journalists. However, being almost certain that I will be the only one to do so, I hope that my whim, far from disturbing in any way the serenity of the festival, will constitute a slight dissonance that will strengthen the harmony of the whole.[87]

The Marquise of O was presented at the opening of the festival, on May 17, and made an impression on the audience. Press coverage was abundant and the reviews, with a few exceptions, laudatory, showing a sincere respect for Rohmer's ambition and integrity and for his fidelity to Kleist's work, which was at that time little known in France. Only a few echoed the laughs that the tearful melodramatic style borrowed from the German author might have provoked in modern spectators, a difference that Rohmer foresaw and represented. In fact, the film, its title, its filming in German, its quality, the emotion it elicited, and even the filmmaker's absence aroused curious attention in Cannes. The showing of *The Marquise of O* was one of the events of the 1976 Cannes Festival, as the special reporter for *Le Progrès* of Lyon wrote:

It's not easy to follow this Éric Rohmer. He became a filmmaker late in life, though his family does not know about it, and he is famous under an assumed name, though people have not succeeded in knowing him. He has made a film that is supposedly detestable, *My Night at Maud's*, which was expected to attract hardly 3,000 spectators, and which has already attracted more than a million. This year, he has become one of the stars of the festival, but with a film more German than those of German filmmakers. He was expected to appear in all his glory, but he wrote to President Favre Le Bret a letter explaining that his

pathological shyness would prevent him from coming. As a result, the Cannes exegetes are having a field day conjecturing about how much humor there is in this letter. Is it a rejection of honors, a profound repugnance to self-advertisement, a lazy unwillingness to take the trouble to answer questions that annoy him in advance, or a desire to continue being a mystery? Go figure . . . But above all, he has presented at Cannes the most unexpected, the most disconcerting film imaginable.[88]

The film had a favorable place in all the predictions. Unsurprisingly, it was remembered best for the award given by the president of the jury, Tennessee Williams. Though Martin Scorsese's *Taxi Driver* won the Palme d'Or, *The Marquise of O* shared with Carlos Saura's *Cria Cuervos* the jury's special prize. But "Erich von Rohmer,"[89] as the journalist Guy Tesseire nicknamed him, was not in Cannes to receive it. On this Sunday, May 30, he was in Ansbach, Bavaria, presenting *The Marquise of O* to the town's residents in their community center, to thank them for their hospitality.

The Marquise premiered on May 26. Without reaching the triumphal success of the last three *Moral Tales*, the film attracted nearly 300,000 French spectators over three months. Rohmer offered a naughty explanation for this unexpected success of an austere film in German, without any actor known on the French side of the Rhine: "I willingly recognize that this film may have met with an artificial audience because of the resemblance of its title to that of *History of O*." The erotic film adapted from Pauline Réage's libertine novel had in fact come out the preceding year. In any case, Nicolas Seydoux, the president of Gaumont, was delighted: "I wanted to tell you how pleased I was. You've made an admirable film. The quality of the images, the beauty of the settings, are equaled only by the power of the story and the director's talent,"[90] he wrote to Rohmer on May 12. As for François Truffaut, he was almost jealous, especially since, he said, he "greatly admired Kleist because when someone introduced to him a woman he found beautiful, he flat-out fainted."[91]

The success of the film abroad was still more surprising, combining recognition and prestige with high ticket sales in a few cases. In Germany, of course, but also in Italy, in Britain, in Canada, in Japan, and even in China, where the film was bought for $5,000 by a distributor in Beijing. The American career of *The Marquise of O* is astonishing. Presented by Rohmer himself in a preview showing at the New York Film Festival on October 19, 1976, the film was widely

praised by critics, came out in about thirty major university cities, brought in more than $150,000, and in February 1977 earned the filmmaker a big headline in the *New York Times* noting the phenomenon: "New York Discovers Kleist and Rohmer."[92]

In the end, with *The Marquise of O* Rohmer's reputation took on a new dimension. His image, which was connected with the *Moral Tales*, now a little petrified as a half-dandy, half-haughty chronicle of contemporary life, found in the historical film and the German language a broader space in which it could blossom. In his way, Pascal Bonitzer noted this change in status in the article saluting the film in the *Cahiers du cinéma*, "Glorieuses bassesses" (Glorious depravities):

> What gives *The Marquise of O* a power and a beauty that were lacking in *Moral Tales*, despite and perhaps because of the cleverness of their fiction, is that the question that seems to drive Rohmer or his cinema is grasped in it in a much more naked, literal, indecent way. More indecent because this time it is the body itself of the Christian, bourgeois woman, which had up to this point been preserved on the periphery of the film by the presence of the "other woman," sexual and atheistic, the seductress, that is represented. It is the Christian body that this film exposes, with a rigorous writing, humor, and perhaps a secret horror that arouses in the theaters where the film is shown exactly the same kind of uneasy laughter—this can be verified—as *The Empire of the Senses*.[93]

Catherine of Heilbronn and the Fools of Criticism

In order to prolong his German experiment, his companionship with Heinrich von Kleist, and the theatrical work he had begun in 1974, Rohmer undertook production of *Catherine of Heilbronn* on the stage of the Théâtre des Amandiers at the Maison de la Culture de Nanterre. In coproduction with the Festival d'automne directed by Michel Guy and the Théâtre des Amandiers under the direction of Raoul Sangla, Films du Losange committed itself financially to this unprecedented venture, leaving the filmmaker completely free in his dramaturgical and scenic decisions and in his choice of actors and technicians. The contract

was signed on March 21, 1979. For almost ten months Rohmer was fully engaged in this adventure that he was very excited about.

Since the transposition of *Die Marquise von O,* Rohmer had wanted to work on a text by Kleist again, and the desire for theater stimulated him. But he could not see himself producing a French classic, even if he greatly admired Corneille's plays, especially his comedies. What attracted him in Kleist, and no doubt reassured him, was the cinematic element included in his works, including his works for the theater. He chose *Das Käthchen von Heilbronn* (Katie of Heilbronn), a wide-ranging play that is as spectacular as a medieval historical fresco, mixing the epic, sentimental, melodramatic, and fabulous genres, a teeming and complex work. In sum, this theatrical experiment was very risky, as Jean Anouilh had learned to his dismay when he tried to adapt and stage the play in January 1967 at the Théâtre Montparnasse, a production very coolly received by the critics. Rohmer did not proceed as he had with *The Marquise of O* and its almost complete fidelity to the text. Here he translated—the play was performed in French— he adapted, cut, thinned out, and moved scenes around, even transposing two dreams (those of Count Frederick von Stahl and Cunegonde von Thurneck, the witch) into cinematic images. "This play is intended to move people and make them weep," he explained. "My first task was to adapt it. It is a *pièce-fleuve*; I reduced it to the main characters. I left out the knightly spectacle side, which had won over the spectators in Max Reinhardt's 1905 production, and which Anouilh was unable to make work ten years ago."[94] Another difficulty was that the play had the particularity of alternating verse and prose. Rohmer wanted to preserve this "magic."

> The passage from verse to prose plays the role of that from recitative to aria in an opera. And it was in order to remain faithful to the music peculiar to the work that I decided to take the risk of translating the German verse into French verse, sometimes classical alexandrines, but not rhymed, and sometimes into free verse, shorter or longer, but this time rhymed.[95]

Rohmer was fond of *bouts-rimés*, and he loved doing this work.

> As for the prose, I translated it, emphasizing the magical and medieval aspects, the fairy-tale dimension, the duality of light and shadow, of the angel and the demon, sometimes giving the very complicated plot a dimension of suspense.

There is a Hitchcock element in Kleist. Let's not be afraid to bring out in this text its resources of terror, curiosity, and reverie. The spectator has to believe in it, as one believes in a picture book, he has to really "get into" this fairy tale. Kleist's theater is the complete opposite of a cold and detached theater.[96]

Rohmer's verse and this insistence on the fabulous were to be two of the most controversial points in the reception of the play.

As is often the case with Rohmer, it was the work with the actors that seemed essential to him. He rehired most of the troupe of actors and actresses he had put together for *Perceval*, his own "Schaubühne." Six of the twelve actors present on the Amandiers stage had moved from the one project to the other: Jean Boissery, Daniel Tarrare, Gérard Falconetti, Pascale Ogier, Arielle Dombasle, and Marie Rivière. Fabrice Luchini was replaced in the leading male role, the Count von Strahl, by a newcomer, Pascal Greggory, who had been found by Gérard Falconetti, a friend of Rohmer's. Greggory recalled: "Rohmer once told me, 'Everything is fortuitous except chance.' Our meeting was more or less that. [. . .] I was living at the home of Christine Delorme, whose mother Maud had inspired the character in *My Night at Maud's*. I ended up calling Rohmer. We made a date to meet, and he received me cordially, and I thought that would be it, but three months later he called to ask me to act in *Catherine of Heilbronn* at the theater."[97] Greggory was twenty-five years old; he had begun acting five years earlier with Jorge Lavelli and Andréas Voutsinas, acted in a film for Adolfo Arrieta in *Flammes* and for André Téchiné in *Les Soeurs Bronte*, the first role in which he attracted attention.

Rohmer entrusted the leading female roles, Catherine and Cunégonde, who are rivals in love and in madness, a brunette and a blonde, an angel and a witch, to Pascale Ogier and Arielle Dombasle. Françoise Quérié, a friend of Marie Rivière's, made her entrance into Rohmer's world:

One afternoon he received me in his office at Films du Losange, and we talked casually over a cup of green tea. I recall only that he asked me to write my date of birth in a school notebook and strongly discouraged me from becoming an actress. On that condition he called me back two weeks later and asked to see me again, and finally, the following year, he engaged me for *Catherine of Heilbronn*. [. . .] I played three roles (a little boy, an angel, and a servant), and it was perhaps for that reason of economy that he hired me.[98]

Rohmer renamed her Rosette, as the actress explains:

> In Kleist's play, I was called Rosalie. Fabrice Luchini, who sometimes came by to
> see us, called me Frousette. Éric named me Rosette by making a kind of contrac-
> tion. That is how I owe to him my name as an actress, which has become simply
> my name. And since it happens that when I first came to Paris, I sold roses on the
> sidewalks of Saint-Germain to pay for my theater courses, it was fate.[99]

The few photographs of the rehearsals emphasize the great complicity that
bound these very young actors, most of them beginners—for Pascale Ogier,
Marie Rivière, and Rosette, it was even the first time they had trod the boards of
a theater—to the man who launched their careers by giving them his confidence.
The rehearsals, which lasted from September 1 to November 7, became more and
more intense. Arielle Dombasle recalled:

> The atmosphere was magnificent. We lived together a lot. Often we were very
> concentrated, to the point of exhaustion, sometimes, it was terribly dissipated.
> We were young, everything was circulating—feelings, bodies, words—and we
> regularly ended up at the Palace, which the two Pascal(e)s frequented very of-
> ten. All that fascinated Rohmer, amused him, and frightened him, too. He liked
> being with us, while at the same time retaining his own life. We were important
> for him: we were beautiful, childish, cheerful, we made him laugh, we told him
> what was happening in our lives, which were often full of encounters, intrigues,
> and reversals. We lived this time very intensely.[100]

Rohmer entrusted the sets and costumes to Yannis Kokkos, Antoine Vitez's
scenographer, who also worked with Jacques Lassalle and Pierre Barrat. The set
was not realistic and resembled the illustrations of fairy tales. Castles, trees, and
rocks were cut out of polystyrene, colored in black or dark blue, then hung from
the flies for different shots. As for the costumes, which were inspired by Arthur
Rackham's English engravings, they played on the gray-blue and autumnal red.
"At first I'd thought of an abstract set," Rohmer explained, "complemented by
slide projections. Yannis Kokkos had the idea of these silhouettes. I would cer-
tainly not have dared take such liberties with every form of verisimilitude if he
hadn't suggested it and if Antoine Vitez's example had not encouraged me to
do so."[101]

Rohmer also gave a role to cinematic images, increasing the share of artifice. They were projected on the sets at two points during the show, at the risk of disturbing the spectators and misleading the senses by illustrating the dreams of certain characters. With Nestor Almendros, Rohmer filmed a few oneiric sequences, fantastic close-ups of deformed faces. Arielle Dombasle recalled:

> He introduced cinema on the stage, which was rare at that time. On stage, I was a pretty blonde, and in these images I had a false skull and black teeth like a witch's. It was extremely intelligent and provocative: the spectator knew that I was a frightening creature, and really saw me as such, whereas the other characters in the play thought I was an innocent girl in love. That greatly shocked people. Part of the audience didn't understand, and the critics found it arrogant! Rohmer liked artifice, the ambience taken from medieval illuminations, with a preciosity so far removed from the naturalism of the usual way of acting. It was very beautiful, poetic and ludic, but it didn't make people laugh.[102]

The reception of *Catherine of Heilbronn*, performed on November 9 and December 8, 1979, in Nanterre, was mixed to say the least. "From the first performance," Arielle Dombasle remembered,

> It was *Hernani*, a veritable battle between the boos and the applause. In France, for a New Wave filmmaker to dare to go to Nanterre to stage this madly romantic text was a major provocation. The critics understood the choice of the mise en scène and the overtly artificial sets, along with the flat, almost false acting style, as pretension or amateurism. But it was an event, so much had Rohmer upset the genre.[103]

Pascal Greggory went even further: "I felt the audience's rejection as I was on stage, and I sometimes returned in tears to my dressing room."[104]

The criticism was ferocious. The violence of its tone is still surprising; sometimes it was genuinely humiliating for Rohmer. In *Le Monde* for November 13, 1979, Colette Godard blasted the show under a shock headline—"Amateurism":

> The show is nothing, not even its negation. The person responsible is Éric Rohmer; it is his first mise en scène, can we call it theatrical? [. . .] We see nothing but people in medieval costumes who have been asked to move or

remain motionless as they utter words. The adaptation is deliberately flat and puerile. Rohmer has chosen, for the enormous roles of the count, Catherine, and Cunégonde actors who have never had to deal with the stage, too malleable, and has them speak in the insipid intonations of amateur thespians. Éric Rohmer has sought the naïveté of a sophisticated comic strip, but he harvests only a monotony without rhythm, a series of tableaux separated by dark moments during which one hears music, always the same. He knows nothing about theater. His mise en scène is marked by an amateurism all the more disconcerting because it gets lost in the beautiful and the luxurious. The venture has at least served to confirm that the theater is a craft and that it has to be studied.[105]

In *Le Figaro*, Pierre Marcabru made wicked fun of

Éric Rohmer, a German teacher at the sub-prefecture's middle school, who writes such nice verse. If Kleist had known that Rohmer would translate him, he would surely have drowned himself earlier."[106]

In *Télérama*, Fabienne Pascaud notes with severity:

Alas, the subtle and distinguished filmmaker of the *Moral Tales* turns out to be completely powerless on the stage. He tried to do something oneiric, magical, fabulous, outside the world. With sets reduced to the purest, almost mystical romantic imagery; with actors who speak falsely to achieve the unreal. He has tried to produce a pretty dream, in the heart of the soul. But because of an awkward naïveté, his mise en scène involuntarily sinks into pastiche. For lack of good direction, the actors are adrift on the big stage. As if they were lost, panicked. Not just anyone can be a man of the theater, even the most theatrical filmmaker there is. A stage is given life differently from a film set, there has to be a rhythm, a duration. Éric Rohmer has produced a huge flop.[107]

Gilles Sandier, the influential critic of *Matin de Paris*, advised Rohmer to "give up the stage and return to his cameras."[108]

All this looks like a flat rejection on the part of theater professionals, launched with all the more cruelty because Rohmer's work and his production of the play

assert his certainty that he is practicing a different kind of theater, apart from the currents and tendencies of the contemporary stage. This rejection was acutely analyzed by Mathieu Galey in *Les Nouvelles littéraires*; he was the only theater critic who proved indulgent regarding *Catherine of Heilbronn*.

> Critics are people ruled by habits. They spend their lives arranging their world in little, hermetically sealed boxes; they take notes, they keep files, they are preservers of order, not to say creation-cops. And this concern to classify everything in compartments does not broaden their minds: for them, anyone who moves out of his box is an offender; artists are under house arrest. Éric Rohmer has just learned that at his expense.[109]

The defense was mounted by a minority, chiefly from people involved in cinema or from intellectuals shocked by this barrage of criticism. Dominique Rabourdin wrote in *Pariscope*, under the headline "It Is Rohmer Who Is Being Assassinated":

> These remarks seem to emanate from a kind of superior authority, a divine justice: Éric Rohmer tried to do theater, and he just didn't have the right. [. . .] Rohmer and his past as a filmmaker have to be paid for. And yet had anyone tried to see his work, they would have found genuine beauties, the kind that are only too seldom seen on the stage. His translation conveys Kleist's style admirably well. Consider also the beauty of the slightest gestures, the intelligence of the division into scenes, the way in which the actors move about on the immense stage of the Théâtre des Amandiers. Listen to the actors, Pascale Ogier, Arielle Dombasle, and Pascal Greggory: they overwhelm us because they are very young, very handsome, and because Rohmer has asked them to act in a register completely different from the one we are used to finding in the theater today. This "right to be different," this new, original, and deeply moving attempt, has to be allowed, rather than simply shouted down.[110]

Rabourdin repeats Boris Vian's 1948 apostrophe: "Critics, you're fools! When are you going to allow freedom?" René Schérer, the filmmaker's younger brother, also flew to the defense of the production in a letter to *Le Monde* in response to

Colette Godard's criticism. In it he proposed a peculiarly Rohmerian "interpretation" of the work, an intention of its mise en scène:

> Éric Rohmer's work admirably emphasizes something that constitutes an essential element of Kleist's play, its oneirism. This play operates in a double register, reality and dream, and Rohmer has succeeded in showing the perpetual oscillation between them. To take only one example, Pascale Ogier's embodiment of Catherine is striking because she makes the implausible plausible, associating in a single attitude, to the precise degree, and as I see it, in an undeniably Kleistian way, the naïveté of passion as it is lived and somnambulistic clairvoyance. To speak of "insipid intonations" (I quote) is nonsense or a deliberate desire to denigrate.[111]

He goes on to point out Colette Godard's "closed-mindedness," her "corporatist reflex," her participation in a "thought police" that reminds him, he says, of "an article that appeared at the time of the New Wave, dragging through the mud Godard, Chabrol, and Rivette, all writers for *Cahiers du cinéma*, for having dared to try their hands 'as amateurs' at an art whose technique they had not mastered!"[112]

Éric Rohmer was incontestably wounded by the critical reception of *Catherine of Heilbronn*.[113] He returned frankly to this polemic a few weeks later in an interview given to the review *Théâtre public*:

> The critics' main reproach, made in very violent terms, is amateurism, platitude, an absence of direction, and I expected that. Because in fact I did not want to direct actors as they are directed today in France. It is certain that there is a kind of misunderstanding between my *Catherine of Heilbronn* and theater people. I have been reproached for having produced an archaic mise en scène dating from 1900 or even earlier . . . But I did not want to yield to the trap of fashion. I call this a "fashion," even if I admire certain things that are currently being done in the theater, such as Vitez's work, for example. But imitating it would have been, for me, yielding to the fashion. In the cinema, I've always remained outside the trends. For theater people, it seems to me, mise en scène consists in a kind of symbolism of the gesture that is developed in parallel with that of the text . . . The text is not performed: one invents a body language that functions along with the text. So far as I'm concerned, my main goal has always been that everything be clearly understood.[114]

Professor Rohmer

In September 1977, instruction in cinema at Paris-I became independent. Jacques Goimard asked Éric Rohmer to increase his pedagogical activity. The filmmaker had been teaching there since 1969, when a diploma in film studies (*licence d'études cinématographiques*) was created. He lectured for two hours every fortnight, before third-year students, on the Practice of Cinema, which he defined this way in his CV:

> Using examples taken from my activity as a filmmaker, I set forth the methods of recording images and sounds, not so much from the technical point of view as from that of their relation to the exercise of the mise en scène, understood in accord with the artistic criteria of the organization of space and time. Then, following a week or two of projections of films, I ask the students to trace the vision of the completed work back to the various operations that have given rise to it. Each year, the films studied are chosen in relation to a specific theme.[115]

It was a concrete way of teaching that allowed Rohmer to "flatten out" his own films by entering into the detail of their conception, their mise en scène, an exercise in which he excelled. Year after year, he took up the following subjects: "cinema and language," "the primacy of plastic expression," "the modalities of discourse," "the end of classical rhetoric," "color," "history and History," "on-screen and offscreen," "the temporality of narration," "the actor's direction," "the technique of sound," "setting in cinema," "cinema and architecture," "cinema and money."[116] He also participated for a time in the private course on the Arts and Techniques of Cinema given at the Nouveau Carré Silvia-Montfort, weekly lectures delivered between 1975 and 1977 alongside colleagues such as Louis Daquin, Jean Rouch, Jean Douchet, and Jean-Paul Le Chanois.

Although he taught at the University of Paris-I with Gérard Legrand, Francis Lacassin, Jean Mitry, Jacques Demeure, Philippe d'Hugues, Michel Mourlet, and Claude Beylie, Éric Rohmer did not manage to obtain a permanent position. He was limited to replacing professors on vacation and giving lectures. Even once his thesis on Murnau's *Faust* had been well and duly defended in proper academic form in early 1972, the university refused him the recognition that he

nonetheless sought with great professional awareness, no doubt for symbolic reasons—"It was the dream and ambition his mother had for him,"[117] Thérèse Schérer suggested. In April 1972 he applied to the Consultative Committee of the Universities (CCU) for certification as a lecturer, but two months later he received a negative response, accompanied by this disparaging assessment: "The time spent teaching is not very conclusive, for lack of a detailed pedagogical attestation. It seems to us that Maurice Schérer, an excellent filmmaker, should find a mooring point in the university other than a post as lecturer, for which he does not meet the required conditions."[118] A historian who was a member of the CCU, Michel Rouche, who had supported Rohmer's application in vain, explained the decision to him this way:

> Although the scientific criteria were good, there was no pedagogical criterion. Following an animated discussion, it seemed that one or two teaching assignments in higher education would resolve all the problems. We cannot make an exception to this rule. Please understand that many regretted this, believing that it amounted to confining instruction in cinema to the academic ghetto. For my part, I strongly hope that you will be able to join us, if only in order to erase from the screen the Napoleonic fantasies that cut us off from the general public. With my sincere regards.[119]

Like the theater milieu in 1979, that of the university was closed to the applicant. This kind of disillusion happened repeatedly in Rohmer's life, from his failures at the École normale supérieure and the *agrégation* to the commission's refusal to grant him an ID card for professional journalists or for the syndicates of professional film directors or television technicians. His career repeatedly collided with such obstacles, then went around them, and finally succeeded in following a singular path to canonization.

However, to support the creation of a specific program in cinema at Paris-I, from the *licence* to the Diplôme d'Études Approfondies and on to the doctorate, Jacques Goimard was counting on Rohmer's notoriety and urged him to back his initiative. The letter that Rohmer wrote to the president of the University of Paris-I in the spring of 1977 shows his pedagogical commitment:

> I think it appropriate that a complete program in cinema be created at Paris-I. At a time when Bergman is the glory of Sweden, and Fellini, almost alone, that

of Italy—just as Godard, not long ago, was that of France, it is extremely important that the cinema not only enter the university but accede to the rank of an autonomous discipline that is not attached to the history of art, sociology, or linguistics. We cannot afford, in France, to fall behind other countries; we must even show the way. The cinema was born in France. For at least thirty years, we have been the sole authorities in matters of film theory. The criticism of other countries merely adapts our systems, with a few months' or years' delay, whether it is a matter of André Bazin's ontology, the politics of the authors of *Cahiers du cinéma*, or Christian de Metz's structuralism. It would be natural for cinema to occupy in the university the place that it has in French cultural life. [. . .] The pioneers of cinema were the children of artists, fairground people or small-time handymen, then it was the turn of the sons at odds with authority, renegades from the Sorbonne. Now comes the time of those holding a diploma. IDHEC, the Louis Lumière school, already exists, but the audiovisual industry needs competent administrators, whether in the public or the private sector. It is currently too often in the hands of bureaucrats who know nothing about cinema, no matter how brilliant and cultivated they may be in other domains. The creation of a program in cinema, in which the practical, historical, and economic part is large, would put the destinies of cinema and television in more expert hands.[120]

From that point onward, instruction in cinema at Paris-I had a certain success. Made independent and continued as far as the DEA in 1977–1978, it bore fruit three years later: seventy-nine students were awarded diplomas in June 1981, of whom thirty-eight immediately found jobs, three-fourths of them abroad.

Rohmer continued teaching, at the rate of fifty hours a year, giving his lectures at the Centre Michelet, room 106, every other Monday from 11 A.M. to noon, and then on Tuesdays from noon to 1 P.M. in the large amphitheater, before the chosen film was shown. Starting in 1984, Claude Beylie, who succeeded Jacques Goimard, became the privileged interlocutor. Rohmer's lectures[121] were meticulously prepared, written out, and organized in black and blue files. They are difficult, with precise technical developments and multiple, erudite examples, and are written in the adopted academic language, far removed from the informal conversations in the offices of Films du Losange. The form is classical, professorial, and academic. Rohmer spoke sitting, in a slightly sentimentious, almost boring tone. The students listened and took notes, in a way completely opposite to that of the no-holds-barred exchanges aroused by the great seminars of the time,

those of Barthes, Foucault, Bourdieu, or Lévi-Strauss at the Collège de France, of Deleuze at Vincennes, of Lacan at the École normale supérieure, or of Derrida and Marin at the EHESS. No personal admissions, no flights of theory, polemics, diatribes, or familiarity; the man remained reserved. Ultimately, he resembled the professor at the Sorbonne that he played in Luc Moullet's *Brigitte and Brigitte* in 1965, severely taking the floor after a report by the two young heroines: "Mesdemoiselles, how dare you offer such a terrible performance?"[122]

On October 29, 1990, at the age of 70, when his retirement from the university was imminent, Éric Rohmer spoke more openly, though still reservedly:

> I think you know that I'm a filmmaker, or more precisely an author and director or scriptwriter and metteur en scène. and even producer. Perhaps you are less aware that I have taught here for the past twenty years, from 1969 to 1989. [. . .] I've always tried to make films in complete freedom, and having a second occupation has meant that I didn't need to make potboilers. That is not the case for many of my colleagues. At the beginning, I considered myself marginal, and even amateur. But my films turned out to be successful, and I have become a real, professional filmmaker [. . .]. This course has become something I do on the side. But since it didn't cost me much time I've had no reason to leave, and I had a small one to stay [. . .]. In France, there are few [filmmakers] who come from schools, but many who come from criticism [. . .]. One might expect that filmmakers who come from criticism would make pedantic films full of cinephile allusions, formalist [. . .] films. In fact, that is not the case![123]

If Professor Rohmer maintained a certain reserve, he nonetheless frequently met with students, who did not hesitate to approach him after his lectures, and then, if their affinities were confirmed, to come to his office at Films du Losange. A first generation, especially female students who were close to Rohmer, appeared in the early 1970s, notably a group of young American girls who were to become his collaborators: Cheryl Carlesimo, Judith Browda, Linda Macklin, Deborah Nathan, and later Mary Stephen, his future film editor. Carlesimo, who worked with Rohmer on some films, described the ambience that reigned in room 106 at the Institut Michelet on Mondays, late in the morning:

> I started attending his lectures in October 1972. I spoke French badly but I wanted to go there anyway. They were very good lectures, well-structured,

people listened attentively to this serious gentleman sitting behind his desk. He talked about Astruc, Bazin, and pronounced the names of American filmmakers, Hawks, Hitchcock, Keaton in the French fashion. It was very exotic for me: it was very charming, very prestigious. An almost magical power emanated from that place, because it was the language of cinephilia. And it happened that they were also my favorite filmmakers. He also talked about linguistics, that was harder. I like the poetry of the Middle Ages and some of the lectures were illustrated by the little films he'd made for educational television, especially on Chrétien de Troyes. Along with other American students, I began to talk with him after the lectures, it's common practice in universities back home. Then I went to his office, at Losange, to drink tea. That was very important for him. It's the heart of all his films: conversations over tea.[124]

Another generation was trained by Rohmer during the 1980s, for example, the director François Ozon, the Chinese writer and filmmaker Dai Sijie, the filmmaker and teacher Frédéric Sojcher (who "has a very intense memory of [his] lectures on Murnau and Griffith"[125]), and the critic and filmmaker Serge Bozon, who was then studying philosophy, and who wrote to Rohmer three years after attending his lectures to ask him to grant an interview for *La Lettre du cinéma*, a review he was founding with a few cinephile friends:

I know how interested you are in lying. So here's a little logical puzzle. After the exhausting filming of his latest film, Éric Rohmer takes a vacation on a very curious island, the Island of the Pure and the Perfidious. The Pure always tell the truth, the Perfidious always lie. Everyone on the island is either a Pure or a Perfidious. The filmmaker sees three inhabitants (A, B, and C). He asks A: "Are you a Pure or a Perfidious?" A replies, stammering incomprehensibly. Éric Rohmer then asks B: "What did A say?" B replies: "A said that he's a Perfidious." Then C speaks up: "Don't believe B, he's lying!" The question is the following: what are B and C, who is a Pure, who is a Perfidious? If you don't find an answer, I will agree to give it to you, as a testimony to my admiration, on the day of the interview for *La Lettre du cinéma*. This interview can take place any time, whenever you are available, starting from the week of May 11–19, during which I will be making a medium-length film in 16 mm. Respectfully yours . . .[126]

The interview did not take place, but Serge Bozon wrote a long article on Rohmer's cinema in the first issue of *La Lettre du cinéma*, in early 1996.

On March 20, 1997, at 5 P.M., Rohmer gave a public lecture at the Collège de France, It was entitled "Cinematic Expression: An Introduction to the Study of Forms," followed by a reception in his honor organized by the administrator of that prestigious institution, André Miquel. This incontestably represented the summit of the filmmaker's academic career—a recognition that came, as always, late, when he was almost 75 years old. Many notebooks as well as a written text of forty-four pages testify to the effort invested in preparing this lecture and the fear that no doubt increased as the date approached. The lecture is philosophical in tone, discussing in a cultivated way the study of cinematic forms in a series of developments on Béla Balázs, André Bazin, André Malraux, and Maurice Merleau-Ponty, full of references to Chaplin, Keaton, Murnau, Griffith, and Lang. It was the professor who talked for almost two hours, not the filmmaker. The theoretician of cinema, not the practitioner of *Moral Tales*, as he stated at the outset:

> First, please excuse me for having chosen a title that is both rebarbative and obscure. And all the more because I did so more or less on purpose. I chose a rebarbative title to dissuade people who would like to hear me talk about my work or my methods of working. The fact that I practice the filmmaker's trade plays no role in the remarks that I am going to make today. The ideas I will set forth I had long before I ever touched a camera or directed actors.[127]

During the following reception, the administrator of the Collège de France, accompanied by Marc Fumaroli—who had introduced Éric Rohmer before his lecture—gave him the college's medal of honor, engraved with a fine portrait of François Ier, the founding monarch. "He was immensely proud and happy about it,"[128] Thérèse Schérer reported.

Recognition by the Public, Critics, and Cinephiles

Éric Rohmer patiently constructed this recognition. It was not achieved until he was in his fifties, whereas Truffaut, Godard, and Chabrol had acquired it twenty years earlier, and Rivette fifteen years earlier. Neither was it connected with the great film festivals or rewards granted by the profession. No Palme d'Or, no

César, no Oscar adorned the office at Films du Losange, even though in 1984 *Full Moon in Paris* was nominated five times, without success, for a César. Except for the jury's special prize for *The Marquise of O*, the Cannes Festival ignored Rohmer, who ignored it in turn because he did not like to go there. The Berlin Film Festival was hardly more generous, awarding two Silver Bears for *La Collectionneuse* in 1967 and for *Pauline at the Beach* in 1983. In the end, it was the Venice Film Festival that turned out to be, (very) belatedly, the central site of Rohmer's canonization, giving him the Career Golden Lion for *The Green Ray* (1986), a prize for the best script for *Rendezvous in Paris* (1995), and in an apotheosis, a Golden Lion for the entire body of his work to an eighty-year-old filmmaker who made an exception and went to receive it on the Lido on September 7, 2001. It was not the four Méliès prizes awarded by the French Critics' Syndicate (Resnais received this prize six times and Truffaut five) for *My Night at Maud's*, *Perceval*, *Pauline at the Beach*, and *Full Moon in Paris*, or the single Louis-Delluc Prize for *Claire's Knee*, that made Éric Rohmer an artist honored by his peers in France—even if they testify to the affection critics usually showed for his films.

The public authorities had only episodic relationships with Rohmer, the ministers of Culture sending him a few lines of conventional congratulation after the awards he received in Venice. Rohmer himself was extremely discreet, indeed circumspect, regarding these relations with the state. He did not like having to depend on public subsidies (his applications for an advance on receipts were quite systematically rejected by the CNC), and he maintained political relations with no one. Few people know that he received the Legion of Honor in 1984, through the mediation and from the hands of his friend Philippe d'Hugues, who was in charge of the lists of the recipients at the CNC. Rohmer never wore the rosette.

Ultimately, the main recognition came from his audience, which was numerous (but neither massive nor popular) and especially loyal. Contrary to the false image of a filmmaker that some people call Parisian and consider reserved for a intellectual cinephile elite, starting in the late 1960s Rohmer's work drew spectators by the hundreds of thousands. In France, during the films' periods of exclusivity, the last four *Moral Tales*, made from 1969 to 1972, attracted three million spectators; the *Comedies and Proverbs* drew two million; while the *Tales of the Four Seasons* drew 1.2 million. As for the films that were not part of cycles, in all they attracted more than 1.5 million spectators. Thus more than eight million people in France went to see Éric Rohmer's twenty-two feature-length films.

However, it is incontestable that it was the cinephiles and critics who best defended and promoted Éric Rohmer's films. Retrospectives and expressions of homage were organized in France rather early on, first in 1965 at Henri Langlois's Cinémathèque, and then regularly: at the Cinéma national populaire de Paris and the Cinéma national populaire de Lyon in May 1967, at the Maison de la Culture de Gennevilliers in March 1970, at the sixth Rencontres Cinématographiques d'Annecy in March 1971. Then there were the prestigious showings of all his films, in January 1997 at the Premiers plans d'Angers Festival, in the spring of 2004 at the Cinémathèque française, and in July 2010 at the La Rochelle Film Festival. Similarly, important conversations with the master about his work and his ideas were published, ranging from sixteen meetings (between 1965 and 2004) with *Cahiers du cinéma* to seven with the editors of *Positif* (between 1986 and 2004). There were also about a hundred interviews with various French reviews and newspapers.

Books on Rohmer's cinema exist; he is far from being a despised, underestimated, ignored filmmaker. He himself was attached to this intellectual mediation, not hesitating to regularly receive critics and journalists in his office at Films du Losange, which explains his close links to Jean Douchet, Claude Beylie, Jean Collet, Joël Magny, Guy Braucourt, Dominique Rabourdin, Henri Agel, Philippe d'Hugues, and Michel Mourlet. French universities were not to be outdone, having devoted almost a dozen important works to the filmmaker, ranging from Michel Marie's study on the first *Moral Tales* in 1970 to the theses written by Maria Tortajada (on libertinage, in 1997), Jean Cléder (*Entre littérature et cinéma*, 1995), Philippe Molinier (on the photography, 1999), and Violaine Caminade de Schuytter (on the body in Rohmer's work, 2008). A class of secondary students at the Collège Cabanis in Brive knew who he was, and entered into contact with him in December 1999 in the context of a unit on "famous people from Corrèze": "You are an original filmmaker and the only Correzian who incarnates the seventh art,"[129] they wrote to him with admiration. In March 2011, a Médiathèque Éric Rohmer was inaugurated in Tulle by François Hollande, at the very time that the latter's campaign for the French presidency was taking off.

Rohmer's films are seen abroad, being regularly shown in many countries,[130] and movie lovers have not failed to pay him homage. In the United States, for example, most of his films premiered at Richard Roud's New York Film Festival during the 1970s, and Rohmer himself went there on three occasions, in 1972, 1976, and 1978. *The Marquise of O* and *Pauline at the Beach* (400,000 spectators),

then *Rendezvous in Paris* ($620,000 in ticket sales), and finally the *Tales of the Four Seasons* series, a surprising success that brought in $3 million for Losange, mark the stages of this American success. The most important program paying homage to him was set up in 2001, *Tales of Rohmer*, with a showing of all his films at the New York Film Forum from February 9 to March 15, and then a retrospective of thirteen films that circulated through about thirty cities over a period of six months. But what touched Rohmer even more is the fact that he was named an honorary member of the Mark Twain Society, replacing Eugene O'Neill, on November 3, 1977, before receiving on June 25, 2006, an honorary doctorate from the University of Notre Dame . . .

"Big Momo" or "Devil of a Man"?

Rohmer maintained relations with other New Wave filmmakers. He exchanged short notes with Jean-Luc Godard and occasionally saw him on his way to and from the Losange offices at number 26, avenue Pierre-Ier-de-Serbie, because the offices of Périphéria, Godard's company in Paris, were right next door. The meetings between these two aloof men were a hilarious ballet of hesitant waltzes—whose silent echoes enlivened Rohmer's conversations.

François Truffaut paid his debt for 1963 and the "felonious" act of having fired the head of *Cahiers* by serving as a kingpin, with his company Films du Carrosse, in coproducing *My Night at Maud's*. Later, their relations were comradely and cordial, consisting of tea taken at La Boulangerie, the cafe next to Carrosse's offices on the rue Marbeuf, a few steps from Losange, and of messages exchanged on the occasion of their films' coming out at the same time. The collection of documents testifies to a definite affection between the two filmmakers, to ten years of complicity, shared readings, winks, and mutual helping hands. On January 2, 1975, Truffaut wrote:

Dear Big Momo,

I am sending you a photocopy of a letter-document that I received from an old-new common friend, Lorette. What she wrote in her hand at the top of the page—"How is Schérer?"—stupefied me because it seems to indicate that she has not carried out the rapprochement of Schérer and Rohmer! For the

moment, I've decided not to reply to her message, not knowing what your in-
tentions are and also because I think the emotional shock will be greater if it
comes from you. The ball is in your court.

Cordially and faithfully yours . . .[131]

The Lorette in question had been one of Maurice Schérer's youthful crushes.
Then came a postcard on the occasion of the release of Truffaut's *The Green
Room*, adapted from Henry James's story "The Altar of the Dead," which Truffaut
had given Rohmer: "My dear Rohmer, your approval touches me. As you know,
the box office for *The Green Room* is a disaster, but your two lines are worth two
hundred thousand tickets sold. See you soon, I hope, yours . . ."[132] On June 8,
1977: "My dear friend, I was scandalized by what I learned about the advance on
receipts for your next film [*Perceval*]. I hope things will work out. Hope to run
into you soon, yours . . ."[133] On January 8, 1979: "I know that you don't eat lunch
but let's have tea together before or after the release of your film. P.S. Do me the
kindness of not going to see *Love on the Run*. Thanks."[134] All these messages, or
almost all, were collected by Rohmer just after Truffaut's death in the autumn of
1984, at a time of great dismay for a man who had also just lost his young muse,
Pascale Ogier. In a manila envelope, he sent a copy of this fetish-treasure to
Claude de Givray, who was getting ready to publish Truffaut's correspondence
at Hatier, in a series directed by Gilles Jacob. "My dear Claude," Rohmer wrote,
"here is the result of my research. I've censored only a very few passages, mainly
one in which François, for the only and last time in our epistolary relations, told
me private things about his emotional life."[135]

The former editor in chief of *Cahiers du cinéma* also entered into closer rela-
tions with Jacques Rivette, despite the quarrel arising from the break in 1963. It
was through a genuine interest in Rivette's experiments and a sincere admiration
for the films that resulted from them, *Mad Love* in 1968 and *Out 1* in 1971, that
Rohmer came back toward Rivette, going so far as to coproduce the latter film
with Losange and to appear in this rambling twelve-hour work, concealed by a
hairpiece, at Rivette's request. Rohmer found the film exciting, and several years
later he wrote:

In my view, it is a unique enterprise, a capital monument in the history of mod-
ern cinema, an essential part of the cinematic heritage. Although *Out 1* belongs

to the family of films known as "improvised," which was made famous by pioneers like Rouch and Cassavetes, it is the only one that systematizes the subject and pushes to its final consequences a method that is never used, normally, without safety nets. With an unparalleled freedom and courage, Rivette moves along the tightrope, without looking for help from either the documentary or fiction. The actor cannot at any time fill in the gaps in his inspiration. As a support, he has only his pure creativity. In my opinion, the most conclusive example is that of Bulle Ogier, who, though lost in the crowd at the beginning, distinguishes herself in the stretch and subjugates us by the radiance of her authority.[136]

If we recall the rivalry between Rohmer and Rivette, this reaction on Rohmer's part is literally chivalric.

Rohmer's closest ties were maintained, of course, with *Cahiers du cinéma*. Less with the review itself, despite the nmany interviews he gave it, than with its book publishing side, which were directed in turn by Jean Narboni, Alain Bergala, and Claudine Paquot. Éditions des Cahiers, born in the early 1980s, published several books by Rohmer, from *Le Goût de la beauté* in 1984 to the scenarios for *Moral Tales, Comedies and Proverbs, Tales of the Four Seasons, Triple Agent*, and the pocketbook reprints of *Faust* and the main articles and interviews from the 1950s. Rohmer was a sure bet for Éditions des Cahiers, almost an annuity, with sales of more than twenty thousand copies of these various titles. But Claudine Paquot was never able to complete the book she wanted to write with the filmmaker, which involved getting him to talk about his work in detail. The proposal was made on five occasions: in June 1987 with Alain Bergala as the interlocutor for a "spoken film book";[137] in February 1988 with Serge Daney, for a "big book of interviews";[138] in January 2003 with Jean Douchet for a "Rohmer at work"[139] in the "archives that you keep in your office at Losange": in September 2003 with Hélène Frappat for a "workshop-book combining interviews and documents";[140] and the last time by Juliette Cerf after *The Romance of Astree and Celadon*.

If *Cahiers* tried so hard to publish this book, it was undoubtedly because Rohmer had made public the existence of these archival treasures and the pleasure he took in digging through them. In spring of 1993, he allowed a film to be made about his work and his working methods, in which he speaks to the camera and to an interlocutor, Jean Douchet, basing himself on his personal documents. The film is entitled *Éric Rohmer, preuves à l'appui*, two fifty-two-minute sessions

recorded for the series *Cinéastes, de notre temps*. André S. Labarthe and Janine Bazin, who had directed the collection of these portraits made for television since 1964, wanted to make a film about Rohmer. In January 1975, Janine Bazin wrote to him: "I am thinking about a *Cinéastes, de notre temps* on you. Would you agree to talk about it with me or at least think about it? And if it is conceivable for you and possible in the near or less near future, think about whom you would like as a friendly adversary."[141] Rohmer rejected the idea: "We'll see later,"[142] he replied during an interview just before he made *The Marquise of O*. It turned out to be a long time. Thirteen years later, Rohmer rejected another proposal, this time formulated, with Janine Bazin's and André S. Labarthe's accord, by Jacques Aumont, a professor at Paris-III and a former critic at *Cahiers du cinéma*. "All the broadcasts in the series," Aumont wrote to him on March 31, 1988,

> will have as their principle a great interest in the work, the thought, and the oeuvre of filmmakers, and very little in their personal lives. In the case of a broadcast about you, this principle becomes an imperative: your express desire not to appear on the screen. The main thread of the broadcast will therefore be the conception of your cinema, in the twofold sense of the expression, developed around a few of its axioms and specific notions, for instance the ontology of cinema and its corollaries, the "taste for beauty," the mise en scène, the cinema as an "art of space," in short, the themes that you defined as a critic and illustrated as a filmmaker.[143]

Aumont proposed to film in the offices of Losange, "following your workday, among your usual collaborators," and to open the discussion with the filmmaker, recorded on tape or filmed from behind, commenting on films and works other than his own, from Murnau to Vermeer, from Renoir to Poussin, from Godard to Balzac. But he met with another refusal.

It took five more years for Rohmer finally to agree, in March 1993. Labarthe offered one explanation: "I think he realized that he now had to leave a statement behind for posterity. Truffaut and Godard had done so long before, during the 1960s, Rivette and Chabrol had just done it, the former in 1990 with Serge Daney and Claire Denis, the latter in 1992 with Jean Douchet. Rohmer felt that it was time. In his broadcast, Rivette told Daney: 'At a certain time, we are no longer sons, we've become fathers . . .' This remark had an impact on Rohmer, he told me himself."[144] On March 5, 1993, Rohmer signed a contract with *Cinéastes,*

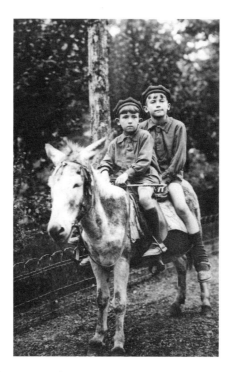

FIGURE 1 René and Maurice Schérer, c. 1930. (Photo from Thérèse Schérer's collection)

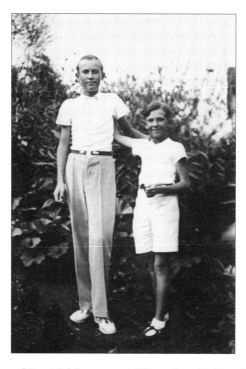

FIGURE 2 Maurice and René Schérer, c. 1935. (Photo from Thérèse Schérer's collection)

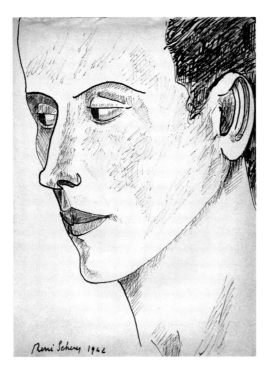

FIGURE 3 René Schérer by Maurice Schérer, 1942. (Photo from IMEC)

FIGURE 4 Thérèse and Maurice Schérer, c. 1960. (Photo from Thérèse Schérer's collection)

FIGURE 5 Maurice Schérer, c. 1970. (Photo from Thérèse Schérer's collection)

FIGURE 6 Laurent, Maurice, and Denis Schérer, c. 1980. (Photo from Thérèse Schérer's collection)

FIGURE 7 Maurice and his students, c. 1952. (IMEC)

FIGURE 8 Jean Douchet, Éric Rohmer, and Jean Roy, c. 1975. (Photo by Dominique Bleton, IMEC)

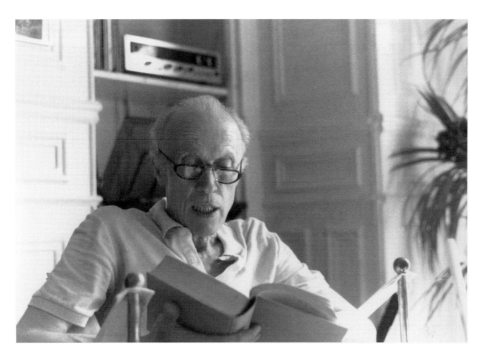

FIGURE 9 Éric Rohmer, c. 1980. (IMEC)

FIGURE 10 Éric Rohmer, c. 1970. (IMEC)

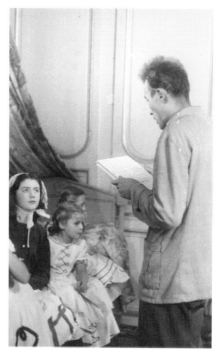

FIGURE 11 Éric Rohmer and his actresses on the set of *Petites Filles modèles*, 1952. (IMEC)

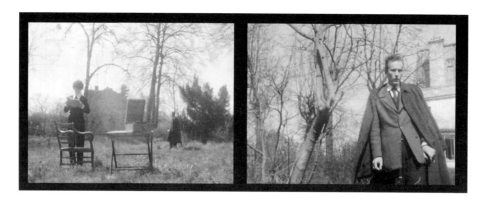

FIGURE 12 Teresa Gratia and Éric Rohmer in *Bérénice*, 1954. (Films du Losange)

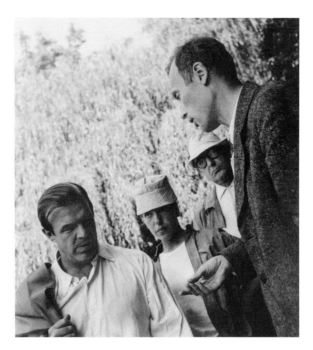

FIGURE 13 Jess Hahn and Éric Rohmer on the set of *The Sign of Leo*, 1959. (Photo from *Cahiers du cinema*, IMEC)

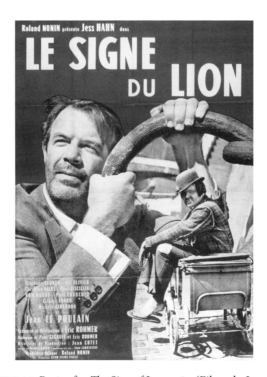

FIGURE 14 Poster for *The Sign of Leo*, 1962. (Films du Losange)

FIGURE 15 Éric Rohmer and Barbet Schroder on the set of *The Bakery Girl of Monceau*, 1962.

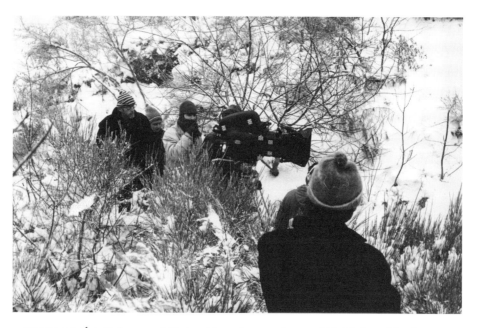

FIGURE 16 Éric Rohmer and Nestor Almendros on the set of *My Night at Maud's*, 1969. (Films du Losange)

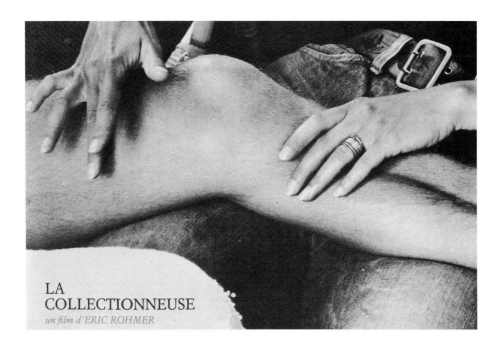

FIGURE 17 Press release for *La Collectionneuse*, 1967. (IMEC)

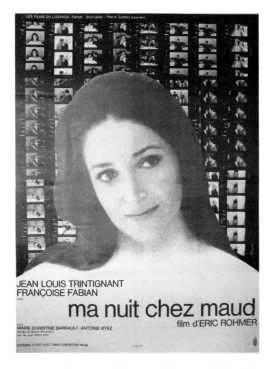

FIGURE 18 Poster for *My Night at Maud's*, 1969. (Films du Losange)

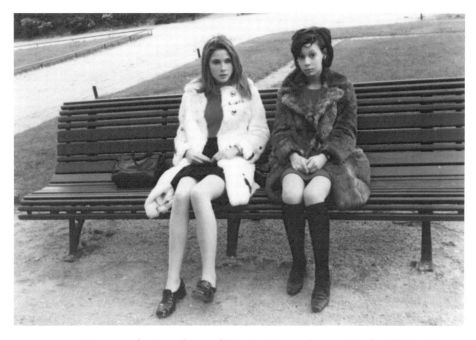

FIGURE 19 Laurence de Monaghan and Béatrice Romand, preparing for *Claire's Knee*, 1970. (Photo by Éric Rohmer, IMEC)

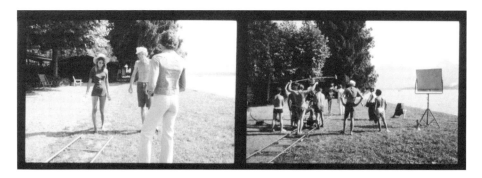

FIGURE 20 Laurence de Monaghan, Éric Rohmer, and Gérard Falconetti (at left), Éric Rohmer and his team (at right) on the set of *Claire's Knee*, 1970. (Photos by Bernard Prim, Films du Losange)

FIGURE 21 Béatrice Romand and Éric Rohmer on the set of *Love in the Afternoon*, 1972. (IMEC)

FIGURE 22 Éric Rohmer and Silvia Badescu on the set of *Love in the Afternoon*, 1972. (Photos by Bernard Prim, Films du Losange)

FIGURE 23 Nestor Almendros, Margaret Menegoz, and Éric Rohmer on the set of
The Marquise of O, 1975. (IMEC)

FIGURE 24 Edith Clever and Éric Rohmer on the set of *The Marquise of O*, 1975. (IMEC)

FIGURE 25 Marie-Christine Barrault and Éric Rohmer, postsynchronization of *The Marquise of O*, 1979. (IMEC)

FIGURE 26 Design for *Perceval*, by Éric Rohmer, 1978. (IMEC)

FIGURE 27 Éric Rohmer, Marc Eyraud, and Gérard Falconetti on the set of *Perceval*, 1979. (IMEC)

FIGURE 28 Cécile Decugis and Éric Rohmer editing *Perceval*, 1979. (IMEC)

FIGURE 29 Éric Rohmer, Maxence Larrieu, and Deborah Nathan, 1978. (IMEC)

FIGURE 30 Éric Rohmer, in *Passage de la vierge*, 1981. (IMEC)

FIGURE 31 Rosette and Éric Rohmer on the set of *Rosette cherche une chambre*, 1986. (Photo by François-Marie Banier, IMEC)

FIGURE 32 Christophe Bernard, Éric Rohmer, Mary Stephen, Virginie Thévenet, François-Marie Banier, and Rosette on the set of *Rosette vend des roses*, 1985. (Photo by Pascal Greggory, from Rosette's collection)

FIGURE 33 Sophie Renoir in *A Good Marriage*, by Éric Rohmer, 1981. (IMEC)

FIGURE 34 Draft of poster of *The Aviator's Wife*, by Éric Rohmer, 1981. (IMEC)

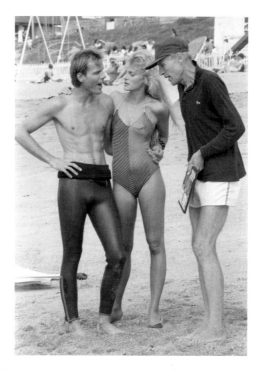

FIGURE 35 Pascal Greggory, Arielle Dombasle, and Éric Rohmer on the set of *Pauline at the Beach*, 1983. (Photo by François-Marie Banier)

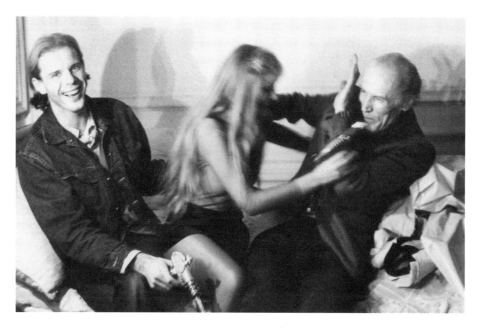

FIGURE 36 Pascal Greggory, Arielle Dombasle, and Éric Rohmer preparing for *Pauline at the Beach*, 1982. (Photo by François-Marie Banier, IMEC)

FIGURE 37 Éric Rohmer on the set of *Full Moon in Paris*, 1984. (All rights reserved)

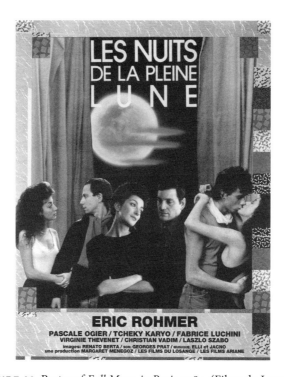

FIGURE 38 Poster of *Full Moon in Paris*, 1984. (Films du Losange)

FIGURE 39 Éric Rohmer, Marie Rivière, Claudine Nougaret, and Sophie Maintigneux (front row) and Rosette and Françoise Etchegaray (back row) on the set of *The Green Ray*, 1984. (Photo from Françoise Etchegaray's collection)

FIGURE 40 Joëlle Miquel, Hervé Grandsart, Sophie Maintigneux, and Pascal Ribier (front row) and Jessica Forde, Françoise Etchegaray, and Éric Rohmer (back row) on the set of *Four Adventures of Reinette and Mirabelle*, 1986. (All rights reserved)

FIGURE 41 Poster of *A Tale of Winter*, 1992. (Films du Losange)

FIGURE 42 Frédéric de Ravignan, Pascal Ribier, Aurélia Nolin, Melvil Poupaud, and Diane Baratier on the set of *A Tale of Summer*, 1995. (Photo by Franck Bouvat, Films du Losange)

FIGURE 43 Éric Rohmer, Alexia Portal, and Didier Sandre on the set of *A Tale of Autumn*, 1997. (Photo by Franck Bouvat, Films du Losange)

FIGURE 44 Éric Rohmer, Françoise Etchegaray, Didier Sandre, and Béatrice Romand on the set of *A Tale of Autumn*, 1997. (Photo Franck Bouvat, Films du Losange)

FIGURE 45 Set of *The Lady and the Duke*, 2000. (Photo from Françoise Etchegaray's collection)

FIGURE 46 Stéphanie de Crayencour preparing for *The Romance of Astrée and Céladon*, 2006. (Photo by Éric Rohmer, IMEC)

FIGURE 47 Letter from Éric Rohmer to the National Library of France, 2003. (IMEC) The text of the letter reads as follows: "Dear Sir/Madam, Please be so kind as to grant M. Maurice Schérer a reader's card for the purpose of preparing a film on Honoré d'Urfé's *L'Astrée*. Sincere regards, The director."

FIGURE 48 Éric Rohmer and Bethsabée Dreyfus on the set of *The Romance of Astrée and Céladon*, 2006. (IMEC)

de notre temps. However, he asked that it be set down in black and white that the film would not be shown before his death. In turn, Labarthe made him add: "without my consent."

Rohmer asked Jean Douchet to be his interlocutor and André S. Labarthe to be the director. The filming took place during a week in May 1993, in the Losange office. "We arrived in the morning," Labarthe went on, "and the three of us talked. Then I went to have lunch with Douchet, and we took our time. Rohmer remained alone, he had his tea, he never ate lunch. In fact, he was preparing his replies and the documents, which he placed within easy reach, in a drawer. The team set up in early afternoon and we filmed with a 16 mm camera and a magazine of ten minutes, which allowed him enough time to develop ideas. He had asked to be filmed from a certain distance, with a wide frame, but I had brought in a small dolly rail that made it possible to come closer, as far as the shoulder of Douchet, who was talking to him. Once, we got a little too close and the camera touched Douchet's shoulder: he was asleep! Rohmer was talking to him as if everything were normal, like a great professional . . . I admire the delicacy he can have: not waking up a friend and making him feel that he's done something wrong."[145] Jean Douchet woke up and took over: "Rohmer really got into it. He'd prepared everything; he knew exactly what he wanted to show in the way of documents, and had formulated his answers before I'd even asked my questions. He was always, and remained right to the end, the *metteur en scène* of everything that could happen to him."[146]

The camera ran for about ten hours; a fascinating complete transcription amounting to two hundred pages has survived.[147] Rohmer is precise, sometimes punctilious, very concentrated. Douchet tries to draw him toward broader themes and centers of interest, but each time the filmmaker recenters the discussion and comes back to the main thread of his thought. The long-standing harmony between the two men made it possible to explore in detail the making of Rohmer's films. The most astonishing thing, which is often amusing, is the appearance of the documents supporting the explanations—notebooks, successive drafts of a scenario, objects, drawings, photographs, 8 mm film cassettes in cookie boxes— that Rohmer brings out like a magician pulling rabbits out of his hat.[148]

The editing was rather long, laborious, and complicated, taking more than eight months. On February 20, 1994, Labarthe wrote to Rohmer: "Here, finished at last, are the two parts of *Éric Rohmer, preuves à l'appui*. You'll see that we've asked Arielle Dombasle to speak the commentary, which forced us to remix the

beginning of the first part. Because, with distance, my voice seemed to me poorly suited to the task. I thought Arielle was very good. In addition, she established, beyond the words, an amusing rapport with you. But I'll let you be the judge of that."[149] Rohmer was in fact going to "judge." "We expected the worst," Labarthe goes on,

> we never had any idea how he would react during those two hours of filming in which he is seen in front of the camera explaining his work, saying things that he didn't necessarily want to reveal. I think he was afraid of his own image, of allowing part of himself to be taken away from him . . . And then, in the end, he was very happy with it. Ten months went by, time may have made his image more bearable for him. The setup amused him, the concreteness of all those documents that he laid before Douchet's amazed eyes, and that piled up on his desk.[150]

Labarthe, Janine Bazin, and Douchet went to see Rohmer to find out if he would agree to let both parts of the program be broadcast. The filmmaker grumbled, obliged them to coax him: "Didn't we sign a contract? . . .The film will not be broadcast before my death." Labarthe replied: "But the contract says 'without my consent.'"[151] So Rohmer consented, asking only that the programs be broadcast on Arte late at night, without advertising or being shown in advance to the press. "The more proofs piled up, the more Rohmer lingered over details that seemed prosaic, the more impenetrable the mystery became," wrote Frédéric Bonnaud in *Libération*. "In the end, after unpacking everything to the point of being engulfed in the evidence provided by his films, he looked triumphant. He'd shown everything, he had fascinated us for two hours by presenting his discourse on method, but he did not reveal himself. The secret remains intact, the creation can continue. A devil of a man."[152]

8

In Pursuit of *Perceval*

1978–1979

Maurice Schérer's vocation as a *metteur en scène* originated in the house in Tulle where he was born. With old wallpaper on the stairway walls that represented medieval damsels wearing hose. One day his father found the little boy collecting tree branches—with the intention of "burning [them], like Jeanne d'Arc!" An early combination of the taste for spectacle and for the Middle Ages that he was never really to abandon: as a professor of French, he took great pleasure in having his students act out passages in *Perceval, ou le Conte du Graal* (Perceval, or the tale of the Holy Grail), a fundamental work in the French tradition of the novel, a repertory of figures and situations that were not yet complicated by metaphor. "What interests me in this text," Rohmer was to explain, "is its concrete side: there are no rhetorical figures, and this story cannot be summed up. [. . .] This simplicity keeps it understandable, more understandable to children than Racine or even, sometimes, Molière."[1]

The Pleasure of the Text

This simplicity of Chrétien de Troyes's text, which displays images without enveloping them in any kind of "literary" artifice, made it very early on one of Rohmer's cinematic dreams. He was already dreaming about it when he made, for educational television, a *Perceval* whose budget was too small to issue a casting call. He returned to the subject a decade later. Was he taking advantage of

the medieval revival that gripped France in the 1970s, through academic reinterpretations and clothing imitating that of the Middle Ages? Perhaps. On the pretext that he had finally found his Perceval when he saw his old actor Fabrice Luchini again, in a film by Pierre Zucca (*Vincent mit l'âne dans un pré*)? Probably. But adapting *Le Roman du Graal* was first of all a solitary enterprise that consisted in making a dead language his own without the betrayals of modern translations. To achieve this, Rohmer went back to the source of his wonder: the verse translation sketched out by Professor Gustave Cohen, which he had long before read with his students. Not moved by prose versions (which according to him flattened out the original octosyllabic verse), Rohmer decided to retranslate everything himself, respecting Chrétien de Troyes's metrical scheme, preserving the archaisms that remained comprehensible (the words "moult," "occire," etc.), and making the language more familiar whenever necessary.

Rohmer was very proud of this work, to the point that he replied sharply to a listener to *Le Masque et la Plume* who thought she recognized in his reversified *Perceval* the prose translation published in the Folio series."[2] Attached, as he repeatedly said, to the sonority of the word more than to its meaning, Rohmer was also attached to the narrative apparatus, which it is important to rediscover in its most material form. An initial version of the scenario made a classical resort to a narrator, whose voice (that of the filmmaker?) was to have accompanied the opening pages of the book, summed up the missing passages, and explained the story's lack of a conclusion (Chrétien never finished the poem). The film ultimately chose to get around that device by leaving it to the characters themselves to recount their stories directly. It was the characters who took responsibility for "occasionally uttering the 'he said' for which the cinema, just like the theater, has no use. But in fact, what do we know?"[3]

From this point of view, *Perceval* is far more than a literary adaptation: it is a literal adaptation. Where any other filmmaker would have simplified the extraordinarily complicated plot of *Le Conte du Graal*, with its series of encounters, reversals, and digressions that conflict with our taste for linear dramaturgy, Rohmer decided to try to preserve most of it. About two-thirds of the original verses were included in his film, and even episodes that might seem peripheral (at least to modern French spectators who have expected, since the seventeenth century, the classical unity of action). Consider the long parenthesis devoted to Gawain's adventures that abruptly interrupts Perceval's itinerary before we finally come back to it in extremis. If Rohmer dares to be unfaithful to his author,

it is to show himself literally more Christian than Chrétien de Troyes; for example, by omitting the incursions of the fantastic (connected with Celtic or pagan beliefs that meant little to him) in order to emphasize the moral dimension of the hero's quest: the discovery of a God of love very distant from the God of glory and war that initially fascinated the apprentice knight. And especially by making Perceval relive the Passion of Christ in a series of Sulpician playlets sung in Gregorian chant. It is not clear that these few liberties Rohmer took with regard to *Le Conte du Graal* sufficed to make it accessible to the 1979 audience.

The Detour Via the Theater

Another of Rohmer's daring ideas, but one which was also based on an age-old tradition, was the device of theater, which he had already experimented with in the "chamber drama" of *The Marquise of O.* The Berlin Schaubühne was not the only theater Rohmer frequented in the 1970s. He was also an attentive spectator at Antoine Vitez's productions, and notably *Andromaque*, staged in 1971 at the theater of the Cité Universitaire. "Not only did I greatly enjoy your *Andromaque*," he wrote to Vitez, "but it also taught me an enormous amount (I could reverse the clauses). You're the first person who I've seen put Racine on the stage. Up to this point, I naïvely thought he was impossible to stage. You have somewhat upset and to a large extent confirmed my conception of one of the few plays that I know almost by heart."[4] At the École nationale supérieure des arts décoratifs, Rohmer had seen performances of extracts from the *Graal Théâtre*, a large cycle conceived by Florence Delay and Jacques Roubaud on the basis of Arthurian texts (and which Marcel Maréchal was soon to repeat in Paris). What interested him most in this blossoming of performances was the use of a circular scenography that placed the spectator in the middle of the actors—a format that had become frequent.

By situating his *Perceval* in a similar arrangement, Rohmer accentuated the effects of distance and archaism. In his mind, he was clearly referring to the "mansion stage" of medieval drama and the mystery plays that were performed inside and then outside churches, and around which a curious audience moved. Thus Perceval would pass from mystery to mystery, through different and interchangeable settings (a castle, a city, etc.), followed by the mobile eye of the camera but within a single space. In addition, there was the commentary

that the characters make on what they are experiencing: for Chrétien de Troyes's frequently elliptical fabulation Rohmer substituted a pure theatricality, a kind of phenomenology of medieval representation, made visible at its birth. "The actors in this film," Rohmer explained, "are narrators who get so involved in their text that they end up acting out what they were supposed to simply say."[5]

To deploy this theatricality, Rohmer drew on actors who had some experience on stage: André Dussollier, fresh from the Conservatoire d'art dramatique, who played with an imposing presence the role of Gawain; Michel Etcheverry, Hubert Gignoux, and Pascale de Boysson, who played respectively the Fisher King, the hermit, and Perceval's mother (Suzanne Flon had initially been slated to play this role, and Roger Planchon that of King Arthur). Around them, and around himself, Rohmer assembled a singular troupe that was to accompany him through the next twenty years—and which consisted solely of very young people who had almost never acted before. There was Fabrice Luchini, who had been hardened, since *Claire's Knee*, by working on texts with Jean-Laurent Cochet—but whom Rohmer had first chosen for his freshness, for the kind of naïve burlesque that emanated from his whole person. Legend even has it that he was chosen over another of Cochet's pupils, a certain Gérard Depardieu, despite the latter's challenge to him: "I'm going to do your Perceval!" There was Arielle Dombasle, a student in René Simon's course at the Conservatoire international de musique de Paris, with her big, long eyes corresponding perfectly to the description of Blanchefleur, her nightingale voice, and her childlike imagination that made Rohmer laugh uproariously. And Pascale Ogier, the daughter of Bulle Ogier, who was studying film at the University of Paris-III, of whom Rohmer grew fond and asked to join the chorus. There was also a very young lycée student named Anne-Laure Meury (one might suspect that Gawain's adventures are there only to stage one episode: that of the "Virgin in sleeves," the little vixen who plots against her elder sister, and to whom Anne-Laure lent the sweet mischievousness of a fourteen-year-old). And then there was Marie Rivière, who tiptoed into Rohmer's theater. "In 1978, after seeing *Love in the Afternoon*, I wrote to him, so much had that film affected me. [. . .] At the time, Rohmer was making *Perceval le Gallois*, and my photo was in no way medieval: ultrashort hair, a miniskirt, and clogs. When I got to the Losange office [. . .], Arielle Dombasle, Fabrice Luchini, all those very extroverted people were there . . . That intimidated me even more. Rohmer said to me: 'You're all red!' And I turned violet . . . The casting was finished, but he found me a little place in the chorus."[6]

Perhaps we should speak, not of a troupe, but rather of a hive, in which energies, proposals, and personalities circulate. Working with Rohmer meant first of all spending long periods of time in his office on avenue Pierre-Ier-de-Serbie: they drank tea, talked about this and that and about *Perceval*, listened to Luchini reciting verses from Chrétien de Troyes in the manner of Louis Jouvet, Michel Bouquet, or a boastful *pied-noir*. They watched the master playing volleyball with his learned property man, Hervé Grandsart . . . The best account of this shared euphoria was probably given by Philippe Collin, shortly after the film was released: in it, a beaming Rohmer allowed himself to be filmed (as he had let himself be filmed on the set by Jean Douchet), delighted by Luchini's verve and the beauty of a group of girls in the flower of youth. But beyond this casual companionship, there was a meticulous preparation in which we recognize the rigor of the great medieval craftsmen. Eighteen months in advance, between two pizza deliveries, Luchini worked on reciting verse, horse-riding, and handling weapons. A year in advance, Rohmer supervised rehearsals in which the harmony among the spoken, sung, and recited parts was perfected. Using a small Super 8 camera, he filmed the men riding horses and looked over everything to be sure that nothing escaped his vigilance. To anticipate the long shot sequences that the actors would have to perform, he organized, shortly before the filming, a general rehearsal in which the whole text was represented in its continuity. Rohmer never came so close to theater in any of his other films. But to a theater that was clearly experienced in accord with the ideal of the Middle Ages: a collective communion in which the overseer remained in the background and sought to be completely in the service of the word.

Music Above All

And in the service of music. Music was another detour taken by Rohmer to transform the *Conte du Graal* into a show, to situate it in a sound space as well as in a visual space. And once again to go back into the past he took current models as his point of departure—musical comedy, for instance. "In a way, I wrote one: *Perceval*! I inserted existing songs, but I changed the words, which were not in the text adapted; thus one might say that I transformed the latter into a musical comedy . . . but without having found a French musician who could compose an original score."[7] In reality, at first he found a musician, and

not a minor one: Antoine Duhamel, one of prestigious composers who had accompanied the New Wave, working for Godard (*Pierrot le Fou*) and Truffaut (*Stolen Kisses*). But they very quickly realized that they were not on the same wavelength, because Duhamel criticized the choice of Arielle Dombasle, whose voice he considered too classical, too operatic, to sing the medieval melody. And above all, because he intended to write film music, which was completely contrary to Rohmer's philosophy: he never wanted film music, but rather music in the film, represented as a fragment of reality on the same basis as faces, landscapes, and objects.

Thus Rohmer turned in a different direction, toward medieval music revisited, which was very much in fashion in the mid-1970s. With the help of Guy Robert, a specialist in the music of the twelfth century (that is, the period when Chrétien de Troyes composed his poem), he entrusted whole sections of the narrative to a chorus, whose function was less to accompany the action than to comment on it directly. A few steps away from the characters, sometimes within the same shot, producing an uninterrupted echo effect that makes the fiction being constructed tangible. Whence Rohmer's attachment to the realism of the instruments used (the lute, the shawm, the transverse flute), to the historical pertinence of the scores used, and to the elegance of the members of the chorus. In fact, after the filming some of them formed a musical group called *Perceval*, while others pursued careers as soloists: this was the case for a young American named Deborah Nathan, whose voice was drowned in the chorus (so that her accent would not be heard), but who discreetly displayed throughout the film her talents as a flutist. She was, in a way, the hidden muse of *Perceval*, as Irène Skoblin had been for *Claire's Knee*: a tutelary presence full of tenderness, a tenderness that was immediately sublimated by artistic practice.

It was through one of his American students from the rue Michelet, Linda Macklin, that Rohmer became acquainted with Nathan, who was a student of Jean-Pierre Rampal's. She was a tall, beautiful brunette who had just arrived in Paris, and whose neighbors complained about her practicing the flute all day. Rohmer suggested that she come to work at Films du Losange every day, in the back room that he used as both a storeroom and a kitchen. Thus began a friendship in which music played an essential role as an object of discussion and of shared experimentation (she played the flute for him, he played the piano after he had gone back to that instrument). Paternally, Rohmer worried when Deborah deviated from her role as a model little girl by going out into Parisian

nightlife. He knew that she had several lovers, but between the two of them there was not the slightest ambiguity.

When she introduced him to her husband, Rohmer wrote her a beautiful letter that leaves no doubt on this subject:

> You can guess how happy I was to see you during the two days you spent in Paris, happy especially to know and to see you happy, wed to a man who seems to me perfect on every level (physical, intellectual, moral) and who suits you in an almost miraculous way. You are very lucky, as am I, after all, having been wed for twenty-five years to a wife of whom I seldom speak: but you can divine, from many clues, the deep and indestructible attachment that I have to her. At a time when, around me, so many couples are breaking up, our marriage has resisted any kind of lassitude, of erosion. I hope, I am sure, that this will also be true of yours.[8]

Rohmer ultimately struck out the word "attachment" and replaced it with "love." Another letter echoes this one. It refers to the courtly love tradition so well represented in *Perceval*. To someone who asked him: "But how do you manage to have tea every day with these magnificent girls?," he replied: "My secret is absolute chastity."

From Painting to Architecture

Perceval's ultimate conservative innovation consists in recreating a pictorial space in conformity with the representations of the Middle Ages. Rohmer did not seek to reconstitute the improbable truth of past times, any more than he did in *The Marquise of O*, except through the image that the people of the past formed of themselves and handed down to us. "In my view, fidelity to a period is fidelity to what remains of the period! It is not a futile quest for what the period in itself might have been."[9] He tracked down these remains with the patience of a Benedictine monk: in churches that he visited with his partner Cheryl Carlesimo, where he paid particular attention to the statues, and at the Bibliothèque nationale, which he had already used while preparing his educational film on Chrétien de Troyes. He returned there accompanied by Arielle Dombasle to consult the iconographic sources from the twelfth century, or to seek the advice of an

eminent medievalist. To Michel Pastoureau, he wrote "I still lack a great deal of information regarding certain gestures in everyday life (in particular, greetings) and the coats of arms of Perceval's companions and adversaries. I was hoping to draw on your knowledge."[10] When necessary, Rohmer himself acted as a historian, for example, to find out what a "petite manche" was: a piece of fabric that a lady could detach from her sleeve to encourage men in combat. He covered whole notebooks with drawings, copying details of clothing and architecture, and often sketching (an unusual practice for him) what can only be called a storyboard.

Does that mean that in making *Perceval* he accepted a cinematic pictoriality that he had always avoided? He was primarily concerned with the historical accuracy of the costumes, and especially of the coats of mail, whose fabrication kept a whole workshop busy (and were terrible straitjackets: Margaret Menegoz drolly recalls the appearance of an extra lying in a hospital, still squeezed into his metal uniform after falling from his horse). Rohmer asked his actors to keep hands spread wide, in the manner of Romanesque miniatures. And he tried to evoke the style of the period by foregoing perspective, which did not yet exist in the art of the time, by attenuating contrasts in light that would be an anachronism. However, he did not curve bodies, as we see them in historiated initials or on tympanums. If Rohmer sought to respect a certain aesthetic framework, he also wanted to avoid any excessively visible artifice and to allow his actors to move around within that framework.

It is here that architecture comes in. With the help of Jean-Pierre Kohut-Svelko (who had been François Truffaut's official set designer), Rohmer transposed onto the horizontal plane Romanesque painting's effect of vertical curvature. In the middle of the circular set, where two trees represented the forest (in accord with the medieval metonymic tradition), Perceval's travels also follow an elliptical itinerary. As if to prove that he invented nothing without basing it on a preexisting reality, Rohmer insisted that "What guided me was that this curved space projected onto a horizontal plane in perspective exists. It is that of the Romanesque church, of the apse. One can move around the altar. So that my set remains within the truth of the Middle Ages, which is not only plane representation on miniatures but also architecture."[11] This is, moreover, the same principle of rotation that presides over the interiors, with their arrangements that vary depending on the angle of filming.

In the ellipse that the itineraries describe here, the reader will have recognized one of the fundamental schemas of Rohmer's work, the very one that in

1964 inspired his *Place de l'Étoile*, with its little character crossing all the intersections that surround the Arch of Triumph. Seen by Rohmer, Perceval is (more than ever) a character who stubbornly moves round and round amid the vestiges of the past—as if he were seeking to detach himself from them, to declare his freedom. More than ever, this film recounts the birth of cinema out of the ruins of the other arts. In the immense mausoleum set up in the studios at Épinay, there was a single creator: Éric Rohmer, constantly on the lookout, rushing here and there, always available for a new task. Marie-Christine Barrault, who played the role of Guinevere, saw him lift his hand as soon as someone was needed: "I'll do it! I haven't anything to do!" He spent his time sweeping the sand that covered the floor, and when a new collaborator came up to him (the fencing master Raoul Billerey), he curtly interrupted him: "Uh . . . uh . . . you're walking on the prairie there." Thanks to *Perceval le Gallois*, he realized a demiurgic dream that was also that of Murnau: recreating the world in accord with his own way of seeing it.

The Triumph of Celluloid

We have just mentioned Murnau. How can we fail to think of the thesis that Rohmer had written on him six years earlier, in which he worked out his theory of space? Even if *Perceval* deviates in many ways from the model he defined there, it returns to the latter's main intuition: the idea of a cinematic space that contains and transcends the pictorial and the architectural and shows them both in their totality and in their limits. Above all, how can we fail to think of "Celluloid and Marble," and the autopsy of the arts that the critic of *Cahiers du cinéma* carried out the better to celebrate the grandeur of the seventh among them? Of course, the arts represented in *Perceval* are nascent: in the film, the novel, theater, music, painting and architecture are renewed at their sources, long before their fall into subjectivity and modernity. To be sure, Rohmer wanted to represent an innocent Middle Ages, far from the mists with which romanticism and disillusion in the manner of Robert Bresson encumbered it (Bresson's *Lancelot of the Lake*, which came out in 1974, was Rohmer's great foil, the film from which he absolutely had to distinguish his own, to the point that he had a fit of jealousy when Margaret Menegoz considered working for Bresson as well). But that innocence is lost forever; it takes the form of a naïve mirage, a stereotype, an interrupted history—one that today only cinema can begin again.

That is how we should understand the reference to Buster Keaton, omnipresent in the many interviews Rohmer gave when his film was released—and which is not merely homage paid to Luchini's deadpan humor or a wink to the twentieth-century audience. Buster Keaton (to whom Rohmer returned in an article published in 1994), was first of all the organizer of a space in which a rectilinear, uniform, and continuous movement prevailed—as it did in *Perceval*. Around Perceval, as around Keaton, the world is presented in its sensible unity, including the artistic forms that are an integral part of it. Whence the expression "documentary filmmaker"[12] that Rohmer claimed with a straight face. Whence his refusal of the subterfuges of editing or the manipulation of the image (with the exception of a single special effect, accepted as such: the drops of blood left on the snow and evoked by a short animated sequence). Whence, finally, his demand for truth with regard to the weight of the coats of mail or the birdsong recorded by Jean-Pierre Ruh in accord with the seasons that punctuate the narrative. With *Perceval*, the cinema is transformed into a Noah's ark capable of restoring to a vanished universe all its coherence and presence.

Then all the conditions were met for reviving a virtue that Rohmer shared above all with Keaton: the spirit of childhood. He wrote:

> The laughter that Buster Keaton elicits is of the same kind as that provoked by a young child who undertakes seriously a task that is clearly beyond his age and his abilities. A child who seeks to act like a "grown-up" [. . .]. It is the laughter elicited by someone who follows his idea all the way to the end—an idea that is both naïve and effective.[13]

Does that not precisely describe Perceval, who seeks awkwardly to apply the teachings of his mother or the wise man met along the way, at the risk of "missing" the Grail and looking like an idiot? In this film, it is as if Rohmer were reaffirming his fidelity to the mother figure and to the whole culture that it bequeathed to him, at the same time that he reaffirmed his impossible emancipation from it. Perceval would like to become a knight by his own means, conquering women and vanquishing men—but the despairing death of his mother at the time of his departure casts over his destiny an ineradicable shadow (all the more cruelly because he was not able to witness that scene). So here he is doomed to turn round and round in a closed space, to "play at being a grown-up" amid infantile representations that can never be forgotten.

The triumph of celluloid, that is, of a cinematic maturity identified with that of the protagonist? On reflection, that would be a hasty conclusion. It seems instead that Rohmer (who had himself lost his mother a few years earlier, and who allowed himself for the first time to be filmed while he was making this film) here repeats the little boy's tentative efforts to assert his identity as best he can. By burning Joan of Arc. Or by imagining himself in the guise of Perceval.

Forbidden to Adults

In addition, in the intensified "public relations" that were to be deployed around this film, children played a central role. Films du Losange produced many pedagogical materials, and the author told anyone who would listen that the octosyllables he had translated were perfectly comprehensible to elementary school students (as they had formerly been for his students at the lycée). This relied to some extent on Coué's method of autosuggestion, and yet there was a core of truth, to judge by the debates organized in the schools. Conversing with Rohmer and his main actor, the pupils very naturally appropriated Perceval's language and the images it elicited. In turn, they staged a theatrical remake, reproducing Rohmer's approach on their miniature scale. We can imagine the pleasure that such exchanges must have given him. And the pleasure that Danièle Dubroux's article might have given him; she was the only one who saw the importance of this childlike dimension:

> The mad look in Fabrice Luchini's eyes [. . .] reproduces that of a child whom reality leaves speechless. But the representational device set up in the film postulates both this symbolic place of the child-spectator (dazzled by the reality that surrounds him) and that of the child-actor, in accord with the demiurgic conventions in force in children's games: the "You'll be Perceval, you'll be King Arthur, you'll be Blanchefleur, and this box will be the castle, this pillar will be a tree . . ." The fact that the actors refer to themselves in the third person when they are in action [. . .] redoubles the effect of this "conventional" distance, whereas adults feel they are being led astray or taken for fools. In fact, they are bad players.[14]

Adults turned out to be bad players at every stage of this great project, forcing Rohmer to fight in a certain solitude. With the help of Margaret Menegoz

and Jacques Flaud (the director of the CNC), he at least managed to obtain an advance on receipts (1 million francs), as well as a significant contribution by foreign television networks (in the amount of 4.5 million francs given by the German channel ARD, the BBC, the Italian RAI, and others). To which we must add the 1.5 million francs that Daniel Toscan du Plantier put on the table for Gaumont. But as Cécile Decugis tells us, "There was a problem with the production. To Rohmer's dismay, Gaumont ended up choosing to give priority to the film Frank Cassenti was making on an equivalent theme (*The Song of Roland*). As a result, the budget for *Perceval* was reduced."[15] This is confirmed by a memo Rohmer scribbled, recommending reductions in each of the planned budget items. The filming in the studio was to last hardly seven weeks, and financing for the film did not exceed 10 million francs. Should we regret, as a journalist tells us Rohmer did, that this was "half the time and the money that he in fact needed"?[16] On the contrary, everything suggests that he foresaw from the outset this delicate balance as he imagined his sets and his dramaturgy, by cultivating a refined amateurism that kept him at the heart of his project.

Even if it meant rousing against him another kind of bad players—to the extent that they challenged the rules of the game that he had set for himself: the actors. In any case, their representatives (the officials of the French actors' union), who issued a communiqué expressing their alarm at the modesty of the remuneration (after a year of unpaid rehearsals) and the sacrifices required (bringing one's own snacks and make-up kits). Rohmer made an exception and wrote a polemical reply to these accusations:

> The actors' union should on the contrary thank me: for having, despite the advantages I was offered in Germany, insisted on making a French film that provided work for French studios, technicians, and actors; for having, instead of increasing the bank balances of Monsieur X or Mademoiselle Y, the perennial stars, given unknown talents an opportunity to show what they could do; [. . .] for having, despite the cowardice of some of our sponsors, managed to pay everyone for their services equitably and promptly. [. . .] The budget item for "actors" was the only one that was not reduced; for having, since there was austerity, begun by imposing this austerity on myself. Not only did I donate my salary to the team, but I tried to eliminate first the items intended to provide for my comfort. I didn't enjoy working eighteen hours a day as an assistant, continuity person, director, and courier . . . I think the unions are attacking the

wrong target. Instead of picking a quarrel with independent producers who are keeping French cinema alive, they would be better advised to attack the monied powers, the monopolies, and the bureaucracy that are smothering it.[17]

A self-serving plea that might serve as a preface to *Comedies and Proverbs*, and to the spartan thrift that they were soon to implement, the better to preserve the director's absolute freedom.

Was Nestor Almendros another bad player, even though for the past decade he had devoted himself to Rohmer's asceticism? Shortly before filming began, he was ready to give it all up, which plunged Rohmer into disarray. Margaret Menegoz testifies to this misunderstanding between the two men, the traces of which persisted throughout the filming:

> Nestor had fought hard to prevent the whole film from being made in the studio and for finding a seventeenth-century castle, a real forest, paths, interiors . . . He was terrified of having to create everything from scratch. In the studios at Épernay, he asked me the same question he'd asked about *The Marquise of O*: "Where is the sun?"—"Wherever you want, Nestor." With his floodlights installed on the catwalks, he could hardly plan variations in lighting. Moreover, he found Luchini repulsively ugly, with his big Adam's apple that cast a shadow."[18]

When it came time to plan a frame, he was irritated to always find in the field this knight he didn't like. And much later Rohmer himself (who was always so respectful of his collaborators) was still annoyed about a shot that he thought too yellow: the one with tears on Blanchefleur's face, associated with the drops of blood on the snow. However, it was he who had wanted artifice, which was developed in *Perceval* as never before, to be based on incontestable historical truth. In this case, lighting by candles. We can understand how one or another of his interlocutors (whether ephemeral like Antoine Duhamel or loyal like Nestor Almendros) might sometimes have lost his cool.

Finally, the journalists and spectators were bad players. The latter didn't exactly rush to admire Perceval's adventures: during its first run scarcely 145,000 tickets were sold. It is true that the journalists did nothing to encourage attendance. Throughout the press, a chorus of voices deplored the film's coldness, its schoolmasterly or theatrical rigidity. Even a critic as moderate as Jean de Baroncelli expressed his regret that such a fine effort kept the audience at such

a distance. And Jean-Louis Bory (though he was one of the first defenders of Rohmer's cinema) delivered the final blow when he wrote:

> I regret that the representation of deep forests was left to a bed of Brussels sprouts on long stems whose ugliness is attenuated only when snow kindly consents to confer on them a bit of the magic they so cruelly lack. As I regret that Perceval, on the pretext of naïveté or an innocence that is also "stylized" [...] is this charmless nincompoop who so little justifies the infatuations of the gentle ladies and sweet maidens [...].[19]

Only Michel Pérez and Michel Marmin defended the explicit archaism of the mise en scène, one in the name of Hollywood classicism, to which *Perceval* is supposed to be paying indirect homage, the other in the name of defending the French language.

Without going into these debates, we can only note the splendid isolation to which Rohmer condemned himself. By refusing to make the slightest concession that might have made his film likable (including reducing its length, which runs to almost two hours and twenty minutes). Like his hero, he pursued a long march through the desert. His horizon was, far more than the Middle Ages or safeguarding a host of vanished arts, the obscure origin of his desire for cinema, something like a fragile Rosebud of which he alone knew the secret.

Six *Comedies and Proverbs*

1980–1986

When at the dawn of the 1980s Éric Rohmer launched into a new cycle of films, he was following several ideas that are only apparently contradictory. The first one was not new; it went back to the conception of the *Moral Tales* in the early 1960s: at that time his goal was to inspire confidence in potential financial sponsors by committing himself to a series of projects defined in advance, while at the same time preventing themes foreign to his "program" from being imposed on him. In the wake of the difficulties he had experienced in financing *Perceval* (and its crushing commercial failure), this strategy seemed once again appropriate. It allowed Rohmer to withdraw into a framework that was reassuring for him and his partners, even if it was an illusory framework. As in the case of Balzac, who regrouped a posteriori the scattered fragments of his *Comédie humaine*.

Theater, Cinema, Television

Was, for instance, the reference to the theater merely an illusion, a mirage? In any case, it had priority among the linguistic elements Rohmer used to present his new series, beginning with the title: *Comedies and Proverbs*, borrowed from Alfred de Musset, from Carmontelle, and from the Countess of Ségur. We also think of René Clair's *Comédies et Commentaires*. Especially since Rohmer, imitating his illustrious elder as well as the seventeenth-century French dramatists, wrote a preface in which he explains clearly his intentions:

The great difference from the preceding is that this new group no longer refers, by its themes and structures, to the novel, but rather to the theater. Whereas the characters in the first [cycle] seek to narrate their stories as well as to live them, those in the second will be concerned instead to stage themselves. Some will take themselves for the heroes of novels, others will identify with characters in comedy, placed in a situation apt to show them to their advantage.[1]

Thus there were to be no more voice-over commentaries that kept the characters in the *Moral Tales* at a certain literary distance. The pairing (sometimes a bit systematic) of an analytical language and an image that constantly denies it was also relegated to the past. The characters of *Comedies and Proverbs* were to be shown simultaneously in situation and in representation, by turns the authors, actors, and spectators of their lives, without it being as easy to distinguish the true from the false, as had earlier been the case.

The proverb that was now going to accompany each of these comedies was certainly a mirage, offering at the end of the credits only a semblance of ironic morality. Besides, in his introductory text, Rohmer recognized the relativity of the framework that he had just put in place. He refused to announce the number and the themes of the films he was working on, as he had done in the case of the *Moral Tales*—because this time almost all the scenarios remained to be written: "The thematic unity, if there is one, will not be given in advance, but discovered as the works appear, by the spectator, the author, and perhaps even the characters themselves."[2] We see looming here the improvisation that was to blossom at the end of the cycle. From one film to the next, this "human comedy" was to be unpredictable, infinitely enriched and diversified in comparison to the elitist microsociety to which the first feature films were confined. The voluble and dominating intellectuals represented in *La Collectionneuse* and *Claire's Knee* were replaced by developing young people or women looking for love. Gégauff's influence finally waned, to the advantage of a humanity that was clearly less flamboyant but much more engaging.

On the other hand, what did not wane was Rohmer's loyalty to the New Wave. At the same time that he laid claim to a theatricality that emerged from his experiments in the 1970s, Rohmer asserted loud and clear that he had not broken with the cinematic style of the 1960s. It even seems that this return to the sources was indispensable for him after his long confinement to the studios where *Perceval* was made. He talked about it, on a militant note, to Serge Daney

and Pascal Bonitzer (who had come to interview him for *Cahiers du cinéma*), denying any nostalgia for past forms: "It would seem that in French cinema, there is currently a return toward pre–New Wave 'quality.' [. . .] if the New Wave is to be transcended, it must not be by returning to the schema of quality, it has to be transcended by a dialectical movement that takes into account what it has been and goes beyond it."[3] "Going beyond" meant first of all changing the team in order to do away with the sclerosis or habit that were threatening to establish themselves. Nestor Almendros (who had gone to work in the United States) was replaced on lighting by Bernard Lutic, who was shortly afterward to leave his post to other head camera operators; Jean-Pierre Ruh, whose insistence on smoking on the set may have turned Rohmer against him, was replaced by Georges Prat, who was to go still further in the practice of direct sound freed of any constraint. And we have already mentioned the emergence, during the making of *Perceval*, of an informal troupe of young actors chosen for their beauty and spontaneity rather than for their experience. They circulated in these *Comedies and Proverbs* like the recurrent characters in Balzac (him again!), but during the radiant years of the 1980s the Losange offices also make us think of Goethe's *Wilhelm Meister* and of a joyous group of mobile theater people in which Rohmer himself, visibly rejuvenated, would play the role of Dr. Faust.

There was also a return to the sources in the economy of production and distribution. It was no longer a question of developing costly projects, or of seeking cofinancing arrangements. By planning only low-budget films, financed by the receipts from the preceding film, and by reducing as much as possible the costs of filming (no assistant or continuity person, no restaurant bills or taxis), Rohmer guaranteed himself complete self-sufficiency. It allowed him to rejoice in "being the most free of all French filmmakers: now, that is a title that I claim, for I see no one who is as sheltered from contingencies as I am. I can make all my decisions myself."[4] This concern to be autonomous was even to lead him to create the Éric Rohmer Company, a microstructure more flexible than Films du Losange had become. This was, moreover, the period when, faced by the steamroller of American commercial cinema (a little earlier, a critic had had fun vaunting Perceval's fragile bravery as being like that of a French Superman), he mounted a ferocious defense of French cinema and the diversity of styles expressed in it. For him, it was a way of defining negatively his "politics of an author"; he was determined to defend his personality against all intermediaries that might alienate it.

That included distributors, whom he suspected of denaturing the exchange between author and spectator. At the time when what were soon to be called "multiplexes" were beginning to spread and investments in publicity were growing (to guarantee the film product an immediate profitability), Rohmer argued for distribution with a human face based on word of mouth and the choice of a small number of theaters where the public could find a filmmaker it liked, thanks to a long period of exclusivity. Was this nostalgia for the neighborhood film theaters of his youth? Or, here again, a mimicry of the theater that would allow him to escape the institutional burdens of cinema? A little of all that, no doubt—to which we must add a new model, thanks to which the old models could be discreetly reconciled. This new model was television.

In the late 1970s, Rohmer discovered a passion for "intimist" telefilms, particularly those broadcast on France 3. In them he saw an example of the chamber cinema that he yearned for, because this cinema that is not a cinema literally moved into the telespectator's bedroom and made all the mirages of the show and commercials disappear to create a direct link. Rohmer and Margaret Menegoz recalled having had the idea of financing *The Green Ray* with the help of an advance broadcast on the television channel Canal+. In the meantime, Rohmer noticed that the small screen was perfectly suited to showing his films insofar as it respected the 1.33 format that he wanted to keep. But what pleased him most in the televisual aesthetics that was being constructed was a sort of epiphany of banality, very close to what he had been seeking in his own work. That is how the move "beyond" the New Wave to which he aspired took on its full meaning: "When I began to take an interest in serials, in little French telefilms [. . .], I found in them a mise en scène that proves that the New Wave existed, that something happened."[5] This reflects his secret ambition, the very one that runs through *Comedies and Proverbs* (while at the same time bringing him back to the impure register of *Sign of Leo*): conceal theatricality at the heart of everyday life, or fiction under the mask of the documentary. The better to make viewers forget, perhaps, the autobiographical novel.

The Hidden Narrative

This autobiographical novel was, however, the very first source of inspiration that operated in the genesis of this new cycle. But Rohmer is very careful not

to mention it in his interviews, or only in an allusive and elliptical manner. He even avoids mentioning a text that he had recently rediscovered through one of his former classmates in the École normale supérieure preparatory course who sent him a photocopy of it. This text, which appeared in the review *Espale* in the 1940s, is entitled "The Marriage Proposal," but it has only a little to do with the future *A Good Marriage*, apart from the anecdote that serves it as a pretext: a young man does not know how to go about asking for the hand of a young woman with whom he is in love. The rest is a hesitant rehearsal of what was to become *The Aviator's Wife*. The insignificance of the dialogues, the spinelessness of the characters, their reverie about a destiny they dare not confront . . . All these commonplaces of postwar literature, all these signs of an exhausted kind of novel seem to call for their cinematic transcendence, even in body of the narrative: the main character (a certain Roger Mathias) wanders around a cinema as if he were no more than a spectator of the spectators.

> He put his hands in his pockets and leaned on the wall: the avenue was well lit by the streetlamps and the lights in the houses: you could almost see the features of passersby on the sidewalk in front of the cinema. He stood up and went out. He went back up the street rather quickly, slowing his pace as he neared Janine's house, which stood at the corner with a small street running parallel to the avenue. He recalled that one day—just two weeks before—he had taken this street to go to Jacques's place, and he had seen her at her window above a kind of garden or courtyard planted with peach or apricot trees. [. . .] Both sides of the door were ajar. Mathias gently pushed them open and entered the bedroom. He groped his way as far as the door, which was almost in front of him, and turned on the light. It was a rather large room that had two alcoves, one for the bed, the other, separated by a curtain, must be a bathroom. [. . .] The wall was covered with photos: views of mountains and portraits of artists; above the night-table, two glazed postcards, one representing Danielle Darrieux, the other Tyrone Power.[6]

We recognize here a frequent situation in the short stories written by the young Schérer: a male character who is stalking someone, seeking to take possession (through his eyes) of the space in which a desired woman moves. But unlike the drafts of *My Night at Maud's* or *Claire's Knee*, here the voyeurism is not

accompanied by an claim to manipulation or mise en scène. It is displayed in its pure gratuitousness, in a passivity that demands no response. If the characters go so far as to imagine that they might marry, that is the result of a misunderstanding (a child taking them for husband and wife), which makes them slide without knowing it toward the possibility of an act. Do we ever know what we're thinking about? That is the question that keeps the narrative in suspense, anticipating the subtitle of *The Aviator's Wife (One Cannot Think of Nothing)*, betraying a microscopic obsession in the writer: spying on his own desires. To such a degree of intensity that the only events that can be envisaged are the dialogues, which are already the dialogues of a film by Rohmer.

There are dialogues again, a surfeit of them, in a second text that can be dated to the same period. Under the title "Une journée" (A day) Maurice Schérer wrote a series of sequences that are hardly narrative, linked simply by a chronological thread that runs from morning to evening. First sequence: we are in Paris, in March 1940, during the "Phony War." In her bedroom, Annie receives a visit from Gérard, who takes advantage of a leave to tell her unpleasant news. He has decided to go back to his wife. Second sequence: Annie is having lunch with Colette, and tells her that Gérard has dropped her. Jacques interrupts their discussion. Claiming he wants to do her a favor, he comes to ask Annie about the stranger seen with her that morning. She sends him away; she has an appointment with her hairdresser. Third sequence: Jacques (who works nights in a postal sorting center) spends his afternoon spying on Gérard, whom he has happened to see in a sidewalk café, and who is joined by a woman. He continues his little game even in the Metro:

> At the Duroc station the people sitting next to Jacques got off: a girl who had entered the car in front of him at Sèvres and had remained there next to the door moved over and leaned against the window in such a way as to conceal the whole line of benches from him. [. . .] The girl took a book out of her bag: an English textbook with pictures. She read with her head bent down and her hair, which she wore very long [. . .] hid almost her whole face. She was wearing a light beige coat with a navy blue leather belt. She couldn't have been more than eighteen years old.[7]

This teenager was to become Jacques's accomplice at the racetrack in the Bois de Boulogne, where he continued to tail Gérard.

Fourth sequence: having returned to see Annie, Jacques throws a violent fit of jealousy. She wards off his reproaches, telling him that the morning visitor came only to tell her that he had gotten married. She shows him a photo of the man in an officer's uniform, in the company of his wife and another woman (the unknown woman seen shortly before, whose identity we will never know). For his part, Jacques tries to arouse Annie's jealousy by mentioning the girl he met. They are half-heartedly reconciled. Fifth and last sequence: in the street, Jacques runs into the girl in question. She refers ironically to the "accident" of this meeting and bids him farewell. "'See you one of these days,' Jacques says. 'Right, one of these days,' she replies. Jacques waits until she has crossed the street. She rings the bell at a door a few meters farther on, next to a bakery. He looks at his watch. 9:15. It is getting colder and colder. 'I'd have done better to go get my coat,' he thinks. He begins to run."[8]

This time, the situation in "Rue Monge" (the future *My Night at Maud's*) is literally reversed: it is the girl with whom the men are closed up in a room who represents the fixed idea, the obsessive and disappointing chimera. She is the one who is met outside through a combination of circumstances that has been more or less provoked, who embodies the opportunity forever lost. Two sides of a single dream that Rohmer was to continue to pursue in his work in the most diverse forms. And in precisely that form in *The Aviator's Wife*. There were in fact a few intermediate versions that sought to complicate the original narrative (by introducing into it a romantic idyll between the adolescent and Jacques, or even by the latter's death after he goes off to war in Algeria), but in the late 1970s the filmmaker faithfully returned to the minuscule anecdote that had served as his point of departure. He took it up again in all its details, including the discussions about the dishes eaten, the pen that does not work, and the Sartrean depression in which his characters get mired because of their inability to "commit themselves," even in love. That is, moreover, the only real hint he provides to explain the genesis of the film: "If there is a very old influence in this story, it would be, strange as it may seem to you, existentialist literature. In the *Moral Tales* there was an anti-existentialist side, a return to classical narration and the description of feelings, whereas there it was more a literature of behavior and, beneath the apparent psychologism, beneath the light-hearted gallantry, it goes as far as certain existentialist anti-heroes situated outside any psychological or moral category, as in the literature of the 1950s."[9] In short, a return to the behaviorism that

so strongly shaped his literary vocation and at the same time to the forestalled autobiography that was its first mask. Even if it meant allowing himself, along the way, a few indecipherable private jokes. "One of Maurice's women friends," his brother René Schérer recalled, "was an airplane stewardess . . . That may have been the source (through a kind of inversion of roles) of *The Aviator's Wife*."[10]

A Chamber Drama Reincarnated

To give life, thirty years later, to this text of his youth, Rohmer took a detour rather similar to the one he chose for his last two films: he made himself a theater director, considering what he had written as raw material that he would only have to adapt. This adaptation took place first through a change in setting—imagined, it is true, as early as the new scenario was written. The racetrack in the Bois de Boulogne was replaced by the Buttes-Chaumont park, which interested Rohmer because of its variations in altitude (like the mountains in *Claire's Knee*) and especially, perhaps, because there the onlookers were arranged around a central set (reproducing the circular theater in *Perceval*). Because it gave this new film, ultimately, its general color. Not only the color green, which is associated with blue and yellow to form the dominants of a very composed image, but also the slightly artificial and old-fashioned "atmosphere" of a nature that looks like it was reproduced in the studio. It is almost like watching a film by Marcel Carné, a filmmaker to whom Rohmer liked to allude during this period. He admired Carné's plastic rigor and the way his narratives were situated in a homogeneous space-time: a single setting, an action restricted to a few hours that ends as it began. These are constraints that take us back beyond French cinema of the 1930s to German cinema of the 1920s and to the "chamber theater" made famous by Murnau.

This chamber theater is even more manifest in the long interior sequences that bring the two main characters together. Equally obvious is the allusion to Carné's *Le Jour se lève* (1939) through the figure of a modest young man winding his alarm clock as if for a countdown, caught in the trap of an impossible love and an ironic fate. Even the final song, with its postcard lyricism ("Paris seduced me"), evokes a whole fatalist mythology contemporary with Maurice Schérer's youth. However, Éric Rohmer asserts here an influence that he had not undergone at that time, and hardly more during the time he was writing for *Cahiers du*

cinéma: that of Marcel Pagnol. At the same time that he set up his equipment in a confined space (a minuscule maid's room, lent by his assistant director, Hervé Grandsart), he took care to make his cutting invisible and to create the effect of a sequence shot. A genuinely Pagnol-like temporal continuity that could also be that produced by television filming with multiple cameras and that allows the actors thus confined to rediscover their freedom.

To be sure, he did not give the actors free rein so far as learning the text was concerned. Anne-Laure Meury recalls that

> on *The Aviator's Wife*, while the technicians were setting up, Rohmer asked us to continue rehearsing, not to stop saying this text. There comes a moment when you crack. You become a machine for saying something that you no longer even feel. [. . .] But he wants that to happen. [. . .] And then the miracle takes place. Just when you no longer think it's possible, [. . .] a new freshness emerges that is extraordinary because it is perfectly under control.[11]

These rehearsals were all the more necessary because Rohmer had chosen very young actors, whom he asked less to play a role (in the traditional sense of the term) than to lend their personalities to the characters of "Une journée," managing in this way to keep the autobiographical narrative at a distance. The boys and girls of the late 1940s were transformed into boys and girls of the early 1980s without anyone being aware of the sleight of hand—except Rohmer himself, who was very amused by the fact that his *Aviator's Wife* was seen as a "contemporary" film. Jacques Rohmer's dreamy double? He became François, who also works in a mail sorting center (as did at that time Rohmer's eldest son, Denis) and who took on the somewhat heavy features of Philippe Marlaud (whose name seemed to predestine him to play an amateur detective; he made his début in a film by Maurice Pialat, in the semidocumentary register of *Passe ton bac d'abord* and was to die tragically, shortly after the filming, in a fire at a campground). What about Annie, the sullen beloved? She was renamed Anne, and she was given her tall, awkward figure, her brusque gestures, and her intense spontaneity by Marie Rivière. The adolescent whose name was never given in the initial text was now called Lucie, that is, Anne-Laure Meury, who once again played hookey to embody the Rohmerian girl par excellence. She is a figure that the 1980 scenario developed significantly by giving a crucial place to the game of hide-and-seek in the Buttes-Chaumont quarter and by introducing an unprecedented insolence.

This is, moreover, one of the great novelties of this cinematic version; Rohmer took his inspiration from the very marked characters of his two actresses: "It's always the girls who decide."[12] Both Anne-Laure, in her wavering between two lovers (a weakness up to that point reserved for men), and Lucie, who stages François's dreams with abundant imagination.

This adaptation to the time is also seen in the choice of other actors: Mathieu Carrière, for instance, who was at the moment the archetype of the "intellectual" young leading man (Rohmer had seen him in Marguerite Duras's *India Song*, a film that greatly impressed him; he also liked his dual Franco-German culture and his love for Kleist). It was Carrière who played the handsome aviator, the modern avatar of the officer on leave in "Une journée." And in another "figure in the carpet" effect, it was Deborah Nathan, the flutist adopted for the filming of *Perceval*, who appeared in a barely glimpsed photo as the mysterious wife of the aviator. In addition, Rohmer took pleasure in giving small roles to a few of the young women gravitating around him at Losange: first, Haydée Caillot, a petulant admirer who had come up to him in the Metro. It was she who took him to see *India Song*. She later wrote him a very Stendhalian letter admitting that on that day she had "almost taken [his] hand."[13] She played the aviator's sister, whose improvised responses were cut out during the editing; but some of her comments (she was herself engaged to marry an aviator) may have enriched the story. And then there was Mary Stephen, a Chinese-Canadian student who had taken Rohmer's courses at Paris-I, and whom he saw again, at her request, to explain to her the budget for *Perceval*. She too was a fan of Duras's cinema, which was not without influence on her own first attempts at film direction. On the set of *The Aviator's Wife*, she was assigned all kinds of jobs: an intelligent extra at Buttes-Chaumont, assistant editor to Cécile Decugis, and even co-composer of the closing melody sketched out by Rohmer.

Another of Rohmer's official editors made her appearance in this film: Lisa Heredia, the enigmatic muse of his new friend Jean-Claude Brisseau. She spent long hours in the Losange office without daring to say a word, and Rohmer liked her ability to listen, her curiosity, her ravenous hunger for literature (she had read all the Countess of Ségur's books). He had her play a role close to her everyday life: the mocking confidante of Marie Rivière, with whom she had hung out on the set of a film by Brisseau, *La Vie comme ça*. On the other hand, the role of the concierge whom the young investigators question is a made-up role that Rohmer gave to Rosette. He liked the

freshness and simplicity of this girl from Normandy who had just arrived in Paris. He took pleasure in hearing her tell her love stories and soon helped her put together her first short films. In *The Aviator's Wife*, as in the films to follow, she was much less and much more than a "Rohmerian actress": a mascot, a sign of recognition, a familiar presence that it was pleasant to see again between sequences. In herself she summed up the direction of actors as Rohmer practiced it, which was (as we know) the opposite of the conventional way of directing actors. It involved reinventing with the greatest naturalness the written text and all it could reveal about the author's initial intentions, as if there were no longer a filmmaker and actors, but only individuals living their lives in front of the camera.

Return to the Lumière Brothers

"The originality of *The Aviator's Wife* does not lie in its way of taking pictures secretly, but rather in its way of making the street, with all its vagaries, the theater of a comedy and moving in it as freely as if one were in the studio."[14] This declaration expresses all the ambiguity of Rohmer's work: if he reinstalled, as we have seen, a theatrical system, it was the better to make it invisible by means of a documentary system. For instance, it was in that spirit that he gave up using 35 mm film (whose overly refined hyperrealism displeased him) in order to make his film in 16 mm, which gave the image a more noticeable grain. That is why he surrounded himself with a team of five or six persons who were hardly distinguishable from the other people in the Buttes-Chaumont park. There was no question of using a sound boom, which would risk attracting attention: the sound engineer Georges Prat set up wireless microphones, using a two-track system that made it possible to record both actors while at the same time attenuating ambient noise. He invented ingenious ways of shooing off the ducks, whose quacking endangered the serenity of the sound track, and of attracting them when Anne-Laure Meury was feeding them bits of bread. The sole problem that could not be gotten around was the "pram rally," as he called it, for which dozens of prams and wailing babies gathered at fixed times. At those moments, filming was halted, and the setting for the following shots was scouted—but for the most part, outside as well as inside, Rohmer made it a point of honor to ensure that the shooting was continuous.

When an unexpected weather event arose, he even found a certain joy in incorporating it into his scenario and consequently upsetting the latter. Georges Prat recalls an anecdote of which Rohmer was fond, in his quest for a form of "report-fiction."[15]

> Just as Anne-Laure Meury and Philippe Marlaud were leaving Buttes-Chaumont, it started to rain. I don't know whether Éric had anticipated this (that would be entirely typical of him!) by having Anne-Laure wear a yellow raincoat . . . It was suggested that we interrupt the filming. "Yes," he said, "but what if it rains for a week?" So he made them cross the boulevard and head for a café. But the café was closed, and we couldn't tell if it was just its closing day or if was closed for the whole vacation (it was early August). I was thinking that I would have to make connecting shots in September . . . But no, the next day the café was open! On the other hand, the weather was fine and the sun was shining on the cars. When the head camera operator, Bernard Lutic, gave us the signal, we went to camouflage things with bits of black fabric. I added a background of light rain, and that worked very well. For Rohmer, it was marvelous and exhilarating that a natural phenomenon had occurred in the course of the shot, and that by a miracle the cafe opened up the following day. A real risk had been taken! But he loved to play with chance.[16]

Playing with chance . . . This formula well describes the experimentation that was begun again with this *Aviator's Wife* (and that had been more or less abandoned after the street scenes in *Sign of Leo*). It went so far that it becomes almost impossible to distinguish between what comes from art and what emerges in nature. While going on countless scouting missions and carrying out meticulous preparations, planning everything right down to the yellow of Anne-Laure Meury's raincoat (or Philippe Marlaud's ballpoint pen), Rohmer was on the lookout for those moments when reality anticipated his fiction. Just like that, as if all his hard work vanished to the advantage of a film that was writing itself. That was how the ancestral ideal of *Perceval* (the artist effaced behind the represented work) was combined with the ambition to continue the modernity of the New Wave, by eliminating the visible traces left by the author and even by the actor, leaving only a two-way mirror in which the spectators would be caught.

Another anecdote recounted by Rohmer is interesting from this point of view: "The people sitting on benches at the top of the Buttes-Chaumont are

regulars who go there every day. So that I was able to mix shots that were made at several days' interval with exactly the same people in the same places."[17] These curious onlookers entered the narrative on several occasions, thanks to a transitional shot in which a vague glance in the direction of the camera sometimes slips in . . . What if they were the true heroes of *The Aviator's Wife*?

The Place of the Spectator

When the film came out in March 1981, this Rohmerian "transparency" aroused a certain amount of enthusiasm, and first of all a hyperbolic, delirious enthusiasm on the part of Rohmer's perennial friend, Jean Parvulesco. His letter is so incredible that we have to cite it at length:

> In this admirable and more than usually mysterious *One Can't Think of Nothing* it appears to me with certainty that in your work moral investigation is [. . .] abyssally manipulated by a coded theological discourse, the latter being [. . .] your great, visionary contribution to the occult advance of divine Providence in action. Am I clear enough? [. . .] This moral instruction serves you [. . .] as a coded language in depth for the affirmation of a secret spiritual science, if it is not forbidden, of a grand theology of deliverance and salvation animated by the visionary breath, by the ardent breath of what a Balzac, himself indebted to the occult teachings of the Society of the Holy Sacrament at the Altar, called, in a profession of faith addressed to Mme Hanska, the torch of the Church of St. John. Now, it happens that that is [. . .] what I thought I had to understand through *One Can't Think of Nothing*, which abruptly put me in a position to decide [. . .] to wage a last battle [. . .]. So you who have so mysteriously done so much for me [. . .] allow me to offer myself a last, final chance of liberation and salvation [. . .]. Give Amira an envelope containing 3,000 francs in my name (how else can I proceed, my bank account has been suspended). With that I can, at the last moment, save everything, tear everything away from the unnamable powers that have so long relentlessly sought to destroy me.[18]

More seriously, three reactions testify to the impressive reality effect produced by this new film. First, the reaction of a pair of spectators who seem to think that the actors are representing their own stories:

> Christian succeeds admirably well in reconciling two professional careers: that
> of an airline pilot and that of an actor. We know how trying jet lag can be,
> but Christian's acting is not affected by it at any time. We have no doubt that
> his night job at the mail sorting center is also fatiguing, [. . .] but wouldn't it
> have been possible to "cut" during editing the moments when François's acting
> deteriorates?[19]

Or the reaction of Nestor Almendros, who points out a few technical defects but
only the better to express his admiration: "I seldom noticed them (and even then
because it's my profession), because the truth of the situations, the settings, the
actors, and especially the dialogues carried me very far away."[20] And finally the
reaction of François Truffaut, who went to see *The Aviator's Wife* twice and, like
the good critic that he remained, tried to understand the secrets of Rohmerian
realism: "Your film is astonishing in its modesty and its reality. I will no longer
be able to oppose cinema vérité and *cinéma-mensonge* because you have com-
plicated things, you have made them considerably more sophisticated. Another
wager won."[21]

Not everyone agreed. The critics proved finicky, especially during a cruel
broadcast of *Le Masque et la Plume* in which François Forestier was dismayed
by such a flood of banalities over a ham-and-cheese sandwich. Ticket sales were
relatively low: slightly more than 11,000 people went to see the film, or ten times
fewer than saw *Perceval*, which was already a commercial failure. It is true that
Rohmer implemented, to his cost, his idea of distributing a film without adver-
tising and in a limited group of theaters. The enigmatic title chosen at the last
minute (over *Un jour exceptionnel*, judged too close to Ettore Scola's *Una gior-
nata particolare*) wasn't exactly likely to draw huge crowds. The disappointment
was such that Truffaut once again gave 1 million francs to his old friend from
Cahiers to allow him to balance his budget.

Paradoxically, if *The Aviator's Wife* attracted so few spectators, it was perhaps
for the reason we have suggested: they are the subject of the film. In it, Rohmer
developed an idea sketched out in *Chloe in the Afternoon* and theorized in *Per-
ceval*: the idea of showing only the pure functioning of the imagination. Then
the anecdote, reduced to the strict minimum, and the Hitchcockian pretext (is
the unknown woman at the Buttes-Chaumont the aviator's wife or isn't she?),
which is immediately forgotten in the shortcuts taken by the narrative, are of
little importance. What is the interest of these hopelessly ordinary boys and girls

bogged down in their sentimental misunderstandings and their communication problems, as people called them in the early 1980s? To justify his spinelessness, François no longer has even the rhetorical brio that the narrator of *My Night at Maud's* deployed. To implement her strategies, Lucie does not have the Mephistophelian status that the woman novelist in *Claire's Knee* attributed to herself. No, these are simply people like you and me, clinging to poor dreams in miniature (a snowball, an aquarium for goldfish), and we "watch them watching."²² Especially the young man, who misses an opportunity for love in order to lose himself in the labyrinth of his fantasies. At times we think of Michelangelo Antonioni's *Blow-Up* (made more than fifteen years earlier than *The Aviator's Wife*), but here the photograph plays only a derisory role, that of an improbable trace or a failed machination. Once again, it is the powers of cinema that Rohmer is representing on the screen, exactly where his disillusioned novelistic writing failed, and where the chatter of his characters failed in turn: the effort to open a breach in the density of the real, to bring out the wonderful within everyday life.

"I am no more important than a paving stone, / Than a sycamore leaf flying down the avenue, / That is going to fall down the steps in the Metro, / Instead of flying up to the sun up there.": that is what Arielle Dombasle sings in the last moments of *The Aviator's Wife*, while François mails a futile letter and disappears into the night like a Peter Schlemihl in pursuit of his own shadow. Everything is said in a few words: the sensation of being nothing and the feeling of the sublime.

Nostalgia for the Romantic

The feeling of the sublime. It changes its form but not its nature in the second film of the cycle. At the beginning there is a literary memory, as was the case for *Claire's Knee* with a few pages of Jean-Jacques Rousseau (but in this case, the reminiscence is better concealed). It seems to be a short story by Balzac entitled "Le Bal de Sceaux" (The ball at Sceaux), where a young woman sets her sights on a man whom she has unilaterally decided to marry. Her excitement reaches the summits when she learns that the lucky man is of high birth:

> This intensified Mademoiselle de Fontaine's secret sentiment. During much of the night she played out in her imagination the most brilliant scenes of the dreams on which she had fed her hopes. Finally, thanks to the chance she had

so often implored, she now had something quite different from an [an ideal being] to create a source for the imaginary riches with which she liked to endow her future life. Not being aware, like most young people, of the dangers of love and marriage, she became infatuated with the deceptive exteriors of marriage and love. In short, her feeling was born as almost all these caprices of youth are born, sweet, cruel errors that exercise such a fatal influence on the lives of girls inexperienced enough to rely only on themselves to achieve their future happiness.[23]

This precedence of the imaginary, precarious privilege of adolescence and Balzacian "romanticism" (the romanticism of *The Lily in the Valley*, which was for Rohmer a cult novel), is found elsewhere, for instance in a short story by the young Schérer. We have already discussed this text, which is called "The Marriage Proposal" but represents precisely a kind of impotence of the romantic: if the lovers dream of marrying, they do so without daring to express this dream to anyone else, or even to themselves; they allow themselves to be buffeted about by the circumstances and the discontinuity of conversations. During these postwar years, it was Maurice Schérer's private life that was trying to prove that it was up to the level of fiction. Witness the Don Quixote–like challenge he sets himself (and meets) by asking for the hand of a girl whom he has just glimpsed at a ball. For him, marriage appears to be the only utopia still allowed, the revenge taken by an anachronistic idealism on the banality of modern times. We have seen the eulogy of it he delivered to Deborah Nathan, who married a man named Charness. Later he became fascinated by the matrimonial projects of Béatrice Romand, his protégée at the time of *Claire's Knee*—whose confidences he listened to with tender concern. From a modest background, this young woman fell madly in love with the son of a good family. But he still had to convince his parents. To make this happen, Béatrice followed the advice of a friend who was a psychoanalyst and let it be thought that she had a Swiss bank account. Their marriage did not last long. After they had set up housekeeping in India, where this brilliant student had gone to teach, he suddenly died and she returned to Paris.

Oddly, in an interview given in 1982 to the newspaper *France-Soir*, Béatrice Romand talked about the husband in question as though he were still alive. However that may be, Rohmer was eager to hear an account of her adventures. He turned on his faithful tape recorder to preserve the remarks that would allow him to construct a character. He even wrote down, in one of the school

notebooks in which he sketched out his scenarios, the actress's words that might be used in a film.

> It's the most respected girls who get married. When you want to marry some-one, you mustn't make love with him. [. . .] I'm not crazy. I'm very sensible. I am the most sensible. I know what I need, what I want. [. . .]—So, handsome and rich?—Yes! You have to aim for handsome. (I'm beautiful and I deserve a man who is handsome, rich, and young.) (Marriage interests me only if it's something extraordinary. A good marriage but not a bad one.) [. . .] I have to be in a privileged milieu in order to do something. [. . .] I would get my footing there more, because for me, that's already very ambitious. For me, the daughter of a concierge. [. . .] *The man should bring in money, I think. These aren't ready-made theories.* [. . .] She would prefer to be the artist in the couple.²⁴

Sometimes these declarations give way to a dialogue with Arielle Dombasle, who argues for a mysterious communication between the sexes.

In the absence of any mention of dates, it is hard to know whether these conversations took place before or after the sojourn in India. It is also difficult to distinguish between what is said by the actress and what is already Rohmer—insofar as he selects, in the reality around him only what corresponds to his fictional design. In reading these pages, one has the impression that the young actress (while at the same time expressing her determination and social ambition) tells the filmmaker more or less what he wants to hear: I dream of a good marriage, it's the most desirable state for a woman. This leitmotif was to be taken up in a song recorded by Arielle Dombasle not long after the film came out. And it was taken up especially by Rohmer himself, who did not hesitate to give it a polemical and provocative twist: "What woman does not prefer to go home rather than work on an assembly line? [. . .] There are two million people out of work. [. . .] So for women, it's better to stay at home than to punch a time card. They think that, women do [. . .] There are many women who secretly aspire to marriage and want to depend on a man. The only real change for them in the last century is in the domain of language: they no longer hide their feelings. Thus Sabine, my character, forgets the ruses of seduction, amorous strategy, and that's too bad. Feminism scares men."²⁵ By making his heroine a double carica-ture (backward-looking and feminist), Rohmer thus indicates the style he has chosen for his *A Good Marriage*.

A Boulevard Theater

The style Rohmer adopted is characterized by a certain curtness (not to say cruelty) in contrast to the sentimental tone that characterized *The Aviator's Wife*. In the first versions of the scenario, he explored this register from two different angles: first, an embryonic short story rather comparable in its distant irony with the *Moral Tales* of the 1940s. The narrator is a woman friend of the main character. Her name is Sabine, and she is an art history student who travels back and forth between Paris and Rouen (where she is a part-time employee in an antique shop). She plunges directly into a proposed marriage that will allow her to rise socially and devote herself to interior decorating. All the elements of the film to come are in place, in terms of sociology and also in terms of dramaturgy: the meeting with the handsome lawyer named Edmond during a reception that echoes the balls of the past. The strategy deployed to make him her husband, and the man's final escape. Only the end differs a little from the future *A Good Marriage*, by stressing a cyclical and optimistic aspect that was later attenuated by having Sabine return to the lover she left at the outset, in order to tell him an advantageous version of her misadventures, and by offering her the reward of a happy end:

> There are men, as we have seen, who cannot bear to be chosen. Others aspire only to that. The young engineer whom she met quite regularly in the train to Paris was certainly too much the handsome man to belong to this last category. We have to believe that Sabine and he chose each other at the same time, and decided by common accord, after a few months of living together, to make the good marriage that both of them were dreaming about.[26]

But that's another story that was to be told only five years later—under the sign of *The Green Ray*.

A new style was soon inaugurated, one that Rohmer had never practiced up to this point but which was to occupy a larger and larger place in his work: that of boulevard theater. People talk a great deal about his similarity to Marivaux; his predilection for Courteline is less well known—and through this detour we come back to Balzac, the satirical Balzac of *Le Faiseur* or *Cousin Pons*. This time, Rohmer abandoned the evanescent anecdote and figures in halftones of

his preceding film; in *A Good Marriage* he sought to establish a situation and develop all its comic potential. A young woman has decided to marry a man "whether or not he wishes it." On the basis of this very simple given, Rohmer began by writing a whole scene, the one at the end, in which the desired man gives in. Then he put down on paper a certain number of notes intended to clarify the theatrical structure of his narrative. For example, he considered presenting the Sunday promenade taken by the two young people as a flashback to avoid disturbing too much the unity of place, which mattered to him. He divides the action into a series of clearly identified and punctuated acts. Finally he presents his characters as if they were in a comedy by Molière: "Sabine Abadie, student in history of art, 26 years old. Clarisse Hecquart, painter on silk, 25 years old. Mme Abadie, mother of Sabine. [. . .] Frédéric Mandar, painter, 38 years old. Edmond Frot, lawyer, 34 years old."[27] Just so many types borrowed from the classical repertory (the passionate woman, the argumentative woman, the Don Juan) associated with an anachronistic provincial setting and yet adapted to contemporary mores.

A few years later, in a show called *Les Acteurs de bonne foi* (The good faith actors), two actresses combined extracts from the film with extracts from a play by Marivaux without there being any visible discontinuity between these texts. That indicates the success of Rohmer's *A Good Marriage*, which is first of all a marriage of the ancient and the modern, and how well he was able to appropriate the conventions of the past to describe this or that character very present in the early 1980s: the backward-looking feminist, as we have said, who dreams both of taking control of a love affair and of succumbing to a Prince Charming (a character anticipated, as Rohmer suggests in his preliminary notes, by that of Anne-Laure in *The Aviator's Wife*). The immature seducer, whether married or a bachelor, who flits around here and there without ever really making a commitment. By exaggerating and mocking the contradictions in which the children of May 1968 got mired, Rohmer developed a kind of reactionary satire that he had adumbrated earlier in *La Collectionneuse*. He did not do so without ulterior motives. After the failure of the first part of his new cycle, the aim of this more amusing comedy was, among other things, to regain the favor of critics and the public. An objective that he was to attain only in part.

To be sure, Georges Charensol and Robert Chazal struggled to find words to express their admiration for these subtle, amusing gallantries in the manner of Marivaux. One hundred thousand spectators went to see the film, which was

honored at the Venice Film Festival in the person of Béatrice Romand (who received a Golden Phoenix award for her acting). This did not entirely blot out the polemic that went on in the meantime, the one regarding the nonselection of *A Good Marriage* at the Cannes Festival. Two votes for it, two against, and the president, Robert Favre Le Bret, cast the deciding vote to eliminate the film. When he divulged this secret of the deliberations, one member of the selection committee, Michel Boujout, was roundly scolded by his hierarchy. He replied vehemently: "There must be a real problem for our elegant seventy-year-old to lose his composure to that point, even going so far as to make use of the boomerang of slander. [. . .] Has he even seen Rohmer's film? I wouldn't swear to it. But let's stop there. One doesn't fire on an ambulance."[28] Where did the problem lie, increasing the gap between two generations of movie lovers? In the view (necessarily contestable) that this was only a "minor" Rohmer film? Or did it lie, more obscurely, in an inexpressible discomfort caused by *A Good Marriage*, which keeps the spectator oscillating between forced laughter and embarrassed identification? Pierre Billard indicated one part of the answer when he criticized the choice of the leading lady: "Béatrice Romand proves to be such a complete pain in the neck that without distinguishing between the actress and her character, one rejects both with the same resoluteness. Playing opposite this unfortunate Béatrice, one of our most solid actors, André Dussolier, seems petrified: Where did they find such a partner for him?"[29] As for Claude-Jean Philippe, he blames this malaise on Rohmer's work: "The goal is to catch the truth in the act of paradox. Sabine's tears—Béatrice Romand's—are both moving and trying. André Dussollier-Edmond's permanent nervous smile is simultaneously touching, enigmatic, and ridiculous, but words are not light enough to express what actually takes place on the screen."[30] Precisely: an excess of reality that was to overflow the limits of traditional comedy.

Where Does Life Begin?

Here we find a very Renoir-like tension, which Rohmer cultivated (not without perversity) on the basis of the antagonism between his two actors. On the one hand, André Dussollier, with all his meticulous professionalism that led him to prowl around the site of the filming in advance, the better to imbue himself with the scene to come. Sometimes with a certain stiffness that (if we believe

the sound engineer Georges Prat) made him hesitant to accept the somewhat trivial lines at the heart of the long, rambling monologue in which he rejects his admirer: "I may see a country house that pleases me enormously. But that's not a reason to buy it, if for the moment I don't feel like going to the country."[31] In the end, Dussollier faithfully played this passage as it was written and segmented. On the other hand, Béatrice Romand was more the type to rebel. She did not like the constraining aspect of the work, so different from the schoolboy fantasy that presided over the filming of *Claire's Knee*. But it was precisely this contrast that Rohmer was secretly trying to bring out: an insolent child among adults, a young woman who embodies her own lived experience playing opposite an experienced theatrical actor. As early as the conversations recorded on tape in his office, he assigned Béatrice this role of a loose cannon. "You have an advantage," he told her, " and that is that you are not a boulevard theater actress. [...] You are modern, you're not at all old-fashioned. You're inimitable, and that's what's interesting."[32]

Nonetheless, Béatrice Romand was not the sole muse of *A Good Marriage*, anymore than she had been for *Claire's Knee*. As usual, to construct his tableau Rohmer mixed several models that he often identified by their initials in his little preparatory notebooks. There was one of his American students, who had been abandoned on the eve of her wedding by a young man in whom she had put great hopes. Especially, there was a young woman who showed up one day in 1978 at the offices in avenue Pierre-Ier-de Serbie. She was tall and beautiful and was working on a book of interviews on a Rohmerian theme if ever there was one: painting and cinema. He graciously allowed himself to be interviewed, but soon it was he who questioned Marie Bouteloup at length. Regarding her passions, her love affairs, the double life that she was leading between Paris (where she worked) and Le Mans (where her husband lived). This theme of the "two homes" fascinated him, having lived the life of a professor who commuted long distances to teach and who continued to divide himself between his work and his family life. One thing leading to another, this romantic curiosity was transformed into a filmmaker's pragmatism. If he wanted to know the train schedules of the trains she took and of the car that picked her up at the station, if he left with Marie (carrying a small Super 8 camera) to explore the old quarter of Le Mans, it was because he knew he had found the setting for his future film. Gradually the female inspirer found herself entrusted with the role of an informal assistant: she took Rohmer to the shops she knew, where permission to film was negotiated in return for a case of

champagne. She lent her own home to house the team and to film the sequences in Sabine's family life. She made the meals, coped with practical problems, and was both the maid of all work and the invisible soul of *A Good Marriage*.

It is pointless to emphasize the economic preoccupation (to use an elegant term) that still determined Rohmer's choices. It did not fail to bear on the climate of the filming. For example, when the actresses (Béatrice Romand, Arielle Dombasle, and the youngest, Sophie Renoir) were forced to take turns at the bathroom door, for lack of sufficient privacy. Or when Béatrice insisted on being able to wash with hot water, even if she had to rush off in a panic to another house. But filming under these unprofessional conditions was above all a way of escaping from "cinema," with the artifices and clumsiness that doing so implied, in order to submerge the actors in a favorable atmosphere. Arielle Dombasle often talked about the state of instability in which Rohmer liked to keep them without their knowing (in the absence of a real slate) precisely when the shooting was to begin, so that they could not separate themselves from their characters.

In the same spirit, he commissioned an eighteen-year-old, Ronan Girre, whom he had met through one of his female students, to compose the music for *A Good Marriage*. At first sight, this young rocker with long hair, cowboy boots, and frilled shirt was very far from his universe. But it amused Rohmer to hear him tell about his failure on the École normale supérieure entrance exam (Rohmer himself had also failed the exam), and he liked the very French aspect of his musical efforts. With the means available to him, Girre composed music for the credits—and he was very surprised to see his proposal accepted without Rohmer thinking it useful to make any change in it. From A to Z, the goal was to work with the elements of the real, with the stammering potential fictions they bore within themselves.

The Apprentice Artist

Two other young persons were part of Rohmer's troupe for *A Good Marriage*. As we have said, one was Sophie Renoir, the grand-niece of Jean Renoir (who had recently died), and whom Rohmer had recruited to play Sabine's younger sister. She shared with Béatrice Romand a certain kind of southern beauty: very dark hair and eyes, an olive complexion, and a full-figuredness that reminds us of the models of Pierre-Auguste Renoir, her great-grandfather. She also shared a

certain energy—that today inspires her hilarious imitations of that other great-uncle that Rohmer was for her. She has to be heard telling about her late arrival on the set (she had taken the train all alone, at the age of 16, and had gone in the wrong direction) and the indecipherable fears and worries of her mentor. She has to be heard telling about the long hours spent in Rohmer's office, eating cookies or listening to Tahitian music in pious silence.

In the marriage engagement sequence (a real reception, to which Marie Bouteloup's neighbors really came in large numbers), we find still another new actress, Virgine Thévenet, a young woman Rohmer met one night at a party at the home of Jean Eustache, and who also became a regular at 26, avenue Pierre-Ier-de-Serbie. Rohmer admired her beauty and her imaginative way of dressing. He encouraged her to put together a book of illustrations inspired by *Perceval's* tableaux vivants. One day he made her laugh by describing in a lapidary formula his wife's activities: "She paints animals."

He said that entirely without condescension. We have seen how much Rohmer enjoyed the company of amateurs, beginners, and dilettantes. In *A Good Marriage* he represented them in the character of Clarisse (Arielle Dombasle), who makes delicate paintings of suns on lampshades. He makes Sabine an apprentice artist who is interested in beautiful objects and pretty paintings, and who, while awaiting her turn to create, awkwardly tries to stage the real, to give form to her romantic dream. No longer just a spectator, but not yet a creator, she reminds us of that intermediate state in which the characters in "La Demande en mariage" floated: that of a desire for fiction that seeks to embody itself in one way or another. While superficially resembling boulevard theater, this film is perhaps still more troubling than *The Aviator's Wife*. In it Rohmer widened the gap between the aspiration to the ideal and everyday life as conceived by Flaubert. He restricted the deployment of the imaginary by choosing some actors who were not very professional and who were sometimes made uncomfortable by the play they were supposed to perform. Through all these invisible strategies, he managed to establish cinema as a horizon of expectation capable of transfiguring the most banal reality.

Thus only a few shots respond, almost secretly, to the famous verses of La Fontaine quoted at the end of the credits ("Quel esprit ne bat la campagne? / Qui ne fait châteaux en Espagne?"):* the shots seen through the windows of the train

* "Who has not dreamed far and wide / of castles in Spain's countryside?" (Jean de La Fontaine, *Selected Fables,* trans. Christopher Wood [Oxford: Oxford University Press, 1995], 163).

during Sabine's incessant commutes between Paris and the provinces, the sunlit countryside, shown us in a very beautiful, subjective panoramic shot—when the young woman has just been left by the man she chose, but does not yet know it. Here, the seventh art casually takes its revenge, because it is the ultimate refuge of the belief in another life.

At the Theater This Evening

Perhaps the reader is now beginning to divine the more or less conscious processes that govern these *Comedies and Proverbs*. It could be said that at the origin of each of these films there is a failed utopia: that of a romanticism fallen into escheat, suffocated by too much reality or lucidity. Thanks to the theater, the Rohmer of the 1980s redeployed this romantic utopia, which went back to his youth, through a spectacular structure that allowed him to shape old, timid ideas of situations. And then, through another detour, he sought to conceal this theatrical device under the appearance of cinematic realism—because he firmly believed in this realism, as the only chance (minimal as it might be) to reopen people's eyes to the miracle.

Here we have a tortuous, mysterious, but perfectly coherent trajectory from one film to another that also includes his youthful writings. A trajectory that became shorter and more radical in the third part of the series, for a very simple reason: the new project that Rohmer pulled out of his storage cartons dated from a period when he had already given up writing novels. Even if we can recognize in it archetypes derived from the first *Moral Tales* (the sensualist à la Gégauff, the dreamer à la Schérer), they are situated from the outset, as early as the end of the 1950s, in the logic of a disillusioned vaudeville. In fact the new project was a draft of a play entitled *Les Vacances* (in homage to the Countess of Ségur?), or in another version, *Friponnes de porcelaine* (in homage to George Meredith, from whom Rohmer took, he said, much of his inspiration for the dialogues). But it was especially Roger Vadim's first films that inspired these four young people gathered in a villa to talk about love and tear each other apart. And the apprentice dramatist (or scriptwriter) was giving very serious thought to Brigitte Bardot to play one of his female characters. At this stage, the opposition between the characters remained imprecise, and we see hardly anything but general ideas emerge: "Organize the mathematics of the plot in the strictest way. It is clear that the

springs of the action will be conflict and betrayal. In the end, everyone feels that all is in order, and that they have escaped a great danger."[33] Elsewhere, we witness the appearance of the motif on the basis of which the whole dramatic machinery was to be developed: the moment when one of the young women almost discovers her lover's infidelity, which a little fabrication prevents her from seeing.

But not until the late 1970s did Rohmer go back to these unfinished pages and pursue his initial intuitions to their ultimate consequences. Then he wrote a series of largely disconnected scenes that he retitled *Loup, y es-tu?* (Wolf, are you there?) and that helped him define the psychology of his characters. First of all, that of Pierre, the bashful lover, through whom Rohmer sketches a singular self-portrait: "He concentrates all his will on pursuing what is legitimately due only to chance."[34] Rohmer's madness and genius could not be better defined. It is Pierre who provokes catastrophes, through his frenetic jealousy and his refusal to admit his beloved's indifference. Opposite him is the Gégauff-like figure represented by Henri, the seducer who lets women come to him—without necessarily being the "scoundrel"[35] that Pierre claims to find in him. Between these two boys, three girls move: Marion, who makes Pierre furious by letting Henri seduce her; Louisette, who also succumbs to Henri's charms (not without Pierre trying to exploit the erotic scene in which he has caught them); and Pauline, an adolescent of 15, who resists Henri's assaults, preferring to flirt with a boy of her own age and keep her distance from this whole merry-go-round.

A trigger, a spark that would allow all these characters to "burn with love" in a convincing way, was still lacking. The actors? Rohmer thought of Arielle Dombasle, Pascal Greggory, and Rosette, and he began to talk to them about a film that was in the works. The setting? Marie Bouteloup told him about a vacation house she had in Jullouville, and they decided to go see what it looked like. "On the way back from this house," Rohmer recounted, "the train was suddenly filled up with unruly soldiers who began shouting, picnicking in the car, drinking. Under those conditions, I couldn't read, it was impossible to read, but at the same time, ultimately, it's easier to write. So I concentrated; I had a notebook [. . .] and I began writing very fast without listening to what was being said around me and I really had the idea of the continuity of the film."[36] This kind of fever continued until the day before the filming of *A Good Marriage*, leading Rohmer to rewrite his scenario in the form of a narrative, then to redeploy the dialogues, and then to firm up the situations, seeking a theatrical mechanics that would be almost perfect.

In the end, *Loup, y es-tu?* started looking like a play by Feydeau, with its cuckoldings and mistaken identities, with its sexcapades that people try to minimize by lying. But it is a Feydeau that dreams of Marivaux or Racine. While flailing about like disarticulated jumping jacks, the characters continue to analyze their feelings, to garb themselves in grand phrases inherited from the seventeenth century—as if there were an irremediable divorce between the idea they have of themselves and the triviality of their sexual desires. This is a hiatus we have repeatedly observed in the *Moral Tales*. Here Rohmer gave it a deliberately caricatural twist, showing us creatures who have, as it were, fallen into theater, prisoners of an endless performance from which all truth has fled.

The Figure in the Carpet

There is another aesthetic model on which Rohmer relied to undertake this new film: painting, which he had somewhat concealed under the false dullness of *The Aviator's Wife* or *A Good Marriage*. It returned to the heart of his preoccupations in this period when he was doing projects for the exhibits at the Grand Palais: a slide show on Titian, another on Raphael, with commentary by the beautiful, deep voice of Féodor Atkine. "One has to manage to be clear," Rohmer (who was still a teacher) explained, "with subjects that are difficult to frame photographically. The madonnas, for instance, have to be seen from below. In the large frescos, it is more difficult to isolate the elements than it is in the work of Giotto, Bosch, or the Carpaccio of Saint Ursula: in Raphael, anecdote plays a much smaller role."[37] Through these two ten-minute films, Rohmer maintained the ideal to which he adhered as an adolescent, when he sought to copy paintings on the basis of photographic reproductions in black and white: giving an account of a work of art with the greatest fidelity, while at the same time appropriating it as much as one can.

Painting also returned in the genesis of *Loup, y es-tu?* in its claim to be systematic. And it did so starting with the material form taken by the writing: these little notebooks in which the filmmaker wrote down (usually in pencil) the successive versions of his scenario. He later showed a few of these to Jean Douchet, during their filmed conversations in which he spoke at length about the beginnings of *Pauline at the Beach*. Their covers shared three colors that were not in any way accidental: blue, red, and white; the latter was to be (even more than

the other two) the dominant color Rohmer wanted for his shots. He talked to Nestor Almendros, who had returned from the United States to make this film, about Eugène Boudin's paintings of Normandy and the brilliant light in which he wanted to drown the image (they even went, by asking for a second positive print, to the extreme limit of overexposure). The scenes first shot in gray weather were reshot when the sun was out, which represented an unprecedented pictorial perfectionism for this filmmaker. For once, they dared to violate the sacrosanct veracity of the places filmed by repainting the hall leading to the bathroom, which was an ugly yellow. But this interventionism had its limits. Discovering that Almendros, being more royalist than the king, had decided to cover over with kraft paper a garish wall covering, Rohmer disagreed. Perhaps because the initiative did not come from him . . . "And maybe it's not so bad, you see, to not always be too systematic."[38]

Similarly, Rohmer made ambiguous use of reference to Henri Matisse, who was one of his favorite painters, and whom he made the official "model" of this new work. Sometimes he was proud of his own daring, if Matisse had allowed himself to do the same before him: erasing and redoing work already done, as we have seen, or else associating the vertical slats of a chair with the horizontal stripes of a swimsuit. Sometimes he pretended to rediscover by accident an image that was just right to confirm his obsessions:

> I'd passed in front of a shop (now gone) where large-format reproductions were sold: there was Matisse's *Romanian Blouse*. I hung it Amanda Langlet's room, and used it for the film's poster. The colors of this Romanian blouse (which are, curiously, those of the French flag) are moreover Pauline's fundamental colors: in this case, that's very intentional![39]

The white sheet and the red life buoy he used to cover the room's radiator, on the pretext that the latter would not have to be repainted, were also very intentional. In reality, he did so to continue by little touches the atmosphere that Matisse suggested, while at the same time seeming to be adapting, in one way or another, to material contingencies. And when his young actress, in a scene in a restaurant, shrugs her shoulders like the woman in the Romanian blouse, that can (obviously) only be the effect of another chance accident. As this pictoriality surreptitiously proceeds we see Jean Cocteau's remark reinvented in reverse: since we have organized these mysteries, let's pretend not to understand them.

The World Is a Stage

This tactic is used still in a still more subterranean fashion in casting—for example, in choosing the actress in question, the one who was to play Pauline. With Rosette at his side, Rohmer dug through the French Production Society's file of child actors. He decided (as he often did) on the basis of a simple photo, and then a voice heard briefly over the telephone. From that point on, his discussions with Amanda Langlet, over the perennial cup of tea in his office at Films du Losange, had nothing in common with the conventional relationship between director and actress. Or even between an adult and an adolescent: Amanda was very surprised to be treated like a grown-up, despite the fact that she was only fifteen and looked like a rather naïve Lolita. Rohmer pretended to consult her regarding the psychological details of her character as he had developed them in the scenario. And if he had her do some film tests, made in Super 8, it was less to cast her (an expression that could only horrify him) than to get her to gradually identify with Pauline. In addition, he did multiple sessions with the tape recorder, in which he liked to play the role of Pierre with her, unless he had her play opposite other actors. If we listen to these tapes, or read the transcript of certain passages, it is hard to distinguish directed improvisation from desultory conversation (about love, marriage, boys . . .). It was precisely that confusion that Rohmer sought to establish from the outset.

He also encouraged this confusion when he let his actors choose the names of their characters. Or when he never ceased, while filming, to revise by hand the typescript of his dialogues, as if to adapt them to the particular diction of each performer. He even went so far as to accept the word "*bouffonne*" (jester) proposed by the young Simon de La Brosse, who played Amanda's boyfriend. To bring Amanda to the verge of tears, he did everything he could when the time came to make her ill at ease (a technique he had used with Laurence de Monaghan while making *Claire's Knee*). In particular, gestures were encouraged in their singularity. While another delicate sequence was being shot, in which Arielle Dombasle expresses in archaic terms her desire to "burn with love,"[40] she put her hand in front of her mouth to indicate that she wanted to interrupt the filming. Off camera, Rohmer signaled to her to continue, and it was that shot that he kept during the editing. Nothing pleased him so much as seeing the actor's truth disguise the artifice of the text, even it meant an awkwardness, a discomfort,

an accepted divorce: that was the lesson taught by Jean Renoir and *The Rules of the Game*, a film that the author of *Pauline at the Beach* watched after his workdays, according to François-Marie Banier, who was serving as set photographer.

Another of Renoir's lessons was the familiar and familial atmosphere in which the shooting took place. They lived in the home of the person concerned; in this case, it was Marie Boutelou who lent her house in Jullouville (and continued to provide meals). A rented villa sheltered the love affair between Pascal Greggory and François-Marie Banier, and on weekends, Arielle Dombasle's rendezvous with her new lover, a certain Bernard-Henri Lévy. Sometimes they partied there, but moderately, because the director kept an eye on his troupe's commitment to their work. As in the time of *A Good Marriage*, a certain good-natured climate was accompanied by an absolute anti-conformism in the distribution of tasks. Were young people supposed to dance to the sound of a record? It was Rohmer himself who composed a homemade "Slow des îles," on which his faithful partner Jean-Louis Valéro put the final touches. Did they need a camera trolley? They would use the housekeeper's car and the athletic Féodor Atkine (who played the role of Henri) to push it down the beach. This constant resort to do-it-yourself and makeshift solutions did not fail to make some people impatient. Especially the head camera operator, as Virgine Thévenet tells us:

> In the United States, Nestor had become a star. Back in France, it drove him nuts to find Éric still quibbling about paying for his coffee. In *Pauline*, Pascal Greggory and Amanda Langlet were supposed to have dinner in a restaurant. Nestor asked: "Where is the restaurant?" Éric replied: "Here, in the house . . . I walked along the beach and I saw restaurants that looked exactly like this dining room."—"Where are the tables? And the extras?"—"You know, they don't have any customers. In any case, we're going shoot from an angle that won't show the other tables." In the end, they made the scene with a single table setting! Nestor didn't understand: "One of them isn't eating?"—"When we shoot from the other side, we'll move the plate and the silverware." After that, Nestor said to himself that it was the last time he was going to work with Rohmer.[41]

As we have already said, this thriftiness is first of all an ethics that forbids members of the team to take themselves too seriously (even when their fame begins to rival that of the boss), and this keeps things floating undecidably between everyday life and its cinematic transposition.

To describe this floating, there is no better metaphor than Pascal Greggory's fruitless efforts to master the technique of windsurfing. Before the filming began, he did some encouraging tryouts on the calm waters of lac d'Enghien. In Normandy, the team had great difficulties filming a shot in which he stayed upright on the board for more than a second, because most of the time the waves upset him—to director's great hilarity. Was Rohmer's cinema a paean to instability?

"Le Lapin de Pauline"

Above all, the actors had to forget that they were being filmed. Although people went every evening with Almendros to watch the rushes in a film theater, they went without the young Amanda, who would so much have liked to accompany them (as Béatrice had during the filming of *Claire's Knee*). Although the preliminaries were extended, to the point of bringing Amanda, Arielle, and Pascal to Jullouvile a few weeks before filming began, when the time came Rohmer vanished amid the countless worries of shooting. Which remained the best way of seeing without being seen and not scaring off his guinea pigs' naturalness. It was only after the fact that they understood everything that Rohmer had shown about them without their knowing it . . . at the risk of feeling somewhat uneasy about it. It was this uneasiness that Féodor Atkine admitted, though he was an actor sure of his charm who had already given his voice to Bruno Ganz in *The Marquise of O*: "He greatly shocked my actor's sensitivity by telling me: 'Anyway, whatever you do in front of the camera, it's fine so far as I'm concerned.' "[42] And it was this uneasiness that was analyzed by Pascal Greggory, who learned to understand better the filmmaker's paradoxes:

> If Rohmer allows himself to take this kind of attitude, it's because before he begins filming, he has spied on us and dissected us, he has revised the script so much [. . .] in relation to us that, in fact, every attitude we might have enters into his plans!!! As individuals, we are much less his actors than his characters!! [. . .] As great as the contact is before filming, once it begins he disappears. [. . .] I'd note here that he also has a real problem about touching, I mean physical contact with people. [. . .] To come back to the simple directing of the actor, let's just say that it's very hard to catch Rohmer's eye.[43]

Finally, Arielle Dombasle also described this uneasiness, after she had seen the audience laugh at her own absurdities, as if all awareness that she had ever been able to play a role had been erased. We will return to these ambiguities in the reception of the film—but let us linger a moment on the article in which these remarks were reported. It is entitled "Le Lapin de Pauline," and bears the signature of Hervé Guibert, who was then writing the cinema column in *Le Monde*. His title is explained by the absence of Amanda Langlet,* who was initially supposed to take part in the interview; but the other actors (Dombasle, Greggory, Atkine, de La Brosse) were there at the offices of Films du Losange to talk about *Pauline at the Beach*. Rohmer was also present, in the background and tense. When Guibert (perversely) proposed a "parlor game"[44] in which a portrait would be drawn of each of those present, beginning with Rohmer, the latter dug in his heels and refused to say anything about his personal life. The more the young people pressured him to play along, the more he invoked the "duty of confidentiality":[45] "Actors must not talk about the director personally. If the actor has an exhibitionist side, he has only to talk about himself."[46] To try to put an end to the discussion, he turned to Guibert and uttered this lapidary formula well-suited to discourage future biographers: "I told you yesterday that I had no life, could you add that happiness has no history?"[47]

The debate did not end there. Unhappy about the indiscreet turn that the article had taken, Rohmer used as a pretext a few words that he had said about Amanda (and which were published despite his warning) to tell the director of *Le Monde* that Hervé Guibert had been "boorish"[48] in this case. Guibert protested that he was innocent:

> The title, "Le Lapin de Pauline," was not in any way accusatory, it was intended to be just as lighthearted and charming as the title of your film. You will understand, I think, that I could not fail to mention the absence of one of the principal actresses, but at no time was she reproached for this absence, which seems as justifiable as the presence of the other actors. Please believe that I am all the more sorry about this misunderstanding because I have done this work with a great deal of enthusiasm and pleasure.[49]

* The French expression "*poser un lapin*" means "not show up for a meeting."

The details of this polemic are unimportant; the essential point was stated by Rohmer between the lines: his obsession with presenting his actors (his characters?) as so many masks capable of concealing his true face.

Many commentators fell into this trap. More than any earlier film of Rohmer's, *Pauline at the Beach* (which came out in March 1983) disoriented the critics, who did not know what to think of these vaudevillian situations—in which the awkwardness of the actors is shown, but never the director's point of view. On *Le Masque et la Plume*, the dinosaur Georges Charensol and the young Turk Gérard Lefort agreed on one thing: if the film made people laugh a lot, that was not Rohmer's intention; he had gotten in over his head. In *Le Figaro*, Claude Baignères delivered the coup de grâce:

> Éric Rohmer's *Pauline at the Beach* is already a strong contender for the prize for the most ridiculous film of 1983. Everything sounds false in this film, which its creator evidently wanted to be deeply moving. The worst part is not a dialogue that was apparently written by an illiterate and that drones on and on, mixing all the maxims of a psychology textbook worthy of the lonely hearts column. No. The worst part is the actors, all of whose gestures and intonations are blunders that the least talented amateur would have wanted to avoid. The prize goes to Arielle Dombasle, who strolls the sands of Deauville [*sic!*] with heavily made-up eyelashes, falsely distinguished enticing smiles, a shrill, shopgirl's laugh, and pouty lips that seem unable to close even when she has finished clucking some banality.[50]

This general misunderstanding (which treats *Pauline* as a sophisticated remake of a recent success, Claude Pinoteau's *The Party*) did not prevent a few critics, such as Emmanuel Carrère and Jean Collet, from being more perceptive. And it did not prevent the film from winning the prize for the best mise en scène at the Berlin Film Festival or from having considerable success in the United States, where it brought in more than $2.5 million. Because of its libertine atmosphere, which had already made *Chloe in the Afternoon* successful there? Probably. However, Rohmer suggested that the reason was that the English subtitles simplified the dialogues.

If there was a misunderstanding on the part of French press and on the part of the audience that went to see *Pauline* (which was nonetheless large), it was in fact in proportion to the enormous cacophony that is the film's subject. "Qui

trop parloit, il se mesfait" (He who speaks too much does himself harm): this sentence from Chrétien de Troyes placed at the end of the credits sets the tone for a concert of discordant voices, a concourse of discourse that exhausts itself testifying to an absent reality. We have already noted how much the characters were victims of language, how often they sank into infernal mistakes (was it Sylvain or Henri who slept with Louisette?) in which the infinite relativity of human speech was betrayed. It is as if Rohmer needed theatrical convention, even of the most restrictive kind, the better to set free the powers of cinema. "I begin from the theater and I hope to come out again."[51] As in Renoir's work, everything takes place in the gap between stage representation and cinematic truth, between long, tiresome speeches and desiring bodies, between the postures of the old repertory and modern-day actors.

There is also a gap in the very special position assigned to Pauline. She is there without being there, in a corner of the picture, escaping, through her discreet grace, the rhetorical performances of her elders (and that is probably the source of the pictorial title *Pauline at the Beach*, which ultimately replaced the unpronounceable *Loup, y es-tu?*). She sometimes relives, without knowing it, mythical moments in the seventh art—such as the Polynesian lovers' idyll in Murnau's *Tabu*, alluded to in dancing to the "Slow des îles." She incarnates, par excellence, what Rohmer expects from cinema: a perpetual and marvelous first time.

Choice and Reverie

When we watch Rohmer at work, a phenomenon is revealed that might be the secret of his artistic approach. It is the anguish involved in choosing. For him, there was no question of choosing between cinema and the other arts, which he never ceased to practice and to mix in an intentional confusion. There was no question of choosing between this or that way of conducting a narrative: as he confided to Claude-Jean Philippe (in an excellent broadcast devoted to *Pauline at the Beach*), he saw to it that he was never confronted by the dizzying sight of the blank page. He spent his writing time recopying and improving the earlier versions of his scenario (there again, we come back to the little boy patiently copying the old masters). There was no question, finally, of choosing among several actors or among too many shots: he relied on fate, which he did everything he could to entrap, in order to ward off the demon of uncertainty.

This "Buridan complex"* goes back to a doubling of personality that we have already had occasion to note, the one that separated Maurice Schérer (with his orderly, hidden, bourgeois life) from the famous filmmaker called Éric Rohmer, surrounded by girls in full bloom and idolizing admirers. This was already the main theme of *Love in the Afternoon*: Can one lead two lives at the same time? The *Moral Tales* and *Comedies and Proverbs* provided fragmentary answers to this question, whether in *My Night at Maud's* or in *The Aviator's Wife*. But Rohmer was far from done with it, and he took it up again in a new film project, a scenario first entitled "The Pied-à-terre," and then "The Apartment," which he wrote with unusual ease in the early 1980s. To be sure, he groped a bit, imagining a peripheral plot (the male character's machinations to arouse or deflect his partner's jealousy) or a cyclical structure like that of *A Good Marriage* (the visit to a real-estate agency that was to mark the beginning and end of the story). But the main lines of the future *Full Moon in Paris* were established fairly quickly. This is shown by a summary dated March 1981, in which only the characters' first names remain vague:

> Counterpart of *Love in the Afternoon* from the point of view of I. (1) She likes to go out. He doesn't. Besides, she sees that she likes to go out without him. He plays a sport she doesn't like. She goes out with K., pretending they are a couple. But she would like not to go home. [. . .] (2) She buys the apartment. At first, she leads the same life, even going to bed earlier and not going out more often. (3) Then she has an affair with K. [. . .] They have sex, but afterward she can't sleep. She dresses and goes out. (4) She walks through the streets and goes into a café. She meets a night-owl who asks her questions. [. . .] As the sun is coming up, she goes home. (5) J. isn't there. She waits, nervous, then goes to bed. He comes home. She tells him that he was right to do that, and that she will only love him the more. He says that he's in love and doesn't love her anymore.[52]

This theme of hesitation, which is stated by the so-called "Champenois saying"[53] placed at the beginning of the film ("He who has two wives loses his soul / He who has two homes loses his mind"[54]), is echoed by another theme in

* A reference to a philosophical paradox known as "Buridan's ass." An ass placed precisely halfway between a stack of hay and a pail of water will die of both hunger and thirst because it cannot make a rational decision to choose one or the other.

a necessary and symmetrical way. This is the theme of reverie, which is adolescence's response to the fear of choosing that being an adult implies. In *Full Moon in Paris*, reverie is developed in three stages that complement one another. Dreaming of another life than one's own: that is the state in which the female character tries keep herself by creating a secret Parisian garden in which she can dream about encounters that remain possible, to the sound of a sweet old tune by Lucienne Boyer ("L'Étoile d'amour"). And, when the apartment ends up being the site of a banal adulterous affair, by going back to the married life she had left (this had already been the ending of *Love in the Afternoon*). Dreaming, also, of images of the Other that emerge in the distance as soon as one takes this position of spectator—or cinephile? Like the François of *The Aviator's Wife*, or the Pierre of *Pauline at the Beach*, the heroine of *Full Moon in Paris* "does a whole number on herself" on the basis of someone glimpsed in a bistro who might be her companion—with her best friend. In this second stage of her reveries, she is aided by a confidant whose tendentious hypotheses complete the orchestration of the delirium of interpretation.

The third stage is the most fascinating: it consists in representing the life of the Other, while at the same time looking as if one is moving away from it. Like Rohmer, the sorcerer's apprentice described here disappears into the background, but only the better to carry out a secret program. But not all that secret, since she announces it at the beginning of the film, in the course of an argument with her fiancé: "You could find someone better: for example, somebody who wants to be with you all the time. And if you find her, if you love her, I swear to you, I'll disappear. But it will cause me a great deal of pain, a great deal."[55] For this prediction to be completely fulfilled its author would also have to be able to forget it. And she would also have to experience as a stroke of fate what is only an effect of her will.

Rohmer in the Land of the Trendy

From this point of view *Full Moon in Paris* is one of Rohmer's most self-reflexive films. It is also the one that most successfully passes itself off as a sociological investigation, as if the virtual dimension that we have just discussed was materialized in a period (the early Mitterand years, the flourishing of independent radio stations, the explosion of festive sexualities) in which the last taboos spared

by May 1968 were broken and in which excess bloomed in all its forms. Curious about the Paris night-world, and about what was beginning to be called the "branchés" (trendy people who are "plugged in"), Rohmer asked questions—of Pascal Greggory, who far from *Pauline*'s romantic sighs, spent his nights partying at Le Palace; of Virgine Thévenet, who lent the film her elegant clothes and her address book; of one of Virgine's young girlfriends, Jezabel Carpi, who was terrorized by the indiscreet questions asked by the old gentleman regarding the men she frequented or her love life. Accompanied by his musical partner from *A Good Marriage* (the dashing rocker Ronan Girre), Rohmer slipped into young people's parties, sat in a corner, and listened to the conversations, as much as the excess decibels allowed him to. People told him about a duo of author-composers, Elli and Jacno, and he especially liked one of their songs ("T'oublier"), which could have been the leitmotif of *Pauline at the Beach*. As soon as he got to the studio where they were recording their next album, he unhesitatingly took an option on three melodies ("Les Nuits de la pleine lune," "Les Tarots," and "Les Sept Îles"), which were in perfect harmony with the film he had in mind. Because of their rather esoteric themes, and especially because, as Jacno noted and Ronan Girre knew very well, "What he liked in my music was that it is completely French. Rohmer is very French, very classical, very literary. He says "*fin de semaine*" instead of 'weekend.'"[56]

This music is heard during a spectacular party scene that is in a way the highpoint of *Full Moon in Paris*. Films du Losange invited the social elite to the Maison des Centraux in the eighth arrondissement for the night of January 31, 1984. According to the sound engineer Georges Prat, far too many people were invited, to the point that the technical team was forced to camp behind the buffet while the crowd passed by. Rohmer was impatient with these imponderables. He tried to prevent the extras from devouring the petits fours, used earplugs to protect himself from the continuous din, and worried about having to use a trolley under pressure from his head camera operator, Renato Berta. It was one of the rare moments in his career since the *Sign of Leo* surprise party when the unpredictable (which he constantly sought, once he was reassured by meticulous preparation) literally caught him unprepared and completely overwhelmed him. That is what gives this sequence its extraordinary documentary truth, although it was written out down the last comma.

In the privacy of his office at Losange, while he was getting ready to film with his actors, Rohmer made it very clear that this night-world was not his: "I went

to the Bains-Douches nightclub once or twice. [...] I can deal with the smoke. But it's the noise. [...] Didn't it damage your hearing? [...] For me, it's impossible to enjoy a piece of music that is very loud. [...] My wife is someone who doesn't like loud noises. [...] I think physical love is connected with music."⁵⁷ The very proper kind of dance hall where one could take girls to dance, for which Rohmer seems to feel nostalgia, no longer existed. He presents today's manners all the more crudely: the erotic parade, for instance, that brings the sexy Christian Vadim together with his heroine Pascale Ogier. He asked the latter, who had been his close friend ever since the performances of *Catherine of Heilbronn,* to imagine the interiors of the two apartments she lived in (her role in *Full Moon* was precisely that of an apprentice decorator). He let her hang Mondrian paintings on the walls, even though he didn't much like Mondrian, and to include in her very up-to-date design little anachronistic winks, which he liked better. Among others, an antique column that might have been a vestige of *Perceval,* right in the middle of the rather bare pied-à-terre that the young woman made for herself. He also gave her a blank check in choosing her costumes, though he had discreetly asked her to use the color gray—which he had decided was to be the dominant shade of his new film.

Mendacious Truth

In reality, if Rohmer thus exploited the "plugged-in-ness" demanded by Pascale Ogier, it was in relation to a character that he clearly conceived on paper. When he transcribed extracts of their recorded conversations, many sentences reflected a preestablished dramatic framework. (For instance, Pascale Ogier saying "Every time I said to myself, for example in love relationships, that I wanted to be loved by a certain person, I've always been loved by him. [...] Ultimately, I thought of renting a studio because it would be my own, personal place."⁵⁸) This starting situation was an impure mixture of autobiographical notations and feminine confidences: those of Pascale Ogier and also Marie Bouteloup, Arielle Dombasle, Irène Skoblin ... and a certain Françoise Etchegaray, to whom we will soon return in her little group. On this basis, Rohmer urged his actress to bring him her own words and her own experience, while at the same time exaggerating it in the direction suited to his project. In the course of a rather lively discussion about the kind of boys who appealed to Pascale, he pushed her so hard that he ended up making her uncomfortable:

"I think you have a model of the male [. . .] (whom I detest, personally): Elvis Presley. You have his photo in your bedroom."—"That? That's Marlon Brando."—"It's the same thing. He's a motorcyclist or a rocker. [. . .] In any case, you're attracted by the type who roars around Paris at two hundred kilometers an hour. [. . .] I think you have a taste for speed."—"I would hate to pride myself on something like that. Because it ends in death. [. . .] My violence is reflected in my vitality, my energy, my desire. [. . .]" —"Violence is, after all, destruction. [. . .] Does destruction interest you? I think it's a character trait that remains a little mysterious, and that I wanted to make you develop a bit."[59]

When it comes to the filming, three anecdotes illustrate this mendacious truth of the Rohmerian actor. The first concerns the breakup scene that concludes the story. To make Pascale Ogier cry, there was no longer even any need for the strategies that had been used with Laurence de Monaghan or Amanda Langlet. Rohmer let the young woman play the situation the way she wanted to, without giving her any particular directives. But he had so subtly identified her with the character of Louise (a name she had chosen) that from the first take her tears flowed with a moving naturalness.

The second anecdote concerns the long argument at the beginning of the film between Pascale and Tcheky Karyo, who played her companion. Karyo, a theatrical actor trained in the Actors Studio method, proposed to express his anger by banging his head on the walls—which belonged more to Pialat's universe than to the moderation Rohmer preferred. Rohmer balked, Karyo persisted, and Rohmer finally exclaimed: "You're getting involved in the mise en scène!" In the end they agreed on a compromise (Karyo giving himself several little slaps) that shows the *metteur en scène*'s concern to welcome an actor's proposals, even if they go beyond the limits he had set.

The third anecdote concerns what is perhaps the only stage direction properly so called in the whole history of the nondirection of actors in Rohmer's style. By entrusting to Fabrice Luchini the role of Octave, Louise's amorous and voluble confidant, the filmmaker made more than ever use of an actor's personal aura. While concealing autobiographical elements in his dialogue (the reference to his years as a commuter-professor), he had Fabrice act out his loudly proclaimed love of fine phrases and pretty women, his intense frustration at being perceived by them as simply a wit, his ambiguous complicity with the troubling sylph Pascale. But when they were filming a dialogue between two characters in a café on the place Saint-Michel, Rohmer suddenly interrupted the operations

and started grumbling in his corner, without being able to explain what was wrong (Luchini did a great imitation of this kind of autism in the filmmaker, who took refuge in trivial, subaltern tasks as if to flee any too direct contact with his actors). Finally, exasperated, he uttered two words: "More like Fernandel!" He said no more, for it was essentially without knowing it that the actors were supposed to sketch their own caricatures.

The Film of an Era

In *Full Moon in Paris*, Rohmer achieved a miraculous balance between this will to stylization and the sense of the detail taken from real life. His actors were the first to benefit from this: first of all Luchini, who moved in one film from the shadows into the spotlight. From an image of a tiresome intellectual that had clung to him ever since *Perceval*, he moved to an image of a brilliant and funny intellectual, and this ensured his enduring popularity. And, of course, Pascal Ogier, who, thanks to a number of interviews (and a prize for acting at the Venice Film Festival) established herself as the absolute archetype of the Parisian woman of 1984 who was eager to multiply her experiences while at the same time pursuing a certain romanticism. She was questioned about everything, people went into raptures over her very fashionable apartment at the heart of the Halles (where she lived with Benjamin Baltimore, the creator of the poster for the film), she was invited to appear in a broadcast of *Aujourd'hui Madame* on "nomadic love," and in it she defended her character's fragile utopia.

Full Moon in Paris was perfectly in phase with the spirit of the time, to the point that it inspired knockoffs, such as *The Night Wears Suspenders*, in which Jezabel Carpi draws a handsome young boy into the labyrinth of the pleasures described as "in." The scenario of this first feature-length film was written in parallel with that of Rohmer's, but the press did not fail to emphasize the connection between the two. The master was annoyed a little, but at the same time delighted by the craze for his new comedy, which corresponded to a very definite plan on his part. He wanted to make a film in which a whole generation could recognize itself, and his attempt succeeded beyond his expectations and beyond the social success *La Collectionneuse* had achieved. For a long time, *Full Moon in Paris* set the image of the "plugged-in" Paris of the 1980s, with its festive and sartorial imagination, its new amorous disorder, its nostalgia for traditions. In Venice, the film

was warmly applauded, even as it was being shown. Rohmer received enthusiastic letters from Nicolas Seydoux (the CEO of Gaumont), Daniel Toscan du Plantier (the director-general of Gaumont who had, five years after *Perceval*, paved the way for a new film to be made in common), and from Jack Lang, the minister of culture, who congratulated him on winning the Méliès Prize. Even those who, like Claude Baignères in *Le Figaro*, had denigrated *Pauline at the Beach* now discovered all sorts of qualities in the dialogue and acting of *Full Moon in Paris*.

In this concert of blessings, a few voices spoke up to express a problem. Not that of noting this or that defect in a film that was almost everywhere greeted as a masterpiece, but a problem consubstantial with the Rohmer effect, with the magnifying mirror that he holds up to his time. Claude-Jean Philippe questioned Rohmer about this, and Rohmer acknowledged that in fact this problem exists, a kind of floating between comedy and tragedy. Serge Daney wonders about this strange gap that prevents the spectator from completely identifying with his Rohmerian "double":

> Rohmer practices a kind of perverse Brechtism. At first, almost by convention, he asks us to "adhere" to the character who, through his caprices, sets the fiction in motion. But the moment when we understand that this character is headed for a deserved punishment and are forced to let him go is precisely the one that the author was waiting for, in order to remain close to him, to console him and enjoy his tears.[60]

Run of Bad Luck

Many tears were to be shed in the year 1984, which was not only a year of success. In the autumn, two of Rohmer's companions from the golden age of *Cahiers* died: Pierre Kast and François Truffaut. As we have said, the latter had grown closer to "le grand Momo," to the point of discreetly financing *The Aviator's Wife* and *A Good Marriage*. Truffaut even elegantly (or diplomatically?) refused to poach Béatrice Romand, who wanted to work with him: "You belong to Rohmer!" In *Le Roman de François Truffaut* that *Cahiers* published not long after Truffaut's death, the author of *Full Moon in Paris* wrote a fine elegiac text in which he resuscitated the great postwar period of cinephilia. He did the same, from a more analytic point of view, in an interview given at the same time and

published at the beginning of *Le Goût de la beauté*: in it, Rohmer undertakes to connect his current work with his critical writing thirty years before.

Other deaths occurred under the sign of tragedy, violence, or excess. In December 1983 his former mentor Paul Gégauff was stabbed to death by his young girlfriend. The latter, Coco Ducados, played the role of the "hideous damsel" in *Perceval*, and she had confided to Rohmer premonitory hints regarding the deterioration of their relationship. In July, it was Gérard Falconetti, the handsome Gilles in *Claire's Knee*, who committed suicide at the age of thirty-five. A tribute to him was arranged at the Cinémathèque française, for which Rohmer composed an emotional portrait. In it he described all the sensitivity he had discerned in this fellow, who had gone to parties with Pascale Ogier and was a loyal friend to Marie Rivière. He described (between the lines) all the suffering of this tormented homosexual, who was never at ease with reality and draped himself in an outward arrogance:

> When I was preparing *Claire's Knee* his agent sent me a photo of him. Since it interested me, I telephoned him. Gérard replied to me with what seemed to me a complacency close to insolence. That pleased me. That characteristic corresponded exactly to the character I wanted him to play. And that's why in my work he constantly played "villains," in *Claire's Knee*, in *Perceval*, and in *Catherine of Heilbronn*.[61]

On October 25, 1984, as he was going by Metro to Pierre Kast's funeral, Rohmer met a friend who told him that Pascale Ogier had died. He hurried off to his office at Losange. Jackie Raynal, who had an appointment with him on that day, remembered the cries of pain that resounded as far as the stairway of 22, avenue Pierre-Ier-de-Serbie. The press and close friends later tried to reconstitute the sequence of events. For the past two months, the success of *Full Moon* had surrounded the young actress in a cloud of euphoria. The day before, there was a party at Le Palace, in the course of which Pascale was said to have taken drugs (she had been "clean" for some time). During the night she had a mild heart attack—and her partner did not immediately call an ambulance. Rohmer was devastated by this death. He conducted the funeral as if he had been both Pascale's widower and her father. In his archives, he set aside a few photos that testify to these mixed feelings worthy of the chaste paternal embraces in *The Marquise of O*

Full Moon in Paris proved to be not only the film of an era but also the endpoint of the first period of *Comedies and Proverbs*. In the summer of 1984, Rohmer turned away from the professionals surrounding him (Renato Berta, Georges Prat) to recruit a new, younger group and undertake a radically different project. But in this new project he still sought, in a world that might be thought materialistic, to relaunch the incessant movement of the imagination.

Toward Jules Verne

This provided an opportunity to see a mystical Rohmer surge up again, along with his fascination with everyday life. At its origin we find, as in *Perceval*, a memory of childhood. In this case, he recalled reading Jules Verne, whose works, in the Nelson edition, adorned the shelves of the public library in Tulle. These volumes were decorated with green motifs, and the young Maurice may have read at that time (or a little later on) an 1882 novel entitled *The Green Ray*, which recounts the voyage, at once magical and comic, of a rich Scottish heiress whom her two uncles are absolutely determined to marry off. For her part, she wants to give her hand only to the man whose thoughts she has read thanks to the famous "green ray" (that is, the last ray of the setting sun), to which legendary properties are attributed. Thus she goes to visit maritime countries in search of a clear sky and a Prince Charming. On the way, she rejects the advances of a tiresome prig named Aristobolus Ursiclos, and then falls into the arms of a young painter—to the point of no longer even paying attention to the green ray when it finally appears.

Of this lovely tale for girls, Rohmer retained mainly the mythical structure. The initiatory voyage, following an ideal that might be embodied in a very specific landscape, and also a few more realistic notations that juxtapose the dream and a trivial ordinary activity, swimming in the sea, which became popular at the end of the nineteenth century.

> During these long days Miss Campbell, leaving her uncles with the suitor of their choice, would wander along the seashore, sometimes accompanied by Dame Bess, but more often alone. She was glad to get away from the crowd of idle people one generally meets at bathing places, whole families whose only occupation seems to be to sit on the beach and watch the tide come in and go

out, while small boys and girls dig and roll around on the sands with a truly British freedom of attitude: grave phlegmatic gentlemen in their somewhat rudimentary bathing costumes, whose principal object in life seems to be to plunge up and down for ten minutes or so in the saltwater; [. . .] negro minstrels [. . .] singing comic songs, surrounded by a circle of children who gravely join in the choruses.

This sort of life at the seaside had no charm for Miss Campbell; she preferred to get away as far as possible from the crowd, who seem as much strangers to each other as though they had come from the four quarters of the globe.[62]

Wouldn't one find here, already, the tourist postcard atmosphere in which another *Green Ray* was to bathe, including a young, romantic woman's reflex to withdraw in order to assert her singularity?

This was in fact to be the subject of Rohmer's film. To define it, he wrote down a few scattered notes toward the end of 1983. He took his inspiration from a classified ad he had read in a newspaper from the Basque coast—where he spent part of his vacation every year, in the house his wife owned there. The ad read this way: "I am beautiful. I am from Biarritz. I should please, and men pay no attention to me, why?" He was also inspired, in a more diffuse way, by his own lonely youth, seeking a sister-soul that his great timidity made inaccessible for him. In the course of the notes, a few intersecting themes emerge: "The sun / The gilt and green / Bodies / Sand, stone / The immensity sea-mountain / Nature animal-vegetable / Ecology—vegetarian, nonviolent / Asceticism—detachment / Solitude—the crowd / The meeting / Luck—chance / Cards—horoscopes / Vacations—work."[63] Especially vacations, which he had made the privileged time of his cinema, from the appalling vacation in *Sign of Leo* to the amorous holidays in *La Collectionneuse*, *Claire's Knee*, and *Pauline at the Beach*. Here and there, a connecting thread emerges: the wandering of a little secretary who would like to take advantage of the summer to meet a boy. Scenes were written out. For example, the protagonist's boredom on a nude beach where the pick-up artists are less interested in her than in two provocative Swedish girls. Or the conclusion of the story (Rohmer often began there): the unhoped-for meeting with a young man with whom she can finally discover the green ray. Several titles were considered. *The Stroller*, *A Vacation Love Affair*, *The Augustans*, which was long to remain associated with the project—and still *The Green Ray*, which clearly appears as the ultimate horizon of this informal story.

This Evening We Improvise

Rohmer had an idea in mind. The success of *Full Moon in Paris* had left him somewhat blasé. Without much enthusiasm, he showed the film to Fabrice Luchini ("It's a little slow at the beginning, and afterward it gets going . . . "), and to Françoise Etchegaray, to whom he had confided his desire not to confine himself to a formula. He had been very impressed by the experiments made by Jean Rouch, Jacques Rivette, and Paul Vecchiali, who brought improvisation into their fiction cinema. And then he had had enough of hearing it said that his cinema was "literary," that only the text made it worthwhile, and that he made his characters speak in an artificial way. Whence the challenge that he announced to Marie Rivière one day: "Éric said: 'I'm reproached for writing sentences that are too long. But in life, people talk a long time without stopping. And I'm going to demonstrate that. No one will see the difference between a text I've written and an improvised text.' That was his basic idea, and he thought that I would be well-suited to realize it."[64] Not without having first considered making Françoise Etchegaray the lead actress in this atypical film. But very soon he came to see that Marie Rivière was the obvious choice.

Not only because she had attended for a while Blanche Salant's course on improvisation, in the context of Actors Studio training (she met there by chance Irène Skoblin, who was to play the role of a providential friend in *The Green Ray*). Above all, because she resembled in many respects the antiheroine that Rohmer had imagined and to whom he gave the name Delphine. In her secret beauty, which did not appear at first glance but revealed itself in moments of elation. In her depressive mask, which often collapsed in crying fits. In her dream of a great love, which she expressed in very simple words. Very far from Arielle Dombasle's sophistication or Béatrice Romand's rhetoric. Rohmer had Marie read a book that bored her to death but which she kept near her in the film: Doestoyevsky's *The Idiot*. He filmed her in the little maid's room which was his usual setting and that he had already evoked in *The Aviator's Wife*. He literally asked her to play an episode from her own life, on the basis of improvisations directed and recorded on tape. They spent long hours in his office, talking about the playing cards that Marie picks up in the street, about her phobia about meat, or the difficulty she has in escaping loneliness. Without too much seeming to, Rohmer guided these discussions in the direction that interested him, putting in

place themes and sequences—while at the same time leaving his actress with the impression that she was the one who was writing the film.

Similarly, he reconstituted a familiar context around Marie by bringing in her friend Rosette as early as these preliminary meetings at Losange and by taking her to film the first scenes at her parents' home or at the homes of their friends. A female context, as well. He explained why to a journalist from *Marie Claire*: "In *The Green Ray*, which was almost totally improvised, I had situations, but no dialogue had been written, and it is certain that when she confided things, Marie Rivière was clearly freer because all the technicians were women. That created an intimacy and a closeness."[65] A closeness in which he took part, so hard did he try to disappear into this feminine world—which he located more and more at the heart of his films. So he could, without blushing, make the troubling confession that prefigures the hero's transformation into a woman in the *Romance of Astrée and Céladon*: "It isn't that I like girls so much as that I feel the girl that resides in every man. I feel it in me."[66] Who are these girls (or almost girls) of Éric Rohmer's, who are so much more likable than Montherlant's? Around Marie Rivière, he brought together his usual gynaeceum: Rosette, as we have said, but also Béatrice Romand and Lisa Heredia, who gathered at the latter's house to shower their friend with advice. A scene that was filmed at one go, on the basis of a simple outline. And which Rohmer found so satisfactory that he decided not to continue it, as he had thought of doing, by coming back to film Lisa taking her sunbath.

Claudine Nougaret, twenty-six years old and a recent graduate of the Louis-Lumière School, was the sound engineer. Behind the camera, Sophie Maintigneux, twenty-three, whom Rohmer had only had make a small test (a sequence on Galliera Square) before giving her a small Aaton 16 mm camera fitted with an old-fashioned zoom lens. Although he sometimes discreetly asked Sophie to use this zoom lens, for instance to reframe Marie's tears, in general he let her set the frame the way she wanted. During the dinner in Cherbourg, she set up in such a way as to be able to make panoramic shots depending on the guests' discussion and on the movements of the sound boom. During Marie's lonely walk through the Norman countryside, she adapted to the actress's wanderings and took the initiative of "stealing" a few shots that were tormented in nature (which further amplified Delphine's emotion). At each stage, the improvisation of the filming corresponded to that of the acting, dispossessing the author of his control while at the same time secretly reinforcing it. François Etchegaray was made supervisor; she had already been associated with the genesis of *Full Moon in Paris*. She

was a very beautiful young woman around thirty years old, with a slender figure and a diction that was by turns aristocratic and plebeian. She combined to some extent the different styles that delighted Rohmer, along with an outspokenness that he liked more than anything. They had met in 1974 in the offices of Élite, Jean Eustache's production company. They met again on the set of *Perceval*, or at the home of their common friend Liliane Dreyfus. They spent hours over cups of tea, talking about literature and painting (Françoise was then living with the painter Robert Lapoujade, whose work Rohmer liked to the point of hanging one of Lapoujade's canvases in his office). Together they undertook the mad project of making amateur films again, as in the heroic age of the New Wave. He suggested that for this project they make use of a structure he had recently created, on the advice of Barbet Schroeder, which he had named "The Éric Rohmer Company." A structure on the margin of Films du Losange that could allow him greater financial and artistic autonomy.

But Françoise hesitated to wear the producer's hat. At first, they launched into the adventure of *The Green Ray* without an official producer, with only a few contracts that Rohmer initialed on the corner of a table. One of them (Claudine Nougaret's) deserves to be quoted. It testifies to the uncertainty Rohmer felt just before shooting began, regarding the form and the economy of his film:

> I would be happy to entrust you with executing, as sound engineer, the tests preliminary to the filming of number 5 of my *Comedies and Proverbs*. Since these tests are to be made before production begins, I ask you to agree that the payment of your salary may be deferred until the film has found financing. In compensation, I commit myself, as manager of the Éric Rohmer Company, to pay you on the basis of the labor union minimum salary [. . .]. This agreement does not exclude sharing in the profits.[67]

These temporary conditions did not fail to create certain tensions. Especially when Rohmer, at the end of a lunch with volunteers playing secondary roles, quibbled about paying for their meals and ended up leaving the restaurant after furiously throwing a bill on the table. The next day, Françoise threatened to abandon everything if he persisted in acting like an ill-tempered miser.

She was the first to dare to stand up to him, and that did not necessarily displease him. She was the first, especially since Barbet Schroeder and with a willingness more complete than Marie Bouteloup's, to go to great lengths to realize

the great Rohmerian dream: working from day to day, with the means at hand, without worrying about the constraints of traditional production (assistant, scriptwriter, work schedule), and freely adapting to circumstances. Thanks to her inexhaustible resourcefulness, it proved possible to film Delphine's vacation in chronological order, picking up occasional actors as they were needed, and living here and there locally. In Cherbourg, they stayed with Rosette's family, and their hosts graciously joined in the improvised sessions while Françoise helped prepare the meals. In Biarritz, she made use of her knowledge of the Basque country to deal with all the logistical problems. She reported to Rohmer a few weeks after filming had started:

> I've been lent a house with three bedrooms and a kitchen not far from the one where I'll be staying myself. In this same house I've made the acquaintance of a woman who teaches French. Her first name is Maria Harmonia, nicknamed Monique; she remembers *The Green Ray* and would be willing to talk about it in front of your camera. [. . .] After having made the rounds of three theatrical companies [. . .] and then of the three young people's associations in Bayonne and Biarritz, it seems that it is through the mediation of the director of the Bayonne chamber of commerce that you will find the "local boys" most in accord with your project.[68]

In the end, to play the young drifters who pursue Delphine and her girlfriend in a sidewalk café, they recruited a friend of Marie Rivière's and also a complete stranger met on the beach at the last minute. The sequence was a small masterpiece of vulgarity caught live. To run the twilight discussion about Jules Verne and the green ray, they found an old German scholar with a white beard who specialized in this odd meteorological phenomenon—and who happened, by the most incredible accident, to be there. Between these two extremes, the whole singularity of the film is revealed. A film that seemed to be written with "the very texture of the real"[69] and yet strangely resembles what its creator imagined.

Miracle at Canal+

Once the film was in the can, it was to remain there for two years. Rohmer still did not know what he wanted to do with it: Make it only the first version of a

more professional 35 mm film? Or perhaps something that would take a new form? As usual, he holed up to watch the rushes and locate the ones that suited his purposes. Cécile Decugis, who has been his official editor since *My Night at Maud's*, decided to make her own film. Despite Rohmer's somewhat perverse predictions, she had gotten along exceptionally well with her young assistant Lisa Heredia, who was patient and talkative. So it was the latter, naturally, that Rohmer asked to take over when Decugis left. She accepted, on the condition that they remain good friends if the undertaking failed. The first day, when she asked him if the lunch break was still far off, Rohmer sniggered: "About twenty hours off! It's 5 P.M." Carried away by her work, the young woman hadn't noticed time passing. She passionately took possession of this material that was difficult to edit and made many astute suggestions—for example, to link the glances of Marie Rivière and her Prince Charming, Vincent Gauthier, during their final meeting in the Biarritz train station. Or to make the confessions of a taxi driver one continuous shot, even if they were filmed at an interval of several hours: at first scandalized by this heresy, Rohmer finally yielded when he saw the result.

For once, Rohmer himself was not afraid to sacrifice this or that whole segment. Thus the discussion about solitude by the women of Biarritz, which constituted part of the remarks Delphine overheard as an echo of her melancholic wandering. He hesitated longer regarding the discussion about the salad, in which Marie Rivière defends the right to be a vegetarian. The scene is one of the most convincing in *The Green Ray*, but at certain places the self-portrait is in danger of turning into caricature:

> And you see the slaughterhouse, the way it is? [. . .] Well, the cow that you raised for a very long time. And then, besides, a cow lives a long time! [*laughter*] [. . .] She walks between the shafts like that, a nice cow, you see, with big eyes and everything. [. . .] And the guy, he kills her like that, and you see the faces of the guys and all that. Well, that's what it is, for sure, when everybody sees that no one will want to eat meat.[70]

As he did when *Full Moon* was being edited (for the conversation in the café with Lázlo Szabó, which he ended up keeping), Rohmer asked advice from his wife, who was asked to view the sequence and who urged him to abbreviate it.

A singular object was beginning to emerge. One essential element was still lacking: the green ray that gives the film its title and that Delphine is supposed

to see in Saint-Jean-de-Luz with her lover. The weather was propitious on the evening Rohmer and his little team arrived in the Basque country. But he did not dare ask Sophie Maintigneux, who was exhausted by the trip and the heavy technical equipment that had to be transported, to wait for the setting sun. Later he did try to draw this green ray on the film itself, which could be no more than a temporary solution. Although he abhorred trickery, they resolved to send a camera operator to the Canary Islands to bring back satisfactory images. Rohmer even allowed the green in question to be slightly enhanced. He knew that this banal story needed magical counterpoints: the playing cards that appear under Delphine's feet, a few notes of music (inspired by Johann Sebastian Bach and put into the form of a fugue by Jean-Louis Valéro), and finally the miracle that they emphasize. A marvelous happy end whose secret seemed to have been lost since *Sign of Leo*.

There were to be several miracles. Convinced by the montage she had seen, Margaret Menegoz agreed to return to take charge of production. The cost of *The Green Ray*, even though doubled by the special effect in the final sequence and by the expenses involved in enlarging to 35 mm, remained modest: 4 million francs—that is, one-third of a normal budget for this kind of film. The American distribution company Orion Classics invested $100,000 as an advance option (not without getting impatient when the finished product was so late in coming). But how to promote such a fragile film, while avoiding disproportionate advertising expenses? Then Margaret Menegoz had a brilliant idea, echoing Rohmer's regarding the new alliance between cinema and television: sell *The Green Ray* in advance to Canal+, the new cable television channel that already had 400,000 subscribers. To get around the legal obstacle that prevented Canal+ from broadcasting a cinematic work before a certain time, the film was redescribed as a telefilm. This made it eligible for subsidies paid to cultural industries. Thus to the 850,000 francs proceeding from the advance sale, twice that much was now to be added. Even before it came out, two-thirds of the money it cost to make *The Green Ray* had been paid back! It would take only 60,000 spectators to pay it all off.

The last obstacle to be overcome: the grumbling of the theater owners, who were worried that the audience would stay away from a film that had already been shown as a preview on television. It was here that an ultimate green ray intervened. Against all normal expectations, and against the opinion of Alain Robbe-Grillet (the very little Rohmerian president of the jury), this cinematic

UFO won the Golden Lion at the Venice Film Festival, and also an acting prize for Marie Rivière. A Golden Lion that coincided with the broadcast on Canal+ and with a flattering word of mouth. In general release, *The Green Ray* attracted more than 460,000 people, not counting those who went to see it abroad. It was certainly one of the most profitable films in the history of French cinema, in terms of the economy of means employed. But was it completely a miracle? At the heart of an almost unanimously enthusiastic press coverage (including Georges Charensol), Gérard Lefort tried to elucidate the success of the gamble Rohmer had taken:

> After (leaden) years of *I-me* cinéma, Rohmer, by the weight of his pen, has just invented *we-they* cinema, a way of entering into empathy, of working with all of us, without however allowing oneself to be devoured [. . .] because if *The Green Ray*, which is a genuine treatise on French style, catalogues with delight every-thing that our ways of speaking does [. . .], it is always done with a light touch, imperceptible, elegant, and well-mannered. Exactly like those distinguished old gentlemen who, sitting in the corner of a bistro, pretend to be rereading Pascal and who, though they seem not to be listening, don't lose a word of a dressing-down that was thought to be private.[71]

In *The Aviator's Wife*, Rohmer had already made this gamble, which consists in dissolving the author's point of view in the anonymity of the spectators. But the audience was probably not as ready as it was in 1986 to accept such a style, which sitcoms and reality shows would soon make common. As for Rohmer himself, he remained completely loyal to his youthful intuitions, which *The Green Ray* realized to the letter. Through the homage to the Ingrid Bergman of *Stromboli*, whose wandering in the desert Marie Rivière relived without knowing it (and we can recall in passing that Rossellini also got a second wind in television). Through the carrying out, in its slightest details, of the program issued in the time of "celluloid and marble": making the cinema the privileged site where the miracle could be reborn, in the apparent absence of any human will. In this respect, the emblematic moment in the film is the one in which Lisa Heredia caresses a dusty statue as she is watched by a depressed Marie Rivière. The statue does not, however, come alive as in Shakespeare's *A Winter's Tale*. But it is reality as a whole, beyond its outdated representations, whose magic Rohmer the film-maker makes us discover.

A Ray That Makes Waves

Not everyone saw *The Green Ray*. That is true in the literal sense, since the last ray of the setting sun remained indecipherable for the audience of Canal+. It is even more true in the figurative sense. If it pleased a great many people, it also annoyed many others because of the way it applied a magnifying glass to trivial everyday life. Many spectators were bothered to recognize themselves so exactly, and one of them went so far as to file a lawsuit. She thought she saw herself in the background of a sequence and complained about being filmed without her knowledge. For his defense, Rohmer outlined an argument that was simultaneously ironic and lyrical:

> It is difficult to agree that just the fact of being filmed, sitting, smoking, in full sunlight, at an undetermined time and date, on the terrace of an elegant restaurant, can be considered any kind of infringement on the private life of Mlle M., if it is in fact she. [. . .] People praised the New Wave of the 1960s, to which I am proud to belong, for having known how to go down into the street and dust off "papa's cinema." And by "street" we must understand not only the paving stones, sidewalls, façades, and display windows, but also the animation created by an authentic crowd. To do away with that background would be to deprive French cinema of its life, of its specificity and its prestige abroad. [. . .] Since the distant origins of cinema, in France appearing on the screen has traditionally been considered an honor rather than an infamy. There, it is no longer the New Wave that must be invoked, but the inventor of cinema himself. Lumière filmed Parisians in the street and invited them to come see themselves on the screen. They were delighted. They did not ask for damages plus interest: they paid for their seats.[72]

Others also ground their teeth, the "professionals of the profession," to use Jean-Luc Godard's expression. Some of them accused Sophie Maintigneux of spoiling the craft by agreeing to work under these primitive conditions. She would in fact have remained without work after the experiment of *The Green Ray*, had not Jean-Luc Godard hired her as head camera operator for *King Lear*. A Jean-Luc Godard who, for his part, had considerably admired Rohmer's film, and who wrote to him: "Dear 'grand Momo,' *The Green Ray* is so splendidly full of youth

and grandeur that these poor words will not be able to express the emotion aroused by so many proofs of faith in human beings and the universe, each one being by turns the point of view of the other. Please tell Marie Rivière how much her invention is equaled only by her probity."[73] Rohmer also received a warm telegram from Agnès Varda who, with her film *Vagabond*, had just ventured into territory close to his. He gave a favorable reception to the initiative of Joël Jouanneau, who had decided to produce a theater play on the basis of dialogues in *The Green Ray*. There were so many tributes to his ambition as an auteur, even if he pretended to be overwhelmed by events.

The last years of the 1980s were those of a Rohmer who had been liberated, as his chains had been removed, and who allowed himself previously unheard-of audacities. Though he had always strictly forbidden himself to intervene in the public arena, he was now seen, for example, to take an interest in an infamous figure: after a series of holdups, Robert Knobelpiess had spent about fifteen years behind bars. He wrote several books on the dysfunctions of the penal and judicial systems. In the spring of 1987, he was once again convicted of participating in a shoot-out and of fleeing arrest, under circumstances that remained obscure. A certain number of left-wing intellectuals organized in support of him— including a young actress with whom he had just begun to form a relationship. The actress was Marie Rivière, who herself wrote a book about this strange affair: *Un Amour aux assises*. She repeatedly appealed to Rohmer to cosign a pro-Knobelpiess manifesto. He went her one better: he wrote, with a view to a new trial, an exculpatory testimonial, emphasizing the role of bad luck in the accused's destiny and also (more prudently) the "elective affinities" that had been able to unite him with his young actress.

> She is an actress whose good heart, thirst for purity, uprightness, and especially the moral demand that made her very severe—too severe, we thought—in the choice of her relations, we have admired. For me, it is absolutely unthinkable that Marie might be able to grant her esteem, her love, her fidelity to a being in whom she had not felt the presence of that same thirst for purity, of that uprightness, that was in her.[74]

Rohmerian liberty also involved making official the Éric Rohmer Company, which had up to that point been only a shadow structure, and in handing over the keys to Françoise Etchegaray to continue the experimentation of *The Green Ray*.

The result was to be *Four Adventures of Reinette and Mirabelle*. However, was that why in the middle of his rejuvenation and renewal, Rohmer suddenly decided to pause and go back to a more classical project?

Goethe in Cergy-Pontoise

Was it due to the relative exhaustion he might have felt while making over several months a second "amateur" film that had less success than the first when it came out? Or was it a desire to complete the cycle of the *Comedies and Proverbs* (into which he was able to fit *The Green Ray* only with difficulty), by returning to number six, which had already been that of the *Moral Tales*? Above all, it was due to an old idea for a scenario that he had been carrying around for a long time and that he wanted to finally give concrete form. According to him, this was even the first "comedy" whose subject he had conceived as such. A comedy mixed, as always, with autobiographical elements, or at least with very personal ones: it crystallizes around a romantic young woman (a sister-soul to the Marquise of O), hesitating between two love objects (like so many Rohmerian creatures), fascinated by a Don Juan (who resembles Gégauff a little), and manipulated in parallel by two confidantes who recall the woman novelist in *Claire's Knee*.

To which Rohmer added two models that confuse matters while at the same time reaffirming the constancy of his inspiration. The first goes back to his youth; he already cited it with veneration in "Celluloid and Marble," and dreamed of making it in a cinematic adaptation that probably turned out to be too expensive for the beginner he then was. It was Goethe's *Elective Affinities*, in which a scientific demonstration serves as the point of departure for an amorous mix-up because of a being's natural attraction for the one whom he is fated to love. The second model was discovered by Rohmer in the early 1980s and influenced several of his following films: the comedies of Corneille, whose theory of dramatic suspense (which Rohmer preferred to Hitchcockian suspense) he greatly admired, and whose rigorously governed amorous choreographies take place within a single space that is not necessarily a kind of prison. We think in particular of *La Place Royale*, which Brigitte Jacques was soon to produce on the stage in the framework of a series of productions of plays by Corneille begun in 1985. To get the knack, Rohmer had fun developing his subject in alexandrine verses that shamelessly acknowledged their second-rate nature: "Je trouve que

tu as, Léa, bien de la chance / De tomber amoureuse avec cette cadence / Et de trouver toujours, sans chercher, un garçon / Qui te plaît sûrement d'une ou d'autre façon. / Moi, le seul qui me plaît . . . / C'est Bastien, je le sais."[75] And a little further on, this cry worthy of Chimène: "Non, je ne le hais point. Simplement, il me semble / Que toi et lui, crois-moi, allez très mal ensemble. / Blanche : Il est beau, je suis moche. Oh, je le sais assez ! / Léa : Blanche, pourquoi vouloir toujours te rabaisser?"[76]

Alongside these noble references, we can assume another that is already perceptible in the title Rohmer adopted for his scenario: *Les Quatre Coins*, a more or less conscious tribute to Sacha Guitry's *Quadrille*. Guitry is an author whom Rohmer had in the past defended only half-heartedly, notably in *La Parisienne*, a propos *Lovers and Thieves* (but he was then still under Truffaut's influence). There is no doubt that when he was about to embark upon *Comedies and Proverbs* he viewed again some of Guitry's prewar films, going so far as to imitate overtly the prologue and epilogue of *Quadrille* in what was to become *Boyfriends and Girlfriends*. However, this comic dimension was not established from the outset in an obvious way. At first, Rohmer endeavored to write "Les malheurs de Mariette" ("Mariette" was the first name given to the future Blanche). Unlike her friend Perrette (who later became Léa), Mariette experiences one amorous disappointment after another and ends up where she started. Rohmer makes her a stubborn idealist who clearly resembles the Marquise of O in her refusal to give up the image of others that she has forged. Thus after a night of love with Fabien, Perrette's boyfriend, she runs away, fearing she will betray her adoration for Bastien: "I don't *want* to love someone else. He's the one I want. You might be a thousand times better, but I want him. I didn't want you."[77]

Little by little, Rohmer came to accept the solution of the happy end, bringing the young woman closer to her friend's boyfriend, while the friend falls into the arms of the Apollo she has so much desired. But this was no longer done, as at the end of *The Green Ray* (or the future *A Tale of Winter*), by waving a magic wand that is supposed to transcend, by its prestige, the gray dreariness of the situations. In *Boyfriends and Girlfriends*, Rohmer reduced the gap between the sublime and the pathetic that he had made one of the great principles of his cinema—or more exactly, to use Léa's own words, between the "extraordinary"[78] and the "solid."[79] It is in the acceptance of the solid (a less brilliant boy, a less romantic story) that the revelation of the extraordinary takes place. It is in the proximity of the pathetic (the meager popular distractions on the outskirts of the

new towns) that the future lovers commune in the apprehension of the sublime. Thus to develop his dialogues and prepare for filming, Rohmer relied on actors who provided him with clichés. There was the beautiful, curvaceous girl from the south, Sophie Renoir, whom he had continued to frequent since *A Good Marriage*. He nicknamed her "the insolent romantic," and he enjoyed her caustic humor so much that one day he invited her to lunch—an event that aroused much commentary in the little world of Losange. He asked her questions about her love life (what would you do if a girlfriend stole your boyfriend?), but he made little use of her impulsive reactions and retorts, in the end constructing a much more prudent character.

Opposed to her was the young ingénue who believes in romantic love but gets along very badly with boys. He found her during an excursion to the Marie-Stuart theater, where he had gone with Haydée Caillot to watch the exercises of pupils in the Actors Studio register. Her name was Frédérique Chaulet, but he renamed her Emmanuelle. She was a young woman who was unprepossessing but knew what she wanted. After an initial interview in Rohmer's office, she contacted him again, and for months she engaged passionately in the game of question-and-answer, to the point that she revealed, for a good cause, whole areas of her reveries and emotional experiences. The two boys still had to be found. Sophie Renoir introduced two of her young actor friends to Rohmer: François-Éric Gendron, who had already appeared in a few light comedies, where his impressive physique won him roles as a handsome fop. He was hired immediately, without the slightest hesitation. And then Éric Viellard, a leading man with a more discreet physique who nonetheless had attracted attention in a television series called *Game, Set, and Match*. That in itself was almost enough to make Rohmer choose him, since he was an assiduous viewer of television broadcasts of the Roland-Garros tennis tournament—where, moreover, one of the sequences in his new comedy was set.

Finally, it remained to define the "place royale," antique and contemporary, where his characters would take their walks. For a long time, Rohmer had imagined situating the action in a new town on the outskirts of Paris. He had recently filmed one of these, Marne-la-Vallée, at the beginning and the end of *Full Moon in Paris*. This time, he was thinking instead about Cergy-Pontoise and about a very specific neighborhood (Belvédère Saint-Christophe); he waited for it to be completed before setting the dates for filming. He liked its bare, atemporal, almost ghostly architecture, well suited to framing the banal flutterings

of a woman's heart. But he made Emmanuelle Chaulet believe that she was the one who had chosen the site. In the course of a conversation she suggested that she could windsurf on the lake at Cergy to illustrate the athletic nature of her character. So Éric and Emmanuelle went to walk there, they took photos, located the possible axes for the shots. During the filming Emmanuelle even went so far as to take up residence there, renting a spartan apartment in the middle of nowhere. She was soon imitated by Sophie Renoir, who was tired of getting up at dawn to catch the train. All the details of a trap were put in place so that an everyday reality could come fall into it.

The Disoriented Demiurge

All the details? Maybe not. For the first time in ages, Rohmer seemed to be grop-ing his way as he looked for locations, and the filming reflected that. For exam-ple, in the apartment in question, which had been chosen for its matchless view of the modern towers of La Défense in the background, seen from the kitchen. But this view was blocked by an enormous pillar in the middle of the living room, which forced the technical team to use all sorts of devices to get around it. Or when it came time to film the "trip to the country" that was supposed to unite Blanche and Fabien in an incipient desire: the green nook that had been chosen turned out to be already occupied, and they had to walk a long way before find-ing another that was suitable. And what was Françoise Etchegaray's role in all this? The superintendant of "vacation films" like *The Green Ray* and *Reinette and Mirabelle* struggled to get her bearings in this more regulated production and in this impersonal setting. Rohmer himself was tempted to interrupt the shooting—as he admitted to Françoise one sad evening while she was accompanying him back to his home in the fifth arrondissement. From this crisis she drew a burst of energy thanks to which the film was somehow or other completed.

But the malaise was general. Rohmer had had the bizarre idea of separating the framing (done by Sophie Maintigneux, with whom he made many prelimi-nary excursions to Cergy) from the camera work, done by Bernard Lutic with the assistance of Sabine Lancelin. The relations between the two were terrible. The relations between the two actresses were equally bad after Sophie's unsuccessful efforts to pal around with Emmanuelle. Anxious and unsure of herself, Emmanu-elle was wary of Sophie and never missed an opportunity to cause problems for

her. When they were supposed to walk down a street in Cergy at a distant and improbable signal from the director (who, to avoid being noticed, limited himself to discreetly lifting his cap), Emmanuelle's indolence brought the confusion to its height. Not to mention the times when she forgot to move out of the field of the camera, so unfamiliar had she remained with the technical vocabulary. Or her repeated crying fits, which moved Rohmer but further slowed the filming.

The auteur of *Boyfriends and Girlfriends* was able to make use of this fragility and awkwardness with a certain perversity. He secretly filmed Emmanuelle when she went to pieces on the street, at the same time scolding her for not making exactly the gestures he expected from her. He took care not to conceal her double chin in a shot in which she collapsed on a sofa, and this caused a serious editing problem for Lisa Heredia. And for her scene of great emotion at the edge of the woods, he led her into a difficulty she had not foreseen:

> I started to cry very quickly. Rohmer wasn't happy at all and said to me: "Stop crying right away! We're not to the close-up yet, and you'll never be able to cry the whole time!" That blocked me, and afterward it was very difficult to play the crying scene in close-up. I saw that scene as one of tenderness and liberation, and it became a tenser scene in which Blanche is nervous and strained. And I think Rohmer, who saw guilt and shame struggling in Blanche, deliberately provoked it.[80]

Nonetheless, the demiurge seemed more than once to have been overtaken by his creatures, who were too willing to move outside the framework he had secretly assigned to them. Emmanuelle's fears had their counterparts in Sophie's revolts; she stood up to Rohmer and sneaked off at night when she felt like it. The same went for Anne-Laure Meury's absences; here she was playing only a secondary role (François-Éric Gendron's perfidious girlfriend), and she took advantage of this to disappear for a whole day, paying no attention to the work schedule. She was not seen until the following day. When questioned by her terrified *metteur en scène*, she deigned to give only an evasive answer: "After all, we're not married!" And it was Anne-Laure who summed up in a straightforward formula the laborious filming of this sixth of the *Comedies*: "Grace had no place on the set. [. . .] I think [that Rohmer] is more at ease with a very small, lightweight team. For *Boyfriends and Girlfriends* it was reduced to the minimum for a normal filming, but for him it was very large."[81]

Should we in fact blame the renewed constraints of more traditional filming and a text written with great precision (which Rohmer, to reassure himself in moments of anxiety, had Sophie frenetically repeat over and over)? Should we wonder about the choice of setting, the empty arena of Cergy-Pontoise, where a few indifferent passersby wander about, and which appears on the screen only as a city testifying to its lack of soul? In any case, the coincidence of the "extraordinary" and the "solid," so essential to Rohmer's universe and particularly to this project, for once functions only middling well. *Boyfriends and Girlfriends* met with the approval of audiences, which greeted this attempt to rejuvenate vaudeville with pleasure, as they had *Pauline at the Beach*: it drew almost 500,000 spectators in general release, which makes it the greatest success in the cycle after *Full Moon*. But the critics remained perplexed, divided between polite support (Michel Ciment), bitter irony (Louis Skorecki), and simple weariness (Gérard Lefort and Serge Toubiana). In retrospect, even the defects of the film become precious. They allow us to explain the miraculous alchemy of *Comedies and Proverbs*—which inspired, between 1980 and 1986, nothing but masterpieces. An alchemy that for Rohmer consisted in concealing his writing strategies, covering his tracks as he moved on, in order to create the illusion of a cinema more real than life itself.

10

The Rohmer of the Cities and the Rohmer of the Countryside

1973–1995

At the beginning of *The Tree, the Mayor, and the Médiathèque*, the novelist Bérénice Beaurivage has fallen in love with a village mayor, rediscovering her rural roots. But when he suggests that she come to live with him in the country, she cries: "No, that's impossible, I need noise, agitation, inconvenience. It's true, here, the lack of life, I don't know, it keeps me from having ideas." With that speech, Arielle Dombasle relaunches a debate regarding the advantages and disavantages of the country and the city that occupies the first twenty minutes of the film. Rohmer does not hesitate to make this long introductory walk across the fields and farmlands last a long time, during which the mayor of Saint-Juire, in Vendée, defends his little village against the prejudices of his new companion, who believes only in Paris.

In Rohmer's work, characters often talk about the places where they live and move.[1] It would be possible to give multiple examples testifying to this: "I don't feel at home in either the city or the provinces," says Blanche in *Boyfriends and Girlfriends*; "The suburbs depress me," Octave retorts in *Full Moon in Paris*. These are banal conversations and important situations that involve a way of life: choosing an apartment in Paris or in the provinces, finding a place to vacation, trying out the habitat in the suburbs, hesitating between living in the suburbs and downtown, in the countryside or in the city. Geographical discussion is a Rohmerian fact, as is announced by the theoretical conception of his cinema founded on articles written very early in his career: "Le cinéma, art de l'espace" in 1948, the architectural episode of his series "Le Celluloïd et le Marbre" in 1955, or later on, his thesis on the organization of space in Murnau's

Faust. The spatial obsession is so fundamental that Rohmer's thinking about cinema, and then his films, revolve around this worldview. In his work, no movement, no conversation regarding places, is anodyne. The organization of space is the great Rohmerian fantasy: everything happens and becomes comprehensible through it.[2]

There are four models of the occupation of space in Rohmer's work: the big city (Paris), the suburbs (the new town), the small town (in the provinces), and the countryside (the metamorphoses of the rural world). This provides a possible classification of the films, thus escaping the law of series as well as that of periods. From *Sign of Leo* to *Astrée*, there is no work that ventures outside this taxonomy. Thus there are films about Paris (short and feature-length films from the 1960s, *Rendezvous in Paris*, and historical works on the capital during the Revolution and the 1930s); films about the suburbs (*Les Métamorphoses du paysage*, 1964, and *Ville Nouvelle*, 1975), and two fictions that are part of *Comedies and Proverbs* and are situated in Marne-la-Vallée (*Full Moon in Paris*) and in Cergy-Pontoise (*Boyfriends and Girlfriends*); the films about the provinces, notably *My Night at Maud's* (Clermont-Ferrand), *A Good Marriage* (Le Mans), *The Green Ray* (Biarritz), and *A Winter's Tale* (Nevers); and finally the films about nature,[3] as is shown by *Fermière à Montfaucon, La Collectionneuse,* a large part of *The Green Ray, L'Heure bleue* (the first of the four adventures of Reinette and Mirabelle), *The Tree, the Mayor, and the Médiathèque, A Tale of Autumn,* and *L'Astrée.* Following the classical Balzacian model, Rohmer opposes Paris to the provinces and the city to the countryside, but he nonetheless takes into account contemporary historical and geographical developments—and in this sense, he is also a modern. He upsets the play of contrasts, blurs oppositions by contrasting, with a critical distance, urban spaces with one another, and brings several different places and atmospheres into a single film. He transcends the traditional paradigm of the city mouse and the country mouse and substitutes for it an ironic, even caustic reflection on the coexistence of the urban and rural worlds.

This is in fact the only subject that can unite in him the filmmaker, the curious intellectual, and the man with principles to forge a citizen of his time. As for the choice between the city and the country, Rohmer resolves this dilemma cherished by his characters by a pirouette: "I think I prefer the country, but I like to live in the city! What I don't like, is the middle-sized city, between the two."[4]

Rohmer the Architect

When he was asked "Why are you interested in architecture?," Rohmer gave two main reasons: "First, I want to be classical, but I want to be modern, too, so I undertook to show the architecture of our time. Second, for my television program *Le Celluloïd et le Marbre* (1966), in which I drew a parallel between the experiments of contemporary artists and those of filmmakers, I had met architects who interested me a great deal. It was they who put me in contact with persons involved in the development of the new towns, in particular Cergy, Évry, Le Vaudreuil, and Marne-la-Vallée."[5] This interest in architecture arose from a regret. In 1955, in the last chapter of his summa, "Le Celluloïd et le Marbre," entitled "Architecture d'apocalypse," Rohmer showed himself both fascinated and frightened by modern architecture, because it had claimed, through the demiurgic personality of artist-thinkers like Le Corbusier, Gropius, and Mies Van der Rohe, the power to rebuild the city on the ruins of the past. He wrote:

> The filmmaker takes the world the way it is, the architect modifies it. His responsibility is frightening, because he cannot build without destroying. Either he builds in the country, and commits an aggression against nature. Or else he builds in an already existing fabric, but has to destroy a fragment of it to replace it with another. It might be objected that the fragment deserved to be destroyed. Thus in the eighteenth century certain medieval edifices were replaced by new ones that were, a century later, destroyed in turn by Haussmann. But currently we see that a legacy that was thought to be without interest deserves to be preserved: Le Corbusier[6] came close to razing what has now become the Musée d'Orsay. Destroying the past is extremely dangerous, it's very serious . . . Architects have a power that can be directed toward the good or toward the bad. They are the only artists who have this power. A painter does not need to destroy the works of his predecessors in order to make his painting, a filmmaker doesn't set fire to the Cinémathèque in order to make his film. The architect doesn't hesitate to do it because he is working in reality.[7]

Just as Victor Hugo, confronted by the destruction of a medieval tower in the Arts et Métiers quarter of Paris, exclaimed: "Not the tower, but the architect ought to be demolished," Éric Rohmer had Fabrice Luchini say, in *The Tree, the*

Mayor, and the Mediathèque: "Capital punishment ought to be reestablished for architects."

Throughout his life, Rohmer maintained this overtly conservative position of hostility to architecture that builds and destroys, not hesitating to criticize most of the new buildings that were integrated into the ancient urban fabric of Paris: the Montparnasse Tower, the Pompidou Center, the French National Library. What he could not bear was the mixture of genres in a city that imposes on us the arrogant coexistence of the monumental ambition of modern-day architects and ancient structures bearing the mark of time. "In the first part of the twentieth century, there were architects with an immoderate pride who wanted to remake the world. They thought architecture was going to change people's lives. It was a totalitarian gesture: eradicate the past and decide for everyone what is good for him, where he should live, and how he should live there."[8] Thus Rohmer was one of the first members of the "Au secours le Louvre!" association, which opposed the project of the "Grand Louvre" and I. M. Pei's pyramid, rebelling, along with Michel Guy and Bruno Foucart, "against an incoherent and unreasonably ambitious program, against the cultural drugstore of the underground space, against a useless pyramid that will denature the most beautiful site in Paris."[9]

This did not prevent him from going—as early as 1965, in connection with the television version of *Le Celluloïd et le Marbre*—to meet a certain number of contemporary architects: Georges Candilis, Claude Parent, and Paul Virilio, with whom he had fruitful dialogues. His position did not basically change, but he was stimulated by the quality of these discussions and aware of his own contemporaneity: filming in the present, in a realistic way, as he planned, required capturing the metamorphoses of the urban landscape and the development of new spaces. That is why as early as the 1960s Rohmer took an interest in the politics of the construction of "new towns" that did not attack the old Paris but sought to build something new on its periphery, in accord with an essentially pragmatic program. "I am not only backward-looking," he explained. "I believe that so long as a convincing architecture is not being proposed, we have to carefully preserve what exists and build elsewhere. That is why I was for the new towns, built alongside the old cities, and I supported the 'Paris parallèle' project in the early 1960s."[10] In 1965, the Gaullist government had just adopted a resolutely planned urban development program for the Paris region. Its goal was to construct eight towns around Paris, within a radius of fifteen to fifty kilometers, to avoid urban concentration in metropolitan France while at the same time remedying the

housing crisis. Everything was placed under the authority of Paul Delouvrier, a senior civil servant and an ardent planner as well as the general delegate to the district of the Paris region from 1961 to 1969. Instead of the eight towns foreseen, five new towns were actually built in the course of two decades, Cergy-Pontoise, Saint-Quentin-en-Yvelines, Marne-la-Vallée, Melun-Sénart, and Évry, to which must be added four urban units in the provinces: Villeneuve-d'Ascq near Lille, L'Isle-d'Abeau near Lyon, Le Vaudreuil in Normandy, and Berre-l'Étang not far from Marseille.

Rohmer very soon conceived the idea of translating his quasi-masochistic interest in new architecture into films. Thus he drew up a four-page initial project for educational television that can be dated to 1967: *Architectopolis. Argument pour un film sur l'architecture française contemporaine*. He was determined to be optimistic: "Everything becomes possible, easy, it seems that everything has been invented or could be invented, on the level of construction techniques, materials and forms. However, architecture is not located in dreams, but at the intersection of dreams and human reality. Architecture is made by human beings, for human beings. It is made by today's people for those of tomorrow."[11] Rohmer would like to film this renewal of "architectural France": "Today, for architecture it is a matter of putting technology in the service of human beings, of creating a monumental universe on their scale, of building a new world under the sign of humanism. Many structures have been built over the past twenty years: French builders have disseminated this work in a country in which the language of the past is exceptionally dense."[12]

The film's goal was to "reconstitute this contemporary French architectural effort, as archeologists reconstituted Pompei, taking as the point of departure the most typical works among those constructed in recent years."[13] In it the power of cinema would bring together "all the structures that modern life requires: houses and factories, theaters and churches, schools, stadiums, airports . . . , grouped according to the logic that presided over their conception and without any ancient monument ever interposing itself between them."[14] For Rohmer, it would be, written in capital letters: ARCHITECTOPOLIS.

Filming was planned in the Paris region to capture live "this world of tomorrow that is being built before our eyes without our noticing it":[15] the Abreuvoir project in Bobigny; the Courtillières project in Pantin; the urban structures in Sarcelles, Épinay, Massy, and Antony; the Maine-Montparnasse quarter; the roundabout at La Défense; the shopping centers in Sceaux and Clichy; the

Renault factory in Billancourt; the apartment building constructed by Jean Prouvé for the Fédération du bâtiment in Neuilly; the Maison de la Radio; the Orly airport; the Palais des Sports in Paris; the university buildings in Orsay; the school complexes in Bagneux and Suresnes; and the Les Blagis primary school in Sceaux. This architectural project made Rohmer oddly lyrical, as if he felt he had to measure up to the ambition to build a new, deliberately futuristic France. "And the camera," he wrote in conclusion,

> will have to rise in an accelerated thrust along the metal wall of a ten-story building, shot in such a way, respecting the laws of perspective, that it seems to be rising into the sky like a rocket. It will slide along the shimmering glass in the sun, and then suddenly, when it reaches the last story, penetrate behind the transparent wall into a human home, into the simple and perfectly arranged interior of a low-cost housing residence where, for the first time since the beginning of the film, flesh and blood people will appear.[16]

The film ends with the children's library in Clamart, where a boy is perusing a big adventure book like those of Jules Verne, with these words about the dream of a future city overlaid on the screen: "The man of tomorrow confronting his destiny, the project's reason for being."[17]

In a second proposal, dated 1968, *Architecture présente*, Rohmer compares this architectural ambition with a way of filming it: the practical question of representing space, buildings, and the people who live in them is here confronted directly, the filmmaker defending the idea of a specificity of cinema as an art of architecture. "Of all the means of expression," he claims,

> television seems to us the most suitable to provide us with serious and detailed information regarding architecture. Film has the privilege of resuscitating true space and absolute grandeur. Its advantage over the pure photograph is clear: movement, that of the camera and that of the subject moving around inside the building, succeeds in suggesting this essential third dimension. In the broadcasts we are proposing to film, we will also reserve a large place for words. The images will be integrated very naturally into the comments of the person who created the forms and will re-create them, as it were, on the screen. The image in turn will provoke thought. We will be allowed to examine all sides of the subject, in both the figurative and the literal senses of the expression. We

will approach architecture through life. It is that life that will serve as the link between the filmmaker's point of view and that of the architect.[18]

Rohmer was finally able to put this discourse on method into practice on the occasion of the making of *Ville nouvelle*. These four fifty-two-minute broadcasts were made in late 1974 and early 1975 for the office directed by Claude Guisard at the Institut national de l'audiovisuel, and broadcast (on the leading French television channel!) in August and September 1975. The project had its concrete origin in an idea conceived by Gérard Thurnauer, the coordinating architect of the new town of Le Vaudreuil. In June 1972, he asked the ORTF[19] to finance, to the tune of 150,000 francs, *Germe de ville*, a "filmed action"[20] that would follow the construction of a prototype apartment building for four thousand residents. The plan was to film right up to the visits of the first apartment owners, and even a few months later, once they had actually moved in, so as to measure the distance between "what is sought at the level of conception and what is found at the level of usage," between "the intellectual discourse of the architects and the popular discourse of the users."[21]

The ORTF soon made a commitment, in March 1973, and enlarged the initial proposal to include "a series of four feature-length films" then titled *Recherche architecturale*,[22] the contract for which Rohmer signed on the following December 13.

Thus three broadcasts were added: *Enfance d'une ville*, centered on the construction underway in the new town of Cergy-Pontoise; *La Diversité du paysage urbain*, which follows the work of members of the Atelier de recherche et d'Études d'aménagement, directed by Bernard Hamburger and Jean-Michel Roux, notably at Villeneuve d'Échirolles near Grenoble and at La Grande Borne, a housing project for fifteen thousand residents constructed near Paris by Émile Aillaud; and *La Forme de la ville*, with the Atelier d'urbanisme et d'architecture in Bagnolet and a few of its collaborators,[23] including Paul Chemetov, who worked together on the project of the new town of Évry, particularly its Arlequin quarter, which was supposed to cover forty-eight hectares, with seven thousand apartments and twenty-eight thousand residents.

Rohmer was interested in the details of each of these projects. He accumulated extensive documentation and met with a number of these architects, who were often young and in the full creative effervsence of the post–May 1968 atmosphere, which was especially rich in theories and practices of architecture

and urban planning. It is surprising and revealing to see this man with tradi-
tional and settled ideas open up to novelty, sometimes of the most utopian kind.
This experimental aspect, which combined concepts with concrete realizations,
excited him. This is shown by a few of his notes written while he was planning
his series alongside Jean-Paul Pigeat of the ORTF's research office, who was a
delegate producer for the Institut nationale de l'audiovisuel and an urban plan-
ner and journalist. "Architectural research on paper is not enough," Rohmer
wrote. "Experimentation is concrete, but precautions must be taken. The experi-
mentation must not be a matter of building bravura showpieces. The works are
successful if they are integrated into an overall conception and the residents'
everyday lives. The results give rise to a way of life and kind of urban planning."[24]
In these notes, Rohmer also gives himself a few guidelines: "France must never
be disfigured, that is trivial, an approach [that is] solely conservative. But the
ambiguity of architectural innovation has to be shown. What about the work and
the nonwork? Architectural thought must challenge itself and that's difficult, but
cinema is the bearer of a discourse on the space of the city."[25]

For Rohmer, the most important thing was no doubt the meetings this
intense work led to, which kept him busy for more than a year, from one spring
to the next, between 1973 and 1974, and then again during the filming and edit-
ing of the broadcasts in late 1974 and early 1975. He wrote a few names in his
notes, in his appointment books, and on the requests for meetings entrusted
to Cléo, Losange's secretary: Émile Aillaud ("To improve my knowledge with
a view to making a film about architectural research currently being discussed
with the ORTF"), Philippe Boudon, Jacques Bosson ("architecture = reconquest
of the body"), Bernard Hamburger ("very interesting"), "young teams: Bernard
Huet, Grumbach, Castro," Chemetov, Tonka, Bofill, and finally "I need notes on
a young architect Castro told me about: Deporzenpac, a misspelled name that
has to be checked."[26]

The four films—made with a team of twelve technicians from the ORTF—
are composed mainly of interviews, individual or collective, on site, and oriented
toward themes taken up in turn: the diversity of cities, their forms, the use of
housing, and the particular case of the birth of Cergy. On this occasion Rohmer
resumed the fruitful conversations he had begun with Claude Parent and Paul
Virilio when he was writing "Le Celluloïd et le Marbre" and "Entretien sur le
béton." But the two most significant meetings probably took place with Roland
Castro and Paul Chemetov. Every time—and Rohmer liked this—they took

walks through the new suburbs, what Castro called "dragnet reconnaissance"[27] and Chemetov called "hikes" or "rounds."[28] In May 1973, after one of these walks around Sarcelles, Castro sent Rohmer a magnificent issue of *L'Illustration* from 1929 that was dedicated to "La maison," accompanied by a note that testifies to their growing closeness:

> I am sending you an issue of *L'Illustration* that I think will interest you. You see in the architecture of the worker's apartments in Staius or in the garden-city of Suresnes examples of low-cost housing in which we find the archetypes of the period around 1925: a whole role of loss or of "in addition." We are far from Sarcelles! I am going to try to get back in contact with you quickly if you want us to continue these dragnet reconnaissance trips in Paris and its suburbs. For my part, I'm interested in this incursion into cinema. I've wanted to do this for a long time.[29]

Paul Chemetov[30] recalls these meetings:

> In 1972, I'd participated in the competition for Évry, and he came to see me the following year. We toured suburbs together. I recall making these rounds with him, by car and then on foot. One thing forever marked me: we were in a little café somewhere in some suburb when he suddenly said to me: "It's all a question of point of view: where do we put the camera?" I found that question astounding, asked in that place. It pleased me as an architect, because architecture is also a question of point of view. Rohmer always had the question in mind as we moved about together: "Where do we put the camera?" I found him nice, astonishing, original, and I really liked going around with him. It was an interesting and informative exercise. I later used it with my students in architecture: go to a place, walk around there, and ask: what do we remove, what do we add, to get another point of view?[31]

Chemetov drew an evocative portrait of this pedestrian and architectural companionship: "For me, he was a Ruskin-like man, a cultivated aristocratic dandy. We also met on the rue Mouffetard because we were neighbors, he was always walking, he was a great walker."[32]

Rohmer took an interest in these architectural groups in the new towns, and he almost felt a certain affection for them. When not long afterward he

was asked: "Would you like to live there?" his response was negative, to be sure, but nuanced:

> That is not the question. This architecture is certainly destined to age better than the towers and apartment blocks that were built during the 1950s. This urban landscape no doubt produces an impression of loneliness and mechanical production, but from a pictorial point of view, I find something beautiful about it: first we see the pure line of the train station, then those big buildings in the background, and then we come to lower structures, to a harmony of blues and whites . . . It may not be very warm but it pleases me. Aesthetically, it's an interesting place.[33]

Paris Seen by . . . Éric Rohmer

But nothing equals Paris, obviously. Or at least a certain idea of the capital as Rohmer loved and celebrated it. In May, 1974, he wrote:

> My idea of Paris? It's very simple. We should (or should have, since it's rather late now) preserve it as it is, without demolishing or building. And not only the "historic" Paris of Philippe Auguste or the tax farmers: I refer to tall the charming places that are being disemboweled in the thirteenth, fifteenth, and twentieth arrondissements. Belleville is almost as important as the Faubourg Saint-Germain. There are other eighteenth-century complexes in France, but Belleville is—was—unique. [. . .] These peripheral neighborhoods needed only a new paint job. They had partly escaped the linearity introduced by Haussmann. They retained a look that was simultaneously rural and typically Parisian. The idea that we have to live in an architecture "of our time" is an impossibly stupid one. For example, I am against "towers." Why should we build tall structures since the intramural population is too dense and must continue to decline? Architecture is never of its time, but either ahead or behind it.[34]

Éric Rohmer loved Paris like a provincial who had gone there at the end of his adolescence to continue his studies and never left. That is, he loved an

old-fashioned Paris, resolutely preserved, the Paris he had experienced ever since he was eighteen years old: the Latin Quarter as an emblem of the Parisian heritage. But as an inveterate walker, he also liked the "old Paris" he found as he strolled about, that of Belleville, of Ménilmontant, of the Butte Montmartre, of the Buttes-Chaumont, of Montsouris, and of the Butte-aux-Cailles, the city in which whole areas changed and disappeared in the course of the urban renovation undertaken during the postwar boom.

Rohmer loved to put his characters in motion in this Parisian urban space that he lived in and defended.[35] In an interview published in a special issue of *Télérama*, "The city in cinema," he explained that he

> was not so much interested in architecture as such as in the urban space in which I can have my characters act. I love the streets, the squares, the shops. Many of my films are based on meetings, and in a city like Paris, there are so many people that they are always somewhat exceptional. What I also like about Paris is that unlike Venice, it is not a city that is too beautiful and resembles a painting. Cinema can therefore slip into it, like life, and that's exciting for the filmmaker. And then there are so many ways of filming Paris. Compare three films made more or less simultaneously in 1959 and 1960: my Paris of *Sign of Leo* does not resemble Rivette's in *Paris Belongs to Us*, which is also very different from Godard's in *Breathless*.[36]

A film about Paris . . . Rohmer never ceased making and remaking it. His first feature-length film, *The Sign of Leo*, and half of the *Moral Tales*, not to mention his sketch *Paris Seen by . . .* on the place de l'Étoile, *Nadja in Paris*, or the long stroll through Paris in *The Aviator's Wife*. This desire is not new, as Rohmer acknowledged:

> When we were young critics, when we were beginning to write about cinema, it seemed to us that French filmmakers didn't film Paris enough, whereas the Americans did it very well, even in the form of stereotypes like the Eiffel Tower and the Arc de Triomphe. François Truffaut said it in *Cahiers*: the Americans are right to film in this way, because that's what Paris is. Personally, I don't avoid either clichés or postcards; in *The Sign of Leo* there are the quays of the Seine, Notre Dame, Saint-Germain-des-Prés . . . Descending into the streets of Paris was almost the New Wave's whole program.[37]

In 1973, the Council of Europe financed a series on the architecture of the continent's capitals, and Rohmer was able to commit to a fifteen-minute documentary on Paris in 1930. "I propose to make," he explained at that time,

> a short film on the façades of the buildings constructed between the world wars. They are far more beautiful than those of the late nineteeth century, which were real assembly-line products. In Haussmann's Paris, there were no more than ten or twelve types of houses. In 1925–1930, on the contrary, there was twice as much variety in ornamentation and structures. The ornamental motifs offer a completely original world of forms. These decorations, long scorned, are now once again à la mode. It is especially the ironwork on the balconies and doors of apartment building that proved to be an unheard-of invention. Wrought iron experienced its finest period.[38]

Rohmer worked in his own way, rambling on foot through the capital, looking for the most appropriate buildings: façades that were concave, convex, projecting toward the street; recesses; loggias; bow windows; curved lines; finely chiseled balconies. In each case, he photographed, classified, inventoried: the Samaritaine department store, the Gare d'Orsay, the rounded apartment buildings on rue Léon-Maurice Nordmann in the thirteenth arrondissement, the Pleyel hall, the town hall in the fourteenth arrondissement, the Édouard-Pailledron swimming pool in the nineteenth arrondissement, the l'Élysées Biarritz near the Champs-Élysées, the Élysée Montmartre, the Raspail cinema, the Monoprix on the avenue d'Orléans, the complexes on the streets of Magdebourg and Courcelles, and the greenhouses in Auteuil and the Jardin des Plantes. In this way Rohmer discovered architects: Jourdain and Sauvage, Auburtin, the brothers Perret, Sarrazin, Sorel, Gabriel Brun, Plumet, Tauzin, Huillard, Süe, Favier, Granet, Nathon, and others, one of the richest periods in French urban development.

Rohmer wrote a four-page synopsis. He was working on the one hand with Roland Castro, an "architectural consultant" who was duly compensated in accord with a contract, at the rate of 2,000 francs, and on the other hand with one of his American students, Cheryl Carlesimo. In the archives there remain a number of index cards, notes, and reviews of books in her hand. She recalls: "We walked a great deal, from morning to late afternoon. We walked, and talked. I talk a lot. I learned French that way, by speaking with Rohmer as we were scouting the façades of buildings. Unfortunately, the film wasn't made: the Council

of Europe wasn't behind the project."³⁹ In addition there were problems with reproduction rights for all the buildings built relatively recently, which were not in the public domain. For example, in 1970 the painter Bernard Buffet was sued by the owner of a building whose façade he had painted; in 1972 a law on the reproduction and the image of private buildings proved to be very strict on this point. When he was planning his films, Rohmer was always worried about the rights that would have to be paid or about a suit that some tactless property owner might bring against him. So then he had to give up a project to which he was nevertheless attached.

The Drab Happiness of the New Town's Development Office

Although devoting a whole documentary to a Paris architectural style seems utopian, Rohmer did not refrain from making the new town appear as a genuine actor in the film. In autumn of 1982 he decided to film part of *Full Moon in Paris* in Marne-la-Vallée, giving the new town an essential role in the fiction. The beginning of the synopsis, dated March 18, 1983, is revelatory:

> Louise is twenty-four years old, she is finishing her doctorate at Arts décoratifs, while at the same time doing an internship in an agency. She lives with her fiancé Rémi in a new town in the Paris region. Rémi, who has just gotten his degree in architecture, works at the town's development office. His job gives him the privilege of living in a comfortable and spacious apartment. He is very satisfied with his situation, and he has less and less desire to go, in the evening or on Sundays, to Paris, which is hardly thirty minutes away by train or car. For her part, Louise longs for the independence she enjoyed when she was a student and still lived in Paris. The story begins at the time when she is preparing to take a decisive step to regain her independence. She earns her own living and prefers to have the luxury of keeping, as a pied-à-terre, the studio in Paris that she has inherited. She needs to go out alone from time to time, to dive back into Parisian night life.⁴⁰

A young woman between two lives, two apartments, Paris and Marne-la-Vallée—that is the geographical fiction of *Full Moon in Paris*.

Éric Rohmer met Henri Jara, the architect for the Établissement public de l'aménagement[41] of the new town of Marne-la-Vallée, and got himself invited to a few guided tours of cerain spaces and residential buildings whose construction had recently been completed. Notably in the commune of Lognes, one of the twenty-four communes of which the new town consisted. Rohmer's problem was in fact to choose where to situate his fiction in this monumental but moth-eaten complex that rose from the earth and in size was almost twenty kilometers square. Guided by the architects of the Établissement public, he entrusted the final choice of the film's location and the characters to his leading lady, Pascale Ogier. "Éric Rohmer," she explained, "knowing my taste for decoration and architecture, which we share, suggested that I perform one of my character's functions by organizing, as Louise does in the film, the different décors in which she lives."[42]

Ogier, who was only twenty-four, was assigned not only to decorate in her own style Louise's small apartment in Paris but also to find the modern apartment she was to occupy with Rémi (Tchéky Karyo) in the film. Rohmer gave her only one hint: "Where would an architect responsible for a new town live?"[43] Ogier spent much of November 1982 running around the area, drawing from her experience three pages of notes that she submitted to her mentor.

Two quarters are currently under construction in a spectacular fashion, the Centre Arcades and Le Mandinet. The former includes above all a monstrous apartment building designed by M. Núñez to rival the Théâtre de Bofill constructed a few hundred meters away. It is to be noted that Núñez, a former associate of Bofill's, hates his guts. In my opinion, it was too pompous a structure, and no municipal official would ever go live there. But it should all the same be seen because one can't believe one's eyes, and that signals its resemblance to the "show politics" of the new towns five or six years ago. The second quarter (Le Mandinet) seems to me much more interesting. It is exactly what the architects and urban planners of the new towns love these days: a postmodern, discreet archtecture; public facilities (a school and little kiosks) designed with sophistication. Situated very close to the RER station, the quarter is arranged around two small lakes. Two apartment buildings seem to me suitable: the Terraces du Parc, because the camera can move back far enough, and Les Portes du Lac, the "top building" of the style, with inhabited false pillars and a barn-like roof. Beautiful five-room apartment on two levels.[44]

Rohmer, together with his muse, chose for Rémi and Louise a split-level apartment in Portes du Lac, a series of small, five-story apartment buildings with white [emboitements] and [vitré] pillars painted blue, built by Roland Castro. This was also a wink at their meeting a decade earlier. "It's a compromise between her ideas and mine," Rohmer commented in *Télérama*. She's the split-level, the fashionable building, and the gray throw on the couch. I'm the choice to turn to Marne-la-Vallée, the desire for comfort without luxury and a modern habitat of an experimental type."[45] In the magazine *Architecture présente*, he explained further:

> In Marne, this apartment allowed me to set up my drama, to move it around, to look at it from different angles. The stairway that resembles a ship's companionway, for example, its multiple possible uses, the different angles from which one can film, right-side up, upside down, from above, from below, where Louise moved in to invent her luminous objects . . . This place is well-suited to my characters, who are in motion, always in transit, never settled.[46]

The situation of the mise en scène in the context of architecture and urban planning was Rohmer's primary concern: a correspondence between space, the characters, and the tensions that move them. In Paris, on the contrary, Pascale Ogier decorated "Louise's studio" in a "modern 1980s style,"[47] with a mixture of prototype new creations (commissioned from Iona Aderca, Christian Duc, Olivier Gagnère, and Jérôme Thermopyles) and older influences (Mondrian, the columns, the drapery, the general use of Bauhaus aesthetics), a decorative balance that resembled to some extent the apartment she was then sharing with Benjamin Baltimore.

Out of thirty-four days of filming in the autumn of 1983, nine were devoted to the sequences in Marne-la-Vallée, weeks five and six in the work schedule. Renato Berta was the lighting engineer, Georges Prat the sound engineer; they worked in different ways in Marne-la-Vallée and in Paris because of the need to adapt to the very different visual and auditory conditions. The light in the suburbs, in apartments with large picture windows, in small buildings that did not look out on one another, was much rawer and whiter than in Paris, where space is more enclosed and confined but also protective and intimate. Similarly, the sounds were astonishingly different: on the one hand, an omnipresent urban environment; on the other, a "rurbanness" mixing country peacefulness with sudden irruptions of modern mechanization.

When the film came out a year later, in September 1984, few reviews empha-
sized the unusual presence of the new town in *Full Moon in Paris*. Marne-la-Vallée
was seen at first as a purely sociological, even psychological, way of defining the
characters, not as a genuine actor in the film. Thus it was not Rohmer's point of
view that dominated, but rather that of Octave, the incorrigible Parisan played
by Fabrice Luchini. "I don't understand how you could go bury yourself there,"
he says to his friend Louise, who replies: "Well, it's because Rémi has gotten an
interesting job in the new town's development authority." [. . .]—"I don't believe
in new towns."—"Well, he does. [. . .] And he also thinks he needs to live where
he works, it's more straightforward."—"If he was building a prison, would he live
on site?"—"I'm afraid he would. That would be his style."—"And you'd follow
him?"—"You see, even now I haven't really followed him. I've kept that room in
Paris and almost all my stuff is still there."[48]

With Cergy-Pontoise, Rohmerian on-the-job training was more consistent
and intense. Twelve years after having devoted a television broadcast to the new
town then being born, Rohmer decided to situate an entire fiction film in it: *Boy-
friends and Girlfriends*, the last work in the *Comedies and Proverbs* cycle. The archi-
tecture and urban planning of a recently completed center play the central role in
it. Moreover, the credits clearly situate the action in Cergy's urban landscape. We
see, in a series of rapid static shots, the main buildings in the Cergy prefecture: the
Grand-Place, the city hall (where Blanche, a young administrative assistant, has
her office), the EDF* tower (where Alexandre works as an engineer), the computer
science school (where Léa takes courses), Cergy-Saint-Christophe (where Fabien,
a designer for a sports clothing business, has his office), the art school (where Adri-
enne is a student), and the adminstrators' restaurant (where people from different
domains meet). Similarly, in the first detailed synopsis, which dates from 1985 and
runs to thirty-seven pages, Rohmer, who was in the middle of his reconnaissance,
held in his hand precise information that clearly architecturalized a fiction whose
plot was based on another kind of arrangement, the geometry of feelings that the
filmmaker called, in an initial title, *Le jeu des Quatre coins*:[49]

> After leaving HEC, Blanche has found a job in a large firm whose headquarters
> is in Cergy, a new town in the Paris region. She has rented an apartment in a

* Électricité de France, the national electrical energy company.

quarter that is still under construction. For the moment, she has only professional relationships with her colleagues. She tries to keep in contact with her old student friends, but it isn't always easy. On this day, she has gone to have lunch in the cafeteria. In comes Léa, a student at the computer science school in the same new town, with her tray and sits down opposite her.[50]

Although the new construction in Cergy-Pontoise began in 1973, its Axe-Majeur quarter was inaugurated by Jack Lang, the minister of culture, in January 1986. This monumental architectural group leads, through twelve stations and over three kilometers, from the center of the Saint-Christophe belvedere (the semicircular place des Colonnes, formed by the imposing buildings designed by Ricardo Bofill in his neoclassical style) to the Étang de Neuville, where an island surmounted by a pyramid was planned. On the way it passes by a white tower 36 meters high and 3.6 meters on a side, created by the Israeli sculptor Dani Karavan, and slightly inclined so as to be the point of departure for the laser ray that marks a direct line putting in perspective an orchard, an esplanade, a broad terrace, and then gardens and hills gradually descending toward the Oise and the pond. Éric Rohmer followed these works with constant interest, as the documents preserved in his archives testify.

He was even involved in the debates and decisions that have punctuated the history of the new town. In 1984, he participated in a conference organized at Beaubourg by Cergy's development authority, where the Axe-Majeur project was presented. Then he gave a lecture in the summer workshops at the University of Cergy, invited by Bernard Hirsch and Michel Gaillard, before visiting the town's main buildings with students and teachers from the school of architecture. Finally, he was associated, at the request of Bertrand Warnier, the secretary-general of the development authority and the kingpin of the new town since its beginning, and Pierre Lefort, the development authority's general director, with the sponsorship of Axe-Majeur in 1985. "You know Cergy-Pontoise well," Warnier wrote to him, "because you have spent time there and that was the occasion for some people from the development authority to meet you. We would be extremely honored and interested in counting you among the sponsors of our town at the time when it is undergoing further development."[51] The filmmaker was in good company: Biasini, Bofill, Duby, Restany, Strehler, Eco, Delouvrier, Boulez, Mendès France, and Wiesel also agreed to participate in this sponsorship committee. Rohmer turned this connection with the development

authority to good account while preparing *Boyfriends and Girlfriends*, touring finished buildings and others still under construction with architects such as Michel Jaouën, who worked for the development authority's office of technical services, or the urban planner Michel Gaillard. He waited until Bofill's Saint-Christophe belvedere was completed in 1986 before actually making his film.

Rohmer explained how his personal knowledge of this space had aroused the desire to anchor a fiction in it.

> The first times I went to Cergy, at the time of my series *Ville nouvelle*, there was still only the prefecture, a shopping center, and the business school. The first residents were moving in and they were like pioneers. [They] had lots of ideas and met with each other in an intensive associative life. This modernity interested me because it suggested a character trait for fictional personages. The personages in *Boyfriends and Girlfriends* are anchored in life: this urban planning gives an architectural form to their hopes, to their ideals, and to their disappointments. Thus Cergy serves as a laboratory for experiments, a space that is utopian and concrete at the same time, where the fiction and the characters can develop without hindrance. Cergy seduced me. The new town is livable, lively, it functions as an urban agglomeration, with its squares, its streets, its spaces. At the same time, the Saint-Christophe quarter truly seemed to have come out of nowhere. My idea consisted in proposing a likable image of this new town, whereas others [Godard, Jean-Pierre Mocky, et al.] had especially stressed its oppressive character. [In my view] it formed an isolated, pacified space where the experience of love and friendship could develop, as in those seventeenth-century plays in which innocent young people meet within an original nature. That was the film, inspired by the places: the first times of a city and the first times of a fiction, and then the way in which they take shape.[52]

Rohmer imagined five characters' sentimental mix-ups, thus defining five lines of conduct. Blanche, Léa, Adrienne, Fabien, and Alexandre, young managers and students typical of the sociology of the new towns, take possession of Cergy's streets, squares, and buildings in accord with their professional or athletic identities and their ways of life. Blanche, who lives in Saint-Christophe, describes her space as a "palace" or "grand hotel," showing herself to be proud of it. Rohmer took advantage of the space to make his creatures live and multiply their trajectories, and thus their possible meetings: the rue des Galéries, the "obligatory"

site of leisure activities in Cergy, constantly provokes such meetings, which are sometimes inopportune, sometimes welcome—"It's a little like being in a village here," Fabien admits, "I've already run into the same person six or seven times." Even the personality of Blanche, between expectations and hesitations, aspirations and timidity, plays with the urban space, situating herself in this place marked by ambivalence and contrast. In this sterilized and superclean setting, these characters, who are in themselves dull and uninteresting, have a powerful sense of belonging. They feel they are participating in a space and a movement of history that bears them, indeed transports them, as Alexandre, who is grandiose in his arrogance, admits: "Here, I feel much better integrated into the immensity of Greater Paris than if I lived in some obscure corner of a Parisian arrondissement. My field of action covers the extent of the Parisian megalopolis."

The film was made entirely in Cergy, in seven weeks, from May 19 to July 5, 1986. Blanche's apartment had been chosen in a model apartment building that had just been finished in Bofill's belvedere, a three-room unit in the southwest wing, looking out on the Oise. As we have seen, Françoise Etchegaray took over the décor at the last moment and sometimes had to improvise, since no one knew the place well. She explains that Rohmer "saw Cergy as a convivial town, even if in the evening there were guys going around with dogs. [. . .] From the outset, I thought it was the pits. He found all that very harmonious, with a somewhat provincial center, these squares with cafés, plane trees, and apartment buildings around them."[53]

When the film came out (it was first shown at the Venice Film Festival in late August 1987 and then in theaters on August 26), the critics rightly emphasized Rohmer's use of Cergy as an urban and architectual framework for the mise en scène. "The characters' behavior is asserted with all the more force and clarity in a framework that suits it perfectly,"[54] wrote Michel Pérez in *Le Matin de Paris*. "The camera movements directed in relation to the décors, the space, the gestures, the perspectives, the urban trajectories, produce a kind of jubilation,"[55] Jacques Siclier added in *Le Monde*, while *Télé 7 Jours* enthused: "Filmed by Éric Rohmer, the new towns have something idyllic about them."[56] That was also the feeling of Jean-Dominque Bauby in *Paris Match*:

> Rohmer does not indulge in the oppressive and sempiternal indictment of our society with which most of his colleagues think it useful to burden their works. In the eyes of a Godard, a Ferreri, or a hundred other filmmakers, the new town

of Cergy would have appeared as the symbol of all kinds of oppression. Nothing of the kind here: already old-fashioned in matters of sentiment, this man of order seeks here to show us a world that works just fine. Not a blade of grass out of place! The real-estate developers should make use of his services: having seen his film, one dreams of going to live in Cergy-Pontoise, and windsurfing after work at the office![57]

It is no doubt a little more complex than that. But it is true that the town officials were very satisfied with *Boyfriends and Girlfriends*. A special showing of the film on September 3, 1987, at the Cergy prefecture provided a good demonstration of this, with the presence of the actors and actresses, the prefect, the director of the development authority, and the vice president of the new town's syndicate. Rohmer sent in his place a letter praising the qualities of the new town, to the point that an editorialist for *La Gazette de Cergy* gushed:

Here, through this film, the dreamed-of city to which everyone could have access. The Saint-Christophe belvedere becomes magical; the lakes at the leisure center take on a Mediterranean air; the pedestrian streets turn out to be welcoming. One might even think that the town's communal syndicate had commissioned this lively documentary . . . But it didn't![58]

Pierre Lefort, the head of the development authority, did not hesitate either: "Thank you again for your magnificent film," he wrote to Rohmer after the showing. "It is a marvelous thank you to all those who have built Cergy-Pontoise, and please believe that they all liked it and are extremely grateful to you for it!"[59]

If we dig a little, as indeed Rohmer himself said a few years later, "we discover what is hidden behind the appearances."[60] He went on:

In Cergy, probably as in any new town, there is a certain mediocrity in the construction of the buildings. You have the ground plan, the façades, the urban planning, and then the workmanship: painting and facing are not always up to snuff, the materials are artificial, and the trees are not big enough or full enough. Exactly the same goes for the characters: they are young women who are learning to become rivals, they have hardly any depth. Life in Cergy was organized around an obsession with being contemporary. Above all, one has to be optimistic, never see life otherwise. It amused me to show that in a fable in

which there was a touch of irony, without aggressiveness. And I'm not sure that when they came out the spectators all wanted to go live in Cergy.[61]

To be sure, Rohmer is prudent, and the two interpretations—dream city, nightmare city—can coexist. He did not want to film Cergy like the high-rise blocks in La Courneuve,[62] which he got to know after his friend Jean-Claude Brisseau, responding to his curiosity, took him to the 4000 in 1977.[63] But he inserted into the dialogues and situations ironic signs that indicate his intentions. "I'm talking to you as if I were trying to sell it to you!" Blanche recognizes while she is showing Léa her apartment and her building in the Belvedere (though Léa is hardly convinced), using advertising language like a Godard character. The deeply equivocal dimension of all Rohmer's cinema here takes on a resounding ambiguity: everything is falsely neutral, indirectly critical, taking on the colors of the likable and reassuring virtues of postmodernism—of which Ricardo Bofill is a kind of emblem—in order to distill from them a mute anguish that accompanies this chronicle of modern life. In 1975, in the film about the birth of Cergy, one of the architects cried: "What's terrible is that these are muted cities." The seductive attraction of Cergy-Pontoise in *Boyfriends and Girlfriends* expresses "in a muted way" the conformism of the beings of the new urbanity. The banality of this ideal of a city is no more than the possible horizon of a drab kind of happiness.

Reinette of the Country and Mirabelle of the Cities

In November 1984, a girl of seventeen repeatedly telephoned Losange asking to speak to Éric Rohmer. The latter ended up taking the call: "I'm preparing a film, excuse me," he said, annoyed, in order to get rid of her. "I'm not available for anyone." "Precisely, that's my name!" the voice at the other end of the line replied. Stunned by this cheek, the filmmaker made a fifteen-minute appointment with her for the following day. "I went to see him," says Joëlle Miquel, a young actress who had loved *Full Moon in Paris*, "and this quarter of an hour lasted an hour, then two, then three . . . , because I told him my stories and he listened to them. I talked to him about the blue hour without knowing that he wanted to make *The Green Ray*. He greatly liked the blue hour, that unique moment of absolute silence in the peace of the countryside just before dawn. Then I talked to him about the waiter in the cafè who didn't want to let me leave because I didn't have

change to pay for my coffee. He turned on his tape recorder, and four hours later he told me: 'I'm going to make a film with you.' "[64]

Rohmer was in fact struck by the verbal vivacity of this young woman, who inserted herself into his daily life for almost four months, telling him several dozen little stories and playlets. The artist in need of imagination seemed to have found a source of information at hand whose profusion surprised and amused him. "*Reinette and Mirabelle* was decided upon very quickly, because I had met Reinette and I thought she was extraordinary," Rohmer confirmed in an interview given to *Positif* in 1987.

One of the first things she said to me was "I organize my life in accord with principles."—"That's very good. What, for example?"—"When I have decided to do something, I do it. Once I'd decided not to talk, and I didn't talk." "That was the starting point for the last episode. The story of the café also happened to her. Then we arranged it. Many coffee drinkers may have experienced this kind of thing. For the third episode, we used another situation: she had told me that she'd met a female swindler. These stories coincided exactly with one of my preoccupations at that point. I wanted to make a film with a girl who has very strict principles, who is somewhat rigid, and then another who, on the contrary, doesn't bother with all that and who is more rebellious, more permissive, more libertarian."[65]

Joëlle Miquel did not appear completely out of nowhere. This sweet-faced brunette with a perpetually astonished look, all frowns and cheerful little smiles, was a young actress trained at the Cours Simon. She was discovered at the age of sixteen, in the role of Vivette in a production of *L'Arlésienne* at the Eldorado, by a woman journalist at *Le Monde*. She also painted, pictures of nudes inspired by the surrealism of Magritte, Dali, and Delvaux. She spent her wild youth in the countryside, near Lyons-la-Forêt in Normandy, before moving, along with her parents. to Gennevilliers on the northern outskirts of Paris. Her precocious personality included an ambition to succeed and the desire to play in several registers: as an actress, a painter, a writer. Although she fascinated Rohmer for a time, with her certainties, her manners, her way of not wanting to grow up, she also irritated some of the actors and actresses who had to work alongside her.

Rohmer did far more than just listen to her as he prepared the film. He wavered between two manners: the originality of *Reinette and Mirabelle* consists in combining them. The film was written in precise dialogues followed to the letter, in the vein of the classic *Comedies and Proverbs*, and the filming was

improvised on the basis of situations developed by the actors and actresses, a procedure that had just been successful beyond his dreams in *The Green Ray*. The latter had succeeded too well," he explained.

> It was too easy to film, too easy to edit. And then people liked it, whereas I thought they wouldn't. That's why I set out immediately afterward to make *The Adventures of Reinette and Mirabelle*. I wanted to see if I was on the right track by checking to be sure that these principles of lightness and improvisation could functdion for another kind of experience. In the improvisation scenes, there was the "Pivot style" and the "Polac style." The former consists in not interrupting the interlocutor, letting him talk and politely pursuing the conversation afterward. Polac means that they had to talk at the same time. In the latter, the naturalness is more complete, because the actresses completely forget the camera, as people do in a normal animated discussion.[66]

It was also a way of returning to the short form, since the film was conceived from the outset as a series of episodes, which brought the filmmaker back to the time of a few projects that had not been realized, such as *Fabien et Fabienne* and *Les Aventures de Zouzou*, or that had been only partially filmed (*Charlotte et Veronique*). With this last series, the common points are many: two girlfriends with different characters, a series of typical meetings and situations, the revelation of a social status and a state of mind, that of university students who have come to live in Paris. To this *Charlotte et Veronique* schema must be added the spice of a twofold supplementary confrontation: the rigorist versus the libertarian; the country mouse and the city mouse. This return to the short, amateur film is thus not to be interpreted, as some have done, as a parenthesis between two ambitious projects, as a minor form chosen by default. It is more a question of a wish claimed, a love of origins, a manner simultaneously modest and audacious of rethinking time, and the making of a film in the mode of narrative experimentation, of the fantasy of meeting, of the pure pleasure of "making films."[67]

The "adventures" Rohmer chose are four in number: in "L'Heure bleue" (The blue hour), Reinette and Mirabelle meet in the countryside after the latter has a flat tire on her bicycle, and it is expertly repaired by the former, who invites her to stay at her home. The first time, they miss the moment of natural silence just before dawn because of the untimely passage of a motorcycle, but this missed rendezvous allows them to stay together longer, until the following blue hour,

which they experience this time. Now friends, the two young women decide to live together in Mirabelle's apartment in Paris, because Reinette is going there to study art. The second episode, "Le Garçon de café" (The café waiter) shows them struggling with a sidewalk café tyrant who claims he has no change when they try to pay for their coffee. For Mirabelle, the thing to do is to slip out without paying; for Reinette, principle requires her to stay and demand the change for her 100-franc bill. In the third episode, "Le Mendiant, la Cleptomane et l'Arnaqueuse" (The beggar, the kleptomaniac, and the swindler), we find the two young women engaged in an ethical debate that opposes them to each other. Reinette gives to all beggars; Mirabelle only to those she likes. Furthermore, Mirabelle helps a woman who is stealing smoked salmon in a supermarket. Reinette is indignant: she thinks that the worst thing one can do for a thief is to help him or her. Mirabelle makes fun of this moralizing virtue. Reinette is caught in her own trap when she finds that she has been swindled, having been relieved of a small sum by a woman who walks around the Montparnasse train station moving the human race to pity by telling the story of her misfortunes. Reinette, when she realizes this, does not fail to tell the woman off. Finally, in the fourth episode, "La Vente du tableau" (The sale of the painting), Mirabelle accuses Reinette of talking too much. Reinette responds with a vow to remain silent for a whole day. Unfortunately, a gallery owner calls to buy one of Reinette's paintings, and she absolutely needs the money. Thus she has to sell a painting to an art dealer by going to his tallery, but not talking to him. Mirabelle's vehemence, when she comes to Reinette's aid, finally saves the day.

Even if we perceive a certain friction between the two young women in the course of the episodes that indicates that they are not prepared to continue their cohabitation or their friendship, Rohmer selected other possible episodes. Thus he was thinking of a story (entitled "Le Téléphone") about a dispute over an excessively long phone call made by a boor in a phone booth; and of another entitled "Mon joli bateau" (My pretty boat), probing a psychodrama about a key that Mirabelle thinks she has lost or had stolen by a boy (whereas in fact Reinette is the guilty one, but "for her [Mirabelle's] own good"). There was a third episode, "La Petite Cousine" (The little cousin) in which Reinette, while waiting for Mirabelle in a sidewalk café, sketches a stranger, Karine, who soon comes to see them and starts a discussion to determine to whom this sketch belongs: to the one who made it or the one who inspired it? All these stories, both those composing the episodes of *Reinette and Mirabelle* and those that remained on

paper, were typed, developed over several pages, dated March 1985, and signed "ER66."[68]

Although from the beginning of the project Rohmer had his "Grainette," soon renamed Reinette, he was looking for a Mirabelle. For a time he assigned the role to one of his favorite actresses, Anne-Laure Meury, who had grown up with him and played in *Perceval* and *The Aviator's Wife* before appearing again in *Boyfriends and Girlfriends*. However, after a few weeks of work, the actress gave up, not being able to get along with Joëlle Miquel, who watched a little too jealously over the strict orthodoxy of "her" stories.

A month before filming began, in May 1985, Rohmer found a replacement: a young student of nineteen who was studying oriental languages, and was planning a career as an ethnologist, but also had her eye on a career as an actress. Jessica Forde was as blonde, sculptural, and elegant as Joëlle Miquel was brunette and doll-like. Forde explained that

> through the intermediary of the photographer Carole Bellaïche, who had just taken a photo of Rohmer and had me pose for a series on beginning actors, he heard about me. He left a message on my answering machine: "Hello, this is Éric Rohmer, I'd like to meet you." I went to Films du Losange, he had me read a text, I think it was taken from one of the *Moral Tales*, and then he told me the next day that the role was for me, even though he'd tried to dissuade me from getting into cinema. But I insisted, so he took me. Before we met Rohmer, we were nothing: it was Joëlle Miquel's first film, and also mine, I was simply taking a theater course. The funniest thing was that the roles were reversed: I was the urban rebel, and I'd been brought up in the country, while Joëlle the country mouse had lived in a housing development near Paris.[69]

The filming of *Reinette and Mirabelle* was one of the most easygoing. The six weeks it took were spread over more than ten months, between June 1985 and March 1986, mainly on weekends and during vacations. Rohmer kept on almost the entire technical team from *The Green Ray*: Sophie Maintigneux as camera operator, a sound engineer (Pierre Camus for "The Blue Hour"; Pascal Ribier, who was making his debut with Rohmer, for the three other episodes), and Françoise Etchegaray as "supervisor" and more, since for the filming of "The Blue Hour" Françoise housed the team for two weeks in her country house near La Ferté-sous-Jouarre. "Rohmer slept on the floor," she recalled, "he'd given his pad

to the sound engineer. I had to heat up the camera with my hair dryer because it wouldn't start. Since we were filming at 4 A.M. to see the blue hour, I preferred not to go to bed. My daughter scrawled a picture of Sophie Maintigneux on the reports. Rohmer said: 'She has to amuse herself!' "[70]

The student's room was reconstituted on the floor above Films du Losange. The café and its terrace where the conflict takes place, and not far from which François-Marie Banier and Jean-Claude Brissau pass, were situated near the rue de la Gaîté, toward Montparnasse, as was the scene with the swindler, Françoise Etchegaray having obtained, for September 9, 1985, an authorization from the SNCF[71] to film in the Gare de Montparnasse the "scene with the student who interviews passersby on the theme of generosity."[72] The Prisunic, where the theft of the salmon occurs, is near another train sation in the very bustling Saint-Lazare quarter. Finally, when winter came, the little team holed up in the Caroline Corre gallery at 14, rue Guénégaud, to film with Fabrice Luchini the episode of the sale of the painting. Françoise Etchegaray recounts that Luchini "imitated Rohmer very well, and one day, Rohmer, who had heard, appeared: 'Go on Fabrice, since that amuses Françoise!' "[73]

The filming in Paris took place almost unnoticed. "It was unauthorized," Jessica Forde recalls, "in the street, in the train station, always furtive."[74] "During the filming of "The Café Waiter," Rohmer said with delight, "we were so inconspicuous that the only people who glanced in our direction thought there was an altercation between the waiter and two customers. Moreover, the poor guy was hassled by other customers who wanted to be served."[75] This waiter, played with panache, stubbornness, and a grandiose pettiness by the actor Philippe Laudenbach, went off to Vienna recover from his upset, writing this little message to his *metteur en scène*: "I'd like to express my gratitude and my friendship. But waiters in Viennese cafés, like their pastries, are exquisite."[76]

Rohmer was rather satisfied with the experiment: "*The Green Ray* and *Reinette and Mirabelle* are two amateur films," he declared. "One is a vacation film, the other a weekend film. They are films that left me intact psycholgically. I rested in them."[77] However, the longer the filming went on, the more the tension rose. Jessica Forde offered an explanation:

> I didn't get along at all with Joëlle Miquel. What interested Rohmer in her was her silly goose side . . . Her naïveté, her way of dressing like a doll, the little girl, slightly stupid, even moralizing side . . . All that amused him but also annoyed

him. Besides, he sometimes got angry and shut himself up in his office, the filming stopped, and didn't start again until the next day or a week afterward. Only she could put him in that state. It was extremely rare that he had conflicts with the actors. He came to see me and murmured: "Jessica, we have to finish this film!" For him, despite its improvised aspect, this film was important, it was the first produced by his own company, the Éric Rohmer Company, independent of Films du Losange.[78]

The "model little girl" aspect, so typical of the Countess of Ségur, is surely what attracted Rohmer in Joëlle Miquel, but it is also what bothered him the more she quarreled with his close collaborators. Thus the idea of continuing the series of the adventures of Reinette and Mirabelle was rather rapidly abandoned.

An ardent advocate of the short film, Rohmer decided to entrust the preview of *Four Adventures of Reinette and Mirabelle*, on Februry 2, 1987, to the International Short Film Festival in Clermont-Ferrand,[79] a major cinematic event in France. Two days later, the film was released in theaters and met with unexpected success, attracting almost 200,000 spectators,[80] which represented a fabulous return on investment for a work whose total cost ran to only 350,000 francs.[81]

However, the critics were rather condescending toward *Reinette and Mirabelle*, embroidering on the themes of "the city mouse and the country mouse,"[82] the "fantasies of the older man,"[83] "the pleasure of repetition,"[84] "girls in bloom,"[85] "the virtue of freshness,"[86] and "the little illustrated Rohmer."[87] We may recall especially, in addition to another cover on *Cahiers du cinéma*[88] and the associated article by Alain Philippon, Serge Daney's article in *Libération*:

This man, who makes us feel that he films only in order to see the turmoil he arouses in his young actresses, produces films so simple in appearance that it is the spectator's turn to be troubled. Because these films are monsters of twisted calculation beneath little irritating things, silly or delicious. Thus the *Four Adventures of Reinette and Mirabelle* is both a new chapter in Rohmer's work and four modest, anonymous episodes made for an ideal television. We may meet Reinette and Mirabelle the way we accidentally come upon an unexpected serial while channel surfing, and they can be solemnly classified in the already voluminous file of Rohmerian heroines. What finer success for an author with aristocratic ideas than to be doubly credible: first in the cinema and again on television, first at the (cinephilic) summit and again at the (telephagic) base?[89]

Lazare Garcin's Report

Rohmer returned to this ultralight way of filming a few years later, while at the same time reasserting his predilection for filming Paris. He undertook a kind of remake of *Paris Seen by* . . . But what might have been no more than an exercise in nostalgia turned out to be a source of real pleasure: between more limiting stories, he took the liberty of filming outside the frame, outside the limits, outside rules and series. *Rendezvous in Paris* is an assemblage of three Parisian sketches having only a geographic and ambulatory connection. Each short film arose from a meeting, a desire to make a variation on a Rohmerian theme, free from any contingency.[90] The first two, "The Seven O'Clock Rendezvous" and "The Benches of Paris," were determined solely by Rohmer's spending time with a young woman and the discussions, stories, and projects that flowed from it. The third, "Mother and Child 1907," is a variation, characterized by pure narrative and pictorial virtuosity, on a story close to those of the old *Moral Tales*.

Rohmer first met Florence Rauscher, renamed Aurore for the film, in the autumn of 1989, almost five years before "The Benches of Paris" was made. "At that time, I was preparing for the École normale supérieure entrance exam at the Lakanal lycée in Sceaux," she says.

> One of my friends, an actor, knew Françoise Etchegaray. It was through her that I met Éric. He liked to meet young women. That was all that happened between us: a meeting. He also met my brother whom he filmed. I went to see Françoise and Éric at Losange. He came in person to get me at Lakanal, it interested him to see how a woman preparing for the ENS entrance exam lived. We had conversations. About all kinds of things, about cinema, about work, about my readings. I was twenty years old, he liked that. There was a big generational gap, but it worked very well. He talked to me about things he'd done at my age or about very current things, sometimes even frivolous ones. I entered his circle, over tea. We also went out together to walk around the site of the future film, or when he was preparing other projects. We walked in parks, in cemeteries. A year after we met, he began thinking about *Rendezvous in Paris*, and we talked about a possible story. He was inspired by my personality to put together the character of the young woman in "The Benches of Paris."[91]

This character has a series of amorous rendezvous in Paris with the same man, a teacher in the provinces who has a pied-à-terre in the suburbs. They meet each time in a different park, which is a way of constantly postponing the adventure's conclusion, out of panic fear of spending their first night together in a hotel. In autumn 1993, the filmmaker began looking for the actor who would play the male lead: a young literature teacher like himself when he was at the lycée in Vierzon, in the early 1950s.[92]

He chose Serge Renko, an actor who was trained for the theater, but who later acted in films for Jean-Pierre Mocky in *Le Pactole* and Anne-Marie Miéville in *Lou n'a pas dit non*. He reports:

> I was very close to one of Rohmer's actresses, Charlotte Véry. She told me that I was the "type to be one of Rohmer's actors." She advised me to write to him, which I did the next day, and she talked to him about me. In his office there were two drawers where he kept letters, photos, and CVs he'd received, a "girls" drawer on the right, and a "boys" drawer on the left. Thanks to Charlotte Véry, I was on top of the left-hand pile: he had picked me out along with two others. He showed the three photos to Aurore Rauscher and asked her with which one she would feel best . . . Aurore pointed to me, and Rohmer called me. When I went to see him, he explained the project and told me that I would be paid at the minimum union rate.[93]

Renko remembers the way Rohmer worked in this preparatory phase. First in his office at Losange:

> He'd written a sketch for Aurore Rauscher and saw her on Tuesday afternoons. They talked of this and that, sometimes about rather superficial things: the latest trend in handbags, currently fashionable diets, the arrival of flowered dresses, horoscopes, girl talk . . . He was clearly more at ease with young women. He established an incredible immediacy in dialogue with them! As for myself, he gave me the text of two scenes in the film. I saw him again a week later and recited the sequences in front of him. This went on for several weeks. Then Aurore came in: we rehearsed with Rohmer in his office. Now we're in the Luxembourg gardens; now, on the Belleville heights; now, in the greenhouses at Auteuil; now, it's the Ourcq canal. He took two chairs, we got on them and talked to each other over the canal . . . After two months, I asked if he could give

me an answer about the role . . . He looked at me, stunned: "But I was satisfied after the first tests. Didn't I tell you?" He'd just forgotten to tell me that he was hiring me.[94]

That was when the phase of advanced preparation began, on site.

The idea for the first sketch, "The Seven O'clock Rendezvous," came to Rohmer in the autumn of 1992, when he met Clara Bellar, the young actress who inspired it. She was then making her theater debut in Marivaux's *Le Jeu de l'amour et du hasard* and wrote to the filmmaker to tell him how much she admired his work, enclosing two tickets for a performance. She was in the right-hand—girls—drawer, along with dozens of others. But she persisted: "Monsieur Rohmer," she wrote on October 29, 1992,

> this must be the seventh time I've sent you a letter, and you've never replied. I've tried everything! From the stupid, awkward first letter to the one with a detached tone; I've also gone to great lengths to be funny, but nothing works. However, you must be pleased to be told over and over that you are loved, that somone has a mad desire to work with you. Could it be that you're blasé? That's not possible! Not you, anyway . . . I turned twenty yesterday and I very humbly ask you for a present: give me a little chance! I am enthusiastic about the idea of doing something with you, to the point that I'd be as delighted to be a fifth assistant, the last property woman, even the boom operator, so as to have the leading role or to be a coscriptwriter . . . In any case, I believe in my star and I know that I will work with you someday. So, as long as that's how it is, if it could be sooner, that would be even better, with respect and impatience, Clara.[95]

Rohmer, touched by this persistence, contacted Clara Bellar and received her. She was as ravishing as she was piquant; they began to talk, notably about music, a passion they shared. He also engaged for his film the young woman's best friend, Judith Chancel, "the two inseparables," as they called themselves in another letter. "We complement one another, the blonde dances, the brunette sings."[96] Clara the brunette was to play Esther, the main character, jealous and uneasy; Judith was Aricie, Esther's rival. Three boys were added, as often happened, at the end of the process: Antoine Basler, Mathias Mégard, and Malcolm Conrath.

The tea ceremony at Losange, held this time every Monday, sometimes took place at the home of the young woman; Rohmer wanted to see how she lived

and to situate her in her two-room apartment on rue Saint-Séverin. Once again, a great closeness grew up between the old man and the rank beginner, as this other letter shows:

> I'm very sad because I miss you! So that you won't forget me, I'm sending you a lot of photos, portaits so you can tell me if you like them and "family photos" because that interests you. I want to work on my piano all day for you. Besides, the best gift you could possibly make me would be to give me a role as a pianist! I would be forced to work 20 hours a day on Mozart, Schumann, Liszt, and the remaining four hours we could use to compose new music . . . or to sleep! With these cheering thoughts I embrace you tenderly, and hope to see you very, very soon.[97]

This kind of platonic love letter was soon transformed into a Rohmerian story, namely a short, fifteen-page script: "One day," she said, "he gave me a scenario. He'd combined two of the stories I'd told him to make just one. We looked for the settings together, and my clothes. Then he listened to me about the choice of boys for the film. He showed me photos and I was able to take the ones that seemed to me best for the roles."[98]

Thus at this point, in 1993, while the film was being sketched out, there was the Monday girl, Clara Bellar, and the Tuesday girl, Aurore Rauscher. The Wednesday girl did not come in until the beginning of 1994. Her name was Bénédicte Loyen, and she was beginning a career in cinema with Tony Gatlif, Andrzej Zulawski, Mocky, and Godard (*The Kids Play Russian*). The story that she was to play in the third sketch, "Mother and Child 1907," is probably the most significant. A painter, hard at work in his studio, pauses to receive a young Swedish girl and show her around Paris. She is not fond of painting, but since she is not ugly, he takes her to the Picasso museum. Shortly afterward, he leaves her there on the pretext of finishing his painting. As he is going home, he sees a young woman in the street who pleases him enormously, and he follows her. Since she is going to the Picasso museum, he goes back there and ends up approaching the young stranger. She is in Paris for just one day and has just gotten married. But she agrees to come up to his studio to have a chaste look at his paintings. Finding, thanks to her inspiration, the final touch for his painting, he has not completely wasted his day.

The actress who played this mysterious young woman, Bénédicte Loyen, who came to Paris from Liège, recalls this adventure: "I met Éric Rohmer through a

girlfriend. I sent him a poem with a photo. He called me quite quickly; I thought it was a friend's practical joke, but it wasn't! I went to see him. We talked, he had me read a text he'd written. He told me he was preparing something, but no more."[99] Once again, it was on the basis of a meeting that the fabric of the film began to be woven. Bénédicte Loyen goes on:

> He'd worked on his scenario for a few weeks to adapt it to my physical appearance, my manner, to what I'd told him. The second time, I met my partner in the film, Michaël Kraft.[100] Afterward, Rohmer and I saw each other: he asked me questions about my life, it was a curiosity that was not at all out of place, a form of complicity. He didn't make direct use of what I told him, but he modeled the character on my personality. Then we did readings of the text, with Michaël Kraft, and then a lot of rehearsals of the different scenes before the filming began. Working on the movements, which were very precise. With him, it was precise and gentle.[101]

To create his painter, Rohmer took his inspiration from Pierre de Chevilly, a figurative artist and Bernadette Lafont's companion: his pictures of people walking, his bluish backgrounds, his paintings of the sea, city, or countryside, pleased Rohmer, and he could film in [Chevilly's] studio in the passage Saint-Sébastien.

As in the case of *Reinette and Mirabelle*, the filming was as simple as it was rapid, and spread over several months, from spring to autumn 1994. The challenge consisted in filming unnoticed in the middle of Paris, in the streets, on the squares, in the parks, sometimes in the middle of a market or a museum, and this enormously amused Rohmer. Two actors, sometimes three or four, were present, along with Diane Baratier as camera operator, Pascal Ribier as sound engineer, François Etchegaray as supervisor, and Rohmer himself, for a team of six persons, or at most eight. The 16 mm camera was light and could be put on a tripod, carried on the shoulder, or moved around using a wheelchair in place of a camera trolley. As for the actors, they were equipped with high-frequency microphones. The few necessary authorizations were requested from city hall, but in the name of a director from Quebec, Lazare Garcin and his small company, La Canadienne européenne de reportages (CER, like "Compagnie Éric Rohmer"), for a "documentary on the benches of Paris." This schoolboy, clandestine humor was one of Rohmer's great pleasures. "For *Rendezvous in Paris*," Françoise Etchegaray recalled, "people saw a guy pushing a wheelchair with a

woman sitting in it holding a camera—some of them thought it was a father with his paraplegic daughter. If anyone asked us something, we said: "You can see that it's just an amateur film!"[102]

Rendezvous in Paris came out in a few theaters on March 22, 1995, and was acclaimed by some critics—Jean-Michel Frodon in *Le Monde* and Thierry Jousse in *Cahiers du cinéma*— as a small masterpiece. However, in general the press seemed a little condescending toward what it considered "amusement films"[103] or "little works without surprises."[104] In *Les Inrockuptibles*, one could even read that "Rohmerian intelligence sometimes suffocates these films."[105] But Jacques Rivette openly expressed his admiration for this supreme form of freedom and elegance:

> I prefer Rohmer's films in which he goes farthest toward minimalism, then they reach the highpoint of mise en scène. The one I would put above all others is *Rendezvous in Paris*. The second episode is even more beautiful than the first, and I consider the third a summit of French cinema. For me, it is the film of absolute grace.[106]

In France, *Rendezvous in Paris* drew only 80,000 spectators, which was amply sufficient to cover the minimal cost but nonetheless did not make it a success. On the contrary, the film had an astonishing run abroad, as if it were the emblem of a typically New Wave Parisian romanticism. It brought in six times as much money in the United States, Japan, and Germany as it did in France, and it attracted an attention from the press that was as abundant as it was dithyrambic.

The Commitment to Environmentalism

On August 26, 1987, when *Boyfriends and Girlfriends* came out, one of the rare polemics over a film of Rohmer's erupted. It was all the more rare (and interesting) because it was overtly political.[107] Louis Skorecki, in *Libération*, entitled his article "Rohmer in the country of *merguez*,"* introducing an angle of attack that he sometimes returned to in his articles a decade later:[108] in Rohmer's work we have a white man's universe purified of any mixture, from which other races and

* Merguez is a sausage typical of North Africa.

the lower classes are absent—unless they are admitted as colorful extras who come from a foreign world. "Éric Rohmer doesn't spend much time with the common people in his films," Skorecki writes.

> One day (he was almost forty years old), he sketched the itinerary of an artist who becomes a homeless bum. It was called *The Sign of Leo* and was his first feature film. This was the only time that, under cover of a fantasized and paranoid autobiography, he came close to the street, to what is sticky and clings to the skin. Thirty years later, at 67, he encountered the people again, even the rabble, one might say. It is summer. Blanche and Fabien are coming out of the water. They walk together, stepping over bodies by the dozens. These groups of proletarians and their families, when one is emerging from one of those series of impeccable images of which Rohmer is so fond seem . . . well, they seem out of place. Messy. Not quite clean. Blanche and Fabian end up eating, without any fuss, the French equivalent of a *merguez-frites*. It doesn't last long: Fabien takes Blanche off into a more civilized undergrowth and there courts her in a very proper way. Before feeling up her breasts, he even asks, in his most candid voice, touching them with the tips of his fingers: "May I?" She immediately replies: "I adore you . . . ," and they roll on the grass. A few moments before, Fabien had explained to us, at the same time as to Blanche, why there were so many proletarians and immigrants there: "They're not people from around here [Cergy], they come from the ugly suburbs." In fact, Arabs had invaded part of the setting of Éric Rohmer's new film. His filmmaker's honesty forced him to show them. But he also should have explained why he didn't make them part of the story. A story is what remains when everything else has been removed: the furniture, the characters, everything. And in this story there is no place for Arabs, or for *merguez*, or for the people.[109]

The sequence Skorecki calls into question was not improvised but written down several months before filming began, being present in black and white in all the versions of the scenario of *Boyfriends and Girlfriends*. Here is one of the first versions:

> Blanche and Fabien leave the roped-off swimming area. In the park, there is a crowd. Groups of Africans or Asians are feasting around fires, to the sound of music from their countries. As they walk along

the ponds, Fabien and Blanche exchange thoughts on what they are seeing.

Blanche: It's strange. New towns are made to do away with social classes and, you see, they reconstitute themselves. The top of the scale is windsurfing. Swimming is less good, but it's still for the privileged people who can afford to pay the entry fee.

Fabien: Ten francs isn't much.

Blanche: It is for families of ten persons.

Fabien: Maybe it's also because swimming and sun are Europeans' obsessions. The farther one goes in this park, the more proletarian it becomes.

Blanche: That doesn't bother me. On the contrary, it interests me.

Fabien: You don't have anything against greasy papers?

Blanche: There aren't that many of them.

Fabien: What about the odor of fried food?

Blanche: I can't say that I love it, but you have to make the best of things.

Fabian: It drives Léa crazy. I brought her here one Sunday. She swore she'd never come back.

Blanche: It's as if I were traveling in a foreign country where I accept things, odors in particular, that would disgust me elsewhere. Here, I feel instead that I'm taking a trip through time. I think I've been taken back to the beginning of the century, when the workers went to picnic on the grass on the banks of the Seine or the Marne. I thought that no longer existed.

Fabien: These aren't people from Cergy. They must come, most of them, from the ugly suburbs, where they live during the week piled all over one another in dilapidated low-cost housing blocks. So for them, this is the palace at Versailles.[110]

We recognize here an old theme of Rohmer's that is present in his critical work: the Westernness of classical beauty, that of the arts (the cinema, music, architecture) and of civilization, does not tolerate mixtures. In Rohmer's cinema, it is in general present in a latent state: in his whole work, no character is black, Eurasian, or North African, and neither does he introduce marks of "foreign" cultures or artistic references that are not to Western works. Similarly, the allusions to the common people and popular culture are rare—even if some of his characters are of middle-class or peasant origins, like the baker girl in the first "moral tale"; Rosette, the candy-seller in *Pauline at the Beach*; Marie Rivière,

the secretary in *The Green Ray*; the hairdresser in *A Winter's Tale*; the manager of the campground in *Claire's Knee*; or the peasants in *Reinette and Mirabelle* or *The Tree, the Mayor and the Médiathèque*. Rohmer's ideal system is aristocratic and white, far distant from any proletarian or globalized culture, and escapes what he calls "the sin of vulgarity," which he describes in a text written in 1957 as one "of those that cannot be pardoned."[111] Rohmer acknowledged that this "aristocratic conception of art" was his own.[112] *Boyfriends and Girlfriends* is in this sense an exception: in it, the implicit is transformed into a condescending quotation and the absent Other irrupts on the screen, but as a stain, a problem, these people who have come from the "ugly suburbs, where they live during the week piled all over one another in dilapidated low-cost housing blocks," these "odors of fried food," these "greasy papers," these "foreign countries," these "workers," these "groups of Africans or Asians [who] feast around fires, to the sound of music from their countries." As if Rohmer, out of honesty, had been determined to preserve objectivity with respect to them. In Cergy, on Sundays, foreign, poor families are present in large numbers near the lake of Neuville; that is a fact that the scenario has foreseen and that the camera records. Rohmer notes it and does not take a position toward it, even if his characters argue over it. Fabien is rather critical, expressing the position of the "little white"; Blanche admits that she is interested, curious, and tolerant, illustrating in her own way the ethnologist's perspective. Two different ways of looking at the elsewhere, the people, foreign or not.

The aristocratic, white ideal cherished by Rohmer has traditionally encountered two types of opposition: that of antibourgeois, anticolonialist critics and that of certain militant feminists. Among the former, generally associated with the far-left press, the most biting text was written by Alain Auger, who was close to Alain Badiou and wrote in his review *L'Imparnassien* in May 1983:

> Rohmer's France is contemporary but profoundly provincial, traditionalist, that of the middle class, of the well-brought-up adolescent, of the provincial dignitary. The route covered corresponds to this unbelievably narrow vision: the Paris of the seventeenth arrondissement or the old-fashioned baroque of the Buttes-Chaumont, Annecy for *Claire's Knee*, Saint-Tropez for *La Collectionneuse*, Clermont-Ferrand for *My Night at Maud's*. The provinces of old tradition, or the legacy of stabilized references in holiday resorts, long polished by the presence of generations of bourgeois. Especially not the modern, mixed

suburbs where all the crises are refracted. Rohmer flushes out the possible modernity of all kinds of archaism. Does that still leave room for a Rohmer who is an investigator of social mores? It is difficult to find the little point heterogeneous with the whole that would tell the truth about it; maybe it's a long-haired postman who rises up from behind a thicket, delivers his telegram, and leaves as he came, or the candy-seller whose overrepresented vulgarity reveals the true vulgarity of the others. Similarly, there is probably a condemnation regarding the basic vacuity of the bourgeoisie which Rohmer's cinema makes into a system, but without the appearance of a credible force that could destroy it, except perhaps in the form of a hint. Rohmer reflects a mirror image of the contemporary bourgeoisie as an empty but reassuring world without crisis that seems to say: "It's true that we're useless, but we really like each other!" In part, that is the contemporary horror, because it is clear that this cinema feeds a nostalgic nationalism based on its parade of exclusions.[113]

Besides, Rohmer is hardly a feminist, and his portraits of girls subjected to the traditonal rituals of seduction have exasperated certain militant supporters of the cause of women. The "Rohmerian" girl is not involved in the feminist battle, with the paradoxical exception of *A Good Marriage*. And the man is rather conservative on this point, implicitly regretting the evolution of women's role: "It used to be," he says in a conversation preparatory to *Boyfriends and Girlfriends*, "that the woman kept the house, she had control over the money. The man couldn't do anything without her permission, and he was financially dependent on her. Moreover, there were women who held salons and had a genuine ascendancy. I think that with the feminists, women have lost more than they have gained."[114] Several feminists attacked Rohmer's "misogyny." "God, women are talkative, tiresome, and incomprehensible, if we limit ourselves to the speeches that the *metteur en scène* gives most of his female characters. This way of seeing women makes us want to clear out as soon as possible."[115] That is a reflex characteristic of these attacks on Rohmer, as much as it is of the commonplaces regarding the mentor of Arielle Dombasle, Béatrice Romand, and Pascale Ogier.

Rohmer always remained more or less impervious to these screeds directed against him. In his view, they missed the only target about which he might be sensitive, that of the mise en scène. Hearing it said that he made reactionary films hardly bothered Rohmer at all. He would have found it far less tolerable

to be accused of making bad films. He was answerable only on the terrain of cinema. All the rest remained very distant.[116]

Few causes disturbed this piquant reserve. No petition, any more than appeals in favor of this or that political candidate. To be sure, he preserved long-term loyalties, notably to a monarchist tradition, right-wing legitimist or Catholic, and even to French Algeria, which linked him to old friends like Jean Parvulesco, and later Philippe d'Hugues and Michel Marmin. Parvulesco, a former OAS official who had become an eccentric writer and an author of esoteric prose, represented right to the end his "henchman," indispensable to the point that Rohmer supported him for a good part of his life, lending him, for example, an apartment in Cergy-Pontoise, paying him for brief appearances in a few films (*Love in the Afternoon, The Tree, the Mayor and the Médiathèque*), or for certain rereadings of scenarios and dialogues. "We saw each other several times a week for forty years," Parvulesco explained.

> I was on salary at Losange as "councilor to the prince," which drove Barbet Schroeder and Margaret Menegoz crazy; they didn't understand either my place or my role with regard to Rohmer. It was an intellectual companionship, a paradoxical friendship. If he had broken with most of his royalist friends, he always remained loyal to me. Our deep relationship arose from Catholicism: I am an agnostic Catholic, Rohmer is a conventional Catholic, a mystic in the Pascalian tradition. He long had a heartrending nostalgia for the monarchy that I would describe as "superior Maurrasism."* But he hid all that. This worldview anchored in the society of the Old Regime came out only in *The Lady and the Duke*. It was very surprising: he hung on as a royalist all his life wihtout every saying it overtly, without trying to make it a value of his cinema. I had become the only person he could talk to about that. Because otherwise he considered his positions to be dangerous for the cinema he wanted to make. He was man torn between a profoundly conservative personality and a work of an absolute neutrality. Pierre Boutang reproached him for his "cowardice" on this point; I admired this double life that made him suffer. I think that's why he remained loyal to me for such a long time.[117]

* Charles Maurras (1868–1952) was the leader of *Action Française*, a monarchist, counterrevolutionary movement.

In this portrait of Rohmer as an ashamed Catholic royalist, Jean Parvulesco ignores (no doubt intentionally) the filmmaker's sole genuine political commitment, which led him to support environmentalism from the 1970s to the 1990s. "He was very involved in environmentalism,"[118] René Schérer explained, emphasizing that the only vote his elder brother ever told him he cast was for René Dumont, the first environmentalist candidate in the presidential election of 1974. "He was not right-wing," Schérer added, "and not left-wing, either . . . He couldn't stand infeudation. In my opinion, he was first of all a ferociously independent anarchist."[119]

In a certain French tradition, legitimist royalism and environmentalism are not contradictory. Concern about the environment is one of the aristocracy's oldest commitments: the lord taking care of his forest and his domain, the physiocratic master seeing to it that rural land is used in a way that is modern and rational but respects nature, the gentleman farmer who listens to his peasants. All that, in the image of the king who protects part of the royal domain inalienable from the crown (royal forests, royal hunting grounds), which under the Republic often became national parks and protected zones. Founded in 1901 by the poet Jean Lahor, the *Revue de la Société pour la protection des paysages et de l'esthétique de la France* illustrates rather well this traditonal tendency of environmentalism, whose most prominent representatives were the poet Sully Prudhomme, Count Cornudet, and the Chevalier de Maupeou, senator from Vendéé. This aristocratic vein in enviromentalism, defending an "aesthetic of France" that was deeply conservative regarding natural balances and an environment to be preserved, was that of Éric Rohmer who, in his own way, had always been an environmentalist, even before the political organization of the movement in the course of the 1970s.

He never joined any political party. But he took part in a number of battles and demands alongside the environmentalists. In each case, these were concrete commitments, the defense of causes that were able to touch him personally, and whose whys and wherefores he could gauge. Put back into perspective, this outlines a coherent action in defense of the environment. Rohmer's first act in this sense was to join, in January 1974, the association *Les droits du piéton* (the pedestrian's rights), whose motto was Sidewalks for Pedestrians![120] The association had existed since 1969, when automobile traffic was at its height in city centers. It took up the defense of that being unknown to the law, the urban walker. This coming to consciousness bore fruit, since as early as 1969, an initial step was

taken by the public authorities; it was symbolic but had very real effects: the generalization of the speed limit in cities to 60 kilometers an hour.

Rohmer also got involved against smokers, writing in May 1980 this missive to the president of the Comité national contre le tabagisme to support its activities:

> With regard to smokers, I do not feel I have a nurse's vocation, I am content to ignore them, to avoid them. My interest bears more on the innocent victims of someone else's vice, the healthy people, the "nonsmokers." They are the ones I blame for not having a sufficiently acute awareness of their rights, first of all the right to health, which is guaranteed, if I am not mistaken, by our constitution. Out of cowardice, timidity, or ignorance, they cannot see in the act of smoking in their presence an act of genuine aggression, as dangerous, and even more, than a shove, a blow struck with the fist, or an insult. Against aggression by smoking, the law provides weapons, and a strike is one of these. A strike against a teacher who smokes, for instance, seems to me both useful and necessary today. Please pardon the vehemence of my tone, but I do not want to miss any opportunity to assert that the act of smoking without permission in the presence of someone else is an act not only impolite but inadmissably violent. This insidious violence involving cars and their chemical pollution, the noise of excessively loud music, for example, in the RER, all that has to be fought.[121]

No one ever smokes in Rohmer's films or during their filming—except in secret, like Serge Renko and Françoise Etchegaray during the making of *Rendezvous in Paris*.

In December 1994, Dominique Voynet, who was the environmentalists' candidate in the presidential election to be held the following spring and who knew that Rohmer occasionally got involved, tried to get him to back her campaign. For example, she invited him to be one of her supporters on a widely viewed television program, *L'Heure de la vérité*, planned for January 15, 1995. "As you may know," she wrote to him,

> this program allows the speaker to invite a certain number prominent figures. I would be very happy for you to be present on the occasion of this event. This program will make it possible to elicit a debate about the values and principles that we share. Your presence on the stage will demonstrate your interest

in environmentalism and your attachment to the pluralism necessary for any democracy. Whatever you decide, dear Éric Rohmer, please know that I feel a sincere admiration for your artistic activity, cordially[122]

Rohmer did not accept the invitation, rejecting the partisan implication as much as he did the request to appear on television, but he in no way denied the "values and principles that we share."[123]

The only candidate for a presidential election that Rohmer ever met and whom he supported more actively by subscription, did not, however, see his effort succeed, because he had to withdraw, not being able to collect the required five hundred signatures of elected officials. The candidate was Pierre Rabhi, a candidate in the 2002 election who had an environmental sensitivity "for an insurrection of consciousnesses," whose main slogan was "Growth is not a solution, it is a problem," and who sought to "achieve liberation from consumer society," to "respect life in all its forms," and to "come back down to Earth,"[124] while at the same time advocating a battle against the depopulation of the countryside. All themes to which the creator of *The Tree, the Mayor and the Médiathèque* was not indifferent.

A Film Under the Influence of High Politics

At the beginning of *The Tree, the Mayor and the Médiathèque*, there is an intertitle that reads: "This history is imaginary. Any resemblance between the characters and this or that figure in the press or in politics can only be accidental. An accident that our story, like so many others, has chosen as its leading thread." Rohmer then lets his film sail on at the whim of seven successive accidents. However, in the whole of his career, there is probably no film less dangerous than this one. The idea of making a political film had been carefully considered. The three subjects that intersect in it—the relations between the city and the country, the protection of the environment, and the criticism of the pretensions of cultural policy—are abundantly documented.[125] The preparation for the work was meticulous. In the press kit, Rohmer offered a further clarification:

This "political" film is not a film with a message. It does not endorse any particular ideology. It praises neither the socialists, nor the environmentalists, nor

the technocrats. Neither does it criticize them. It does not make fun of Parisian-
ism, of parochialism, of wheeling and dealing, or political mores in general. The
electoral campaign and the problems of the development of the territory offer
here a simple background for an ironic reflection of the role of chance in his-
tory, starting from a village mayor's ambition.[126]

This series of negations is high comedy. The filmmaker, obviously is not fooled
by it: *The Tree, the Mayor and the Médiathèque* is a marvelous satirical tract, with
a mordant irony that bites fairly. It is directed precisely against the socialists, the
technocrats, the environmentalists, Parisianism, parochialism, wheeler-dealers,
political mores, the electoral campaign, the development of the territory, and
a mayor's ambitions. Beneath its outward appearance as an amateur film and
its acknowledged lightness of tone, this is perhaps one of Rohmer's most ambi-
tious films, the only one in which his involvement in his time is expressed. In
two years, 1991 and 1992, Rohmer accumulated a considerable documentation
around his project.

He was passionately interested in a phenomenon that was transforming rural
space: less and less farmland, but more and more "rural residents," that is, rural
residents of a new kind. The rural exodus was followed by an "urban exodus," the
dissemination of the urban into the countryside that was diagnosed in a book
that became a classic, *La Rurbanisation ou la Ville éparpillée* (Re-urbanization,
or the scattered city), by Gérard Bauer and Jean-Michel Roux, published in 1976.
This transformation of the countryside is at the heart of the problems and the
speeches in the film, notably the speech made by the mayor of the village, who
is himself a neo-rural resident who wanted to flee Paris and settled in the coun-
try of his ancestors. Rohmer had been interested in this subject for some time.
We find its first trace in July 1973, in a letter from Aline Baillou, the minister of
agriculture, asking Rohmer to make a documentary on the "regeneration of the
forest": "You could show how, as a result of the new rural population that is par-
ticularly interested in this reforestation, a life is currently being recreated on the
basis of lands where nothing would grow anymore."[127]

Apart from reading the press, three sources of inspiration seem to be the
most direct. The annotation of *L'Actualité économique*, a monthly periodical
published by the Crédit Agricole bank of Corrèze, which Rohmer saved during
this whole period, and in which sentences and arguments that appear in the film
can be found:

The underdevelopment of the French countryside is not inevitable. On the contrary, rural France harbors a enormous potential wealth that has only to be exploited, provided that the series of actors concerned, from the state to the local collectivities, by way of the region and the department, play actively and in a concerted way their role as developers of the territory. The rural world can boast about its advantages: proximity to raw materials, the quality and availability of the space, quality of life.[128]

This language used by the local administration is the very stuff of Rohmer's irony. In the same way, the report that Ségolène Royal, soon to be the young minister of the environment, published with Robert Laffont in 1990, *Pays, Paysans, Paysages* (Country, farmers, landscapes), with "Ten Proposals for Rural Renewal," is found, in certain fragments, literally transposed into the mayor's socialist and rural-environmentalist discourse. Finally, Pierre Gevaert's book published in early 1992 (*L'Avenir sera rural*; The future will be rural) is not very far from other passages in the film that reflect its spirit from a caustic point of view.

Cultural policy in general, and socialist cultural policy in particular, which dreamed of a network of médiathèques set up far and wide, was also at the center of the filmmaker's critical attention. In it he saw an excessive "Langian"[129] voluntarism typical of cultural democratization.

Rohmer took his inspiration from the construction of recent médiathèques, notably in western France, and from certain excesses that accompanied this all-out diffusion of culture. This was the case, for example, in Quimper, where a very controversial médiathèque brought to light the municipality's megalomaniac practices, accompanied by a certain chaos, the whole business having political supports and relays in the capital. This affair was in the news, both local and national, in early 1992. Another controversy of the same type arose in Saint-Romain-au-Mont-d'Or, near Lyon, where a médiathèque project imposed by the mayor had led to polemics. Rohmer even replied to the main plaintiff, who wrote to him after having seen *The Tree, the Mayor and the Médiathèque*:

Your appeal touches me. You ask me if my story is fictitious. Yes, but alas, there are only too many examples in France of mayors abusing the power that the law of decentralization gives them. Today, there are no longer so many villages like yours, like mine in Vendée, whose outskirts have not been disfigured by modern structures, that one must not seek to preserve them absolutely. I would

be happy, if it would be of any help, to lend you my film free for a showing that you would organize at your convenience.[130]

Rohmer had his subject in its different components—the metamorphoses of the rural landscape, the diffusion of cultural policy, the sometimes ill-considered powers of the municipal officials, and the political context of a certain socialist panic—as unfavorable electoral results loomed: the cantonal elections of 1992 and the legislative elections of 1993. But he was still looking for the precise place to set this film conceived as an environmental and political experiment.

A double coincidence was to favor his designs, a provoked coincidence, however, because Rohmer had begun to talk about his idea to a few people close to him: during a conversation with Arielle Dombasle and her companion, Bernard-Henri Lévy, in the first days of 1992, he mentioned this project about "a left-wing mayor in a village, who wants to save his skin in the elections by building a médiathèque."[131] On May 6, Arielle Dombasle wrote him this enthusiastic and delighted reply:

Dear Éric,

I am enclosing these admirable color photographs taken by my friend Christian (a shoe designer) who has a fiancé in Vendée who is a socialist mayor! What a coincidence . . . The "chateau maison" is of indeterminate period, a little fifteenth, sixteenth, eighteenth, and beginning of the nineteenth centuries. It lacks shutters on the façade. But it's marvelous, a little dilapidated, with a great garden that my friend Christian has refurbished. There's little greenhouse, two small vegetable gardens, a labyrinth, a poultry yard (various ducks, midget and laying hens), a gardener, a farmgirl, lots of bedrooms to house everyone, and a very interesting view of the fields . . . It seems to me the ideal place! Two hours by train from Paris. Moreover, his fiancé is a recently elected socialist mayor. Before, he was an auctioneer in Paris, and he is trying to come up with brilliant ideas for the village (like having streetlights designed by Garouste). I think of you very often and I give you a big hug.

Kisses,
Arielle.[132]

Arielle Dombasle's friend was the shoe designer Christian Louboutin, who toward the end of 1991 opened a shop on rue Jean-Jacques-Rousseau, in the second arrondissement, and who was soon to win international notoriety. The friend of her friend was Bruno Chambelland, the owner of this estate that he had recently remodeled, who had in fact been mayor (unaligned but close to the socialists) of Saint-Juire-Champgillon, a village of four hundred and fifty inhabitants not far from La Roche-sur-Yon in the department of Vendée.

Furthermore, it happened that Chambelland and Louboutin were friends of Pascal Greggory, who had spent many weekends in the chateau in Vendée with François-Marie Banier. "Rohmer talked to me about this project," Greggory recounts,

> and I talked to him about Bruno Chambelland, the mayor of Champgillon. He was interested. Then I asked Bruno if he thought it would be possible to receive the whole team for the film and that it be filmed in his village. That amused him. For Éric, it was very important that everyone stay in the chateau. There were about a dozen bedrooms, sagging beds, two bathrooms but not enough water for everyone. It was pretty rustic, but the grounds were magnificent. It was the kind of "stroke of luck" that delighted Rohmer.[133]

Éric Rohmer and Françoise Etchegaray informed themselves about Saint-Juire-Champgillon, and found there two go-betweens who, for twenty months—the length of time taken by the preparation and then the filming—were to prove very valuable. First, a young resident of Sables-d'Olonne who had fallen in love with Saint-Juire, and who, at the request of the municipality, had carried out in 1991 an investigation on the little town on the basis of interviews. It inspired Rohmer to conduct his own study of the terrain, the one that, in the form of conversations between a woman journalist and certain villagers, figures in the film itself. This report of about forty pages was also to pass under the yoke of Rohmer's irony.[134]

Jean-Claude Pubert, a twenty-five-year-old history student living in Saint-Juire, was Rohmer's other essential correspondent. Pubert knew everything about the village, its culture, and its heritage. He had published, with a carpenter friend, Christophe Cosson, a small book that greatly pleased Rohmer, *Le Parler Saint-Juirien*,[135] which listed the expressions and idioms typical of the area. He

was efficient in gathering information for the filmmaker, thanks to his documentary knowledge, his index cards, and everything he could collect in situ. It was he who provided the documents on Bruno Chambelland's electoral campaigns in 1989 and 1992—for example, a tract, "Vote for Bruno Chambelland, a Candidate Without a Political Label," that bore this slogan: Listen, Think, Act.[136]

Without seeking to construct an actual médiathèque, Chambelland advocated a project of architectual and cultural renovation that was more modest but very real. He had had the area around the church and the municipal library refurbished, so the latter could present three small exhibits at the same time during the summer. And he promised to install the much-touted wrought-iron street lamps designed by Garouste, "things that will remain and that people will come to see a hundred years from now."[137] In his program, Chambelland wrote: "It is not acceptable that just because we live in a very small commune, we are deprived of the cultural nourishment that people easily obtain in a large city.[138] Finally, and this was the high point of his participation in the preparation of the film, Jean-Clauded Pubert found the tree that Rohmer was looking for and photographed it for him:[139] a hundred-year-old white willow in front of the school, protected by a stone wall dating from the nineteenth century.

Rohmer's real invention was the médiathèque itself, whose architectural modernity and immoderate size for a small Vendean village far exceed Saint-Juire's municipal projects. To conceive it "virtually," the filmmaker also received indispensable help from the architect Michel Jaouën. The two men met, as we have seen, in Cergy-Pontoise when Rohmer was preparing *Boyfriends and Girlfriends*, since Jaouën was in charge of the new town's office of technical services. In the meantime, the architect had become a friend of Jean Parvulesco, who lived in Cergy in an apartment made available to him by Rohmer. Jaouën and Parvulesco came to see the master of Losange in early 1991, wanting to introduce him to an actress. Rohmer took no interest in the actress, the architect said:

> Instead, he kept turning to me. We spoke about architecture, urban planning [. . .] We probably mentioned territorial questions, the relation between cities and agriculture, the role of the new towns in the Paris region. Françoise Etchegaray later confirmed that Rohmer had constructed the scenario on the basis of this encounter [. . .]. She told me she'd never seen him so excited: "We went into the kitchen to make tea and he said to me: 'He mustn't leave, we have to keep him talking . . . ' A few weeks later, Jean Parvulesco called me and

said: "What you told him fascinated him and he wants to make a film with you. Would you be an actor?" One doesn't turn down such an offer.[140]

In the course of the spring of 1991, Michel Jaouën met Éric Rohmer on several occasions, the two men working on the preparation for a film that at that time bore a code name that was as mysterious as it was revealing: "HP" for "high politics."[141] "He told me the story of the film," the architect continued.

> [He said] "It takes place in a village, a community center is to be built, and political and environmental problems will arise in connection with it." I told him that it shouldn't be a community center . . . Rather a médiathèque, a project a little too large for the village, a little incongruous, but almost possible, which is very typical of the late 1980s. Many mayors launched into sumptuous projects whose scale was incompatible with their financial resources. Starting from the idea of a médiathèque, I added a swimming pool, an open-air theater. Thus it was an unrealistic project, slightly mad, but described in a realistic way.[142]

The next step in this process was the fabrication of a fake project. They planned a médiathèque (as if it were really going to be built) that Jaouën himself would present in the film (in which he would be renamed "Antoine Pergola"). "That sounded like an Italian and an architect."[143] At Rohmer's request, Jaouën went to Saint-Juire, met Bruno Chambelland, prepared plans and drawings, designed the project, then made a scale model. "Rohmer was convinced that I would cut the tree down," Jaouën added. "I knew he would be, and as a kind of joke, I kept it, which of course I would have done anyway in a real project. He had to change part of the dialogue."[144] This médiathèque, though it is the only "extravagance" in the film, thus remains absolutely realistic. One would think it had emerged from the Langian imagination of a socialist official. It is only a little caricature, but above all it is the extra turn of the screw that makes the film work as fiction.

"Oh! Lettuces!"

Éric Rohmer finished writing a first draft of the scenario in late 1991. In it he narrates the ambition of Julien Deschaumes, the socialist mayor of Saint-Juire, who, to win over his citizens before an election—and also his new fiancée from

Paris, Bérénice Beaurivage—proposes the grandiose project of constructing a cultural and athletic center that would include, in addition to a swimming pool and an open-air theater, a library, a videothèque, a discothèque, and an exhibition hall, combined in a médiathèque. But the mayor encounters resistance: on the part of the environmentalists, headed by a teacher, Marc Rossignol, who loves a century-old willow threatened by the project, and on the part of a Parisian woman journalist, Blandine Lenoir of the monthly *Après-demain*, who has come to Saint-Juire to carry out a study of the village and its inhabitants.[145]

The first scene was entrusted to the Dechaumes/Beaurivage couple, played, naturally, by Pascal Greggory and Arielle Dombasle, who were at the origin of the project. For about twenty minutes, the lovers walk through pastures, undergrowth, and cultivated fields, proceeding on foot, in several stages, from the chateau to the city hall, all the while discussing the respective good deeds and bad deeds of Paris and the countryside. Arielle Dombasle's feigned, admiring astonishment—"Oh! lettuces!"[146]—responds to the neo-ruralism of the mayor, who would like his village to have the best of urban life: constructing the médiathèque would be a dream for him, because "the city would come to the country." But his Parisian fiancée calls him a snob and a dandy, and then launches into a paean to the big city as the only space where multiple, exciting encounters occur. "In Paris," she concludes, "anything can happen."

The environmentalist teacher, played by Fabrice Luchini, is caustically voluble and inveighs against the projected médiathèque and all the modern nuisances symbolized by this kind of cultural construction. He dismisses out of hand: architects ("Some guys shoot kids with a machine gun, I shoot architects."); pseudo-respect for the environment and the cultural legacy ("It's respectful, so it's the lesser evil, we can no longer do anything to stop it."); parking lots, traffic circles, all car-based urban planning ("France is disfigured by on-ramps . . . It is subjected to the dictatorship of the highway department."); the pollution of high-speed trains, with fast, omnipresent traffic ("With a high-speed train it will no longer be travel but simply transfer. I like to travel, I hate being transferred."); the power of municipal officials ("The worst are the mayors, they disfigure France with a policy whose goal is to insidiously urbanize villages. That impulse comes entirely from above, following the model promulgated by the ministry of culture."). To the contrary, he celebrates the past of the area and its countryside: "A site is a work of art, we have to preserve them all. In the old days, peasants were artists." We recognize here, conveyed by the actor's terrible irony, the heart of Rohmer's discourse and his environmental commitments.

The study undertaken by the journalist Blandine Lenoir, opposing the mayor and taking the side of the teacher and his tree, allows Rohmer to bring into his film the register of the interview, which he had been fond of ever since the 1960s. Thus the journalist interviews (on camera) a village shopkeeper, a young conscientious objector, two peasants, an old craftsman, and the teacher. The filmmaker obviously takes great pleasure in this improvised speech. To play this ambiguous character—it is because of her and her article that the project will be buried, but she embodies the prototype of the contemporary journalist, wily and duplicitous—Rohmer hesitated for a long time between several young actresses who were near the top of the "girls" pile in the right-hand drawer of his desk at Losange.

One of them was Fabienne Babe, who had recently written to him:

> I really like the photo in the last *Cahiers du cinéma*, showing you filming. The years are going by . . . and my desire to make a film with you remains. Sooner or later I had to tell you that clearly, whatever the cost. I would like to realize this dream before I'm an old maid. I would be delighted to come by to see you at teatime in the coming days. Please let me know.[147]

But Isabelle Carré was also in the running; she had sent him her first letters after *The Green Ray*, had "seen all [his] films and like them enormously," and "was waiting for the person with whom it will be magical," dreaming of "talking for a very long time with [him] as the actress who played in *Reinette and Mirabelle*."[148] And also Hélène Fillières, who wrote to him at the age of twenty, after having approached him on the sidewalk on rue Malebranche:

> Monsieur Rohmer, as you suggested to me the day before yesterday when I bothered you in the street, I am taking the liberty of writing to you. I am currently doing a master's degree in English literature at Censier, but I am also making my debut as an actress. I really like very much what you do. It was your films that my parents took me to see for the first time. I find them very pointed, very funny, and what you talk about reassures me every time. I am not able to speak to you as I would like to, but I hope that you will want to see me again.[149]

In the end, none of these three young actresses was chosen. Rohmer chose for the role Clémentine Amouroux, who had already appeared in *Perceval*, that major factory producing Rohmerian actors.

It all ended with songs, as it had to in political France as Éric Rohmer saw it. This song, "Nous vivrons tous à la campagne" ("We'll all live in the country") was written and composed by the filmmaker. Every actor has his own particular melody, and it was the chorale of Sainte-Hermine, the neighboring town, that intoned the refrain:

And the country will be beautiful,
We'll see the swallows again,
The fields will be covered with flowers,
Where ladybugs will nestle.
No more insecticides,
Or pesticides,
No more asphalt
Or superhighways.
Oxygen,
Not kerosene,
No waste disposal centers,
No nuclear power plants.
No ozone hole,
Or development zones.
No more médiathèques,
The library in an old attic,
The vidéothèque in an old mill,
And the discothèque in the wine cellar.[150]

The thirty-two days of filming were spread over almost eight months, from March to September 1992, on weekends or during two-week vacations. Some scenes were filmed in Paris, for example, the first one, at Lipp, a brasserie on the boulevard Saint-Germain that Rohmer knew well. This was a kind of prologue in the form of a political conversation between two of Rohmer's friends: on the right, Jean Parvulesco; on the left, François-Marie Banier. In the film, Banier plays the director of the political weekly *Après-demain*, for which Blandine Lenoir writes. The monthly's offices are on rue Bleue, precisely in the Paris offices of the IMEC, directed by Olivier Corpet, a place for the preservation and consultation of archives where Rohmer decided to deposit his own materials. The hilarious, partly improvised scene in which the scale model of the

mediathèque is presented to the mayor and his fiancée was filmed in the office of Michel Jaouën's architectural firm in Cergy.

But most of the film is situated in Saint-Juire, where the team had set up in Bruno Chambelland's notorious chateau. As often in Rohmer, it was a very small team, including Pascal Ribier as sound engineer, Françoise Etchegaray, and a newcomer as camera operator, Diane Baratier, the daughter of a filmmaker who had had his moment of fame in the late 1950s, Jacques Baratier, the author of the films *Goha* and *Sweet and Sour*. However, Rohmer wanted to continue his collaboration with Sophie Maintigneux, who had worked with him for ten years. But she had decided to move to a different cinematic system. "She was tired of amateur filming with two portable floodlights and that old 16 mm camera bought from ORTF for *The Green Ray*, which she had ended up hating."[151] So Rohmer wanted to hire a "beginner,"[152] or at least a young camera operator who had just graduated, had limited experience, and would agree to film under his extremely spartan conditions. He was not fond of working with people who had already been trained in a system other than his own, whether they were technicians or actors. He talked about his search to the people around him. His film editor, Mary Stephen, spoke to him about Néna Baratier, who was herself a film editor and the mother of Diane Baratier, a twenty-eight-year-old technician had studied at the Louis Lumière school and then been first or second assistant on a few short films, commercials, and a couple of feature-length films (Mocky's *Il gèle en enfer*, Pinheiro's *La Femme fardée*, Pollet's *Trois jours en Grèce*), often under the direction of one of the most important head camera oprators of the New Wave, Raoul Coutard. Diane Baratier:

> I sent my CV. Six months later, Rohmer called me. He gave me an appointment for the next day, at Losange. I thought there were several of us competing. We drank tea, we talked . . . He asked me if I had a driver's license. Since I did, he said: "In that case, I'll take you on."— "Oh? Aren't you seeing other people?"— "No, it's you." The conditions were clear: "You will be alone, without an assistant, or electricians, or machinists, you'll be participating, and we'll work only on weekends and during vacations." I'd made only one short documentary film as head camera operator, so I was surprised and impressed.[153]

The first scene filmed, at Lipp, was not very good from a technical point of view. Carrying the camera on her shoulder, Diane Baratier moved a little too much;

she was not yet used to Rohmer's principles. Rohmer was not satisfied with the rushes, but he retained his confidence in the young technician. "I think he appreciated my seriousness in the job, my 'I'll hang on and it will get better' side . . . But from then on we put the camera down!"[154] Once they arrived in Saint-Juire, they got to know each other by working together, the filmmaker training his young head camera operator, perfecting a method that never again failed, whatever the film, for more than a decade.[155]

> We did the cutting as we went along, at the same time as the scouting: we determined the axes and the frames in advance. Everything was prepared, and since Rohmer filmed only what he needed, there weren't that many options in doing the cutting. There was neither fat nor backup, all those shots that usually slow down filming. He quickly taught me two things. On the one hand, his main principle: fluid continuity, on the other, the technique of using minimal lighting, which was extremely effective and ingenious, and which he had perfected with Almendros. Finally, he really liked 16 mm, its grain, its depth of field, the lightness and maneuverability of the camera.[156]

The Tree, the Mayor and the Médiathèque is a "very little"[157] film, fragile, experimental, even if Rohmer put a lot of himself and his current preoccupations into it. Some people openly made fun of this system. In *Studio*, Alain Chabat and Dominique Farrugia mockingly announced the film this way: "With Arielle Dombasle and Fabrice Luchinegger. An android socialist teacher constructs a ping-pong table. At the end he gives it a blow job. A riot of special effects by the author of *Contes de la lune vague après l'orage*."[158] But the way the film was brought out, playing on this "small is beautiful"[159] aspect was very intelligent: a single preview for the press, at the last minute, in the only theater where it was to be shown, the Cinéma Saint-Germain-des-Prés. The release was set for February 12, 1993, a month before the legislative elections that would bring the right wing back to power, provoking a severe crisis in the Socialist Party—all elements that drew attention to this "political film." Moreover, Rohmer was aware of this, acting as a true strategist of this form of "antipromotion" in collaboration with Régine Viall,[160] who was in charge of distribution at Films du Losange: "Although it is true that I am not doing any advertising for this film," he recognized in a long interview granted to *Les Inrockuptibles* that

it is also true that I am doing what might be called anti-advertising: by the absence of advertising, I am negatively awakening the audience's curiosity. I live in a world that operates on advertising, and the simple fact of not doing any is an original way of doing it. I have therefore taken advantage of the circumstances to release *The Tree, the Mayor and the Médiathèque* without advertising and without a press campaign.[161]

The film was successful. It was a surprise, almost a vogue, as it was described by the future actress of *Rendezvous in Paris*, Clara Bellar: "People fought to get into the theater, insulted each other, sneaked in. I was turned away twice because it was already sold out. And the audience was so young and so enthusiastic!"[162] In eight weeks at the Cinéma Saint-Germain, the film attracted 48,000 spectators, an exceptional number. In all, *The Tree, the Mayor and the Médiathèque* brought in almost 200,000 spectators in France, for receipts of 3 million francs, twice what the film cost. Rohmer was decidedly a profitable filmmaker.

The reactions Rohmer received were revelatory and numerous. Pierre Zucca, a filmmaker friend, sent Rohmer this note: "Thanks for this film, which is funny, simple, and right in both form and content. Our weight, acquired over the years, a weight that is not commercial, and although measured, is measured by its extreme lightness. I hope this film works: there was a long line when I went, at 6 P.M. on Sunday. The bird Zucca."[163] In the archives we also find a letter from a long-standing Rohmerian, the director Marie-Claude Treilhou, who made *Simone Barbès ou la Vertu*: "Éric, one hardly dares say it: you are really so good, again with this last film, that it shouldn't be allowed. It's marvelous, so joyful and stimulating. This strange period is very honored to have you as its psyche. What joy!"[164] We will mention also the note written by a Catholic critic, the Jesuit priest Jean Mambrino, who was very fond of the author of *My Night at Maud's*:

I have just seen, and been enchanted by, *The Tree, the Mayor and the Médiathèque*. With an entirely new method (which attracts some people's scorn) you have created a delectable work that makes us think. The great art is to have combined slowness and rapidity. There is an immemorial immobility and a protean lightness. It's very funny, and sad and tender, as ephemeral as clouds and heavy with humanity. A gravity, but that of childhood . . . As I came out of the theater and walked down the street, I was grinning ear to ear! I am happy and proud of having you as a reader and a friend.[165]

But perhaps the reaction that pleased Rohmer most was the editorial in a little review, *Sites et Monuments*, a environmentalist quarterly with a conservative tilt close to his own:

> Let us draw attention to Éric Rohmer's latest film, *The Tree, the Mayor and the Médiathèque*. If ever a film took up the themes to which we devote ourselves here, it is this one: the attachment to a rural site, the misdeeds of decentralization when it encounters, as is often the case, the megalomania of the mayor, the life and survival of a village, an architectural project "integrated into the site," the problem of access . . . To the point that we hear a character say: "France is in the hands of the highway department."[166]

With a few rare exceptions, the criticism was unexpectedly good for a film that basically did without press previews and deliberately ignored journalists. A presumptuousness that could have cost it dearly. Instead, in mid-February 1993 it was jubilation that Rohmer elicited among critics. "Rohmer the enchanter" read the headline in *Cahiers du cinéma*, whose readers soon ranked *The Tree, the Mayor and the Médiathèque* among the "ten best films of 1993."[167] Freddy Buache, in *La Gazette de Lausanne*, was perhaps the most subtle:

> One must hurry off to see Rohmer's latest opus. In it we discover, under cover of a deliciously irreverent comedy, that in the age of media, language operates as politics. Into this verbal round-dance that is both not very serious and very serious, Rohmer slips the authentic speech of local peasants in sequences that are virtually documentary. A surprising reality effect in such an impeccably smooth-running machine. A film made with means that were few but incredibly well mastered, showing a rare freedom and vivacity, overflowing with intelligence and humor, it easily outdistances the allegedly accomplished films that are its contemporaries.[168]

Jean Collet, whom Rohmer knew well because Collet had been on his thesis committee, was the most enthusiastic: "Under a fable-like title," he wrote in *Études*,

> and in a comic tone, here is cinema that is unidentified, exceptional, familiar and Martian, a booby-trap, a bone thrown to those who want at any price to recognize before they discover. It is not every day that we find a French film

that approaches reality with such serene good-naturedness, without polemical intention or message. And that nonetheless takes as its subject the most important of all: happiness. Still less often do we have the pleasure of seeing combined in a work of fiction the savor of a fable and the distance of a moralist.[169]

However, it is with a certain sadness that we must conclude this chapter with the announcement of a death. On Saturday, April 19, 1994, around 5 P.M., about two years after having acquired the status of a hero, the aged white willow fell, uprooted by the storm that on that day ravaged part of western France. Several days later, an article appeared in the local newspaper under the headline "Symbol of Rohmer's Film, the Tree Was Felled by the Storm":

> Immortalized by the filmmaker, who had made it the warhorse of the teacher Fabrice Luchini's struggle against a planned médiathèque, it had become the most visited site in Saint-Juire. Numerous artists had come to paint it, and the school situated across the street was soon to be named "The White Willow."[170]

In the autumn of 1994 a young tree of the same species was planted on the site of the old one. Jean-Claude Pubert, Rohmer's correspondent in Saint-Juire, had the last word by attributing "two bodies" to the tree: "Fortunately, its cinematic career promises it a fine posterity."[171]

11

In the Rhythm of the Seasons

1989–1998

Tales of the Four Seasons. That is the title Rohmer decided to give to a new cycle he began to arrange around 1988. He had often shown the seasons in his films, and in a not very conventional way, whether it was the excited winter of *My Night at Maud's* or the depressed summer of *The Green Ray*. But with the exception of *Love in the Afternoon* (in which the narrative extends over several months), he had not yet had the opportunity to show them in their development and their diversity. That is what he wanted to do in this new series, even if he had to rely on classical metaphors: the blossoming girls or young women of *A Tale of Springtime*, the woman in love in hibernation of *A Tale of Winter*, the prolonged vacations of adolescents in *A Tale of Summer*, and the noonday demon[1] in *A Tale of Autumn*. To tell the truth, these seasonal indications play somewhat the same role as the proverbs at the head of the *Comedies*: they are deliberately misleading points of reference, in the shelter of which the filmmaker can reinvent his freedom. The latter was to be greater than ever in *Tales of the Four Seasons*, to the extent that this time Rohmer wrote his scenarios only four or five years before they were filmed and allowed himself, between each of these "big" films, to indulge in less ambitious sketches and experiments.

One Shouldn't Think of Anything

Which does not mean that the composition of the cycle as a whole, with its echoes and effects of parallelism, was not premeditated far in advance in his mind, and analyzed afterward, as is shown by a text in which Rohmer (for once) interprets his own work. To be sure, in these new *Tales* it is no longer a question of a thematic coherence given from the outset, as in the time of the *Moral Tales*:

> However, we can discern a posteriori in their structure and their problematics analogies, oppositions, and even true symmetries. For example, the third tale (Autumn) rhymes with the first (Spring), being, like it, about "thought" in the broad sense, and describing one or several actual or supposed machinations. The fourth (Winter) and the second (Summer) reflect inverted images on each other: one woman-three men and one man-three women, respectively. They have, we might say, as their essential object a "faith" in one's choice that is certain in one case, and an almost as certain faith in one's nonchoice in the other.[2]

Since Rohmer authorizes us to do so, let us shift the chronology around a little to regroup in a first phase the *Tale of Springtime* (1990) and the *Tale of Autumn* (1998). Two films that develop in a minor key, in a muted way, far from the great sentimental organ tones that are deployed in the two other movements of the cycle. Perhaps, in fact, because their object is essentially resistant to the spectacle that is cinema: it is indeed thought, envisaged from the philosophical point of view and then in its practical implications.

Is Rohmer a philosopher? We know that in the Schérer family, that vocation was allotted to his younger brother René, and we know what a brilliant career he had in that area. We know the elder brother's loyalty to the writings of Alain, the ultimate representative of a Cartesian tradition that had to some extent fallen into escheat. We divine in him an intimidated curiosity with regard to this discipline that he never approached except as an amateur. This curiosity was passionately reawakened in the late 1980s, at the very time when the filmmaker returned to music. As if he needed, during the latency period between each of his cycles, to enrich his knowledge of this or that extracinematic domain: in the early 1970s, it was German literature, and at the end of that same decade, theatrical mise en scène. Soon, he was to publish a book entitled *From Mozart to Beethoven* that

testifies to the extent of his reading on musical creation as it has been envisaged by philosophers, and notably by Kant, whom Rohmer reread very seriously during the gestation of *A Tale of Springtime*. He talked about this with Anne-Laure Meury, who had him go back to the *Fundamentals of the Metaphysics of Morals* to help her prepare for an examination. He talked about it again with Claire Barbéris, a brilliant *agrégée* in philosophy introduced to him by Françoise Etchegaray, and whom he also questioned about new tendencies.

His reflections inspired an initial scenario entitled "The Confidant," in which the influence Kant's work exercised on Rohmer at this time is evident. Everything takes place from the point of view of the protagonist, a young woman in love with purity who breaks with her lover in the very first scene because she can no longer tolerate the lies. She makes friends with a girl who for her part engages in multiple machinations: an effort to throw herself into the arms of her father in order to turn him away from a stepmother she detests. The story of "The Lost Necklace" (that was to be the title of a second version of the scenario), which implies that the stepmother in question has stolen a piece of family jewelry. These are so many indications of the fragility of human testimony, which will lead the young woman (she is already called Jeanne) to qualify her demand for sincerity and to return to the boy whom she had left. Afterward, Rohmer omitted this epilogue and this prologue, whose cyclical irony returned too much to his *Comedies*, and the moral dimension of his first *Tales*. By omitting the character of the boyfriend, he accentuated the theoretical aspect of Jeanne's experience; as a good Kantian she seeks to test the limits of thought and knowledge, at the risk of a certain dryness in the narrative device. Detached from the time of the narrative and its affective ties, the young woman finds herself reduced to the status of a witness. A witness to a truth that never lets itself be taken by surprise.

More secretly, the director develops a cinematic (and autobiographical) aspect that continues his earlier films. Like Louise in *Full Moon in Paris*, like Delphine in *The Green Ray* (and like Rohmer himself in his youthful years as a commuter-prof hesitating between several careers), Jeanne is par excellence someone who does not stay in the same place. Who has not found a space equal to her desires, and finds herself bouncing from one apartment to another, from the city to the country, without a home base. To this internal disorder is added the disorder that is displayed before her eyes: that of broken and recomposed families, in which a dilettantish intellectual couples up with a student much younger than he, and in which his own daughter (as if out of lover's spite toward her

father) bills and coos with a man of forty. Here we see looming the temptation of a somewhat reactionary comedy of manners, a temptation that is developed in *A Tale of Autumn*. For all that, Rohmer does not abandon his leading thread, which is the quest for an impossible harmony—and at the same time a problematic truth. In the wake of *Pauline at the Beach*, the ingenue in *A Tale of Springtime* refuses to allow herself to be confined in other people's plots, at the price of remaining in the position of a spectator that we have already mentioned. She intends to assert and analyze her own thought ("I think a lot about my thought,"[3] she declares right at the beginning of the film), but the whole underlying logic of the narrative is to draw her toward letting go.

A letting go that is prepared or consecrated by musical epiphanies borrowed from Beethoven or Schumann, under cover of which Rohmer transgresses his sacrosanct principles by using an extradiegetic music and even a dolly-out shot that is, to say the least, unusual. A letting go that consists in no longer thinking about anything (to give the lie to the subtitle of *The Aviator's Wife*) and delivering herself over to chance. For example, the chance of numbers, brought in at the only moment in the film in which something could happen, namely sexual relations between Jeanne and her young friend's father. And especially the chance that finally allows Jeanne to discover the "truth": the allegedly stolen necklace had in fact been mistakenly put in a shoe box. In this indirect way, it is the objectivity of cinema that transcends the opacity of consciousnesses. And that, no matter how doubtful it may be, makes possible a fragmentary divination. "My point of view is not that of God," Rohmer explained, "because God understands his creation, it is [the point of view of] Plato's Gyges mentioned in the film. Gyges makes himself invisible and can be involved in the game, but only as a partial observer who does not have access to the secret of beings. [. . .] That's what interests me in cinema, respecting the mystery of subjectivity."[4]

The Great Gap

We see the challenge looming into which the filmmaker threw himself by inaugurating these *Tales of the Four Seasons*: rediscovering the philosophical ambition of *Six Moral Tales* (or in any case, of *My Night at Maud's*), while remaining loyal to the ordinary humanity of *Comedies and Proverbs*. Deepening the gap between themes that had become austere again, and characters who remained

stubbornly commonplace, as if to finish concealing his point of view (that is the ideal that he was to defend in his preface to Balzac's *La Rabouilleuse*, that of an author who would vanish into the very profusion of life). It has to be recognized that this alchemy did not fully succeed in *A Tale of Springtime*. First, because the microsociety described here is a kind of caricature of the "little Rohmerian world," in its hushed settings in which nothing seeps in from the outside world. To be sure, Rohmer adapted to the imponderables with his usual vivacity. Was the lovely apartment on rue Richer that Bernard Eisenschitz lent him ornamented with two futile pillars that weirdly delimited the kitchen? No matter, he would add a few lines of dialogue to ironize about this whim on the part of the architect. Are the trees in bloom earlier than foreseen? They would simply start filming a few days earlier, in a house near Fontainebleau that belonged to one of the actresses (Florence Darel). And when they started to film her "Amazonia," a strange landscape that was drowned in mist on that day, Natasha (the character Darel plays) recognizes this resistance of the real.

As for the rest, everything fits together with an almost disturbing ease. That is why, moreover, the filmmaker temporarily laid *A Tale of Winter* aside; although it should have been the first of his new cycle, its distribution was more difficult. Seen also in Rohmer's telefilm *Les Jeux de société*,[5] Florence Darel was the archetype of the kind of girl Rohmer cherished, with her pouty child's face straight out of the works of the Countess of Ségur, her modest clothes that they went together to buy at Agnès B. Furthermore, she played the piano, a talent she was able to display in *A Tale of Springtime*, where she was, so to speak, in her element: country house, bourgeois family, Russian origins . . . It was not the first time that this Rohmerian confusion between character and person had occurred—but in this case it took the form of a cliché from which the beginning actress had great difficulty escaping. Shortly after the film came out, she heard herself showered with insults by Maurice Pialat (who had earlier directed her in an advertising video clip, and this was not his first outrage), on the pretext that by working with Rohmer, she had shamefully "collaborated"! She tried to get a new start through theatrical experience without arousing renewed interest on the part of the author of *A Tale of Springtime*, who had identified her forever with her Lolita role.

So far as the father figure was concerned, the identification became more troubling. Rohmer conferred the role on Hugues Quester, whom he would have like to use in 1979 in *Catherine of Heilbronn*, so much did he admire Quester's

performances for Patrice Chéreau. It did not displease him to use experienced actors (from Jean-Marc Bory to Jean-Claude Dreyfus, by way of Dider Sandre) and to juxtapose them with inexperienced girls. The implicit list of tasks he delegated to Quester was still more perverse, and the actor was able to take him very subtly at his word. He used his tall stature, somewhat vampire-like figure, and calculated clumsiness to become a strange kind of double . . . of Rohmer. A double who resembled one of Murnau's creatures, Nosferatu or Tartuffe, with his abrupt way of popping up in the shot and letting his desire be seen. This exchange of personalities was made without words, as had occurred earlier with Trintignant and would occur later with Melvil Poupaud. It operated through suggestion enveloped in a prudish modesty that forbade the filmmaker to communicate anything at all to his masculine doubles. It remains that discovering Quester as a shadowy version of Rohmer contributes to the caricatural atmosphere we have discussed.

An atmosphere that was definitely preconceived, as if the better to prove that people are comprehensible only on the surface, in the pure exteriority that fascinated Maurice Schérer when he read American postwar novelists. And to respect the "Gyges" point of view toward which the young student of Kant nostalgic for Plato tended, to such a point that her own interiority was also effaced. For the role of Jeanne, Rohmer chose a young actress who had recently graduated from the Conservatoire (and whom he had caught sight of a few years earlier in a film by his friend Claudine Guilbaud, *L'Été de mes quinze ans* [The summer I was fifteen]). Her name was Anne Teyssèdre. Like so many others , she had written to tell him about her desire to work with him. Their first meeting delighted her, because Rohmer, forever at war with physical objects, was unsuccessfully trying to insert a poster into a mailing tube. She immediately pleased him with her insolence, her intelligence, and her knowledge of philosophy, which inspired them to have long conversations (even if the actress claimed that she could not read and defined herself as a "filousophe" ("swindler/philosopher") who had obtained her master's degree only by fraud. Was it their friendship that gave Rohmer the idea of making Jeanne a philosophy teacher? At least that is what he let her think, just as he had let Emmanuelle Chaulet think she had "chosen" Cergy-Pontoise. But she was to be a philosophy teacher as he imagined one. She could not wear a leather miniskirt, like Claire Barbéris. Or express the exuberant imagination that Anne Teyssèdre displayed in real life. He imposed on her a restraint, even a neutrality, that he considered inseparable from her role.

Feeling confined in this straitjacket, Teyssèdre constantly deviated from what Rohmer expected of her: having her her cut very short the day before filming began, against Rohmer's will; smoking in front of him (a supreme heresy that had earlier gotten Zouzou excluded from the Rohmerian Olympus!), claiming that they were herbal cigarettes; and making a cheat sheet for the sequences shot in a car, because she had not dared say that she had just barely passed her driver's exam. Rohmer noticed this, and concealed (as best he could) Françoise Etchegaray at the driver's feet, to guide her efforts to use the pedals. All this brings us back to the great gap we mentioned, which in this case proceeded more from Renoir than from Murnau. A great admirer of *Elena and Her Men* and *The Testament of Doctor Cordelier*, Rohmer played on the distance between the actor and the character, and all the more if the latter was himself remote. What he did not foresee is the possibility that this gap might become a disengagement, one that sometimes leaves the spectator of *A Tale of Springtime* with the impression that the lead actress is irrelevant to the story being told. That did not prevent the film from being selected for the Berlin Film Festival and being warmly received by the critics. Nor did it prevent Rohmer from having a very special fondness for this film, perhaps because beyond its apparent coolness a genuine art of poetry is murmured.

A Comedy of Marriage

We have noted the comic temptation that emerged in *A Tale of Springtime*. A sketched satire of manners, too dark to really provoke laughter (except in the anthology scene, where people discourse on the "transcendental" as they slice up a sausage, and where Éloise Bennet, who was also seen in *Les Jeux de société*, did a new *précieuses ridicules*[6] number). Not until the fourth part of the cycle, made ten years later, did Rohmer go all the way with his desire for comedy. For all that, *A Tale of Autumn* is situated in a very different genre. It is freed of any grimace or cruelty and is attached only to mistaken identities and misunderstandings that temporarily separate the characters, followed by a happy ending. In Eugène Scribe's day, this was called a "*comédie d'intrigue.*" In Howard Hawks's time (theorized by Stanley Cavell), it would have been made into a "comedy of remarriage." Even as he fully acknowledged the homage to Hawks (who was one of his masters during his apprenticeship as a cinephile), Rohmer did not forget

Hitchcock's lesson about suspense. Thus in *A Tale of Autumn*, he makes it a point of honor to arouse interest only on the basis of a very tightly knit plot. But the spectator is delighted—and laughs—to learn a little more about the characters.

This plot can be summed up in a few words, especially since the characters in question belong (a priori) more to a repertory of archetypes than to the mysterious humanity of *My Night at Maud's*. A woman in her forties, Isabelle, is sad to see a friend of her own age, Magali, dying of boredom in a prolonged celibacy. Through a classified ad, Isabelle meets a distinguished man in his forties, Gérald, with whom she flirts for a short time just to get to know him better. Finally she tells him that she has picked him out for her friend. He agrees to meet the friend at the reception after Isabelle's daughter's wedding. Despite Magali's suspicions—she quickly perceives what is going on—she and the stranger enter into a romantic idyll. It is in fact a comedy of marriage, whose savor and humor reach a climax at the moment when Gérald discovers Isabelle's plot. It is as if the veil of appearances were torn asunder all at once to allow the very fabric of the narrative to emerge.

If *A Tale of Autumn* thus unveils its reflexive dimension, it goes much further than what can be divined in a first, amused, and superficial version. On closer inspection, we see that here Rohmer is telling us all the stages through which he passes to make a film, and in particular this one. Let us pause a moment to examine each of them. The first and most important is that of reverie. We have already noted the central place it occupies in the Rohmerian universe—being preferred to the choice that arouses anguish and that must be avoided at any price. We can recall that between the end of one filming and the writing of a new project, Rohmer accorded himself a long period of reverie (preferably associated with walking or with desultory conversation) that allowed him to gradually clarify the ideas he had in mind. Two shots in *A Tale of Autumn* provide a marvelous illustration of this stage: at the beginning, when Isabelle remains pensive in the midst of a banal family discussion, and at the end, when she has succeeded in bringing Magali and Gérald together, but casts a melancholy look into the distance that takes the place of a postscript in the credits. The history of this shot tells us a great deal about the "floating attention" that was at the heart of Rohmer's process of creation. While his editor Mary Stephen was dealing with this last sequence, Rohmer gave her free rein and took a short nap, like François in *The Aviator's Wife*. When he woke up, Mary handed him a proposal for ending the film in an unexpected way: using a shot of Anne (Marie Rivière) taken

without her knowledge, showing her dancing and looking into the distance with a dreamy air. Rohmer approved the idea and later said that this image (along with the other we mentioned) constituted one of the most beautiful in *A Tale of Autumn*. "A film editor's work," Mary Stephen shrewdly remarked, "sometimes consists in bringing out a director's intention, even if he has not expressly asked that it be done, out of modesty or self-censorship. It is not a rewriting, because it is more like the work of restoring a painting: one makes the hidden strokes come out again."[7]

Concealing One's Hand

This episode is all the more interesting because Rohmer's work consisted, on the contrary (in *A Tale of Autumn* even more than in his earlier films), in effacing as he went along anything that might resemble personal inspiration. The latter showed through here and there in the first drafts of the scenario dating from 1992 (that is, five years before filming began). In these drafts, the future character of Isabelle experienced more openly the frustration that is this story's real point of departure: "Everybody thinks she is happy and serene," Rohmer wrote at that time. "But she hides her concern and and tries to calm her anxiety by launching into this machination."[8] An anxiety explained, in this case, by her husband's infidelities and by the desire to make him jealous by letting herself be courted. To complicate matters, Rohmer also imagined a former liaison between the future Magali and a man whom she meets again long afterward (the future Gérald?). Bu that would be too similar to the theme of *A Tale of Winter*, he noted in the margin of his manuscript. He drew with a firm hand the characters of his personages, who were supposed to be attracted to each other by elective affinities. That is why a calculator like O. (that is his only name for the moment) should get along better with M. than with N., whose temperament is too close to his own. He says in his defense:

> I'm not a calculator, but I'm aware of realities, and particularly of the realities of the modern world. It's a world that interferes with communication, that sets up a network of communication between beings that is not the natural network: that is closer, for example, to that of geographical proximity. It is easier to enter into contact with someone in a distant country than with one's next-door

neighbor. Since this artificial network exists, one should make use of it, instead of waiting for the woman of his life to come knock on his door.[9]

All these theoretical bases were gradually blurred in the course of successive rewritings, as were the references to real persons (Rohmer's great friend Liliane Dreyfus) or to literary models (Balzac's *Modeste Mignon*, in which a romantic girl falls in love with an artist through his letters, which are in fact written by his secretary). Like Isabelle in *A Tale of Autumn* composing her clandestine classified ad, Rohmer systematically omits everything superfluous to leave only the simplest and most neutral framework.

The third stage is also present in a very concrete way in the body of the narrative: that of scouting. At the beginning of the film, it is Isabelle who goes to visit the vineyard owned by her woman friend, and it is the latter who explains to her in detail the principles of her work. In the genesis of *A Tale of Autumn*, it is Rohmer who sought a place where he could set his story, a place he would never have filmed before (like Balzac, he is concerned with the geographical diversity of his work as much as with its sociological diversity). His young woman friend Florence Rauscher told him about the area in southeast France where she was born, in the heart of the Rhone valley, on the border between the departments of Ardèche and Drôme; more precisely, between Bourg-Saint-Andéol and Saint-Paul-Trois-Châteaux. A film festival was being planned there; Rohmer made an exception and agreed to participate in it—it was an opportunity to scout possible settings for the film he was to make (moreover, he returned there to present the finished film a year after it was made). Delighted by the beauty of the region and the quality of its wine, even though he was not a great wine drinker, he walked around, took photos, talked with people. For example, with Sabine Gossens, who from Bourg managed the Rauscher family's wine-making domain, and whom he questioned at length about her work. She was a not an agriculturist like the others; she had not grown up in the countryside and considered herself primarily an "artisan." Nonetheless, Rohmer used this peculiarity to construct the character of Magali—at the risk of arousing the ire of a female winemaker who saw the film and reproached him for the artifice of his dialogues, and to whom he humbly justified himself:

Like you, I think there are not enough films about rural areas and peasant life. But I do not feel competent to deal with this important subject from the inside.

I took it up only obliquely, incidentally, wanting to vary the professions of my
characters. And of course I cannot have practiced all trades in addition to that
of filmmaker (and teacher).[10]

In the Saint-Paul area, his interlocutors were Martine and Fabien Limonta,
who organized the film festival, and at whose home he filmed the marriage
sequence. He asked them many questions about the weddings of their two
daughters, about how the guests were received or how the tables were arranged.
He listened to them tell, with an indignation that he shared, about the fatal day
when the century-old cypresses that concealed the nearby Tricastin nuclear
power plant were cut down. He remembered all this in the final scenario of *A
Tale of Autumn*, and used it to put flesh on the narrative skeleton he had con-
ceived. Martine Limonta recalled how much his story "was already constructed
and perfectly coherent."[11] Except during the scouting in Vendée for *The Tree, the
Mayor and the Médiathèque*, Rohmer had never before cultivated to this point
the confusion between his imagination and that of a space he discovered.

Rosine's Bra Strap

Cinema, an art of space. But also an art of the actor, that is (so far as Rohmer was
concerned), the art of finding the actor who will fully occupy his job—unlike the
metteur en scène, who wanders about like a soul in search of incarnation, flirting
with the idea of playing a role before finally handing his text over to someone
else. Each of these nuances is present at the heart of the narrative, and so are
even the conversations with the actors that constituted the essence of Rohmerian
direction: the conversations between Isabelle and Gérald, in which Isabelle tries
out her seduction of Gérald while at the same time making him take up his role
as the lover of another woman. For *A Tale of Autumn*, there was no need for these
long preliminary discussions, insofar as the casting concerned above all actors in
their forties: Alain Libolt, a former leading man and an experienced stage actor,
the very archetype of the actor, with his unctuous diction and gluttonous appetite
for texts, with his old-fashioned elegance and politeness, which gave the figure
of Gérald a somewhat faded charm. Already considered for *A Tale of Springtime*,
Libolt was chosen without hesitation and was allowed to adapt dialogues that
were more literary than oral—as Rohmer's male actors were generally allowed

to do. Rohmer had Gérald say things Alain had said off the record, playing the devil's advocate and praising the beauty of Tricastin's industrial towers. In this way we come back to the theme of *Métamorphoses du paysage*, but it is the actor who has the feeling that he is taking charge of it.

Regarding the roles of Isabelle and Magali, Rohmer had more hesitation. Françoise Etchegaray suggested that he have Magali played by Christine Boisson, but he was thinking rather of a pair with two of his fetish actresses: Béatrice Romand, who had just told him that she would like to work with him again, and Marie Rivière, who had remained his very dear friend from the miraculous time of *The Green Ray*. Who would play which one? Casting Béatrice as Isabelle and Marie as Magali would in fact reproduce a situation in *The Green Ray*, that of the well-intentioned girlfriend who advocates "doing something" to find a man. And we have seen how much Rohmer (especially for this last *Tale*) wanted to diversify his human comedy, to offer the maximum of combinations within the generic framework he had set for himself. Thus it was Marie Rivière who would play Isabelle, with an imaginativeness and sensuality that she had not much expressed up to that time. Béatrice Romand was to play Magali, a sort of negative version of the Sabine that she played in *A Good Marriage*: not at all someone who wants to get married, but someone who is guided toward the encounter without knowing it, while at the same time wanting to believe, right to the end, that she is only obeying her own desire. "It doesn't matter that you found him through an ad, what counts is that I noticed him without knowing anything about that."[12] Here we see what is probably the ultimate secret of Rohmer's art of mise en scène: letting the actor imagine that he is running the show, whereas in fact everything has been decided by a discreet demiurge lurking in the shadows.

Rohmer let his two actresses take inoffensive intiatives, so long as they did not contradict the characters he had conceived, and on the contrary even helped them identify themselves with these characters. For example, when Marie Rivière maliciously violated the instructions followed during the rehearsals by abruptly unfastening the bottom of her skirt to show more leg, at the precise moment when shooting was to begin. Or when Béatrice Romand, annoyed at having to call her son Léonce, insisted on renaming him Léo. She also wanted to impose her cult of organic food on the meals that brought the whole team together in a property that had been renamed "the convent." But that was not to the taste of Françoise Etchegaray, and their polemic degenerated into a Homeric conflict. Without seeming to, Rohmer made use of these tensions, notably when filming

a scene in a car between Alain Libolt and Béatrice Romand. The latter remained completely inaccessible, refusing to look at her partner and responding only reluctantly. At these times, the actress's repressed rage exceeded the limits of her role, and in that very way gave it an unhoped-for truth.

This strategy also worked with the extras, who had been gathered in unusual numbers (unusual since the party in *Full Moon in Paris*), because there had to be a crowd at the wedding reception that was to be filmed at the Limontas' home. A big spread was put on, but the extras were not allowed to touch it as long as filming had not begun. The problem was that there was no slate, just a little notebook entrusted to the improvised "script girl," Bethsabée Dreyfus. And that the director did not seem to know what he wanted. That was the impression he left on Cathérine Molini, one of the guests at this true-false wedding without an obvious project manager.

> He told us: "All of you go over there," vaguely, without explaining what we were supposed to do. He walked up and down, looked at the sun from time to time, seemed to be dreaming. "So, shall we start?" the camera operator said impatiently. And Rohmer replied: "Not yet." In fact, [. . .] we understood afterward, he was watching the actors and trying to catch them off guard. We didn't even hear someone cry "Action!" We didn't find out that we were being filmed until we saw ourselves in the film when it was shown.[13]

See only without being seen. That is the great Rohmerian credo, which is *mis en abyme* in *A Tale of Autumn*, even in its counterexamples and its awkward avatars. The film opposes to Rohmer's mischievous double, played by Isabelle (who knew how to disappear behind her creation when the time came), an inexperienced sorceror's apprentice in the person of the young Rosine. She is engaged to be married to Magali's annoying son (Léo), even as she flirts with a seductive and graying philosophy professor (Étienne). We see here the continuation of the ballet of generations that was begun by *A Tale of Springtime*, as if to finish qualifying the "young-ism" attached to Rohmer's reputation. Above all, we see the theme of *Full Moon in Paris*: a woman who is hesitating between two styles of emotional life and who takes refuge in the role of *metteur en scène* by throwing her lover into the arms of another woman. A very bad *metteur en scène*, because she makes it clear to Étienne that she wants to marry him to Magali, and vice versa—and naturally provokes reticence and discomfort on their part.

This failure of the second machination is curiously (deliberately?) followed by Rohmer's failure when he has to enliven this very theoretical part of the scenario. To play Léo, he wanted a boy with a southern accent that could counterbalance the excessively Parisian style of the other actors. He received a letter from a certain Stéphane Darmon, written in passionate terms: "Like the director Marc Allégret, who throughout his career gave a helping hand to unknown young actors named Michèle Morgan, Jean-Pierre Aumont, Brigitte Bardot, and Gérard Philipe, I would so much like you to help launch my career so that I too could contribute my talent and the best of myself to French cinema."[14] He brought hardly anything to the film but his inexperience, though his director (who had, however, been warned by Françoise Etchegaray) did not seem to be very bothered by that. Another, still more tortuous casting choice was to give the role of Étienne to Didier Sandre, a prestigious stage actor. Rohmer had much admired him in a telefilm, L'Allée du roi, in which he played an elegant Louis XIV. It was this somewhat rigid dignity that he wanted to exploit in A Tale of Autumn—even if the actor felt a bit uncomfortable and cast a look at the female characters that was frequently jealous.

For the role of Rosine, he chose Alexia Portal, a sophisticated brunette who had already played in television productions that were more classical. Whence, perhaps, the mischievous pleasure Rohmer took in upsetting her. When they were filming the wedding scene at Saint-Paul, he agreed to film a second take only when she insisted on it, after having stammered in the first one: of course, Rohmer kept the first one when the film was edited. These methods irritated the young actress, who did not hide her irritation in the interviews she gave later on. "I was frustrated as an actress, because once a tone had been set, we could have tried to find others! I would have liked to communicate more with Éric."[15] But this frustration and irritation served to characterize Rosine, her difficulty in putting into practice her matrimonial projects as well as her difficulty in choosing between two incompatible masculine types. To be a good metteur en scène, Rohmer seems to be saying between the lines in A Tale of Autumn, you have to be able to give up your own desires and ultimately your control. You have to let reality (at least apparently) come before the fiction you have written.

Witness the moment when, by a precious inattention, Rosine's bra strap slips down her bare arm. When a spectator asked him if that was foreseen in the scenario, Rohmer said it was not. "It's one of those accidents that lend charm to a scene and that I carefully retain—on condition, however, that they do not cut

the thread of the narrative. In reviewing this passage, I find extremely graceful the movement with which Alexia adjusts her top. Thanks for having noticed this little detail, fortuitous but essential."[16] Under its light and libertine exterior, no film reflects better than this one Rohmer's thought, wholly attached to what detaches itself from it.

"You must awake your faith"

Meanders of thought in the first and last of the *Tales*. Adventures of faith in the two central parts of the tetralogy. A faith that has a major place in Maurice Schérer's private life, but which Éric Rohmer always refused to illustrate explicitly in his films (in this he is very different from Robert Bresson, who remains his privileged contrary in every respect). Two exceptions prove this rule of silence that Rohmer's Catholicism imposed on itself in his films: the Christmas mass in *My Night at Maud's*, with its impersonal homily that the discussions on Pascal's wager complicate; the Christ-like Passion represented in *Perceval*, in which the temptation to depaganize the medieval myth is expressed. But essentially the believer that Rohmer remained disappeared behind the filmmaker he became, as if to avoid the dangers of the edifying style. As if to respect, especially, the mad gamble that took shape long before upon discovering *Stromboli*: making cinema the territory of a reconquest of the religious.

Thus he had to move forward incognito, even if it meant coming as close as possible to the focal point that was never named. The opportunity was provided to Rohmer by his (re)discovery, in the mid-1980s, of Shakespeare's play *A Winter's Tale*. A lover of the Comédie-Française's plays (to which he regularly took his two sons) and broadcasts of theatrical performances on television (which constituted a large portion of his nascent collection of videocassettes), he was very impressed by the BBC version of *A Winter's Tale* he saw on television one evening. He was less impressed, somewhat later, by Luc Bondy's production of the play, with Michel Piccoli in the role of King Leontes. The problem was that he did not experience again the extraordinary emotion he had felt as he watched the final scene of Shakespeare's play: the one in which the dead queen's confidante Paulina presents her to the weeping king in the form of a statue. Before the dazzled eyes of the sovereign, his daughter Perdita, and the whole court, the statue resumes human form and begins to move.

Rohmer was so fascinated by this theatrical miracle that he cited it textually within his film, through the mediation of a performance attended by the characters in his fiction. One might even wonder whether he did not conceive his whole cinematic *Winter's Tale* just to film this suspended moment—which constitutes a parenthesis in his work, something ordinarily not well suited to theater. First, he thought big: Françoise Fabian in the role of Queen Hermione, Jean-Claude Brialy in that of Leontes. "I've always considered you a great Shakespearian actor," he wrote to his former actor in *Claire's Knee*, but I had to see you last evening on television for the click to occur in me. On seeing your sublime gendarme I immediately thought of my Leontes."[17] From the Ferbach series[18] to Shakespeare, it was only a step—one that Brialy was entirely prepared to take: "I will be, as you know, very glad to meet you again around a camera, [. . .] and if I am free for *A Tale of Winter* I will be at your disposal to try to render unto Shakespeare what is Rohmer's."[19] But in the end neither he nor Fabian was available. Rohmer then chose Diane Lepvrier, whose haughty beauty he had admired in Alain Cavalier's *Le Combat dans l'île*. And then Roger Dumas, whose photo he had picked out of a register of actors. Once the photo had been provided with a false mustache, Rohmer congratulated himself on finally finding his Leontes. In the role of Paulina, Danièle Lebrun completed a distinguished and slightly starchy cast. A costume designer was recruited by Margaret Menegoz (who liked his work as an assistant for the costumes in Roger Planchon's *Louis, enfant roi*). His name was Pierre-Jean Larroque and he suggested gilt breastplates against a red background, inspired by the famous canvases that Rubens devoted to Marie de Medicis: we see foreshadowed here a minimalist seventeenth century that was to be, fifteen years later, that of *The Romance of Astrée and Céladon*.

All this had the advantage of not being too expensive. A reverse shot was made of the audience, with a few extras melting into the shadows, in the Gérard-Philipe theater in Saint-Denis. And with two actor-spectators scrutinizing the void, since the Shakespearian scene could be filmed only at the Théâtre du Rond-Point a few weeks later (in the absence of the head camera operator, Luc Pagès, who had become Rohmer's official collaborator since *Les Jeux de société*). It did not matter. More or less deliberately, the filmmaker was moving toward a poor-man's theater. A kind of vaguely absurd ruin, but one on the basis of which everything was possible. "You must awake your faith,"[20] Paulina warns at the outset, between a fragment of neoclassical décor and a piece of crimson curtain. All through his *A Tale of Winter*, Rohmer multiplies the signs of a lost faith that

punctuate the itinerary of his heroine, just as the playing cards found in the street punctuated the quest in *The Green Ray*. Here it is the evocation of Plato's theory of reminiscence, "a convenient form of explanation connected with the beliefs of his time that finally does not prove that the soul is immortal qua substance, but affirms the presence in our faculty of knowledge of something anterior to experience."[21] There we see the karmic beliefs in metempsychosis or reincarnation explained to Rohmer by his great friend Haydée Caillot, and defended by her at the heart of the film, alongside a Jean-Claude Biette who remains silent (in truth, this sequence was only half improvised). Without forgetting the references to Victor Hugo and Blaise Pascal through the voice of a librarian who constantly lectures on the history of ideas. So many extinct stars and contradictory demigods, each of whom, in his or her own way, asks to be reborn from its ashes.

From the Plausible to the True

And without forgetting, either, the laws of plausibility. Rohmer intended to respect them all the more strictly because he had set out to recount, in his turn, "an old fairy tale":[22] the story of a young woman of modest social standing named Félicie, who has experienced an intense vacation love affair but has lost track of her lover because she failed to give him the right address when they separated. Five years later, she is still hoping to see her Prince Charming turn up on some streetcorner. A providential accident rewards her patience, and her suffering. For Rohmer, it is absolutely important that this invention be credible in its smallest details (unlike *The Green Ray*, where the fantastic came in without warning). His character mistakenly said she lived in Courbevoie, whereas in fact she lives in Levallois? To make sure that this error would have really made her unfindable, Rohmer sent two letters: one to Françoise Etchegaray, 36, rue Victor-Hugo in Courbevoie, the other to the actress who was to play Félicie, General Delivery in the same city. Both letters were returned "Not at this address" and "Not claimed," respectively. He discovered that by a stroke of bad luck (very real, this time) the building at 36, rue Victor-Hugo was being demolished . . . in both Levallois and Courbevoie.

These precautions were echoed in the scenario, in which Rohmer (who was as Cartesian as he was Pascalian) took care to justify everything that might seem arbitrary. In an intermediary version, he devoted an entire scene to detailing

Félicie's car breakdown the better to prepare the "accidental" meeting on the bus. Right in the middle of the film, he kept a long explanatory sequence in which his protagonist clarifies every aspect of her misadventure. "What I wanted to show," Rohmer replied to Alain Bergala (who had pointed out that Hitchcock would not have had any such scruples), "is that something that can be considered implausible isn't, in the end, and may even be true."[23]

The plausible, or the first step toward truth, passing by way of the legible: this is the third notion dear to Rohmer, for whom it was important that the spectator know all the whys and wherefores of his story. Whence the importance of movements within his films, which allow him to delimit with precision the space in which his characters are situated. He sometimes went back to the sites of the filming (as he did while Lisa Heredia was editing *Full Moon in Paris*) to be sure that they had really left out a step in a character's ascent of a stairway. Since Lisa Heredia was at that point working with Jean-Claude Brisseau, Mary Stephen returned to edit *A Tale of Winter*. Without daring to stand up to Rohmer as her predecessor had done, in the years to come she nonetheless allowed herself a few audacities, to which the filmmaker turned a blind eye. For example, she ventured to omit a few steps in a character's movement. But for the time being, she was completely absorbed by her renewed closeness to the author of *The Aviator's Wife* and did not permit herself to challenge his requirements. For example, those that consisted in scattering the beginning of his *Tale* with clues to prevent the spectator from getting lost: at the end of the prologue, a voice-over imposed on a love scene ("You're imprudent, you know!") indicates clearly how Félicie got pregnant by Charles. As she travels back home, two shots showing the "town of Levallois" remove any ambiguity regarding the fatal misunderstanding that blinded her.

On the way to the revelation, other constraints turn up. For example, the impossibility of situating the final meeting with the beloved in a real bus, because the shot/reverse shot technique leads to inextricable problems of matching when used with passengers filmed live. Rohmer thus made up his mind to do something he did not like at all: he rented a bus and used extras who had to be paid, and he had to time stoplights. Carrying a small videocamera, he secretly filmed hours and hours of rehearsals in buses, and it was Françoise Etchegaray who occupied the place of Charles's "girlfriend" (a role that would finally be played by Marie Rivière). The actor who played Charles, Frédéric van den Driessche, being available only on certain dates, the chronological order of the sequences was changed—and that was not to Rohmer's taste, either—so as to film this one first.

When the day came, their hearts weren't in it. "I only respected what was written," Rohmer noted, "I hadn't been impelled by the dynamism of the filming, my actors weren't into it, and neither was I, we did it cold."[24] On the other hand, he had a lot of fun staging the long conversation from the inside of a car, sitting on the backseat next to his camera operator, while his sound engineer Pascal Ribier crouched in the trunk. This allowed him to avoid the not very plausible windshield point of view (which he nonetheless used in *A Tale of Autumn*), instead giving himself the vantage of an invisible observer.

The Taste for Ugliness

We see that Rohmer did not deny himself small infidelities to truth, if that was the price he had to pay to portray reality. What counted was that this reality (including even the artifices that compose it) became that of his main character and was no longer his own. It was especially in that spirit that he conceived the prologue to *A Tale of Winter*, in which we see a few images of Félicie's lost summer. These are only a series of animated postcards, punctuated with beatific smiles and conventional poses. And by sentimental music that seems to imitate that of a cheap video clip. Rohmer was a little ashamed of this melody (which he wrote), and did not dare show it to his usual composer, Jean-Louis Valéro. As excited as a teenaged conspirator, he made use of his film editor's musical knowledge to work out a fugue that the two of them signed with a transparent pseudonym: Sébastien Erms, that is, Éric Rohmer and Mary Stephen (or else perhaps, more secretly, Éric Rohmer and Maurice Schérer). To complete this amateurism, he did not want the recording to be too clean and had it played again on a cheap piano, as if Félicie herself were playing these modest notes, in memory of the handsome lover she had lost.

This handsome lover would himself conform to the image that she had retained of him (this time it was the actress who picked the actor's face out of an actor's registry.) The actors who played Loïc and Maxence, the two men between whom she hesitates before falling into the arms of Charles, were also in conformity with her tastes. The first was Hervé Furic: he was totally credible in the role of an excessively serious librarian who impresses Félicie by his erudition but fails to seduce her physically. The second was Michel Voletti, an actor whom Rohmer had seen earlier in a feature-length film by Mary Stephen (*Justocoeur*),

and whom his actress had (once again) warmly recommended to him for the role of Maxence. Whence a strange casting against type: too affected to play a macho protector, too massive to look like a coiffeur, Michel Voletti exceeded the limits of his role and thus revealed its caricatural aspect. That did not necessarily displease Rohmer, who had learned, as we have said, many lessons from Renoir, and sometimes chose his actors without regard to the characters they were to play, as if to test the strength of his realism.

What did displease him was that his dialogues were not followed to the letter. Pascal Ribier recounts an episode that is eloquent in this respect:

> Since it was a rather long scene, Rohmer could not determine exactly what was not working. Until he noticed that the text was not being respected: Michel Voletti had slightly abridged his speech. The nuance that Rohmer had tried to express was in tatters . . . He [Rohmer] flew into a rage, we reworked the acting and went on. It was the only time I ever saw him actually direct actors to explain what he had written! That was something he never did.[25]

Around the couple formed by Maxence and Félicie, Rohmer pieced together a provincial love nest more real than the real ones, thanks to a boy to whom Haydée Caillot had introduced him, a certain Jean-Luc Revol who later became a theatrical director. To prepare *A Tale of Winter*, Revol performed the same unofficial functions Marie Bouteloup had at the at the beginning of *Comedies and Proverbs*: those of an informal assistant, assigned to make available to the film the places and people he knew in the area. In this case, in Nevers, where his aunt had a hair salon that became, almost without modification, the one that Maxence runs. Rohmer took care to avoid any reference to *Hiroshima mon amour* (Resnais's film, part of which had been made in Nevers), but as his love-birds walk through the old streets, he had them see, as if by accident, Saint Bernadette's reliquary.

It is clear that it was not only out of thriftiness that Rohmer moved into already existing settings, in the provinces, in the suburbs of Paris, and in Paris itself (the mother's apartment, "in the 'Levitan' style, as people used to say"[26]). " More than ever, he decided to conceal himself in the fabric of everyday life, as trivial and banal as possible, with its tasteless wallpapers, the gray drabness of mass transit, and the special meals people grant themselves because it's Sunday. Filmed in 16 mm, *A Tale of Winter* offers the least polished and, it has to be said, also the least

beautiful image in all of Rohmer's cinema (which did not fail to bother certain critics, such as Jean Roy in *Humanité*, who lamented this uniform ugliness). Although he allowed himself to retouch the real here and there, by slipping a Kandinsky into Loïc's living room or birdsong into the sound track, he did so like a painter discreetly enhancing his palette. Even if he chose the dullest colors.

Tears of Joy

On the basis of this lackluster and muffled background, we see a model emerging. Not a model in Bresson's sense, with all that might imply in the way of manipulation and obsession (Rohmer was ferociously opposed to that authoritarian conception of the way to direct actors). No, a flesh-and-blood being who could make his or her own the feelings of the character sketched on paper. During the gestation of *A Tale of Winter*, Rohmer had lengthy discussions with a girl who had shown up one day in his office, thanks to a telephone prank. Her name was Anne-Sophie Rouvillois, and she was a little the archetype of *The Indecisive [Woman]*—that was the scenario's first title—hesitating between several indeterminate vocations, incapable of entering into a love affair with a boy. Not very different from Delphine in *The Green Ray*, or from the suffering of the young Schérer. Rohmer watched her tears flow with curiosity, he listened to her hesitations and tried to help her overcome her stagnation. He did not ask her to act in one of his films (only a small role in *Les Jeux de société*), but it was at her home that the prologue to *A Tale of Winter* was filmed in June 1989. On the Île-aux-Moines in the Gulf of Morbihan in Brittany, in memory of an an old seaside story already placed under the sign of Shakespeare: *The Tempest*. In the home of the Félicie of this new story, we find a few traces of Anne-Sophie's melancholy.

Another woman had burst into Rohmer's office a few months earlier. She was one of the countless actresses who wrote to him in the hope of working with him, and her letter had gone unanswered. She telephoned him to invite him to the showing of a short film, but that did not interest him. Just before he hung up, she proposed to come deposit a videocassette at his office. That way she would have a good reason to return: to get it back. That was when Rohmer began to enter into conversation with Charlotte Véry. He detested the film in qustion, but he was intrigued by this decisive, cheerful young woman who did not hesitate to say what was on her mind and went straight to the point. For several months,

they resumed the ritual meetings over a cup of tea, a few cookies, and a tape recorder. Rohmer was particularly attentive to Charlotte Véry's blunders, her inexactness in the use of language (she said "*frustre*" instead of "*fruste*"). He made use of her in writing Félicie's dialogues. As soon as he had given her the role, they reread all her speeches together, so she could substitute her own words for his sometimes outmoded turns of phrase.

For a time, Rohmer considered having Félicie's mother played by Charlotte Véry's real mother. He abandoned the idea, but Véry's mother told him with emotion that in his film "I found my daughter again 'as she really is.' "[27] He relied on his actress's biography (she worked part-time as a makeup woman) to make his character a hairdresser. He used her pictorial talents to make the poster for the film, an incredibly naïve one with its two small figures lost in a storm. And he was not shocked to learn that she had donated most of her fee to the Church of Scientology—according to Béatrice Romand's indignant account. "It's a good thing that she has faith," Rohmer is supposed to have commented, a sentence that sums up in itself the whole spirit of *A Tale of Winter*. What shocked him more was the young woman's advocacy of nudism. She liked to go nude on the beach and was not at all embarrassed to play a sex scene. During the filming, Rohmer took refuge in the hall (as he had done with Zouzou when he was making *Love in the Afternoon*), and engaged in frenetic calisthenics. Prudery, perhaps. And a refusal to confront the emotional response that Charlotte Véry elicited in him, which sometimes led the two of them to the verge of flirting with each other. Certainly, he had a tendency to delegate to his actress the audacities he did not allow himself to avow. "Currently, people are a little puritanical in this domain," he dared say without laughing, "it is said that these poor actresses are forced to take their clothes off: I don't believe that at all. In my opinion, if they are naked, that is because it was their idea: 'Ah! If only I could be filmed naked!' "[28]

A more likable Rohmer was revealed in contact with Charlotte Véry. A Rohmer who was capable of abandoning all his caution and his fears and throwing himself headlong into a cinematic adventure. For several years he had been hesitating in the construction of *A Tale of Winter* because he had not found the person who could make this scenario come to life. After months of converstions, he finally told Charlotte Véry that they might make a short film together in June, at the Île-aux-Moines. But suddenly the pace accelerated, and even before they filmed the prologue, she knew that a real feature-length film would follow, that winter. Rohmer wrote her a letter that rings like a wager:

I suppose your play had all the success it deserved. I knew I was not wrong to entrust you with the leading role in my next film, but it's always pleasant to have a confirmation, especially if it's as impressive as this one. I hug you very affectionately. Éric. P.S. Don't be frightened by my haste. My filming will be like the heroine: she has her obsession and makes up her mind very quickly.[29]

Once the filming was completed, Rohmer strongly reaffirmed (in a rambling interview with Alain Bergala) this parallelism between Félicie's story and that of the film about it: the triumph of faith, which miraculously transcends the anguish of choosing.

"There are no good or bad choices. What is necessary is that the question of choice not come up at all."[30] Félicie experiences this suspension of all questioning on two occasions: before the altar of the church in Nevers and before the stage where the Shakespeare play is being performed. What she feels then is a religious emotion, but one that can be expressed only through cinema. What other art could represent so truthfully the position of the spectator, a spectator who knows because he or she sees? It is this cinematic revelation that is at the heart of *A Tale of Winter*, along with the whole autobiographical subtext it presupposes (the young Schérer's trips back and forth between Paris and the provinces, his hesitations between this or that life choice, the discovery of *Stromboli*, in which the theme of his future work was foreshadowed: the cry, precisely, of faith resounding from the depths of the desert. For that revelation to take place, two conditions had to be fulfilled: the absolute acceptance of mediocrity, which makes the miracle in the next to last sequence all the more marvelous, and a return to the spirit of childhood incarnated by a little girl who holds the heroine's hand throughout the film, constantly jabbering incoherently—but nonetheless showing her a path of some kind.

This spirit of childhood, combined with Félicie/Charlotte's proverbial lack of education, alludes to the Christian tradition of the pure and the meek who will inherit the earth. It also alludes to the thematics of "celluloid and marble," as Rohmer's cinema had faithfully developed it: the idea of an excess of culture that had to be sacrificed to recover the right to see the world innocently. The famous "tears of joy" that ran down Blaise Pascal's face are here shed by a child, as if it were the first time. It is a semi-illiterate who senses all the beauty of Shakespeare's *A Winter's Tale*, with its fantastic invention and solemn declaimers, because she grasps it far beyond language.

That she is living,
Were it but told you, should be hooted at
Like an old tale: but it appears she lives,
Though yet she speak not.[31]

But in the scene where the dead mother comes back to life, where she finally offers herself again to her daughter's embrace, a third motif is revealed—which could lead us onto the terrain of psychoanalysis. What is cinema, if not the hope of re-creating the link to the mother? A mother who, to make films, had adopted the pseudonym "Éric Rohmer."

To Be or Not to Be

A girl and three boys in *A Tale of Winter*. A boy and three girls in *A Tale of Summer*. There the mirror effect stops immediately, because it would be impossible to imagine two characters more unlike than Félicie and Gaspard (the name given, with a wink to the Countess of Ségur, to the protagonist of the third *Tale*, whose genesis is mixed with that of the second, though it was made four years later). For the first time in years, Rohmer imagined a scenario around a male figure. This did not fail to cause him some problems, as he candidly admitted to Alain Bergala: "I felt myself somewhat uncomfortable, less at ease than if it had been a female character. [. . .] Who can say, I don't know, have I feminized myself to that point?"[32] The problem in question may have had another source as well. After all, Gaspard's masculinity is like that of the smooth talkers in *Six Moral Tales*, mired in their grandiloquent phrases and tendentious discourses. Like *La Collectionneuse* and *Claire's Knee*, *A Tale of Summer* is a vacation film, but one in which people spend most of their time analyzing their feelings so as to avoid having to live them.

Many, including Rohmer himself, have enjoyed commenting on the existential emptiness that summer vacations reveal in his cinema. There has also been much talk about the bad faith that characterizes his heroes (more clearly than his heroines), who are obsessed with the idea of applying to reality an interpretive system that reassures them. In *A Tale of Summer*, this emptiness and this bad faith recover their most literal meaning: that of the void and of the absence of faith. Here there is no longer any trace of the narcissistic veneer (in the manner

of Gégauff) that still adorned Henri (in *Pauline at the Beach*) or Alexandre (in *Boyfriends and Girlfriends*). The character of Gaspard is a man without qualities who expresses, with an overwhelming frankness, the sensation of his own insignificance. "It seems to me that the world exists around me, but I don't. I am not, I'm transparent, invisible. I see others, but they don't see me."[33] It wouldn't take much for this "invisibility complex" to take us back to the dereliction of *Sign of Leo*. In any case it reveals one of Éric Rohmer's secrets, beyond the bragging of his first films and the strident circular reasoning of his beginnings. An uneasiness that is not only the legacy of a generation confronted by the ideological chaos of the postwar period and the defeat of utopias (first of all that of the Christian utopia, which had become too heavy to bear for a young intellectual of the 1940s). An uneasiness that was primarily that of a subject powerless to define himself as such.

We can make fair use of this autobiographical key, because Rohmer himself did not hesitate to suggest it in the interviews that accompanied the release of *A Tale of Summer*. "Of all the films I've made, I think this is the most personal vehicle. Everything that is in this film is true. They are either things that I experienced in my youth or things that I noticed."[34] Or again: "I have carried with me the story of this film, which was in part inspired by events that occurred during my adolescence, for a long time."[35] We will not try to determine by close inspection exactly what these facts were or to dissect the confusion of feelings experienced—in the shadow of young girls in Tulle or of the adored but inaccessible Odette (who became Maud in the fiction). Neither will we linger any longer over a curious maternal tropism that once again seeks to make the platonic confidante play a privileged role in *A Tale of Summer*: "I will never forget our walks,"[36] Gaspard tenderly whispers to her at the end, as if to pay homage to a foundational experience that is supposed to have consisted in making love through words.

It suffices to note the constancy of a theme inaugurated in *My Night at Maud's* and further elaborated from *Love in the Afternoon* to *A Tale of Winter*, and developed in all its implications, even if they are the most anguishing: hesitation. More profoundly than Félicie, Gaspard is indecisive, waiting for destiny to decide for him among the three girls. First there is Léna, who is his heart's ideal choice, and whom he assiduously pursues despite the cruelties she inflicts on him (at least verbally). Then there is Solène, a vacation lover who tries to gain a more serious ascendancy over him. Between these two girls stands Margot, the

confidante we have mentioned. Gaspard tells her the smallest details of his emotional hesitations and at the same time pursues a flirtation with her that cannot be acknowledged. The young man's indecision culminates in a crucial question: with which one of these three partners will he sail to Cythera? That is, in the setting chosen for the film, to the Île d'Ouessant.[37] Through an irony of fate, a deus ex machina intervenes to free him from his doubts.

All through this long ramble within himself, other signs take shape. Like the first of Rohmer's heroes, Gaspard is very capable of using his eyes to take possession of space. That is the theme of a slow, silent prelude devoted to surveying the places where he looks for his beloved: it makes us think of Rohmer's early praise for Flaherty's *Nanook of the North* through the sequence of the hunter patiently waiting for his prey. The amateur hunter in *A Tale of Summer* also tries to control time, through thought. Whence the "habit of chance"[38] that he has acquired, which allows him to lay traps around a reality that escapes him. Traps that are just so many small, still clumsy devices—but that prefigure in their own way the great, subtle trap that cinema is, according to Rohmer.

On the Lookout for the Real

Does that mean that the filmmaker is taking revenge on his character (on himself?) by deploying so many certainties that the latter is unsure of himself? To draw that conclusion would be to neglect the phase of writing, which always brought Rohmer back to his demons of hesitation, groping, uneasiness. All the more so in the case of *A Tale of Summer,* for the reasons that we have already mentioned and that explain the long maturation of the project. He returned to it in the early 1990s, recording conversations with Anne-Sophie Rouvillois (who was perpetually undecided), trying out combinations of a male figure and three female figures who were at that stage designated only by letters. He worked out with excessive precision the relations that were estblished among them, as if to assure himself a stock of romantic material that he could later omit: for example the former liaison between the future Gaspard and Léna, or Margot's jealousy, far more explicit than it would be in the final version. He developed long digressions on the male or female character traits, or on the protagonist's psychology, his fear of looking others in the face, his desire to prove that he is a man, his unstable identity. "So, with me you're yourself?" his confidante finally asks him.

He: I don't know.

B: What? You said *yes*.

He: I'm certainly closer to myself, but what is my self? It's me with my dreams, and I've never dreamed about you. I wouldn't have imagined you in advance. You don't correspond to a true idea I might have had. But I think my mistake is to have ideas.[39]

The uncertainties are not limited to these preliminary versions. *A Tale of Summer* is one of the rare films in which Rohmer omitted a whole section of the text after it had been filmed. This was a passage in the long discussion between Léna and Gaspard on the beach, in which they both disappear into their rhetoric of resentment. A question of pacing? Probably. But also, for the director, it was the difficulty of controlling his actress's outbursts, which went beyond those of the character. Rohmer had given the role of Léna to the young Aurélia Nolin (the daughter of an actress he had met years before, Catherine Hubeau). In his office, he took photos of her siren's profile and her haughty figure. But during the filming she let herself be submerged by the emotions she was supposed to portray. Pascal Ribier explained:

> That long sequence began with a dolly out and ended with a shot of her going away. It was a nightmare! Because once, she headed in the wrong direction; another time, her partner was too far behind her—or else they didn't hear each other . . . And when the shot was finally good for both of them, she came back into the frame, saying "Was I good?," whereas Éric wanted her to disappear completely. As a result, this shot is loaded with everything that came before.[40]

It sometimes happened, as we have seen, that Rohmer made use of a certain discomfort on the part of his actor to give this or that situation all its weight of lived reality.

And then a few encounters accelerated the process of creation. Through Arielle Dombasle, Rohmer made the acquaintance of a young actor with whom she had just made Raoul Ruiz's *Fado, majeur et mineur*. He was not yet twenty-five years old, but his name was already well known: Melvil Poupaud. Ever since he was a child, he had played a great number of roles in films by Ruiz, Jacques Doillon, and Jean-Jacques Annaud. He had started playing leading men in the 1990s—not without a touch of obsolescence mixed with his handsomeness that

did not displease Rohmer. Moreover, the scenario retained several unutterable speeches redolent of the 1930s ("Tu aimes me mettre en boîte sur les points où j'aime m'y mettre aussi.";[41] "You like to make fun of me on the same points as I do"). Rohmer was a little worried about Melvil's ability to articulate clearly, especially on the beach, where a high-frequency microphone could not be pinned on him. He tried a little experiment: he turned up the radio to the maximum, went into his kitchen, and asked Melvil to read his text in a loud and intelligible voice. That was as far as his direction of the actor went. As was also the case with Trintignant and Quester, a mysterious delegation was established, a relaying that had no need of words. Tacitly, Melvil Poupaud understood himself as the double of an adolescent of earlier days, the future Éric Rohmer, whose present tics he silently made his own: the habit of rubbing his hands or biting his lips as a sign of indecisiveness. A photo taken on the site showed them dressed in the same way, with white polo shirts, straw hats, and dark glasses. Melvil was the ideal double who allowed the autobiography to be embodied.

There were other encounters: at a cocktail party celebrating Losange's thirtieth anniversary, no doubt by an arranged accident, Rohmer ran into his actress in *Pauline at the Beach*, Amanda Langlet, whom he had not seen in ten years. It was she who was to play the role of Margot, a name she chose (she said), but which was already written in the margins of the scenario. This time there was no question of constructing the character together in the course of desultory conversations. The text, nothing but the text. And when Amanda Langlet departed from it (long enough to make an off-color allusion, during her first sequence in the crêperie), it was not well received. As for the third woman in love, she would be played by Gwenaëlle Simon, a beginner who had invited Rohmer to watch her act in the theater, telling him: "I love your films, I love you through your films, and I'd love you to love me, too. That's all."[42] This self-assurance is perfectly in tune with the style of Solène, the "pirate's daughter" who takes Gaspard out on a boat and dictates his decisions to him. Moreover, Gwenaëlle Simon was from Saint-Malo, on the Breton coast, and that finally convinced Rohmer.

In fact he situated *A Tale of Summer* in Dinard, not far from Saint-Malo and from Paramé, which was where he had married Thérèse Barbet in 1957. A region to which he had had occasion to return later on, and of whose beauties he was well aware: the Solidor tower (which gave its name to a famous singer), the customs officers' path that winds around the beaches and lent itself to the long walks that constituted his vacations. It happened that Françoise Etchegaray was

well acquainted with a local filmmaker, Alain Guellaff, who did the job formerly entrusted to Jean-Luc Revol (for *A Tale of Winter*), and which was soon to be assigned to Florence Rauscher for *A Tale of Autumn*: that of a guide who prepared the terrain, introduced people, suggested places to film. It was in a shop he arranged to make available that the film's crêperie, called the "Crêperie du clair de lune," was set up and identified by a vague sign. That was all that was required for the crêpe maker across the street to call the police, complaining about this unfair competition! Françoise Etchegaray had to go to great lengths to calm the waters, while Rohmer shook with repressed laughter.

That was one of the rare infractions of the principle of discretion that he was determined to respect at every step in the filming of *A Tale of Summer*. Shortly before, he had spent a week on site with Diane Baratier, examining possible frames and locating backgrounds. The first day of shooting, they set off on a ferryboat with a small team that included no more than a dozen people. Rohmer had nonetheless granted himself the luxury of a script—but it was in part to please Bethsabée Dreyfus, the daughter of his friend Liliane of whom he had become fond and who remained his helping hand throughout his last films. The actors were asked to carry the equipment, and Rohmer himself pushed the dolly (another luxury that was allowed in order to accompany the characters' rambles on the beach). To limit a too spectacular use of the boom, high-frequency microphones were cleverly camouflaged: in Amanda Langlet's blouse, or in Aurélia Nolin's long hair. To avoid attracting groups of onlookers or people looking at the camera, Rohmer, made unrecognizable by his dark glasses and kerchief on his head, moved away from the filming team and waited for the crowd's curiosity to dissipate. Then he inconspicuously lifted his kerchief, which meant, in his coded language: "Action!"

La Fabrique du Conte d'été (The making of *A Tale of Summer*) has to be seen. It is a feature-length documentary put together by Jean-André Fieschi on the basis of moments filmed on-site by Françoise Etchegaray (among many other informal "making of" films made by her, which remain an archival treasure to be explored). In it the making of *A Tale of Summer* resembles a bizarre Balzacian conspiracy led by a tall old man with a masked face leading his little troupe onto strategic sites and communicating with his players only through signs. In fact, every detail was decided in advance, in the mind of the *metteur en scène* and in his preliminary discussions with Diane Baratier or Pascal Ribier. It remained only to make a few adjustments and to keep an eye out for the event that was

going to rise up within the shot. "Everything was planned," Melvil Poupaud reported:

> Éric had calculated the schedule of the tides, the statistics for the sun, he had scouted the sites a year in advance . . . When we were finally ready to start filming, he was very excited during the shooting, very attentive to the camera. That confirmed the impression that I had when he chose me: everything was already in place, everything was already framed, he was just waiting for reality to come into the field.[43]

To carry out this operation, three key elements were necessary: ruse (that is, in fact, meticulous preparation), silence (seeing without being seen), and capture (allowing the long-awaited object to suddenly appear). We have described Rohmer as a hunter; he could also be described as a vampire—a brilliant, perverse vampire, of course, one who used cinema's shortcuts to take possession of real life.

Real life continued all around, as it was secretly filmed in *La Fabrique du Conte d'été*. We see, for example, a cloud of sadness that passes across Amanda Langlet's face when the filming of her sequences is over and she has to say goodby to Melvil (a trace of this will be found in *Contes secrets*, a film about Rohmer's actors in which Marie Binet brings her together with her former partner during a melancholic interview). A moment of euphoria when, after having vainly sought the green ray, Rohmer consoled himself by dancing up a storm in a nightclub—he who usually strongly disapproved of his young collaborators' nocturnal excesses. An opening at a cinema, because it was the preview in Dinard of Claude Chabrol's new film entitled *La Cérémonie*:

> Rohmer waved to Chabrol from far off in the theater. He had taken his seat in a row where he was alone, he didn't want people to notice him, whereas he was all they could see . . . After the showing he hurried home. When I got back, I found him in the living room, looking at his rushes on the videotape player. As if he were comparing his work with Chabrol's, and saying to himself: "Is it really good?"[44]

As if what mattered was what his film shows him, Éric Rohmer: real life, once again, overflowing on all sides. Alongside the phantom of a young man who has not been able to seize it.

"I always notice the music"

What does *A Tale of Summer* tell us? Nothing, perhaps. The notion that fascinates the Gaspard in question, and with which he identifies himself. And at the same time, as we have said, the announcement of an artist's vocation that drops its clues all along the narrative without overtly claiming to be accepted as such. Because the character is still young and has not yet found his way. And also because of a crucial shyness in Rohmer: if he dared to insert quotations of his own work here (both retrospective and prospective), they are hidden quotations, figures in the carpet. A dark silhouette that passes in the street and stands out against a background of brightly lit signs—and it is a night sequence from *Sign of Leo*. A boy who fidgets before his reflection in a mirror, like Daniel Pommereulle in *La Collectionneuse*. Margot's knee dangled in the foreground, as if to evoke fleetingly *Claire's Knee*. Not to mention the indirect, underground, and constant metaphor constituted by music, the genuine representative of cinema within the film.

Music is omnipresent from the writing of *A Tale of Summer* on, through many a version of the sea shanty that Rohmer struggled to write. Arranged by Mary Stephen, the melody contains hidden echoes of *Percival*. The lyrics narrate the odyssey of a proud "pirate's daughter" who, in a first version, strangely resembled Félicie in *A Tale of Winter*:

> I've sought him for months, for years
> On land and on the oceans
> I've never found him again
> But he wasn't a dream
> Dream . . . Dream . . . Dream!
> Then suddenly he appears
> It's him this time, that's sure
> Yes, I see him, hear him, touch him
> I feel the freshness of his lips
> It's him . . . It's him![45]

Rohmer informed himself about the Breton repertory. He consulted Philippe Eidel, a specialist in Celtic rock music (a continuation of their discussions can be found in the film's dialogues). He tried to guide Melvil Poupaud, whose talents

as a guitarist helped define the musical color of the film, onto this terrrain. But Poupaud took a lot of persuading, even though he did adapt for his guitar the song Gaspard writes for his beloved.

This "pirate's daughter" was also to be sung to the accompaniment of an accordion. Even though that produced a few strident notes that Rohmer afterward enjoyed as a good joke.

> In that melody there are four or five successive keys. We'd found a sailor-accordionist in Saint-Malo: but these modulations could not be played on his instrument, which was diatonic; it could be played only in certain keys. That is why at one point in the scene he stops playing and starts singing. I didn't know about this distinction between chromatic and diatonic accordions! But it allowed me to enrich the film.[46]

An enrichment that was made from a poverty, more or less arranged, and a proclaimed amateurism: so that art can develop all its promises, it has to return to childhood and repeat its learning process before our eyes. That is the meaning of these sequences around Solène, in which a still imperfect score is awkwardly sight-read. And it is also the meaning of the exchange with the old terre-neuvas,[47] improvised like the others. On the pretext of singing a few classics of the sea shanty genre, it very naturally takes the form of a trial-and-error pedagogy.

In this way, *A Tale of Summer* suggests an artistic autobiography. In the conditions under which it was filmed (as they are shown reflexively in *La Fabrique du Conte d'été*), which offered the precise antithesis of the torments with which the character struggles: the privilege granted to doubt, secrecy rather than logorrhea, the capture of the changing aspects of the external world—which supplants the fear of being caught in the trap oneself by following the itinerary that is shown at the same time, and whose rhythm Rohmer respects as he might for a child. "If Gaspard seems indecisive," he explains,

> it is because he simply does not want to commit himself. It's an existential choice connected with a moment in his life, with this vacation, with his youth. Thus this indecisiveness may conceal a genuine indetermination. When I made *A Winter's Tale*, I gave it the provisional title *The Indecisive [Woman]*, whereas the heroine knows very well what she wants. But since what she has chosen

is impossible, she tacks back and forth between the boys she has met without choosing any of them. [. . .] Gaspard, on the other hand, has chosen not to choose.[48]

Until the little event that comes in extremis to deliver him from his nonchoice: the opportunity to leave his little lovers there by going off to La Rochelle to get back a tape recorder. A stroke of luck, in short. But a stroke of luck that may be, in Éric Rohmer's work, only one of the masks of art.

The Lover of Depth

The whole press saluted *A Tale of Summer* as one of the masterpieces of a film-maker who had become classical. Shortly before it came out in June 1996, the film had been screened at the Cannes Festival (where it was shown as the conclusion of the "Un certain regard" section). It drew more than 300,000 spectators in general release. That is less than the future *A Tale of Autumn*, and more than *A Tale of Winter*, as if the "cycle effect" gradually won Rohmer an increasingly loyal audience (that had already been the case for the two preceding series). The third tale elicited a real craze abroad—and especially in Japan, where Rohmer's cinema was adored: the handsome Melvil and his "pirate's daughter" became icons there, deliciously anachronistic, and with a very French youth. In this symphony of praise, a single discordant note made itself heard. It appeared tardily, however, and had to do with precisely the musical dimension of the work:

> The "sea shanty" that Melvil Poupaud writes laboriously and that one of his three girlfriends intones with apparent delight, as if it were by Jacques Brel, exasperates me because it is really insipid, both the words and the music, and I have the impression that Rohmer's rigorous but phobic aesthetics implies precisely that it should be insipid, in case (a prospect that terrifies him) it might risk breaking the line he wants, and produce an explosion of music, a momentary explosion, a foreign body.[49]

Signed by Michel Chion in *Positif*, these few lines struck Rohmer's sore spot. He even cited them bitterly in one of his last interviews (with Violaine de Schuyter), even though in general he never reacted to what was written about his films.

So what was this sore spot? The term "vocation" would no doubt be too strong—but it seems that the future Rohmer had felt, ever since his childhood, a pronounced attraction to music. An attraction that remained in suspense, as did his talents as a painter and his ambition to be a writer. Seventy years later, he mentioned this episode with muted regret: "I should have started piano in my early childhood: one of my aunts was a very good pianist, but she thought that I wasn't talented, and that it was better that I devote myself to my studies. They weren't incompatible."[50] From then on, he never ceased to present himself as a handicapped pianist: at the age of twenty, he did not even know how to play with two hands. Gégauff, who played with brio, tried to help him get back to the piano, but it did not work; when he finally returned to it (when he was past sixty, in the secrecy of his office at Losange), it was as if he were engaging in a pleasure that was vaguely guilty and that must not be allowed to be too widely known. Only a few friends and initiates were invited to share these moments of music with him: Deborah Nathan-Charness, the flutist in *Perceval*, with whom he pursued the dialogue through the mediation of the flute and the piano. Mary Stephen, his film editor, whom he liked to have sight-read this or that classical score (unless he made use of it to compose one of the kazoo melodies that he mischievously slipped into his films as a way of thumbing his nose at the "forbidden music" of *Six Moral Tales*). And, of course, Arielle Dombasle, to whom he offered the privilege of attending his recitals:

> Éric was very proud of having learned to play the piano so late in life. I already had a certain experience with music, and I hoped for something a little virtuoso—but it was completely analytic. He tried to explain every note in detail, in a laborious way, asking himself all kinds of questions about harmony . . . It made me terribly impatient! But I didn't show that too much, and I learned a lot.[51]

But she sometimes dared to contradict the master, if he denigrated Wagner or praised Schubert. As soon as it was a question of music, the polemic between them became a passion.

> For if Rohmer liked to play music, as an enlightened and obstinate dilettante, and liked to listen to it (a pleasure he enjoyed sharing with Françoise Etchegaray), above all he liked to talk about it. To compare the merits of different versions, to dissect the subtleties of a work, to inquire into the hidden underpinnings of

a genesis. "In this domain," Pascal Ribier says with amusement, Rohmer had hobbyhorses. He believed that Mozart had written inverted scores, that they contained a theme that could be rediscovered . . . He had asked me: "How can I do it? I have a recording that I'd like to play backward."—"I'll record it for you in reverse." He gave me his cassette. Then he listened to it, comparing it with the score.[52]

A trace of this interpretive madness is found in a book he published in 1996, the very year *A Tale of Summer* came out. He entitled the volume *De Mozart en Beethoven: essai sur la notion de profondeur en musique* (From Mozart to Beethoven: Essay on the notion of depth in music). At the outset, he declared himself to be an amateur musicologist, and did not mention his experience as a pianist (in an interview given to *France Musique* regarding this publication, he claimed to be barely able to read music!). But as the title indicates, he was an amateur who set extraordinarily ambitious intellectual goals for himself. A thousand miles away, a priori, from the "musiquette"[53] composed through the mediation of Gaspard.

In *De Mozart en Beethoven*, Rohmer touches, to be sure, on a few subjects that may seem futile: for example, the irritation he feels on hearing disks broadcast in public places (that was already the case in the 1930s, when the effluvia of popular songs rose up to his childhood room), or, on the contrary, the pleasure one might feel on falling asleep to the sound of a piece of music one has chosen. Along the way he reveals certain obsessions of his generation, as when he engages in a taxonomy of dances in relation to races and cultures (it was more prominent in the first version of the manuscript) or lingers at length on the German character of Mozart's genius. He finally returns, and this is no surprise, to the distrust that the cinematic use of music inspires in him: he sees in it simultaneously the "false friend"[54] and the "true sister"[55] of the seventh art. A false friend because it limts the objectivity and complexity peculiar to the image, with a few exceptions: Jean-Pierre Melville in *Les Enfants terribles*, with his fragments of Bach distributed in an arbitrary manner, or Marguerite Duras citing Beethoven in *India Song*. And especially Jean-Luc Godard, who also cited Beethoven in several of his films: as a rule, the music in question is the late quartets, the very ones that Rohmer introduced Godard to (he does not mention that) but whose reuse in film made Gégauff scream in protest (he recounts this in veiled terms).

Music is a true sister of film because the elected domains of these two arts are too close to have the right to fuse with each other: "The art of cinema is, basically, that of making us discover the melody, the secret song of beings and the world that ordinary perception conceals from us. The beauty it reveals, to those who have felt it, is more musical than pictorial in essence."[56] Here we recognize, almost word for word, a lyrical affirmation that was already made in "Celluloid and Marble" forty years earlier. Just as we recognize a Germanic musical pantheon that ranges from 1780 to 1820, and that Rohmer already at that time made the standard of universal beauty. But what makes *De Mozart en Beethoven* deeper is what Rohmer expects from this music, and what it alone can give him: an immediate access to being, which is the great conquest of nascent classicism beyond baroque esotericism or Romantic subjectivity. A kind of immense challenge that was issued at a certain moment in history and that it seems almost impossible to accept. Or at least very difficult to express: to do so, Rohmer multiplies philosophical quotations, from Hegel to Schopenhauer, and passing essentially through Kant (it was in fact the reading of a book on philosophers and music that triggered his writing this book). He presents extracts from scores to be sight-read and manipulates references and notes in a great solipsistic giddiness that inspired in critics no more than a polite silence—and a certain puzzlement in the reader. As if words were clearly exhausted by pursuing an ontological mystery that resisted them.

Chamber Music

A perpetual apprenticeship, an interminable analysis . . . These are indeed the weaknesses that characterize the anti-hero of *A Tale of Summer* and keep him in a prolonged adolescence. Éric Rohmer's sovereign response was to make *A Tale of Summer* in such a way that this *being* (so sought after by the mind) was able to express himself within the field of the camera. From this point of view, music constitutes a leading thread that allows us to divine the movement of his creation. For example, let us go back a decade to the period when Rohmer had his one and only play, *Le Trio en mi bémol* (The Trio in E-flat), produced on stage. There again, he acted as an "amateur author," taking care to desacralize the conditions of his work: "I wrote this text in the form of a play, but without thinking of the theater. I thought it could be integrated into one of my films. That did not

occur, but the management of the Renaud-Barrault happened to have the text in its hands, and proposed to produce it. I was delighted."[57] It is true that at the outset this test was to be the fifth episode of the *Adventures of Reinette and Mirabelle*. This is proven by a first version in which the character of Adèle is named Mirabelle, and finds herself struggling with a record seller who is as irascible as the café waiter in the second sketch. What has to be explained is that after having developed his text toward a theatrical form, Rohmer set out to look for a place that might accept it.

He first sent his play to Yannis Kokkos, his head set designer at the time of *Catherine of Heilbronn*. The response was enthusiastic:

> A few lines to tell you how much I liked *Le Trio en me bémol*, which seems to me a marvelous variation on the relations between Alceste and Célimène.* At least that's how I read it. I would really be very happy to participate in its production [. . .]. I have a feeling that the Théâtre Ouvert is not the right place for the *Trio*. Consider instead L'Escalier d'Or, where I am currently working. It is connected with the Théâtre de la Ville and seems to me to correspond to the spirit of the play as you imagine it.[58]

Yannis Kokkos designed a beautiful, simple set, very long, with the melancholic procession of the seasons in the background. But it was Pascal Greggory (to whom Rohmer had also given the play) who obtained the agreement in principle of Francis Huster, who was then artistic director of the Théâtre du Rond-Point. In August 1987 a contract was signed for a series of performances in this small theater, from November 28 to December 31. The length of time planned for rehearsals was ample: a little more than three months, in the course of which Rohmer was to direct his two actors like a demanding orchestra conductor, more strictly than if they were making a film. He adjusted their movements down to the millimeter, insisted on the articulation of every single word, and conducted multiple rehearsals in the Italian manner—as if to reinforce a mechanical knowledge of the text that would make it possible, when the time came, to rediscover it. He showed Jessica Forde, who had played Mirabelle and was now playing Adèle, films in which Brigitte Bardot appeared (as he had done with Arielle Dombasle

* The hero and heroine of Moliére's play *Le Misanthrope*.

for *Pauline at the Beach*), urging her to adopt that look and that pouty baby voice. But he did so at the risk of exposing her to the mockery of certain critics: "How can we believe in the innocence of Jessica Forde, whose blunders in both voice and movement are so staggering in such a place and under the direction of such a *metteur en scène*? How can we believe in the attachment of Pascal Greggory, whose tone is more right—even though he seems not really to know what to do with his body—to such a girl?"[59]

Rohmer cared very little about these wrong notes. Once the performances had begun, he left his actors complete freedom, and if he came back to see them, it was to marvel at the "little music" that was now produced all by itself. He liked to hang around this Théâtre du Rond-Point, which was still haunted by the shade of Jean-Louis Barrault, and where spoofs were sometimes staged in the main theater alongside performances of Corneille's *Le Cid*. On the occasion of Francis Huster's birthday, Rohmer even amused himself by exchanging his identity as Éric Rohmer for the cast-off garments of a phantom dear to him. He disguised himself as Wolfgang Amadeus Mozart and delivered before a camera a droll oration on the theme of the genius in search of an impossible reincarnation. It is in fact this theme of reincarnation that is central to *Le Trio en mi bémol*: since there could be no question of equaling Mozart, let us allow him to return in his initial freshness, in his spontaneous rediscovery by a young person. The male character (Paul) is a cultivated music lover who would like to influence the musical tastes of his former lover and faithful friend Adèle. Paul expresses many Rohmerian motifs: notably, the idea that the affinity between two beings is conveyed first of all by music. We also find a few characteristics of Loïc, the future librarian in *A Tale of Winter*, in Paul's desperate efforts to "cultivate" Félicie (and Shakespeare's play is in fact mentioned when they are discussing going to the theater together). Paul slips into a birthday gift a CD of Mozart's *Trio in E-flat*, which he has had the pleasure of hearing Adèle humming from memory. He waits for her to speak to him about it herself, but she does so only in extremis because she has not found the disk, which was too well hidden.

Another Rohmerian theme: that of the misunderstanding, which inspired *A Tale of Winter* and blooms tragically in *The Romance of Astrée and Céladon*. Until Adèle, by a miraculous coincidence, gives Paul the *Trio in E-flat* in turn. It is this miracle that he has been hoping for with all his heart. That instant when the other person, as if by chance, anticipates his desire for depth and takes possession of the being of which classical music is the program. The play stages all

this in the manner of a theorem—which would be a little dry if a real chamber orchestra did not play in conclusion the Mozart fragment so long awaited. It lacks, perhaps, the embodiment that constitutes the beauty of Rohmer's cinema (which did no harm to the *Trio*'s success with audiences and critics, or to its many later revivals by amateur theater companies). But in it is revealed, as we have said, the fantasy of reincarnation that runs through all his work: I disappear, and let young creatures live in my place.

From Video Clip to Video Clip

This phenomenon is expressed all the better in "small forms," in which Rohmer operates incognito. The video clip, for example, with which he enjoyed experimenting in the late 1980s, when television music channels and singer-actresses were flourishing. It happened that Rosette wanted to make her début in singing. To a melody by Jean-Louis Valéro, Rohmer polished lyrics for her that easily equal those for of "pirate's daughter" in terms of naïveté:

> Drink your coffee, it'll get cold,
> Drink your coffee, it'll get cold.
> Every morning you tell me,
> Drink your coffee, it'll get cold.
> But snug in my little bed,
> My little goose-feather bed,
> I wake slowly,
> Stretching carelessly . . .

Here we are not far from the *Trio in E-flat*, with this woman-child who has to be awakened, just as in the play she has to be awakened to great music. And here Pascal Greggory plays a similar killjoy role: that of the person who prevents people from sleeping too late, who determines the schedule and makes the coffee, performing this thankless task with a very Rohmerian rigor.

A rigor that was confirmed by a very precise mise en scène, with its short liminal shots that define the space of the apartment, or a stairway that winks at Murnau's *The Last Laugh*. However, the director engaged in a strange game of hide-and-seek by refusing to assume the artistic responsibility for his video clip.

In a letter to the journalist Olivier Séguret, who was guilty of having written about "Drink Your Coffee . . . " as if it were a film by Rohmer, the latter makes his position clear:

> You imply that this is one of my own works (or opuscules), on the same foot-ing as *The Green Ray* or *Reinette and Mirabelle*. [. . .] But the only thing I want to say and can say is that my role in the enterprise is that of producer. [. . .] This video clip is a means of "promotion" intended to touch the audience by its intrinsic value, not by its signature. In this is I am in conformity with what is currently done in the domain of promotion. I see no reason why an exception should be made for me. To put it clearly, I do not want my name to be used for the purposes of advertising. That is why I have ordered the publisher [. . .] to omit any mention of me on the cover, which in addition bears a completely unattractive photo taken by a stranger without my permission. It is not that I feel in any way dishonored to see my name associated with this enterprise. If Rosette's modesty tends to attribute [the song] to me, my modesty, equally great, would attribute its conception, in part, to Rosette.[60]

Modesty, really? The inferiority complex of an amateur who hesitates to affix his signature as soon as it is a question of music? A refusal to accept responsibility for the furtive, bare passages in the video clip in question? There is something of all that in Rohmer's reaction—and even the inverse, since in the end "Drink Your Coffee . . . " was to be very officially shown in theaters as a prelude to *Boy-friends and Girlfriends*. And there is, above all, the intermittent desire to cover his tracks. As if his work could exist without him, even through avatars as infan-tile as this one.

Not long afterward, he repeated and refined the experiment. Arielle Dom-basle was in contact with AB Productions to plan a video clip based on a melody called "Amour symphonique": in it she sang about her love of opera and her vocation as a great diva. This universe is far away from that of Rohmer, who did not care for the excesses of the German or Italian repertories (only Mozart's *Don Juan* was pleasing to his ears). He nonetheless decided, out of curiosity or friendship, to film this "Amour symphonique." Film in the literal sense of the term, since it was he who, at the age of seventy, held the camera. In the hall of the brand-new Opéra Bastille, he recorded a show that was anything but Rohme-rian: a troupe of dancers in kitsch bodysuits performing a sensual choreography

around a frenzied Arielle. To bring out her lyrical talents, he enjoyed composing a little pastiche: "Arielle had a melody in mind," he says, "but she is not a pianist, and she asked me to play the piano. Let's say that I pushed on the keys while she sang! That is how I vaguely contributed to conceiving a bit of opera that some-what resembles Wagner."[61] One could hardly be more humble, to the point that this "Amour symphonique" never appeared in Éric Rohmer's filmography.

However, it contains two signature effects that are as discreet as they are inimitable. One of them takes us back to *The Aviator's Wife*: in the penumbra in which the opera audience is plunged, Rohmer discerns a young man who is literally fascinated and who, at the end of the video clip, disappears into the tide of anonymous passersby. An almost imperceptible image, but one that confirms the ghostly status that the filmmaker secretly assigns himself. The other effect foreshadows a film that was not be made until ten years later. Inside the prosce-nium arch of the Opéra Bastille (filmed furtively during an interval), he stuck up images of Arielle the singer standing out against a blue background. This was already, in a crude form, the technique of superimposing on a painted backdrop that was perfected in 2000 in *The Lady and the Duke*. But that is another story.

12
Filming History

1998–2004

"History has always interested me," Éric Rohmer acknowledged. "I could have chosen history, I could have taught it, as I taught literature in my youth. But literature is also history, in a way. History interests me as such, that is, I love the past, I'm curious about it, I've read history books."[1] In Rohmer's work, this interest—which is transformed into a solid knowledge of history, and to which extensive reading, documentary work, and films testify—is combined with a state of mind profoundly oriented toward the past, its knowledge, and its preservation. He is not only curious about history; this filmmaker known for his ability to shape in the present his contemporaries' sometimes ephemeral conversations, habits, and fashions, devoted more than a fifth of his films (five feature-length films out of twenty-three) to history, all of them conceived outside the story cycles: *The Marquise of O, Perceval, The Lady and the Duke, Triple Agent,* and *The Romance of Astrée and Céladon.* Rohmer noted that "making historical films is a temptation for filmmakers, even those who are not especially interested in history. I think there are few filmmakers who haven't made films set in earlier periods."[2]

We would like to make an attempt to understand this "temptation" on the basis of Rohmer's two major historical films, which were made in the early years of the current century, during the last period of his professional life: *The Lady and the Duke* and *Triple Agent,* to which we will add works or projects that preceded and sometimes prefigured them: *Les Jeux de société,* made for television in 1989, and *Sophie Arnould,* an unfinished scenario written with Arielle Dombasle in the mid-1990s.

For Rohmer, filming history[3] has first of all a quasi-archeological interest: rediscovering, reconstituting, and recording, thanks to the camera, the ways men and women of the past imagined their times. This temptation is central to Rohmer's historical project.

"Film is first of all a tool for bearing witness," he declared. "In this sense, it is an archiving tool that allows us to preserve. It is interesting to try to reconstitute what would have happened in earlier periods if there had been film."[4] This impossible hypothesis—"If there had been film"—aroused Rohmer's curiosity: *The Marquise of O, Perceval, The Lady and the Duke*, and *Triple Agent* all place at the heart of the process of cinematic recording the reconstitution of a past way of seeing things, through a restitution of the visual, verbal, and mental context peculiar to the periods and the historical texts adapted. In *The Marquise of O*, in addition to the words, it is the ways of uttering them and also the gestures, emotions, attitudes, costumes, and interiors that are rendered "as they once were." In *Perceval*, the characters move in what seems to be a restitution of the mental universe of the Romanesque period, the thirteenth century of Chrétien de Troyes. In *The Lady and the Duke*, this work of reconstruction is taken all the way: the French Revolution is resuscitated and moves, even in its paintings, through effects produced by the digital superimposition of the action on ancient images. Finally, more classically, in *Triple Agent* it is a meticulous reconstitution of settings, costumes, photos, interiors of the 1930s, and the culture of Russian counterrevolutionaries in Paris that enables the filmmaker to "transform history into spectacle." Thus Rohmer does not interpret the past and never truly takes the place of the historian. But he reconstitutes the conditions of the possibility of a period's point of view, notably through an effort of visual and verbal archeology.

In his "costume dramas," Rohmer offers a historical portrait of a way of seeing. He situates the spectator at the heart of the story by assuming the systems of representation chosen and meticulously reconstituted. Contemporary spectators are asked to project themselves into the past. Rohmer does not "modernize" the past through film, he reproduces its experience. As he wrote apropos of *The Marquise of O*: "Rejuvenating the work does not mean, for us, modernizing it, but rather returning it to its time."[5] It is always a matter of "recreating the world as people of the time saw it,"[6] not from today's point of view, whether the latter is that of the contemporary imagination (the mythical view of history in Hollywood films, for example) or that of historians themselves (for whom history is written

on the basis of the present). Thus from this point on we enter into an extremely coherent system that we have called "filming history" in Rohmer.

Games and Songs of the Enlightenment

On November 9, 1987, Éric Rohmer signed a contract with the French television channel France 3 and the production company Initial for a fifty-two-minute film entitled *Les Jeux de société*. This was, for him, a relatively large project costing 2.5 million francs. In addition to the filmmaker's fee (100,000 francs), much of the money went to pay the actors. In six periods, there were thirty-five roles played by fifty-eight different actors and actresses, and this represented a quarter of the budget. These historical projects were also important to Rohmer, because they allowed him to escape routine, collaborating with dozens of actors and technicians, as he had in making *Perceval* and was soon to do again with *The Lady and the Duke*. These films were conceived as interludes, undertaken while he was working on his major series. Thus *Les Jeux de société* drew out a constant historical thread in his work, while at the same time filling an empty period between two cycles, *Comedies and Proverbs* and *Tales of the Four Seasons*. It was a way of escaping a system that was too coherent and repetitive, a way of varying styles, settings, and methods of filming.

Hence Rohmer began to work with the little production company, Initial, that was run by one of his former students, Denis Freyd,[7] who had attended his lectures at the Sorbonne in 1978 and wrote under his direction a thesis on Carlos Saura. In April 1987, Freyd founded his own production company, and one of its first projects was this adaptation for television of the *Histoire de la vie privée* edited by Georges Duby and Philippe Ariès.[8] Rohmer recalled this offer:

> One day, a young producer phoned me: "Would you like to participate in a series on the *Histoire de la vie privée*? I've bought the rights to the volumes edited by Duby." At that point I was relatively free. I said: "Why not, send me the books." The books were delivered to me; I found nothing, nothing at all, that could give me the idea of any kind of story for a film on private life. On the other hand, when I was young, after the war, I had read a little book on party games based on scenes of game-playing in Rabelais, Saint-Simon, Musset, Balzac, Barbey d'Aurevilly, and the Countess of Ségur, and at the time it made

me want to make a film. So I proposed this subject. My reading of Duby was not
very convincing, even if I'm certain that I could have found interesting things
in his work. But I will always prefer to read literary authors of the past rather
than historians. For example, Restif de La Bretonne or Sébastien Mercier. In
find much more precise things in them.[9]

This reaction of Rohmer's tells us much about his relation to historians: he pre-
fers literature based on history to their interpretations of history. Denis Freyd
considered approaching other European directors, with the idea of making an
international series for television. This was a failure; no other film was ever made.
Then he set up, for this film alone, a coproduction involving Initial, France 3, the
television channel La Sept, and Rohmer's company.

Rohmer took advantage of the theme set—"Parlor games, dealt with in a
diachronic fashion from the Roman Empire down to our own time, from the
point of view of the relations between private life and public life"[10]—to engage
in extensive documentation, as he liked to do.[11] He soon decided that each of the
games illustrated in his film should be related to a precise period in French his-
tory and to a literary text that made it the heart of its fiction.[12] Rohmer liked this
kind of meticulous restitution of the rules of the games, the costumes and décors
of the period, the words and the ways of saying or singing them (Old Picard for
Adam de la Halle,[13] classical diction and choreographies for blindman's bluff).
This is what Denis Freyd called in a letter "the desire that dialogues, costumes,
and accessories be true in relation to the games and periods chosen."[14]

In Rohmer's archives there are three files stuffed with notes, index cards,
photocopies and reproductions, and documents, all accumulated by Hervé
Grandsart, who is listed in the credits for his "historical research." He was the
person relied upon in that domain. He was not a historian by training or pro-
fession, but he was an expert and a collector who specialized in the periods
of the Old Regime and was capable of conducting extraordinarily meticulous
research in libraries or the National Archives in order to find documents, dis-
cover places, run down historical figures, and sketch their portraits. As a "detec-
tive of history,"[15] he provided the filmmaker with his historical raw material. "I
met Rohmer in connection with *The Marquise of O*," he recalled.

I'd been a messenger boy at Losange since 1973, a jack-of-all-trades. I'd started
there when I was very young, after studying history of art and law, and I never

left. At first, I defined myself as a "detail man." Rohmer needed certain skills that I could provide for him. For each of the history films, from *The Marquise of O* onward, I dug up documents, places, or I lent objects, accessories. Rohmer was seeking to recreate in minute detail atmospheres of the past, and seeking above all pictorial truth. He was not a man who loved objects, and in fact he owned few of them.[16]

For *Les Jeux de société*, Hervé Grandsart played a central role, accumulating documentation and scouting to find places to film, for example Bourrienne's[17] town house on rue d'Hauteville in the tenth arrondissement; the Hôtel de Sully, which belonged to the Caisse Nationale des monuments hisoriques; sites in the Marais quarter of Paris; the Château Rotonde and the gardens of the hermitage at Condé-sur-l'Escaut; and the Château de Beloeil in Belgium. Rohmer, for his part, sketched certain scenes inspired by the costumes and interiors of the period, documents that he submitted to the head camera operator, Luc Pagès. The filming of the six historical episodes was done three times a week between February 1988, for the Parisian sites, and June–July 1988 for the scenes in Condé-sur-l'Escaut and Beloeil. However, because of a long, continuous blue scratch on the negative of the Directoire sequence, the whole sequence had to be redone during another week of filming in late September 1988, the insurance company paying the sum of 102,673 francs for the damage. This was the first and only time that Rohmer experienced this kind of problem.

Rohmer was no doubt kept busy chiefly by his work with the legion of actors. He had been able to bring together several generations and groups of actors: friends, like Jean Douchet, Alexandra Stewart, Pascal Greggory, Françoise Etchegaray, Daniel Tarrare, Anne-Sophie Rouvillois, Rosette; young actresses he was currently working with and who were simultaneously acting in *A Tale of Spring*, such as Florence Darel and Éloïse Bennett. And a large contingent of students from the École professionnelle supérieure d'art dramatique de Lille, who had performed a play Rohmer had much admired at the Comédie des Champs-Élysées in February 1987, Arthur Schnitzler's *Anatole*.[18] It was with this troupe that he rehearsed the most.

The film was broadcast on France 3 in August 1990, as part of the *Océaniques* program, and was praised by a few columnists who liked the *metteur en scène*'s subtle art: "With these televised *Jeux de société*," wrote Marc Joyeux in *Le Quotidien de Paris*, "Éric Rohmer draws on history and scholarship to continue

to create his very particular kind of cinema and to amuse himself in complete freedom with his loveliest toy, language. We know that in that domain he is a true craftsman."[19]

In October 1994, Arielle Dombasle sent Éric Rohmer a thirteen-page typescript, "Les Vengeances bienfaisantes," a scenario based on the biography of Sophie Arnould, an actress and singer famous in the late Enlightenment, "the wittiest of the bacchantes,"[20] who symbolized the spirit and the torments of the eighteenth century. She was at the heart of the famous quarrel between the admirers of Gluck and those of Piccinni. "We worked on this project for two years," Dombasle said.

> I wanted to play an eighteenth-century singer. It was Éric who talked to me about Sophie Arnould. I was very taken with her. I wrote a short scenario and submitted it to him. He rewrote and corrected it; we worked together on this new version. With musician friends who played the viola da gamba and other ancient instruments, we exhumed this singer's repertory on the basis of historical documents . . . But the film was not made, I don't know why.[21]

Rohmer put Grandsart to work on this project. He collected a fine body of documents at the National Library, a treasure accumulated between November 1994 and January 1995. On the occasion of this plunge into the Enlightenment and the Revolution, Rohmer took a passionate interest in the period, and went to the theater to see eighteenth-century plays, notably entertainments by little-known authors (Fagan, Collé, Barthe, Forgeot) performed by Rémi de Fournas at the Cognacq-Jay museum in February 1995. It is certain that we glimpse here the historical impregnation that was to lead him to make his great work, *The Lady and the Duke*.

An English Lady in the Revolutionary Agony

In early 1998, Éric Rohmer came across an old issue of the magazine *Historia* in which there was a short article on an English noblewoman who had lived in Paris during the Revolution, Grace Dalrymple Elliott, and on her memoirs, *Journal of My Life During the French Revolution*, written at the request of the king of England, George III, in 1801. They were translated into French in 1861

and published by Michel Lévy Frères under the title *Mémoires de Mme Elliott sur la Révolution française*. It was a text that Rohmer had already read in part, because ten years earlier, while collecting documents for *Les Jeux de société*, he had had Hervé Grandsart photocopy a chapter on the Palais-Royal, the temple of gambling at the end of the Old Regime and the beginning of the Revolution.

As often happened with Rohmer, it was a detail that caught his attention: he wanted to find the town house where Grace Elliott stayed in Paris and whose address was provided in the magazine article.

> The author said that Elliott's town house still stood at a certain number on the rue de Miromesnil. I'm very interested in places: I was particularly struck by the fact that this house still exists, that it can be localized. And that gave me the idea for a film: a film that would be set in those places, precisely. The most curious thing is that I have since learned that the article was wrong: the building on the rue de Miromesnil was built after the Revolution, so Grace Elliott could not have lived there! However, without that error, I'm not sure that this article would have produced such a brain wave in me.[22]

This trigger, this revealing detail, exists, to be sure, but so does the content of the text: Grace Elliott's memoirs deeply interested Rohmer. First, there was a judgment regarding the Revolution that was very close to Rohmer's own, that of an "incorrigible royalist,"[23] as the English lady called herself in her memoirs. Grace Elliott, who had taken up residence in France in 1786, saw Revolutionary demands increasing and the king's sovereignty disintegrating, and then she witnessed with horror the fall of the monarchy, the execution of Louis XVI, the republican "excesses" and the demagogic drift of her only lover and confidant, the duke of Orléans, who had become Philippe Égalité and went so far as to vote in the Convention for his cousin's execution. For her, the Revolution was no more than a regression to a barbarous state disguised by the name of Republic, whose principal instrument was the guillotine.

But hammering this discourse home was not at all Rohmer's intention; he accused films about the Revolution of delivering a "judgment" (generally negative) and of lacking a "point of view." A point of view is neither royalist nor republican, but assumes first of all a singular way of seeing things that is conveyed by cinema, and only by cinema. In a director's statement, Rohmer wrote:

> Films naïvely seek to make us direct spectators of the events they relate and in so doing only render still more doubtful the truth they claim to discover. It seems on the contrary that an objective view can be achieved only through the filter of an initial subjectivity. In other words, a witness's testimony may well be partial, biased, mendacious, but qua testimony its existence is nonetheless undeniable.[24]

In Grace Elliott's memoirs, Rohmer had such a "point of view" and, moreover, a largely unknown document to boot: the event related as it was directly experienced by the narrator or heard from the mouth of a third party in circumstances always described in minute detail. "It offers us," Rohmer emphasized, "the history not only of a woman's trials, but also of her way of seeing things. And it is natural that a filmmaker would want take advantage of the boon of having such a text."[25] Rohmer had discovered not a literary masterpiece but an inhabited, embodied, detailed narrative that allowed him to imagine a film. "When I read it I found the film ready-made," he even said. "I admired the well-rendered dialogues, which I practically copied, and the very lively description of places. It was an individual destiny confronted by events that overwhelmed it. Situating a personal drama in historical circumstances is for me the best approach to history, what satisfies best my taste for authenticity."[26]

What finally persuaded him was Grace Elliott's ambivalence itself, the mysteries that surrounded her, that confused things, and ultimately transformed her into a typically Rohmerian heroine, with that contradiction between what she said and what she was, between what she wrote and what she did. She was no doubt a double agent, serving Marie-Antoinette with respect to England, and providing a mailbox in Paris for Charles Fox, an English pro-Revolutionary leader. Although she was harassed and monitored, she was still protected, notably by Robespierre, who saved her when she faced prosecution and then escaped the guillotine, even though she was then in prison as suspect. All these ambiguities made Grace Elliott a captivating figure for Rohmer.

Before launching into this historical adaptation—or rather, the better to launch into it—Rohmer asked Hervé Grandsart to examine, evaluate, and research the text. Rohmer did not request the aid of an advisor who was a historian or a specialist on Grace Elliott, even though there are some;[27] instead, he relied on his long-standing partnership with Grandsart, whom he described this way in an interview:

If I drew on my researcher, that is because he is very good with details. He knows all the pictures in all the museums and all the buildings in Paris, all the eighteenth-century houses. He knows exactly what an eighteenth-century window looks like, what the stone of the houses was like, the proportions of the rooms, the colors of the hangings, the way fruit looked, the quality of the clothes . . . That is the kind of thing I really care about, the kind of mistakes I don't want to make.[28]

Grandsart was in fact an expert on French eighteenth-century painting and furniture, an admirable connoisseur of Old Regime Paris, and had already worked on a film about the Revolution, Andrzej Wajda's *Danton* (1982). Rohmer gave him a twofold assignment. First, to assess the veracity of Grace Elliott's memoirs, which some historians suspect of being a forgery written half a century later. Then, to find the town house on the rue Mirmesnil where Elliott lived. "Sherlock"—as the researcher-detective nicknamed himself, consequently calling Rohmer his "dear Watson"[29]—set out in search of information. The results of this first Benedictine work: in late February 1999, Grandsart was able to show that Grace Elliott's account was indeed authentic, even if it includes errors written in her hand; on the other hand, he certified, in a "critical study of the house occupied by Grace Elliott," that the English noblewoman did in fact live at 31, rue de Miromesnil.

Reassured and excited by this initial research, Rohmer asked his sleuth to research exhaustively the places, people, and objects that appear in Grace Elliott's memoirs. Between January and April 1999, Grandsart accomplished a titanic amount of work, of which there remain in Rohmer's archives about twenty files in black spiral bindings. Finally, on March 17, April 15, and May 17, 1999, Grandsart proposed possible places where the filming could be done "within a maximum radius of forty kilometers around Paris," duly located, photographed, and commented upon. Nine places were envisaged, notably Bourrienne's home on rue d'Hauteville, which had already been used in *Les Jeux de société* and was to represent Grace Elliott's town house.[30]

Rohmer sometimes took part in this research, diving into albums of music and Revolutionary songs, visiting the places recommended by Grandsart. But he concentrated his efforts primarily on writing the scenario adapted from Grace Elliott's memoirs. Seven little school notebooks testify to this, bringing together all his notes and index cards. A thirty-six-page handwritten scenario

was created, and then an eighty-seven-page version, which was finally reduced to a seventy-five-page typescript dated January 1999 and entitled *L'Anglaise et le Duc*.

Experimentation in Images

How should the Revolution be represented? Alongside historical research, Rohmer reflected on the visual conception of his film. For a time, he considered using natural settings, but he was wary. He did not want to shut himself up in chateaus and eighteenth-century salons that had, moreover, usually been restored a century later. He wanted to film Paris and its exteriors, a Revolutionary capital with its vast perspectives, its squares, its streets in the grip of urban riots. In this regard, he feared artifice: How could the period atmosphere be reproduced in a studio, with fake paving stones and trompe-l'oeil façades? Could he film in the actual streets of Paris? He was not thinking of doing that, either: "The face of Paris has changed so much," he wrote in his director's statement, that no view of the Revolutionary period remains, even the rue Saint-Honoré, even the place de la Concorde, which has been disfigured by car traffic, and anachronisms lurk all along the street."[31] Rohmer did not want to cheat on what he cared most about—the mise en scène of space—or with what led him to choose this text—the narrator's way of seeing things. "If Grace Elliott sees only by fragments," he avers, "these moments have to have an absolute authenticity and integrity. She has to be able to see, and to make us see, on the morning of August 10, from her attic on the rue de Miromesnil, beyond the panorama taking in more than a kilometer, the flashes and smoke of the cannonade that has begun in the courtyard of the Tuileries; or, crossing the place de la Concorde, to cast with us a glance, even a furtive one, at the hundred-odd bodies that lie on it."[32] Rohmer wanted to "breathe with [her]" the air of those Revolutionary days. To that end he chose to superimpose the action, the characters and the scenes that he was to film on the only realistic background that had come down to him from Revolutionary Paris: its images, its paintings, its engravings, and immense treasury that historical research had just brought to light in connection with the bicentennial of the Revolution[33] and that he had been able to assess during his long visits to the Carnavalet museum, the richest in the world for this kind of sources.

Rohmer soon acquired an extensive knowledge of these images, works by Louis-Léopold Boilly, Hubert Robert, Pierre-Antoine Demachy, Jean-Baptiste Lallemand, or slightly later, paintings by Jean-Baptiste Corot and Horace Vernet. The style of *The Lady and the Duke* is that of the paintings and images of the period, approaching very closely a form of pictorial realism. The characters act in the visual universe that was their own, at least as artists of the time conceived and rendered it. Rohmer explained this in exemplary fashion in a long interview he gave to *Cahiers du cinéma* when the film came out, declaring: "I wanted reality to become a painting."[34]

So that this injunction might take form, he chose a singular technique: animation by superimposition. As early as 1990, he had taken an interest in this technique on the occasion, as we have seen, of a collaboration with Arielle Dombasle on the video clip *Amour symphonique*. "He superimposed me on the image," she recalled. "It was the first time he had touched a computer. He loved it, he was very amused by these visual effects. That was where the idea of using it to make a whole film came from."[35]

A decade later, these effects had become much more realistic and precise, thanks to advances in digital technology. "Obviously, one sees that it's faked," Rohmer commented. "It's not a question of achieving an absolute realism, but another kind of truth that for me overmatches the falsity of constructed or reconstituted settings. I wanted to recreate the broad perspectives of Paris, the grandeur of its panoramas, and this film, using that particular technique, made it possible to show a Revolutionary city as it had never before been seen in the cinema."[36] The fact that an eighty-year-old artist, used to the old, traditional ways of making films, envisaged using the ne plus ultra of digital techniques is so rare and astonishing that it deserves to be stressed.

However, we can understand this challenge in another way: Would Rohmer be able to master a film whose technology was so recent and experimental, a work whose filming promised to be complicated, with a great number of extras, and a very considerable budget? The filmmaker clearly asked himself the same question. He insisted on making a full-scale test on two short sequences: the rue de Miromesnil, daytime, when Grace Elliott leaves her town house in a carriage; and the arrival of this same carriage under the porch of a house in the rue de Lancry, at night, where the heroine, accompanied by a coachman, is received by a woman friend. Two views of the Paris of the beginning of the nineteenth century, reproduced with precision, served as models for the pictorial background.

On April 26, 1999, a small team gathered around Rohmer at the Duboi studio in Saint-Ouen, with two extras and Florence Rauscher, who played the English noblewoman for this test of superimposition.

For Rohmer, it "worked," he was convinced of it. He felt that through these new techniques of superimposition—which were ultimately simple and original—he had rediscovered the poetry of the silent film, an essential Rohmerian point of reference. The poetry of the films that dared to tackle Revolutionary lyricism: David W. Griffith's *Orphans of the Storm*, with its distinctive use of sets and painted backdrops, or Abel Gance's *Napoléon*, with its superimpressions of shots of the sea, animals, allegories, and paintings on images of the Convention, of Danton, of Bonaparte.

However, all that was expensive. An initial estimate foresaw a budget of around 30 million francs, by far the largest for any of Rohmer's films, twenty times that of *The Tree, the Mayor and the Médiathèque. The Lady and the Duke*: a Rohmerian blockbuster. In addition, there was the age of the captain and the relative inexperience of part of the crew: the head camerawoman, Diane Baratier, had never made a big film, and neither had the production director, Françoise Etchegaray. That scared Margaret Menegoz, the head of Films du Losange, who doubted the project's viability. The crisis came to a head in December 1999, on the occasion of an additional twofold uncertainty: the request for an advance on receipts was rejected, and the studio specializing in digital special effects, the Duboi studio, proved overtly skeptical with regard to the twenty-five minutes of superimpositions foreseen in Rohmer's work plan.

Then Margaret Menegoz tried to reframe the project. She wanted to impose on Rohmer an artistic director in charge of the digital effects, and then as his assitant she thought of Roger Planchon, who had just made a historical film, *Lautrec*, for Losange. Next she demanded a production director other than Françoise Etchegaray, and finally she expected Rohmer to provide a detailed explanation of the film, shot by shot, camera movement by camera movement. Éric Rohmer, who had founded Films du Losange thirty-six years earlier and was making his twenty-first feature film, did not accept any of these demands.

"We went our separate ways," Margaret Menegoz explained, giving her point of view.

Françoise Etchegaray refused to allow me to hire a production director . . . However, I was prepared to produce *The Lady and the Duke*, but on certain

conditions. They had, after all, worked on the film for almost a year, the historial research had been done, the sets and costumes were already being made, digital tests had been carried out, and almost all the money had been gotten together. When this disagreement got more serious, Françoise and I met with Rohmer on two occasions, and he wanted us to find a way to get along. But I no longer wanted to work with Françoise Etchegaray. I was hurt by this separation, it made me sick. I've never been able to see *The Lady and the Duke*, or even *Triple Agent* or *L'Astrée*, for that matter; it would have been too painful.[37]

Rohmer said little about this episode, which was painful for him as well, but probably also liberating—like the tardy emancipation of an eighty-year-old artist who finally takes responsibility for his freedom, including the craziest: an experimental film costing tens of millions of francs. In an autobiographical confession he said only: "During the 1990s, everything went smoothly. Problems returned with my 'costume' film, *The Lady and the Duke*. Its weight was too great for Losange, especially since the advance on receipts had been refused. Françoise Etchegaray and I called upon Pathé."[38]

In the first months of the new millennium, Pathé, a large production company directed by Jérôme Seydoux that specialized in popular films, did in fact rescue Rohmer's Revolutionary project. However, for a few weeks, uncertainty reigned. In terms of production, Françoise Etchegaray had only two (small) trumps in her hand: the Éric Rohmer Company could advance a little money, 2 or 3 million francs, to continue tests and the preparation for the film, and Canal+ and the producer Nathalie Block-Lainé guaranteed 8 million francs—in other words, hardly a third of the budget. "At first," Françoise Etchegaray recounts,

I found every door closed, as if by accident! We were in the middle of nowhere, with almost nothing, trying to keep a costume drama with special effects going . . . Then I thought of Hollywood. I knew that Coppola and Scorsese, and Lucas knew Rohmer, and for them, 30 million francs wasn't much. So I called Pierre Cottrell, an old collaborator with Losange who knew the Americans well. He had some doubts, then advised me to contact . . . Pathé. Why not? That had never crossed my mind, but I could always try: I asked him to serve as an intermediary.[39]

Pierre Cottrell was very close to Pierre Rissient, an old cinephile buddy of his who was an advisor at Pathé, for which he kept tabs on a few big names in international cinema: Jane Campion, Martin Scorsese, Clint Eastwood, Wong Kar-wai. Rissient had the ear of the firm's decision makers: François Ivernel, Romain Le Grand, and Léonard Glowinski. He explained:

> One day Cottrell said to me on the phone: "Do you think Pathé would be interested in Rohmer's film?" I passed on the proposal, and everything happened very quickly. It came at just the right time: Pathé was developing a subsidiary, Pathé Images, with films that had prestige and international standing, as Sony Classic and Studio Canal were also doing. Having a film by Rohmer in its catalogue was interesting for Pathé Images. There was a brief discussion about the budget, and perhaps the actress . . . I didn't look into that in detail, but on the whole it was a collaboration that went really well.[40]

Thanks to Pathé's involvement, the production of *The Lady and the Duke* was definitively arranged in the spring of 2000, and with the participation of Canal+, a small German company (KC Medien AG, headed by Dieter Meyer), and the European investment fund Eurimages, 38 million francs were amassed.

Although the break with Losange had a collateral victim, Hervé Grandsart, it sealed the close collaboration between Rohmer and Françoise Etchegaray. Clearly, he had preferred to make his film with her. Thus in January 2000, the "supervisor," also called "Etché," took control of *The Lady and the Duke*. She saved the production, chose the collaborators, dismissed some people, and prepared, with renewed enthusiasm, a filming that promised to be complex. Henceforth Françoise Etchegaray and Éric Rohmer formed a genuine professional couple, and this amused Etchegaray, who nicknamed herself "concubine no. 2":

> My darling, I learn with concern that a new concubine has expelled the other one. I am so sad that I am immediately taking a powder and going off to weep elsewhere over your culpable frivolity . . . Oh yes! I know that you are in the hands of concubine no. 1, so too bad, well done! Until tomorrow, unless some morning creature replaces the creature of the dawn. Without bitterness but . . . with disappointed tenderness all the same!! F.[41]

Little notes were also pinned up over Rohmer's desk or left lying on it: "Éric, I ran by and now I'm running off. I'll be there Monday afternoon. Love, F."[42] Or:

"Éric, I've got a tewibble code and am going home to bake some asbirin. It's the Easter code. Til tomowow, wuv, F."[43]

An Improvised Concatenation

In January 2000, even before receiving assurance that the venture would proceed, Françoise Etchegaray launched the preparations for *The Lady and the Duke*, using money provided by the Éric Rohmer Company. The first task concerned the technical work necessary to make an ambitious historical film: paintings, sets, costumes, accessories, the "rendering" of the Revolutionary atmosphere to which Rohmer was so attached.[44] The important research done by Hervé Grandsart could be used, and Rohmer himself followed things very closely at this stage. His realist obsession and fetishizing of the truth led him to an astonishing sophistication in detail. He went so far as to learn by heart the times of sunrise and sunset on certain Revolutionary days, August 10 and September 2 and 3, 1792, and also those of a solar eclipse that was visible in Paris on September 16, 1792, between 7:43 and 8:10 A.M.

The work on the paintings was already well underway. Rohmer met Jean-Baptiste Marot in July 1998, at the beginning of the project, knowing that outside views of Revolutionary Paris would be decisive for the visual success of the film. At thirty-six, Marot had already worked on painted backdrops for the theater with Stéphane Braunschweig at the Odéon; Alvine de Dardel, the head set designer for the Théâtre des Amandiers who had earlier worked on *Jeux de société*, introduced Marot to the filmmaker. Rohmer followed Marot's work very closely all through the spring of 1999, meeting weekly with him and exchanging references, research, proposals, and counterproposals. Marot explained:

> My specialty and my main plastic interest is perspective. Perhaps it allowed me to understand all the constraints and rigors of the camera. I had also worked a great deal with the techniques of chiaroscuro, of photography. Finally, I made use of new computer technologies to be extremely precise. I knew that a difference of a few millimeters could be catastrophic on the screen, making the characters look like they were walking fifty centimeters above the ground . . . Rohmer was very interested, very present. He was redoubtably precise, knowing how high the moon was on a certain evening, the distortions of perspective

in this or that street. For him, everything was important: the dates, the signs, the window frames. As in an investigation, nothing could be left to chance.[45]

Marot would begin by making a sketch; then Rohmer would imagine the movements of the characters, carriages, horses, and crowds within it, and approve the sketch. The angles and focal distances of the camera were calculated using the computer. Then came the execution of the actual painting, whereas the image, in a reduced format, was given to set designers and costume makers as a reference. Some paintings were inspired by existing pictures, views of the Pont au Change, the Pont Saint-Michel, or the church of Saint-Roch. The rest of the work was based on the sites, maps from the period, engravings in the Carnavalet museum, the first photographs of Paris made by Marville in the 1850s, before Haussmann's renovations. "As soon as I went outside in Paris," Marot recalls, "all I saw was what could be from the Revolutionary period. Drawing implies an intense visual concentration that focuses on the slightest details, a cornice, a balcony. I became obsessed with old Paris."[46] In all, thirty-six paintings of Paris and of the countryside around the capital, sixty centimeters by forty, were completed by the beginning of the year 2000, and served as backgrounds for seventeen minutes and fifty-seven seconds of film. It was a veritable collection of "historical paintings of the French Revolution."[47]

It took almost twenty people to realize the digital special effects for these seventeen minutes and fifty-seven seconds. When he had conceived the idea of digital superimpositions, Rohmer contacted, with Françoise Etchegaray and Diane Baratier, the main French company for special effects, Duboi, in Saint-Ouen, which had won fame in 1995 for its digital manipulations in *La Cité des enfants perdus*, a film by Marc Caro and Jean-Pierre Jeunet. Duboi then put together nearly twenty minutes of film that were hailed by the press and the world of cinema as a symbol of "innovation French style."[48] The company accepted Rohmer's proposal with interest, but remained skeptical regarding its realization and the somewhat old-fashioned rendering the filmmaker wanted. "Rohmer didn't like special effects," Françoise Etchegaray explained, "neither Hollywood's nor Duboi's; what he was seeking was more like a spirit of childhood: animated pictures, like those of magic lanterns."[49] In Rohmer's work, technology served first of all to return toward the origins of cinema, not to project oneself into a science fiction future.

After the first tests in April 1999, which were not very conclusive, a solution was found. Duboi served as a framework and infrastructure, notably thanks

to its large, perfectly equipped studio in Saint-Ouen, but it was a smaller company that was to produce the digital special effects themselves: the Buf company headed by Pierre Buffin, a specialist in animation known throughout the world, and also a former architect. He stood two meters tall and was culturally refined, an admirer of Ray Harryhausen and a connoisseur of nineteenth-century magic lantern slides and phantasmagoria. According to Etchegaray, "he immediately understood what Rohmer wanted."[50] Concretely, in the studio the team used a digital camera to film against a green background each scene that was to be superimposed in the postproduction phase; this presupposed a perfect adjustment, down the last centimeter, of all the positions and movements on the set. For this purpose, the space of the painted picture, with its perspectives, had to be projected on the floor by means of laser beams, a surveyor's technology applied to cinema by Éric Faivre and his small company, Les Ateliers de Bercy. This highly precise collaboration was indispensable for making the film. Ten collaborators from Buf worked for six months to create these special effects, between July and December 2000. Rohmer validated all the models in which the placement of scenes and different layers of light and the calibration of the background and the characters had been worked out and the elements to be added (birds, water, smoke, fires, skies) had been included. Then all these digital images had to be transferred to 35 mm film. The first attempts were catastrophic. In the end, this phase was saved by the intervention of Daniel Borenstein, who had explored this technique in Yousry Nasrallah's film *El Medina* and repeated this kind of transfer for *The Lady and the Duke*. The skies of the Paris region were thus preserved in extremis. Altogether, these operations cost 3 million francs.

For the remaining forty-seven minutes of the film, Rohmer used more classical techniques, which nonetheless required major and expensive preparatory work. Set designers, painters, portraitists, carpenters, cabinetmakers, graphic designers, costume designers, dressers, property assistants, makeup specialists, wigmakers, shoemakers, hairdressers, armorers, stuntpeople, specialists in horses and carriages—in all, fifty-seven collaborators representing about 15 percent of the budget, more than 4 million francs, of which 2.3 million were spent on costumes and 1 million on the construction and painting of the sets.

Rather than film in period interiors, Rohmer chose paintings as backgrounds, thereby giving his project an acknowledged pictorial ambition. The eleven interiors for this film (Grace's apartment, the house in Meudon, the Revolutionary tribunal, the Conciergerie, the hall in the Palais Royal, etc.) were all

conceived in the studio, in a single structure of hardly a hundred square meters, with movable partitions ingeniously arranged and covered with painted backdrops. It was the association of the construction manager Jérôme Pouvaret and the set designer Antoine Fontaine that allowed the realization of this extremely original conception—this "bricolage,"[51] as Rohmer liked to call it— chosen to be in better visual continuity with the external atmosphere of the streets of Paris painted by Jean-Baptiste Marot. Pouvaret had worked with Rohmer on *Les Jeux de société* and came from the scenography of expositions, working regularly with movable partitions. As for Fontaine, he had worked mainly in the theater (notably with Patrice Chéreau and Richard Peduzzi) and considered himself primarily a painter. He also took his inspiration from the documentation and the images collected by Hervé Grandsart. "The basic model for the interiors," he explained,

> was Grace Elliott's apartment. All that was fixed. I added the movable partitions, which made it possible to reconfigure the size of the rooms in relation to other places. It was a sort of quick change of setting. We moved the partitions, then we stapled the painted backdrops on the walls. Next we changed the openings to the outside and the furniture. And the following day, we filmed on a new set. Usually, this kind of film is made using two sets with fixed parallel sets. For *The Lady and the Duke*, everything was concentrated in a small space; that was faster, less hard to deal with. But it was also risky and tense: we had to move from one set to the other over the weekend so that the filming could continue Monday morning. That was a real challenge. But what pleased me was being able to move, in the same space, from aristocratic settings to much commoner ones, such as offices, a prison, the Revolutionary tribunal. It was a fascinating job.[52]

The conception and making of some two hundred costumes for *The Lady and the Duke* was entrusted to Pierre-Jean Larroque, who had already worked on *A Tale of Winter* ten years earlier and had in the meantime received a Caesar award for Roger Planchon's *Lautrec*. The costumes had to respect two priorities: verisimilitude and correctness in detail, Rohmerian watchwords. But also something to which Larroque was very sensitive, a satisfactory integration into the paintings, both interiors and exteriors, that could be defined as acclimatization. Beginning work in April 1999, Larroque had time to look for inspiration: the paintings of Boilly, Demachy, David, and Regnault, portraits of the new political leaders, medallions of Revolutionary celebrities, members of the National Guard,

and numerous illustrated fashion magazines. To these must be added regular visits to the Carnavalet museum and other places where old things could be found. This antique hunting led to a valuable discovery in the summer of 1999: a series of gouaches by Mallet representing the typical characters of Revolutionary Paris, extremely refined clothed portraits, precise and in color. Rohmer immediately liked the "very precise aspect"[53] and the true detail. The gouaches were to serve as the point of departure for several dozen costumes. Larroque says:

> Éric Rohmer [. . .] expresses his feelings and desires in very few words [. . .].
> If he isn't happy, he grimaces! [. . .] What matters more than anything is verisi-
> militude and concreteness. It is probably in that way that the historical "implau-
> sible truth" can manifest itself. [. . .] He does not succumb to the anecdotal, to
> what "prettifies" or makes "truer." [. . .] Sometimes the fragile and sensual side
> of the English noblewoman had to be revealed: the nightgown had to evoke a
> sigh of the body. [. . .] Her very beautiful cleavage is no less important.[54]

Rohmer also wanted actresses and actors in the film to wear period undergarments: the former wore corsets, petticoats, and stockings inspired by the period; the latter wore breeches and tight stockings, which was important for the characters' gestures and truth. "For example, the actress told me that she was a little uncomfortable,"[55] Rohmer commented.

Finally, hundreds of objects, pieces of furniture and accessories, appeared in *The Lady and the Duke*, all of them precisely listed by Hervé Grandsart and classified scene by scene in the spring of 1999. But they still had to be found. An antique dealer in Le Moutet, near Toulouse, Jean-Jacques Lecerf, proved extremely helpful. He provided the film's property managers with the furniture, dishes, toilet articles, games, tables, and office and administrative equipment they needed. To be sure, according to Gransart, who was very punctilious from this point of view, "everything is not perfect, far from it."[56] But according to Françoise Etchegaray, who negotiated the loan and the insurance on this collection for a little more than 400,000 francs, "it was an extraordinary Aladdin's cave. He had been collecting this stuff since he was fourteen years old. All these objects and furniture are authentic, and actually date from 1792, not from 1789."[57] As for the writings in the film—letters, notes, warrants, posters, signs, passports—they were entrusted to a talented calligrapher, Katell Postic, who took her inspiration from documents in the archives. All these experts formed a continuous chain

from the preparation to the filming to the postproduction, an improvised concatenation of technicians for whom Rohmer had great admiration and who gave *The Lady and the Duke* its truth.

Apocalypse Now . . .

Rohmer carried out major casting work, in cooperation with Françoise Etchegaray, to find fifty-three actors and actresses to play the fifty-three roles in the film. Not to mention the extras. The filmmaker began by drawing on the two drawers in his desk at Losange, the "girls" and the "boys," where CVs and photos had been accumulating since the beginning of the *Tales of the Four Seasons* series ten years earlier. Starting in summer of 1999, he devoted several afternoons a week to receiving these actors, both those whom he already knew and newcomers picked out from photos. In this way he had rather quickly chosen the actors for most of the main roles.[58] Serge Renko recounts an experience that many other actors in this film shared:

> Rohmer called me one morning, in late 1999: I'm preparing a film on the Revolution, and I have a role for you, it's a Girondin, Vergniaud, who comes from the Limoges area as you do; he's about your age and resembles you a little, do you agree? Do you like the Girondins?" We spent an afternoon together talking about the film, the character, the Revolution. He showed me a medallion portrait of Vergniaud, it looked like it could work. I read little things about him, then I did some costume tests with Pierre-Jean Larroque. That was important for Rohmer: he needed to see the actor in costume. A few months later, we rehearsed on Mondays and Tuesdays, and filmed on Wednesdays and Thursdays. It all went fast and well.[59]

The two leading roles, Grace Elliott and the Duke of Orléans, were also cast rather early in the process. For the former, Rohmer was lucky, as he acknowledged: "I've often been lucky with my films. I say that because I believe that it was really luck and not my doing at all. For example, to play Grace Elliott, I came across an actress whom I liked. I'd seen fifteen English films with English actresses who had been recommended to me and whom I didn't like. And Lucy Russell, I found her just like that, by chance."[60]

Chance was helped along, however, by placing a classified ad in specialized periodicals in England and with the main casting agencies. The filmmaker and Losange were looking for "a young English actress who speaks French well, blonde with blue eyes, for a film based on Grace Elliott's memoirs."[61] Rohmer had already rejected Emma Thompson, who wanted to make the film. Lucy Russell, for her part, had studied more than two years at the Sorbonne and spoke French fluently; she had worked in the theater, performed a dozen roles on the London stage, and made her cinema début in a friend's film, *Following*, the first feature-length film by Christopher Nolan, a young filmmaker who was later to make a name for himself. On August 19, 1999, Russell reported to her agent:

> Having read the ad, I'm sending you a CV, a photo, and a cassette of me speaking French. I read Mrs. Elliott's memoirs this morning, and I found a tone that reminded me of my grandmother. I think Grace Elliott was a kind of eighteenth-century Pamela Harriman,[62] with a remarkable life and an enormous amount of sang-froid. To cite Rudyard Kipling, Grace Elliott "walked with kings, and never had a common air." When I read the ad I was really very enthusiastic. I have high hopes of being cast for this role.[63]

When he learned of this letter, which had been sent to Losange by the English agent, Rohmer contacted Lucy Russell, who lived on Cristowe Road in London. "I knew Rohmer's name," she recalled.

> I knew it was quality cinema, but I'd never seen any of his films. At the time, I was working as a secretary in a bank to earn a living, and oddly enough my neighbor in the office was a fan. Rohmer was simply his favorite filmmaker. He lent me his videocassettes. I loved *A Tale of Winter* and *Perceval*. I arrived in Paris not long afterward. The first meeting at Losange was terrifying. I was awful. The language was too complicated. I knew it would be difficult, but not to that point. Rohmer was kind and asked me to come back anyway, he must have seen my potential. I was then asked to learn the text of the scenario by heart without trying too hard to understand it. That's what I did, but I continued to be bad. Rohmer terrified me and I stammered. He was patient, he thought I could master the language. I couldn't utter simple phrases like "Help me get ready." So I went to the Alliance Française in London and I was taught to make my mouth work. Say quickly: "Les chaussettes de l'archiduchesse sont-elles sèches?" And

also: "Tourne ton cou, Auguste, t'as le tour du cou trop juste." I love that last one. And little by little, I got better. What astonished me the most was that Rohmer never really had doubts about me.[64]

It was while watching Caro and Jeunet's *La Cité des enfants perdus* to form an idea of what Duboi's special effects were like that Rohmer noticed Jean-Claude Dreyfus, and especially his "Bourbon profile,"[65] as the filmmaker liked to call it. Philippe d'Orléans, Louis-Philippe's father, was in fact the cousin of the Bourbon brothers Louis XVI, Louis XVIII, and Charles X. Dreyfus, for his part, was a leading figure in French theater. Trained by Tania Balachova, he had acted with Lassalle, Régy, Rosner, Engel, Vincent, Savary, and Bénoin. He had lent his imposing physique and his deep, sensual voice to great authors both ancient and contemporary, from Shakespeare to Peter Handke. In the cinema, he had been widely used as a supporting actor—by Mocky, Corneau, Lelouch, Boisset, Pinoteau, and Marboeuf, filmmakers who were not really Rohmerians. But his energy and volubility pleased Rohmer, who saw in him an ultimately realistic incarnation of the duke of Orléans's ambiguous charisma: a man whom his admirers long considered a possible regent for a kingdom rid of the absolute monarchy, but who nonetheless revealed himself to be power-less, reduced to silence by the contradictions in which he got mired—until he met death under the Terror's guillotine. It was the first time Rohmer had hired a popular actor. Fabrice Luchini, Pascal Greggory, and Arielle Dombasle grew up with his cinema and had gradually become famous, in part thanks to him. In the case of Jean-Claude Dreyfus, things were different: Rohmer offered an important role to "Monsieur Marie," who had become one of "the most popu-lar persons in France"[66] through repeated television commercials for ready-made meals that had been running since 1986. A kind of Don Patillo or Mère Denis[67] on national television. Besides, Dreyfus is an attractive person with whom the filmmaker was soon to get along rather well, a very colorful figure in the Batignnolles quarter who owned two dogs, seven cats, and a collection of pigs of all kinds (stuffed, porcelain, fur, papier-mâché . . .), about 2,500 in number.

When Pathé took over the production of *The Lady and the Duke*, for a time the only question Rohmer was asked concerned the main actors who were sup-posed to carry the film. At Pathé, nothing was going to be forced on him, but they would nonetheless like the film to rest on shoulders stronger than those

of a young English unknown and on a renown more prestigious, especially abroad, than that of a promoter of good ready-made meals. Two names were suggested: Kristin Scott Thomas insistently and Gérard Depardieu greedily. "I had to force them to accept Dreyfus. Although he enjoyed a certain fame, it wasn't easy. Objections, and even suggestions, are always made,"[68] the filmmaker said. He also stubbornly defended Lucy Russell for the role of Grace Elliott. Pathé yielded.

On March 20, 2000, the filming of *The Lady and the Duke* began on Duboi's big, 1,000-square-meter set in Saint-Ouen, which had been rented for three weeks, to be followed by twelve weeks on the smaller, 350-square-meter set on the same site. This location, with its impeccable technical characteristics, cost 800,000 francs. For Rohmer, it was another world. In a way, he had been dreaming when he decided to make, at the age of eighty, a "Griffith-style" film. Faced with the reality, he was terrified, almost paralyzed on the first day of filming. "*The Lady* was *Apocalypse Now*," Françoise Etchegaray recalled. It was she who led Rohmer onto the big set at Saint-Ouen:

> A hundred persons were waiting there. When Rohmer entered the first day, he jumped back and left again: "Françoise, come here immediately! I'm sure that at least half these people are not needed!" I had to explain what each of the technicians present were supposed to do. He began by spending his time looking for those he could dismiss.[69]

That wasn't so easy: it was a large project, to be sure, but there was little fat to be trimmed. Rohmer insisted on relying on his usual pillars, who, instead of coming alone, simply had more help than usual. Dianne Baratier, the camera operator, had three assistants, including Florent Bazin, André and Janine's son, as first assistant; Pascal Ribier, the sound engineer, had two assistants as well as two sound-effects men; the team of electricians and machinists consisted of ten people. But the construction of the sets and the partitions, the stapling of the backdrops, the extremely meticulous preparation of the scenes performed against a green background—all that required skills and personnel. And the sweepers, about whom Rohmer immediately complained, were useful for keeping the backgrounds absolutely clean at all points during the filming.

Rohmer soon took the measure of this lack of measure. "What stunned me," Françoise Etchegaray goes on,

was how quickly he succeeded in coping with a hundred people on the set. He disappeared for two hours, he had two degrees of fever, he buried himself under a blanket, and I scolded him a little: "Éric, everybody is useful here, you have to come direct things, as usual . . ." Then, once I'd reasoned with him, he accepted the situation and threw himself into it. This man who had built his cinema on scenes with two or three actors was impressive in the crowd scene of the massacre at the Carmes prison.[70] In a single day, everything was put in place.[71]

Thus Rohmer changed his habitual way of filming: for the first time, he used a combo, a small monitor screen that allows direct video feedback of the shot. He moved away from the epicenter of the set and the actors. This more remote, somewhat isolated view helped him take his distance on the mass of technicians and actors, but did not prevent him from delegating his two intermediaries to change an angle, redo a gesture, inflect the collective movement: Françoise Etchegaray, who remained alongside him, and Bethsabée Dreyfus, his "companion"[72] and assistant for the extras. Rohmer was determined to retain, as he had before, a certain time for rehearsals, notably for the main actors and the scenes with a more developed text.

The filming ended on June 30, 2000, with the last shots in the film, in which each important character comes to face the camera and look the spectator in the eye. Françoise Etchegaray concludes: "He told me he'd imagined these shots the day before. He'd done something he'd never done before: he decapitated the characters. Stunned, I said to him: "You've decapitated them with the frame?" Then he was very happy: "Ah, you've seen it! It's very good!"[73] But there remained six months of postproduction for the special effects and the editing of *The Lady and the Duke*, which was entrusted, as usual, to Mary Stephen, who (finally) worked on her own with the filmmaker at her side.

Rohmer's Revolution

The viewing of the first working copy took place at Pathé on December 22, 2000, at 10 A.M. As he came out of the projection room, Pierre Rissient wrote to the filmmaker: "Dear Éric Rohmer, Seen this morning with pleasure, attention, your film—unique, fluid, mature—bravo and thanks. Personally, I didn't sense a problem of time, but I would be curious to tell you about a few considerations, if only

for the exchange of ideas about cinema, mise en scène, because several times I was stopped dead by memories and thoughts. It is not the film's least merit to remind us that the seventh art continues so much the others but cannot be conflated with any of them."[74] This first version of the film was two hours and fifteen minutes long. Between the lines of this friendly and cultivated note, we perceive a slight difficulty with the "problem of time." The management team at Pathé wanted to reduce the copy to run closer to two hours, but without entering into conflict with Rohmer. Pierre Rissient remembers:

> There were a certain number of little details that made the film look "amateur" in the negative sense of the term—extras, attitudes, poorly made clothes, a useless section of stairway. All that distracted attention a bit, it wasn't important but could seem annoying. Rohmer was very good about it. We were able to talk about it, and then I showed him the details on the editing table. He cut some bits, about ten minutes. We wanted the film to be as little rough as possible with respect to the audience. Everything was done gently, everyone contributed.[75]

Rohmer appreciated the gesture made by Pathé, and was aware of his responsibilities. He wanted the film to work, so he himself reduced *The Lady and the Duke* to two hours and five minutes.

Although it was ready, the film was not shown at the 2001 Cannes Festival, because it was not chosen by the selection committee. This launched a small polemic, some people seeing it as political censorship. It was thus the fifty-eighth Venice Film Festival that introduced *The Lady and the Duke*, deciding on this occasion to award Rohmer a Golden Lion for the whole of his work rather than put the film in the general competition. The filmmaker was very happy. He even agreed, at Pierre Rissient's request, to travel to Venice to receive his reward there. "Éric Rohmer wishes to be alone with his wife in his hotel (far from the Lido, and with two bedrooms)," Rissient wrote to Alberto Barbera, the director of the Venice festival. "Éric is still just as insistent that there be a single photographer for the award of the Golden Lion, who will remain at a respectable distance that will nonetheless allow him to do his work well."[76]

The ceremony took place on September 7, just before the official showing of *The Lady and the Duke*, which was applauded by the international press. Rohmer received a letter of praise from the French minister of culture, Catherine Tasca:

Your legendary discretion has long kept you far away from festivities, honors, and consecrations. Because you have made a moral choice, which is also an aesthetic choice: that of effacing yourself behind your films. [. . .] What you communicate chiefly through your works suffices and at the same time frustrates us. Secretly, we dream of breaching this rampart of discretion to enter into dialogue with you, to talk about your films, to hear your testimony and your opinions, in short, to benefit from your presence. The only reproach one can make to a great artist is that he has stopped creating. Our most cherished desire is that you will stay behind the camera for a long time yet. May this homage done you encourage you to do that. With all my admiration.[77]

The Lady and the Duke came out in France on September 5, 2001, in about fifty theaters. Copies were not distributed in large numbers. Pathé remained prudent—"They don't believe in the film,"[78] Françoise Etchegaray even thought. That did not prevent it from being successful: 44,133 tickets were sold during the first five days, for an excellent average of 865 spectators per copy. Admissions at L'Arlequin and Le Balzac, cinephile strongholds in Paris, ran to about 3,000 a week. The success was not only immediate but lasting: over twelve weeks, the film sold a total of 247,300 tickets in France.

The film also had great success abroad, in Italy, in Japan, in Britain, and in Germany. In the United States, *The Lady and the Duke*, after a preview at the New York Film Festival on September 19, 2001, and then a presentation at the Tribeca Film Festival in early May 2002, went into general release on May 10, 2002, and was widely discussed and praised. "Viva Revolution. So lovely but so reactionary,"[79] said Jim Hoberman in the *Village Voice*; "Pure visual poetry that captivates, and a graceful sense of space and time,"[80] Bruce Handy wrote in *Vanity Fair*; "An irresistible magic lantern show![81] announced A. O. Scott in the *New York Times*.

Rohmer received an enormous amount of mail about the film from spectators, most of them anonymous. This touched him greatly, even if he did not have the energy to reply to all of them. Let us quote two letters form well-known admirers. First, Maurice Béjart, the choreographer:

In the meanders of a long career I have never had a chance to meet you, so I am writing to tell you how much your film moved, astonished, amused, surprised, and dazzled me . . . Thanks for having once again made us think that true cinema still exists. Sincerely and admiringly yours."[82]

Second, the actress Jeanne Balibar:

> Your film is an incredible splendor, and on leaving the theater I was gripped
> by the desire, no doubt preposterous, to write and tell you how much I love
> your films and how important they have been for me. How much I loved, for
> almost as long as I have been going to the cinema, rediscovering them each
> year. [. . .] I must tell you what unreasonable love I have for Haydée Polit-
> off, Marie Rivière, and Pascale Ogier, and how much they are actresses who
> fill me with wonder, thanks to you. I should also mention Zouzou, whom
> I have never seen anywhere but in *Love in the Afternoon*, but whom I find
> overwhelmingly funny and elegant. For my part, I never write to anyone,
> and have always considered it somewhat obtrusive for an actress to reveal
> to a director her feelings with regard to his work. I don't know what got into
> me this evening, but I must say it suddenly seems to me more joyful than
> anything else.[83]

The reception by the French press was exceptional. The articles were many
and long, and placed the film at the heart of a veritable controversy, in the best
sense of the term: *The Lady and the Duke* was a film that people discussed,
weighed, judged, and criticized. "The Rohmer Revolution" was the headline in
several newspapers. For all of them, in fact, it was a revolutionary film in both
senses of the expression. Both revolutionary (in the sense of what impresses,
astonishes, dazzles) and a work on the Revolution, illustrating a certain idea of
the historical event that divided opinion and elicited debate.

Almost three-quarters of the critics' opinions of the film were generally pos-
itive.[84] This defense mainly involved praise for the film's form. Rohmer's experi-
mentation, plus a recognized mastery of mise en scène, led many columnists,
often in the most influential periodicals, to support a "revolutionary author who
is still young"[85] and who, at the age of eighty, had not had enough and redoubled
his audacity and risk-taking. The risk thus overcome led many critics to give pri-
ority to celebrating the film's form over an analysis of its royalist content. In *Les
Inrockuptibles*, Serge Kaganski, who had three months earlier denounced *Amélie
Poulain* as a backward-looking and reactionary film, almost "Vichyist," found
nothing objectionable in the clearly counter-Revolutionary import of *The Lady
and the Duke*, which was saved from opprobrium precisely by its revolutionary
form. He wrote:

An ideological indictment of Rohmer seems beside the point, because the film-maker evokes the mechanism of the Terror more than he criticizes the Revolution in itself, and because he is chiefly interested in the complexity of a woman and her oblique view of events, without having the intention to produce an overall, pamphlet-like image against the Revolution. *The Lady and the Duke* is a moving and fascinating portrait of a heroine, combined with a dazzling and singular formal purpose.[86]

In a certain way, Rohmer's work is the anti-*Amélie Poulain*: it is aesthetically revolutionary and politically reactionary, whereas Jeunet's film is rather left wing, with its nostalgia for the Paris of the people, but formally conservative.

We find the same kind of reasoning in the main forums of cinematic criticism. As Jacques Morice wrote in *Télérama*:

What, people worry about a royalist? A scandal? Not really. Each person is free to judge whether the regicide and the Terror that followed were a liberation, a horror, or a necessary phase. *The Lady and the Duke* has at least the merit of provoking a debate. But ultimately—and the film's ideological interest proceeds from this—it seeks less to defend this or that camp than to show the ambiguity and the compromises characteristic of each of them as soon as feeling gets involved. In its form—and that is what the film's exceptional interest resides in—it is an object so surprising and fascinating that dazzled, one can say: Rohmer is first of all a revolutionary author who is still young.[87]

This was soon reaffirmed by Olivier Séguret in a column in *Libération* entitled "A Model":

Royalist? Reactionary? Rohmer is always contested in the mode of a somewhat dubious political suspicion. Let us leave that aside, for once: the film-maker's implacable success in his mind-boggling cinematic enterprise has been confirmed over time as far more interesting than his possible, banally human contradictions. Because what Rohmer has achieved, no one before him ever achieved over such a long time. He has survived all the metamorphoses of the industry, when he did not anticipate them (he is clearly the true father of light cinema become digital). He has established, to the point of incarnating its archetypes, his creative freedom and his independence of mind.[88]

This plea on behalf of a Rohmer revolutionary through form was even made by Jean Roy in the Communist daily *L'Humanité*: "Let us vote to reprieve Éric Rohmer!"[89] he wrote with humor. This paper in the Jacobin tradition had no difficulty making itself the advocate of a royalist adversary.

Some periodicals, though in the minority, nonetheless insisted on emphasizing the ideological character of the film. On the left, the antiracist monthly *Ras l'front* attacked it vehemently.[90] So did *Rouge* and *Politis*. Jean-Pierre Jeancolas wrote:

> There are good political reasons for not liking Éric Rohmer's film. To the former aristocrats, elegant and suffering, he opposes revolutionaries whom he immediately discredits by their outward appearance: the representatives of the Parisian municipality are small, ugly, sly men, and the sansculottes of the Revolutionary Committees are hideous gnomes with baleful faces leering libidinously. This time it's the argument made by the propaganda films of the 1940s. It operates at a very low level.[91]

Angelo Rinaldi, in a column in the *Nouvel Observateur*, was also outraged: "This lacks the ambiguity that is one of the pillars of a living work. The Whites are always innocent of any fault, the Blues are always black. Monsieur Rohmer is the Brecht across the way."[92] *Marianne* was the most important left-wing periodical to make the case against *The Lady and the Duke*, "Le film qui enterre 1789" (The film that buries 1789), four pages long and opening with a clarification by Jean-François Kahn, the magazine's boss, entitled "L'aveu de la haine au peuple" (The admission of hatred for the people).[93]

It is certain that Rohmer's view of the Revolutionary crowds is degraded and degrading. The emblem of this rejection in the film remains the encounter between the frightened and disgusted Grace Elliott in her coach and the common people passing by in a procession, carrying on a pike the head of the princess of Lamballe, who had been killed on September 3, 1792. The iconography of this scene of horror is clearly counter-Revolutionary, and the nature of this Parisian crowd is related to that described by Gustave Le Bon in his famous essay of 1895, *The Crowd: A Study of the Popular Mind*, which pointed to the "popular madness" of the sansculottes' processions.[94] Pascal Greggory reports a revealing discussion with Rohmer on this subject: "When I told him," Greggory says, "that the revolutionaries in *The Lady and the Duke* were frightening, he replied:

"When you make a revolution, that's what you look like."[95] In Rohmer's work, the rejection of ideological excess, of the historical tabula rasa, is embodied in this phobic fear of the people that he hardly bothers to conceal.

On the other hand, the right-wing press usually expressed its support for *The Lady and the Duke*, surely seeing in it formal audacity but above all a "truth finally said about the Terror, the darkest page in our history."[96] In *Présent*, an extreme right-wing daily, Pierre Malpouge was jubilant: "Éric Rohmer makes his counterrevolution! For once, the Terror is not magnified. It's enough to make the unconditional supporters of 1789 grind their teeth. That tells you whether this film deserves an enthusiastic hat tip!"[97] In *Éléments*, a magazine in the royalist tradition edited by Alain de Benoist, a figure in the "new right," we find identical praise for a film portraying a "Terror finally unmasked."[98] But it was no doubt Marc Fumaroli who appeared as Rohmer's closest ideological supporter, in a long article published by *Cahiers du cinéma*, "Cinema et Terreur." Fumaroli, an erudite and brilliant professor, clearly resituates Rohmer's film in a long counter-Revolutionary tradition extending from Chateaubriand to Taine, from Burke to Griffith, a vein both literary and visual that gives the filmmaker's project all its depth. In this sense, *The Lady and the Duke* is absolutely faithful to Rohmer's view of the past, a view that had always mixed history and aesthetics: tradition is not behind us but ahead of us, it constitutes true modernity. It was by returning to the origins of cinema, indeed to pre-cinema and magic lanterns, that Rohmer rediscovered the counter-Revolutionary tradition, but he also advanced toward the most radical kind of formal innovation.

At the Sources of the Skoblin Affair

In 2001, Éric Rohmer was already working on another film. The success of his most ambitious project gave him a new burst of energy. He launched into a new historical work, which presupposed research, documentation, costumes, sets, and the casting of a relatively large number of actors and actresses—and moreover, in part in a foreign language he did not know: Russian.

He was inspired by a news item that made headlines in the late 1930s:[99] the kidnapping of the Russian General Miller, on September 22, 1937, right in the middle of Paris. Miller was the head of an association of White Russian officers in exile, the ROVS. Seven years earlier, his predecessor, General Koutiepov,

had also been kidnapped. The Soviet secret services were strongly suspected of having gotten rid of ideological adversaries in this way, executing them on Stalin's orders. The Red agents had surely benefited from complicities. Suspicion focused on Nikolai Vladimirovitch Skoblin, a former hero of the civil war and the president of the Kornilov regimental association, a leading figure among Russian emigrés in Paris. If he was not directly involved in the first kidnapping, he was at the heart of the second, that of Miller, whose confidence he had won through his almost filial piety. Skoblin was in fact a shady agent: a White Russian, he was supported by the Soviet secret services, but he was also in contact with Nazi Germany, having established relationships with Reinhardt Heydrich, the head of German espionage.

The interplay of the spies was complex: it was organized around the rivalry in Moscow between Marshal Tukhachevski, the Red Army's chief of staff, and Stalin. The two men were trying to eliminate each other. Miller, under Skoblin's influence, played the Tukhachevski card, and tried to win secret support for Tukhachevski from Hitler, Stalin's enemy, with whom Miller was in contact. But the Führer switched alliances, did not support Tukhachevski, and warned Stalin, who seized this opportunity to get rid of his rival through a "great purge" in the summer of 1937. Miller's kidnapping completed this purge, Stalin wishing to produce his testimony regarding the rapprochement with Nazi Germany at Tukhachevski's trial in Moscow.[100] As for Skoblin, he was to be spirited out of France to Barcelona, and then to Gerona, where he was liquidated by the Soviet secret services.

If the Soviets had a hold on him, it was through his way of life: he was comfortably set up in Paris in the company of his wife, the singer Pleviskaia, the "nightingale of Kursk," who had already been famous in the last years of Czar Nicolas II, before whom she had sung. She met Skoblin, who was wounded and sick, in Simferopol in 1920. They went into exile together, her husband organizing concert tours in Europe, before settling in Paris in 1927. Part of the money required for the couple's opulent lifestyle came from the Soviet secret services. Although he was an agent of the Soviets, Skoblin was an admirer and staunch supporter of General Miller, whom he nonetheless betrayed, ripped to shreds, and cornered in September 1937. The end of this incredible story came in December 1938, when Plevitskaia was convicted in the Paris Palais de Justice for "complicity in violence done to the person of General Miller." The singer was severely sentenced to twenty years in prison. Imprisoned at

La Petite Roquette in Paris, and then at Centrale in Rennes, she died there in September 1940.[101]

Rohmer was fascinated by this affair, and proposed an adaptation in his fashion. He inverted the relation between history and fiction cultivated in his historical films since *The Marquise of O* by taking as his point of departure a historical fact contemporary with his own personal history (he was seveteen in 1937) and by clothing it in imagination. This time he sought mystery, opacity. Everything remains deliberately ambiguous in his work: the characters are simultaneously more common, less flamboyant, and more mysterious, secret. Fiodor Voroninie, the spy inspired by Nikolai Skoblin, loses his prestige and his aura, but also his reputation and his evil powers as a traitor in the pay of the Soviets. He is not an ordinary secret agent, and first experiments with the trade through words: Where do lies begin? Where does truth end? What can he say, or not say, to his wife? What will she believe, or not believe? Divine or suppose? There is little action but more doubts, indecisiveness, complexity. Similarly, the female character is completely altered: the eccentric singer, a famous diva, becomes Arsinoé, a beautiful Greek wife, a painter whose health is shaky. The point was to preserve the verisimilitude of using the French language—the couple speak French to each other, they are no longer two Russian emigrés naturally speaking their own language in exile—and to balance relationships so as not to emphasize the traits of the conspiracy. In historical reality, Rohmer explained,

> this woman seems to have led her husband by the nose. She lived in luxury, and that is what witnesses gave as an explanation for the affair: Skoblin is supposed to have betrayed those who trusted him in order to get the money needed to pay for the way of life his spouse required. It was she, in a way, who made him a Soviet agent. In my film, the husband's betrayal is no longer about money, but about love: he wants to return to his country, and to take his wife to live on the shores of the Black Sea, in a healthy climate.[102]

Thus in Rohmer's film, the doubts concerning the reality of Skoblin/Voronin's betrayal are never resolved.

If the filmmaker refused to adhere openly to the betrayal thesis, that was also because he was told this story by Nikolai Skoblin's niece, Irène. The latter, as we have seen, had frequented Rohmer since the late 1960s. The young Irène Skoblin had inspired the two female characters in *Claire's Knee*: the brunette has her

character, the blonde her physical appearance. Her family narrative runs counter to the generally accepted claim that Skoblin was a traitor—not to make a hero of him, but to restore his complexity. Irène Skoblin explained:

> I think Éric expected me to reveal to him my uncle's soul, his ghost . . . I was probably the only person who could, thanks to the friendship and confidence we shared, shape the flesh-and-blood character for him. I told him from the outset that I didn't know whether he was guilty or not. [. . .] I was like a medium, I made people come back, live again. [. . .] What I would like to do is to re-establish doubt.[103]

Rohmer paid homage to her by sending her the third version of the scenario, in May 2002:

> The care you have taken to preserve the memory of your uncle touches me. Allow me on this occasion to thank you for having helped me prepare my film and express my hope that it will serve, if only indirectly, the cause of your family by opening up perspectives much broader than those in which historians have thus far remained confined. Of course, your name will appear in the credits: I mention [you] under the heading "Research and Documentation." I embrace you affectionately and hope to see you soon, your Éric.[104]

Éric Rohmer and Irène Skoblin worked together for two years, 2001 and 2002, seeing each other one afternoon a week: she told him the details of this story and sought and found documents, such as the indictment read during Plevitskaia's trial in 1938 and the singer's diary. She constructed hypotheses and participated in Rohmer's rewriting, or at least read and validated the various stages in the scenario. For his part, the filmmaker dissected the chief reference book, though it was hostile to Skoblin, Marina Grey's *Le général meurt à minuit: l'enlèvement des généraux Koutiepov (1930) et Miller (1937)*. He also met with a group of young Russians descended from the generation of the Paris exiles, from whom he requested rereadings and advice: Michel Eltchaninoff, a professor of philosophy at the Sorbonne and a specialist on Dostoyevsky; his brother Alexandre, an antique dealer and collector who was passionately interested in history and was president of an association providing aid to Russians who had settled in France; and Andrei Korliakov, the author of *Émigration russe en photos, 1917–1947*.[105]

Written notebooks, and then different versions of the scenario, piled up from April 2001 to June 2002. We find first a green school notebook entitled *Triple A. 001*—the first time the title given to the film is mentioned, a wink to the genre, and an original source through its numbering. These are notes that were taken on the basis of conversations with Irène Skoblin and notes on historical readings, index card portraits of each character, gradually evolving toward the elaboration of a story properly so called. Then come, in notebooks 002 and 003, Russian chants and songs, notably the *Song of the Young Workers* (1932), to music by Shostakovich with French lyrics by Jeanne Perret; notes on Russian history; digressions on Russian and German philosophy; and large fragments of dialogue. An initial thirty-page synopsis is dated March 16. Finally, the definitive scenario, typed from the manuscript version with additions and corrections, reached sixty-six pages in June 2002.

Triple Agent also had a private source and follows an autobiographical line. Rohmer, as we have seen, emerged from adolescence in the late 1930s, moved from Tulle to Paris, where he studied at the lycée Henri-IV, took a furnished apartment in the Latin Quarter, and hung out with a group of young people. From that period he recalled conversations, newsreels, and newspaper headlines, but above all manners, bodies, fabrics, colors, and sounds, such as the "squawking of swallows" and songs. Also, ways of pronouncing words, for example, the word that was then on everyone's lips, "fascist," which was said with an "ss" and not a "ch," as the following generation pronounced it. Here he situated himself in a personal way of seeing the period between the two world wars,[106] as had Resnais in *Stavisky*, *Life is a Bed of Roses*, and *Not on the Lips*; Truffaut in *The Green Room*; and Marguerite Duras in *India Song*. Rohmer willingly recognized this private contribution: "I show communist teachers like the ones I had [. . .]; foreign policy seemed complex. Nonetheless, there were quite a few pacifists."[107]

Rohmer acknowledged other references, "less my memories of the time than my literary memories."[108] Dostoyevsky's character Mitia Karamazov, or the atmosphere of *The Possessed*, a novel about another conspiracy, that of the Decembrists. "[Dostoevsky is] the author who inspired me most for this film,"[109] the filmmaker noted. We also find traces of Balzac's *Une ténébreuse affaire*, a masterpiece of which Rohmer knew several passages by heart. And traces of Joseph Conrad's *Secret Agent*, which Rohmer read and from which he gained "the idea of a history much stronger than the characters."[110] But there were also cinematic

influences. First of all, Alfred Hitchcock, with memories of *Under Capricorn*, a great paranoid film, and *Vertigo*, mystery incarnate. "Rohmer knew all that by heart," Françoise Etchegaray explained. "First, because he was a contemporary of the story recounted; then because he was a Hitchcockian: *Triple Agent* is *Vertigo*, people disappear into thin air."[111] To this we can add Fritz Lang's American films, such as *Beyond a Reasonable Doubt*, with its systematic doubt that undermines the spectator right up to the end of the story.

There remains another source which, oddly enough, Rohmer never mentioned: a short story written by Nabokov in 1943, "The Assistant Producer."[112] Vladimir Nabokov, a White Russian who belonged to the high aristocracy, had passed through Berlin and then Paris, where he lived from 1937 to 1939, at the time of the Miller/Skoblin affair and Plevitskaia's trial, and he was well acquainted with these events. He wrote an account of them during his exile in Boston during the Second World War; it centered on the eccentric character of the singer, " 'La Slavska': "Style: one-tenth gypsy, one-seventh Russian peasant (which she was originally), and five-ninths popular—and by popular I mean a whole salmagundi of artificial folklore, military melodrama, and official patriotism."[113] In Nabokov's account, Nikolai Skoblin becomes the "dashing General Golubkov," a tacky military hero essentially preoccupied with his own fame, a member of the Union of White Russian Soldiers, and a spy in troubled waters: "He was not only a spy with many talents (a triple agent, to be exact), he was also an excessively ambitious individual."[114] Golubkov situates himself at the exact intersection of the interests of the Nazis and those of the Soviets. The "triple agent"—written out in full and in italics in Nabokov's text—organizes with flaunted cynicism the kidnapping of his old rival and master, General Fedechenko, before disappearing into a halo of mystery. The story ends with La Slavska's trial ("humbly knitting in a corner"), her imprisonment, and wretched death.

This story is at the antipodes of the Rohmerian spirit: Nabokov's moving farce is scathing, manipulating grotesque puppets on the derisory stage of an implausible tale. But in it we find cited literally the very title Rohmer chose: *Triple Agent*. Is that why Rohmer—out of sensitivity, the pride of an artist burdened with such a precursor, and fear of the holders of rights to the work of the Russian-American author[115]—never mentioned this source? In any case, it is certain that he read Nabokov's story at the beginning of his preparation for making the film. The collection, entitled *Mademoiselle O*, was in his archive, with a bookmark (a mass transit coupon dated January 2001) placed at the beginning

of the story "The Associate Producer." Thus we can infer that at the beginning of work on *Triple Agent* the regular user of the Paris Metro read Nabokov's story with as much interest as irritation.

From *Vertigo* to Mortification

The success of *The Lady and the Duke* in autumn 2001 led Éric Rohmer and Françoise Etchegaray to think that for *Triple Agent* they would continue coproduction with Pathé. The estimated cost of the film wavered between 2.5 and 3 million euros, which was not high for a costume drama, but expensive with respect to Rohmer's economy. Pierre Rissient was optimistic in a letter to the filmmaker dated September 11, 2001, one week after the release of *The Lady and the Duke*:

> Bravo and Thanks, in well-deserved capital letters, certainly for the film, its quality, its qualities, its singularity, its integrity, its intrepidness, its acuity, among other things, but also for your extreme professionalism in promoting it, or is that the professionalism of Maurice Schérer? Must I admit that I sometimes think of Maurice Schérer (is that because I read your first texts, and met you when you were still M. S. ?) [. . .] This genuine success [. . .] leads me to tell you that all of us at Pathé Images wish to follow you in your upcoming ventures. It seems to me that we are not wholly undeserving of this privilege, because we have loyally followed you on this film, more expensive, and more risky, than others. Not going on together might look like a disavowal, and I don't think that is your feeling.[116]

However, a few weeks later, in spring of 2002, Jérôme Seydoux, the head of Pathé, rejected the project when he learned about the scenario. "He didn't believe in it at all, we didn't understand why,"[117] Rissient admits, embarrassed with respect to Rohmer. "One of his advisors convinced him to reject it because at one point Rohmer mentioned that he wanted to make the film in black and white. "That served as a pretext,"[118] Françoise Etchegaray said. Etchegaray, *Triple Agent*'s executive producer, set out again in search of financing—all the more necessary, because once again, Rohmer's request for an advance on receipts was refused and so was coproduction with Arte.[119] Seeking actors and actresses who spoke Russian, "Etche" turned to Dinara Droukarova, an actress who had been

launched by Vitali Kanevsky in *Bouge pas, meurs, ressuscite* and *Une vie indépen-dante*, and who had been living in Paris for the past few years. By chance, she happened to be the wife of Jean-Michel Rey, the director of Rezo Films, who got in touch with Françoise Etchegaray. "He immediately wanted to produce the film,"[120] she recalled. With the Euroimages fund and small companies in Italy (Bim Distribuzione), Spain (Alta Producción and Tornasol Films), Greece (Strada Productions), and Russia (Mentor Cinema Company), the Éric Rohmer Company and Rezo put together a budget of 2 million euros. The film was made cheaply, but at least it became possible.

During the preparation for *Triple Agent*, the filmmaker hesitated between several options for the filming. He fairly quickly gave up the idea of black and white, because he feared leaving an impression of nostalgia. In addition, he perceived that it was going to be very difficult for him to reproduce the system of superimpositions that had functioned for *The Lady and the Duke*. He had in fact thought for a moment of starting out from the 1930s type of image, from the French cinema of the period, inserting his own scenes into it through digital effects. He and Françoise Etchegaray set about viewing and collecting such films, but they were disappoined. The images of Paris life, especially the outside ones, were very rare in these works that had been made essentially in studios. As for documents of contemporary life, they were either focused chiefly on great events or presented too rapidly and disjointedly. Rohmer found only a very few stock shots, background images of Paris, and scenes that might really be suitable: a fine auto tour through the streets around the Concorde in Guitry's *Le Nouveau Testament* or crowds and onlookers on the quays of the Seine in Renoir's *Boudu sauvé des eaux*.[121]

In late January 2003, another indispensable preparatory task was tackled: the "Russification" of part of the scenario. A few translations were necessary, as was a rereading of the scenario and the dialogues by a "Russian eye," then the preparation of the actors and a follow-up during the filming. Through the actor Serge Renko, who was of Russian origin, Rohmer met Pierre Léon and his brother Vladimir, both of whom were film directors and also Russian on their mother's side. "First," Pierre Léon explained,

> there was an extraordinary coincidence. [. . .] It was a story that we had studied ten years earlier, being convinced that our grandfather was mixed up in it. [. . .] Thus we were ready to work on the film, we knew the affair well. [. . .] Then my work consisted, on the set, in being sure that the dialogues were

properly pronounced. Rohmer cares a lot about his text, he doesn't want any improvistion or approximation. So I attended all the sequences in which Russian was spoken. I was a kind of spy. [. . .] I had a headset, I heard everything that was going on, including among the extras. They were speaking in Russian, and it was important that they not say just anything, start talking about Yeltsin, Poutin, or even Saddam Hussein—which they liked to do."[122]

Rohmer also asked one of his actresses, Charlotte Véry, to paint pictures for the character of Arsinoé, who is a rather traditional artist working in a figurative genre that might be compared with the style of Tamara de Lempicka. With Charlotte Véry, Rohmer looked for pictures from the 1930s and 1940s in Paris galleries specializing in Russian or Ukrainian painting, genre scenes from which the young woman took her inspiration for a portrait of a child, a merry-go-round with wooden horses, a cat on a roof, flowers and bulbs, a Metro exit, a woman and children lying in the grass, and female swimmers on the beach in bathing suits—in all, fourteen canvases commissioned and selected by the filmmaker.

Obviously, choosing the actors was a crucial stage. To play the couple Fiodor-Arsinoé, Rohmer sought a Russian actor and a Greek actress, both of whom needed to speak French, which was not easy to find in French cinema. For the actress, Rohmer had viewed two films, Theo Angelopoulos's L'Apiculteur (The beekeeper), with Nadia Mourouzi, and Chabrol's Merci pour le chocolat (Thank you for the chocolate), with Anna Mouglalis, both of them of Greek origin. But Mourouzi did not speak French well enough, and Mouglalis was much too young. An agent who had French-speaking Greek actors in his team was contacted in Athens. He sent cassettes in Greek and in French to Paris. The first one Rohmer viewed was the right one: Katerina Didaskalou, an actress in her forties well-known in Greece—notably for having played the high priestess of Olympia, lighting the flame at three consecutive Olympic Games, between 1984 and 1992, posing as a Hellenic allegory on all the official programs. She had taken courses at the French Institute in Athens and at Columbia University, acted on the stage, in cinema, and especially in Greek television series. Rohmer invited her to Paris, where she met with him all one afternoon in his office.

On the other hand, finding a Russian actor who spoke good French turned out to be an insoluble problem. During the summer of 2002, Rohmer, who was very eager to work with a Russian actor, launched his search, thanks to Irène Skoblin, Sylvie Pagé, a casting agent, and Laurant Daniélou, who worked with

Rezo but had long been posted in Russia as a cultural advisor. In Moscow and Saint Petersburg the two women met about thirty actors, the kind of "handsome Russians in the their forties who please women,"[123] such as Sergueï Bodrov, Merab Ninidze, Valery Kislov, Alexis Batoussov, Karel Roden, Petr Václav, and Grigory Manoukov, the latter being the only one that Rohmer and Françoise Etchegaray were to receive in Paris, but in vain.[124] "Many actresses, and good Russian actresses, spoke French fluently, but few actors, especially between 40 and 45 years old,"[125] Irène Skoblin wrote on July 16, 2002. At the end of the summer of 2002, Rohmer and Françoise Etchegaray organized in Paris a casting session with Russian actors living in France, once again seeing about twenty people, including Alexis Sérébriakov, who had acted for Yolande Zauberman, and Dany Kogan, who had acted for Georges Lavaudant and Daniel Mesguisch. Another failure. Until early 2003, the filmmaker tried to find that rara avis, a male Lucy Russell or Katerina Didaskalou. Not succeeding, Rohmer decided to work with Serge Renko, who was of Russian origin and whom he knew well from having directed him in a sketch in *Rendezvous in Paris* and as Vergniaud in *The Lady and the Duke*. But Renko did not speak Russian. "I'd studied Russian at the lycée, and I'm of Russian origin, but I don't speak it, I can barely stumble along," Renko acknowledged:

> Françoise told me that there were only a few scenes in Russian, but that Rohmer wanted a real Russian. I'm an actor, so I can do accents . . . Éric and I read the scenario together. He didn't hide the fact that if he found a suitable Russian, he would take him instead of me. [. . .] In view of the scenario, and the quantity of scenes in French, it was impossible to hire a Russian. So Éric gave up, and decided in my favor . . . Then I told Éric that I knew someone who could help me: Svetlana Léon, the mother of Pierre and Vladimir, who was playing my aide-de-camp Tchernov in the film. [. . .] Svetlana had me work twice a week for three months. Finicky Russians will know, obviously, that I'm not Russian.[126]

Pierre Léon also worked with Serge Renko as a trainer for the scenes in Russian, to teach him to learn the language phonetically along with its musicality. "It was hard for Serge," he recalled. "I moved close to him, I said the words to him, and he really repeated the music. So long as he could retain it, reproduce it, it worked. But after a while, it got complicated."[127] There were only a dozen Russian sentences, but the management of the Cossack museum in Courbevoie, where

a scene in the film was made, was scandalized: Renko was stammering Russian with a . . . Ukranian accent.

Three months before filming began, Serge Renko and Katerina Didaskalou met . . . and got along well. The couple worked, and Rohmer was partly reassured. Two weeks beforehand, the Greek actress returned to Paris and the two "spouses" saw each other every day, and then every weekend during the filming. "Just before," Renko recalled, "there was a very amusing period in which I was rehearsing with Éric, who was playing the role of Arsinoé: it was hysterically funny! After two readings of the scenario, he wanted to stop so as not to wear out the scenes."[128] To complete the casting of the French roles, Rohmer chose Cyrielle Clair and Amanda Langlet, actresses he knew, and Emmanuel Salinger, a young actor who had made a good impression in Arnaud Desplechin's *La Sentinelle* and then in *Une histoire qui se dessine*, a ten-minute short made by Rosette in 1999. "He really looks like a communist student,"[129] Rohmer told his producer.

Rohmer and his usual group (Diane Baratier as camera operator, Pascal Ribier as sound engineer), aided by a team of some fifty people—technicians, machinists, electricians, builders, set designers, painters, dressers, wardrobe people, and makeup specialists—filmed from March 20 to May 15, 2001. Almost the whole film was recorded in the studio, with the exception of a few outdoor shots in the streets around the Porte d'Auteuil and near the Orthodox chapel on the rue Lecourbe. The studio was in Stains, in Seine-Saint-Denis, in the great northern suburbs of Paris. Rohmer went there every day by rail and managed never to miss his train back at 5:45 P.M. In studio 500, the filmmaker decided to continue an experiment close to that of *The Lady and the Duke*; on movable partitions, he used painted backdrops by Antoine Fontaine depicting interiors from the 1930s, in which the dominant colors were yellows, browns, and ochers. The somewhat outmoded atmosphere was heightened by the furniture, the objects, and the utensils, which were fairly typical of this old-fashioned vein. For the urban outdoor backgrounds visible through the false windows, a special photographic procedure was used: giant views of buildings around the Porte d'Orléans dating from the period were reproduced and assembled by Nicolas Leclère and Jean-Claude Moireau. The scenes in the Voronins' apartment, that of their communist neighbors, and of the the hotel at the end, were all filmed in this way. In addition there were ten days of filming in a rented house at Maisons-Lafitte, in the western suburbs, an empty building on lovely grounds that the decorators and property persons could furnish as they wished. A few additional scenes were

filmed in the Cossack museum—"which hasn't changed since the 1930s"[130]—and in a Russian restaurant on the rue Saint-Guiolaume in Courbevoie, as well as in the Cercle national des armées on the place Saint-Augustin, where the most spectacular sequence in the film takes place: a Russian dance, with the Ararat string quartet directed by Jean-Claude Tchevrekdjian.

Pierre-Jean Larroque and his team worked on about fifty costumes, using the documentation collected by specialists on the Russian community in Paris and Rohmer's precise instructions. Notably, regarding Arsinoé's wardrobe, which included a becoming negligee in light-colored satin and a sheath dress ordered by Fiodor from a dressmaker especially for the ball, in watered silk dyed in a green loaded with dark blue. "Without knowing it," Larroque explained regarding this cinephilic fetish, "she was wearing the ambivalent color of the heroine of *Vertigo*. Living and sacrificed, she is a body banished into a picture whose codes she does not know."[131]

On the set, a little off to the side, Rohmer sat behind the monitor, and sent Françoise Etchegaray to be with the actors or Bethsabée to be with the extras, in case some detail, word, or movement had to done again. Pierre Léon, who helped with part of the filming, recounts that Rohmer "has a kind of island all his own—almost entirely around the combo [. . .]. He rehearses a lot beforehand, but afterward his interventions are no more than adjustments. For example, as soon as someone has done something that looks like an actor's tic, he leaves his chair and runs over to attenuate it. That is the only kind of correction he makes: no remarks on psychology, dramaturgy, or placement."[132] Bethsabée Dreyfus confided that "he was nonetheless tired sometimes, I woke him up from time to time, we talked, we joked."[133]

The only worry concerned Katerina Didaskalou, who proved to be a romantic diva, with her good and bad sides. Among the latter: a decided narcissism that marred most of the two-person scenes. The actress sucked the blood out of the eyeline matches, destroyed the balance of the shot-reverse shots, and tried to throw off her partners, Serge Renko or especially Cyrielle Clair, of whom she seemed to be jealous. Katerina Didaskalou was one of the rare actors who forced Rohmer to do second takes, going so far as to throw herself at his feet and recommencing her melodramatic effects, bursting into tears and once crying theatrically to the stunned filmmaker: "You take me for a cucumber! I'm always badly dressed. I'm not a cucumber."[134] She later admitted that she "had been pushed to [her] limits by [her] passion for this role and by [this] unusual way of working."[135]

But Rohmer finally declared himself very satisfied with his film, and especially with the acting of his Hellenic discovery: "I was so eager to be able to contemplate my film as a whole," he wrote in late summer 2003, when the editing was almost finished,

> that my hand was almost paralyzed. The editing, like the filming, went very well. The film benefited from many strokes of luck, and the main one was having found you right from the start with the certainty that you were the one I was looking for. And you have, moreover, exceeded all my hopes. Every day these last two months I discovered in your acting nuances, refinements, a variety, that I had not always noticed during the filming and especially a quality of emotion that becomes more intense every time I re-view a scene that does not suffer from repeated passages over the "table" and that sometimes even becomes increasingly intense up to the fifth, the tenth viewing! Bravo. I embrace you affectionately.[136]

Triple Agent was presented, as a worldwide preview, in competition at the Berlin Film Festival on February 15, 2004. It did not receive a prize. The filmmaker, who had remained in Paris, and the two principal actors, who were in Berlin, were disappointed. One month later, the film opened the retrospective showing of all Éric Rohmer's films at the Cinémathèque française, in the old Théâtre de Chaillot. On March 17, *Triple Agent* went into general release. The critical reception was favorable, notably in the periodicals one might expect (*Le Monde*, *Les Inrockuptibles*, *Cahiers du cinéma*, *Positif*), but not wildly enthusiastic; thus the film went relatively unnoticed and was far from triggering a critical and political event like the one that accompanied *The Lady and the Duke*.

Certain letters pleased Rohmer, including one from his brother, René Schérer—"Dear Maurice, marvelous! It's more than I hoped for, thanks infinitely."[137]—and one from François-Marie Banier: "I'm stunned by this masterpiece. Éric, I congratulate you. What construction and what fluidity. The rhythm is pulsating. What choices in everything, actors, newsreels, music, colors, the stairway, the houses, the blue Citroën, the costumes. Respect."[138]

But *Triple Agent* was a box-office failure: only 60,000 tickets were sold, which saddened Rohmer all the more because he was convinced that he had made one of his finest films. "He didn't understand," Françoise Etchegaray recalled. "He was confounded. He thought he had made his *Vertigo*, and he rebelled when

he was told that people didn't understand *Triple Agent*. Moreover, he said that compared to *Vertigo*, his film was for choirboys."[139] But that place had perhaps already been taken: Christophe Barratier's *Les Choristes* came out on the same day as *Triple Agent* and attracted a large part of the audience and enjoyed a phenomenal success (8.5 million tickets). "Éric was very proud to earn money with his films," Françoise Etchegaray concluded. "Here, probably for the first time, he lost some and caused others to lose money. He was extremely mortified. He told me he was afraid he'd end up like Godard."[140]

13
A Tale of Winter

2006–2007

As an adapter, Rohmer never sought the obvious. He refrained from adapting Balzac or Dostoyevsky, authors who were his favorites and whose books he recommended to Jacques Rivette in the 1950s (the advice did not fall on deaf ears). He also refrained from putting Stevenson, another of his favorite writers, on the screen. And he long nourished the dream of adapting *The Master of Ballantrae*, an epic about the somber rivalry between warring brothers, to the point of making scouting trips in Scotland. According to him, these novelists were already *metteurs en scène*, and the cinema could hardly add any surplus value to them. To assert his powers as a filmmaker and thaumaturge, he had to base himself on a work that had more or less fallen into neglect. Or that had become difficult to decipher for a modern reader: to differing degrees, that was the case for *The Marquise of O*, *Perceval*, and Grace Elliott's memoirs. But from there it was a big step to seek out *L'Astrée*, Honoré d'Urfé's neglected, immensely long novel of the early seventeenth century, in which so-called Gallic shepherds redrew the map of love through many oratorical jousts and preposterous turnabouts, and Rohmer hesitated a long time before taking it. Especially since an initial and considerable pitfall presented itself.

Return to Sources

It was not so much a matter of adapting *L'Astrée* as it was of adapting an adaptation, or rather of realizing it with the greatest possibly fidelity. He owed this

adaptation to Pierre Zucca, an author of films whom Rohmer held in high esteem. Like most modern publishers of *L'Astrée*, Zucca chose to focus the narrative around its central theme: the love affair between the shepherdess Astrée and the shepherd Céladon, impeded by a misunderstanding that forces the young man to do penance and resort to trickery to finally get back together with his beloved. He kept a famous episode within these episodes, that of the magic Fountain of Love that allows Astrée to see her heart's desire again, through a marvelous metaphor that seems to anticipate cinema, or in any case an oneiric cinema in which Zucca deliberately situates himself as an heir of Jean Cocteau. He even accentuated the *mise en abyme* effects (already perceptible in the baroque structure of the text) by imagining a rather mad final sequence in which Céladon contemplates the body of the sleeping Astrée, which is transformed into a fabulous landscape while Céladon himself visibly shrinks. At the height of this fantasy, the film narrative takes us back to the present of the seventeenth century and to Honoré d'Urfé, who has just died without being able to complete his book.

A strange metaphor, this time, for Pierre Zucca's own destiny. After presenting his project to Margaret Menegoz (on Rohmer's advice) and then to Daniel Toscan du Plantier, both of whom found it too complicated to finance, Zucca died of cancer in January 1995. In a letter to Rohmer, Nicole Zucca thanked him for having constantly defended her brother's work, "that of an author who, like Molière or almost, died in spite of himself, virtually on the stage, having written the last word of his scenario literally the day before he died."[1] Rohmer's admiration for the man went so far as to lead him to consider making the cinematic *Astrée* Zucca envisioned. It was, after all, not the first time he had encountered Honoré d'Urfé's novel: when he was still teaching at a lycée, he had had his students read selected parts of the book. And when he was making programs for educational television, he had considered a project of adaptation proposed by George Gaudu, which bizarrely expressed the impossibility of filming *L'Astrée*. In it the novel's shepherds and shepherdesses were called together for a great, melancholy chorus by a narrator who supposedly kept his distance from the fantasy.

For other reasons, Zucca's scenario put Rohmer in an awkward position. First, he was not certain that he could show on the screen the ideal Arcadia evoked by d'Urfé, the country of Forez traversed by the waters of the Lignon (whose late twentieth-century equivalent is the department of Haute-Loire in south-central France). In early 1999, he did some casual scouting on site but

soon had to return to the preparation of *The Lady and the Duke*. "As for *L'Astrée*, which has survived all these years," Zucca's wife (who had accompanied Rohmer on his excursion) wrote to him, "I think it will wait a while to find out what its cinematic destiny will be."[2] Rohmer returned to it five years later, after making *Triple Agent*, but perceived the liberties Zucca had taken in his adaptation, liberties that were not in line with Rohmer's understanding of the text and that accentuated a fantastic or erotic dimension he dared not make his own. So he decided to go to the Bibliothèque nationale François Mitterand (a place he detested more than all others!) to read the five thousand pages of the complete text of *L'Astrée*. He found the only modern edition of the book too expensive. He wrote himself a letter of recommendation on the letterhead of the Compagnie Éric Rohmer, addressed to the staff at the BnF: "I ask you to grant M. Maurice Schérer a reader's card, so that he can prepare a film on Honoré d'Urfé's *L'Astrée*. [. . .]. The manager, Éric Rohmer."[3] Did he read from front to back this series of narratives embedded in each other, a rhetorical mirror effect that enchanted the courts of Europe? Certainly not. From this literary monstrosity, which has become terribly exotic in our eyes, he took in his turn only what interested him.

He was interested only in the love affair of Astrée and Céladon, the story that runs like a leitmotif throughout the book and that inspired the title of his film. For aesthetic as well as economic reasons, he set aside most of the motifs considered baroque, which in his opinion blurred the pure line of the narrative: the motif of the Fountain of Love we have already mentioned. And also that of the judgment of Paris, the pretext for Céladon going into disguise the first time in order to approach the nude Astrée. Present in Zucca's scenario, this simulacrum disappeared from Rohmer's, where it is recounted only after the fact. He also condensed situations and dialogues and eliminated characters: Sylvandre, for example, whose speech in defense of fidelity in love is put in the mouth of Lycidas. Along the way, he amused himself by imagining a dialogue version in Alexandrine verse, he who had read Corneille long before he discovered d'Urfé:

Céladon: Astrée, écoutez-moi. Répondez, je vous prie.
Astrée: D'un fourbe déloyal je ne suis point l'amie.
Céladon: Si vous êtes assise ici sur ces rochers,Serait-ce dites-moi pour vouloir m'éprouver ?,Car ils portent je sais le nom de jalousie,Mais sachez-le: jamais je ne vous ai trahie.[4]
Céladon: Astrée, listen to me. Reply, I beg you.

Astrée: I am not the friend of a faithless scoundrel.

Céladon: If you are sitting here on these rocks,

Tell me, is it to test me?

Because they bear, I know, the name of jealousy,

But know this: never have I betrayed you

But basically, as is shown by the different manuscript versions, Rohmer's work consisted in simplifying the characters' language, making the use of the imperfect subjunctive[5] more discreet. Not without hesitations, erasures, and rewritings. And without, for all that, completely eliminating all the archaisms. Thus the profundity that he took a mischievous pleasure in preserving, especially since it echoed the bravado of a female candidate for the presidency in 2007.[6] If we had to sum up in a single word Rohmer's rewriting of *L'Astrée*, we could say that it aspired, in the profusion of baroque artifices and mysteries, to emphasize the birth of a classical form.

The Traces of the Ghost

A somewhat ghostly concept, but one that Rohmer had never ceased to define, from "Le Celluloïd et le Marbre" to *De Mozart en Beethoven*—by way of the seventeenth-century pastoral of *Jeux de société* and Raphaël's arabesques by way of drawing. Since he could not accede to this improbable definition, he once again set about reconstituting its traces, its vestiges, its vanished representations. With Diane Baratier doing the lighting and Pierre-Jean Larroque the costumes, he looked to the Italian Renaissance painter Paolo Veronese and illustrations contemporary with *L'Astrée* in which the figures appeared in dress of the time of Louis XIII. He preferred to choose another anachronism suggested by Michel Lasne's engravings: shepherds dressed in the antique style, living amid Renaissance chateaus. He gave his photography director models less flamboyant than Veronese: Simon Vouet's mythological paintings, notably an *Amour et Psyché* that appears in the film. But for all that there was no question of composing a pictorial image, as Almendros had in *The Marquise of O*, or of shooting in 35 mm (as Diane Baratier initially proposed), or of a digital format (which would have required the use of a generator). The filming was to take place in Super 16, which would afterward be enlarged. And for the first time two cameras would be used,

the second one held by Françoise Etchegaray, who captured happy unexpected incidents on film: for example, Astrée's running after Céladon, which in editing opportunely replaced a shot in which the boy's hat flew off.

This more flexible arrangement made it possible to save time by avoiding variations in light between a shot and a reverse shot. Time was in fact limited in a filming during which Rohmer, doubled over with scoliosis, could move around only with difficulty, leaning on Bethsabée Dreyfus's arm or sitting in a wheelchair. Above all, it made it possible to give priority to the natural, as if the semidocumentary spirit of *Comedies and Proverbs* was disappearing into the isolation of a French-style garden. Rohmer even forwent modeling the drapery of dresses in accord with a strict pictoriality, in the manner of certain Japanese filmmakers or of Murnau in *Faust*. He told his actors to take this or that posture and was delighted when the wind came along to disarrange them. It is in that respect that cinema surpasses literature, and even painting. To the question "What do I add?," the filmmaker replied:

> Nature! In this novel, landscapes are mentioned but not described. The sense of nature that appeared toward the eighteenth century, with Jean-Jacques Rousseau, did not yet exist; one doesn't feel nature really living. Thus what cinema contributes is elements like wind (I was lucky to have wind) that are not at all in the novel.[7]

Moreover, he made it a point of honor to record the whole sound track directly, except for a few birdsongs that he was fond of and that were added during the mixing.

That is why he insisted on filming in places where there was not the slightest noise. As if the smallest detail might betray the twenty-first century. And that is why he quickly abandoned the idea of filming in Haute-Loire, the historical cradle of the Eden described in the book, which is now full of species of trees that did not grow there in the seventeenth century (to which it might be objected that there were no Gallic shepherds in the seventeenth century, either, but it is an aesthetic framework that it is important to call to mind, far more than an objective truth). He asked the advice of Jean-Paul Pigeat, who was the codirector of *Ville nouvelle* and who is now the curator of the Château of Chaumont-sur-Loire. "You are right," Pigeat replied,

The disastrous plantings of conifers spoil everything. Last summer I visited the Bâtie d'Urfé,[8] where the house has been rather well restored. But the environment is not great, even though that has to do especially with the flat geography of the site: it's a marshy area. To find beautiful country you have to go toward Boën and Montbrison. Honoré's Lignon is largely imaginary.[9]

The filmmaker's physical condition no longer allowed him to move around as he had earlier, to go camera in hand and sometimes accompanied by his actors to scout the locations that might be suitable for filming. It was Françoise Etchegaray who crisscrossed France looking for the utopian setting. She sent Rohmer postcards that amount to records of her travels. This one, for example, which lists the names of the chateaus she also inspected: "Here are the gardens at Villandry as . . . they no longer look now. The rest is all rain and mud, but the orchards are in bloom. From Vendôme to Chaumont, from Amboise to Chenonceaux (Barri), from Clos Lucée to *L'Astrée*, I'm thinking only of you."[10] She brought back photos and films in the course of a journey that lasted for months. Shortly before filming began, she finally discovered the place they had dreamed of: the valley of the Sioule, in Auvergne, which offered miraculously protected landscapes and, especially, a river deep enough (unlike the Haute-Loire) for Céladon to drown himself in.

On the other hand, the river ran so fast that Céladon's (attempted) suicide had to be signified by an ellipsis, a procedure Rohmer seldom used, but which amused him as it would a neophyte filmmaker. He also enjoyed, perhaps for the first time, "rigging" the perception of space, since it was on the banks of another river (the Beuvron) that the boy's body was washed up and found by the nymphs. As for the chateaus, Jean-Paul Pigeat put that of Fougères and that of Chaumont at the disposition of the film's team. Struck down by a heart attack on October 7, 2005, at the age of fifty-nine, he was never to see *The Romance of Astrée and Céladon*. The shooting at Chaumont was soon interrupted, because the Fête des Jardins upset the work schedule. Thanks to Françoise's address book, they fell back on a third chateau whose gardens were configured like a labyrinth. Rohmer adapted to this new unforeseen problem. He completely recut the scene between Céladon and the nymph Galathée, sending the latter down a blind alley where her amorous madness comes a cropper.

The Implausible Truth

Let us consider this taste for gaps, which we have mentioned several times. If Rohmer settled himself in an anachronistic structure, if he called himself a "preserver of the heritage,"[11] it was the better to encourage the gaps or rents that the present of filming deepens when confronted by a prestigious literary or pictorial past. In his office at Losange, he had Stéphanie Crayencour, a young woman he was considering for the role of Astrée, strike poses in the manner of Leonardo da Vinci's paintings. He liked the way she held her head and her generous bosom, as one might have said in the seventeenth century. Once the shooting had begun, the very contemporary slovenliness of the attitudes she struck and her diction did not quite fit the framework. Rohmer adapted. As he adapted to the cell phone that Cécile Cassel (the daughter of Jean-Pierre Cassel) concealed under the sleeves of her nymph's tunic. Or the relaxed style of Jocelyn Quivrin, another young, up-and-coming actress who had so much insisted on having a role in *L'Astrée* that Rohmer finally capitulated. In turn, he convinced her that his practice of a single take was well founded, despite the frustration it might inspire (as it did in Alexia Portal during the filming of *A Tale of Autumn*). He reminded her of the counterexample of the Russian cinema, where every shot was loaded with the maximum intensity. For his part, Rohmer preferred the actor's irregularities that gave his story the imperfection of life.

Being aware of this, and the risks it implied for the quality of their performance, some actors limited the terrain in advance. That was the case for Serge Renko, who was used to Rohmer's cinema and played the role of the druid Adamas (which was originally to be played by Pascal Greggory). It was also the case for a newcomer whom Françoise Etchegaray had discovered in a theater class when they had almost given up hope of finding an actor to play Céladon in the film. Rohmer had long been thinking about a boy named Thierry Amiel, who was a singer and had no desire to become an actor—and whose tests, moreover, had turned out to be unpersuasive. When Rohmer saw Andy Gillet come into his office, with his androgynous beauty and the elegance of a Greek statue, he had only to listen to him read a few lines of Racine to be immediately convinced. "Éric had me meet Andy," Serge Renko recalled, "and then I called him to ask if we could meet to prepare our scenes. I had worked hard on d'Urfé's text; I must have spent two months finding the music of the language, of these very

long sentences full of interpolated clauses . . . I saw that Andy had done exactly the same work!"[12] Work that was all the more necessary because the scenario included a long theological discussion on the comparative merits of paganism and monotheism. If they were unhappy with a scene while they were filming, the actors arranged a little code: a wink to Diane Baratier, who would accidentally(!) drop the camera so that they would be forced to start over.

The only other reason to start over (or not to keep the scene during the editing phase, as is shown by Bethsabée Dreyfus's script reports) was not respecting the text as it was supposed to be spoken and articulated. On this point, Rohmer remained inflexible, though he did accept, here again, slight deviations from seventeenth-century pronunciation. Alain Libolt, whom he asked to read a few extracts from *L'Astrée* in voice-over, remembered that at the time of *The Lady and the Duke*, the filmmaker regretted there was no record of the sound of the contemporaries of the Revolution. We recall his requirements concerning the prewar pronunciation restituted in *Triple Agent*. In the present film, he was well aware that he was walking a tightrope: "There are impossible pronunciations. [. . .] one cannot have actors say '*Il étoit*,' '*je voudrois*,' '*C'est moué, le roué!*' That can be done in the theater—but the cinema is an art that addresses a larger audience; the beauties of this prose would disappear if part of it struck the spectator as ridiculous."[13]

This was a danger posed above all by Céladon's final disguise; he dresses as a woman in order to see Astrée again. She has forbidden him to reappear before her, and he is prepared to respect this taboo to the point of absurdity. How can a spectator in 2007 be expected to accept such a situation, which is conventional in the baroque repertory but collides with the classical and modern predilection for the verisimilar? Rohmer did not make up his mind to use a subterfuge that was too obvious, which would consist in having a woman's voice read Céladon's lines in this scene. For his part, Andy Gillet was overtly hostile to this procedure and tried to prove that he could speak in a falsetto (which resulted, at best, in giving him the hoarse voice of a heavy smoker). In the end, they decided, on Pascal Ribier's advice, to use a subtle and almost imperceptible technique, postsynchronizing the scenes in question, which made it possible to distinguish Céladon's voice from the sounds around him, and then reworking this voice with the help of the Institut de recherche et coordination acoustique/musique. "My cinema is realist." Rohmer insisted. "There, I was taking a risk, I wasn't sure. That's why I made sure that Céladon and Astrée were about the same height.

I disguised him with a wimple, so that he would be less easily recognizable. We tried to hide his chin as much as possible."[14] In fact, it was less verisimilitude that was sought than an implausible truth that could be embodied, precisely, only by the realism of Rohmerian cinema.

A Film That is Too Much?

Walking a tightrope, we said. Françoise Etchegaray succeeded in financing *The Romance of Astrée and Céladon* without encountering too many obstacles. Notably, thanks to an unhoped-for subsidy granted by the CNC; this, combined with the European coproductions associated with Rezo, made it possible to raise the (rather modest) amount of money Rohmer had set as his goal. But the film was to prove to be a very vulnerable project. First, because of several blunders on the director's part that bordered on masochism. He incurred bitter reproaches by failing to inform Sylvie Zucca regarding the development of his project, and by embroidering explanations in his interviews meant to distinguish his *Astrée* from Pierre Zucca's scenario. "I don't understand, Monsieur Rohmer," Zucca's widow wrote to him. "On the one hand, you recognize that Pierre was a great filmmaker, and on the other, as if in a blind spot, you interfere with the memory of his last years. Probably I am the only one touched by it."[15] In truth, for Rohmer it was chiefly a matter of scrupulously justifying each of the licenses he had taken with regard to his sources of inspiration. That is what led him to a second and more serious blunder: a notice placed at the end of the credits, to which he doggedly clung despite his producer's warnings. Here is what it says: "Unfortunately, we have not be able to situate this story in the region where its author placed it. The plain of Forez is now disfigured by urbanization, the widening of roads, the narrowing of rivers, the planting of conifers. We had to choose another part of France as the setting for this story, landscapes that have preserved the essence of their wild poetry and their bucolic charm."

One can easily imagine the reactions of the notables of the ancient Forez on reading these lines when they gathered in the Bâtie d'Urfé to celebrate the four hundredth anniversary of the book's publication and to attend the long-awaited showing of *The Romance of Astrée and Céladon*. The legal reaction was not slow in coming: Pascal Clément, the president of the Conseil général de la Loire (and former Keeper of the Seals) had a summons for urgent proceedings issued and

filed a suit for defamation against the company that produced the film. In the press, he poured out vengeful declarations, insisting that the film could very well have been made on the sites that had been denigrated. For his part, Rohmer prepared arguments that are little masterpieces of bad faith:

> These facts are in no way dishonoring, quite the contrary. The presence of a relatively dense population and good roads is a positive feature of the department. I said that for my film I preferred places that "have preserved their wild poetry and their bucolic charm." That suggests that these places are situated in depopulated areas, far away from the "development" and "growth" of our country. It is rather these regions that ought to feel "defamed." [. . .] I am reproached for using the word "disfigured." I recognize that in general it has a negative connotation, but not always a negative denotation.[16]

Or, still more tortuously:

> [. . .] The Conseil général de la Loire denounces as defamatory an allegation that it itself makes in the promotional brochure *L'Essor*, published on the occasion of the fourth centennial of *L'Astrée*. On page 19, a German specialist on the seventeenth century says that the bucolic country depicted in Honoré d'Urfé's novel had already changed in appearance [by] the following century, as is testified by Jean-Jacques Rousseau in his *Confessions*. [. . .] Either my allegation is not defamatory, and the accusation is groundless. Or else, if it is defamatory, the Conseil général de la Loire, which is responsible for the publication, must also be accused of defamation, which is logically impossible, since one cannot be simultaneously plaintiff and accused for the same cause, that is, be something and its contrary, at least in the Aristotelian perspective which is still the one under which we live.[17]

Were these malicious sophistries put forward at the hearing? That is not likely. It was, moreover, for technicalities (neglecting to summon the CER, the coproducer of the film with Rezo) that the plaintiff's suit was twice dismissed.

A second trial awaited *The Romance of Asrée and Céladon*. Applauded at the Venice Film Festival and commended by Rohmer's traditional supporters among the critics, the work unleashed a flood of irony on the part of his detractors. This cinematic anomaly was mocked as everything from rural pornography

to senile amateurism. In this ferocious vein, the prize undoubtedly goes to Patrick Besson, writing in *VSD*:

> *The Romance of Astrée and Céladon* is a film that is too much, or rather not enough. Not enough images, not enough words, not enough acting, not enough wit, not enough insouciance, not enough gravity. It is a film that lacks everything. It looks as if it had been made under an occupation much more severe than the German Occupation. The occupation of age? [. . .] The camera doesn't hold steady. The lighting doesn't illuminate. The actors even seem to have trouble moving about. Rohmer has specialized in finding young actors who were buried immediately after they worked with him. I'm afraid for Véronique Reymond, Mathilde Mosnier, Priscilla Galland. But this *Romance* is so little a film that maybe this time the evil spell won't work.[18]

In *Charlie Hebdo*, Philippe Lançon was amused to see the showing gradually deserted by groups of spectators (fewer than 50,000 went to see the film). At the same time, he is touched by the Don Quixote–like solitude of the old filmmaker: "Éric Rohmer would no doubt have liked [. . .] to go back in time, to meet d'Urfé, to ask him for a few tips on the places and people. But that is not allowed. His turkey is an impossible little dream, an ersatz product."[19]

Lançon didn't know how right he was. With this last feature-length film, Rohmer recalled once again what his cinema had been and what he continued to expect from it. But he did so in such a discreet manner that many people were completely fooled. To be sure, in the interviews that accompanied the release of the film, he offered a few authorized interpretive clues. The theme of fidelity, essentially, which had run though his work ever since *My Night at Maud's*, and that had been complicated, since *Trio in E-flat*, by a supplementary motif: fidelity to an oath of silence that a man has imposed on himself while waiting for it to be broken by the beloved. Or else this or that esoteric form (the triangle, the circle) that reaffirms, as if by chance, the permanence of a worldview. We could seek for and find many other quotation effects. Note, for example, that the three women who compete for Céladon's favors (Astrée, Galathée, and Léonide) are the moral doubles of the three girls among whom Gaspard hesitates in *A Tale of Winter*. This might lead us toward the secret text of the film, which is both autobiographical and theoretical—and which Rohmer seems not to be writing for himself alone.

What is this text about? It is the story of a young man struck by an amorous curse. And who withdraws into the desert for a long time, where he calls in turn upon poetry, song, and painting to bring back to life the distant image of his beloved, because he no longer has the right to appear before her. He is allowed only to see her without being seen, while she is asleep, and through a stratagem that relates him to a woman. In telling this tale, Rohmer transposed the stages of his personal itinerary and the constants of his vocation as a filmmaker. An erotic constant: the one which, as in Murnau, envelops the woman in a taboo that cannot be transgressed—unless by disappearing, like Céladon, without a trace or by vanishing into the feminine. That is the price to be paid for the high point of sensual turmoil (unprecedented in Rohmer's work, and no doubt in the whole history of cinema) represented by the final scenes: a boy who has become a girl among girls, the spectator of their disrobing and their pleasures, the innocent participant in their caresses—as if the suspect and subjective dimension of desire could be erased. What a distance has been covered between the dominating masculinity of *The Kreutzer Sonata* or *Claire's Knee* to arrive at this becoming-another already anticipated in *The Green Ray*! But for all that, a little frightened by his own audacities, the author of the film calls upon Honoré d'Urfé's sentences (read by Alain Libolt) the better to remain in his shadow.

This brings us to another constant, this time aesthetic in nature. It consists in relying on old masters in order to have an opportunity to express oneself. In *The Romance of Astrée and Céladon*, Rohmer replayed one last time a childhood role he played with his cousins, dressed as a girl, in the attic in Tulle. He redeployed once again "Le Celluloïd et le Marbre," with its idea of the seventh art as a kind of phoenix capable of rising from the ashes of its models. If he still sought to retrace the vanished forms of classicism, it was cinema alone that could reveal the secret to him, the secret called "being," with or without a capital letter. "All-powerful God, make this not be a dream! Make it live!—I live." Such were (more or less) the last words that Éric Rohmer made the characters in his films say.

Rohmer and Other People

"It's not myself I see in my films, it's the world I've filmed."[20] That is the conclusion of a long interview Rohmer gave to *France Culture* two months before he died, referring to his imaginary museum and his personal film archive. In the

latter, Éric Rohmer's work was the subject of a constantly running retrospective. The filmmaker liked to watch his old films, to comment on them with Diane Baratier, to show them to Bethsabée Dreyfus. He was proud of them. Especially since he really felt he had given birth to an autonomous world that existed outside him and would survive him. He no longer felt the need (as Truffaut long did) to refer to tutelary filmmakers, with the exception of artists such as Griffith, Murnau, or Hitchcock, whom he sometimes revisited—but more or less in relation to one of his current projects. When Françoise Etchegaray showed him Ingmar Bergman's last work (*Saraband*), he was astonished by the darkness into which the Swedish filmmaker had sunk. It seemed to him so diametrically opposed to his own universe.

As much as from the cinema of the past, he protected himself from the cinema currently being made. Unlike Rivette, Rohmer never haunted dark theaters with the obsession of seeing everything. He preferred to devote himself to his own work. Jean Douchet recalled:

> The only time we went to see a film together was when Jean Eustache showed us his first film (*Les Mauvaises Fréquentations*). I admit that we were both a little stunned by the quality of the film! But although he supported Eustache, Rohmer was not at all interested in having heirs. He realized that it was impossible to appropriate his form of writing.[21]

Although Rohmer defended four or five directors between 1980 and 2010, he did not do so to find possible disciples. He was looking instead for experimental doubles who would encourage him in the work he was pursuing—while at the same time allowing him to say what he did not like in French production.

That was the case par excellence for Pierre Zucca, with his ironic and labyrinthine fables (*Roberte* in particular, according to Pierre Klossowski), in which Rohmer welcomed the return of a rare commodity: narrative. "I did not know Pierre Zucca well," he said shortly after the latter's death.

> We met three or four times at most and we did not have time to say much to each other, except in our last conversation regarding *L'Astrée*, the film that he was preparing and that I would have liked to help him produce. But I admired his films. I would even say that I took delight in them. [. . .] His films, in their scenario and their mise en scène, offer a tight, polyphonic structure underlying

linear exteriors that make them capable of holding up over time and winning an audience that is finally weary of the vague, soft, invertebrate cinema that is too often produced today.[22]

Although he was concerned to restore the prestige of narrative, Rohmer was equally eager to see the rebirth of the virtues of cinematic dialogue, cultivated as such. This was the ideal he defended as early as 1948 in his programmatic article "Pour un cinéma parlant." And he referred to this ideal forty years later to praise a cerebral comedy by Jacques Davila entitled *La Campagne de Cicéron*. He gave this eulogy an exceptional publicity by addressing the author in an open letter in *Cahiers du cinéma*:

> I have seen your film. It was an enchantment. More than that: a shock. Of the same kind that I felt, one evening in 1946 or 1947, at the Raspail studio, where *Les Dames du bois de Boulogne* was shown. [. . .] Just as Bresson, in 1945, challenged the "poetic realism" of the interwar period, you sweep away the modish (and already outmoded) aesthetics of the 1970s and 1980s: the expressionism, the theatricality that imagined it was style, the cult of the publicity photo that has nothing to do with pictoriality, the poverty of the narrative and the dialogue that no longer revealed some kind of modernity, but only impotence pure and simple.[23]

To this was added, in Davila's as in Zucca's work, a humor that delightfully contrasted with the pompousness mocked here. Once again, Rohmer was drawing attention to a marginal filmmaker the better to attack conventional cinema with his sarcasms—though he occasionally returned to the tone of an art historian he had taken during the heroic times at *Cahiers du cinéma* or during the polemical period when he was writing for the review *Arts*.

The pursuit, then, of a subterranean but tenacious taste for novelty, not to be confused with the avant-garde, since it might consist in rehabilitating classical notions that a certain academicism had devalued. It was this taste that he tried to defend in speaking with Gilles Jacob, a general delegate at the Cannes Festival, who had invited him to sit on the jury for a "Rossellini prize."

> Wouldn't Rosselini—who often encouraged talented young people—have liked to see his prize given to people who are still in the shadows? Therefore the names I would like to mention are Rozier, Zucca, Akerman, or again Vecchilia,

Garrel, et al. There are others, in France and throughout the world, whom unfortunately I do not know, since I seldom go to the cinema. I fear that those of my colleagues on the jury who go to the cinema more often will take the trouble, willingly or unwillingly, only for recognized values.[24]

In the 1980s, Rohmer liked films that were not the most consensual ones: Pierre Zucca's *Rouge-gorge*, Chantal Akerman's *Golden Eighties* (in which he fell in love with the singer Lio, and which revived his desire to make a musical comedy), or Paul Vecchiali's *C'est la vie aussi . . .* , sharply reproaching the critics at *Cahiers du cinéma* for not having done more to support this last film.

Rohmer was to confirm his support for Vecchiali in a very concrete way. He was curious about this free agent of French cinema, who created the Diagonale production company in 1976, a seedbed for singular personalities (Jacques Davila, Gérard Frot-Coutaz, Jean-Claude Biette, and Marie-Claude Treilhou). Even if he was not unconditionally enthusiastic about all their films, he was sensitive to this alternative culture on the periphery of an establishment that he considered sclerotic. Through the intermediary of Haydée Caillot, he received regular news about this group. In 2003, Vecchiali made *A vot'bon coeur*, in which he took pleasure in (fictively) assassinating all the members of the committee that granted advances on receipts. "Jacques Le Glou produced this film with me," Vecchiali recounted. "He absolutely wanted there to be a 35 mm copy . . . When he found that out, Rohmer called Marie Binet [formerly Bouteloup] to ask her to give me 30,000 euros. He saw the film only afterward, and he didn't talk to me about it any more than the preceding ones!"[25] The episode at least qualifies the reputation for stinginess a little too hastily attached to Rohmer's name.

Rohmer provided substantial aid for another young filmmaker, but in order to help him get started. One day in 1975, he had gone to the Olympic Entrepôt in the company of Béatrice Romand to attend a program of short films. Disappointed by the poor quality of what he saw, he tried to make his way down the row of spectators so as to leave the theater. While he was doing so, a different film began. Two blossoming girls engaged in tender frolics, followed by sentimental colloquies. Rohmer sat down again, charmed by this medium-length film in Super 8, which was titled *La Croisée des chemins* and was made by a certain Jean-Claude Brisseau. A few days later, Brisseau burst into the Losange offices to hear Rohmer's impressions. It was the beginning of

a paradoxical friendship between an established filmmaker and a lycée teacher in his thirties who lived on the cheap in the building where he was born, on the fringe of the eighteenth arrondissement, and with his friends put together amateur films as best he could. It was this amateur side that attracted Rohmer, who was about to begin his own return to his sources with *The Aviator's Wife* (he was to rediscover some of this freshness in *L'Amour*, Philippe Faucon's first film). He also liked Brisseau's "big mouth," which provided a breath of authenticity and eccentricity. Brisseau invited Rohmer to see a Hawks film again, have a snack in his modest lair, or visit with him the suburban no-man's-lands that he knew so well.

An artistic capillarity was emerging. Rohmer asked Brisseau to film the rehearsals for *Perceval* in Super 8, gave him two silent roles in this film, and then a speaking role in *Reinette and Mirabelle*. He borrowed Brisseau's companion, Lisa Heredia, whom he asked to act in turn, and whom he soon hired as his film editor. He lent Brisseau his troupe of actors, from Daniel Tarrare to Marie Rivière. The latter, with Lisa Heredia, played the main roles in Brisseau's first real feature film: *La Vie comme ça* (1978), a quasi-Brechtian chronicle of life in big groups and violence in the workplace. Thanks to Rohmer's intervention with his friend Jean Collet, who was assigned to the Institut national de l'audiovisuel, this fragile film could be mixed, shown, and followed by new projects for television (*L'Échangeur*, *Les Ombres*). The auteur of *The Green Ray* used all his influence to get Margaret Menegoz to produce (successfully) Brisseau's next films: *Sound and Fury* and *White Wedding*. The relations between Losange's grande dame and this not very diplomatic giant were stormy, and deteriorated until they broke off altogether.

As for Rohmer, he always left his door open to this difficult protégé, to the point of annoying even Françoise Etchegaray, who complained about it with her usual humor: "Brisseau has begun his shady activities, known as 'castingue.'[26] That got us a troop of very scantily dressed (even undressed) chicks. Moreover, they hang out in the hallways! I take the liberty of drawing your attention to the fact that the abbreviation 'CER' does not stand for Cortège d'évaporées à rhume."[27] When these somewhat prolonged casting sessions got the director of *Secret Things* sued by unhappy "chicks," Rohmer did not hesitate to sign a petition supporting a filmmaker he admired, even if, in his heart of hearts, he was interested less in Brisseau's aspiration to become a professional than in the rough, disjointed, wild aspect of his entrance into cinema.

Éric Rohmer's Workshop

Rohmer, it seems, moved in the opposite direction in the early 1980s. He cast off as much of his mastery as he could to rediscover the almost infantile origin of his desire to tell stories. He had already had fun playing the narrator to patch up a bizarre film directed by Aurora Cornu (*Bilocation*), an eminently boring tale with esoteric mysteries, a quest for the Holy Grail, and paranormal phenomena to top it all off. Later on he amused himself by reformatting a project conceived by Liliane Dreyfus: a musical comedy entitled *Dominique*, a pretext to invent operetta verses and develop a pseudo-feminism à la Rohmer. And he took an extreme pleasure in acting, whether it was a matter of Mary Stephen's *Justocoeur* (in a sequence filmed at the Cité universitaire) or two shorts made by Haydée Caillot in 1980. In one of these, *Et dixit le mage*, he made himself look like a solemn magus, whom we suspect of breaking into wild laughter between two takes. In the other, *Passage de la Vierge*, he plays with a muddled conviction the role of . . . a serial killer who preys on prostitutes!

More seriously, for him these short films were an opportunity to meet possible future collaborators. Such as Pascal Ribier, recruited in 1987 by Haydée Caillot for *Qui êtes-vous, Dorothée Blanck?* Ribier recounted:

> One day she told me, "Éric Rohmer is looking for a sound engineer, and I mentioned you to him. He's going to come to the shoot." So he came to see us—but since he preferred to be a participant rather than an onlooker, he helped us with the sound boom. The filming was done in an attic room with a low roof, and it was a little uncomfortable for him, because he's tall. He wasn't a good sound boom man, but I told him what to do . . . At moments, with him, the world was upside down!"[28]

A sound boom man with Haydée Caillot, a cameraman with Rosette, who, probably at his instigation, wrote between 1982 and 1987 a series of little films of which she is the heroine. But Rohmer was also an actor, and this time in a role that fitted him like a glove: that of the papa professor, appearing in the first episode (*Rosette sort le soir*) to supervise his daughter's nights out while at the same time correcting a pile of student papers. It was one of the hats that Rohmer wore in the low-tech genesis of these five short films. On the one hand, he encouraged

their writing, which allowed him to reincarnate a very old dream of films with episodes that had never been realized (*Charlotte et Véronique, Fabien et Fabienne, Les Aventures de Zouzou*). He revised Rosette's text and held the camera, as we have said, capturing by the by a backlit shot or a somewhat risqué undressing, setting up micro-situations to be developed later on (for example, that of "Drink Your Coffee . . . "). On the other hand, he disappeared into all that youth overflowing around him, as if he were there only to record (objectively) the shivers of desire and the beginnings of fiction. Rosette played at being the woman in love, Pascal (Greggory) the seducer, Arielle (Dombasle) the vamp, Virgine (Thévenet) the prostitute, François-Marie (Banier) the worldly man, Jean (Parvulesco) the wheeler-dealer, Béatrice (Romand) the fortune teller . . . It was like a childhood of Rohmer's cinema that was developed here, in which each of the figures in his human comedy was reduced to a kind of caricature; not very far from his cherished Countess of Ségur, but in the Parisian ambience of the 1980s, which a relaxed filming in Super 8 captured very naturally.

This experiment enchanted Rohmer to the point that he repeated it a decade later, in 1996. Thanks to the receipts brought in by *The Tree, the Mayor and the Médiathèque* and then by *Rendezvous in Paris*, the CER was granted an automatic subsidy by the CNC. Busy with his *Tales of the Four Seasons*, Rohmer proposed to use this money to make a miniseries that would be called *Anniversaires* (*Birthdays, Anniversaries*), in which (in the framework of this generic theme) he would give a blank check to one or another of his women friends to make the short film she had in mind. In truth, this fine principle was applied only once, in the case of the second part of the series (*France*), the responsibility for which Rohmer entrusted, with his eyes closed, to Diane Baratier. "One day," she recounted,

> I asked Éric to accept me as a film editing intern, to see how he edited the rushes I had filmed. He replied: "My head camera operator can't be present in my editing room! I'm too critical. If you want to learn film editing, you'll have to edit your own rushes. So make a short film in the framework of the *Anniversaires* series." I have no talent as a writer, but I wrote something that he fixed. Subsequently, he never came to the set, or to the editing . . . That is why my film is rather different from the others in the series.[29]

In *France*, Diane Baratier describes the everyday life of a young woman engine driver in the Metro—who, on the day of her birthday, waits in vain for a guy

to call. A sort of dreamer like Marie Rivière, but immersed in a disenchanted vapidity in which the Rohmerian point of view has little place. When an actress who had been dismissed tried to drag him into a dispute, the filmmaker again showed his discretion:

> Don't worry. There is no "behind the scenes" in this quarrel, which concerns only you two. Out of friendship and because I liked her subject, I asked Diane to be the "nominal" director of her short film, which amounted to paying her bills for film, the laboratory, various kinds of equipment, the editing room, etc., and giving my verbal promise to divide any receipts among all the participants. Knowing from experience that the school of mise en scène has to begin with learning responsibilities, I insisted on leaving my camera operator free to make her own choices and not getting involved in the filming, the preparation, or the editing of the film. That is what was decided between us last winter, and I am keeping my promise.[30]

For the three other films in the *Anniversaires* series, the process was more complicated. In each case, Rohmer approved a scenario that had been proposed by one of his friends (Rosette, Florence Rauscher, or Anne-Sophie Rouvillois). Little by little, he appropriated it through a growing profusion of handwritten annotations in the margins of the dialogues, so that it almost became a Rohmer film. In *Les Amis de Ninon*, in which Rosette decided to organize a party with all her old lovers, the depressing climate of the party in question (punctuated by a bit of contemporary music that Pascal Greggory listens to over and over) awakens echoes of *Sign of Leo*. In *Heurts divers*, misunderstandings connected with going off daylight savings time favor improbable romantic events, evoking the epiphanies in *The Blue Hour*, *The Green Ray*, and especially *An Exceptional Day* (the first title of *The Aviator's Wife*). In *Des goûts et des couleurs*, a boy and a girl go into ecstasies over their "elective affinities" that make them love the same books, the same colors. . . . We think of the trompe-l'oeil ideal in *Boyfriends and Girlfriends*—until the final disillusionment in which the unpredictable movement of cinema triumphs, as in each of these short films.

Rohmer remained incredibly faithful to himself, even in these sketches he claimed to have entrusted to students in his workshop. His name appears in the credits only in connection with the decoupage (an expression that has no longer been much used since Marcel Carné). But he was the one who chose most of the

actors and provided the mise en scène, in company with his usual team: Diane Baratier as camera operator, Françoise Etchegaray as producer. And it was, of course, with Mary Stephen that he carried out the final step of editing the films. He felt a kind of joy in working, between two major films, in such a premeditated mixture of anonymity and amateurism. This gave these little films a strangely hesitant aspect, as if they weren't sure of where they came from or who had constructed them. When they were very discreetly released in theaters, Olivier Séguret expressed his perplexity in *Libération*: "Beneath what might at first be accepted as a clever pastiche or a testimony to an honest complicity, we soon see emerging a way of proceeding that takes us back rather to the notions of a pale copy and empty imitations."[31] Room for improvement . . .

In the late 1990s, Rohmer began a new and more ambitious series. Its title was *Le Modèle* (The model), and it examined the mysterious relationship that unites a painter with the young women he takes as the object of his art. Six short films were to develop this theme, two of which are no more than outlines: *Une histoire qui se dessine*, a sketch in which Rosette and Emmanuel Salinger tease each other by playing at being artists for tourists who steal the show. And *Un dentiste exemplaire*, a scenario proposed by Aurélia Alcaïs. Rohmer had a true affection for this young woman, who was only an insolent adolescent when she first visited Losange, and who remained very close to him for the rest of his life. It was to her that he said in a melancholic mood, recalling the hours he had spent reading to her the verses of his great poets: "Now I know them all by heart." She played small roles in *Les Jeux de société* and *A Tale of Autumn*, and she was to play the main role in *Un dentiste exemplaire* (whose scenario had in the interim been rewritten by Haydée Caillot, after which Rohmer expurgated her erotic sallies): the role of a little salesgirl who hesitates to pay for her vacation by posing for nude photos, until she notices that her dentist does the same thing.

Two other films take up the most Rohmerian themes: *La Cambrure*, brilliant dialogues on the mirror effects between painting and life. The male lead, who is studying the history of art, is a kind of Buñuelian fanatic who is trying to find in his beloved the trace of pictorial models he admires. In passing, Rohmer takes pleasure in providing a new version of a recumbent nude by Degas, while at the same time letting his distrust with regard to fetishistic imitation be seen. *La Proposition*, which was to be his last work (2009), is a somewhat more tortuous puzzle. Ten years earlier, a young specialist in short films, Sybille Chevrier, had sent him a script entitled *Alice malgré elle*. It recounts the misadventures of a

young woman whose car breaks down and who goes into a house to ask for help and ends up being a nude model for a painter—who takes her for someone else. A few years later, Anne-Sophie Rouvillois wrote a new version of this subject (*Nature morte*) which Rohmer rewrote in turn, to the point of making it unrecognizable: in *La Proposition*, it is the young woman who toys with the inflammatory idea of pretending to be the model, to the point of undressing herself in the studio of a painter who has asked nothing of her. This was a way for Rohmer to turn the proposition around, to efface the artist's desire and stage only that of the model. Anne-Sophie accepted his revisions with good grace. "I agree to be credited," she wrote to him. "However, since there are many new elements with which I had nothing to do, I would like both of us to be credited. And since you don't want to be credited, unless under a pseudonym, it seems to me the best way would be to credit 'Thingamabob and Anne-Sophie Rouvillois,' or 'Anne-Sophie Rouvillois and Thingamabob.'"[32] In the credits, only her name appears.

For *Le Nu à la terrasse*, the next-to-last part of the series, which was made shortly after *The Romance of Astrée and Céladon*, Rohmer took the pseudonym of Annie Balkarash. This was a quasi-anagram of Hannibal Carache, one of the nicknames he invented for himself using rebuses and other plays on words that he exchanged with Françoise Etchegaray. Inspired by his liking for hoaxes, masks, and mystifications, this choice also reflected the theme of the short film, which was inspired by Joëlle Miquel. A young couple who has just moved into an apartment hang on the wall a canvas that intrigues them: a nude on the terrace, obviously painted during the interwar period. When one day the man's grandmother comes to lunch at their apartment, she mysteriously gets up and leaves during the meal, on the pretext that she has forgotten to take her medicine. Shortly afterward, the painting disappears without any rational explanation. After the grandmother's death, the young people find it at her home: thanks to a key she had had made, she had stolen this nude, for which she herself posed. This is one of the very rare appearances in Rohmer's work of old age and death, two things he never ceased to ward off. It is also an indirect homage to Edgar Allan Poe's "The Purloined Letter," which reminds us how much art consists in hiding oneself in plain sight.

This is an idea developed especially in *Le Canapé rouge* (2004), which is the most successful work in the series *Le Modèle*, to the point that it can be deciphered as an ironic testament. It was inspired by informal discussions among Rohmer, Marie Rivière, and Charlotte Véry, and by a draft scenario that each of

each of the actresses submitted to the filmmaker. It was also inspired by Charlotte's painting activity, and an important role in *Le Canapé rouge* was played by her companion (Philippe Caroit): that of Marie's lover. This thirty-two-minute story put itself under the sign of displacement, doubling, and double dealing. So that this clandestine lover who, like Marie, is married, can have her constantly before his eyes while he works, the character played by Marie asks a woman friend to paint her portrait. Lying on the couch. Once the painting is completed, she is disappointed, because one hardly sees her face, which is hidden by her hair. "It's your quintessence!" Charlotte tells her. "It's your quintessence!" her lover spontaneously repeats, eliciting in her an explosion of joy. Between the lines, Éric Rohmer tells us here the most secret things about himself: his liking for a double life (the filming was done in his own office, by moving the furniture around), the refusal to show his true face, the cinematic detour necessary to leave the image of his profound being.

14

In Pain

2001–2010

In early October 2001, one month after his visit to the Venice Film Festival, Éric Rohmer was operated on for an aneurysm of the abdominal aorta at the University Hospital on boulevard Jourdan. A hypertrophied vein had put his life in danger, and he risked having a major vascular incident at any time. The decision was made in late August 2001. It was a man on reprieve who went to Venice, and the speech he gave on receiving the Golden Lion award honoring his career achievement bore signs of this. He began by asking his audience to remember all the people in his films who were now dead: Pascale Ogier, Nestor Almendros, Gérard Falconetti, Paul Gégauff, Michaël Kraft . . .

Working in Pain

The operation lasted eight hours and left a scar twenty centimeters long on his abdomen. Then Rohmer had to stay home, on the rue d'Ulm, for three months, but he went back to work quite soon, receiving Françoise Etchegaray every weekday from 9 A.M. to 6 P.M., as if he had already returned to his office on avenue Pierre-Ier-de-Serbie. Work, in this case the preparation for *Triple Agent*, was the only way he could ward off the fear of death. A way of postponing the ineluctable in an old man who pursued, against his doctor's advice, ambitious films that generated fatigue and tensions. Just as the 1990s had been a period characterized by a certain lightheartedness associated with the happiness of filming, so now

the following decade was characterized by difficulty and pain. But it was by surmounting, at whatever cost, the obstacles causing him to suffer that he acquired a feeling that he was almost immortal.

Now he was never without pain. A photo shows him walking across a bridge in Venice, on September 6, 2001: his emaciation is clear, he's all skin and bones. Floating in a jacket that has become too big, he is stiff, halting, bent; his previously long-limbed body has settled, he has already lost almost ten centimeters in height. This diminution was inevitable, the result of the scoliosis that had affected him since the 1960s but gradually grew worse in a degenerative way. The deviation caused by the rotations and asymmetrical settling of the spinal column was a terrible ordeal that destroyed the bones. Starting around 2000, this deformation peppered the twisted spinal column with tiny fractures of the vertebrae that caused him great suffering and further compressed his frame (by 2009 he had lost almost twenty centimeters in height) and left him broken in two, constantly bent forward. The scoliosis also led to respiratory problems, a sensation of suffocating, and sometimes even episodes of apnea. In the course of his last ten years, Rohmer fainted several times, especially toward the end of a meal or after it.

He confronted this suffering with courage, even if he occasionally complained about it. But he did it in his own way: alone and without an escape hatch. He rejected any serious treatment and any medication to attenuate the pain. "He never wanted to take any medicine that might alter in any way his lucidity," Barbet Schroeder reported regarding the filmmaker's last years. "At the end of his life, he suffered terrible agonies. I said to him: 'Come now, I promise you that opium won't make you lose your lucidity, it just attenuates the pain.'—'No, no, and no!!!' he replied angrily. It was as if for him everything was LSD."[1]

Although his body was affected, his clarity of mind and even his energy remained intact. "At the end, he was bent over double, but during the filming of L'Astrée his acuity was in no way diminished,"[2] Bethsabée Dreyfus, his friend and personal assistant, recounted. In addition to the film shoots, Rohmer's last years were marked by relatively major cinephile activities and writing projects. Rohmer never stopped working—even when after the exhausting filming of L'Astrée in 2006, at the age of eighty-six, it was clear that he could no longer make a feature film by himself.

He still directed shorts, as we have seen, but above all he wrote. Texts for other people, such as the scenario Étoiles étoiles, or for himself, but he no longer

wrote projects for films. Most of what he wrote consisted of scholarly works with a strong autobiographical bent. For example, a well-informed and detailed study on the etymology of the name of his native town, Tulle: "Et si Tutela venait de Tulle?," a twenty-five-page article published in the *Revue des lettres, sciences, et arts de la Corrèze* in 2007, and an essay on the Countess of Ségur, who had been his favorite author since his childhood, an ambitious work left unfinished in December 2009. He also continued to compose the songs, poems, *bouts-rimés*, puns, or charades that he had always enjoyed and that fed his companionship with Françoise Etchegaray. For instance, a fable in verse that begins this way:

> C'était au temps béni, où, entre toutes choses,
> Paris se proclamait fier de ses maisons closes.
> L'une que fréquentait un émir d'Arabie,
> Était sise avenue Pierre-Ier-de-Serbie,
> Au vingt-six m'a-t-on dit bien que ce numéro
> N'abrite de nos jours que d'honnêtes bureaux.[3]

This was followed by a story of prostitutes on vacation, whose only point is to make Françoise Etchegaray divine a play on words (seaside vacation): "Know only that the lesson to be drawn from this rosy tale is only the name of the very innocent and familial occupations in which you are currently indulging on the Basque coast, and that I hope are as beautiful as (but better-behaved than) those of the ex-lodgers at no. 26, accompanying this highly moral wish with my most affectionate embraces . . ."[4]

He continued to refuse invitations to travel or to present his films. Whether a retrospective organized by Aldo Tassone in Florence in the autumn of 2005, the book of interviews and cooperative writing imagined by Louis Skorecki[5]—the critic at *Libération* whom Rohmer liked, the last one whom he made a point of reading regularly—or the defense, at the University of Caen, of a thesis written on his work by Violaine Caminade de Schuytter: "Le Corps chez Éric Rohmer," in autumn 2008.

On the other hand, he took an active and benevolent part in certain reprintings of his written works. When in March 2006 Antoine Gallimard proposed to reprint Rohmer's first and only novel, *Élisabeth*, more than sixty years after it had been published by the same house, Rohmer replied favorably. He worked with the publisher Philippe Demanet, changed the title—he would have preferred

Pluie d'été, but it was already taken, so he chose instead *La Maison d'Élisabeth*—and gave, as a kind of afterword, an interview concerning his vocation and his literary tastes. The novel came out in May 2007, on the occasion of the Cannes Festival, and had a new life (more than 5,000 copies sold), a belated critical career (about fifteen articles and reviews), and about ten translations into foreign languages.

The following autumn, Rohmer's first book on cinema, the essay on Hitchcock he wrote in 1957 with Claude Chabrol, was republished in the Ramsay Cinema series, preceded by an unpublished interview on the author of *The Man Who Knew Too Much*. Rohmer gave interviews to the magazine *Le Diable probablement* in spring of 2008, and to *Positif*, on the theme of the beach, in spring of 2009. Then he entered into the spirit of the game of rereading his flagship article, "Le Celluloïd et le Marbre," in the context of a long interview given to the radio channel *France Culture* in October 2009.[6] Two weeks later, in November, he gave another interview: two afternoons of three hours each on the films made for educational television. Rohmer allowed the recording of these long and fascinating confessions made under the guidance of Hélène Waysbord and filmed by Jean-Louis Cros.[7] This was a very rare event and was the last filmed interview with Rohmer. The meeting took place in the film theater at the Musée pédagogique on the rue d'Ulm, the old theater of Henri Langlois's Cinémathèque française, to which Rohmer was literally carried from his apartment across the street by Françoise Etchegaray at the beginning of each of the two afternoons of filming. His last appearance in public occurred on March 17, 2009. Rohmer had agreed to go to Fémis, the film school on rue Francoeur, to meet with first-year students to whom he showed *The Lady and the Duke* in order to explain his work on the paintings, the sets, and the digital effects. "He sometimes fell asleep, and I woke him," said Françoise Etchegaray, who was at his side during the showing of the film. Then, during the discussion, he was charming, brilliant, and extremely touched by the reception given him by these very young people."[8]

Prolonged Friendships

Éric Rohmer regularly received his women friends, the ones the press had often called *Rohmériennes*, actresses and collaborators in his films. All through these

years, Françoise Etchegaray remained the indispensable "concubine," working with the filmmaker every day during the unchanging office hours, 9 to 5. The trips to and from the offices on avenue Pierre-Ier-de-Serbie and the Latin Quarter were nonetheless long and complicated. Rohmer, walking with increasing difficulty, refused to take a taxi, preferring to take two buses with a transfer at Montparnasse. Starting in 2007, the filmmaker, who insisted fiercely on going to his professional office, could no longer move around by himself: traveling to the office in the morning and returning in the evening took two hours, usually in the company of Françoise Etchegaray or Rosette.

These prolonged friendships brought together in his office, as a group or one on one, his main actresses—Marie Rivière, who filmed a daily chronicle of these meetings, *En compagnie d'Éric Rohmer*, Arielle Dombasle, Charlotte Véry, and Florence Rauscher—for the ritual tea at 5 P.M., which was now carefully "decaffeinated" and for which they were gradually to take responsibility when Rohmer was no longer able to prepare it by himself. Arielle Dombasle described these meetings and discussions:

> We acquired a habit. Since I'd made quite a few films with my Mini DV camera, I showed them to him and we talked about them. He was always interested. Once, after a certain time, he agreed to be filmed in my *Traversée du désir*, an inquiry in which I asked people the same question: "What was your first desire?" It was a subject that made him uncomfortable but he was willing to answer. He talked about the twigs he had collected in his garden when he was a child, in order to burn Joan of Arc. This story of a childhood pyromaniac desire, retrieved from my old friend's distant past, greatly touched me."[9]

There were also his oldest buddies, like Jean Parvulesco, who showed up without warning and always a little clandestinely, or Hervé Grandsart, the erudite esthete who worked in the offices next door to Films du Losange—with whom Rohmer reconciled around 2005 and whom he received until the end.

But after Françoise Etchegaray, it was no doubt Bethsabée Dreyfus who was the most regular visitor, to the point that for Rohmer she was, as he himself said, his "preferred female companion."[10] She had worked with him on all his films from *A Tale of Summer* on, as a script girl, assistant, or costume designer, and over the preceding fifteen years she had become a close friend. From the age of

seventeen to thirty-two, from the time when he taught her Latin at the request of her mother (Liliane Dreyfus), she had grown up in this crucial friendship:

> We saw each other every Wednesday. At first, we went for walks, to the museum, sometimes to see a film, and he also had me attend the editing sessions for some of his films. He liked to see me, he asked me questions about my life, my habits, my clothes, my furniture, my health, everything. He enjoyed my spontaneity, my freshness, they kept him alert. He liked the way I was dressed, he found me elegant. I made him laugh, and I was very talkative. I showed him how people my age talked, that intrigued him greatly. I found him interesting, full of culture and humor. It was a friendship that consisted of uninterrupted conversations and continual walks. He also played the piano for me, read me poetry. And above all, we watched films together: Hitchcock, Murnau, the films people sent him. And his own films, his feature films, his educational television films. He loved the Derrick series and sports, which he often watched on television: the Roland-Garros [tennis tournament], track and field . . . It had become a ritual: after lunch, every Wednesday, we watched a film or television program. Until the end of his life.[11]

The last years were painful but brought them even closer together:

> He was physically diminished, and that made him sad. He was in pain, but his mind was intact, and he was afraid of suffering. "The hardest thing," he said, "is to be conscious of one's physical collapse." Setting up the DVD was a veritable comedy sketch, it sometimes took fifteen or twenty minutes, but he insisted on doing it himself. Everything became very slow. But he was proud, even vainglorious, and couldn't stand having anyone help him.[12]

This family of actresses and collaborators was essential for Rohmer. He was all the more hurt by the attitude of one of them who turned against him. While making his short film *Le Nu à la terrasse* with two actors he had met during the filming of *The Romance of Astrée and Céladon*, Fanny Vambacas and Olivier Blond, he reconnected with an old acquaintance, Joëlle Miquel—who had been, as we have seen, the actress who inspired and played Reinette in *Four Adventures of Reinette and Mirabelle* twenty years earlier. In the meantime, she had become

a novelist and had published four books, including *L'Appel des sirènes* in 1999 and *L'Enfant rire*, published by the Mercure de France in 2007. Rohmer took his inspiration from a short narrative she had written down and confided to him to put *Le Nu à la terrasse* into dialogue form and make a film of it, noting in the credits: "based on an idea of Joëlle Miquel's." However, the latter was furious when she saw that Rohmer had not released the film under his own name, but concealed himself under the pseudonym Annie Balkarash.

In late 2008, Miquel brought a lawsuit against Rohmer, claiming the status of coauthor, not only of *Le Nu à la terrasse* but also to *Reinette and Mirabelle*, and the royalties pertaining thereto, which represented a relatively large sum for the 1986 feature film. The case went to trial, which deeply wounded the filmmaker, who was powerless to resist such a claim. He contacted a lawyer who specialized in royalties, Emmanuel Pierrat, who advised him to collect favorable testimonials from other actors and actresses who had worked on films of the same kind, in which the share of conversations and improvisations was important in the elaboration of the dialogues. Rohmer had often taken his inspiration from the narratives and experiences of his collaborators to conceive his stories. Thus Marie Rivière testified regarding *The Green Ray*, Arielle Dombasle and Pascal Greggory regarding *The Tree, the Mayor and the Médiathèque*, Florence Rauscher and Clara Bellar regarding *Rendezvous in Paris*, and finally Jessica Forde, who played Mirabelle in the film at issue. Forde recalled:

> When it came to a trial, Éric called me and asked if I could testify. I wrote a letter about *Reinette and Mirabelle* in his favor. It is certain that if Joëlle Miquel became the "coauthor" of Reinette and Mirabelle, then many actors and actresses, beginning with Fabrice Luchini, Marie Rivière, and Arielle Dombasle, ought to ask even more for other films! It was ridiculous. When you worked with him, you knew his method, you knew exactly how he took his inspiration from the life of his actors and actresses. We gave him stories, expressions, anecdotes, part of our lives, and he transformed them into a story, dialogues, and a film.[13]

Jessica Forde also said how much Rohmer suffered from this conflict he had not been expecting: "It destroyed him, he saw his last year spoiled because of that. He was sick about it, wounded, very unhappy."[14] In 2012, all of Joëlle Miquel's demands were rejected by the court.[15]

The Last, Unfinished Works

It was with an iron will that Éric Rohmer went every morning to his office during the last three years of his life, 2007 to 2009. On the austere wooden table, he wrote two texts by hand. One was addressed to Françoise Etchegaray. After making her first feature films, *La Règle du je*, with Marie Matheron, *Sept en attente*, with Clémentine Amouroux, and a portrait of Philippe Garrel in the *Cinéastes, de notre temps* series, she was eager to film this scenario written by her mentor. The other text was an essay on the Countess of Ségur, her universe, her style, her influence on the filmmaker, and the recognition that this major work in French literature ought to enjoy.

In 2007, after *The Romance of Astrée and Céladon*, Arielle Dombasle wanted to work with Rohmer again. Since he had decided not to launch into another feature film of his own, the actress asked him to write a scenario that she would perform and that Françoise Etchegaray would direct. The trio immediately began to hold work sessions around a tape recorder in Rohmer's office. Rather quickly, the inspiration took as its point of departure a film subject of Haydée Caillot's written in 1999 and entitled *Les Corneilles* (The crows). The story concerns the friendship of a singer (a role already assigned to Arielle Dombasle) and a Karmic astrologer. The film was supposed to be produced by Films du Losange, but was never made, having fallen victim to the quarrel between Éric Rohmer and Margaret Menegoz over *The Lady and the Duke*.

The scenario Rohmer wrote, which was entitled successively *Karmas croisés*, *Mars et Mercure*, and then *Étoiles étoiles*,[16] was about a female pop singer, eccentric, weird, and Catholic, who is trying to free herself from her mother's influence. She moves to the south, to Arles, and makes friends with an astrologer known for her radio broadcasts and specialized books that predict the future in relation to karma and metempsychosis, the past and future incarnations of her relatives, listeners, and clients. The two friends meet two men, a publisher and the director of the local radio station, both of them residing in Arles. The singer ends up with the radio man, and the astrologer, overcoming her fear of bad karma, with the publisher. Rohmer even wrote a love scene for Arielle Dombasle, no doubt the most daring carnal encounter in his filmography, which closes with this formula worthy of a Sacha Guitry: "One night is an eternity, two is already becoming vulgar." The film is also a musical comedy, which was

essential for the actress-singer, who asked Marcela Coloma to adapt airs from Bach, modernizing them for the guitar in a very bright pop style.

For the role of the astrologer, Françoise Etchegaray got in contact with Béatrice Dalle, who accepted the offer and met Arielle Dombasle—"An extraordinary face-to-face meeting,"[17] the director recalled. In the spring of 2009, the scenario was presented to the advance on receipts committee, chaired by Florence Malraux. Éric Rohmer cranked out a little letter of recommendation to the chair, but it was not sufficient: once again, he failed to get a subsidy from the CNC.[18] His reaction was fatalistic: "After all, it's your film, don't be discouraged,"[19] he said to Françoise Etchegaray when he heard the bad news.

Finally Éric Rohmer returned to Maurice Schérer and one of the loves of his youth: the Countess of Ségur. The old man went back to these books he had read as a teenager, *Les Petites Filles modèles*, *Les Malheurs de Sophie*, *Les Vacances*, *Les Bons Enfants*, along with books by Jules Verne and Robert Louis Stevenson, and put them at the center of an ambitious essay begun in the autumn of 2008. The reader will recall that in the early 1950s an adaptation of *Les Petites Filles modéles* was supposed to be Rohmer's first feature film, and it had remained a failure for which the filmmaker never pardoned himself.

In 1952, in an apostrophe to the Countess of Ségur, he wrote:

> Even in the painting of these model girls, your touch, dear Countess, no matter how rosy it might be, cannot mask the accuracy, the exact precision of the trait. Your world of childhood owes nothing to the prestige of the unexpected and the exotic. Candidly, it exhales only the familiar fragrance of long, peaceful memories. "There is a sentence in *Vacances* that made me pensive when I was little," one of Montherlant's characters tells us. Paul says to Sophie: "So you forgot me?" And she: "Not forgotten, but you were sleeping in my heart, and I didn't dare awaken you." That is how the precious anthology of our early years sleeps within us.[20]

What Rohmer undertakes to do, half a century later, resembles a new awakening: making his childhood readings come back as the memory of his unfinished film. In the meantime, Sleeping Beauty has not found her Prince Charming: the Countess of Ségur is still an author not much esteemed, whose true value literary criticism is still not able to recognize, according to Rohmer. This lack of recognition is for Rohmer an injustice and a windfall:

it leaves the field open for his own effort to rehabilitate her work and stimulates his analyses.

Rohmer's essay, entitled *La Grande Comtesse modèle*, combines autobiographical interpretation and comparative study. On the one hand, the goal is to return to the traces of a "life with the Countess,"[21] of the young reader's first emotional excitement, of the childhood games in Tulle, in the family garden, the grounds of the lycée, and at the seaside during vacations. These memories summon up the characters of the novels, then attach themselves to the heady but unhappy experience of the 1952 film. On the other hand, the analyst is determined to compare with precision each of the Countess of Ségur's works to his own films, for example, *Les Petites Filles modèles* and *A Tale of Autumn*, *Les Bons Enfants* and *Claire's Knee*, *Les Vacances* and *Pauline at the Beach*. Or to compare certain themes that recur in the novels (the geometrical precision of space, the moral conversations, the objects hidden or lost, the misunderstandings and confusions regarding culpability and innocence) with scenes in *Place d' Étoile*, *Full Moon in Paris*, *Boyfriends and Girlfriends*, *Six Moral Tales*, or *A Tale of Spring*.

Of this work there remain twenty-four manuscript pages of a green Clairefontaine notebook, representing what we can consider about one-third of Rohmer's project, which is therefore both large-scale and unfinished. In it we learn personal things about the adolescent's habits, the meaning of Catholicism in the believing adult who "nonetheless finds the [Countess's] conception of Providence simplistic,"[22] and a lucid judgment concerning the reasons for the failure of his adaptation of *Les Petites Filles modèles*:

> Although the first films made by my comrades at *Cahiers du cinéma* were masterful, mine, made seven years before the New Wave, was a catastrophic enterprise. The first error: making an adaptation rather than choosing an original subject, even though I had in my drawer the manuscript of *Moral Tales*, which had been rejected by Gallimard because it was too classical. The second blunder: choosing the Countess of Ségur's *Les Petites Filles modèles*, on the pretext advanced by my producer that a film for children would attract crowds of spectators. Finally, the third cause for the failure: the necessity of entering into the system of the cinema industry, which required having recourse to a more or less fictitious "technical advisor." The filmmaker who was imposed on me had the courtesy to leave me my freedom, but he imposed on me, for the filming and sound, technicians who were crammed with the principles acquired at the

IDHEC and who constantly broke my momentum. This was a blessing in disguise, because it allowed me to forget this failure more rapidly and start out on a new footing.[23]

The manuscript ends, interrupted, with the "joy" that this prolonged reading of childhood gave Rohmer, "a joy also felt when watching Howard Hawks's comedies, where the closeness of the natural and the artificial is very similar to Jean Renoir's."[24] Hawks and Renoir, coexisting with the Countess of Ségur: Éric Rohmer could not have chosen better references to conclude his work.

Françoise Etchegaray—who participated in Rohmer's work in her own way, through regular discussions of Verne and Stevenson, authors whom she knew, and regular trips to the Gibert bookstore to provide the filmmaker with reference books—was not too fond of this project, which she was later to say "smelled like the end":

> Without at all being aware that he was going to die, Rohmer had launched into this book with a young man's curiosity and ambition. Personally, I was afraid of this business of the Countess of Ségur, because the circle was too perfect: he was going back to his first film, as if it was written that this would also be the last thing he would do. When I asked him about this, he got angry. As if he didn't like it that I didn't like this project.[25]

"Get me out of here"

On December 29, 2009, Françoise Etchegaray accompanied Éric Rohmer home on the bus. The tension was palpable. The filmmaker did not understand why his closest collaborator was leaving for two weeks, at the beginning of January, with a camera on her shoulder, to film the last long-distance voyage of the Jeanne d'Arc, the navy's helicopter carrier, "leaving him all alone" in Paris, as he put it. He was gripped by fear at the idea of not finding anyone to accompany him on his trips to avenue Pierre-Ier-de-Serbie. "I want to go work in the office," he barked. "And what are you going to do on that boat, it's a farewell voyage!"[26] That closed the discussion. The two friends looked out in silence at Les Invalides, a monument Rohmer cherished above all others, which the bus was passing just then.

Two days later, around 6 P.M., before the New Year's Eve party she was to attend at the home of some friends, Françoise Etchegaray received a telephone call. Laurent Schérer told her that his father had just had a stroke. "But everything is all right," he immediately added. "He has regained consciousness and we're leaving for the hospital." After they reached the Salpêtrière hospital, Rohmer suffered a second stroke, six hours later. This time he fell into a coma and was immediately transferred to the intensive care unit. His wife Thérèse and his two sons, Denis and Laurent, were at his side. Françoise Etchegaray, who had been informed at 1 A.M., came in: "The first thing an intern told me, in front of the door," she recounted, "was: 'He's going to die, the family wants to be alone.' I simply replied: 'I'm going to stay here,' and I went in."[27]

The filmmaker's two "families" were gathered together around his bed: the Schérers, who were taking back the private man, and the Rohmers, represented by his closest and most faithful collaborator. "I'd never seen them, they'd never seen me," Françoise Etchegaray went on.

> It was the first time we'd been in each other's presence, in front of the body. It was a shock for them as it was for me. They had taken back Maurice Schérer. He was no longer Éric Rohmer. I think they had suffered terribly from this partitioning of two universes. They had felt themselves excluded from a life, almost humiliated, while at the same time they found that perfectly normal. Facing death, they took complete possession of him. But Éric had asked that I be called immediately. In the name of thirty years of daily work, he had insisted on my being there. Thus it was a symbolically violent confrontation.[28]

Maurice Schérer soon woke up, but he remained extremely weak. He was transferred to the neurological intensive care ward. He was able to write a few words on a notepad placed next to his bed, communicating in this way with his family, who took turns at his bedside, and with his collaborator, who was allowed to be there. "He wrote to me on paper," she recalled, but "he also wrote to me on my hand, with a felt pen. For a long time I kept his few words on my skin: 'Get me out of here.'"[29] On Thursday, January 7, Françoise Etchegaray agreed to get Arielle Dombasle into Rohmer's room. The actress explained:

> I wanted to see him before he died, to tell him how important he'd been, like a great magus. I went at 10 P.M., with Françoise, to the Salpêtrière. We weren't

allowed to see him, the family didn't want it. We sneaked in through the emergency room and looked for the neurology ward. There was somebody in front of the door, but he recognized me and let me through. I went in with Françoise. We sat near the bed. There was a big notebook lying next to him. I wrote: "Éric, you're not here for long, you'll be out soon." In his elegant hand he replied: "I want to get out as soon as I've recovered my strength (which is still great)." I wrote again: "We can't stay, we have to let you rest. A big THANK YOU." And we left, weeping.[30]

A few hours later Maurice Schérer fell into a coma again. Unconscious, he received the last rites. He died on the morning of Monday, January 11, at the age of eighty-nine.

In the course of the day, Margaret Menegoz took responsibility for announcing the death to the news agencies. The following Thursday, the body of Maurice Schérer and Éric Rohmer was given a religious burial in the church of Saint-Étienne-du-Mont, on the Montagne Sainte-Geneviève, in front of the Pantheon and two hundred meters from his home on the rue d'Ulm. Strict family privacy was not absolutely respected. Françoise Etchegaray had arranged for a small number of the filmmaker's closest collaborators to be present. Jean Douchet recalls:

> What struck me the day of his burial was seeing that there were truly two families: the Schérers and the Rohmers. The Schérers were his real family, or his friends, and the Rohmers were the cinema. One can't say that his death was mise en scène—and yet at the same time it matters that the mass was celebrated in this church of Saint-Étienne-du-Mont, where Pascal was buried! That is not completely a matter of chance.[31]

For the Schérers, it was Thérèse's parish church, which Maurice attended. For the Rohmers, it was a homage to *My Night at Maud's*.

The cinema world[32] met to pay homage to Éric Rohmer a few days later, at the Cinémathèque française. From Switzerland, Jean-Luc Godard sent a short film, three minutes and twenty-six seconds long, in honor of an old friend. The voice of the author of *Breathless* talked about their common youth, against the background of the titles of Rohmer's articles in *Cahiers du cinéma*. "I wanted to use the titles of his articles," Godard explained, "to talk about things I'd seen or

done with him when we were young at *Cahiers* in the 1950s. I have trouble saying anything else about him. You can talk about people only on the basis of what you've shared with them."[33]

In *Libération*, to the question "Why do you make films?," Éric Rohmer had replied: "I am convinced that in filming I find a happiness that I would no doubt never have been able to find in the practice of other arts."[34]

Notes

The Mysteries of "Le grand Momo"

1. Institut mémoires de l'édition contemporaine archive (hereafter IMEC) at the abbey of Ardenne, fonds Éric Rohmer, dossier "Papiers personnels, divers" (*RHM* 134.17). The bibliographic code RHM provides the location of the materials in the archive.
2. IMEC, fonds Éric Rohmer, dossier "Correspondance professionnelle, lettre D" (*RHM* 113).
3. IMEC, fonds Éric Rohmer, dossier "Papiers personnels, divers" (*RHM* 134.17).
4. Interview with Thérèse Schérer, 23 May 2011.

1. Maurice Schérer's Youth: 1920–1945

1. We refer here to the works of Alain Maury, the GénéaCorrèze associations, and the Amis du lycée Edmond-Perrier, which did genealogical research on Maurice Schérer published in the review *Racines en Corrèze* (no. 1 [2010]) and in the leaflet *Éric Rohmer* (pp. 8–9) published by the intercommunal mediatheque of Tulle on the occasion of its inauguration on 31 March and 1 and 2 April 2011.
2. Interview with René Schérer, 28 September 2010.
3. IMEC, fonds Éric Rohmer, dossier "Papiers personnels, divers" (*RHM* 134.17).
4. Interview with Éric Rohmer, by Noël Herpe and Philippe Fauvel, *Le Celluloïd et le Marbre* (Paris: Éditions Léo Scheer, 2011), 161.
5. Gilbert and Yannick Beaubatie, *Tulle de A à Z* (Paris: Éditions Alan Sutton, 2009).
6. Maurice Schérer, "Et si Tutela venait de Tulle?," *Bulletin de la Société des lettres, sciences et arts de la Corrèze* 109 (2007–2008). The whole collection of notes and manuscript versions necessary for the writing of this chapter has been preserved at the abbey of Ardenne: Institut mémoires de l'édition contemporaine archive (hereafter IMEC), fonds Éric Rohmer, dossier "Toponymie de Tulle" (*RHM* 129/130).
7. Éric Rohmer, interview preparatory to *Boyfriends and Girlfriends*, with Sophie Renoir, IMEC, fonds Éric Rohmer, dossier "L'Ami de mon ami, préparation du tournage" (*RHM* 37.1).

8. Interview with Rohmer, by Herpe and Fauvel, *Le Celluloïd et le Marbre*, 144.

9. Interview with René Schérer, 28 September 2010.

10. Interview with Rohmer, by Herpe and Fauvel, *Le Celluloïd et le Marbre*, 115.

11. Interview with René Schérer, 28 September 2010.

12. Ibid.

13. Interview with Éric Rohmer, 23 December 2008.

14. "Éric Rohmer et le Quartier latin," *Bulletin du 5ᵉ arrondissement de Paris* (Spring 1973).

15. Interview with Éric Rohmer, 23 December 2008.

16. Interview with Rohmer, by Herpe and Fauvel, *Le Celluloïd et le Marbre*, 144.

17. IMEC, fonds Éric Rohmer, audio archives, interview preparatory to *A Tale of Springtime*, with Claire Barbéris (*RHM* 39.7).

18. Interview with Éric Rohmer, 23 December 2008.

19. Ibid.

20. Letter from Maurice Schérer to his parents, 10 June 1940, private collection of Thérèse Schérer.

21. These letters preserved by Éric Rohmer were not deposited at the IMEC. They remain in the Schérer family's private collection and will be indicated here as belonging to the "private collection of Thérèse Schérer."

22. Letter from Maurice Schérer to his parents, 11 June 1940, private collection of Thérèse Schérer.

23. Letter from Maurice Schérer to his parents, 18 July 1940, private collection of Thérèse Schérer.

24. Interview with Rohmer, by Herpe and Fauvel, *Le Celluloïd et le Marbre*, 110–111.

25. Letter from Maurice Schérer to his parents, 13 September 1940, private collection of Thérèse Schérer.

26. Letter from Maurice Schérer to his parents, 11 November 1940, private collection of Thérèse Schérer.

27. Letter from Maurice Schérer to his parents, 29 November 1940, private collection of Thérèse Schérer.

28. Interview with Rohmer, by Herpe and Fauvel, *Le Celluloïd et le Marbre*, 144–145.

29. Philippe Sauzay, "Le Destin malheureux de Marc Zuorro (1907–1956), que connurent et méconnurent Sartre et Revel," *Commentaire*, Autumn 2008.

30. Interview with Éric Rohmer, afterword to the reprint of his novel *La Maison d'Élisabeth* (Paris: Gallimard, 2007), 213.

31. IMEC, fonds Éric Rohmer, audio archives, interview preparatory to *Boyfriends and Girlfriends*, with Emmanuelle Chaulet (*RHM* 37.1)

32. Interview with René Schérer, 28 September 2010.

33. In 2008, more than fifty-five years after their break, Odette Sennedot happened to run into Rohmer on the boulevard Saint-Germain. The filmmaker was overwhelmed. A few weeks later, at his request, she returned to him a "journal" of the Occupation, written at that time by Maurice Schérer, in which she was often mentioned. She also told him that she had an incurable illness and was soon going to commit suicide.

34. Especially since he personally knew one of the victims, a former classmate.

35. Interview with René Schérer, 28 September 2010.

36. Interview with Rohmer, afterword to *La Maison d'Élisabeth*, 211–212.

37. These photographs were not deposited in the fonds Éric Rohmer at the IMEC; they are part of the private collection of Thérèse Schérer.

38. IMEC, fonds Éric Rohmer, dossier "Papiers personnels, documents en lien avec René Schérer" (*RHM* 128.1).

39. Interview with René Schérer, 28 September 2010.

40. Ibid.

41. Letter from Maurice Schérer to René Schérer, 3 August 1940, private collection of Thérèse Schérer.

42. Ibid.

43. Letter from Maurice Schérer to René Schérer, 13 August 1940, private collection of Thérèse Schérer.

44. Letter from Maurice Schérer to René Schérer, 24 November 1940, private collection of Thérèse Schérer.

45. Interview with René Schérer, 28 September 2010.

46. IMEC, fonds Éric Rohmer, dossier "Papiers personnels, documents en lien avec René Schérer" (*RHM* 134.17).

47. IMEC, fonds Éric Rohmer, dossier "Critique littéraire" (*RHM* 101.23).

48. IMEC, fonds Éric Rohmer, dossier "Papiers personnels, documents en lien avec René Schérer" (*RHM* 128.2–128.8).

49. IMEC, fonds Éric Rohmer, dossier "Éric Rohmer écrivain: poèmes" (*RHM* 102.11).

50. Ibid., poem entitled "Saltimbank," dated 1943.

51. Ibid.

52. Ibid.

53. Ibid.

54. IMEC, fonds Éric Rohmer, dossier "Éric Rohmer écrivain: nouvelles" (*RHM* 102.9).

55. Ibid.

56. Ibid.

57. IMEC, fonds Éric Rohmer, dossier "Éric Rohmer écrivain: nouvelles" (*RHM* 102.10).

58. Ibid.

59. Ibid. This story was published in the collection *Friponnes de porcelaine* (Paris: Stock, 2014).

60. IMEC, fonds Éric Rohmer, dossier "La Femme de l'aviateur, premières ébauches" (*RHM* 21.1). This story was published in the collection *Friponnes de porcelaine*.

61. IMEC, fonds Éric Rohmer, dossier "Ma nuit chez Maud, premières ébauches" (*RHM* 3.1). This story was published in the collection *Friponnes de porcelaine*.

62. IMEC, fonds Éric Rohmer, dossier "Rohmer écrivain: romans" (*RHM* 102.2).

63. Ibid.

64. Ibid.

65. This is the first version, the longest and most complete, of the interview given by Éric Rohmer to Jean-Noël Mouret with a view to the afterword for the reprint of *La Maison d'Élisabeth*. IMEC, fonds Éric Rohmer, dossier "Rohmer écrivain: romans" (*RHM* 102.9).

66. Interview with René Schérer, 28 September 2010.

67. Interview with Rohmer, by Mouret.

68. Interview with Éric Rohmer, by Samuel Blumenfeld, *Le Monde des livres*, 18 May 2007.

69. Interview with Rohmer, by Mouret.

70. This comparison and these analyses are shared by Fabrice Gabriel, "La Genèse du genou," *Les Inrockuptibles*, 24 May 2007; Baptiste Liger, "Le Bal des anciens débutants," *Lire*, June 2007;

Patrick Grainville, "Cela s'est passé un été, au bord de l'eau," *Le Figaro littéraire*, 17 May 2007; Philippe Azoury, "Rohmer persiste et signe," *Libération*, 26 June 2007

71. The opening of the novel reads as follows: "He turned around suddenly, like a child caught doing something he shouldn't. Élisabeth smiled. 'Did I scare you? You were so absorbed that you didn't hear me coming.' He set down the oilcan and stood up; he had taken off his jacket and put on a white shirt spotted with grease and paint. 'How could you put such a horrible thing on your body?'"

72. IMEC, fonds Éric Rohmer, dossier "Rohmer écrivain: romans" (*RHM* 102.3).

2. From Schérer to Rohmer: 1945–1957

1. Interview with Éric Rohmer, by Noël Herpe and Philippe Fauvel, *Le Celluloïd et le Marbre* (Paris: Éditions Léo Scheer, 2011), 86.

2. *L'Équipe*, 21 June 1948, IMEC, fonds Éric Rohmer, dossier "Coupures de presse, faits divers et autres sujets" (*RHM* 120).

3. On the "disengagement" of postwar writers, see Antoine de Baecque, "Oh, moi, rien! La Nouvelle Vague, la politique et l'histoire," *L'histoire-caméra* (Paris: Gallimard, 2008), 141–205; Emmanuelle Loyer, "Engagement/désengagement dans la France de l'après-guerre," in *Les Écrivains face à l'histoire*, ed. Antoine de Baecque (Paris: Éditions de la BPI Centre Georges Pompidou, 1998).

4. IMEC, fonds Éric Rohmer, dossier "Papiers personnels, portraits photographiques d'Éric Rohmer" (*RHM* 128.5).

5. IMEC, fonds Éric Rohmer, dossier "Papiers personnels, dessins divers" (*RHM* 128.6).

6. IMEC, fonds Éric Rohmer, dossier "Éric Rohmer professeur, enseignant dans le secondaire" (*RHM* 106.3).

7. Ibid.

8. Ibid.

9. Alexandre Astruc, *Le Montreur d'ombres. Mémoires* (Paris: Bartillat, 1996).

10. Interview with Éric Rohmer, by Jean Narboni, afterword to *Le Goût de la beauté* (Paris: Éditions de l'Étoile/*Cahiers du cinéma*), 1984.

11. Ibid.

12. Dudley Andrew, *André Bazin* (Paris: Éditions de l'Étoile/*Cahiers du cinéma*), 1983.

13. *Samedi Soir*, 3 May 1947, IMEC, fonds Éric Rohmer, dossier "Coupures de presse, faits divers et autres sujets" (*RHM* 120).

14. "Poucette et la légende de Saint-Germain-des-Prés," IMEC, fonds Éric Rohmer, dossier "Courts métrages pour le cinéma, films non aboutis" (*RHM* 85.6).

15. On Paul Gégauff, see Jean-Baptiste Morain, *Le Mauvais Génie des jeunes Turcs et le poète assassiné, ou Paul Gégauff, romancier et scénariste*, directed by Jean-Paul Török (DEA en Études cinématographiques, Paris-I, 1990); Antoine de Baecque, "Le Premier des Paul," special issue on Claude Chabrol, *Cahiers du cinéma* (October 1997), reprinted in *Feu sur le quartier général!* (Paris: Petite bibliothèque des *Cahiers du cinéma*, 2006).

16. "Mort d'une vieille vague," *Paris Match*, 7 January 1984.

17. Éric Rohmer, "La Vie c'était l'écran," in "Le Roman de François Truffaut," special issue, *Cahiers du cinéma* (December 1984).

18. Ibid.

19. Interview with Paul Gégauff, by Guy Braucourt, *Image et Son*, no. 246 (January 1971).

20. There are multiple versions of *The Tempest*, in the form of novels, tales, stories in dialogue, and synopses. See IMEC, fonds Éric Rohmer, dossier "Éric Rohmer écrivain" (*RHM* 102.10). The novel version begins with this warning: "Ultimately, this novel is about courage, the courage of a woman facing several men who, in one way or another, are blackmailing her."

21. *La Tempête*, IMEC, fonds Éric Rohmer, dossier "Éric Rohmer écrivain" (*RHM* 102.10).

22. "Chantal, ou l'épreuve," IMEC, fonds Éric Rohmer, dossier "La Collectionneuse, premières ébauches" (*RHM* 2.1). This story begins with these lines: "Nothing is more feminine than vengeance. I mean that women have this advantage over us, that they can carry out what we always plan without actually undertaking it. Our bitterness, though it is just as strong, moves us only when our blood is up and almost all of us prefer to leave it to destiny to justify us, even if we feel that law and fate are against us. There are cases in which reacting with rage would reveal our wounds: that is more than we want to admit. Women, on the other hand, are all the more determined to belittle us because they take pleasure in humiliation."

23. "Le Genou de Claire" (also sometimes called "Qui est comme Dieu?"), IMEC, fonds Éric Rohmer, dossier "*Le Genou de Claire*, premières ébauches" (*RHM* 5.1/5.3). The story was published in the collection *Friponnes de porcelaine* (Paris: Stock, 2014).

24. Antoine de Baecque, *La Cinéphilie. Invention d'un regard, histoire d'une culture (1944–1968)* (Paris: Fayard, 2003).

25. André Bazin, "Pour une nouvelle avant-garde," *L'Écran français*, 21 December 1948.

26. Laurent Mannoni, *Histoire de la Cinémathèque française* (Paris: Gallimard, 2006).

27. Ibid., 222–223.

28. Ibid., 216.

29. *Combat*, 21 July 1953.

30. IMEC, fonds Éric Rohmer, dossier "Activités diverses, cinéphilie et CCQL" (*RHM* 110.1).

31. *L'Écran français*, no. 144 (30 March 1948).

32. The meeting took place at Gallimard, which published *La Revue du cinéma* and where Auriol had an office, on 14 April 1948.

33. Interview with Éric Rohmer, 23 December 2008.

34. Ibid.

35. Éric Rohmer, "Le Cinéma, art de l'espace," *La Revue du cinéma*, no 14 (1948).

36. The article is based on the "geometry of the burlesque" (Chaplin, Clair, Keaton), on Eisenstein (the "pure development of masses in space"), on German expressionism (Murnau and the metaphysics of space), and on contemporary directors (Welles and his wealth of spatial imagination; Wyler and his "psychological space"; Hitchcock and his stylization of space; Bresson and the pure expression of space).

37. Interview with Jean Douchet, 8 November 2010.

38. Interview with Jean-Luc Godard, by Alain Bergala, *Jean-Luc Godard par Jean-Luc Godard* (Paris: Éditions *Cahiers du cinéma*, 1985), 9.

39. Éric Rohmer, "Festival Hitchcock: Les Enchaînés," *La Revue du cinéma*, no.15 (1948).

40. Ibid.

41. In the course of the spring of 1949, Maurice Schérer seems to have experienced his first Cannes Festival, concerning which he kept a diary that has remained unpublished in his archives, "Notes sur le 4e Festival de Cannes (1949)." The result is negative, a veritable dirge for current cinema. "What today we have for cinema—the art of our time—is no longer anything but a lie," he writes. Of course, he lists a few more reassuring names, Josef von Sternberg, Bresson, Renoir, Rossellini, but "there are not even ten who deserve to be called creators." The disappointments dominate: *Los Olvidados, Miracle à Milan, Mademoiselle Julie*, that is, Luis Buñuel, Vittorio De Sica, Alf Sjöberg. "We need a total cinema, a cinema of existential expression, of depth, of madness and hope—or else nothing at all," he concludes. IMEC, fonds Éric Rohmer, dossier "Activités diverses, cinéphilie et CCQL" (*RHM* 110.2).

42. Éric Rohmer, "L'Âge classique du cinéma," *Combat*, 15 June 1949.

43. Éric Rohmer, "Réflexions sur la couleur," *Opéra*, no. 202 (1949).

44. Éric Rohmer, "Preston Sturges ou la mort du comique," *Opéra*, no. 206 (1949).

45. Éric Rohmer, "Le Festival du film maudit," *Les Temps Modernes*, no. 47 (1949).

46. Éric Rohmer, "Préface," a text written with a view to publshing his main critical texts, , 1963, IMEC, fonds Éric Rohmer, dossier "Éric Rohmer critique, essayiste, critique de cinéma" (*RHM* 99.19).

47. IMEC, fonds Éric Rohmer, dossier "Activités diverses, cinéphilie et CCQL" (*RHM* 110.3).

48. Interview with Éric Rohmer, 23 December 2008.

49. Interview with Claude de Givray, 25 November 2010.

50. Interview with Philippe d'Hugues, 11 October 2010.

51. IMEC, fonds Éric Rohmer, dossier "Activités diverses, cinéphilie et CCQL" (*RHM* 110.4).

52. Ibid.

53. Jean Gruault, *Ce que dit l'autre* (Paris: Julliard, 1992), 143–144.

54. Claude Chabrol, *Et pourtant je tourne . . .* (Paris: Robert Laffont, 1976), 86.

55. Paul Gégauff, "Entretien avec Fabienne Pascaud," in *La Nouvelle Vague, 25 ans après*, ed. Jean-Luc Douin (Paris: Éditions du Cerf, 1983), 127–128.

56. Quoted by Jean-Baptiste Morain, *Le Mauvais Génie des jeunes Turcs*, op. cit., 15.

57. Letter from Philippe d'Hugues to Antoine de Baecque, 14 October 2010.

58. Interview with Jean Douchet, 8 November 2010.

59. When Éric Rohmer published the official photo in 1959 in no. 100 of *Cahiers du cinéma*, of which he had become editor in chief, he mentioned in a legend all the names present on this image, which is no doubt the most famous picture of the origins of the postwar golden age of cinephilia. He forgot only one name, his own (interview with Jean-Charles Tacchella, 11 October 2010).

60. Jacques Rivette, "Nous ne sommes plus innocents," *Bulletin du ciné-club du Quartier Latin* (March 1950).

61. IMEC, fonds Éric Rohmer, dossier "Activités diverses, cinéphilie et CCQL" (*RHM* 134.4).

62. Interview with Francis Bouchet, 8 April 2011.

63. Ibid.

64. Interview with Jean Douchet, 8 November 2010.

65. Even if it's false . . . Truffaut, who wrote in the *Bulletin du ciné-club du Quartier Latin*, never published anything in *La Gazette du cinéma*, precisely because he was in Germany.

66. Letter from François Truffaut to Éric Rohmer, November 1950, IMEC, fonds Éric Rohmer, dossier "Correspondance professionnelle, François Truffaut" (*RHM* 113).

67. Interview with Francis Bouchet, 8 April 2011.

68. Interview with Éric Rohmer, 23 December 2008.

69. Jean-Paul Sartre, "Le Cinéma n'est pas une mauvaise école," *La Gazette du cinéma*, nos. 2–3 (May–September 1950).

70. In all Jean-Luc Godard published twelve articles between June and November 1950, spread over four issues of *La Gazette*. He was therefore one of the full-fledged members of the journal, occupying, to judge by the tables of contents, a growing place—he published eight articles in numbers 4 and 5 (October and November 1950) alone. Among them we find notes on Elia Kazan (*Panic in the Streets*), Max Ophuls (*La Ronde*), Sergei Eisenstein (*Viva Mexico!*), George Cukor (*Gaslight*), Grigori Kozintsev and Leonid Trauberg (*The Overcoat*).

71. Jean-Luc Godard, "Pour un cinéma politique," *La Gazette du cinéma*, no. 3 (September 1950).

72. Interview with Francis Bouchet, 8 April 2011.

73. Interview with Éric Rohmer by Narboni, *Le Goût de la beauté*, 14.

74. *Bérénice et La Sonate à Kreutzer*, Éric Rohmer collection (Potemkine, 2013), DVD/Blu-ray.

75. Jean Cocteau, "Quelques notes autour du 16 mm ou conseils aux jeunes cinéastes," *Combat*, 14 November 1949.

76. *La Gazette du cinéma*, no. 1 (May 1950).

77. Éric Rohmer, "Nous n'aimons plus le cinéma," *Les Temps Modernes*, no. 44 (October 1949).

78. *Bulletin du ciné-club du Quartier Latin* (October 1949).

79. Interview with Éric Rohmer, 23 December 2008.

80. *Bulletin du ciné-club du Quartier Latin* (November 1949).

81. Ibid.

82. *Bulletin du ciné-club du Quartier Latin* (January 1950).

83. Ibid.

84. Interview with André S. Labarthe, 15 November 2010.

85. A young acquaintance of Schérer's and Gégauff's and an actress making her debut, Josette Sinclair also appeared two years later in the feature film *Les Petites Filles modèles*.

86. IMEC, fonds Éric Rohmer, dossier "Activités diverses, cinéphilie et CCQL" (*RHM* 110.4).

87. *Le Monde*, 14 October 1950; the affair was mentioned again in *Le Monde* on 4 November 1950.

88. IMEC, fonds Éric Rohmer, dossier "Activités diverses, cinéphilie et CCQL" (*RHM* 110.4).

89. Ibid.

90. Ibid.

91. Jacques Rivette, "Festival du film maudit," *La Gazette du cinéma*, no. 4 (October 1950).

92. Antoine de Baecque, *Les Cahiers du cinéma. Histoire d'une revue*, vol. 1, *À l'assaut du cinéma* (Paris: Éditions de l'Étoile/*Cahiers du cinéma*, 1991).

93. André Bazin, ill, tubercular, and forced to enter a sanatorium in the spring of 1951, was not present to edit the first issue of *Cahiers du cinéma*.

94. Andrew, *André Bazin*; de Baecque, "Un saint en casquette de velours," in *La Cinéphilie*, 33–61; Dudley Andrew and Hervé Joubert-Laurencin, eds., *Opening Bazin. Postwar Film Theory and Its Afterlife* (New York: Oxford University Press, 2011).

95. de Baecque, "La Morale est affaire de travelling," in *La Cinéphilie*, 177–188.

96. André Bazin had taken in François Truffaut in 1952 after choosing him as his secretary, and then got him out of prison before training him as a critic.

97. Claude Chabrol, *Et pourtant je tourne . . .*, p. 88.

98. However, the pseudonym Éric Rohmer did not appear on articles on cinema until 1955.
99. Rohmer wrote on *The Lady Vanishes*, *I Confess*, and *Vertigo*.
100. On *Europe 51* and *Voyage en Italie*, and along with Truffaut, he also conducted a long interview with the Roman master in July 1954.
101. On *The Big Sky* and *Gentlemen Prefer Blondes*.
102. On *The Blue Gardenia*.
103. *Cahiers du cinéma* (November 1951).
104. *Cahiers du cinéma* (May 1952).
105. *Cahiers du cinéma* (July 1952).
106. In the table of contents for this special issue of *Cahiers du cinéma* on Hitchcock, we find, in addition Éric Rohmer's presentation, an article by Alexandre Astruc, "Quand un homme . . . ," an essay by Claude Chabrol, "Hitchcock devant le mal," and a long interview conducted in several stages by François Truffaut and Claude Chabrol in which Hitchcock acknowledged, for the first time, a metaphysical inspiration.
107. *Cahiers du cinéma* (October 1953).
108. "Enquête sur la critique," *Cahiers du cinéma* (May 1952).
109. Rohmer, "La Vie c'était l'écran."
110. Interview with Godard by Bergala, *Jean-Luc Godard par Jean-Luc Godard*, 15.
111. Gégauff, "Entretien avec Fabienne Pascaud," 126.
112. IMEC, fonds Éric Rohmer, dossier "Éric Rohmer professeur, enseignement secondaire" (*RHM* 106.3).
113. Ibid.
114. Interview with Éric Rohmer, 23 December 2008.
115. *Le Carrefour du monde*, IMEC, fonds Éric Rohmer, dossier "Éric Rohmer écrivain: nouvelles" (*RHM* 102.10). The scenario begins with Karel killing himself with a revolver in 1951, at the Marco Polo Café in Saint-Germain-des-Prés. It continues with a flashback to Karel's arrival in Paris a few years earlier, pursued by "Marxist" secret agents. Karel Carossa is the former leader of Nazi youth organizations in Hungary and a war criminal, who in France soon becomes the head of the Insurrectional Movement of the True Hungary, an anticommunist party. He is hunted down by Théo Goldstein, a press attaché at the Soviet embassy in Paris who is in fact an agent of the political police. Karel is also a cynical, brilliant seducer and bon vivant, and soon becomes a figure in Saint-Germain-des-Prés high society. He charms both Catherine, the daughter of the director of the Vieux-Colombier Theater and a rising party hostess in Saint-Germain-des-Prés, and Tania, the daughter of the former head of the Milice in Vichy who was shot after Liberation, whom he met at a party. The police force Tania to spy on Karel; she ends up committing suicide. Understanding this act of sacrifice, Karel also kills himself.
116. *Une femme douce*, IMEC, fonds Éric Rohmer, dossier "Une femme douce, films non aboutis" (*RHM* 79.12). This project was published in the collection *Friponnes de porcelaine*.
117. Letter from François Truffaut to Éric Rohmer, December 1954, IMEC, fonds Éric Rohmer, dossier "Correspondance professionnelle, François Truffaut" (*RHM* 113).
118. *Présentation ou Charlotte et son steak*, IMEC, fonds Éric Rohmer, dossier "Courts métrages, Charlotte et son steak" (*RHM* 80.3).
119. Interview with Éric Rohmer, 30 May 2008.
120. Interview with Éric Rohmer, by Frédéric Bonnaud, *Libération*, 3 June 1996.

121. Ibid.

122. On this lost film, the first large-scale inquiry was François Thomas's "Rohmer 1952: *Les Petites Filles modèles*," *Cinéma 09* (Spring 2005). He had access to the fonds Sylvette Baudrot at the Bifi/Cinémathèque française.

123. IMEC, fonds Éric Rohmer, dossier "*Les Petites Filles modèles*, préparation du tournage" (*RHM* 79.5).

124. Up to that point, the first film of the New Wave was considered to be Agnès Varda's *La Pointe courte*, made in 1954, or if the movement is strictly defined, Jacques Rivette's *Paris Belongs to Us*), begun in 1957. The first film to be released in theaters was Claude Chabrol's *Le Beau Serge*, in June 1958.

125. IMEC, fonds Éric Rohmer, dossier "*Les Petites Filles modèles*, écriture de l'oeuvre" (*RHM* 79.5).

126. Thomas, "Rohmer 1952: *Les Petites Filles modèles*."

127. Éric Rohmer, *La Grande Comtesse modèle*, IMEC, fonds Éric Rohmer, dossier "Éric Rohmer essayiste, critique littéraire" (*RHM* 99.20).

128. IMEC, fonds Éric Rohmer, dossier "*Les Petites Filles modèles*, écriture de l'oeuvre" (*RHM* 79.5).

129. Claude Beylie, "De la comtesse de Ségur à Jules Verne," *L'Avant-scène cinéma*, no. 355 (December 1986).

130. Jean-Luc Godard, "*Les Petites Filles modèles*," *Les Amis du cinéma*, no. 1 (October 1952).

131. Éric Rohmer, "Note d'intention," IMEC, fonds Éric Rohmer, dossier "*Les Petites Filles modèles*, écriture de l'oeuvre" (*RHM* 79.5).

132. IMEC, fonds Éric Rohmer, dossier "*Les Petites Filles modèles*, préparation du tournage" (*RHM* 79.5).

133. An expression of Claude Beylie, in one of the very rare articles mentioning this film, "De la comtesse de Ségur à Jules Verne."

134. Chabrol, *Et pourtant je tourne . . .* , 88–89. Jean Douchet reports that Rohmer was very annoyed because the police who had arrested him had confiscated his camera, a Bell & Howell lent by Douchet to make tests with the girls.

135. Letter from Guy de Ray to Éric Rohmer, 23 July 1952, IMEC, fonds Éric Rohmer, dossier "*Les Petites Filles modèles*, préparation du tournage" (*RHM* 79.5).

136. Two reports were published in the press regarding the filming of *Les Petites Filles modèles*, one in the daily *Paris-Normandie*, the other in the weekly *Radio-Cinéma-Télévision* (later *Télérama*), which sent a journalist to the shoot, the young Claude-Marie Trémois, and put the actress who played Sophie on its cover for 12 October 1952.

137. Interview with Pierre Guilbaud, 21 September 2011.

138. Interview with Sylvette Baudrot, 17 September 2011.

139. Quoted in Thomas, "Rohmer 1952: *Les Petites Filles modèles*."

140. Gégauff, "Entretien avec Fabienne Pascaud," 125.

141. *Les Amis du cinéma*, no. 1 (October 1952).

142. Interview with Pierre Guilbaud, 21 September 2011.

143. Interview with Cécile Decugis, 17 November 2010.

144. Interview with Pierre Guilbaud, 21 September 2011.

145. Ibid.

146. IMEC, fonds Éric Rohmer, dossier "*Les Petites Filles modèles*, réception" (*RHM* 79.6).

147. Éric Rohmer, Jean Douchet, *Preuves à l'appui*. Complete transcript, 1993, IMEC, fonds Éric Rohmer, dossier "Films pour la télévision, *Preuves à l'appui*" (*RHM* 98.1).

148. Interview with Pierre Guilbaud, 21 September 2011.

149. Claude-Marie Trémois, "Le Public n'a jamais vu ces films. Pourquoi?," *Radio-Cinéma-Télévision* (1959), IMEC, fonds Éric Rohmer, dossier "*Les Petites Filles modèles*, réception" (*RHM* 79.6).

150. Noël Herpe, "Rohmer, Éric," in *Dictionnaire de la pensée du cinéma*, ed. Antoine de Baecque and Philippe Chevallier (Paris: Presses Universitaires de France, 2012), 606–610; Jacques Aumont, *Les théories des cinéastes* (Paris: Armand Colin, 2001); de Baecque, "Éric Rohmer, moderne et classique: quand le celluloïd devient marbre," in *Cahiers du cinéma. Histoire d'une revue*, 1: 220–232.

151. *Cahiers du cinéma* (February 1957).

152. *Cahiers du cinéma* (August 1958).

153. *Cahiers du cinéma* (October 1956).

154. *Cahiers du cinéma* (January 1957).

155. Ibid.

156. *Cahiers du cinéma* (June 1957).

157. "Il faut être absolument classique" (One must be absolutely classic). Rimbaud wrote: "Il faut être absolument moderne" (One must be absolutely modern).

158. The articles making up "Le Celluloïd et le Marbre" appeared in February, July, October, and December 1955. They were grouped together in a book, preceded by an unpublished preface dating from 1963, and followed by a set of interviews conducted by Philippe Fauvel and Noël Herpe, published by Éditions Léo Scheer in 2010.

159. Nicolas Boileau-Despréaux (1636–1711) was the great theorist of French classicism; Jean-François de La Harpe (1739–1803) was the author of *Cours de littérature ancienne et moderne*, which dealt at length with French classicism.

160. *Cahiers du cinéma* (February 1955).

161. *Cahiers du cinéma* (July 1955).

162. *Cahiers du cinéma* (January 1959).

163. *Cahiers du cinéma* (May 1953).

164. *Cahiers du cinéma* (July 1953).

165. *Cahiers du cinéma* (April 1957).

166. *Cahiers du cinéma* (October 1954).

167. Ibid.

168. *Cahiers du cinéma* (February 1955).

169. *Cahiers du cinéma* (December 1955).

170. Ibid.

171. Ibid.

172. *Cahiers du cinéma* (March 1953).

173. Ibid.

174. *Cahiers du cinéma* (November 1955).

175. Roger Caillois, "Illusions à rebours," *NRF* (December 1954–January 1955); Claude Lévi-Strauss, "Diogène couché," *Les Temps Modernes* (March 1955).

176. Regarding these canons of beauty, Rohmer, questioned a few years later in connection with an inquiry conducted by Claude Gauteur and Albert Memmi concerning Jews and the way they were seen in France, said he could not reply, because although there were Jews in his entourage,

he was incapable of recognizing them: "They're Whites!" On the other hand, he said he didn't like *Hiroshima mon amour* because he could not understand how a French woman could fall in love with an Asian. Interview with Claude Gauteur, 11 March 2012.

177. *Cahiers du cinéma* (December 1955).

178. *Cahiers du cinéma* (July 1957).

179. In 1952, the term "Third World" first appeared in an article by Alfred Sauvy in *France Observateur*; in 1961, with the publication of Frantz Fanon's *Les damnés de la terre*, the role of the dynamic actor in history shifted from the Western working class to a world in the process of decolonization, promoted to the status of proletarian on the worldwide scale. The decade between these two dates was occupied with the discovery of the Other, of "peripheral civilizations" through the anthropological works of Lévi-Strauss (*Race and History* in 1952; *Tristes tropiques* in1955), Jacques Soustelle (*La Vie quotidienne des Aztèques* in 1954), or Georges Balandier (*Afrique ambiguë* in 1957).

180. *Cahiers du cinéma* (August 1956).

181. *Cahiers du cinéma* (September 1957).

182. Quoted by de Baecque, "La Morale est affaire de travelling," in *La Cinéphilie*, 183.

183. Interview with Godard, by Bergala, *Jean-Luc Godard par Jean-Luc Godard*, 18.

184. Letter from Louis Marcorelles to Éric Rohmer, IMEC, fonds Éric Rohmer, dossier "Correspondance professionnelle, Louis Marcorelles" (*RHM* 113).

185. IMEC, fonds Éric Rohmer, dossier "Coupures de presse, sur la politique" (*RHM* 120).

186. Interview with Jean Parvulesco, 18 October 2010.

187. Hélène Liogier, "1960: vue d'Espagne, la Nouvelle Vague est fasciste. Ou la Nouvelle Vague selon Jean Parvulesco," *1895*, no. 26 (December 1998).

188. Dominique Bluher and François Thomas, eds., *Le Court Métrage français de 1945 à 1968. De l'âge d'or aux contrebandiers* (Presses Universitaires de Rennes, 2005).

189. It was long thought that *Bérénice* was lost. But in 1965 Rohmer included six minutes of the film, attributed to a fictive British filmmaker, Dick Peters, in the program he made for educational television, *Les histoires extraordinaires d'Edgar Poe*. Discovered in his office and restored, *Bérénice* has been made available in the DVD boxed set "Rohmer, l'intégrale."

190. The monologue underlines the dramatic role of the sonata: "Music is a terrible thing. It is said that it pacifies, that it ennobles. That isn't true. It limits itself to communicating a certain excitement to you, a pure excitement, an excitement that has no outlet. It increases your inner torment without providing you with the nourishment needed to relieve it."

191. Interview with Pierre Rissient, 23 November 2010.

192. Letter from François Truffaut to Éric Rohmer, 17 April 1956, IMEC, fonds Éric Rohmer, dossier "Correspondance professionnelle, François Truffaut" (*RHM* 113).

193. *Arts. 1952–1966. La Culture de la provocation*, texts collected and presented by Henri Blondet (Paris: Tallandier, 2009).

194. On Jacques Laurent, the director of *Arts*. *Arts. 1952–1966*, 15–37.

195. de Baecque, "Comment François Truffaut a écrit 'Une certaine tendance du cinéma français,'" in *La Cinéphilie*, 135–167.

196. Antoine de Baecque and Serge Toubiana, *François Truffaut* (Paris: Gallimard, 1996), 240.

197. Interview with Éric Rohmer, 23 December 2008.

198. Ibid.
199. Letter from François Truffaut to Éric Rohmer, 9 August 1956, IMEC, fonds Éric Rohmer, dossier "Correspondance professionnelle, François Truffaut" (*RHM* 113).
200. Letter from François Truffaut à Éric Rohmer, late August 1956, IMEC, fonds Éric Rohmer, dossier "Correspondance professionnelle, François Truffaut" (*RHM* 113).
201. Letter from François Truffaut to Éric Rohmer, Spring 1956 IMEC, fonds Éric Rohmer, dossier "Correspondance professionnelle, François Truffaut" (*RHM* 113).
202. Interview with Claude Chabrol, by Charlotte Garson, special issue on Éric Rohmer, *Cahiers du cinéma* (February 2010).
203. Claude Chabrol and Éric Rohmer, *Alfred Hitchcock* (Paris: Éditions universitaires, 1957), 153.
204. IMEC, fonds Éric Rohmer, dossier "Éric Rohmer essayiste, critique de cinéma" (*RHM* 99.1). Zig and Puce are characters in a Franco-Belgian comic book series created by Alain Sant-Ogan in 1925. They have a pet auk named Alfred.
205. Interview with Éric Rohmer, 13 June 2008. This interview was published as a preface to the German edition of the book (edited by Robert Fischer, Berlin: Alexander, 2013: 200).
206. Ado Kyrou, *Les Lettres nouvelles*, no. 47 (March 1957); quoted by Dominique Rabourdin in his preface to the Ramsay reprint (Paris, 1986) of the book in 1986: "Why reprint the first book on Hitchcock" (4).
207. *Cahiers du cinéma* (August 1958).

3. Under the *Sign of Leo*: 1959–1962

1. "Le Signe du Lion," manuscript synopsis, IMEC, fonds Éric Rohmer, dossier "*Le Signe du Lion*, écriture de l'oeuvre" (*RHM* 1.1).
2. Ibid.
3. *Le Signe du Lion, découpage dactylographié*, BiFi, fonds François Truffaut, dossier "Éric Rohmer."
4. Interview with Jean Parvulesco, 18 October 2010.
5. Interview with Pierre Cottrell, 2 February 2011.
6. *Le Signe du Lion*, typed synopsis, IMEC, fonds Éric Rohmer, dossier "*Le Signe du Lion*, écriture de l'oeuvre" (*RHM* 1.1).
7. Arthur Rimbaud, "Chanson de la plus haute tour."
8. Interview with Éric Rohmer, by Noël Herpe and Philippe Fauvel, *Le Celluloïd et le Marbre* (Paris: Éditions Léo Scheer, 2011).
9. Interview with Philippe Collin, 22 September 2010.
10. Interview with Pierre Rissient, 23 November 2010.
11. Éric Rohmer, "Nous n'aimons plus le cinéma," *Les Temps modernes*, no. 44 (October 1949).
12. Interview with Pierre Lhomme, 3 December 2010.
13. Éric Rohmer, typed response to Jean Parvulesco's questionnaire, IMEC, fonds Éric Rohmer, dossier "*Le Signe du Lion*, réception" (*RHM* 1.13).
14. Interview with Philippe Collin, 22 September 2010.
15. Interview with Claude-Jean Philippe, 16 September 2010.
16. Interview with Pierre Lhomme, 3 December 2010.
17. Interview with Pierre Rissient, 23 November 2010.
18. Interview with Claude Chabrol, by François Guérif, *Un Jardin bien à moi* (Paris: Denoël, 1999).

19. Contract created by Roland Nonin, June 1959, IMEC, fonds Éric Rohmer, dossier "*Le Signe du Lion*, production" (*RHM* 1.1).
20. Letter from Éric Rohmer to Roland Nonin, 9 April 1960, IMEC, fonds Éric Rohmer, dossier "*Le Signe du Lion*, réception" (*RHM* 1.14)
21. Letter from Roland Nonin to Éric Rohmer, Paris, 14 March 1962, IMEC, fonds Éric Rohmer dossier "*Le Signe du Lion*, réception" (*RHM* 1.14).
22. Draft of a letter from Éric Rohmer to Peter Von Bagh, Paris, May 1966, IMEC, fonds Éric Rohmer, dossier "*Le Signe du Lion*, réception" (*RHM* 1.14).
23. Press kit for *Le Signe du Lion*, May 1962, IMEC, fonds Éric Rohmer, dossier "*Le Signe du Lion*, promotion" (*RHM* 1.8).
24. *L'Express*, 3 May 1962.
25. Letter from J.-P. Bachollet to Éric Rohmer, Paris, 11 May [1962], IMEC, fonds Éric Rohmer, dossier "*Le Signe du Lion*, courrier des spectateurs" (*RHM* 1.19).
26. *France Observateur*, 10 May 1962.
27. *Cahiers du cinéma*, July 1962.
28. *La Nation française*, 1962; *Santanyi*, 30 May 1964.
29. *Santanyi*, 30 May 1964.
30. Rohmer, typed response to Parvulesco's questionnaire.
31. Ibid.
32. Ibid.
33. Ibid.
34. Ibid.
35. *La Nation française*, op. cit.
36. *France Observateur*, 6 April 1961.
37. Letter from Nino Frank to Éric Rohmer, Paris, 22 December 1959, IMEC, fonds Éric Rohmer, dossier "Correspondance professionnelle, Nino Frank" (*RHM* 113).

4. Under the Sign of *Cahiers*: 1957–1963

1. The term "young Turks" is political in origin; it was often applied to the youngest, most enthusiastic and radical reformers in various parties. The expression had its origin in the party of the "young Turks" who sought to reform the Ottoman Empire at the end of the nineteenth century. In France, between the two world wars, this term was used to designate the left wing of the Radical party, which wanted to thoroughly renovate this old-fashioned party.
2. Antoine de Baecque, *Les Cahiers du cinéma. Histoire d'une revue*, vol. 1, *À l'assaut du cinéma* (Paris: Éditions de l'Étoile/*Cahiers du cinéma*, 1991).
3. Letter from Éric Rohmer to the Commission de la carte d'identité des journalistes professionnels, 6 January 1958, IMEC, fonds Éric Rohmer, dossier "Correspondance professionnelle, *Cahiers du cinéma*" (*RHM* 115.42).
4. *Cahiers du cinéma* (January 1959).
5. *Cahiers du cinéma* (January 1959).
6. With the exception of Walter Benjamin and Siegfried Kracauer (whom neither Bazin nor Rohmer had read at this time), especially "The Work of Art in the Age of Its Mechanical Reproduction," an essay Benjamin wrote in 1935.

7. Éric Rohmer devoted three articles to Bazin's thought and to *Qu'est-ce que le cinéma?* In *Cahiers du cinéma*, January 1959, "La somme d'André Bazin"; in *Arts*, 21 January 1959, "Un grand événement cinématographique: la parution du premier tome de *Qu'est-ce que le cinéma?* André Bazin's last work." Then in *Le Monde*'s supplement "Le Siècle du cinéma," January 1995, "La Révolution Bazin: le mystère de l'existence," a title the newspaper gave to a six-page article written by Rohmer on this occasion and which he himself entitled "L'ontologie d'André Bazin."

8. Articles appeared in *Cahiers du cinéma* on *The Quiet American* (August 1958), *Vertigo* (March 1959), *The Virgin Spring* (April 1959), and *Picnic on the Grass* (December 1959).

9. The *Cahiers du cinéma* roundtables on *Hiroshima mon amour* (August 1959) or on criticism (December 1961).

10. Rohmer conversed with Cukor (January 1961), Astruc (February 1961), Preminger (July 1961), Langlois (September 1962), Rouch (June 1963), and Rossellini (July 1963).

11. At the same time, he was writing in the review *Cinéma 59*, edited by Pierre Billard (he began in *Cinéma 57*), and working for *Radar* and *Détective* to make a living. Michel Delahaye's main texts have been collected under the title *À la fortune du beau* (Paris: Capricci, 2010).

12. Interview with Michel Delahaye, 22 September 2010.

13. Interview with Barbet Schroeder, 7 December 2010.

14. Interview with Jean Douchet, 8 November 2010.

15. de Baecque, *Les Cahiers du cinéma. Histoire d'une revue*, 1: 157–159.

16. Interview with Éric Rohmer and Jean Douchet, *Cinéma 84*, "La Critique en question," no. 303 (March 1984).

17. Letter from Louis Marcorelles to Éric Rohmer, with this phrase: "Le Fullerisme infantile, ce fascisme de nursery cher à certains," IMEC, fonds Éric Rohmer, dossiers "Correspondance professionnelle, Louis Marcorelles" (*RHM* 113).

18. Interview with Michel Mourlet, 8 December 2010.

19. Interview with André Labarthe, 15 November 2010.

20. Interview with Jacques Rivette, 18 January 2011.

21. Letter from François Truffaut to Éric Rohmer (on *Passions juvéniles*, a film by Ko Nakahira), IMEC, fonds Éric Rohmer, dossier "Correspondance professionnelle, François Truffaut" (*RHM* 113).

22. Letter from Jacques Doniol-Valcroze to Éric Rohmer, 21 August 1958, IMEC, fonds Éric Rohmer, dossier "Correspondance professionnelle, Jacques Doniol-Valcroze" (*RHM* 113).

23. Ibid.

24. Ibid.

25. To the point, moreover, of getting the editor in chief, who was responsible for the publication, sued in 1961 by Claude Autant-Lara, the director of *Tu ne tueras point*, who was furious about the way his film was treated in an article by Jean Douchet.

26. Interview with Thérèse and Laurent Schérer, 27 November 2010.

27. The equivalent of an average salary in a government job (today, with all the precautions that this kind of anachronistic comparison demands—about 2,000 euros).

28. Letter from the Commission de la carte d'identité des journalistes professionnels to Éric Rohmer, 26 December 1957, IMEC, fonds Éric Rohmer, dossier "Correspondance professionnelle, *Cahiers du cinéma*" (*RHM* 115.42).

29. Letter from Éric Rohmer to the Commission de la carte d'identité des journalistes professionnels, 6 January 1958, IMEC, fonds Éric Rohmer, dossier "Correspondance professionnelle, *Cahiers du cinéma*" (*RHM* 115.42).

30. *Le Monde* was the favored newspaper in the 1970s, followed by *Libération* in the 1990s. This is very clear in the different strata of the (many) newpaper clippings saved by Rohmer throughout his life. IMEC, fonds Éric Rohmer, dossier "Coupures de presse" (*RHM* 120.121).

31. Letter from Lydie Doniol-Valcroze to Éric Rohmer, August 1958, IMEC, fonds Éric Rohmer, dossier "Correspondance professionnelle, *Cahiers du cinéma*" (*RHM* 115.43).

32. Interview with Thérèse and Laurent Schérer, 27 November 2010.

33. Ibid.

34. Ibid.

35. de Baecque, *Les Cahiers du cinéma. Histoire d'une revue*, vol. 2 (Paris: Éditions de l'Étoile/*Cahiers du cinéma*, 1991), 7–31.

36. *Arts*, 9 May 1956.

37. *Arts*, 14 March 1958.

38. *Cahiers du cinéma* (December 1961).

39. Antoine de Baecque, "François Truffaut et la politique des copains," in *Pour un cinéma comparé. Influences et répétitions*, ed. Jacques Aumont (Paris: Cinémathèque française/Mazzotta, 1996), 51–68.

40. Éric Rohmer, "La Vie c'était l'écran," in "Le Roman de François Truffaut," special issue, *Cahiers du cinéma* (December 1984).

41. *Cahiers du cinéma* (January 1962).

42. *Arts*, 14 November 1960.

43. Letter from François Truffaut to Helen Scott, 26 September 1960, collection François Truffaut, BiFi/Cinémathèque française, dossier "Helen Scott."

44. *Signes du temps* (December 1962).

45. *Cahiers du cinéma* (December 1962).

46. Ibid.

47. Antoine de Baecque, *Les Cahiers du cinéma. Histoire d'une revue*, 2: 20–31.

48. Letter from Jacques Doniol-Valcroze to François Truffaut, 15 June 1962, BiFi/Cinémathèque française, fonds François Truffaut, dossier "*Cahiers du cinéma*."

49. Letter from François Truffaut to Jacques Doniol-Valcroze, 5 July 1962, BiFi/Cinémathèque française, fonds François Truffaut, dossier "*Cahiers du cinéma*."

50. Letter from Jacques Doniol-Valcroze to Éric Rohmer, July 1962, IMEC, fonds Éric Rohmer, dossier "Correspondance professionnelle, *Cahiers du cinéma*" (*RHM* 115.44).

51. Letter from Éric Rohmer to Jacques Doniol-Valcroze, July 1962, IMEC, fonds Éric Rohmer, dossier "Correspondance professionnelle, *Cahiers du cinéma*" (*RHM* 115.44).

52. Letter from Jacques Doniol-Valcroze to Éric Rohmer, July 1962, IMEC, fonds Éric Rohmer, dossier "Correspondance professionnelle, *Cahiers du cinéma*" (*RHM* 115.44).

53. *Cahiers du cinéma* (August 1962).

54. Questioned on this point, Jean Douchet replied that he supported the New Wave in the "unwritten cinephile life," in the course of discussions and oral polemics among critics.

55. *Cahiers du cinéma* (September 1962).

56. Texts accompanying a letter from Éric Rohmer to François Truffaut, IMEC, fonds Éric Rohmer, dossier "Correspondance professionnelle, François Truffaut" (*RHM* 113).

57. Interview with Éric Rohmer, by Gégard Guégan, *Les Lettres françaises*, 1964, IMEC, fonds Éric Rohmer, dossier "Entretiens avec Éric Rohmer" (*RHM* 125.4).

58. Éric Rohmer, "Carnets noirs," IMEC, fonds Éric Rohmer, dossier "Notes de travail diverses" (*RHM* 134.17).

59. Éric Rohmer, notes to Pierre Cottrell, IMEC, fonds Éric Rohmer, dossier "Correspondance professionnelle, Pierre Cottrell" (*RHM* 113).

60. Interview with Éric Rohmer in the review *Nord-communications*, 1962, IMEC, fonds Éric Rohmer, dossier "Entretiens avec Éric Rohmer" (*RHM* 125.5).

61. Éric Rohmer, *Charlotte et Véronique*, version 1960, IMEC, fonds Éric Rohmer, dossier "Films non aboutis, 'Charlotte et Véronique'" (*RHM* 80.13). Seventeen episodes were planned: 1. Charlotte and Véronique are traveling to Paris by train. 2. They move into a cheap hotel on the Left Bank. 3. An old man flirts with them and helps them leave without paying the bill. 4. They gradually learn the paradoxes and mysteries of the French capital. 5. Philosophy in the boudoir. 6. Véronique gives math and French lessons to a lazy little boy. 7. Charlotte as a barmaid. 8. Charlotte and Véronique boast of having each seduced a remarkable young man and notice that their respective lovers are the same person. 9. Charlotte gets herself into an absurd situation and can escape it only by pushing it to the limit. 10. A Sunday spent doing nothing with friends. 11. Weekend in an Isetta. 12. Helping the police: they accidentally unmask a dangerous criminal. 13. Interview on TV as model students. They cannot do on camera what they do every day, laugh instead of cry. 14. Hitchhiking on the Côte d'Azur. 15. They pass themselves off as Hollywood stars. 16. Charlotte as a tourist guide. She mixes up everything, recounts historical adventures in her own way. 17. Véronique, an inexperienced water-skiing teacher.

62. Éric Rohmer, Jean-Luc Godard, *Charlotte et Véronique*, version 1957, IMEC, fonds Éric Rohmer, dossier "Films non aboutis, 'Charlotte et Véronique'" (*RHM* 80.13).

63. Éric Rohmer, *Un petit cancre modèle*, 1958, IMEC, fonds Éric Rohmer, dossier "Films non aboutis, "Charlotte et Véronique'" (*RHM* 80.12).

64. Interview with Éric Rohmer, by Frédéric Bonnaud, *Libération*, 3 June 1996.

65. Éric Rohmer, Guy de Ray, notes for *Charlotte et Véronique*, 1961, IMEC, fonds Éric Rohmer, dossier "Films non aboutis, 'Charlotte et Véronique'" (*RHM* 80.12).

66. Ibid.

67. Interview with Éric Rohmer, by Simon Monceau, *Bande à part* (July–August 1967).

68. Éric Rohmer, *Une femme douce*, synopsis, IMEC, fonds Éric Rohmer, dossier "Films non aboutis, *Une femme douce*" (*RHM* 79.12).

69. Éric Rohmer and Jean Douchet, *Preuves à l'appui*, complete transcription, 1993, IMEC, fonds Éric Rohmer, dossier "Cinéastes de notre temps, *Preuves à l'appui*" (*RHM* 98.1).

70. Interviews conducted with Éric Rohmer by Jean-Noël Mouret with a view to the afterword for the reprint of *La Maison d'Élisabeth* (IMEC, fonds Éric Rohmer, dossier "Rohmer écrivain: romans" [*RHM* 102.9]), and Samuel Blumenfeld, *Le Monde des livres*, 18 May 2007.

71. Éric Rohmer, "Carnets noirs," IMEC, fonds Éric Rohmer, dossier "Notes de travail diverses" (*RHM* 134.17).

72. Interview with Éric Rohmer, by Guy Braucourt, *Écran*, no. 47 (1974).

73. Éric Rohmer, "Avant-propos," *Six contes moraux* (Paris: Éditions de L'Herne, 1974), 9–14.

74. Interview with Éric Rohmer, in the review *Nord-communications*, 1962, IMEC, fonds Éric Rohmer, dossier "Entretiens avec Éric Rohmer" (*RHM* 125.5).

75. Éric Rohmer, *La Boulangère de Monceau*, scenario 1962, IMEC, fonds Éric Rohmer, dossier "La Boulangère de Monceau" (*RHM* 80.14).

76. Ibid.

77. Ibid.

78. Interview with Barbet Schroeder, 7 December 2010.

79. Ibid.

80. Ibid.

81. Ibid.

82. Ibid.

83. Éric Rohmer, *La Boulangère de Monceau*, structural analysis, IMEC, fonds Éric Rohmer, dossier "*La Boulangère de Monceau*" (*RHM* 80.15).

84. Éric Rohmer, "Carnets noirs," IMEC, fonds Éric Rohmer, dossier "Notes de travail diverses" (*RHM* 134.17).

85. Interview with Barbet Schroeder, 7 December 2010.

86. Interview with Claude de Givray, 25 November 2010.

87. A cinephile expression forged on the model of the star Angie Dickinson, who appeared notably in Howard Hawks's *Rio Bravo*.

88. Michèle Girardon died in 1975, at the age of 37, the victim of an illness. She was supposed to appear in the project *Une femme douce*.

89. Interview with André Labarthe, 15 November 2010.

90. Interview with Barbet Schroeder, 7 December 2010.

91. Ibid. The diamond shape also designated the four intial associates, like the four corners of the geometrical figure: Éric Rohmer, Barbet Schroeder, Jean Douchet, and Georges Bez.

92. Jean Douchet, *30 ans du Losange*, a brochure published by Films du Losange in 1992. See also Jean Douchet, "Un esprit Nouvelle Vague: Les Films du Losange," in de Baecque *Pour un cinéma comparé*, 69–76.

93. Éric Rohmer, "Carnets noirs," IMEC, fonds Éric Rohmer, dossier "Notes de travail diverses" (*RHM* 134.17).

94. Éric Rohmer, *La Carrière de Suzanne*, structural analysis, IMEC, fonds Éric Rohmer, dossier "La Carrière de Suzanne" (*RHM* 80.21).

95. Éric Rohmer, "Le Revolver," story, 1949, IMEC, fonds Éric Rohmer, dossier "La Carrière de Suzanne" (*RHM* 80.20). This short story was published in the collection *Friponnes de porcelaine* (Paris: Stock, 2014).

96. Éric Rohmer, *La Carrière de Suzanne*, scenario, 1962, IMEC, fonds Éric Rohmer, dossier "*La Carrière de Suzanne*" (*RHM* 80.20).

97. Interview with Barbet Shroeder, 7 December 2010.

98. *Les Nouvelles littéraires*, 20 January 1965.

99. *L'Humanité*, 3 October 1966.

100. *Le Monde,* 3 March 1974.

101. *Les Nouvelles littéraires*, 4 March 1974.

102. Hélène Frappat, *Jacques Rivette, secret compris* (Paris: Éditions des *Cahiers du cinéma*, 2001); Marc Cerisuelo, "L'art en avant de l'action, Jacques Rivette critique," *Études cinématographiques*, no. 63 (1998); Antoine de Baecque, *Les Cahiers du cinéma. Histoire d'une revue*, 1: 232–241.

103. Interview with Jean Douchet, 8 November 2010.

104. Interview with Philippe d'Hugues, 11 October 2010.

105. Interview with Michel Delahaye, 22 September 2010.

106. Interview with André Labarthe, 15 November 2010.

107. Interview with Barbet Schroeder, 7 December 2010.

108. Ibid.

109. Interview with Michel Delahaye, 22 September 2010.

110. Interview with André Labarthe, 15 November 2010.

111. Letter from Jacques Doniol-Valcroze to Éric Rohmer, July 1962, IMEC, fonds Éric Rohmer, dossier "Correspondance professionnelle, *Cahiers du cinéma*" (*RHM* 115.44).

112. Antoine de Baecque, *Les Cahiers du cinéma. Histoire d'une revue*, 2: 61–70.

113. *Cahiers du cinéma* (August 1959). Michel Mourlet has collected most of his texts and his cinematic thinking in a book entitled *Sur un art ignoré*, published by Éditions Henri Veyrier in 1987, and then by Ramsay in 2007.

114. On Charlton Heston, Mourlet gushes: "His presence in a film suffices to elicit beauty: the contained violence suggested by the somber phosphorescence of his eyes, the aquiline profile, the proud arch of his brows, the prominent cheekbones, the bitter, hard curve of his mouth, the fabulous strength of the torso—that's what is given" ("Apologie de la violence," *Cahiers du cinéma* [May 1960]).

115. *Cahiers du cinéma* (August 1959).

116. Ibid.

117. Ibid.

118. *Cahiers du cinéma* (January 1962).

119. *Cahiers du cinéma* (December 1962).

120. Interview with Barbet Schroeder, 7 December 2010.

121. This hostility to General de Gaulle, accused of "selling off Algeria cheap" and being an "authoritarian figure," is still perceptible in November 1970, a few days after the great man's death, at the time when the place de l'Étoile was officially renamed the "place du Général de Gaulle": Rohmer protested, but at a little distance, saying that he was "taking a walk" not far from the traditional opponents of the Algérie française stripe.

122. Interview with Barbet Schroeder, 7 December 2010.

123. Interview with Michel Delahaye, 22 September 2010.

124. Antoine de Baecque, "Le Passage au moderne," in *La Cinéphilie. Invention d'un regard, histoire d'une culture (1944–1968)* (Paris: Fayard, 2003), 295–341.

125. *Cahiers du cinéma* (November 1963).

126. *Cahiers du cinéma* (March 1952).

127. In "Photogénie du sport" (*Cahiers du cinéma* [October 1960]), regarding the rebroadcast live of the Olympic Games in Rome in a movie theater in 1960: "I know, it isn't a film. One of the clearest originalities of our review has been talking about films that people don't talk about, considering so-called commercials as works of art, which they are. It is important to pursue this exploration without neglecting the parallel activities of a means of expression which, too sure of its good conscience and the indiscreet zeal of its worshippers, today runs no greater risk than allowing itself to be imprisoned in the same ivory tower as the other contemporary arts." This is a "modernist" manifesto if ever there was one.

128. *Cahiers du cinéma* (June 1963).

129. In a few "Notes sur l'ordre moderne," Rohmer wrote in 1963: "It seems that for the past ten years art has slowed its advance, without for all that admitting its sterility. We have entered into the age of a new order, the modern order, in which the conventions of serial music and those, less acknowledged, of abstract painting, make disciples of Schönberg or Webern, of Kandinsky or

Klee, classics in their own right, cured of any appetite for death or apocalypse." (A text that Rohmer wanted to use as a "preface" to his critical works, and that was finally published as a posthumous introduction to *Le Celluloïd et le Marbre*, [Paris: Éditions Léo Scheer, 2011]).

130. Douchet was later to say: "We are proudly aware that *Cahiers* was profoundly modern. We were the ones who impressed intellectuals and artists in other domains. But the race toward modernity changed things, when the review suddenly gave itself "intellectual guides." It lost its advantage, and in a certain way, its prestige. Rohmer and I were then classed as antimoderns, which is totally false" (interview with Jean Douchet in *Les Inrockuptibles*, 27 October 1999).

131. Interview with Michel Delahaye, 22 September 2010.

132. Éric Rohmer, chronology for *Cahiers du cinéma*, 2007, IMEC, fonds Éric Rohmer, dossier "Correspondance professionnelle, *Cahiers du cinéma*" (*RHM* 115.44).

133. Interview with Rohmer, by Douchet, *Les Inrockuptibles*, 27 October 1999.

134. Letter from Jacques Doniol-Valcroze to Éric Rohmer, March 1963, IMEC, fonds Éric Rohmer, dossier "Correspondance professionnelle, *Cahiers du cinéma*."

135. Rivette and Doniol understood that Douchet was the true supporting pillar of Rohmer's *Cahiers*; it was he who attracted writers, organized the editing, set the tone regarding films, and incarnated *Cahiers*'s taste. He was the one they wanted to get rid of first, especially after a violent altercation between Doniol and Douchet in which the latter shouted at the former, regarding a divergence of opinion about Mankiewicz's *Cleopatra*: "You founded *Cahiers*, but you are not *Cahiers*, you've never been *Cahiers*!"

136. "L'histoire des *Cahiers du cinéma* vue par Jacques Doniol-Valcroze," an interview published in Emmanuelle Astruc's thesis for the Diplôme des Études Approfondies, "L'Histoire des *Cahiers du cinéma*" (Paris-I, 1988), 52–53.

137. Interview with Léonard Keigel, 17 November 2010.

138. Letter from Marie-Claire Sarvey to Éric Rohmer, 11 May 1963, IMEC, fonds Éric Rohmer, dossier "Correspondance professionnelle, *Cahiers du cinéma*" (*RHM* 115.44).

139. Letter from Jacques Doniol-Valcroze to Éric Rohmer, 31 May 1963, IMEC, fonds Éric Rohmer, dossier "Correspondance professionnelle, *Cahiers du cinéma*" (*RHM* 115.44).

140. The sum of 7,535 francs represented nine months of salary for Rohmer.

141. Letter from Jacques Doniol-Valcroze to Éric Rohmer, 30 May 1963, IMEC, fonds Éric Rohmer, dossier "Correspondance professionnelle, *Cahiers du cinéma*" (*RHM* 115.44).

142. "L'histoire des *Cahiers du cinéma* vue par Jacques Doniol-Valcroze," an interview published in Astruc, "L'Histoire des *Cahiers du cinéma*," 53.

5. The Laboratory Period: 1963–1970

1. Letter from Georges Sadoul to Éric Rohmer, 24 August 1963, IMEC, fonds Éric Rohmer, dossier "Correspondance professionnelle, Georges Sadoul" (*RHM* 113).

2. Letter from Michel Delahaye to Éric Rohmer, 8 November 1963, IMEC, fonds Éric Rohmer, dossier "Correspondance professionnelle, Michel Delahaye" (*RHM* 113).

3. Letter from François Truffaut to Éric Rohmer, 12 April 1965, IMEC, fonds Éric Rohmer, dossier "Correspondance professionnelle, François Truffaut" (*RHM* 113).

4. *Cahiers du cinéma* (July 1963).

5. Antoine de Baecque, *La Cinéphilie. Invention d'un regard, histoire d'une culture (1944–1968)* (Paris: Fayard, 2003), 321.

6. *Arts*, 21 October 1964.

7. It was almost two years before Rohmer published in *Cahiers du cinéma* again, and then solely texts or interviews as a filmmaker. He responded to the inquiry "Sept questions sur le cinéma" (January 1965) and gave his point of view in eight replies to a questionnaire on "the problems of film narrative" in November 1966. In the meantime, Jean-Claude Biette, Jacques Bontemps, and Jean-Louis Comolli got Rohmer to talk in an interview entitled "L'Ancien et le Nouveau" (November 1965), which was presented in the review in a way that was as adroit as it was awkward:

 > It is with a filmmaker, Éric Rohmer, with whom we have long wanted to talk. But for us, at *Cahiers*, this can involve only restoring to Éric Rohmer a voice that, even though it was stilled on the occasion of the abandonment of one form of writing for another, has never ceased to guide us. For on leaving the marble of *Cahiers*, has he not given on celluloid his finest critiques? This interview must be read in the perspective of clarifying our own critical positions, putting the accent on the continuity of a line taken by *Cahiers* for which Éric Rohmer and Jacques Rivette both provided, for what was best in our positions, the same orientation and the flexibility, which was greater than has sometimes been thought. The title we give to this interview echoes this concern.

8. Interview with Éric Rohmer, by Hélène Waysbord, 2009, in the *Le Laboratoire d'Éric Rohmer, un cinéaste à la Télévision scolaire* (Paris: CNDP/CRDP/SCEREN, 2012), DVD boxed set.

9. Éric Rohmer, "La Vie c'était l'écran," in "Le Roman de François Truffaut," special issue, *Cahiers du cinéma* (December 1984): 35.

10. Éric Rohmer, preparatory interview with Emmanuelle Chaulet, tape preparatory to *L'Ami de mon amie*, 1985, IMEC, fonds Éric Rohmer, dossier "*L'Ami de mon amie*, préparation du tournage" (*RHM* 37.1).

11. Interview with Thérèse Schérer, 27 October 2010.

12. Instead of "Maurice Schérer, born in Tulle, March 21, 1920," IMEC, fonds Éric Rohmer, dossier "Papiers personnels, divers" (*RHM* 134.17).

13. Letter from Éric Rohmer, 10 October 1966, IMEC, fonds Éric Rohmer, dossier "Activités diverses, CCQL et cinéphilie" (*RHM* 110.4).

14. Interview with Thérèse Schérer, 27 October 2010.

15. Such collections exist for Jean-Luc Godard (*Godard* [Paris: Denoël, 1968], republished and complemented by Alain Bergala, *Jean-Luc Godard par Jean-Luc Godard* [Paris: Éditions *Cahiers du cinéma*, 1985] and for François Truffaut (*Les Films de ma vie* [Paris: Flammarion, 1975]). But Jacques Rivette has always opposed such a volume. As for Claude Chabrol, he is the only member of the *Cahiers* group of the New Wave who has written his memoirs: *Et pourtant je tourne . . .* (Paris: Robert Laffont, 1976).

16. Rohmer accepted the proposal, and wanted to coauthor the work with Jean Narboni, whose article on Nicholas Ray's film *Bigger than Life* (1956) he had noted in *Cahiers du cinéma*. The work was not written, because the young critic left to do medical service on the island of Réunion. Interview with Jean Narboni, 14 May 2011.

17. Letter from Folon to Éric Rohmer, 24 August 1963, IMEC, fonds Éric Rohmer, dossier "Correspondance professionnelle, Folon" (*RHM* 113).

18. Here is the organization Rohmer foresaw for such a collection, *L'Âge classique du cinéma*: "1. The classical age of cinéma; 2. We no longer like cinéma; 3. The Festival du film maudit; 4. For a speaking cinéma; 5. Cinéma, an art of space; 6. Vanity of painting; 7. Reflections on color; 8. Tastes and colors; 9. Cinemascope; 10. South Pacific; 11. Faith and mountains; 12. Olympic Games; 13. Isou or things as they are; 14. On three films and a certain school; 15. Rediscovering America; 16. Jean Renoir's youth; 17. The man, the ape, and the Martian; 18. Lessons to be learned from a failure (Huston); 19. Welles; 20. The taste for beauty." IMEC, fonds Éric Rohmer, dossier "Éric Rohmer critique, critique de cinéma" (*RHM* 99.19).

19. In certain book projects "Le Celluloïd et le Marbre" appears in an annotated edition: Éric Rohmer, *Le Celluloïd et le Marbre*, July 1963, IMEC, fonds Éric Rohmer, dossier "Papiers personnels, divers" (*RHM* 99.19).

20. Éric Rohmer, "Avant-propos," *Le Celluloïd et le Marbre*, July 1963, IMEC, fonds Éric Rohmer, dossier "Papiers personnels, divers" (*RHM* 99.19).

21. Ibid.

22. Ibid.

23. Letter from Éric Rohmer to Philippe d'Hugues, 17 January 1974 (we thank Hugues for having given us a copy of this letter).

24. Interview with Jean Narboni, 14 May 2011.

25. Letter from Jean Narboni to Éric Rohmer, 23 May 1983, IMEC, fonds Éric Rohmer, dossier "Correspondance professionnelle, *Cahiers du cinéma*" (*RHM* 115.45).

26. Interview with Jean Narboni, 14 May 2011.

27. Ibid.

28. Éric Rohmer, *L'Évolution des mythes dans le cinéma américain depuis 1945*, project, IMEC, fonds Éric Rohmer, dossier "Activités professionnelles, Éric Rohmer professeur" (*RHM* 107.6).

29. Letter from Jean-François Allard to Éric Rohmer, 24 June 1963, IMEC, fonds Éric Rohmer, dossier "Télévision, correspondance professionnelle" (*RHM* 95.6).

30. Letter from Éric Rohmer to Georges Gaudu, 26 June 1963, IMEC, fonds Éric Rohmer, dossier "Télévision, correspondance professionnelle" (*RHM* 95.6).

31. Letter from Georges Gaudu to Éric Rohmer, IMEC, fonds Éric Rohmer, dossier "Télévision, correspondance professionnelle" (*RHM* 95.6).

32. Cécile Kattnig, "Pour une histoire de l'audiovisuel éducatif (1950–2007)," *Bulletin des bibliothèques de France*, no.1 (2008); and Laurent Garreau, "Essai de chronologie de la Télévision scolaire," Denis Maréchal, "La télévision scolaire dans les fonds de l'INA," and Béatrice de Pastre, "Le Bulletin de la Radio-Télévision scolaire" (contributions to the colloquium Pour une histoire de la Radio-Télévision scolaire (Thierry Lefebvre, Laurent Garreau), Université Paris Diderot, 28 November 2012.

33. Éric Rohmer asked to be tenured and salaried by the RTS, but this was never granted him. So he earned a living "intermittently," as he wrote on a questionnaire from the French Social Security system in November 1967. "I do not have tenure and I teach at my convenience," he added. In 1966, a card as "television director" was even refused him; he felt this as another professional wound, but it did not reduce his determination to be a "filmmaker and fully a filmmaker." On 18 August 1966, Claude Contamine, the adjunct general director of the ORTF, wrote to him: "I regret to inform you that the examination of your file by the commission has shown that you do not meet the required criteria for the card of television director and as a result it was not possible to approve your candidacy." IMEC, fonds Éric Rohmer, dossier "Télévision, correspondance professionnelle" (*RHM* 95.7).

34. Éric Rohmer, "Le Cinéma didactique," 1966, IMEC, fonds Éric Rohmer, dossier "Télévision, deux textes sur la télévision" (*RHM* 95.3).

35. Interview with Rohmer, by Waysbord, in *Le Laboratoire d'Éric Rohmer*.

36. Éric Rohmer, "Mes dates-clés," *Libération*, 17 March 2004.

37. As Rohmer himself called it in the previously cited interview with Frédéric Bonnaud in *Libération*, 3 June 1996.

38. Ibid.

39. Ibid.

40. *Nadja à Paris*, IMEC, fonds Éric Rohmer, dossier "Courts métrages pour le cinéma, Nadja à Paris" (*RHM* 81.3).

41. Complete transcript of the interview with Nadja Tesich, 1963, IMEC, fonds Éric Rohmer, dossier "Courts métrages pour le cinéma, Nadja à Paris" (*RHM* 81.3).

42. Ibid.

43. Ibid.

44. Éric Rohmer, "Le Goût du risque," *Libération*, 6 March 1992.

45. Letter from Nadia Tesich to Éric Rohmer, 22 August 1964, IMEC, fonds Éric Rohmer, dossier "Courts métrages pour le cinéma, Nadja à Paris" (*RHM* 81.3). Nadia Tesich returned to Rutgers University in New Jersey. After they exchanged few postcards and letters, they lost contact with each other in late 1966. The thirteen fragile minutes of *Nadja in Paris* remained the only testimony to her love for that city and her friendship with Rohmer, which constitute the whole value of the film.

46. Interview with Alfred de Graaff, 14 March 2011.

47. *Paris vu par…*, press kit, IMEC, fonds Éric Rohmer, dossier "Courts métrages pour le cinéma, Place de l'Étoile" (*RHM* 81.6).

48. In *La Muette*, Chabrol skewered acerbically the bourgeois hypocrisy that sought refuge in an apartment in the sixteenth arrondissement; Doucher took Saint-Germain-des-Prés as the urban setting of a libertine tale about imposture; Pollet set his camera on the Rue Saint-Denis, where a man takes a prostitute to his place but can't say anything to her; Rouch recorded, in what amounts to a single, tense scene near the Gare du Nord, a man's declaration of love to a woman before he commits suicide; Godard followed the trajectory of a letter sent from Montparnasse to Levallois by a woman between two men, an experimental painter and a coach-builder for fine automobiles.

49. In the archives there is a press clipping from *France-Soir* about an elegant young woman, Christine Arnaux, who used her umbrella to defend herself against an attacker. Here we find a science of fighting with an umbrella, sketched out with savoir-faire and illustrated with photos. "In the hands of a woman trained in its use, the innocent umbrella becomes a weapon as redoubtable as a sword," the article explains, citing the teachings of Roger Lafond, a former instructor in Joinville's batallion who guarantees that after five fifteen-minute lessons, "You will no longer fear anyone." IMEC, fonds Éric Rohmer, dossier "Courts métrages pour le cinéma, *Place de l'Étoile*" (*RHM* 81.4).

50. Guy Debord, "Théorie de la dérive," *Les Lèvres nues*, no. 9 (November 1953), in *OEuvres* (Paris: Gallimard, 2006), 251–257.

51. *Paris vu par…*, press kit, IMEC, fonds Éric Rohmer, dossier "Courts métrages pour le cinéma, Place de l'Étoile" (*RHM* 81.6).

52. Ibid.

53. A budget of 64,400 francs, the same sum as received by Pollet, Chabrol, Douchet, Rouch, and Godard. Films du Losange, fonds Éric Rohmer, dossier "*Paris vu par...*"

54. Rohmer, "Le Goût du risque."

55. Nestor Almendros, *Un homme à la caméra* (Paris: Hatier, 1980), 30.

56. Ibid., 31.

57. Interview with Barbet Schroeder, 7 December 2010.

58. Almendros, *Un homme à la caméra*, 37. See also: "Entretien avec Nestor Almendros," by Renaud Bezombes, Philippe Carcassonne, and Jacques Fieschi, *Cinématographe*, no. 44 (1979).

59. Rohmer, "Le Goût du risque."

60. *Combat*, 21 October 1965.

61. Ibid.

62. *Télérama*, 7 November 1965.

63. Interview with Éric Rohmer, 23 December 2008.

64. Letter from Albert Ollivier to Mag Bodard, 21 December 1963, IMEC, fonds Éric Rohmer, dossier "Une femme douce, éléments de production" (*RHM* 79.12).

65. Letter from Éric Rohmer to Albert Ollivier, 10 February 1964, IMEC, fonds Éric Rohmer, dossier "Une femme douce, éléments de production" (*RHM* 79.12).

66. Éric Rohmer, *Fabien et Fabienne*, synopsis, IMEC, fonds Éric Rohmer, dossier "'Fabien et Fabienne,' éléments de production" (*RHM* 133.20).

67. Éric Rohmer, *Un fou dans le métro*, scenario, IMEC, fonds Éric Rohmer, dossier "Un fou dans le métro" (*RHM* 85.7). The scenario was published in the collection *Friponnes de porcelaine* (Stock, 2014).

68. Interview with Barbet Schroeder by Stéphane Delorme, *Cahiers du cinéma* (February 2010).

69. Éric Rohmer, *Les aventures de Zouzou*, synopsis, IMEC, fonds Éric Rohmer, dossier "Les aventures de Zouzou" (*RHM* 133.21). On Zouzou, see her memoirs, *Jusqu'à l'aube,* written in collaboration with Olivier Nicklaus (Paris: Flammarion, 2004).

70. Ibid.

71. Ibid.

72. Letter from Jean-José Marchand to Barbet Schroeder, IMEC, fonds Éric Rohmer, dossier "Les aventures de Zouzou" (*RHM* 95.9).

73. Interview with Rohmer, by Waysbord, in *Le Laboratoire d'Éric Rohmer.*

74. Éric Rohmer, "Le Cinéma didactique," 1966, IMEC, fonds Éric Rohmer, dossier "Télévision, textes sur la télévision" (*RHM* 95.3).

75. To see these educational films, use the bonus in the DVD edition of *L'Ami de mon amie* (Métamorphoses du paysage); the DVD produced by the review *Cinéma 09* (Spring 2005): *Mallarmé*; *Victor Hugo architecte*; *Victor Hugo,* Les Contemplations; the four DVDs in the boxed set *Le Laboratoire d'Éric Rohmer, un cinéaste à la Télévision scolaire: L'Homme et les Images*; *Entretien sur le béton*; *Histoires extraordinaires d'Edgar Poe*; *Postface à L'Atalante*; *Les Cabinets de physique au xviiie siècle*; *Perceval*; *Don Quichotte*; *Les Caractères de La Bruyère*; *Entretien sur Pascal*; *Mallarmé*). Most of the other programs were brought out as the Éric Rohmer collection (Paris: Potemkine, 2013), DVD/Blu-ray.

76. Pierre Léon, "Rohmer éducateur," *Cinéma 09*, Spring 2005.

77. Olivier Séguret, "La bouillotte Rohmer," *Libération*, 16 March 2005.

78. Philippe Fauvel, "L'Homme, les Images et le Cinéma d'Éric Rohmer," booklet for the *Le Labora-toire d'Éric Rohmer*, 34.

79. *Bulletin de la Radio-Télévision scolaire*, no. 72 (May 1968).

80. Éric Rohmer, "Chronologie de ma vie," *Cahiers du cinéma* (March 2004).

81. It was Jean-Claude Biette who commissioned this text from Éric Rohmer, in a letter written from Rome on 9 November 1966. He was eager to publish it in the Italian review edited by Gian Vittorio Baldi. IMEC, fonds Éric Rohmer, dossier "Correspondance professionnelle, Jean-Claude Biette" (*RHM* 113).

82. Éric Rohmer, "Le Cinéma didactique," 1966, IMEC, fonds Éric Rohmer, dossier "Télévision, textes sur la télévision" (*RHM* 95.3).

83. Ibid.

84. Ibid.

85. Ibid.

86. Éric Rohmer, "Communication écrite pour le Congrès international des organismes de radio et de télévision sur la Radio-Télévision scolaire," May 1964, IMEC, fonds Éric Rohmer, dossier "Télévision, textes sur la télévision" (*RHM* 95.4).

87. Édith Moyal, "Homme mystérieux de la Nouvelle Vague, Éric Rohmer tourne aussi pour la TV scolaire," *Télérama*, 2 February 1966.

88. Éric Rohmer, "Le Cinéma didactique," 1966, IMEC, fonds Éric Rohmer, dossier "Télévision, textes sur la télévision" (*RHM* 95.3).

89. Interview with Rohmer, by Waysbord, in *Le Laboratoire d'Éric Rohmer*.

90. Arnaud Macé, "Entretien sur Pascal (1965): le catholicisme comme principe de mise en scène," *Cahiers du cinéma* (March 2004).

91. *Perceval, Les Histoires extraordinaires d'Edgar Poe, Les Caractères de La Bruyère*, Les Contempla-tions *de Victor Hugo, Victor Hugo architecte*, and *La Sorcière de Michelet* (not signed by Rohmer).

92. Interview with Rohmer, by Waysbord, in *Le Laboratoire d'Éric Rohmer*.

93. Ibid.

94. Éric Rohmer, "Fiche pédagogique: *Victor Hugo*, Les Contemplations. *Livres V et VI*," *Bulletin de la Radio-Télévision scolaire* (May 1969).

95. Séguret, "La bouillotte Rohmer."

96. IMEC, fonds Éric Rohmer, dossier "Télévision, Stéphane Mallarmé" (*RHM* 87.1).

97. Éric Rohmer thought first of Charles Denner, "who resembled Mallarmé," but the actor from the Théâtre National Populaire was not free at the time of filming. Jean-Marie Robain was an actor already forgotten in the 1960s, but who had been famous for having performed in Jean-Pierre Melville's film adaptation of Vercors's novel *Le Silence de la mer* (1947).

98. Letter from Andrée Hinschberger to Éric Rohmer, 17 November 1967, IMEC, fonds Éric Rohmer, dossier "Télévision, Stéphane Mallarmé" (*RHM* 87.2).

99. André S. Labarthe, *La Saga: Cinéastes, de notre temps. Une histoire du cinéma en 100 films.* (Nantes: Capricci, 2011).

100. Valérie Cadet, "Toile de fond," in the catalogue for the retrospective *Cinéastes de notre temps* (Paris: Éditions du Centre Pompidou, 2011), 2.

101. Ibid., 3–4.

102. André S. Labarthe, "Janine Bazin," in the catalogue for the retrospective *Cinéastes de notre temps*," 7.

103. Regarding Två Människor (*Deux êtres*), *La Gazette du cinéma*, no. 4 (September 1950).

104. Interview with André Labarthe, 15 November 2010.

105. *Télérama*, 6 April 1965.

106. Notably on John Ford's *The Man Who Killed Liberty Valance*, which came out in 1962.

107. Éric Rohmer, handwritten presentation of the broadcast "Le Celluloïd et le Marbre," 1965, IMEC, fonds Éric Rohmer, dossier "Télévision, *Le Celluloïd et le Marbre*" (*RHM* 86.8).

108. Interview with André Labarthe, 15 November 2010.

109. Ibid.

110. Éric Rohmer, handwritten presentation of the broadcast "Le Celluloïd et le Marbre," 1965, IMEC, fonds Éric Rohmer, dossier "Télévision, Le Celluloïd et le Marbre (*RHM* 86.8).

111. Ibid.

112. Ibid.

113. Interview with Éric Rohmer, by Noël Herpe and Philippe Fauvel, *Le Celluloïd et le Marbre* (Paris: Éditions Léo Scheer, 2011), 91–92.

114. Interview with André Labarthe, 15 November 2010.

115. Interview with Rohmer, by Herpe and Fauvel, *Le Celluloïd et le Marbre*, 92–93.

116. Interview with André Labarthe, 15 November 2010.

117. Denise Basdevant, *Étudiante sur la montagne Sainte-Geneviève*, synopsis, 1966, IMEC, fonds Éric Rohmer, dossier "Une étudiante d'aujourd'hui" (*RHM* 81.9).

118. Ibid.

119. Denise Basdevant, "Emploi du temps de Mme Sendron, fermière à Montfaucon, notes," 1968, IMEC, fonds Éric Rohmer, dossier "Fermière à Montfaucon" (*RHM* 81.10).

120. Éric Rohmer, *La Sportive* (provisional title), director's note, IMEC, fonds Éric Rohmer, dossier "Projet La Sportive" (*RHM* 85.8).

121. Interview with Rohmer, by Bonnaud, in *Libération*.

122. Among them were the journalists Jacques Fauvet, Pierre Sabbagh, and Gaston Bonheur; and the historians Jean-Baptiste Duroselle, Marcel Merle, Georges de Boisvieux, France Ngo Kim, Jean Planchais, Maurice Duverger.

123. Éric Rohmer, "Fiche pédagogique sur *Les Métamorphoses du paysage*," *Bulletin de la Radio-Télévision scolaire* (June 1964); Cyril Béghin, "Usage pédagogique de l'ironie," *Cahiers du cinéma* (March 2004).

124. Éric Rohmer, "Le cinéma didactique," 1966, IMEC, fonds Éric Rohmer, dossier "Télévision, deux textes sur la télévision" (*RHM* 95.3).

125. Rohmer, "Fiche pédagogique sur *Les Métamorphoses du paysage*."

126. Claude Parent, *Vivre à l'oblique* (Paris: Bibliothèque nationale, 1970), 14–15.

127. Letter from Claude Parent to Éric Rohmer, 16 May 1969, IMEC, fonds Éric Rohmer, dossier "Télévision, *Entretien sur le béton*" (*RHM* 87.9).

128. Éric Rohmer mentions them in his conversations with Hélène Waysbord for *Le Laboratoire d'Éric Rohmer*.

129. Greeting card from Paul Virilio to Éric Rohmer, January 1968, IMEC, fonds Éric Rohmer, dossier "Correspondance professionnelle, Paul Virilio" (*RHM* 113).

130. Interview with Rohmer, by Waysbord, in *Le Laboratoire d'Éric Rohmer*.

131. *Cahiers du cinéma* (November 1965).

132. *Cahiers du cinéma* (April 1968).

133. Laurent Mannoni, *Histoire de la Cinémathèque française* (Paris: Gallimard, 2006), 347–403.

134. An expression coined by Jean Cocteau, quoted by Mannoni in *Histoire de la Cinémathèque française*, 237.

135. *Cahiers du cinéma* (April 1968).

136. We thank Laurent Garreau for giving us access to this material.

137. Greeting card from Henri Langlois to Éric Rohmer, January 1969, IMEC, fonds Éric Rohmer, dossier "Correspondance professionnelle, Henri Langlois" (*RHM* 113).

138. Interview with Jackie Raynal, 16 March 2011.

139. Motion approved at the assembly of 29 June 1969 on audiovisual teaching, IMEC, fonds Éric Rohmer, dossier "Télévision, divers" (*RHM* 95.18).

140. Interview with Éric Rohmer, by Serge Toubiana, *Le Débat*, no. 3 (1988).

141. *À propos de* Toni et de Païsa (1967), *À propos de* Tabou (1968), *À propos de* L'Intendant Sansho (1968), *Extraits de* À nous la liberté, *un film de René Clair* (1968), *Initiation au cinéma 1: aller au cinéma* (1968), *Initiation au cinéma 2: voir le film* (1968), *Initiation au cinéma 3: connaître le passé du cinéma* (1968), *Les Trois Lumières, postface* (1968), Tabou *de Murnau* (1968), *Postface à* L'Impératrice rouge (1969).

142. Laurent Garreau, *Le Cinéma au CNDP, 1962–1975*, internal document, Centre national de documentation pédagogique, 2011.

143. Jacques Rivette, *Jean Renoir, le patron*, program for the series *Cinéastes de notre temps* (1966).

144. Quoted by Fauvel, "L'Homme, les Images et le Cinéma d'Éric Rohmer," 33–35.

6. Four *Moral Tales*: 1966–1972

1. Éric Rohmer, "Chantal," manuscript draft, 17 November 1949, IMEC, fonds Éric Rohmer, dossier "*La Collectionneuse*, écriture de l'oeuvre" (*RHM* 2.1).

2. Ibid.

3. Ibid.

4. Ibid.

5. An unpublished narrative that Rohmer had written in 1949.

6. Letter from Dominique de Roux to Éric Rohmer, Paris, 5 March 1967, IMEC, fonds Éric Rohmer, dossier "Correspondance professionnelle, de Roux" (*RHM* 113).

7. Interview with Barbet Schroeder, 7 December 2010.

8. Éric Rohmer, "Chantal," manuscript draft, 17 November 1949, IMEC, fonds Éric Rohmer, dossier "*La Collectionneuse*, écriture de l'oeuvre" (*RHM* 2.1).

9. Interview with Jackie Raynal, 16 March 2011.

10. Interview with Pierre Cottrell, 2 February 2011.

11. Interview with Philippe Rousselot, 14 February 2011.

12. Interview with Éric Rohmer, by Fabien Baumann and Adrien Gombeaud, *Positif* (July 2009).

13. Interview with Barbet Schroeder, 7 December 2010.

14. Interview with Jackie Raynal, 16 March 2011.

15. Interview with Éric Rohmer, by Thibault Maillé, "La Musique dans l'oeuvre cinématographique d'Éric Rohmer" (DEA thesis in musicology, Paris-IV, June 1992).

16. Catherine Deneuve, letter to Éric Rohmer [1967], IMEC, fonds Éric Rohmer, dossier "Correspondance professionnelle, Deneuve" (*RHM* 113).

17. *Le Canard enchaîné*, 8 March 1967.

18. *Télérama*, 12 March 1967.

19. Draft of a letter from Éric Rohmer to the president of the CNC, IMEC, fonds Éric Rohmer, dossier "*Ma nuit chez Maud*, préparation du tournage" (*RHM* 3.7).

20. Letter from François Truffaut to Mag Bodard, Christmas 1967, IMEC, fonds Éric Rohmer, dossier "*Ma nuit chez Maud*, préparation du tournage" (*RHM* 3.7).

21. Letter from Claude Lelouch to François Truffaut, 14 May 1968, IMEC, fonds Éric Rohmer, dossier "*Ma nuit chez Maud*, préparation du tournage" (*RHM* 3.7)

22. Ibid.

23. Letter from François Truffaut to Éric Rohmer, 7 July 1981, IMEC, fonds Éric Rohmer, dossier "Correspondance professionnelle, Truffaut" (*RHM* 113).

24. Éric Rohmer, "Rue Monge," manuscript draft, August 1944–November 1945, IMEC, fonds Éric Rohmer, dossier "*Ma nuit chez Maud*, écriture de l'oeuvre" (*RHM* 3.1).

25. Éric Rohmer, "Rue Monge," manuscript draft, August 1944–November 1945, IMEC, fonds Éric Rohmer, dossier "*Ma nuit chez Maud*, écriture de l'oeuvre" (*RHM* 3.1).

26. Letter from Antoine Vitez to Éric Rohmer, 18 June 1968, IMEC, fonds Éric Rohmer, dossier "*Ma nuit chez Maud*, préparation du tournage" (*RHM* 3.8).

27. Interview with Françoise Fabian, 1 June 2011.

28. Ibid.

29. Interview with Jean-Louis Trintignant, 7 January 2011.

30. Ibid.

31. Interview with Jean-Pierre Ruh, by Noël Herpe and Priska Morrissey, in *Rohmer et les Autres*, ed. Noël Herpe, 210 (Presses universitaires de Rennes, 2007).

32. Interview with Cécile Decugis, 17 November 2010.

33. Interview with Barbet Schroeder, 7 December 2010.

34. Interview with Pierre Cottrell, 2 February 2011.

35. *France-Soir*, 17 May 1969.

36. *Le Nouvel Observateur*, 30 June 1969.

37. Interview with Éric Rohmer, by Rui Nogueira, *Cinéma 71* (February 1971).

38. Éric Rohmer, *Le Genou de Claire*, manuscript draft, 5 December 1949, IMEC, fonds Éric Rohmer, dossier "*Le Genou de Claire*, écriture de l'oeuvre" (*RHM* 5.2).

39. Interview with Pierre Cottrell, 2 February 2011.

40. Interview with Barbet Schroeder, 7 December 2010.

41. Ibid.

42. Interview with Pierre Cottrell, 2 February 2011.

43. Quoted in a letter from Catherine Girard to Éric Rohmer, May 1969, IMEC, fonds Éric Rohmer, dossier "*Le Genou de Claire*, préparation du tournage" (*RHM* 5.12).

44. Interview with Éric Rohmer, by Michel Marie; "Fonction de la parole dans le récit, étude des quatre premiers contes moraux d'Éric Rohmer" (master's thesis, University of Vincennes, 1970).

45. Interview with Laurence de Monaghan, 16 February 2011.

46. *Le Nouvel Observateur*, 11 January 1971.

47. Éric Rohmer, "Lettre à un critique à propos des 'Contes moraux,'" *La Nouvelle Revue française*, March 1971.

48. Ibid.

49. Éric Rohmer, handwritten transcription for *Claire's Knee*, IMEC, fonds Éric Rohmer, dossier "*Le Genou de Claire*, préparation du tournage" (*RHM* 5.12).

50. Interview with Béatrice Romand, 11 January 2011.

51. Letter from Éric Rohmer to Béatrice Romand, Paris, 10 June 1971, IMEC, fonds Éric Rohmer, dossier "Correspondance personnelle" (*RHM* 129).

52. Letter from Jacques d'Arribehaude to Éric Rohmer, 13 March 1967, IMEC, fonds Éric Rohmer, dossier "Correspondance professionnelle, Arribehaude" (*RHM* 113).

53. Interview with Irène Skoblin, 16 April 2011.

54. Éric Rohmer, *Le Genou de Claire*, manuscript draft, 5 December 1949, IMEC, fonds Éric Rohmer, dossier "*Le Genou de Claire*, écriture de l'oeuvre" (*RHM* 5.1).

55. Jean-Jacques Rousseau, *Les Confessions*, part 1, book 4.

56. Ibid. Translation by W. C. Mallory (London: Aldus Society, 1903).

57. Letter from Éric Rohmer to Béatrice Romand, Paris, 10 June 1971, IMEC, fonds Éric Rohmer, dossier "Correspondance personnelle" (*RHM* 129).

58. Interview with Éric Rohmer, by Louis Skorecki, *Libération*, 4 April 1990.

59. *Love in the Afternoon*, typed synopsis with manuscript annotations, IMEC, fonds Éric Rohmer, dossier "*L'Amour, l'après-midi*, écriture de l'oeuvre" (*RHM* 7.15).

60. *L'Amour, l'après-midi, scénario, Six contes moraux* (Paris: Petite Bibliothèque des Cahiers du cinéma, 1998), 222.

61. Éric Rohmer, interview preparatory to *Conte d'hiver*, with Charlotte Véry, 8 February 1989, IMEC, fonds Éric Rohmer, dossiers "*Conte d'hiver*, préparation du tournage" (*RHM* 42.2).

62. Interview with Pierre Cottrell, 2 February 2011.

63. Interview with Bernard Verley, 4 January 2011.

64. Ibid.

65. Interview with Éric Rohmer, by Jacques Siclier, *Le Monde*, 31 August 1972.

66. Interview with Zouzou, by Annie Destin, *Elle*, September 1972.

67. Interview with Bernard Verley, 4 January 2011.

68. *Les Lettres françaises*, 6 September 1972.

69. *Écran 72* (November 1972).

70. *Le Nouvel Observateur*, 4 September 1972.

71. *L'Affiche rouge*, 1972.

72. Interview with Pierre Rissient, 23 November 2010.

7. On Germany and the Pleasure of Teaching: 1969–1994

1. Interview with Laurent and Thérèse Schérer, 27 October 2010.

2. Ibid.

3. Interview with Éric Rohmer, by Claude Beylie, *Écran 24* (April 1974).

4. Interview with Éric Rohmer, by Pascal Bonitzer and Michel Chion, *Cahiers du cinéma* (April 1983).

5. *Cahiers du cinéma* (February 2010).

6. Éric Rohmer and Jean Douchet, *Preuves à l'appui*, complete transcript, 1993, IMEC, fonds Éric Rohmer, dossier "Films pour la Télévision, *Preuves à l'appui*" (*RHM* 98.1).

7. Interview with Laurent Schérer, 29 October 2010.

8. Éric Rohmer, "Activités exercées en matière de recherche," CV intended for the Conseil supérieure des universités (CSU), July 1980, IMEC, fonds Éric Rohmer, dossier "Éric Rohmer professeur" (*RHM* 107.10).

9. Ibid.

10. Mireille Latil Le Dantec, "De Murnau à Rohmer: les pièges de la beauté," *Cinématographe* nos. 23–24 (January–February 1977); Hervé Joubert-Laurencin, "Une trouble affinité de main: Rohmer et Murnau," in *Pour un cinéma comparé. Influences et répétitions*, ed. Jacques Aumont (Paris: Cinémathèque française/Mazzotta, 1996); Janet Bergstrom, "Entre Rohmer et Murnau: une histoire de point de vue," in *Rohmer et les Autres*, ed. Noël Herpe, 21–28 (Presses universitaires de Rennes, 2007); "On est toujours dans l'image," interview with Éric Rohmer, by Noël Herpe, *Positif* (September 2004). The discussion is essentially about Murnau and the view defended by Rohmer.

11. *La Revue du cinéma*, no. 14 (1948).

12. The premiere of *Faust* took place in Berlin on 14 October 1926.

13. Interview with Éric Rohmer, by Noël Herpe and Philippe Fauvel, in *Le Celluloïd et le Marbre* (Paris: Éditions Léo Scheer, 2011), 116.

14. Ibid.

15. Ibid.

16. Georges Sadoul, *Histoire générale du cinéma*, vol. 5 (Paris: Denoël, 1950), 214.

17. This bibliographical work helped Rohmer discover an important text by Erwin Panofsky, "Style and Medium in the Moving Pictures," whose comparative study of Dürer and Murnau exercised a definite influence on him.

18. Éric Rohmer, *L'Organisation de l'espace dans le* Faust *de Murnau* (Paris: Union générale d'éditions, 1977), 21.

19. Le Dantec, "De Murnau à Rohmer: les pièges de la beauté."

20. Rohmer, *L'Organisation de l'espace dans le* Faust *de Murnau*, 107.

21. Ibid., 112.

22. Ibid., 114.

23. Ibid., 122.

24. Éric Rohmer, "Activités exercées en matière de recherche," CV intended for the CSU, July 1980, IMEC, fonds Éric Rohmer, dossier "Éric Rohmer, professeur" (*RHM* 107.10).

25. Joubert-Laurencin, "Une trouble affinité de main: Rohmer et Murnau," 79.

26. Letter from Jean Collet to Éric Rohmer, 13 June 1974, IMEC, fonds Éric Rohmer, dossier "Correspondance professionnelle, Jean Collet" (*RHM* 113).

27. Letter from Christian Bourgois to Éric Rohmer, 12 October 1976, IMEC, fonds Éric Rohmer, dossier "Correspondance professionnelle, Christian Bourgois" (*RHM* 113).

28. Dominique Rabourdin reprinted the book in 1991 in his series published by Ramsay paperbacks; it was reprinted again in 2000 by Claudine Paquot in the Petite bibliothèque des *Cahiers du cinéma*.

29. *L'Avant-scène cinéma* nos. 190–191 (1977).

30. Letter from Robert Chessex to Éric Rohmer, 5 November 1977, and letter from Éric Rohmer to Robert Chessex, 28 November 1977, IMEC, fonds Éric Rohmer, dossier "Correspondance professionnelle, Robert Chessex" (*RHM* 113). At the death of Robert Chessex in April 1987, Rohmer had these precious archives deposited at the Cinémathèque française.

31. In November and December 1986, a Murnau retrospective was organized in France, circulating in several theaters in Paris and in the provinces. The catalogue reprints Rohmer's article on *Tabu* published in *Cahiers du cinéma* in March 1953.

32. The text of the lecture is reproduced in the *Süddeutsche Zeitung* (11 May 1979) under the title "Éric Rohmer. Topologien. Aus seiner Dissertation über Murnau."

33. The thesis on *Faust* was translated and published by Wagenbach Verlag in Berlin, in 1979, as were several other works by Rohmer: his *Contes moraux*; his adaptation of *La Marquise d'O*; *Le Goût de la beauté*; his play *Trio en mi bémol* (performed at the Düsseldorfer Schauspielhaus in March 1990); his essay on music, *De Mozart en Beethoven*; and his first novel, *Élisabeth*. A few complete retrospectives of his films were also organized, at the Arsenal in Berlin in April 1975, at the Kommunales Kino in Frankfurt in 1979, and at the Würzburg Festival in January 1983, while special numbers of *FilmKritik* (August 1982) and of the review *Revolver* (March 2004) were devoted to him.

34. Letter from Rainer Böhlke to Éric Rohmer, 16 February 1993, IMEC, fonds Éric Rohmer, dossier "Correspondance professionnelle, Rainer Böhlke" (*RHM* 113).

35. Rohmer mentioned another delicious detail in a later interview: "I was curous to read *The Marquise of O* for a reason that had nothing to do with the book. Roland Barthes had written a study, *S/Z*, on Balzac's story 'Sarrazine.' That is a text I don't like at all, because I love Balzac and I think that Balzac's genius in no way appears in Barthes. It was a study of the language of the nineteenth century, and somewhere Barthes wrote: 'I could also have chosen *The Marquise of O*' I said to myself, 'Hmm, *The Marquise of O* what's that?' In a bookstore, I came across the book, I bought it, I read it, and I said to myself: 'Hmm, that would make an extraordinary film.'" Interview with Éric Rohmer, by Priska Morrissey, *Historiens et cinéastes: rencontre de deux écritures* (Paris: L'Harmattan, 2004), 213.

36. Éric Rohmer, "Cahiers noirs," IMEC, fonds Éric Rohmer, dossier "Papiers personnels" (*RHM* 134.17)

37. "Everything has been contemplated: the characters' motivations can be discerned only through the painting of their behavior," Rohmer wrote. "Pour un nicht . . . ," typescript, IMEC, fonds Éric Rohmer, dossier "*La Marquise d'O* . . ., préparation du tournage" (*RHM* 11.8).

38. Éric Rohmer and Jean Douchet, *Preuves à l'appui*, complete transcript, 1993, IMEC, fonds Éric Rohmer, dossier "Films pour la télévision, *Preuves à l'appui*" (*RHM* 98.1).

39. Éric Rohmer, "Cahiers noirs," IMEC, fonds Éric Rohmer, dossier "Papiers personnels" (*RHM* 134.17).

40. Ibid.

41. The German word *Raum*, from Old High German *Rûm*, can be translated by "space."

42. Letter from Lotte H. Eisner to Éric Rohmer, 11 July 1977, IMEC, fonds Éric Rohmer, dossier "Correspondance professionnelle, Lotte H. Eisner" (*RHM* 113).

43. Cyril Neyrat, "La pesanteur du théâtre et la grâce du cinéma: dispositifs de guerre chez Kleist et Rohmer," in *Rohmer et les Autres*, 51–59.

44. Pascal Bonitzer, *Éric Rohmer* (Paris: Éditions des *Cahiers du cinéma*, 1999), 71.

45. Éric Rohmer, *La Marquise d'O*, typescript scenario, 1974, IMEC, fonds Éric Rohmer, dossier "*La Marquise d'O* . . . , écriture de l'oeuvre" (*RHM* 10.1).

46. Éric Rohmer, "Cahiers noirs," IMEC, fonds Éric Rohmer, dossier "Papiers personnels" (*RHM* 134.17).

47. Ibid.

48. Ibid.

49. Éric Rohmer, "Note sur la mise en scène," typescript, IMEC, fonds Éric Rohmer, dossier "*La Marquise d'O . . .* , préparation du tournage" (*RHM* 11.9). This "note" was included in the press kit for the film.

50. In November 1973 Rohmer consulted a more conventional adaptation of *La Marquise d'O*, entitled *Die Gräfin von Rathenow* (The Countess of Rathenow), done for the theater by the dramatist Hartmut Lange, who worked for the Berlin Schaubühne troupe, and also a construction corresponding to a play adapted from Kleist's novella for German television. But these readings, which he considered disappointing, confirmed him in his initial intuition, which was also confirmed by Margaret Menegoz's opinion: it would be better to return more radically to the whole of Kleist's text.

51. Interview with Éric Rohmer, by Claude Gauteur, *Le Film français*, 4 July 1975.

52. "To show Bruno Ganz how to act, I showed him Fragonard's painting *Le Verrou* [The lock] . . . and he contemplated it for half an hour. I don't think a French actor would have done that. German actors have always acted like that, like characters from *Le Verrou*. Then I understood that they knew where they were going, and that was fine with me." Interview with Rohmer, by Morrissey, *Historiens et cinéastes: rencontre de deux écritures*, 221.

53. The painting belongs to the Detroit Institute of Arts (U.S.). It was shown in early 1975 in Hamburg, on the occasion of a Füssli retrospective at the Hamburger Kunsthalle. We can assume that Éric Rohmer, who traveled to Germany regularly at that time, went to see it.

54. Interview with Rohmer, by Herpe and Fauvel, *Le Celluloïd et le Marbre*, 120–121.

55. Hubert Damisch, "L'appel au tableau dans *La Marquise d'O . . .* Le temps de la citation," *Cahiers du cinéma* (March 2004).

56. Interview with Barbet Schroeder, 7 December 2010.

57. Emmanuèle Frois, "Géométrie du cœur. Margaret Menegoz, âme des Films du Losange," *Le Figaro*, 25 May 2002.

58. Interview with Margaret Menegoz, 29 November 2010.

59. Ibid.

60. Starting with *The Green Ray* (1985), Françoise Etchegaray performed this essential function in the Rohmerian system.

61. Margaret Menegoz, "Un réalisateur français sous pavillon allemand," *L'Avant-scène cinéma*, no. 173 (1976).

62. Letter from Éric Rohmer to Klaus Hellwig, 29 April 1974, IMEC, fonds Éric Rohmer, dossier "*La Marquise d'O . . .* , préparation du tournage" (*RHM* 11.10).

63. Ibid.

64. Ibid.

65. *50 Jahre Schaubühne* (Berlin: Theater der Zeit, 2012).

66. Peter Stein made a name for himself with his productions of plays by the British dramatist Edward Bond, *Saved* (1968) and *Early Morning* (1969), and with his 1968 production of Goethe's *Torquato Tasso* in Bremen, starring Bruno Ganz and Edith Clever. Then came Brecht's *Mother Courage* (1970), Ibsen's *Peer Gynt* (1971–1972), and a version of Kleist's *Prince of Homburg*, whose European tour was a revelation, especially in France at the Odéon in 1972 and 1973. Peter Stein is thus a "Kleistian" (whose plays are often performed at the Schaubühne), but he is also attached

to young German authors, like Peter Handke and Botho Strauss. He knows how to call on other directors, such as Claus Peymann, who produced Handke's *Der Ritt über den Bodensee* (The ride across Lake Constance), an important dramatic event in 1971, or Klaus Michael Grüber, who established himself at the Schaubühne in 1974 with a production of Euripides's *Bacchae*, starring Bruno Ganz, Otto Sander, Jutta Lampe, and Michael König.

67. Quoted in Peter Iden, "La Schaubühne et les acteurs allemands," press kit for *La Marquise d'O*, IMEC, fonds Éric Rohmer, dossier "*La Marquise d'O . . .*, presse" (*RHM* 14.1).

68. Quoted in *Klaus Michael Grüber* (TNS éditions, 2012), 14.

69. Letter from Éric Rohmer to Maria Schell, IMEC, fonds Éric Rohmer, dossier "*La Marquise d'O . . .*, préparation du tournage" (*RHM* 11.2).

70. Peter Iden, "La Schaubühne et les acteurs allemands" press kit for *La Marquise d'O*, IMEC, fonds Éric Rohmer, dossier "*La Marquise d'O . . .*, presse" (*RHM* 14.1).

71. Éric Rohmer, "Note sur la mise en scène," typescript, IMEC, fonds Éric Rohmer, dossier "*La Marquise d'O . . .*, préparation du tournage" (*RHM* 11.9).

72. Letter from Klaus Hellwig to Éric Rohmer, 25 October 1974, IMEC, fonds Éric Rohmer, dossier "*La Marquise d'O . . .*, préparation du tournage" (*RHM* 11.3).

73. Letter from Edith Clever and Bruno Ganz to Éric Rohmer, 24 November 1974, IMEC, fonds Éric Rohmer, dossier "*La Marquise d'O . . .*, préparation du tournage" (*RHM* 11.4).

74. Letter from Éric Rohmer to Maria Schell, IMEC, fonds Éric Rohmer, dossier "*La Marquise d'O . . .*, préparation du tournage" [*RHM* 11.2]).

75. The actress was disappointed and sad, writing to Rohmer that she was nonetheless "resolved to make herself a thousand years older to play this role." Letter from Maria Schell to Éric Rohmer, 18 February 1975, IMEC, fonds Éric Rohmer, dossier "*La Marquise d'O . . .*, préparation du tournage" (*RHM* 11.2).

76. Note from Bernhard Minetti to Éric Rohmer, IMEC, fonds Éric Rohmer, dossier "*La Marquise d'O . . .*, préparation du tournage" (*RHM* 11.5).

77. Letter from Olga Horstig-Primuz to Éric Rohmer, 4 November 1974, IMEC, fonds Éric Rohmer, dossier "*La Marquise d'O . . .*, préparation du tournage" (*RHM* 11.6).

78. Letter from Oskar Werner to Éric Rohmer, 27 April 1975, IMEC, fonds Éric Rohmer, dossier "*La Marquise d'O . . .*, préparation du tournage" (*RHM* 11.7).

79. Interview with Laurent Schérer, 27 October 2010.

80. Interview with Margaret Menegoz, 29 November 2010.

81. Interview with Cheryl Carlesimo, 9 June 2011.

82. Interview with Margaret Menegoz, 29 November 2010.

83. Nestor Almendros as head cameraman, assisted by Jean-Claude Rivière, Bernard Auroux, and Dominique Le Rigoleur; Jean-Pierre Ruh and Louis Gimel as sound engineers, assisted by Michel Laurent; Jean-Claude Gasché, Georges Chrétien, Angelo Rizzi, and André Trieli as electricians and scene shifters.

84. Nestor Almendros, *Un homme à la caméra* (Hatier, 1980), 111–113.

85. When the editing was finished, Rohmer composed a mischievous poem summing up the adventure of this film which, according to him, "made itself": "Having fallen asleep one day / On the bench of velvet / Or leatherette, what's the diff / Of an auditorium whose door / Never opens to intruders, / I had incongruous dreams . . . / Alas, they were not dreams! / And since then,without rest or respite, / I seek the odious rascal / Who committed this attack. / For I see neither my *metteur / en scène*, nor the sound / Engineer, or even the boom operator, / Or the courier or the

pianist / Telling me, some fine morning, / Pretending to be Tintin: / "Well, don't get mad, / For, yes, I'm the papa!" IMEC, fonds Éric Rohmer, dossier "Éric Rohmer écrivain, poèmes" (*RHM* 102.11).

86. *Télérama*, 29 April 1976.

87. Letter from Éric Rohmer to M. le président Favre Le Bret, draft, IMEC, fonds Éric Rohmer, dossier "*La Marquise d'O . . .*, réception" (*RHM* 14.17). This letter was published in *Le Film français*, 17 May 1976, and reprinted in *L'Avant-scène cinéma*, no. 173 (1976.)

88. Bernard Frangin, *Le Progrès de Lyon*, 18 May 1976.

89. *Le Quotidien de Paris*, 26 May 1976.

90. Letter from Nicolas Seydoux to Éric Rohmer, 12 May 1976, IMEC, fonds Éric Rohmer, dossier "*La Marquise d'O . . .*, réception" (*RHM* 14.18).

91. Letter from François Truffaut to Éric Rohmer, 2 January 1975, IMEC, fonds Éric Rohmer, dossier "Correspondance professionnelle, Truffaut" (*RHM* 113). Truffaut later filmed, in *The Woman Next Door*, this scene of emotional fainting in the manner of Kleist.

92. *New York Times*, 6 February 1977.

93. Pascal Bonitzer, "Glorieuses bassesses (*La Marquise d'O . . .*)," *Cahiers du cinéma* (December 1976). This text is important, because it inaugurates in Bonitzer's work, more than his earlier article on *My Night at Maud's*, the Rohmermian reflection that led to his major essay of 1999.

94. Éric Rohmer, "Réconcilier théâtre et cinéma," *Journal de la Maison de la Culture de Nanterre*, no. 2 (1979). The long version of this interview can be consulted in IMEC, fonds Éric Rohmer, dossier "Éric Rohmer dramaturge, *Catherine de Heilbronn*" (*RHM* 103.7).

95. Éric Rohmer, "Note sur la traduction et la mise en scène," 1979, IMEC, fonds Éric Rohmer, dossier "Éric Rohmer dramaturge, *Catherine de Heilbronn*" (*RHM* 103.1).

96. Ibid.

97. Interview with Pascal Greggory, by Serge Bozon, *Cahiers du cinéma* (February 2010).

98. Interview with Rosette, by Serge Bozon, *Cahiers du cinéma* (February 2010).

99. Ibid.

100. Interview with Arielle Dombasle, 24 October 2011.

101. Éric Rohmer, "Réconcilier théâtre et cinéma."

102. Interview with Arielle Dombasle, 24 October 2011.

103. Ibid.

104. Interview with Greggory, by Bozon, *Cahiers du cinéma* (February 2010).

105. *Le Monde*, 13 November 1979.

106. *Le Figaro*, 14 November 1979.

107. *Télérama*, 5 August 1980.

108. *Le Matin de Paris*, 13 November 1979.

109. *Les Nouvelles littéraires*, 24 November 1979

110. *Pariscope*, 19 November 1979.

111. Letter from René Schérer to the director of *Le Monde*, 14 November 1979, IMEC, fonds Éric Rohmer, dossier "Éric Rohmer dramaturge, *Catherine de Heilbronn*" (*RHM* 104.1).

112. Ibid.

113. However, Rohmer returned to *Catherine de Heilbronn* when he filmed a performance of the play for television, using video, his first and only professional experiment with this medium. On the stage of the Amandiers, he modified and increased the lighting, used four cameras in the theater, and had his actors perform without an audience. After the editing, the "filmed performance" was broadcast on 6 August 1980 on Antenne 2 at 8:30 p.m.

114. Interview with Éric Rohmer, by Alain Girault and Michel Marie, *Théâtre public*, no. 31 (January–February 1980).

115. Éric Rohmer, "Activités exercées en matière d'enseignement," CV intended for the CSU, July 1980, IMEC, fonds Éric Rohmer, dossier "Éric Rohmer professeur" (*RHM* 107.10).

116. Éric Rohmer, "Cahiers noirs," IMEC, fonds Éric Rohmer, dossier "Papiers personnels" (*RHM* 134.17).

117. Interview with Thérèse Schérer, 27 October 2010.

118. IMEC, fonds Éric Rohmer, dossier "Éric Rohmer professeur" (*RHM* 107.11).

119. Letter from Michel Rouche to Éric Rohmer, 12 December 1972, IMEC, fonds Éric Rohmer, dossier "Éric Rohmer professeur" (*RHM* 107.11).

120. Letter from Éric Rohmer to the president of the University of Paris-I, 1977, IMEC, fonds Éric Rohmer, dossier "Éric Rohmer professeur" (*RHM* 107.13).

121. Let us cite two examples of the courses given by Professor Rohmer: Understanding a Film, a course given in 1982–1983 whose objective was to inquire into the means a filmmaker has "for transforming the photograph of reality into a personal vision." It consisted of the following developments: "1. Introduction: understanding a film (quotations from Renoir, Bresson, Pudovkin). 2. Cinematographic beauty. 3. History of the image. 4. The technical point of view. 5. How to judge the image? 6. The setting. 7. Conception and realization. 8. Mise en scène. 9. Why film? 10. The cinema as a tool: sound, editing. 11. Cinema and language (quotations from Saussure, Barthes, Bazin, Malraux, Jakobson). 12. Cinema and improvisation." Then, in the second-year course, Conception and Realization of the Film, planned this way: "1. Introduction. 2. Function of film. 3. History of the image. 4. Birth and prehistory of cinema. 5. Cinematic technique: the image. 6. Cinematic technique: sound. 7. Cinematic technique: decoupage [structural analysis]. 8. Cinematic technique: montage [editing]. 9. Cinematic technique: production. 10. Cinema and information, 1. 11. Cinema and information, 2. 12. Cinema and information, 3." Éric Rohmer, "Cahiers noirs," IMEC, fonds Éric Rohmer, dossier "Papiers personnels" (*RHM* 134.17).

122. It should be noted that Moullet's *Brigitte et Brigitte* picks up the aborted project of "Charlotte et Véronique." Thus Rohmer's presence is a wink as much as a homage.

123. Éric Rohmer, "Cahiers noirs," IMEC, fonds Éric Rohmer, dossier "Papiers personnels" (*RHM* 134.17).

124. Interview with Cheryl Carlesimo, 9 June 2011.

125. Letter from Frédéric Sojcher to Éric Rohmer, 25 January 2006, IMEC, fonds Éric Rohmer, dossier "Éric Rohmer professeur" (*RHM* 108.1).

126. Letter from Serge Bozon to Éric Rohmer, 28 April 1993, IMEC, fonds Éric Rohmer, dossier "Éric Rohmer professeur" (*RHM* 108.1). Bozon's text appeared in the first issue of *La Lettre du cinéma* (1996) and was entitled: "À propos d'Éric Rohmer: variations sur *L'Arbre, le Maire et la Médiathèque* ou les petites histoires des grandes possibilités évanouies."

127. Éric Rohmer, "Cahiers noirs," IMEC, fonds Éric Rohmer, dossier "Papiers personnels" (*RHM* 134.17).

128. Interview with Thérèse Schérer, 27 October 2010.

129. Letter from students at the Collège Cabanis de Brive to Éric Rohmer, December 1999, IMEC, fonds Éric Rohmer, dossier "Correspondance diverse."

130. In Scandinavia, in the early 1970s the reviews *Chaplin* in Sweden and *Kosmorama* in Denmark published special issues on the director of *Love in the Afternoon*; in the Netherlands, the review *De Revisor* conducted a long interview with the filmmaker in April 1976. In February 1985 Rohmer traveled with his wife to the Rotterdam International Film Festival, held from 30 January to 1 February, asking Hubert Bals, its director, to book him a room "in comfortable old hotel in the Dutch style" rather than in the Hilton, where the celebrities were staying. The Cinemathèque of Portugal organized a retrospective in June and July 1983, while Spain awarded Rohmer the Reino de Redonda Prize, amounting to 6,000 euros, and presided over by an admirer, the author Javier Marías, in April 2004. In Moscow, Naoum Kleiman's Museum of Cinema paid homage to Rohmer for a month, in May 1997. However, it was, in addition to Germany, in Italy, Japan, and the United States where the most fervent Rohmerians were found. In Florence, no less than three tributes and retrospectives succeeded one another between 1980 and 2002, each time under the influence of Aldo Tassone, whereas the city of Pescara gave the filmmaker the Ennio Flaiano Prize in 1985. In 1998, *A Tale of Autumn* drew 250,000 Italian spectators, Rohmer's largest success on the other side of the Alps. [Le Printemps du cinéma français] in Tokyo was dedicated to Rohmer in 1973, with a showing of *Love in the Afternoon* at the French embassy; in 1982, the main repertory theater in the Japanese capital honored the author of *A Good Marriage* with a nine-film retrospective; subsequently, *Rendezvous in Paris* met with great success only in Japan, with more than 100,000 spectators, accompanied by a special issue of *Marie Claire* on Japan offering a fifteen-page interview with the "confidant of women."

131. Letter from François Truffaut to Éric Rohmer, 2 January 1975, IMEC, fonds Éric Rohmer, dossier "Correspondance professionnelle, François Truffaut" (*RHM* 113).

132. Letter from François Truffaut to Éric Rohmer, IMEC, n.d., fonds Éric Rohmer, dossier "Correspondance professionnelle, François Truffaut" (*RHM* 113).

133. Letter from François Truffaut to Éric Rohmer, 8 June 1977, IMEC, fonds Éric Rohmer, dossier "Correspondance professionnelle, François Truffaut" (*RHM* 113).

134. Letter from François Truffaut to Éric Rohmer, 8 January 1979, IMEC, fonds Éric Rohmer, dossier "Correspondance professionnelle, François Truffaut" (*RHM* 113).

135. Letter from Éric Rohmer to Claude de Givray, September 1984, IMEC, fonds Éric Rohmer, dossier "Correspondance professionnelle, Claude de Givray" (*RHM* 113).

136. Letter from Éric Rohmer to Stéphane Tchalgadjieff, 28 June 1990, IMEC, fonds Éric Rohmer, dossier "Correspondance professionnelle, Tchalgadjieff" (*RHM* 113).

137. Letter from Alain Bergala to Éric Rohmer, 1 June 1987, IMEC, fonds Éric Rohmer, dossier "Correspondance professionnelle, *Cahiers du cinéma*" (*RHM* 115.45).

138. Letter from Claudine Paquot to Éric Rohmer, 9 February 1988, IMEC, fonds Éric Rohmer, dossier "Correspondance professionnelle, *Cahiers du cinéma*" (*RHM* 115.45).

139. Letter from Claudine Paquot to Éric Rohmer, 14 January 2003, IMEC, fonds Éric Rohmer, dossier "Correspondance professionnelle, *Cahiers du cinéma*" (*RHM* 115.45).

140. Letter from Claudine Paquot to Éric Rohmer, 12 September 2003, IMEC, fonds Éric Rohmer, dossier "Correspondance professionnelle, *Cahiers du cinéma*" (*RHM* 115.45).

141. Letter from Janine Bazin to Éric Rohmer, January 1975, IMEC, fonds Éric Rohmer, dossier "Correspondance professionnelle, Janine Bazin" (*RHM* 113).

142. Interview with André Labarthe, 15 November 2010.

143. Letter from Jacques Aumont to Éric Rohmer, 31 March 1988, IMEC, fonds Éric Rohmer, dossier "Correspondance professionnelle, Aumont" (*RHM* 113).

144. Interview with André S. Labarthe, 15 November 2010.

145. Ibid.

146. Interview with Jean Douchet, 8 November 2010.

147. *Preuves à l'appui*, interview with Éric Rohmer, by Jean Douchet, typescript of the complete transcript, 1993, IMEC, fonds Éric Rohmer, dossier " 'Cinéastes, de notre temps,' *Preuves à l'appui*" (*RHM* 98.1).

148. "Listen," he said to Douchet, "let's be precise. Here I've got a few little documents that I can in fact show you, I must have certain notebooks, yes, here they are. We're going to begin with the first draft of the ideas on paper. And it's in a very little notebook that I dug up specially for this broadcast. I was looking and I noticed that in it was the idea for *Reinette and Mirabelle*, the idea for *The Green Ray*, the idea for *A Tale of Autumn*. All that was contemporary, and it was written in a little notebook that I carried along with me on vacations, because on vacations I walk around with a little backpack and I prefer very light notebooks. This one must date from 1983, because it was during the summer of 1983 at Biarritz that I had the idea for *The Green Ray*. On the other hand, when I walk in Paris, I have a larger bag and a somewhat larger notebook. Like this one, you see . . . " Éric Rohmer and Jean Douchet, *Preuves à l'appui*, complete transcript, 1993, IMEC, fonds Éric Rohmer, dossier "Films pour la télévision, *Preuves à l'appui*" (*RHM* 98.1).

149. Lettre d'André S. Labarthe to Éric Rohmer, 20 February 1994, IMEC, fonds Éric Rohmer, dossier "Films pour la télévision, *Preuves à l'appui*" (*RHM* 98.1).

150. Interview with André S. Labarthe, 15 November 2010.

151. Ibid.

152. *Libération*, 14 March 1996.

8. In Pursuit of *Perceval*: 1978–1979

1. Interview with Éric Rohmer, by Arnaud Spire, *La Nouvelle Critique* (April 1979).

2. Draft of a letter from Éric Rohmer to François-Régis Bastide, Paris, 5 March 1979, IMEC, fonds Éric Rohmer, dossier "Correspondance professionnelle, Bastide" (*RHM* 113).

3. Éric Rohmer, "Le Film et les Trois Plans du discours: indirect/direct/hyperdirect," *Cahiers Renaud-Barrault* (October 1977).

4. Letter from Éric Rohmer to Antoine Vitez, 22 May 1971, IMEC, fonds Vitez.

5. Éric Rohmer, "Note sur la traduction et sur la mise en scène de Perceval," *L'Avant-scène cinéma*, 1 February 1979.

6. Interview with Marie Rivière, by François Gorin, *Télérama*, 23 September 1998.

7. Interview with Éric Rohmer, by Noël Herpe and Philippe Fauvel, *Le Celluloïd et le Marbre* (Paris: Éditions Léo Scheer, 2011),151.

8. Draft of a letter from Éric Rohmer to Deborah Nathan, IMEC, fonds Éric Rohmer, dossier "Correspondance personnelle" (*RHM* 131).

9. Interview with Éric Rohmer, by Claude-Jean Philippe, *Le Cinéma des cinéastes*, France Culture, 25 February 1979.

10. Draft of a letter from Éric Rohmer to Michel Pastoureau, Paris, November 1977, IMEC, fonds Éric Rohmer, dossier "*Perceval*, préparation du tournage" (*RHM* 16.3).
11. Interview with Éric Rohmer, by Gérard Vaugeois, *L'Humanité Dimanche*, 7 February 1979.
12. Interview with Rohmer, by Philippe, *Le Cinéma des cinéastes*.
13. *Positif* (June 1994).
14. Danièle Dubroux,"Un rêve pédagogique," *Cahiers du cinéma* (April 1979).
15. Interview with Cécile Decugis, 17 November 2010.
16. Interview with Éric Rohmer, by Patrick Thévenon, *L'Express*, 20 March 1978.
17. Éric Rohmer,"La réponse de Rohmer," *Le Film français*, 17 March 1978.
18. Interview with Margaret Menegoz, 20 November 2010.
19. *Le Nouvel Observateur*, 12 February 1979.

9. Six *Comedies and Proverbs*: 1980–1986

1. Éric Rohmer, press kit for *The Aviator's Wife*, 1981, IMEC, fonds Éric Rohmer, dossier "*La Femme de l'aviateur*, promotion" (*RHM* 23.2).
2. Ibid.
3. Interview with Éric Rohmer, by Serge Daney and Pascal Bonitzer, *Cahiers du cinéma* (May 1981).
4. Ibid.
5. Ibid.
6. Maurice Schérer, "La Demande en mariage," *Espale*, [1946?], IMEC, fonds Éric Rohmer, dossier "*La Femme de l'aviateur*, écriture de l'oeuvre" (*RHM* 21.1).
7. Maurice Schérer,"Une journée," manuscript draft, IMEC, fonds Éric Rohmer, dossier "*La Femme de l'aviateur*, écriture de l'oeuvre" (*RHM* 21.2).
8. Ibid.
9. Interview with Rohmer, by Bonitzer and Daney, *Cahiers du cinéma*.
10. Interview with René Schérer, 28 September 2010.
11. Interview with Anne-Laure Meury, by Bruno Joliet, *Cinéma 87* (September 1987).
12. Éric Rohmer, *La Femme de l'aviateur*, in *Comédies et Proverbes* (Paris: Petite bibliothèque des *Cahiers du cinéma*, 1999), 49.
13. Interview with Éric Rohmer, by Haydée Caillot, typed transcript, IMEC, fonds Éric Rohmer, dossier "Correspondance personnelle" (*RHM* 131).
14. Interview with Rohmer, by Bonitzer and Daney, *Cahiers du cinéma*.
15. Ibid.
16. Interview with Georges Prat, 3 June 2011.
17. Interview with Rohmer, by Bonitzer and Daney, *Cahiers du cinéma*.
18. Jean Parvulesco, letter to Éric Rohmer, Paris, 5 March 1981, IMEC, fonds Éric Rohmer, dossier "Correspondance professionnelle, Parvulesco" (*RHM* 113). Amira Chemakhi was Films du Losange's accountant, who good-humoredly allowed his silhouette to appear in *The Aviator's Wife*.
19. Maurice and Christine Jacquet-Ronai, letter to Éric Rohmer, Paris, 1981, IMEC, fonds Éric Rohmer, dossier "*La Femme de l'aviateur*, réception" (*RHM* 23.10).
20. Nestor Almendros, letter to Éric Rohmer, on the airplane from Paris to New York, 25 August 1981, IMEC, fonds Éric Rohmer, dossier "*La Femme de l'aviateur*, réception" (*RHM* 23.10).

21. François Truffaut, letter to Éric Rohmer, 27 February 1981, IMEC, fonds Éric Rohmer, dossier "Correspondance professionnelle, Truffaut" (*RHM* 113).

22. Rohmer, *La Femme de l'aviateur*, in *Comédies et Proverbes*, 31.

23. Honoré de Balzac, "Le Bal de Sceaux," in *Nouvelles et contes*, vol. 1, *1820–1832*, Quarto Collection (Paris: Gallimard, 2005), 296.

24. Éric Rohmer, manuscript transcript for *A Good Marriage*, IMEC, fonds Éric Rohmer, dossier "*Le Beau Mariage*, préparation du tournage" (*RHM* 24.4).

25. Interview with Éric Rohmer, *Le Nouveau F* (June 1982).

26. Éric Rohmer, *Le Beau Mariage*, manuscript draft of a synopsis, 28 December 1980, IMEC, fonds Éric Rohmer, dossier "*Le Beau Mariage*, écriture de l'oeuvre" (*RHM* 23.31).

27. Éric Rohmer, *Le Beau Mariage*, manuscript draft of dialogues, [1980?], IMEC, fonds Éric Rohmer, dossier "*Le Beau Mariage*, écriture de l'oeuvre" (*RHM* 23.32).

28. Michel Boujout, *Les Nouvelles littéraires*, 27 May 1982.

29. Pierre Billard, *Le Point*, 7 June 1982.

30. Claude-Jean Philippe, *7 à Paris*, 19 May 1982.

31. Éric Rohmer, *Le Beau Mariage*, in *Comédies et Proverbes*, 119.

32. Éric Rohmer, interview preparatory to *A Good Marriage* with Béatrice Romand, [1980?], IMEC, fonds Éric Rohmer, dossier "*Le Beau Mariage*, préparation du tournage" (*RHM* 24.4).

33. Éric Rohmer, *Friponnes de porcelaine*, manuscript draft of a play, IMEC, fonds Éric Rohmer, dossier "*Pauline à la plage*, écriture de l'oeuvre" (*RHM* 26.1).

34. *Loup, y es-tu?*, manuscript draft of dialogues, IMEC, fond Éric Rohmer, dossier "*Pauline à la plage*, écriture de l'oeuvre" (*RHM* 26.2).

35. Ibid.

36. Éric Rohmer and Jean Douchet, *Preuves à l'appui*, complete transcript, 1993, IMEC, fonds Éric Rohmer, dossier "Films pour la télévision, *Preuves à l'appui*" (*RHM* 98.1).

37. Interview with Éric Rohmer, by Bruno Villien, *Beaux-Arts*, 1 September 1984

38. Ibid.

39. Interview with Éric Rohmer, by Noël Herpe and Philippe Fauvel, *Le Celluloïd et le Marbre* (Paris: Éditions Léo Scheer, 2011), 121.

40. Éric Rohmer, *Pauline à la plage*, in *Comédies et Proverbes*, 135.

41. Interview with Virginie Thévenet, 18 March 2011.

42. Interview with Féodor Atkine and Pascal Greggory, by Philippe Reynaert, *Visions*, [1983].

43. Ibid.

44. Interview with Éric Rohmer, Arielle Dombasle, Pascal Greggory, Féodor Atkine, and Simon de La Brosse, by Hervé Guibert, *Le Monde*, 24 March 1983.

45. Ibid.

46. Ibid.

47. Ibid.

48. Éric Rohmer, letter to the director of *Le Monde*, Paris, 24 March 1983, IMEC, fonds Éric Rohmer, dossier "*Pauline à la plage*, réception" (*RHM* 28.11).

49. Hervé Guibert, letter to Éric Rohmer on the letterhead of *Le Monde*, Paris, 27 March 1983, IMEC, fonds Éric Rohmer, dossier "*Pauline à la plage*, réception" (*RHM* 28.11).

50. Claude Baignères, *Le Figaro*, 25 March 1983.

51. Interview with Éric Rohmer, by Pascal Bonitzer and Michel Chion, *Cahiers du cinéma* (April 1983).

52. Éric Rohmer, *L'Appartement*, manuscript draft of a scenario, 1981, IMEC, fonds Éric Rohmer, dossier "*Les Nuits de la pleine lune*, écriture de l'oeuvre" (*RHM* 29.1).

53. Éric Rohmer, *Les Nuits de la pleine lune*, in *Comédies et Proverbes* II (Paris: Petite bibliothèque des *Cahiers du cinéma*, 1999), 9.

54. Ibid.

55. Ibid., 28–29.

56. Interview with Jacno, by Philippe Bonnell, *VSD*, 27 October 1984.

57. Éric Rohmer, interview preparatory to *Full Moon in Paris*, with Fabrice Luchini and Pascale Ogier, IMEC, fonds Éric Rohmer, dossier "*Nuits de la pleine lune*, préparation du tournage" (*RHM* 29.9).

58. Éric Rohmer, manuscript transcription for *Full Moon in Paris*, 1983, IMEC, fonds Éric Rohmer, dossier "*Nuits de la pleine lune*, préparation du tournage" (*RHM* 29.9).

59. Ibid.

60. Serge Daney, *Libération*, 4 September 1984.

61. Éric Rohmer, typed text on Gérard Falconetti, 1984, IMEC, fonds Éric Rohmer, dossier "textes, sujets divers" (*RHM* 101.26).

62. Jules Verne, *Le Rayon vert* (Paris: Le Livre de Poche), 79–80.

63. Éric Rohmer, *Le Rayon vert*, manuscript draft of dialogues, IMEC, fonds Éric Rohmer, dossier "*Le Rayon vert*, écriture de l'oeuvre" (*RHM* 32.1).

64. Interview with Marie Rivière, 25 January 2011.

65. Interview with Éric Romer, by Caroline Rochmann, *Marie Claire* (December 1987).

66. Ibid.

67. Contract between Éric Rohmer and Claudine Nougaret, Paris, 9 July 1984, IMEC, fonds Éric Rohmer, dossier "*Le Rayon vert*, production" (*RHM* 32.5).

68. Letter from Françoise Etchegaray to Éric Rohmer, Saincy, 4 June 1984, IMEC, fonds Éric Rohmer, dossier "*Le Rayon vert*, préparation du tournage" (*RHM* 32.8).

69. Éric Rohmer,"Nous n'aimons plus le cinéma," *Les Temps modernes* (June 1949).

70. Éric Rohmer, *Le Rayon vert*, manuscript draft of dialogues, [1984], IMEC, fonds Éric Rohmer, dossier "*Le Rayon vert*, écriture de l'oeuvre" (*RHM* 32.6).

71. Gérard Lefort, *Libération*, 3 September 1986.

72. Éric Rohmer, "Déposition d'Éric Rohmer au sujet de la plainte de Mlle Moreau," typed text with handwritten annotations, [1986?], IMEC, fonds Éric Rohmer, dossier "*Le Rayon vert*, correspondance" (*RHM* 33.14).

73. Jean-Luc Godard, letter to Éric Rohmer, October 1986, IMEC, fonds Éric Rohmer, dossier "Correspondance professionnelle, Godard" (*RHM* 113).

74. Éric Rohmer, testimony for the trial of Roger Knobelpiess, [1989], IMEC, fonds Éric Rohmer, dossier "Textes, sujets divers" (*RHM* 101.26).

75. "I think you're very lucky, Léa, / To fall in love at this rate / And to always find, without even looking, a boy / Who is sure to please you in one way or another. / As for me, the only one who pleases me . . . / [Léa:] It's Bastien, I know." Éric Rohmer, *Les Quatre coins*, manuscript draft of scenario, [1982], IMEC, fonds Éric Rohmer, dossier "*L'Ami de mon amie*, écriture de l'oeuvre" (*RHM* 36.2).

76. "No I don't hate you. It just seems to me / That you and he, believe me, really don't go together. [Blanche:] He's handsome, I'm ugly. Oh, I know that well enough! [Léa:] Blanche, why do you always try to belittle yourself?" Ibid.

77. Éric Rohmer, *Les Quatre coins*, manuscript draft of scenario, September 1982, IMEC, fonds Éric Rohmer, dossier "*L'Ami de mon amie*, écriture de l'oeuvre" (*RHM* 36.3).

78. Éric Rohmer, *L'Ami de mon amie*, in *Comédies et Proverbes* II, 129.

79. Ibid.

80. Interview with Emmanuelle Chaulet, by François Thomas, in *Rohmer et les Autres*, ed. Noël Herpe, 229 (Presses universitaires de Rennes, 2007).

81. Interview with Meury, by Joliet, *Cinéma 87*.

10. The Rohmer of the Cities and the Rohmer of the Countryside: 1973–1995

1. Thomas Clerc, "Rohmer l'urbain," in *Rohmer en perspectives*, ed. Sylvie Robic and Laurence Schifano (Presses universitaires de Nanterre, 2013).

2. Ibid. And in the same volume, the chapter by Charles Coustille: "Où qu'on aille, on est condamné à la province. Éric Rohmer et la conversation ordinaire."

3. Not to forget an obvious subcategory, the beach films: *La Collectionneuse*, in part; *Pauline at the Beach*; *The Green Ray*; *A Tale of Summer*; and the beginning of *A Tale of Winter*. Interview with Éric Rohmer, by Fabien Baumann and Adrien Gombeaud, in "Positif à la plage," special issue, *Positif* (summer 2009).

4. Interview with Éric Rohmer, by Claude Beylie and Alain Carbonnier, *L'Avant-scène cinéma* 336 (January 1985).

5. Interview with Éric Rohmer, by Thierry Jousse and Thierry Paquot, *La Ville au cinéma* (Paris: Éditions des *Cahiers du cinéma*, 2005), 21.

6. For Rohmer, Le Corbusier was a "personal enemy." Interview with Éric Rohmer, by Philippe Fauvel and Noël Herpe, *Le Celluloïd et le Marbre* (Paris: Éditions Léo Scheer, 2011), 156.

7. Interview with Éric Rohmer, by Claude-Marie Trémois, *Télérama*, 9 February 1994.

8. Interview with Rohmer, by Beylie and Carbonnier, *L'Avant-scène cinéma*.

9. "Au secours le Louvre!," IMEC, fonds Éric Rohmer, dossier "Coupures de presse, divers documents reçus."

10. Interview with Rohmer, by Jousse and Paquot, *La Ville au cinéma*, 21–22.

11. Éric Rohmer, *Architectopolis*, film project, IMEC, fonds Éric Rohmer, dossier "*Ville nouvelle*" (*RHM* 88.1).

12. Ibid.

13. Ibid.

14. Ibid.

15. Ibid.

16. Ibid.

17. Ibid.

18. Éric Rohmer, *Architecture présente*, film project, 1968, IMEC, fonds Éric Rohmer, dossier "*Ville nouvelle*" (*RHM* 88.2).

19. The ORTF was dissolved and split up in 1974, after the presidential election. Valéry Giscard d'Estaing, seeking to distance himself from the state television on the Gaullist model, reformed public television. From this resulted the channels TF1, Antenne 2, FR3, and the Institut national de l'audiovisuel.

20. *Germe de ville* was to become the fourth episode of Rohmer's *Ville nouvelle*, entitled "Logement à la demande" (Housing on demand).

21. Gérard Thurnauer, *Germe de ville*, an action plan filmed at Le Vaudreuil, 1972, IMEC, fonds Éric Rohmer, dossier "*Ville nouvelle*" (*RHM* 88.3).

22. Éric Rohmer, *Recherche architecturale*, March 1973, IMEC, fonds Éric Rohmer, dossier "*Ville nouvelle*" (*RHM* 88.4).

23. But also: Jean Deroche, Georges Loiseau, Jean Perrottet, Jean Tribel, Michel Corajoud, Borja Huidobro, Enrique Ciriani, and Valentin Fabre.

24. Éric Rohmer, "Notes sur l'architecture," 14 March 1973, IMEC, fonds Éric Rohmer, dossier "*Ville nouvelle*" (*RHM* 88.5).

25. Ibid.

26. Éric Rohmer, "Notes diverses," n.d., IMEC, fonds Éric Rohmer, dossier "*Ville nouvelle*" (*RHM* 133.16).

27. Letter from Roland Castro to Éric Rohmer, May 1973, IMEC, fonds Éric Rohmer, dossier "*Paris 1930*" (*RHM* 95.1).

28. Interview with Paul Chemetov, 15 November 2010.

29. Letter from Roland Castro to Éric Rohmer, May 1973, IMEC, fonds Éric Rohmer, dossier "*Paris 1930*" (*RHM* 95.1).

30. Chemetov's project for the construction of Évry came in second and was finally not approved, but he was to build, for example, the ministry of finances at Bercy and the place Carrée at the Forum des Halles, a building and a space that Rohmer liked very much, as well as a number of mediathèques. See the interview with Paul Chemetov by Françoise Puaux, in "Architecture, décor et cinéma," *CinémAction* (second trimester 1995); Paul Chemetov, "L'homme fabricateur de rêves, mécanicien de son destin," *Polyrama* (December 2003); Paul Chemetov, *L'Architecte et la Médiathèque* (Saint-Benoît-du-Sault, France, Éditions Tarabuste, 2009).

31. Interview with Paul Chemetov, 15 November 2010.

32. Ibid. Chemetov adds: "Rohmer was angry with me a little later on, when he asked me to build an elevator for his building on the rue d'Ulm. After visiting the site with him, I entrusted the task, which was complex (it was a crooked staircase in a building from the 1890s), to one of my assistants. I think [Rohmer] was annoyed that I didn't do it directly, myself, and he gave me the cold shoulder."

33. Interview with Rohmer, by Beylie and Carbonnier, *L'Avant-scène cinéma*.

34. Interview with Éric Rohmer, by Philippe Seulliet, *Le Quotidien de Paris*, 28 May 1974.

35. Éric Rohmer was involved in lengthy legal proceedings seeking to prevent the construction of a ten-storey apartment building across the street from his building on the rue d'Ulm. A member of the property-owners' association for his building, he was not able to get the construction permit for this apartment building cancelled, but its height was limited to eight stories.

36. Interview with Rohmer, by Trémois, *Télérama*.

37. Interview with Rohmer, by Beylie and Carbonnier, *L'Avant-scène cinéma*.

38. Interview with Rohmer, by Seulliet, *Le Quotidien de Paris*.

39. Interview with Cheryl Carlesimo, 9 June 2011.

40. Éric Rohmer, *Full Moon in Paris*, synopsis, 18 March 1983, IMEC, fonds Éric Rohmer, dossier "*Les Nuits de la pleine lune, écriture de l'oeuvre*" (*RHM* 29.1).

41. Public Development Authority.

42. Interview with Pascale Ogier, by Alain Philippon, *Cahiers du cinéma* (October 1984).

43. Pascale Ogier, "Mon travail avec Rohmer," press kit for *Full Moon in Paris*, IMEC, fonds Éric Rohmer, dossier "*Les Nuits de la pleine lune*, presse" (*RHM* 30.1).

44. Pascale Ogier, "Notes de repérage," IMEC, fonds Éric Rohmer, dossier "*Les Nuits de la pleine lune*, préparation du tournage" (*RHM* 29.2).

45. Interview with Rohmer, by Trémois, *Télérama*.

46. Interview with Éric Rohmer, by Jean-Michel Hoyet and Marie-Christine Loriers, *Architecture présente* (November–December 1984).

47. Marie-Claude Dumoulin, "Chez Pascale Ogier, une déco super branchée," *Marie Claire* (January 1984).

48. Éric Rohmer, *Les Nuits de la pleine lune, Comédies et Proverbes* Paris: Petite bibliothèque des *Cahiers du cinéma*, 1999), 12–13.

49. A children's game played on a four-cornered court.

50. Éric Rohmer, *Boyfriends and Girlfriends*, synopsis, 1985, IMEC, fonds Éric Rohmer, dossier "*L'Ami de mon amie*, écriture de l'oeuvre" (*RHM* 36.2).

51. Letter from Bertrand Warnier to Éric Rohmer, 13 October 1986, IMEC, fonds Éric Rohmer, dossier "*L'Ami de mon amie*, préparation du tournage" (*RHM* 37.2).

52. Interview with Éric Rohmer, by Antoine de Baecque, in special issue on Cergy-Pontoise, *Libération*, 29 March 2002.

53. Interview with Françoise Etchegaray, by Stéphane Delorme, *Cahiers du cinéma* (February 2010).

54. Michel Pérez, *Le Matin de Paris*, 26 August 1987.

55. Jacques Siclier, *Le Monde*, 27 August 1987.

56. *Télé 7 jours*, 28 August 1987.

57. Jean-Dominque Bauby, *Paris Match*, 27 August 1987.

58. *La Gazette de Cergy*, 2 September 1987.

59. Letter from Pierre Lefort to Éric Rohmer, [1987], IMEC, fonds Éric Rohmer, dossier "*L'Ami de mon amie*, réception" (*RHM* 38.7).

60. Interview with Rohmer, by de Baecque, *Libération*.

61. Ibid.

62. Jean-Claude Brisseau, *L'Ange exterminateur. Entretiens avec Antoine de Baecque* (Paris: Grasset, 2006), 52.

63. The "4000," La Cité des 4000, is a housing project begun in 1956 that was originally intended to have four thousand apartments. Godard's 1967 film *Two or Three Things I Know About Her* is set there.

64. Interview with Joëlle Miquel, by Peter Falknerod, *Ouest-France*, 7 February 1987.

65. Interview with Éric Rohmer, by Gérard Legrand, Hubert Niogret, and François Ramasse, *Positif* (February 1987).

66. Ibid.

67. David Vasse, "Éloge de la forme courte: à propos de *4 aventures de Reinette et Mirabelle* et des *Rendez-vous de Paris*," in *Rohmer et les Autres*, ed. Noël Herpe, 105–111 (Presses universitaires de Rennes, 2007).

68. Éric Rohmer, *Le Téléphone, Mon joli bateau, La Petite Cousine, Reinette et Mirabelle*, March 1985, IMEC, fonds Éric Rohmer, dossier "*4 aventures de Reinette et Mirabelle*, écriture de l'oeuvre" (*RHM* 34.7).

69. Interview with Jessica Forde, 24 November 2010.

70. Interview with Françoise Etchegaray, by Stéphane Delorme, *Cahiers du cinéma* (February 2010).

71. Société Nationale des Chemins de fer français, the French national rail company.

72. Filming permit, Gare Montparnasse, SNCF, 9 September 1985, IMEC, fonds Éric Rohmer, dossier "*4 aventures de Reinette et Mirabelle*, tournage" (*RHM* 34.4).

73. Interview with Etchegaray, by Delorme, *Cahiers du cinéma*.

74. Interview with Jessica Forde, 24 November 2010.

75. Interview with Rohmer, by Legrand, Niogret, and Ramasse, *Positif*.

76. Card from Philippe Laudenbach to Éric Rohmer, [1987], IMEC, fonds Éric Rohmer, dossier "*4 aventures de Reinette et Mirabelle*, réception" (*RHM* 35.10).

77. Interview with Rohmer, by Legrand, Niogret, and Ramasse, *Positif*.

78. Interview with Jessica Forde, 24 November 2010. On the Éric Rohmer Company, see Philippe Fauvel's master's thesis, "La Compagnie Éric Rohmer. Enquête sur la méthode et l'amateurisme tardif d'Éric Rohmer" (thesis defended at the University of Amiens, 2010).

79. This ninth Festival international du court métrage in Clermont-Ferrand in February 1987 presented, in addition to the preview of *Reinette et Mirabelle*, all of Rohmer's short films: eleven films from 1950 to 1968, twenty-four films for educational television, two programs from the series *Cinéastes, de notre temps*, and the four films made for the ORTF, *Ville Nouvelle*.

80. 181,839 to be precise.

81. 346,039 francs to be precise.

82. Robert Chazal, *France-Soir*, 4 February 1987; and Anne de Gasperi, *Le Quotidien de Paris*, 4 February 1987.

83. Jacques Siclier, *Le Monde*, 10 February 1987.

84. Michel Pérez, *Le Matin de Paris*, 4 February 1987.

85. Gilles Le Morvan, *L'Humanité*, 4 February 1987.

86. Michel Boujut, *L'Événement du jeudi*, 5 February 1987.

87. Jean-Philippe Guérand, *Première* (February 1987).

88. *Cahiers du cinéma* (February 1987).

89. "Rohmer côté court," *Libération*, 4 February 1987.

90. Vasse, "Éloge de la forme courte: à propos de *4 aventures de Reinette et Mirabelle* et des *Rendez-vous de Paris*."

91. Interview with Florence Rauscher, 26 September 2011.

92. That was the feeling of Serge Renko, among other actors, when he said: "People always find themselves in the roles they play, more or less, even Rohmer himself." Interview with Serge Renko, 12 March 2011.

93. Interview with Serge Renko, 12 March 2011.

94. Ibid.

95. Letter from Clara Bellar to Éric Rohmer, 29 October 1992, IMEC, fonds Éric Rohmer, dossier "Correspondance professionnelle, Bellar" (*RHM* 113).

96. Letter from Clara Bellar and Judith Chancel to Éric Rohmer, 28 September 1992, IMEC, fonds Éric Rohmer, dossier "Correspondance professionnelle, Bellar" (*RHM* 113).

97. Letter from Clara Bellar to Éric Rohmer, [1992], IMEC, fonds Éric Rohmer, dossier "Correspondance professionnelle, Bellar" (*RHM* 113).

98. Interview with Clara Bellar, by Jeanne Baumberger, *Le Méridional*, 26 March 1995.

99. Interview with Bénédicte Loyen, 16 March 2011.

100. Michaël Kraft, a young actor recommended by Marie Rivière, had performed on the stage with Jean-Claude Fall, Claude Régy, and Joël Jouanneau, and in Pascal Thomas's film *Les Maris, les Femmes, les Amants* (1989), committed suicide shortly after *Rendezvous in Paris*, in 2001.

101. Interview with Bénédicte Loyen, 16 March 2011.

102. Interview with Etchegaray, by Delorme, *Cahiers du cinéma*.

103. Claude-Marie Trémois, *Télérama*, 22 March 1995.

104. Danielle Attali, *Le Journal du dimanche*, 19 March 1995.

105. *Les Inrockuptibles*, 22 March 1995.

106. *Les Inrockuptibles*, 18 March 1998.

107. Éric Rohmer was moreover particularly excited by Louis Skorecki's text, even if he was not in agreement with its content, as Régine Vial, who was reponsible for distribution at Films du Losange, testified: "Finally, a bad review!" he exclaimed on discovering the article. Interview with Régine Vial, 8 March 2012.

108. Rohmer was a reader of *Libération* and liked Skorecki's art of excoriating contrarianism, cutting out and preserving dozens of his columns, for example the series devoted to Lang, Hawks, Walsh, Rossellini, Renoir, and his own films. Between November 2000 and April 2001, Skorecki wrote regularly about Rohmer in his column, and with a certain provocativeness tinted with admiration, was obviously trying to pick a fight. "In this silent cinema," he wrote, "there is a kind of temptation to ethnic cleansing, a fascination with the purity of a language that would have to be called 'Aryan,' were it not for the murderous use made of this word a few years later. A few irreproachable artists, Griffith, Lang, Murnau, attest to this fascination. Rohmer's cinema, though of course we do not wish to accuse him of 'Aryanization,' descends directly from this art of the silent film that distrusts everything that resembles mixture or blending. Confronted by the trivial temptation of an impure cinema (Lubitsch, Laurel and Hardy, Stroheim, Chaplin), the cinephile has long preferred Fritz Lang's haughty elegance and especially Buster Keaton's imperturbable architectures" (*Libération*, 14 November 2001). Rohmer then decided to address to the columnist for *Libération* a five-page letter, at the heart of which is praise for a "simian cinema" diametrically opposed to the "Aryanism" that Skorecki points to in his work: "Since you provoke me, allow me to reply to you," he writes as an introduction. He defends Keaton, and especially Hawks and Renoir, "who have nevertheless become indefensible today," because in their films "the characters are apes, in the physical sense of the term, and that is no longer acceptable. They are apes and that is why they have a soul; let him understand who can, my master Alain would have said. In *Elena et les hommes*, see Mel Ferrer's sublime simian elegance. I had entitled my review of the film for *Cahiers du cinéma* 'Les singes et Vénus,' but that was censored by Doniol. 'We can't call someone an ape,' he told me . . . I say no more, because there is no word to express something that escapes all conceptual thought." Rohmer concludes with this homage: "Your faithful reader, who generally likes to follow your writing and does not hold against you your reservations concerning Renoir and Hawks, because as some might say, as usual, 'all tastes are natural.' Sincerely yours." Letter from Éric Rohmer to Louis Skorecki, [2001], IMEC, fonds Éric Rohmer, dossier "Correspondance professionnelle, Skorecki" (*RHM* 113).

109. Louis Skorecki, *Libération*, 26 August 1987.

110. Éric Rohmer, *Boyfriends and Girlfriends*, scenario, 1985, IMEC, fonds Éric Rohmer, dossier "*L'Ami de mon amie*, écriture de l'oeuvre" (*RHM* 36.2).

111. This refers to a text on Frank Tashlin and *The Girl Can't Help It*, with Jayne Mansfield, a film one might think completely opposite to Rohmer's tastes. But by a rather typical paradox of *Cahiers*-style thinking, the critic made good use of the film by relating it to the classical standard: in it, Jayne Mansfield becomes the classical beauty of her time. *Cahiers du cinéma* (November 1957).

112. Ibid.

113. Alain Auger, "Rohmer et la comédie. Le semblant du social," *L'Imparnassien*, no. 3 (May 1983).

114. Éric Rohmer, interview preparatory to *Boyfriends and Girlfriends*, with Sophie Renoir, IMEC, fonds Éric Rohmer, dossier "*L'Ami de mon amie*, préparation du tournage" (*RHM* 37.1).

115. Anne de Gasperi, *Le Quotidien de Paris*, 15 March 1995.

116. A written play on words by Rohmer (who loved that sort of thing) on the strong men of the French Communist Party expresses quite well this playful distancing that the man adopted vis-a-vis De Gaulle's politics: "J'ai fait un rêve étrange, il n'avait pas d'époque. / La dame de Nohant qui portait une toque / Une jupe à volants et un paletot noir / S'avançait à grands pas dans la fraîcheur du soir. / Derrière, l'auteur des Nourritures terrestres / En vieil habitué des voyages pédestres / Allait et regagnait lentement du terrain. / Il disait, sans d'autant quitter son air serein : / "Il faut absolument, ce soir, que je la joigne." / Il le fit, sur ce point, oui, mon rêve en témoigne. / Ce qu'il lui dit je ne sais pas / Car le songe s'arrête là. / Et la fable n'a pas besoin / Qu'il ait continué plus loin. / Moralité: George marchait, André la joignit [Georges Marchais, André Lajoinie]." (I had a strange dream, it wasn't situated in time. / The lady from Nohant who wore a fur hat / A skirt with flounces and a black coat / Was quickly walking toward me in the cool of the evening. / Behind, the author of the *Nourritures terrestres*/ As if long used to traveling on foot / Was going and slowly gaining ground again. / He said, without ceasing to look serene: / "I absolutely must catch up with her tonight." / He did it, on this point, yes, my dream testifies to that. / What he said to her I do not know / Because the dream stops there. / And the story does not need / Him to continue further. / Moral: George was walking. André met him.) IMEC, fonds Éric Rohmer, dossier "Éric Rohmer écrivain, poèmes" (*RHM* 102.12).

117. Interview with Jean Parvulesco, 18 October 2010.

118. Interview with René Schérer, 28 September 2010.

119. Ibid.

120. "Les trottoirs aux piétons!," IMEC, fonds Éric Rohmer, dossier "Coupures de presse, documentation diverse" (*RHM* 120).

121. Letter from Éric Rohmer to the president of the Comité contre le tabagisme, May 1981, IMEC, fonds Éric Rohmer, dossier "Correspondance professionnelle, divers" (*RHM* 117.9).

122. Letter from Dominique Voynet to Éric Rohmer, December 1994, IMEC, fonds Éric Rohmer, dossier "Correspondance professionnelle, Voynet" (*RHM* 113).

123. Moreover, in the archives we find the trace of certain punctual actions, for example, a check written to support and join the association "VI. V. RE," which organized an effort to take back and reopen the Villemin garden and to classify as pedestrian zones the Valmy and Jemmapes quays in the tenth arrondissement; a subscription to the Comité de réflexion, d'information et de lutte anti-nucléaire, which fought at The Hague the accumulation of nuclear waste; or again a subscription to the magazine *Sortir du nucléaire*, published by the networks Sortir du nucléaire and Les Européens contre Superphénix. IMEC, fonds Éric Rohmer, dossier "Documentation diverse" (*RHM* 120).

124. Pierre Rabhi, "Pour une insurrection des consciences," IMEC, fonds Éric Rohmer, dossier "Coupures de presse, documentation diverse" (*RHM* 120).

125. IMEC, fonds Éric Rohmer, dossier "Coupures de presse, documentation diverse" (*RHM* 120).
126. *The Tree, the Mayor, and the Mediatheque*, IMEC, fonds Éric Rohmer, dossier "*L'Arbre, le Maire et la Médiathèque*, promotion" (*RHM* 48.1).
127. Letter from Aline Baillou to Éric Rohmer, July 1973, IMEC, fonds Éric Rohmer, dossier "Correspondance professionnelle, Aline Baillou" (*RHM* 113).
128. *L'Actualité économique/CAC*, February 1991, IMEC, fonds Éric Rohmer, dossier "*L'Arbre, le Maire et la Médiathèque*, préparation du tournage" (*RHM* 45.9).
129. A reference to Jack Lang, minister of culture from 1981 to 1986 and from 1988 to 1992.
130. Letter from Éric Rohmer to Gilles and Charline Lauga, 12 July 1993, IMEC, fonds Éric Rohmer, dossier "*L'Arbre, le Maire et la Médiathèque*, réception" (*RHM* 48.5).
131. Interview with Arielle Dombasle, 24 October 2011.
132. Letter from Arielle Dombasle to Éric Rohmer, 6 May 1991, IMEC, fonds Éric Rohmer, dossier "*L'Arbre, le Maire et la Médiathèque*, préparation du tournage" (*RHM* 45.10). There is an article in *Vogue* in April of 1994, "House of Style," on Bruno Chambelland's property.
133. Interview with Pascal Greggory, 14 January 2011.
134. At the beginning of this inquiry we read:"Saint-Juire-Champgillon, nestled in the heart of the lower Vendean *bocage*, is indeed the more than living symbol of the peaceful and "Sweet France" that the poet Charles Trenet sings. It is in fact a country where the impious regrouping of lands has not yet gotten the better of all the sunken lanes that are so moving and so secret; the regrouping that, in the early 1970s, cravenly scorned the dead and history on the pretext of a basely materialist efficiency. Oh, yes, for lovers of pure and silent Nature, this adorable village, where an intimate alliance between the land and the inhabitants has been admirably maintained, is a jewel, a jewel both natural and architectural. And consequently it is a privileged place where people can still enjoy another art of living! It is impossible to remain unmoved by the testimony borne by the stone paths in the village, so evocative of the placid serenity of the man of the earth." "Saint-Juire-Champgillon, présentation," typescript, IMEC, fonds Éric Rohmer, dossier "*L'Arbre, le Maire et la Médiathèque*, préparation du tournage" (*RHM* 45.11).
135. Christophe Cosson and Jean-Claude Pubert, *Le Parler Saint-Juirien* (Éditions Hécate, 1990).
136. The tract's argument goes like this: "Will the canton of Sainte-Hermine soon be deserted? For the past thirty years, the canton has been losing its inhabitants. In 1962, 9,089; in 1968, 8,124; in 1990, 7,428. In thirty years, the canton has lost almost two out of every ten inhabitants. We have to stop this hemorrhaging." Then come the developments on employment, the superhighway, agriculture, ecotourism, concluding with this campaign promise: "Develop our sites and monuments, renovate our villages while respecting their character. To improve everyday life is to make people want to live in the country again." IMEC, fonds Éric Rohmer, dossier "*L'Arbre, le Maire et la Médiathèque*, préparation du tournage" (*RHM* 45.12).
137. Bruno Chambelland, "Écouter, réfléchir, agir," 1992, IMEC, fonds Éric Rohmer, dossier "*L'Arbre, le Maire et la Médiathèque*, préparation du tournage" (*RHM* 45.13).
138. Ibid.
139. Letter from Jean-Claude Pubert to Éric Rohmer, IMEC, fonds Éric Rohmer, dossier "*L'Arbre, le Maire et la Médiathèque*, préparation du tournage" (*RHM* 45.14).
140. Interview with Michel Jaouën, by Vincent Guigueno, in Herpe, *Rohmer et les Autres*, 219–223.
141. A certain number of dossiers and files in the fonds Rohmer at the IMEC that are connected with *The Tree, the Mayor, and the Mediatheque* are marked "HP," a mysterious term that means "high politics."

142. Interview with Jaouën, by Guigueno.

143. Ibid.

144. Ibid.

145. Fabienne Costa, "Prière d'insérer: *L'Arbre, le Maire et la Médiathèque*," in Herpe, *Rohmer et les Autres*, 151–156.

146. The actress explained that she was brought up in the countryside and knew all about the names of vegetable and animal species. Pascal Greggory, for his part, said that he got into his role (also cobbled together) by putting on suits that had been worn by Bruno Chambelland, the mayor of Saint-Juire, whom he knew well, developing a look between political representative and gentleman farmer. Rohmer also gave him a hint for putting together his character: "Take an interest in Julien Dray."

147. Letter from Fabienne Babe to Éric Rohmer, 27 May 1991, IMEC, fonds Éric Rohmer, dossier "Correspondance professionnelle, Fabienne Babe" (*RHM* 113).

148. Letter from Isabelle Carré to Éric Rohmer, 24 September 1991, IMEC, fonds Éric Rohmer, dossier "Correspondance professionnelle, Isabelle Carré" (*RHM* 113).

149. Letter from Hélène Fillières to Éric Rohmer, 20 April [1991], IMEC, fonds Éric Rohmer, dossier "Correspondance professionnelle, Hélène Fillières" (*RHM* 113).

150. Éric Rohmer, "À la campagne," song, 1992, IMEC, fonds Éric Rohmer, dossier "*L'Arbre, le Maire et la Médiathèque*, écriture de l'oeuvre" (*RHM* 45.9).

151. Interview with Diane Baratier, 11 March 2011.

152. Interview with Etchegaray, by Delorme, *Cahiers du cinéma*.

153. Interview with Diane Baratier, 11 March 2011.

154. Ibid.

155. Diane Baratier then worked as head camerawoman on all Rohmer's films up to *The Romance of Astrée and Céladon*.

156. Interview with Diane Baratier, 11 March 2011.

157. The film, whose cost was a rather minimal 1.5 million francs, was financed in large part by Canal+. Françoise Etchegaray, who attended the negotiations between Rohmer, Nathalie Bloch-Lainé, and René Bonnell in the latter's office at Canal+, told how the filmmaker managed to leave with a check for more than a million francs in his pocket. He kissed his collaborator in the elevator and then took her to lunch at a pizza parlor.

158. Alain Chabat and Dominique Farrugia, *Studio Magazine* (October 1992).

159. Interview with Régine Vial, 8 March 2012.

160. Régine Vial did not send out a press release until 28 January 1993, two weeks before the film came out: "Ladies and gentlemen, we are very happy to announce the release of Éric Rohmer's latest film on 12 February next: *The Tree, the Mayor, and the Mediatheque*, with Pascal Greggory, Arielle Dombasle, and Fabrice Luchini. We have not been able to show you this film in preview because Éric Rohmer has just completed it. He wanted to get it out very quickly because the film's subject seemed to him rooted in current events and connected with the different political ideas that will be debated during the upcoming elections. You will find enclosed a press kit, along with an invitation to go see the film in the theaters."

161. Interview with Éric Rohmer, by Serge Kaganski, *Les Inrockuptibles* (March 1993).

162. Letter from Clara Bellar to Éric Rohmer, 20 February 1993, IMEC, fonds Éric Rohmer, dossier "Correspondance professionnelle, Clara Bellar" (*RHM* 113).

163. Letter from Pierre Zucca to Éric Rohmer, IMEC, fonds Éric Rohmer, dossier "*L'Arbre, le Maire et la Médiathèque*, réception du film" (*RHM* 48.5).

164. Letter from Marie-Claude Treilhou to Éric Rohmer, IMEC, fonds Éric Rohmer, dossier "*L'Arbre, le Maire et la Médiathèque*, réception du film" (*RHM* 48.6).

165. Letter from Jean Mambrino to Éric Rohmer, 15 February 1993, IMEC, fonds Éric Rohmer, dossier "*L'Arbre, le Maire et la Médiathèque*, réception du film" (*RHM* 48.7).

166. *Sites et Monuments*, no. 141 (second trimester 1993).

167. *Cahiers du cinéma* (March 1993); *Cahiers du cinéma* (February 1994).

168. Freddy Buache, *La Gazette de Lausanne*, 22 February 1993.

169. Jean Collet, *Études*, April 1993.

170. "Symbol of Rohmer's Film, the Tree Was Felled by the Storm," *Presse Océan*, 4 May 1994.

171. Letter from Jean-Claude Pubert to Éric Rohmer, 23 June 1994, IMEC, fonds Éric Rohmer, dossier "*L'Arbre, le Maire et la Médiathèque*, réception du film" (*RHM* 45.1).

11. In the Rhythm of the Seasons: 1989–1998

1. An allusion to Psalm 91:6: "the destruction that wastes at noonday."

2. Letter from Jean-Claude Pubert to Éric Rohmer, 23 June 1994, IMEC, fonds Éric Rohmer, dossier "*L'Arbre, le Maire et la Médiathèque*, réception du film" (*RHM* 45.1).

3. Éric Rohmer, *Conte de printemps, Contes des quatre saisons*, op. cit., 17.

4. Interview with Éric Rohmer, by Marie-Noëlle Tranchant, *Le Figaro*, 4 April 1990.

5. "Parlor games" or, literally, "social games."

6. An allusion to Molière's play of the same name, about women who love excessively flowery language.

7. Interview with Mary Stephen, by Charles Tesson, *Cahiers du cinéma* (February 2010).

8. Éric Rohmer, *Conte d'automne*, manuscript draft of the scenario, 1992, IMEC, fonds Éric Rohmer, dossier "*Conte d'automne*, écriture de l'oeuvre" (*RHM* 55.1).

9. Ibid.

10. Draft of a letter from Éric Rohmer to Renée Agnard, [1998], IMEC, fonds Éric Rohmer, dossier "*Conte d'automne*, réception" (*RHM* 57.6).

11. Interview with Martine Limonta, by Victor Franco, *Le Figaro Magazine* (Rhône-Alpes edition), 7 November 1998.

12. Éric Rohmer, *Conte d'automne, Contes des quatre saisons*, 180.

13. Interview with Catherine Molin, by Victor Franco, *Le Figaro Magazine* (Rhône-Alpes edition), 7 November 1998.

14. Letter from Stéphane Darmon to Éric Rohmer, Paris, 6 March 1997, IMEC, fonds Éric Rohmer, dossier "*Conte d'automne*, préparation du tournage" (*RHM* 55.8).

15. Interview with Alexia Portal, 28 April 2011.

16. Draft of a letter from Éric Rohmer, 29 September 1998, IMEC, fonds Éric Rohmer, dossier "*Conte d'automne*, réception" (*RHM* 57.6).

17. Éric Rohmer, draft of a letter to Jean-Claude Brialy, 14 February [1991], IMEC, fonds Éric Rohmer, dossier "*Conte d'hiver*, préparation du tournage" (*RHM* 42.5).

18. French television series about a policeman named Ferbach (1991–1994).

19. Jean-Claude Brialy, letter to Éric Rohmer, Paris, 26 February 1991, IMEC, fonds Éric Rohmer, dossier "*Conte d'hiver*, préparation du tournage" (*RHM* 42.6).

20. William Shakespeare, *Conte d'hiver*, French trans. by Émile Legouis, quoted by Éric Rohmer in *Conte d'hiver, Contes des quatre saisons*, 228.

21. Éric Rohmer, *Conte d'hiver, Contes des quatre saisons*, 234.

22. Ibid., 229.

23. Typed interview with Éric Rohmer, by Alain Bergala and Laure Gardette, 17 February 1992, IMEC, fonds Éric Rohmer, dossier "*Conte d'hiver*, réception" (*RHM* 44.8).

24. Ibid.

25. Interview with Pascal Ribier, 7 February 2011.

26. Typed interview with Éric Rohmer, by Alain Bergala and Laure Gardette, 17 February 1992, IMEC, fonds Éric Rohmer, dossier "*Conte d'hiver*, réception" (*RHM* 44.8).

27. Letter from Margot Tronchon to Éric Rohmer, Paris, 23 December 1991, IMEC, fonds Éric Rohmer, dossier "*Conte d'hiver*, réception" (*RHM* 44.10).

28. Interview with Éric Rohmer, by Noël Herpe and Philippe Fauvel, in *Le Celluloïd et le Marbre* (Paris: Éditions Léo Scheer, 2011), 124–125.

29. Letter from Éric Rohmer to Charlotte Véry, 10 June 1989, IMEC, fonds Éric Rohmer, dossier "*Conte d'hiver*, préparation du tournage" (*RHM* 42.6).

30. Éric Rohmer, *Conte d'hiver, Contes des quatre saisons*, 221.

31. William Shakespeare, *Conte d'hiver*, French trans. by Émile Legouis, quoted by Éric Rohmer, *Conte d'hiver, Contes des quatre saisons*, 229.

32. Typed interview with Éric Rohmer, by Alain Bergala and Laure Gardette, 17 February 1992, IMEC, fonds Éric Rohmer, dossier "*Conte d'hiver*, réception" (*RHM* 44.8).

33. Éric Rohmer, *Conte d'été, Contes des quatre saisons*, 89.

34. Interview with Éric Rohmer, by Cédric Anger, Emmanuel Burdeau, and Serge Toubiana, *Cahiers du cinéma* (May 1996).

35. Interview with Éric Rohmer, by Jean-Michel Frodon, *Le Monde*, 6 June 1996.

36. Éric Rohmer, *Conte d'été, Contes des quatre saisons*, 125.

37. An island off the western tip of Brittany, known in English as Ushant.

38. Éric Rohmer, *Conte d'été, Contes des quatre saisons*, op. cit., 82.

39. *Conte d'été*, typed scenario with handwritten annotations, IMEC, fonds Éric Rohmer, dossier "*Conte d'été*, écriture de l'oeuvre" (*RHM* 51.17).

40. Interview with Pascal Ribier, 7 February 2011.

41. Éric Rohmer, *Conte d'été, in Contes des quatre saisons*, 91.

42. Gwenaëlle Simon, letter to Éric Rohmer, Paris, [1993], IMEC, fonds Éric Rohmer, dossier "*Conte d'été*, préparation du tournage" (*RHM* 52.8).

43. Interview with Melvil Poupaud, 27 May 2011.

44. Ibid.

45. Éric Rohmer, *Conte d'été*, song manuscript, IMEC, fonds Éric Rohmer, dossier "*Conte d'été*, écriture de l'oeuvre" (*RHM* 52.1).

46. Interview with Rohmer, by Herpe and Fauvel, *Le Celluloïd et le Marbre*, 144.

47. Terre-neuvas: fishermen who used to fish off the Grand Banks of Newfoundland.

48. Interview with Éric Rohmer, by Marie-Noëlle Tranchant, *Le Figaro*, 5 June 1996.

49. *Positif* (October 2002).

604 ■ 11. In the Rhythm of the Seasons: 1989–1998

50. Interview with Rohmer, by Herpe and Fauvel, *Le Celluloïd et le Marbre*, 144.
51. Interview with Arielle Dombasle, 24 October 2011.
52. Interview with Pascal Ribier, 7 February 2011.
53. Interview with Rohmer, by Herpe and Fauvel, *Le Celluloïd et le Marbre*, 143.
54. Éric Rohmer, *De Mozart en Beethoven: essai sur la notion de profondeur en musique* (Arles, France: Actes Sud, 1996), 105.
55. Ibid., 107.
56. Ibid., 109.
57. Interview with Éric Rohmer, by Brigitte Salino, *L'Événement*, 26 November 1987.
58. Letter from Yannis Kokkos to Éric Rohmer, Paris, 1 January 1987, IMEC, fonds Éric Rohmer, dossier "*Trio en mi bémol*" (*RHM* 104.2).
59. *Le Monde*, 11 December 1987.
60. Letter from Yannis Kokkos to Éric Rohmer, Paris, 1 January 1987, IMEC, fonds Éric Rohmer, dossier "*Trio en mi bémol*" (*RHM* 104.2).
61. Interview with Rohmer, by Herpe and Fauvel, *Le Celluloïd et le Marbre*, 146.

12. Filming History: 1998–2004

1. Interview with Éric Rohmer, by Priska Morrissey, *Historiens et cinéastes: rencontre de deux écritures* (Paris: L'Harmattan, 2004), 207.
2. Ibid.
3. In addition to Priska Morrissey's book (the interview with Éric Rohmer and his relation to history is on pages 207–238), see the interview given by Rohmer to *La Nouvelle Revue d'histoire*, no. 23 (March–April 2006): "Le regard du cinéaste," and the studies by François Amy de La Bretèque, "La représentation de l'histoire dans les films d'Éric Rohmer," *Cinéma et audiovisuel se réfléchissent. Réflexivité, migrations, intermédialité* (L'Harmattan, 2002); and "Éric Rohmer et son rapport à l'histoire, en particulier dans ses 'Tragédies de l'histoire,'" in *Rohmer en perspectives*, ed. Sylvie Robic and Laurence Schifano (Presses universitaires de Nanterre, 2013). On *Perceval*, the encounter between Éric Rohmer and Jacques Le Goff is interesting in its very difficulty: *Ça/Cinéma*, no. 17 (1978).
4. Interview with Rohmer, by Morrissey, *Historiens et cinéastes*, 207.
5. Éric Rohmer, "Note sur la mise en scène," typescript, IMEC, fonds Éric Rohmer, dossier "*La Marquise d'O . . .*, écriture de l'oeuvre" (*RHM* 10.8).
6. Interview with Rohmer, by Morrissey, *Historiens et cinéastes*, 207.
7. Denis Freyd went on to become an important producer, especially for the brothers Jean-Pierre and Luc Dardenne, Abderrahmane Sissako, and Patricia Mazuy.
8. Georges Duby and Philippe Ariès, eds., *The History of Private Life*, trans. Arthur Goldhammer, 5 vols. (Cambridge Mass.: Harvard University Press, 1987–1991).
9. Interview with Rohmer, by Morrissey, *Historiens et cinéastes*, 225.
10. Contract for the film *Les Jeux de société*, 9 November 1987, IMEC, fonds Éric Rohmer, dossier "*Les Jeux de société*, préparation du tournage" (*RHM* 93.2).
11. In his archives there are many photocopies of period musical scores and engravings, as well as books such as Eymery's *Les Jeux des quatre saisons ou les Amusements du jeune âge*, Bertin's

Jeux de l'enfance, and Delarue's *Jeux de l'enfance et de la jeunesse*, all copied at the Bibliothèque nationale.

12. The thirteenth century is seen through the game of Robin and Marion, as described in a text by Adam de la Halle; the time of Louis XIV is conveyed through blindman's bluff, as described in a poem by Régnier-Desmarets; the Louis XVI style follows the twists and turns of the game "I love my lover," as described in Panckoucke's *Encyclopédie méthodique*; the period of the Directory is concerned with *la sellette*, a betting game in fashion between the end of the Revolution and the beginning of the Consulate; the Imperial age is viewed through charades, as described in a vaudeville piece by Dumersan and Sewrin; finally, the July Monarchy was fascinated with *mouche*, a card game illustrated by a passage in Honoré de Balzac's *Béatrix*.

13. A thirteenth-century trouvère who wrote in the Picard language.

14. Letter from Denis Freyd to Charles Greber, 3 August 1990, IMEC, fonds Éric Rohmer, dossier "*Les Jeux de société*, préparation du tournage" (*RHM* 93.3).

15. Interview with Hervé Grandsart, 22 March 2011.

16. Ibid.

17. Louis Antoine Fauvelet de Bourienne (1769–1834).

18. This refers to Anne Baleyte, David Conti, Xavier Blanc, Florence Masure, Olivier Derousseau, Philippe Capelle, Gilles Masson, Pascal Derwel, Corinne Ortega, Véronique Gonse, Marie Ter-lutte, Isabelle Vazeille, and Bernard Debreyne.

19. Marc Joyeux, *Le Quotidien de Paris*, 20 August 1990.

20. Arielle Dombasle described Sophie Arnould this way: "Colorful, extraordinarily adventurous, living life to the hilt, through the Revolution, the Terror, and the Directory, in a terribly fanciful way." Interview with Arielle Dombasle, 24 October 2011.

21. Interview with Arielle Dombasle, 24 October 2011.

22. Quoted in Marie-Laure Guétin, "Des décors révolutionnés: le Pari(s) historique d'Éric Rohmer," in Robic and Schifano, *Rohmer en perspectives*.

23. Grace Elliott, *Journal de ma vie durant la Révolution française* (Éditions de Paris, 2001), 14.

24. Éric Rohmer, "Avant-propos," Elliott, *Journal de ma vie durant la Révolution française*, 5.

25. Ibid.

26. Ibid., 6.

27. The reference is to Jo Manning, an American scholar working on a biography of Grace Elliott for Simon & Schuster: *My Lady Scandalous: The Amazing Life and Outrageous Times of Grace Dalrymple Elliott, Royal Courtesan and Survivor of the Reign of Terror* (2005).

28. Interview with Rohmer, by Morrissey, *Historiens et cinéastes*, 214.

29. Letter from Hervé Grandsart to Éric Rohmer, IMEC, fonds Éric Rohmer, dossier "*L'Anglaise et le Duc*, écriture de l'oeuvre" (*RHM* 58.2).

30. All this spatial scouting work was later to be used by Hervé Grandsart in his collaborations with other filmmakers, for example, with Benoît Jacquot for *Adolphe*, *Sade* or *Les Adieux à la reine*.

31. Éric Rohmer, "Note d'intention," inserted at the beginning of the scenario for *The Lady and the Duke*, January 1999, IMEC, fonds Éric Rohmer, dossier "*L'Anglaise et le Duc*, écriture de l'oeuvre" (*RHM* 58.1).

32. Ibid.

33. Antoine de Baecque and Michel Vovelle, eds., *Images de la Révolution française* (Paris: Publications de la Sorbonne, 1988).

34. Interview with Éric Rohmer, by Patrice Blouin, Stéphane Bouquet, and Charles Tesson, *Cahiers du cinéma* (July–August 2001).

35. Interview with Arielle Dombasle, 24 October 2011.

36. Interview with Éric Rohmer, by Marie Marvier, *L'Express*, 6 September 2001.

37. Interview with Margaret Menegoz, 29 November 2010.

38. Éric Rohmer, "Mes dates clés," *Libération*, 17 March 2004.

39. Interview with Françoise Etchegaray, 2 July 2012.

40. Interview with Pierre Rissient, 23 November 2010.

41. Note from Françoise Etchegaray to Éric Rohmer, IMEC, fonds Éric Rohmer, dossier "Correspondance professionnelle, Françoise Etchegaray" (*RHM* 113).

42. Ibid.

43. Ibid.

44. Guétin, "Des décors révolutionnés: le Pari(s) historique d'Éric Rohmer"; Florence Bernard de Courville, "*L'Anglaise et le Duc*: le réel et le tableau," in *Rohmer et les Autres*, ed. Noël Herpe, 170–181 (Presses universitaires de Rennes, 2007).

45. Interview with Jean-Baptiste Marot, 29 October 2010.

46. Interview with Jean-Baptiste Marot, by Christophe Chauville, *Repérages* (September 2001).

47. These paintings were presented during an exhibit: *Tableaux pour le cinéma de Jean-Baptiste Marot*, Espace Commines, Paris 3e, from 21 to 29 September 2001. The catalogue provides good-quality reproductions.

48. *Duboi. Trucages numériques haute résolution, plateaux de tournage et motion control*, a leaflet issued by Duboi, 1995, IMEC, fonds Éric Rohmer, dossier "*L'Anglaise et le Duc*, préparation du tournage" (*RHM* 59.7).

49. Interview with Françoise Etchegaray, 2 July 2012.

50. Ibid.

51. Interview with Rohmer, by Morrissey, *Historiens et cinéastes*, 216.

52. Interview with Antoine Fontaine, by Patrick Caradec, *Le Film français*, 7 September 2001.

53. Interview with Pierre-Jean Larroque, by Michelle Humbert, in *Rohmer et les Autres*, 214.

54. Ibid.

55. Interview with Rohmer, by Morrissey, *Historiens et cinéastes*, 223.

56. Letter from Hervé Grandsart to Éric Rohmer, 1 July 2001, IMEC, fonds Éric Rohmer, dossier "*L'Anglaise et le duc*, réception" (*RHM* 67.8).

57. Interview with Françoise Etchegaray, 2 July 2012.

58. François Marthouret (Dumouriez), Léonard Cobiant (Champcenetz), Caroline Morin (Nanon), Alain Libolt (the Duke of Biron), Héléna Dubiel (Mme Meyler), Daniel Tarrare (Justin, the porter), Charlotte Véry (Pulchérie, the cook), Rosette (Fanchette, the servant from Meudon), Marie Rivière (Mme Laurent), Serge Renko (Vergniaud), Jean-Louis Valero (the singer), Michel Demierre (Chabot), Christian Ameri (Guadet), and Éric Viellard (Osselin). Rohmer also asked his friend François-Marie Banier to play the role of Robespierre. Banier put together a rather lordly Incorruptible, the complete opposite of the usually very dark image of Robespierre common in films about the Revolution. Here Robespierre pacifies, calms the hotheads, seeks the happy medium, and comes closer to present-day historians' interpretation, which emphasizes his responsibility for the Terror, but also the central, moderate place between factions and fanatics of all kinds that he tried to occupy throughout his political career. "Banier has the same sly look as Robespierre," was the only remark made by the filmmaker, who thought highly of this original interpretation.

59. Interview with Serge Renko, 12 March 2011.
60. Interview with Rohmer, by Morrissey, *Historiens et cinéastes*, 223.
61. Casting call, IMEC, fonds Éric Rohmer, dossier "*L'Anglaise et le Duc*, préparation du tournage" (*RHM* 62.4).
62. A British aristocrat, Pamela Harriman, Winston Churchill's daughter-in-law, was the first female U.S. ambassador to France, from 1993 to 1997.
63. Letter from Lucy Russell to Michelle [?], 19 August 1999, IMEC, fonds Éric Rohmer, dossier "*L'Anglaise et le Duc*, préparation du tournage" (*RHM* 62.5).
64. Interview with Lucy Russell, by Nicolas Rey, *Le Figaro Magazine*, 1 September 2001.
65. Interview with Jean-Claude Dreyfus, by Bruno Soriano, *France-Soir*, 14 July 2001.
66. Corinne Lellouche, "L'homme aux 2,500 petits cochons," *Paris Magazine*, 1 May 2000.
67. Other figures appearing in television commercials for pasta and detergents, respectively.
68. Interview with Rohmer, by Morrissey, *Historiens et cinéastes*, in the manuscript version, 94.
69. Interview with Françoise Etchegaray, 2 July 2012.
70. A former Carmelite monastery that had been transformed into a prison during the Revolution.
71. Ibid.
72. Interview with Bethsabée Dreyfus, 9 March 2011.
73. Interview with Françoise Etchegaray, by Stéphane Delorme, *Cahiers du cinéma*, February 2010.
74. Letter from Pierre Rissient to Éric Rohmer, 22 December 2000, IMEC, fonds Éric Rohmer, dossier "*L'Anglaise et le Duc, postproduction*" (*RHM* 66.3).
75. Interview with Pierre Rissient, 23 November 2010.
76. Letter from Pierre Rissient to Alberto Barbera, 19 June 2001, IMEC, fonds Éric Rohmer, dossier "*L'Anglaise et le Duc*, promotion" (*RHM* 66.4).
77. Letter from Catherine Tasca to Éric Rohmer, 7 September 2001, IMEC, fonds Éric Rohmer, dossier "*L'Anglaise et le Duc*, réception" (*RHM* 67.8).
78. Interview with Françoise Etchegaray, 2 July 2012.
79. Jim Hoberman, *Village Voice*, 14 May 2002
80. Bruce Handy, *Vanity Fair*, May 2002.
81. A. O. Scott, *New York Times*, 10 May 2002.
82. Letter from Maurice Béjart to Éric Rohmer, 11 October 2001, IMEC, fonds Éric Rohmer, dossier "*L'Anglaise et le Duc*, réception" (*RHM* 67.10).
83. Letter from Jeanne Balibar to Éric Rohmer [2001], IMEC, fonds Éric Rohmer, dossier "*L'Anglaise et le Duc*, réception" (*RHM* 67.10).
84. Pascal Manuel Heu, "*L'Anglaise et le Duc*, la critique et l'histoire, l'esthétique et l'idéologie: coïncidence ou corrélation?" (paper read at the colloquium Images, médias et politique, ed. Isabelle Veyrat-Masson, Jean-Pierre Bertin-Maghit, Sébastien Denis, and Sébastien Layerle, INA-ISCC-CNRS, Paris, 18–20 November 2010). This text can be consulted online at www.univ-paris3.fr/images-medias-et-politique-79687.kjsp.
85. *Télérama*, 5 September 2001.
86. Serge Kaganski, *Les Inrockuptibles*, 4 September 2001.
87. Jacques Morice, *Télérama*, 5 September 2001.
88. Olivier Séguret, *Libération*, 17 March 2004.
89. Jean Roy, *L'Humanité*, 7 September 2001.
90. One of *Ras l'front*'s main contributors was Éric Rohmer's own son, Denis, who on this occasion took the name of his grandmother: Monzat.

91. Jean-Pierre Jeancolas, *Politis*, 6 September 2001.

92. Angelo Rinaldi, *Le Nouvel Observateur*, 6 September 2001.

93. *Marianne*, 3 September 2001.

94. Gustave Le Bon, *Psychologie des foules* (Alcan, 1895).

95. Interview with Pascal Greggory, by Serge Bozon, *Cahiers du cinéma* (February 2010).

96. *Rivarol*, 31 August 2001.

97. Pierre Malpouge, *Présent*, 14 September 2001.

98. *Éléments*, December 2001.

99. Marina Grey, *Le général meurt à minuit: l'enlèvement des généraux Koutiépov (1930) et Miller (1937)* (Paris: Plon, 1981); Christian Brosio, "L'incroyable affaire Miller," *Le Spectacle du monde* (March 2004).

100. This plan failed because General Miller was poisoned, probably by one of his jailers.

101. Both La Petite Roquette and Centrale were prisons.

102. Interview with Éric Rohmer, by Marie-Noëlle Tranchant, *La Nouvelle Revue d'histoire*, no. 23 (March–April 2006).

103. Interview with Irène Skoblin, by Noël Herpe, Priska Morrissey, and Cyril Neyrat, *Vertigo*, no. 25 (Spring 2004).

104. Letter from Éric Rohmer to Irène Skoblin, 13 March 2003, IMEC, fonds Éric Rohmer, dossier "*Triple agent*, préparation du tournage" (*RHM* 133.12).

105. Andrei Korliakov, *Émigration russe en photos, 1917–1947* (YMCA Press, 2003).

106. Jérôme Lachasse, "Le Temps d'un retour: la représentation de l'entre-deux-guerres dans le cinéma français (1944–2011)" (master's thesis, Paris-I, 2013).

107. Interview with Éric Rohmer, by Noël Herpe and Cyril Neyrat, *Vertigo*, no. 25 (Spring 2004).

108. Ibid.

109. Ibid.

110. Ibid.

111. Interview with Françoise Etchegaray, 2 July 2012.

112. This story, the first Nabokov wrote in English, was later published in French translation in a collection entitled *Mademoiselle O*.

113. Vladimir Nabokov, *Mademoiselle O* (Paris: Presses Pocket, 1991). This copy, along with the Carte Orange coupon, is in the filmmaker's archives, IMEC, fonds Éric Rohmer, dossier "*Triple agent*, préparation du tournage" (*RHM* 133.10).

114. Nabokov, *Mademoiselle O*, 114.

115. A fear that was apparently ungrounded, since in spirit the two views of this affair by Nabokov and Rohmer are diametrically opposed.

116. Letter from Pierre Rissient to Éric Rohmer, 11 September 2001, IMEC, fonds Éric Rohmer, dossier "*L'Anglaise et le Duc*, réception du film" (*RHM* 67.8).

117. Interview with Pierre Rissient, 23 November 2010.

118. Interview with Françoise Etchegaray, 2 July 2012.

119. A Franco-German TV network that promotes programming in the areas of culture and the arts.

120. Ibid.

121. At Rohmer's request, Françoise Etchegaray selected about twenty minutes of filmed news that was finally reduced to a few significant shots placed at the beginning and the end of the film. These were Pathé newsreels: the formation of Léon Blum's cabinet at the time of the Popular

Front in 1936, the strikes, the meeting at which the president of the council declared his opposition to the war, and very beautiful images of the civil war in Spain, apparently shot by Joris Ivens. "Politics is referred to by the newsreels," Rohmer explained. "It had to be shown that we are moving into tragedy and that the time of the happiness of life was over: it's a classical procedure, which had already been used in broadcasts by Marc Ferro and by Harris and Sédouy. These are known facts but they allow us to indicate the climate of the time. I hesitated for a long time before including them, asking myself whether they weren't going to be shocking or out of tune, whether they would be useful . . . And it was while the film was being edited that I made my choice." *Vertigo*, no. 25 (Spring 2004).

122. Interview with Pierre Léon, by Marie Anne Guerin and Cyril Neyrat, *Vertigo*, no. 25 (Spring 2004).
123. Letter from Sylvie Pagé to Éric Rohmer and Françoise Etchegaray, 26 August 2002, IMEC, fonds Éric Rohmer, dossier "*Triple agent*, préparation du tournage" (*RHM* 69.8).
124. However, they were to choose him for the role of Boris in *Triple Agent*.
125. Letter from Irène Skoblin to Éric Rohmer, 16 July 2002, IMEC, fonds Éric Rohmer, dossier "*Triple agent*, préparation du tournage" (*RHM* 69.9).
126. Interview with Serge Renko, by Marie Anne Guerin, *Vertigo*, no. 25 (Spring 2004).
127. Interview with Pierre Léon, by Marie Anne Guerin and Cyril Neyrat, *Vertigo*, no. 25 (Spring 2004).
128. Interview with Serge Renko, 12 March 2011.
129. Interview with Françoise Etchegaray, 2 July 2012.
130. Ibid.
131. Interview with Larroque, by Humbert, in *Rohmer et les Autres*, 213–217.
132. Interview with Léon, by Guerin and Neyrat, *Vertigo*.
133. Interview with Bethsabée Dreyfus, 9 March 2011.
134. Interview with Françoise Etchegaray, 2 July 2012
135. Letter from Katerina Didaskalou to Éric Rohmer, 5 June 2003, IMEC, fonds Éric Rohmer, dossier "*Triple agent*, réception" (*RHM* 71.12).
136. Letter from Éric Rohmer to Katerina Didaskalou, IMEC, fonds Éric Rohmer, dossier "*Triple agent*, postproduction" (*RHM* 71.6).
137. Card from René Schérer to Éric Rohmer, 7 April 2004, IMEC, fonds Éric Rohmer, dossier "*Triple agent*, réception" (*RHM* 71.13).
138. Letter from François-Marie Banier to Éric Rohmer, 28 January 2004, IMEC, fonds Éric Rohmer, dossier "*Triple agent*, réception" (*RHM* 71.14).
139. Interview with Françoise Etchegaray, 2 July 2012.
140. Ibid.

13. A Tale of Winter: 2006–2007

1. Letter from Nicole Zucca to Éric Rohmer, 6 November 2007, IMEC, fonds Éric Rohmer, dossier "Correspondance professionnelle, Nicole Zucca" (*RHM* 113).
2. Letter from Sylvie Zucca to Éric Rohmer, [6 February 1999], IMEC, fonds Éric Rohmer, dossier "Correspondance professionnelle, Sylvie Zucca" (*RHM* 113).

3. Éric Rohmer, letter of recommendation for the Bibliothèque nationale François Mitterand, 23 September 2003, IMEC, fonds Éric Rohmer, dossier "*Les Amours d'Astrée et de Céladon*, écriture de l'oeuvre" (*RHM* 73.4).

4. *The Romance of Astrée and Céladon*, draft manuscript of the dialogues, IMEC, fonds Éric Rohmer, dossier "*Les Amours d'Astrée et de Céladon*, écriture de l'oeuvre" (*RHM* 72.13).

5. Tense and mood commonly used in early seventeenth-century French but seldom used now, even in literature.

6. Ségolène Royal, the candidate of the Socialist Party.

7. Interview with Éric Rohmer, by Noël Herpe and Philippe Fauvel, *Le Celluloïd et le Marbre* (Paris: Éditions Léo Scheer, 2011), 101.

8. The name of the d'Urfé family chateau.

9. Jean-Paul Pigeat, fax to Éric Rohmer, 24 January 1999, IMEC, fonds Éric Rohmer, dossier "Correspondance professionnelle, Jean-Paul Pigeat" (*RHM* 113).

10. Card from Françoise Etchegaray to Éric Rohmer, [2005], IMEC, fonds Éric Rohmer, dossier "*Les Amours d'Astrée et de Céladon*, préparation du tournage" (*RHM* 74.1).

11. Interview with Rohmer, by Herpe and Fauvel, *Le Celluloïd et le Marbre*, 100.

12. Interview with Serge Renko, 12 March 2011.

13. Interview with Rohmer, by Herpe and Fauvel, *Le Celluloïd et le Marbre*, 101.

14. Interview with Éric Rohmer, by Noël Herpe and Philippe Fauvel, *Positif* (September 2007).

15. Letter from Sylvie Zucca to Éric Rohmer, 2 October 2007, IMEC, fonds Éric Rohmer, dossier "Correspondance professionnelle, Sylvie Zucca" (*RHM* 113).

16. Éric Rohmer, manuscript text with a view to the trial concerning *The Romance of Astrée and Céladon*, [September 2007], IMEC, fonds Éric Rohmer, dossier "*Les Amours d'Astrée et de Céladon*, litige avec le Conseil général de la Loire" (*RHM* 78.19)

17. Ibid.

18. *VSD*, 5 September 2007.

19. *Charlie Hebdo*, 19 September 2007.

20. Interview with Rohmer, by Herpe and Fauvel, *Le Celluloïd et le Marbre*, 172.

21. Interview with Jean Douchet, 8 November 2010.

22. Éric Rohmer, draft manuscript of a speech paying homage to Pierre Zucca, IMEC, fonds Éric Rohmer, dossier "Papiers personnels" (*RHM* 134.22).

23. Éric Rohmer, "Lettre à Jacques Davila," *Cahiers du cinéma* (March 1990).

24. Letter from Éric Rohmer to Gilles Jacob, [1987], IMEC, fonds Éric Rohmer, dossier "Correspondance professionnelle, Gilles Jacob" (*RHM* 113).

25. Interview with Paul Vecchiali, 30 November 2010.

26. French pronunciation of "casting," read "casting couch."

27. Letter from Françoise Etchegaray to Éric Rohmer, IMEC, fonds Éric Rohmer, dossier "Correspondance professionnelle, Françoise Etchegaray" (*RHM* 113).

28. Interview with Pascal Ribier, 7 February 2011.

29. Interview with Diane Baratier, 11 March 2011.

30. Draft of a letter from Éric Rohmer to Nathalie Schmidt, [1996], IMEC, fonds Éric Rohmer, dossier "Correspondance professionnelle, Nathalie Schmidt" (*RHM* 113).

31. Olivier Séguret, *Libération*, 27 March 1998.

32. Card from Anne-Sophie Rouvillois to Éric Rohmer, [10 November 2004], IMEC, fonds Éric Rohmer, dossier "Correspondance professionnelle, Anne-Sophie Rouvillois" (*RHM* 113).

14. In Pain: 2001–2010

1. Interview with Barbet Schroeder, 7 December 2010.
2. Interview with Bethsabée Dreyfus, 9 March 2011.
3. "It was in that blessed time when above all other things / Paris proclaimed itself proud of its brothels. / One frequented by an Arabian prince, / Was located on Avenue Pierre-Ier-de-Serbie, / At number twenty-six, I'm told, though this address / These days houses only respectable offices."
4. "C'était au temps béni . . . ," note from Éric Rohmer to Françoise Etchegaray, IMEC, fonds Éric Rohmer, dossier "Correspondance professionnelle, Françoise Etchegaray" (*RHM* 113).
5. Louis Skorecki devoted two final series of columns to Éric Rohmer in June 2004 and in January 2005 before leaving *Libération* in 2006.
6. Éric Rohmer, *Le Celluloïd et le Marbre* (followed by a conversation with Philippe Fauvel and Noël Herpe), op. cit.
7. The interview with Éric Rohmer by Hélène Waysbord (2009) is included in DVD 2 of the boxed set *Le Laboratoire d'Éric Rohmer, un cinéaste à la Télévision scolaire*, (CNDP/CRDP/SCEREN, 2012).
8. Interview with Françoise Etchegaray, 7 June 2013.
9. Interview with Arielle Dombasle, 24 October 2011.
10. Interview with Bethsabée Dreyfus, 9 March 2011.
11. Ibid.
12. Ibid.
13. Interview with Jessica Forde, 24 November 2010.
14. Ibid.
15. Joëlle Miquel appealed this court verdict.
16. The different versions of the scenario of *Étoiles étoiles* were preserved by Françoise Etchegaray. We thank her for allowing us to consult these documents. Other versions can be found at IMEC, fonds Éric Rohmer, dossier "Karmas croisés" (*RHM* 79.13).
17. Interview with Françoise Etchegaray, 7 June 2013.
18. Resubmitted to the commission on advance on receipts in late 2010, after being reworked, *Étoiles étoiles* was rejected again.
19. Interview with Françoise Etchegaray, 7 June 2013.
20. Éric Rohmer, "Lettre ouverte à la comtesse de Ségur," 1952, IMEC, fonds Éric Rohmer, dossier "*Les Petites Filles modèles*, écriture de l'oeuvre" (*RHM* 79.5).
21. Éric Rohmer, "La Grande Comtesse modèle," IMEC, fonds Éric Rohmer, dossier "Éric Rohmer essayiste, critique littéraire" (*RHM* 99.20).
22. Ibid., 43.
23. Ibid., 1–2. According to most of the testimony by those who were present during the editing and saw a version of the film, the latter was longer than one hour and fifteen minutes. It was therefore a genuine feature film.
24. Ibid., 82.
25. Interview with Françoise Etchegaray, 7 June 2013.
26. Ibid.
27. Ibid.
28. Ibid.

29. Ibid.

30. Interview with Arielle Dombasle, 24 October 2011.

31. Interview with Jean Douchet, 8 November 2010.

32. Informed a few days earlier that Rohmer was dying, the editorial staff of *Libération* was able to offer readers an eleven-page special section on Tuesday, January 12. The front-page headline "Rohmer, au bout du conte" was accompanied by a photographic portrait taken by Carole Bellaïche in the late 1980s. The long obituary written by Philippe Azoury was followed by testimonials from Rohmerians such as Fabrice Luchini, Arielle Dombasle, Marie Rivière, Melvil Poupaud, Barbet Schroeder, Pascal Greggory, and Serge Renko, while Didier Péron's editorial deplored the "death of one of the greatest French filmmakers, a sort of national treasure or giant of the New Wave." Among the heirs, the press in general put forward a few names, Emmanuel Mouret and his films *Vénus et Fleur* and *Fais-moi plaisir!*, the German filmmaker Rudolf Thome, the Korean Hong Sang-soo. The critics Bertrand Bonello, Bruno Dumont, Jean-Claude Brisseau, Benoît Jacquot, Olivier Assayas, Arnaud Desplechin, Luc and Jean-Pierre Dardenne, and Danièle Dubroux saluted "the great geometer," the architect, the detective, even the "punk filmmaker." Three weeks later, *Cahiers du cinéma* also put Rohmer on its cover, and followed this with fifty pages devoted specially to analyses and testimonials. Among the latter, that of Mary Stephen, his film editor for the past twenty years and eight films, says: "I learned of his death when I returned from editing, on my birthday. I saw that way of saying goodbye as a particularly strong and affectionate sign on his part. It was a very Buddhist moment, because we are now linked forever. The same day, a longtime woman friend, whom I had introduced to Éric earlier, called me from Barcelona to tell me that she was expecting a baby and that she had left a message on Éric's answering machine to let him know. I am in regular communication with close *Rohmériennes*, including Françoise Etchegaray, who often interrupts our conversations to take care of her daughter, who has been pregnant for a few months. The last words of the last lines of Éric's feature film were: 'Live, Céladon, live, live, live!' We are alive. Éric would be very happy about that." All of the articles in the press and documents relating to the death of Éric Rohmer are preserved in the IMEC, fonds Éric Rohmer, dossier "Papiers personnels" (*RHM* 134.23).

33. Interview with Jean-Luc Godard, by Sylvain Bourmeau, Ludovic Lamant, and Edwy Plenel, *Mediapart*, 10 May 2010.

34. "Pourquoi filmez-vous?," special issue, *Libération* (May 1987).

Index

actors in, 350–51; international success of, 352; promotion of, 351–52

Pauwels, Louis, 93

Pays, Paysans, Paysages (Laffont and Royal), 421

Perceval (film), 192; actors and preparation for, 311; Almendros and misunderstanding over, 319; architecture and, 314–15; casting of, 310; children and publicity of, 317; costumes and accuracy for, 314; educational television version of, 307–8; failures of, 319–20; financial problems of, 317–18; historical reconstruction in, 476; Keaton and, 316; literal adaptation of, 308–9; music in, 311–13; painting and, 313–14; period detail in, 313–14; set design in, 314–15; theater as device in, 309–11

Perceval, ou le Conte du Graal (de Troyes), 307–8

Pérez, Michel, 320, 397

Peters, Dick, 565*n*189

Petites Filles modèles, Les, 4, 548–50; adaptation of novel for, 73–74; artifacts remaining from, 80; casting for, 75; CNC difficulties for, 76–77; crew conflict during production of, 78–79; crew for, 77; displeasure with, 81; editing of, 79; failure of, 80–81, 548–50; financing of, 72; Kéké, Joseph, halting completion of, 80; living conditions while making, 77–78; locations for, 76; press on filming of, 563*n*136; statement of intent for, 74–75

Philippe, Claude-Jean, 198–99, 223, 353, 360

Philippon, Alain, 405

philosophy: education and focus on, 12–13; *Tales of the Four Seasons* and, 435–36

Pialat, Maurice, 329, 438

piano, struggles learning, 467

Pickpocket, 123

Pierrat, Emmanuel, 546

Pigeat, Jean-Paul, 386, 522–23

"Pivot style" of improvisation, 401

Place royale, La, 373

Planchon, Roger, 486

Plato, 450

plausibility, *A Tale of Winter* and, 450–52

poetry: death and, 25; on Etchegaray, 542; film and, 189; love in, 24–25; on *Die Marquise von O*'s completion, 586*n*85; youth and, 24–25

Pointe courte, La, 563*n*124

"Polac style" of improvisation, 401

politics, 3; Algerian War and, 161–62; of *Cahiers du cinéma*, 159–61; denial of leftist, 207; environmentalism and, 417–19; of family, 6; film criticism in 1968 and, 207–9; film criticism in late 1940s and, 41–42; Mac-Mahon school and, 160–61; newsreels and, 608*n*121; *The Tree, the Mayor, and the Médiathèque* and, 419–20, 430. *See also* conservatism

Politoff, Haydée, 217–18, 254

Pommereulle, Daniel, 217

Ponge, Francis, 24

Portal, Alexia, 447

portrait painting, 24

Positif, 466, 543

Possessed, The (Dostoyevsky), 508

Poucette et la légende de Saint-Germain-des-Prés, 33–34

Poupaud, Melvil, 460–61, 463, 465

"Pour un cinéma parlant" (Schérer, Maurice), 44

"Pour un cinéma politique" (Godard, Jean-Luc), 54

Pouvaret, Jérôme, 492

Practice of Cinema, teaching, 293

Prades film festival, 222

Prat, Georges, 323, 331, 356

Présent, 504

Présentation, 71–72

"Preston Sturges, ou la mort du comique" (Schérer, Maurice), 45

Prince of Homburg, The, 272

privacy. *See* secrecy

Proposition, La, 537–38

pseudonyms: of Chabrol, 55; in *La Gazette du cinéma*, 55–56; of Godard, Jean-Luc, 71; influences in choosing, 55–56; meaning of, 56; secrecy and, 1–2; for short films, 56–58, 538; of Truffaut, 55; writing and, 24–26, 30, 55

Pubert, Jean-Claude, 423–24, 433